HENRY MOORE

For Rachel, Elisha, and Keith

ULRICH RUCHTI, DESIGNER
ANN GOEDDE, EDITOR

First published in the UK in 1977 by
Thames and Hudson Ltd, London

Printed and bound in Japan

SCULPTURE AND ENVIRONMENT

PHOTOGRAPHS AND TEXT
BY DAVID FINN

FOREWORD BY
KENNETH CLARK

COMMENTARIES BY
HENRY MOORE

—

THAMES AND HUDSON
LONDON

ACKNOWLEDGMENTS

Working on this book over a period of years has been a major adventure for me, and there have been many times when I felt the project would fail. It would certainly have failed if it had not been for the extraordinary support I received from good friends and members of my family at critical moments, and I am grateful for the opportunity to thank them publicly for their generous help.

As in any major undertaking of this sort, it is impossible to speak directly to all who should be thanked. For instance there is that wonderful Miss Suzuki in Tokyo who managed to discover against all odds where the missing Henry Moore *Upright Motive* was hiding; I give her due credit in my introductory essay, but alas I have lost track of her and cannot thank her properly. There is the sympathetic woman at a switchboard in Zollikon, Switzerland, who searched her memory to recall that the *Falling Warrior* was on the shore of Lake Zurich when all others in town seemed to have forgotten. And there is the good-natured soul who loaned a camera to me to photograph the *Reclining Figure* in front of the NorthPark Bank in Dallas, Texas, which I came across unexpectedly on a business trip to Texas.

But there are also many friends, associates, and members of my family who deserve all the thanks I can give them. There is my Japanese colleague, Tom Hara, who made certain that I fulfilled all my business obligations while I was hunting for the Henry Moore sculpture in Tokyo. There is also Mr. Masahide Totoki, president of Dentsu PR Center, Ltd., in Tokyo, who arranged a veritable caravan to take me and my family and friends to the magnificent open-air museum at Hakone to photograph the great *Reclining Figure: Arch Leg*. There is Ms. Lorna Noble of Hewland, Ruder & Finn in London, who performed the heroic task of arranging to get my photographs out of customs at Heathrow Airport and of providing tape-recording and slide-projector equipment for the recording sessions at the homes of Lord Clark in Saltwood and Henry Moore in Much Hadham. There is my son, Peter, who spent many hours organizing and marking hundreds of slides for the presentation to Clark and Moore in England and who, together with my nephew Brian Ruder, helped carry my heavy photographic equipment around Australia, Japan, Italy, and England.

My daughter Amy, who is a gifted photographer in her own right, was of immense help in printing many of the black-and-white photographs that appear in the book. And to round out my debt to my family, I owe an apology to my niece and nephew Robin and Danny Halpern-Ruder for not attending their wedding (for which I could scarcely forgive myself) scheduled in Harrison, New York, on the very day I had what I thought to be an unbreakable date on the other side of the Atlantic to present my photographs to Lord Clark and Henry Moore.

The artbook publisher Harry N. Abrams was, of course, the great inspiration for this book, as he has been for all those I have produced in recent years. Not only did he encourage me to do the impossible, photographing Henry Moore sculptures in so many countries, but it was he who devised the format of the book to give the reader the experience of joining the photographer in his travels. And it was Martin Levin, Vice-President of Times Mirror, who urged me to write my own text explaining how the book was initially conceived and describing some of the memorable experiences I had in searching out sculptures in different countries and photographing them in all kinds of weather.

Finally there is my wife, Laura, whose patience those many times when I shamelessly kept her waiting in order to capture just a few more of the marvelous details that kept floating into my lens was stretched to extraordinary limits. More than once in the early days of our adventures she threatened never to travel with me again if I insisted on taking my camera along! To my great relief she never carried out her threat, and eventually I learned to measure my photographing time accurately enough to avoid imposing a burden on her. Indeed our trips proved to be so rewarding to both of us that Laura has since become a most gifted travel agent, dedicated to helping others find the same joy in visiting distant lands that we have. We both share the hope that this record of our travels will inspire others to make similar journeys and to discover for themselves those beautiful places where art and environment interact to create rare experiences that can never be forgotten.

CONTENTS
AND
ALPHABETICAL LIST
OF
SCULPTURES
WITH
LOCATIONS

CONTENTS

Alphabetical List of Sculptures
 with Locations 10
Foreword by Kenneth Clark 13
Introduction: Photographing Henry Moore
 Sculptures Around the World 23

JAPAN 45
Hakone, *Reclining Figure: Arch Leg* 46
Tokyo, *Upright Motive #8* 52

AUSTRALIA 57
Melbourne, *Draped Seated Woman* 58
Adelaide, *Reclining Connected Forms* 62

ISRAEL 67
Tel Aviv, *Reclining Figure* 68
Jerusalem, *Three Piece #3, Vertebrae* 73
Jerusalem, *Upright Motive #7* 78
Jerusalem, *Reclining Figure: External
 Form* 82
Jerusalem, *Relief #1* 87
Jerusalem, *Draped Seated Woman* 90

FRANCE 95
Paris, *Reclining Figure* 96

ITALY 103
Turin, *Two-Piece Reclining Figure #5* 104
Prato, *Square Form with Cut* 108

SWITZERLAND 115
Zurich, *Working Model for UNESCO
 Reclining Figure* 116
Zollikon, *Falling Warrior* 120

GERMANY 125
Freiburg, *Reclining Figure: External Form* 126

Stuttgart, *Draped Reclining Woman* 130
Cologne, *Draped Reclining Figure* 134
Duisburg, *Two-Piece Reclining Figure #1* 138
Duisburg, *Working Model for Locking
 Piece* 144
Essen, *Upright Motive #1: Glenkiln
 Cross* 148
Recklinghausen, *Two-Piece Reclining
 Figure #5* 152
West Berlin, *The Archer* 157

THE NETHERLANDS 161
Arnhem, *Warrior with Shield* 162
Otterlo, *Upright Motives #1, #2, #7* 168
Otterlo, *Two-Piece Reclining Figure #2* 174
Otterlo, *Animal Head* 176
Rotterdam, *Wall Relief* 178

BELGIUM 183
Antwerp, *King and Queen* 184
Brussels, *Locking Piece* 190

DENMARK 195
Louisiana, *Two-Piece Reclining
 Figure #5* 196

SWEDEN 203
Goteborg, *Two-Piece Reclining Figure #3* 204

ENGLAND 209
London, *Knife-edge: Two Piece* 210
London, *Locking Piece* 216
London, *Time/Life Screen* 222
London, *Draped Reclining Figure* 230
London, *Three Standing Figures* 233

London, *Reclining Mother and Child* 240
London, *Draped Seated Woman* 244
London, *Two-Piece Reclining Figure #3* 246
London, *Two-Piece Reclining Figure #1* 248
Harlow New Town, *Harlow Family Group* 252
Harlow New Town, *Upright Motive #2* 256
Stevenage, *Family Group* 258
Totnes, *Memorial Figure* 264
Cambridge, *Three-Piece Reclining
 Figure #1* 268
Cambridge, *Falling Warrior* 272
Cambridge, *Seated Man* 276

SCOTLAND 281
Edinburgh, *Reclining Figure* 282
Edinburgh, *Two-Piece Reclining
 Figure #2* 288
Shawhead, *Standing Figure* 292
Shawhead, *King and Queen* 298
Shawhead, *Upright Motive #1:
 Glenkiln Cross* 306
Shawhead, *Two-Piece Reclining
 Figure #1* 308

IRELAND 313
Dublin, *Standing Figure: Knife-edge* 314
Dublin, *Reclining Connected Forms* 318

CANADA 321
Toronto, *The Archer* 322

THE UNITED STATES 327
New York, *Reclining Figure* 328
New York, *Family Group* 338
New York, *Working Model for The Arch* 342
New York, *Animal Form* 346
New York, *Three-Way Piece #1: Points* 352
New York, *Reclining Connected Forms* 356

Purchase, New York, *Reclining Figure* 360
Purchase, New York, *Working Model for
 Locking Piece* 364
Purchase, New York, *Double Oval* 368
Purchase, New York, *Large Two Forms* 374
Rochester, New York, *Three-Piece
 Reclining Figure #1* 380
Rochester, New York, *Upright
 Motive #5* 386
Rochester, New York, *Upright
 Motive #8* 392
Buffalo, New York, *Two-Piece
 Reclining Figure #1* 396
New Haven, Connecticut, *Draped Seated
 Woman* 400
Providence, Rhode Island, *Three-Piece
 Reclining Figure #2: Bridge Prop* 404
Princeton, New Jersey, *Oval with Points* 410
Philadelphia, *Three-Way Piece #1:
 Points* 416
Baltimore, *Reclining Connected Forms* 422
Columbus, Indiana, *The Arch* 430
Moline, Illinois, *Hill Arches* 438
Chicago, *Nuclear Energy* 446
Dallas, Texas, *Two-Piece Reclining
 Figure #9* 452
Fort Worth, Texas, *Upright Motives #1,
 #2, #7* 456
Stanford, California, *Working Model
 for The Arch* 462
Los Angeles, *Three-Piece Reclining
 Figure #1* 464
Universal City, California, *Standing
 Figure: Knife-edge* 468
Los Angeles, *Two-Piece Reclining
 Figure #3* 470
THE FLORENCE EXHIBITION, 1972 473
HENRY MOORE'S HOME IN MUCH
 HADHAM 485

ALPHABETICAL LIST OF SCULPTURES
WITH LOCATIONS

(The numbers following the locations refer to pages)

Animal Form, 1969–70	The Museum of Modern Art, New York	346–51
Animal Head, 1956	Kröller-Müller Museum, Otterlo, the Netherlands	176–77
The Arch, 1963–69	Bartholomew County Public Library, Columbus, Indiana	430–37
	Forte di Belvedere, Florence (exhibition)	482
The Arch, Working Model for, 1962–63	The Museum of Modern Art, New York	342–45
	Stanford University, California	462–63
The Archer, 1964–65	National Museum, West Berlin	157–60
	Nathan Phillips Square, Toronto	322–26
Double Oval, 1967	Pepsico, Inc., World Headquarters, Purchase, New York	368–73
Draped Reclining Figure, 1952–53	Wallraf-Richartz-Museum, Cologne, Germany	134–37
	Time/Life Building, London	230–32
Draped Reclining Woman, 1957–58	Kunstgebäude, Stuttgart, Germany	130–33
Draped Seated Woman, 1957–58	National Gallery of Victoria, Melbourne, Australia	58–61
	Hoglands, Much Hadham, England	492
	Hebrew University, Jerusalem	90–94
	London County Council (Stifford Estate), Stepney	244–45
	Yale University, New Haven, Connecticut	400–403
Falling Warrior, 1956–57	Zollikon, Switzerland	120–24
	Clare College, Cambridge University, England	272–75
Family Group, 1948–49	Barclay School, Stevenage, Hertfordshire, England	258–63
	The Museum of Modern Art, New York	338–41
Harlow Family Group, 1954–55	Harlow New Town, Essex, England	252–55
Hill Arches, 1973	Deere & Company, Moline, Illinois	438–45
King and Queen, 1952–53	Middelheim Open-Air Museum, Antwerp	184–89
	Glenkiln, Shawhead, Dumfriesshire, Scotland	298–305
Knife-edge: Two Piece, 1962–65	The House of Lords, London	210–15
	Hoglands, Much Hadham, England	491
Large Two Forms, 1966–69	State University of New York, Purchase	374–79
	Forte di Belvedere, Florence (exhibition)	475
Locking Piece, 1963–64	Banque Lambert, Brussels	190–94
	Tate Gallery, The Embankment, London	216–21
	Hoglands, Much Hadham, England	487
Locking Piece, Working Model for, 1962	Lehmbruck Museum, Duisburg, Germany	144–47
	Pepsico, Inc., World Headquarters, Purchase, New York	364–67
Memorial Figure, 1945–46	Dartington Hall, Totnes, Devonshire, England	264–67
Nuclear Energy, 1964	University of Chicago, Illinois	446–51

Oval with Points, 1969	Princeton University, New Jersey	410–15
	Forte di Belvedere, Florence (exhibition)	474
Reclining Connected Forms, 1969	University of Adelaide, Australia	62–66
	Trinity College, Dublin	318–20
	900 Park Avenue, New York	356–59
	United States Fidelity and Guarantee Co., Baltimore	422–29
Reclining Figure, 1951	Scottish National Gallery of Modern Art, Edinburgh	282–87
Reclining Figure, 1956	Pepsico, Inc., World Headquarters, Purchase, New York	360–63
Reclining Figure, 1957–58	UNESCO Building, Paris	96–102
Reclining Figure, Working Model for UNESCO, 1957	Kunsthaus, Zurich, Switzerland	116–19
Reclining Figure, 1963–65	Lincoln Center, New York	328–37
Reclining Figure, 1969–70	Tel Aviv Museum, Israel	68–72
	Forte di Belvedere, Florence (exhibition)	481
Reclining Figure: Arch Leg, 1969–70	The Woods of Sculpture, Hakone, Japan	46–51
Reclining Figure: External Form, 1953–54	Israel Museum, Jerusalem	82–86
	University of Freiburg, Germany	126–29
Reclining Mother and Child, 1960–61	Minerals Separation Building, London	240–43
Relief #1, 1959	Israel Museum, Jerusalem	87–89
	Hoglands, Much Hadham, England	490
Seated Man, 1964	Lekhampton House, Cambridge University, England	276–80
Sheep Piece, 1972	Hoglands, Much Hadham, England	489
Square Form with Cut, 1969–70	Prato, Italy	108–14
	Forte di Belvedere, Florence (exhibition)	477
Standing Figure, 1950	Glenkiln, Shawhead, Dumfriesshire, Scotland	292–97
	Forte di Belvedere, Florence (exhibition)	483
Standing Figure: Knife-edge, 1961	MCA Building, Universal City, California	468–69
	St. Stephen's Green Park, Dublin	314–17
	Forte di Belvedere, Florence (exhibition)	479
Sundial, 1965–66	Hoglands, Much Hadham, England	488
Three Piece #3, Vertebrae, 1968–70	Israel Museum, Jerusalem	73–77
Three-Piece Reclining Figure #1, 1961–62	Churchill College, Cambridge University, England	268–71
	Rochester Institute of Technology, New York	380–85
	Los Angeles County Museum of Art, California	464–67
Three-Piece Reclining Figure #2: Bridge Prop, 1963	Brown University, Providence, Rhode Island	404–9
Three Standing Figures, 1947–48	Battersea Park, London	233–39
Three-Way Piece #1: Points, 1964	Columbia University, New York	352–55
	Fairmount Park, Philadelphia	416–21

Time/Life Screen, 1952–53	Time/Life Building, London	222–29
Torso, 1967	Forte di Belvedere, Florence (exhibition)	480
Two-Piece Reclining Figure #1, 1959	Lehmbruck Museum, Duisburg, Germany	138–43
	Chelsea School of Art, London	248–51
	Glenkiln, Shawhead, Dumfriesshire, Scotland	308–12
	Albright-Knox Art Gallery, Buffalo, New York	396–99
Two-Piece Reclining Figure #2, 1960	Kröller-Müller Museum, Otterlo, the Netherlands	174–75
	Scottish National Gallery of Modern Art, Edinburgh	288–91
Two-Piece Reclining Figure #3, 1961	Goteborg, Sweden	204–8
	London County Council (Brandon Estate), Southwark	246–47
	University of California at Los Angeles	470–72
Two-Piece Reclining Figure #5, 1963–64	Società Assicuratrice Industriale, Turin, Italy	104–7
	Festspielhaus, Recklinghausen, Germany	152–56
	Louisiana Museum, Humblebaek, Denmark	196–202
Two-Piece Reclining Figure #9, 1968	NorthPark National Bank, Dallas, Texas	452–55
Two-Piece Reclining Figure: Points, 1969–70	Forte di Belvedere, Florence (exhibition)	476
Upright Motive #1: Glenkiln Cross, 1955–56	Folkwang Museum, Essen, Germany	148–51
	Glenkiln, Shawhead, Dumfriesshire, Scotland	306–7
	Forte di Belvedere, Florence (exhibition)	484
Upright Motive #2, 1955–56	Harlow New Town, Essex, England	256–57
	Hoglands, Much Hadham, England	486
Upright Motive #5, 1955–56	Formerly on loan, Rochester Memorial Art Gallery of the University of Rochester, New York	386–89
Upright Motive #7, 1955–56	Israel Museum, Jerusalem	78–81
Upright Motive #8, 1955–56	Chiyoda Insurance Co., Tokyo	52–56
	Formerly on loan, Rochester Memorial Art Gallery of the University of Rochester, New York	392–95
Upright Motives #1, #2, #7, 1955–56	Kröller-Müller Museum, Otterlo, the Netherlands	168–73
	Amon Carter Museum of Western Art, Fort Worth, Texas	456–61
Wall Relief, 1955	Bouwcentrum, Rotterdam, the Netherlands	178–82
Warrior with Shield, 1953–54	Arnhem, the Netherlands	162–67
Woman, 1957–58	Forte di Belvedere, Florence (exhibition)	478

FOREWORD
BY
KENNETH CLARK

No doubt the all-important moment in the creation of a work of art is the moment in which it is conceived in the imagination—the moment realized in the sketch or maquette. The next important step is the execution, in which the first conception must be consolidated and enlarged. But there remains a third stage, much less vital, but still highly valued in all the great ages of art—the presentation. A work of art should not exist in a vacuum. This was taken for granted in Gothic times, when sculpture was generally integrated with architecture. But even in the Renaissance, when the individual work of art began to claim autonomy, great pains were taken in placing and presenting it. In Florence a committee of artists, including Leonardo da Vinci, spent days considering the right position of works such as Donatello's *Judith and Holofernes* and Michelangelo's *David*. As for the present fashion of showing pictures without frames, it would have seemed inconceivable during the Renaissance, when the frame often preceded the realization of the picture. To treat works of art as if they were pure essences to be held up to the light in a test tube is historically, as well as aesthetically, ludicrous.

This is particularly true of Henry Moore's sculpture. It is closely connected with the earth and is an emanation of vital forces; it is also a concentration and rediffusion of space. Placement (to use a term adopted in this book) can completely alter these factors. Thoroughly to understand Moore's sculpture we should see his greatest pieces under varying circumstances, and, by a fortuitous

coincidence, this is now possible. David Finn, a photographer of genius, is a passionate and most perceptive admirer of Moore's work and owns several of the sculptor's major pieces, so he has learned how to look at them with the daily consideration that they require. This knowledge he has already shown in his remarkable book *As the Eye Moves*. It happens also that his profession takes him all over the world—to Japan and Australia no less than to Europe and many parts of the United States. He can, therefore, see and photograph most of the great Moore sculptures that are scattered around the globe and compare the settings of different casts of the same piece—in Australia and Ireland, in Jerusalem and the Netherlands, in England and Germany. The result is most illuminating and worth a shelf of words. In fact, David Finn has added some words, notes to each set of photographs, which show a remarkable understanding of Moore's work and, in their straightforward way, are more enlightening than the metaphysical speculations of critics. They are perfectly in keeping with Moore's own comments on the photographs.

The photographs are superb. One can believe David Finn when he says that while he is photographing a piece by Henry Moore he is in a state of total absorption like that experienced during a moment of creation. It is extraordinary how he has responded to the different messages the pieces give in their different situations.

What general conclusions can one draw from this book? First, that sculpture

in the streets of modern cities is no longer viable and that even in city squares or piazzas it is seldom a source of satisfaction. This is due to the pressure of modern life and to our enemy-friend the internal-combustion engine. In the cities of today everyone is hurrying about his business, traffic roars by, and if someone were to pause and look at a piece of sculpture at the junction of two roads, he might risk his life. Moore himself, in one of his comments (see p. 164), gives a good example of the futility of placing sculpture in busy thoroughfares, Hubert Le Sueur's statue of Charles I at the junction of Whitehall and Trafalgar Square, which no one could walk around without risk to life and limb. At least

BIRDCAGE WALK, LONDON

three of Moore's works in London attract no attention because of their locations. One of them, the first to be executed, is the screen of four reliefs above the second floor of the Time/Life Building in Bond Street. These reliefs are among the best of Moore's abstract designs. They were intended to be mounted on a single rod, so that they could be turned around and set at different angles, but the authorities found that the rod might rust and the reliefs fall onto the heads of passers-by. In fact nobody raises his eyes to them, and it would be much better if they were in a sculpture gallery, where they could be seen at eye level and rotated.

Another Moore sculpture in London that is often overlooked is the two-piece figure opposite the House of Lords. David Finn records the policeman's comment

on it (see p. 210) and I do not doubt that this would represent the opinion of 99 percent of those who notice the work at all. But very few do, as they are thinking only of the bus that they hope to catch a few yards further on. As a matter of fact, I think that this piece, although one of Moore's most refined and subtle works, is too self-contained for its position. One of the great craggy recliners, that on pages 380–85 for example, would have better withstood the competition of Pugin's Neo-Gothic architecture—but I doubt if the policeman would have liked it any better. I am amazed to find that there is in London, beside a street called Birdcage Walk, which I frequently traverse, a very fine piece of Moore's sculpture that I have never noticed (see pp. 240–43). It seems from the photographs to be quite nicely placed. But what a waste!

The most ironic example of a wasteful urban location is not in philistine England, but in Arnhem, the Netherlands. David Finn inquired of the city's inhabitants, the hotel porters, the museum staff, where he could find Henry Moore's *Warrior with Shield* (see pp. 162–67). Not one of them knew. He found it at last in the very center of the town, at the junction of two main streets, and photographed it most beautifully in the morning mists. Apparently no one had looked at the piece for years. Here I should add that David Finn, in addition to his other qualifications, has amazing tenacity of purpose. His account of how he ran to earth pieces such as the *Chiyoda* figure in Tokyo (see pp. 52–56) recalls passages from Robert Louis Stevenson's *Kidnapped*. One cannot resist the somewhat

CHIYODA INSURANCE CO., TOKYO

disillusioning thought that many pieces that must have cost their purchasers tens of thousands of pounds have made no impact whatsoever on the public.

This conclusion should not deter architects from including pieces of Moore's sculpture in their plans. Inevitably, much of Moore's sculpture must be put into a semi-urban, or at least an architectural, setting, and those pieces that have been commissioned by civic authorities or large corporations will have to be related to

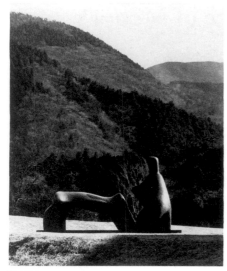
HAKONE, JAPAN

public buildings. Here we reach a second difficulty of placement. In Gothic, Renaissance, and Baroque times there was an organic relationship between architecture and sculpture, because ornament and building maintained a unity of style. But modern architecture is devoid of ornament. Moore's sculptures, with their bursting vitality, their confluence of living forces, can have no organic relationship with austere glass boxes or cement beehives. The relationship can only be that of contrast. It must be admitted that if the sculpture is not placed too near the building, and if the building itself has some distinction, this contrast can be effective (see pp. 52–56; 368–73). But when the buildings are not only modern but commonplace, Moore's sculpture cannot participate in a general impression and can satisfy only those who are prepared to concentrate on its formal

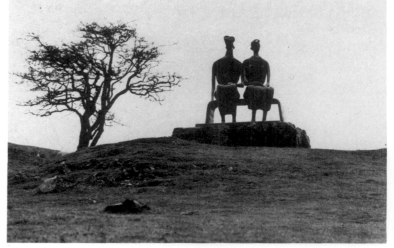
GLENKILN, SCOTLAND

qualities in isolation (see pp. 244–45; 246–47). One must hope that the taxpayers never discovered what had been paid for this beautiful, but ineffective, addition to their sordid surroundings. Also, Moore's sculpture gains nothing from being outdoors if the setting is cramped (see pp. 222–29) or includes too many discordant types of architecture (see pp. 422–29).

On the whole, the most successful relationships between works by Moore and examples of modern architecture are to be found on college campuses (see pp. 90–94; 380–85; 410–15)—and even more so in the spacious surroundings of modern offices, such as those of Pepsico, Inc., at Purchase, New York (see pp. 360–79). In these locations the figure is not only placed with a sufficient surrounding of grass and trees, but with the possibility of a skyline; also, it is seen by numerous people every day. The ideal of public display, it seems to me, has been achieved at the Kröller-Müller Museum at Otterlo, the Netherlands, where the three *Upright Motives* (see pp. 168–73) must bring to a halt the most hasty visitor, and the beautiful *Reclining Figure* (see pp. 174–75) seems to grow out of the earth and become an inhabitant of the woods. Moore himself does not think it gets enough light and prefers another piece in the bright sunshine of Israel (see pp. 82–86). But I think he can afford to have one work in which his mysterious connection with natural forces is unmistakable.

I have progressed from architectural settings to those that Moore likes best, where the sculpture is related to sky, trees, and rocks with no disturbing verticals and horizontals, and there is no doubt at all that these are the placements

in which his work can be seen at its best. A splendid example is at the Israel Museum (see pp. 73–77); another, even more moving in its tranquil acceptance of natural beauty, is in the outdoor sculpture museum at Hakone, Japan (see pp. 46–51); and a magnificent setting is that of the piece by the sea at the Louisiana Museum in Humblebaek, Denmark (see pp. 196–202). These are not only ideal settings visually; the fact that the sculpture can be reached only after a short walk puts the spectator in the right frame of mind. All great works of art should be approached in a spirit of pilgrimage.

For this reason the supreme examples of siting Moore's work are Tony Keswick's placements of four pieces on his sheep farm at Glenkiln in Dumfriesshire, Scotland (see pp. 292–312). To visit the farm involves a long motor drive through beautiful country and reaching at least one of the sculptures demands a considerable climb. But everyone who sees the works in this setting comes away deeply moved. These placements could not have been achieved by a public body, however enlightened—only by an individual, with a deep admiration for Moore's work, a creative imagination, and a large area to explore. The siting of the Glenkiln pieces is what one might call a Wordsworthian use of sculpture and is, as far as I know, unique.

This book makes one realize that the appeal of Moore's sculpture is almost universal. France, as usual, is an exception; the only Moore in France, that in front of the UNESCO Building in Paris, was put there by an international team of architects and an English secretary general, and its position has since been

ruined by rebuilding. But to look through the Table of Contents is to see that Moore's sculpture has spread around the world in a way that has no equal. There may be in this an element of prestige and competition. But the real explanation is that in an age of materialism, when rigid architecture and rapid transport have made it impossible for us to associate with the underlying powers of physical life, both geological and organic, the contemplation of Moore's sculpture can bring our minds back to the basis of nature, to the force of gravity and the inexplicable power that enables a tree to support its branches or a child to be born.

I have been looking with deep admiration at Moore's work for forty-six years and have had the privilege of seeing many of his sculptures in his company at various stages of their evolution, so I ought to know his work fairly well. But David Finn's photographs of the pieces in their different surroundings have shown me much that I did not see before. They are the ideal "follow-up" to the great Florence exhibition, which was a revelation to even the most passionate admirer of Henry Moore and left his few detractors speechless. Nothing can take the place of a real experience, but David Finn's photographs are the next best thing.

INTRODUCTION
PHOTOGRAPHING
HENRY MOORE
SCULPTURES
AROUND THE
WORLD

The idea for this book emerged one day in 1970 during a lunch with Henry Moore; Harry Abrams, the publisher; and his editor-in-chief, Milton Fox. Moore was in New York for the joint exhibition of his works, "Henry Moore: Carvings 1961–70, Bronzes 1961–70," at the Marlborough and Knoedler Galleries. My book *As the Eye Moves* (New York, 1973), which contains over one-hundred photographs of a single Henry Moore sculpture, was scheduled for publication by Abrams, and we found ourselves talking about other books that might be published on his work in the future.

In the course of the conversation Moore explained some of his ideas about sculpture and its environment. He said that he thought sculpture looked best out-of-doors, where it has the most light and can be seen against the sky or other backgrounds provided by nature. He also believes that a work of sculpture interacts with its environment and that casts of the same work in different locations produce different experiences. To illustrate his point, he referred to the placement of some of his own works in different cities around the world, and it suddenly occurred to me that Henry Moore probably has more sculpture in public places throughout the world than any other sculptor in history. Indeed the quality that has made his works landmarks in so many different countries is the universality of his vision.

"How about a book on Henry Moore sculptures around the world?" I asked. "With me doing the photography, of course," I added cheerfully. The others

laughed. "That's quite an excuse for traveling," Moore remarked. "If you'll take the photographs, we'll publish it," Abrams replied—half seriously, I thought at the time. But for me it was the beginning of an enterprise with many rewards—not only the opportunity to travel widely but, what was even more exciting, to meet frequently with Moore to review the steadily growing collection of photographs for the projected volume.

 The first step was for Henry Moore's devoted secretary, Mrs. Betty Tinsley, to make up a list of public places in which, according to her records, Henry Moore sculptures were located. This took her a few weeks, but in due time I received a detailed memorandum from her with the requested information, and it became my travel guide for the following four years.

Without Mrs. Tinsley's list, this book would never have existed. Even with it, however, there were many difficulties in locating the sculptures. Mrs. Tinsley had the names of the sculptures and the cities in which they were located—but no addresses. Occasionally she had been given the name of a museum or of a company in a particular city, but even then, the information sometimes proved to be incorrect.

And so my travels around the world in search of Moore sculptures were indeed an adventure, a journey across continents that I undertook with specific goals in mind but no clear idea of how I would achieve them. It proved to be a great experience.

In almost every city I visited, the task of locating the sculpture (and in some instances that of photographing it) became a story in itself. Telling just a few of these stories helps to explain how the project was carried out.

A few months after the plan for the book was conceived, I was in Tokyo in connection with some other assignments. Mrs. Tinsley's list indicated that a cast of Henry Moore's *Upright Motive #8* (see pp. 52–56) was owned by the Okura Company in Tokyo. I decided to start my photographing for the book with this sculpture, not knowing that the information on Mrs. Tinsley's list was incorrect.

I knew that the Okura Hotel had a museum on its grounds, and so, on my first day in Tokyo, just before going into my initial round of meetings, I asked Miss Masa Suzuki, a most efficient secretary from Dentsu PR Center, Ltd., to check with the hotel and find out exactly where the Moore sculpture was. Later in the day I returned, expecting to have all the details, but, to my dismay, I learned that the management of the Okura Hotel knew nothing about a Henry Moore sculpture. "How could that be?" I asked incredulously. Perhaps, I thought, the name Henry Moore was unfamiliar to the Japanese, in which case the sculpture might be there, as indicated by Mrs. Tinsley, without being recognized by the hotel management as a work by Moore. I took a quick taxi ride over to the hotel,

looked in every corridor, lobby, meeting room, garden, etc., for the *Upright Motive*. No Henry Moore!

Back I went to our office to talk to my friend Miss Suzuki about other Okura companies which might be located in Tokyo. "Are you kidding?" she asked. "Okura is as common a name in Japan as Smith is in the United States!" She would have to check through scores of listings in the telephone book if she were to do a thorough search of all the Okuras in Tokyo. I felt we had no other choice and persuaded her to spend most of the following day doing just that.

At the end of the second day I received bad news again. There was no Okura Company in Tokyo with a Henry Moore sculpture. Now I was in despair. Where could I turn? Was the sculpture owned by an Okura Company in another city in Japan? Was Okura the wrong name? Was there really a Henry Moore in Japan? I thought of telephoning Mrs. Tinsley and asking her to check her records again, but I realized that she must have given me all the information she had. If the information was wrong, there was nothing she could do about it.

On the third day my plea to the dedicated Miss Suzuki was to call every art editor in town, the head of every contemporary art gallery, every museum curator —and anybody else she could think of—and see if she could find any clues to the sculpture's whereabouts. Again she tried, and again she drew a blank. Many of those she contacted asked her to please call them back if she located the Moore sculpture and tell them where it was.

I was ready to give up, but not Miss Suzuki. She said that she had an uncle

who knew everybody of importance in Tokyo and that she would call him that evening to see if he could help her. I had little hope, particularly since the next day was my last in Tokyo. But the following afternoon, as I was delivering a talk in the offices of the Nihon Keizai Shimbun, I suddenly saw that lovely young lady burst into the rear of the auditorium and wave to me in wild jubilation. I don't know how I ever finished that speech. When it was all over she rushed to the front of the auditorium and shouted "I found it! I found it!"

How the discovery was made she didn't explain, but at that point it didn't matter. I grabbed my camera, and the two of us jumped into a taxi that took us to a suburb of Tokyo. A half hour later we arrived at a beautiful building, the offices of the Chiyoda (not the Okura!) Insurance Company, and I walked into the lobby ready to discover the Moore. There was one more moment of astonishment when I discovered in the lobby a large sculpture by the Italian sculptor Emilio Greco, and I wondered for an instant if there had been another mistake. But no, we turned around and went into a large courtyard at the side of the building, and there, in monumental splendor, was our Henry Moore.

My next trip to Japan was equally eventful. This time I planned to

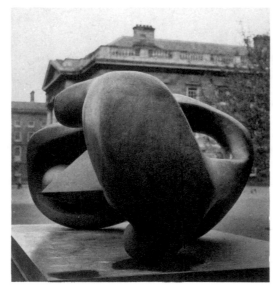

TRINITY COLLEGE, DUBLIN

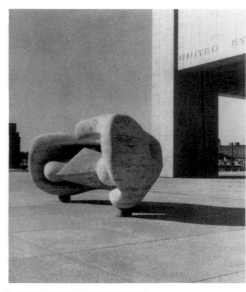

BALTIMORE, MARYLAND

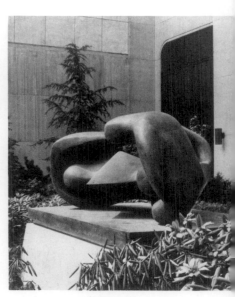

900 PARK AVENUE, NEW YORK

photograph a new Moore sculpture that had only recently been installed in the "Woods of Sculpture" (Chokoku-no-Mori) at Hakone, about sixty miles north of Tokyo. This sculpture museum was made possible through the generosity of one of the most remarkable art patrons I have ever met, Nabutaka Shikanai, president of Fuji Telecasting Company, Ltd. Mr. Shikanai had heard about my project and invited me to lunch in his offices, where we talked excitedly about our favorite twentieth-century sculptors for several hours. Although our conversation took place through interpreters, I had the strange feeling that we were talking the same language and that each of us understood completely what the other was saying. Mr. Shikanai told me all about the outdoor museum in Hakone—how he had conceived the idea, what he hoped the museum would accomplish—and described some other imaginative projects he had in mind, such as setting up streets lined with sculpture in Tokyo and Osaka. He explained how proud he was to have acquired Moore's *Reclining Figure: Arch Leg* (see pp. 46–51) and to have placed it in such a dramatic setting. Delighted that I planned to photograph the piece, Mr. Shikanai asked if I would mind having a television crew follow me around to film a documentary on my method of photographing sculpture.

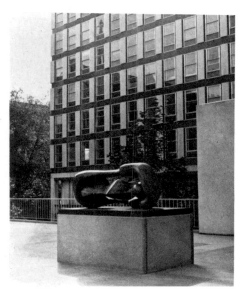

UNIVERSITY OF ADELAIDE, AUSTRALIA

Little did I know how it would feel to take photographs of a sculpture under the watchful eyes of television cameras! I usually prefer to be alone while photographing sculpture, because I become totally absorbed in what I am doing. It takes all my concentration to search for and discover the views of the work that I want to capture on film. The sense of being on stage was therefore strange and distracting to me. Not only was it difficult for me to keep my lens moving freely around the sculpture, but I also had to play hide-and-seek with the other cameramen. Just as I would focus on a particularly exciting shot, out would dart a television camera photographing me as I took the picture—and the frame would be ruined. After a while the cameramen realized what I was trying to do, and I realized what they were trying to do, so we managed to accommodate each other. It proved to be one of the most difficult photographing sessions I had, but the results were among the best I achieved.

Another adventure involved an expedition to Moline, Illinois, to photograph *Hill Arches* on the grounds of Deere & Company headquarters (see pp. 438–45). Moore had seen photographs of the setting and liked it so much that he asked me to make a special trip to Moline for my book. When I called Mr. William Hewitt, chairman of the board of Deere & Company (whom I had never met) to make arrangements, he wanted me to come to Moline when he would be there, so we could spend some time together. This turned out to be something of a problem. I boarded a plane one day in March 1975, heading toward Chicago where I would get a connecting flight to Moline. During the flight, however, the pilot

announced that there was a blizzard in Chicago and that our plane would be diverted to Detroit. I had to cancel my photography date and take the next plane back to New York after spending a frustrating day in the air, going nowhere. I reset the date for April—and at the last minute called ahead to see if there was any snow on the ground in Moline. Sure enough there was, so I canceled the trip again, fearful that the snow might create a difficult background against which to set off the sculpture properly. It was not until May that I finally made the trip—and this turned out to be the perfect time. The weather was so beautiful, in fact, that when I arrived around midday at Mr. Hewitt's office and saw the sculpture in its magnificent setting, I insisted on delaying the lunch that had been planned and spent the next hour and a half in utter delight, photographing what was clearly an outstanding example of Moore's work.

The headquarters of Deere & Company is spectacular in its own right and is visited by about fifty-three-thousand people a year. The building, completed in 1964, was designed by Eero Saarinen. It is a magnificent structure, both inside and out, and the grounds are just as impressive, with twin lakes created by the landscape architect in front of the building and lovely sloping hills on the other three sides. The spot Mr. Hewitt had in mind for the *Hill Arches* was an island in the nearest lake. Initially, the little island was flat, but he had it built up to create the proper hill shape for the sculpture—just one example of his painstaking care in placing the work.

The day I visited Moline, Mr. Hewitt was so intrigued by my frenzied

photographic activity as I moved around the sculpture that he stood by, holding my camera equipment for quite a while. At lunch afterward, we enjoyed discussing Moore's work in a lovely, airy dining room with windows overlooking the sculpture. By chance, Stuart Dawson and Masao Kinoshita, two of the landscape architects who had been responsible for the grounds, were there, and we spent some time talking about different environments for sculpture and why the placement of *Hill Arches* at Moline had turned out to be so successful.

Perhaps the most interesting journey I made was a three-week trip through central Europe planned solely for the purpose of Moore-hunting. My wife and I worked out an itinerary based on Mrs. Tinsley's list, and we drove from city to city, looking for the sculptures. Our information about these cities did not include even a hint as to where the sculptures were located; it was entirely up to us to figure out where each piece was.

We started in Zurich, Switzerland, a city we had visited before and had thoroughly enjoyed. Stopping there for several days, we wandered about the city, and I spent two afternoons photographing the Moore *Reclining Figure* in front of the museum (see pp. 116–19) and the *Falling Warrior* in Zollikon, a community a few miles away that is also on Lake Zurich (see pp. 120–24). The former was easy to find, but the latter presented a problem. We drove outside of Zurich along the left side of the lake for about ten minutes until a sign told us Zollikon was ahead. When we reached the town, we drove around the area for a while, hoping to spot the sculpture. Zollikon was a suburban community with lovely walks and

a fine view of the lake—but no Moore. We asked passers-by about the sculpture, stopped at a restaurant to inquire, called at the central police station—nothing. To explain the kind of thing I was looking for, I showed everybody Polaroid pictures of other Moore sculptures I had photographed, but nobody knew what I was talking about. Finally we were told of a lady who worked as a switchboard operator and who knew every inch of the town. She smiled sweetly when we asked our question and directed us back to the lakeshore.

As we drove along the shore, we saw a rather dramatic sculpture of a bull that was obviously not by Moore, and we wondered if the lady had been mistaken. But then, as we drove further on, we came upon the *Falling Warrior* in a marvelous setting beside the lake. The sun was dipping in the west, and for approximately forty minutes I had a fine time photographing the sculpture. I was finally stopped by a team of eight street cleaners who came to clean the area with hoses. After waiting a few minutes for me to finish, they blew a whistle to get me out of the way. When I didn't leave, they started up the hoses, and I got a shower just as I finished.

From Switzerland we drove into Germany. Freiburg was our first stop, a lovely university town with a fine cast of Moore's *Reclining Figure: External Form* that we found on the campus right in front of the administration building (see pp. 126–29). Next we drove through the Black Forest to Stuttgart. Stuttgart is a rather large, modern city, and it took us the better part of an afternoon to find the Moore *Draped Reclining Woman* that we were looking for (see pp. 130–33).

Then on to Cologne, again a big, modern city. We were disappointed in the famous long shopping mall, where the whole town seemed to walk in the evening; although a good idea in principle, it was carried out so poorly that we thought it an especially ugly example of urban design. But the cathedral was beautiful, and so was the museum, and fortunately the Moore was right in the courtyard of the museum, so that was easy. Our next stop was Duisburg and a real landmark, the Lehmbruck Museum, which owns Moore's *Two-Piece Reclining Figure #1* (see pp. 138–43). We had been told that everybody in Duisburg knows where the Lehmbruck Museum is located since the sculptor Wilhelm Lehmbruck was the town's most famous native son. This did not prove to be true. Even when we were just a few blocks away, we had difficulty getting directions. After Duisburg came Essen (a cast of Moore's *Upright Motive #1: Glenkiln Cross* is in the museum; see pp. 148–51) and Recklinghausen, where Moore's *Two-Piece Reclining Figure #5* stands in front of the Festspielhaus, a beautiful theater in the town's suburban area (see pp. 152–56)—and then Arnhem in the Netherlands.

There were few towns we enjoyed seeing more than Arnhem, where we had been told there was a fine work by Moore. After a week in Germany, visiting nothing but cities that had been built (or rebuilt) in the last twenty-five years, it was a pleasure to move back a few centuries in an old Dutch town that was filled with history. We stayed in a small hotel bordering a lovely body of water and watched the mist slowly settling in the early evening. The next day we had a terrible time finding the Moore. His *Warrior with Shield* (see pp. 162–67) turned

out to be right in the center of the city—but nobody knew it was there! The early morning fog lifted just as I was photographing the sculpture, and it was marvelous to see the town gradually taking shape as the sun emerged.

Our next stop in the Netherlands was Otterlo and the Kröller-Müller Museum and sculpture park. It was October and the leaves were turning, the most beautiful time possible to photograph the several Moores in the park—*Upright Motives #1, #2, #7*; *Two-Piece Reclining Figure #2*; and *Animal Head* (see pp. 168–73; 174–75; 176–77). After this, we went to Rotterdam to photograph the Moore reliefs at Bouwcentrum and then on to Belgium to photograph the *King and Queen* in Middelheim Park at Antwerp (see pp. 184–89). We gave up our car in Brussels (after a quick drive to Ghent to see the great Van Eyck altarpiece and to Bruges for the Michelangelo *Madonna* and several Memling panels) and flew to Denmark. There I photographed a cast of Moore's *Two-Piece Reclining Figure #5* at the Louisiana Museum in Humblebaek, just a few miles north of Copenhagen (see pp. 196–202). After this I made a one-day trip by myself to Goteborg, Sweden, to photograph Moore's *Two-Piece Reclining Figure #3* (see pp. 204–8), and then to London and home to New York.

There are many cities I would never have visited if it had not been for this project, among them Dartington, England; Dumfries, Scotland; Adelaide, Australia; and Columbus, Indiana. Even in cities I knew well, I saw neighborhoods that were new to me—Battersea Park, Southwark, and Stepney in London, as well as the nearby Harlow New Town and Stevenage. Other cities were part of my

regular business itinerary—Jerusalem, Paris, Tokyo, Los Angeles, Philadelphia, Chicago, Toronto, and, of course, New York. I suppose it's not surprising, but after traveling around the world, some of the last photographs for the book were taken in the courtyard of the Museum of Modern Art in New York, which is just a ten-minute walk from my office.

Wherever I went, weather was a problem. It was raining when I was in West Berlin, and there was nothing I could do but photograph *The Archer* (see pp. 157–60) in the midst of a heavy downpour. The same was true of the *Upright Motive* in Essen, Germany (see pp. 148–51) and the first time I photographed the *Nuclear Energy* in Chicago (see pp. 446–51) and the four sculptures in Glenkiln, Scotland (see pp. 292–312). In many cities the sky was a flat gray when I arrived, which I found as frustrating as rain. My favorite sky-scape occurs on a clear day when a few clouds drift by as a backdrop for the sculpture. A cloudy sky with grays, whites, and blacks is second best. I drove almost one-hundred miles to reach Columbus, Indiana, watching a flat gray sky all the way, hoping that by the time I arrived there would be some variation in the cloud formations; I wasn't too lucky, but there was just enough variety overhead to help a little. In some places the sky was in the process of changing while I was photographing—or worse still, while I was searching for the sculpture in a strange city; then I would get almost frantic in my efforts to beat the weather. Sometimes I started on a gray day and the weather broke while I was working, and I felt as if I had been blessed. As I became more experienced, however, I came to realize that even bad weather has its

advantages; although color shots come out best when the sun hits the bronze or stone directly, black-and-white photographs are often better when there is no sun, so that one doesn't have to struggle with harsh contrasts of light and shadow.

One of my persistent ideas was to photograph a sculpture whenever possible without people or cars in the background. I realize that this has the disadvantage of not showing the scale of the work and that without any recognizable object nearby against which to measure it a small piece can look gigantic. But I always felt that composing a photograph with the sculpture seen against fixed backgrounds such as trees, buildings, and sky was difficult enough—or at least that this was the exciting challenge of the project. People who might happen to be in the area would present accidental shapes difficult to integrate into the setting, and their presence in the photograph would not be consistent with the purpose I had in mind. What I was trying to do was to discover photographic patterns that showed the work off to best advantage in each site, and I just couldn't do this with people, bicycles, cars, or any other moving objects that happened to pass by.

In general, I spent about an hour with each sculpture. My approach was to first take full views of the work from every conceivable vantage point as I moved around the sculpture. Then I would move closer to take some semi-detail shots, capturing the basic forms of sections of the sculpture and paying special attention to the interplay of sculptural contours and textures with those of the background. Finally I would move in for closer details, taking small segments of the work that I thought looked particularly striking, always keeping an eye on the background.

I would do all of this in black-and-white, but in the course of making these shots I would make a mental note of the views I thought would be most effective in color shots. Then I would take one or two rolls of color film, repeating the same three stages—long views, semi-close-ups, and details. During the course of this activity I would become totally absorbed in the work, discovering forms that were reminiscent of other Moore sculptures and some that were radically different, and I would almost always end up awed by the subtlety and strength of the figure and by the astonishing range of form that characterizes Moore's sculptures.

Photographing intensely is exhilarating and exhausting. I could not bear interruptions while I was working. (My wife, whose patience during this whole venture was extraordinary, made a point of always leaving me alone when I was photographing; she looked at the sculpture when we came upon it, admired it for a few minutes, and then went away with the understanding that we would meet again in an hour.) When I was through, I always experienced a curious sense of fulfillment, with fragments of the images I had photographed swimming around in my mind for hours.

My original plan for this book was to photograph every Moore sculpture that was located in a public place. But as time went on, I heard of new works that had recently been installed, or had somehow been left off the original list. There were also a few cities that had been on my itinerary which I did not manage to visit during the time I worked on the book—Montreal, Canberra, Vancouver, Seattle, Johannesburg. I intended to go to most of these places, but after five

years of work on the project, I realized that I already had far too much material, so I decided to stop photographing and begin work on the manuscript.

For a long while I wondered about the text. Half way through the project, I realized that the main theme of the book should be sculpture and its environment. That was when I had the idea of talking to Kenneth Clark about the project. Shortly afterward I had an opportunity to visit Lord and Lady Clark in London, and I showed them some of the photographs I had taken. Both were extremely enthusiastic, so much so that I found myself asking whether Lord Clark would consider spending a day with Henry Moore, looking at the final set of photographs together and tape-recording their reactions to different sites. He instantly agreed, and we tentatively set a date for about a year later.

Moore was also pleased with this approach to producing a text for the book, but he was uneasy about the possibility of it being an imposition on his friend Lord Clark. The latter assured him this was not the case, and I spent the following year completing my photographs and selecting for our meeting those prints and transparencies that I thought appropriate for the exhibition.

I do not have an accurate record of how many photographs I took during my journey, but certainly there were many thousands. From among these, I selected about six-hundred black-and-white and four-hundred color photographs to show Kenneth Clark and Henry Moore. With the help of my daughter Amy, I made prints of the black-and-whites—a monumental task in itself—and mounted them in groups on large 30 × 40″ boards. I then filed my transparencies in a series of trays

in order to transport the whole rather bulky package to England for our meeting.

The plan was for all of us to meet at Moore's house in Much Hadham, where we could spend the day looking at the photographs and tape-recording the conversation about the various sites. Ms. Lorna Noble of my company's London office did a heroic job of arranging for all the photographs to be delivered to Moore's house (they almost didn't get through customs in time!) and for the appropriate equipment to be set up in one of Moore's studios. At the last minute, however, we had to change our plans, because Lady Clark had been ill and Lord Clark did not want to leave Saltwood.

In an effort to save the project, I offered to give my photography show twice, once to Moore, in Much Hadham, and the next day to Lord and Lady Clark, at Saltwood. Both Moore and Lord Clark agreed, and, to my great relief, Lorna Noble was able to change her arrangements on short notice and set up the necessary facilities in both locations. As it turned out, there were advantages to this altered procedure, for each viewer was able to say what he thought without being too greatly influenced by the other's observations. The remarks made by Moore were tape-recorded, and he subsequently edited them as notes for the photographs that I had shown him. (In the months following that recording session, I unexpectedly photographed several additional sculptures, and, although I did show Moore these later photographs, I was not able to record his comments. Wherever possible I have, therefore, made reference to Moore's reactions in my own notes on these sculptures.) I also gave Lord Clark a transcript of his remarks,

and it was on the basis of reading them that he generously offered to write the Foreword for this book.

The final selection of photographs in the book has been made largely with Moore's help. As we went through the prints together, he pointed out those that he felt showed the sculpture and setting in the most interesting or revealing way. He understood that my purpose was also to produce photographs which were in themselves aesthetically satisfying, and the ones we agreed on were chosen with both criteria in mind.

Having now taken many thousands of photographs of Moore's sculptures in public places in different countries around the world, what conclusion can I make about the placement or siting of such works? The most obvious conclusion is that there is no substitute for nature as the ideal environment for a Moore sculpture. A tree (or a forest) in the background, a grassy slope underfoot, a clear view of the sky above, perhaps some water off in the distance or a mountain rising up against the sky—these are ideal. Moore's forms and surfaces are taken from nature, and when his sculptures are placed in the kind of natural environment which inspired them, the total effect can be awesome. The few places we visited in which Moore sculptures were placed in such idyllic settings were magnificent to behold. These locations were masterpieces of placement, and it is well worth traveling long distances to see them.

The character of the setting unquestionably affects the experience one has when viewing a particular sculpture. This is most clearly demonstrated by the

photographs I have taken of casts of the same sculpture in different settings. In Glenkiln, Scotland, the site of the *King and Queen* is as marvelous as the sculpture itself, and my impulse was to take photographs that showed the whole panorama (see pp. 298–305). At Middelheim in Belgium the setting for the *King and Queen*, while lovely, was far less monumental, and my camera eye was drawn to details of the sculpture rather than to the landscape (see pp. 184–89).

I photographed the same detail of *Reclining Connected Forms* in Adelaide, Australia; Dublin, Ireland; New York; and Baltimore; and yet the respective backgrounds produced dramatically different effects (see pp. 62–66; 318–20; 356–59; 422–29). The same is true of the casts of the *Two-Piece Reclining Figure #1* photographed in Duisburg, Germany; London; Glenkiln, Scotland; and Buffalo, New York (see pp. 138–43; 248–51; 308–12; 396–99). Even more striking in this regard are the details of *Three Way Piece #1: Points* in New York and Philadelphia, which almost seem to belong to different sculptures because the former is on a high pedestal and one looks at the forms from below, while the latter is on a low pedestal and one looks directly into the forms (see pp. 352–55; 416–21). Similar differences can be found among the four casts of *The Arch* (see pp. 342–45; 430–37; 462–63; and p. 482) and the four casts of the *Locking Piece* (see pp. 144–47; 190–94; 216–21; 364–67).

There is value in placing Moore sculptures in heavily populated areas, such as in sculpture parks, on university campuses, and even on city streets. Works in such locations can be seen and enjoyed by large numbers of people in the course

of their daily activities, and the sculptures thereby become part of people's general experience of the place. But several factors must be kept in mind. When sculpture is placed in an urban setting, care must be taken to leave as much space as possible around the work. Open sky and sunlight must be available, and there should, if possible, be some greenery around the sculpture. Furthermore, the pieces should be placed in positions that provide the best architectural backgrounds. Busy thoroughfares are not desirable because people do not have time to look at anything while hurrying to get somewhere, but settings in which people naturally gather to stand or rest can be very effective.

When urban settings are planned with care, the reward is great. As Ada Louise Huxtable wrote about the Moore *Reclining Figure* at Lincoln Center:

When the pool in front of the Vivian Beaumont Theater at Lincoln Center has water, the Henry Moore provides that essential fulfilling element of style and definition that raises the whole complex to urban art. Not least is the strong evocative sensuosity of the work, as opposed to geometric abstractions.

In sculpture parks one must also guard against distraction. To the extent that sculptures by different artists are crowded into a relatively small area, people will pay less attention to each work individually. If there are several sculptures in such an area, they must be spaced out so that the works can be seen and experienced one at a time.

There is an infinite number of places in which sculpture can be placed to good advantage—in cities, in the country, outside of buildings, in courtyards.

After going through the photographs in this book, Henry Moore stressed this point saying:

The whole effect of the book should be to show architects, government officials, and the general public that there are hundreds of public places which are well suited for the placement of sculpture. It is a mistake to think there is only one place that is right for works of art. A book like this will explain why people don't have to look for special sites for sculpture; there are hundreds of sites available today which would be fine if someone decided to use them. It is particularly important to tell this to people who control towns and parks and rural areas. They should look upon their responsibility in regard to sculpture the same way the head of a household thinks of the environment in which he wants to raise his children. He wouldn't want to have a house without pictures, without ornaments, without carpets, without a garden if he can have one. He would try to create a varied and interesting place for his family.

I think that the authorities, whoever they are, should look upon towns as though they are creating a house for the inhabitants to enjoy and to live in.

Even though the book is completed, I think I shall go on photographing Henry Moore sculptures in public places wherever I find them. The act itself has become such a rewarding and meaningful way to absorb the rich qualities of his major works that I don't want to stop. And the marvelous thing about Moore's works is that no matter how often one sees them, viewing them again—particularly out of doors—is always a new experience. The combinations of forms one can discover are literally infinite.

JAPAN

RECLINING FIGURE: ARCH LEG

1969–70. BRONZE, L. 14′6″. THE WOODS OF SCULPTURE, HAKONE, JAPAN

Located in the mountains near Tokyo, *Reclining Figure: Arch Leg* is in the center of an outdoor museum created through the generosity of Mr. Nobutaka Shikanai, president of Fuji Telecasting Company, Ltd. There are many other works by contemporary sculptors in the museum, but this great piece by Moore, which is frequently reproduced on the museum's posters and catalogues, is considered to be the outstanding piece of the collection.

On the day I traveled to Hakone to photograph this piece, Mr. Shikanai arranged for television crews to accompany me, and a film was made as I photographed the Moore

sculpture. Although sections of the outdoor museum may be somewhat overcrowded with sculptures, the breathtaking setting provides a background for the Moore figure that is, I believe, unequaled. When I showed the photographs to Kenneth Clark, he called Hakone (which he had visited some years earlier) "an absolute masterpiece of place." I was careful to photograph *Arch Leg* without any interference from other sculptures (or from the crowds watching me work) and to capture the marvelous interrelationship between the contours of the figure and the dramatic lines of the hills beyond.

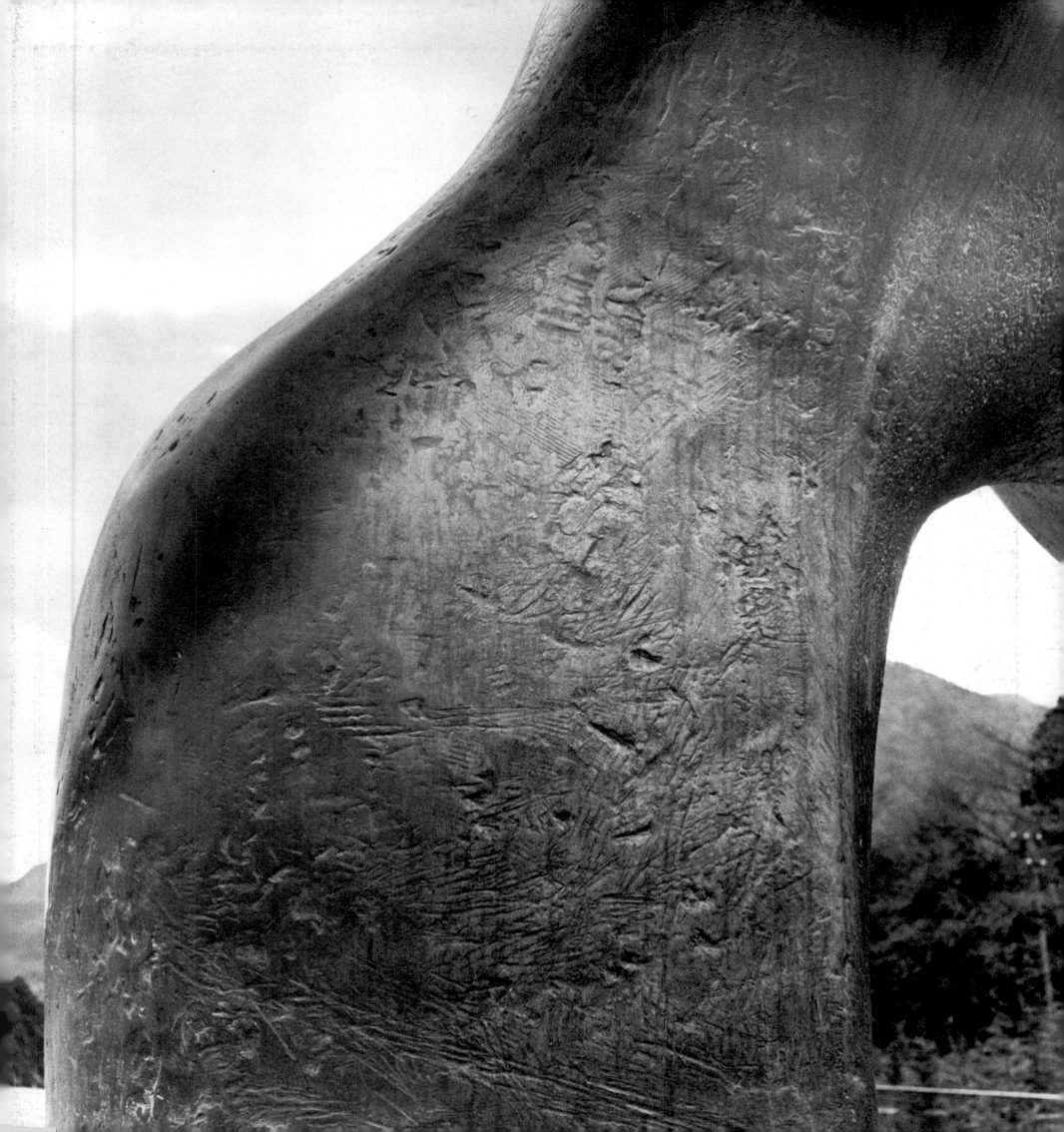

I think the figure looks well up against a mountain. I especially like the detail photographs that show depth rather than outline. Seeing the sculpture in this location shows what can be done when putting a sculpture in the right place.
—Henry Moore

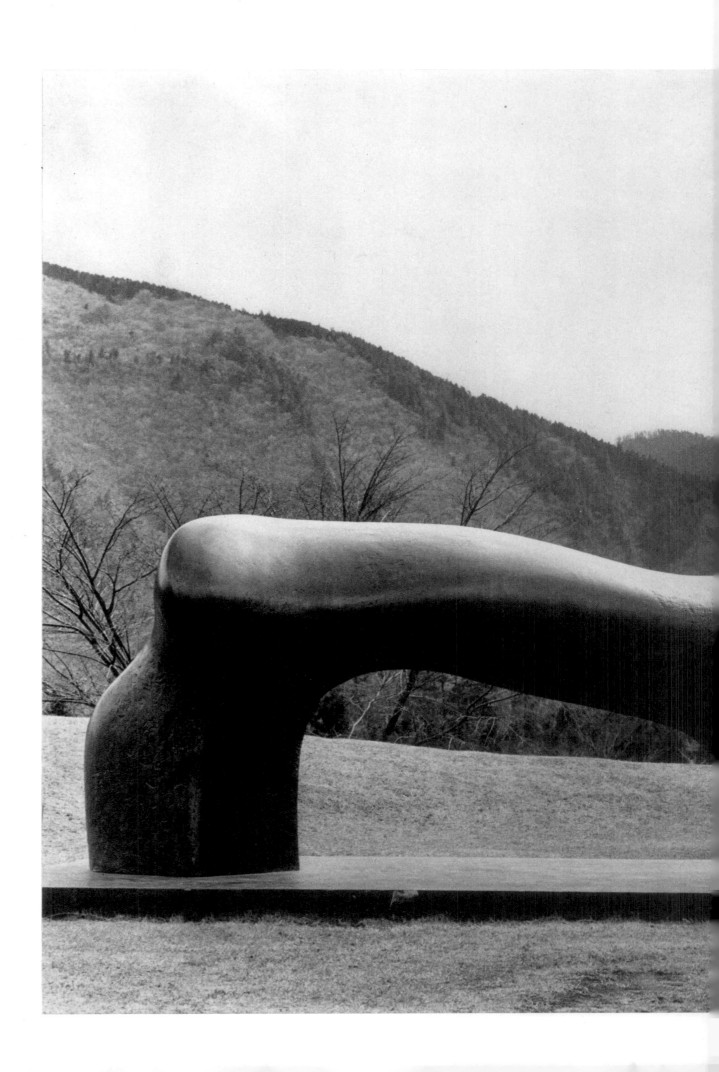

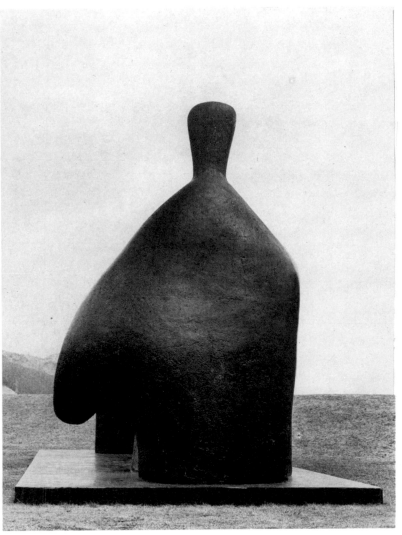
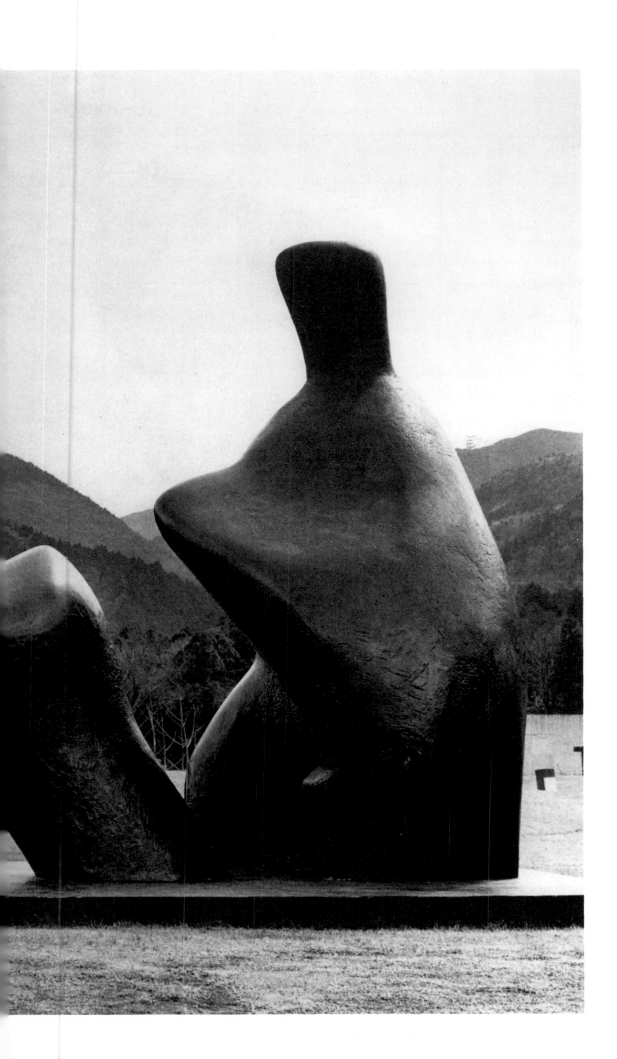

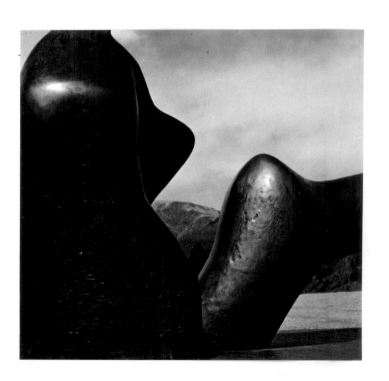

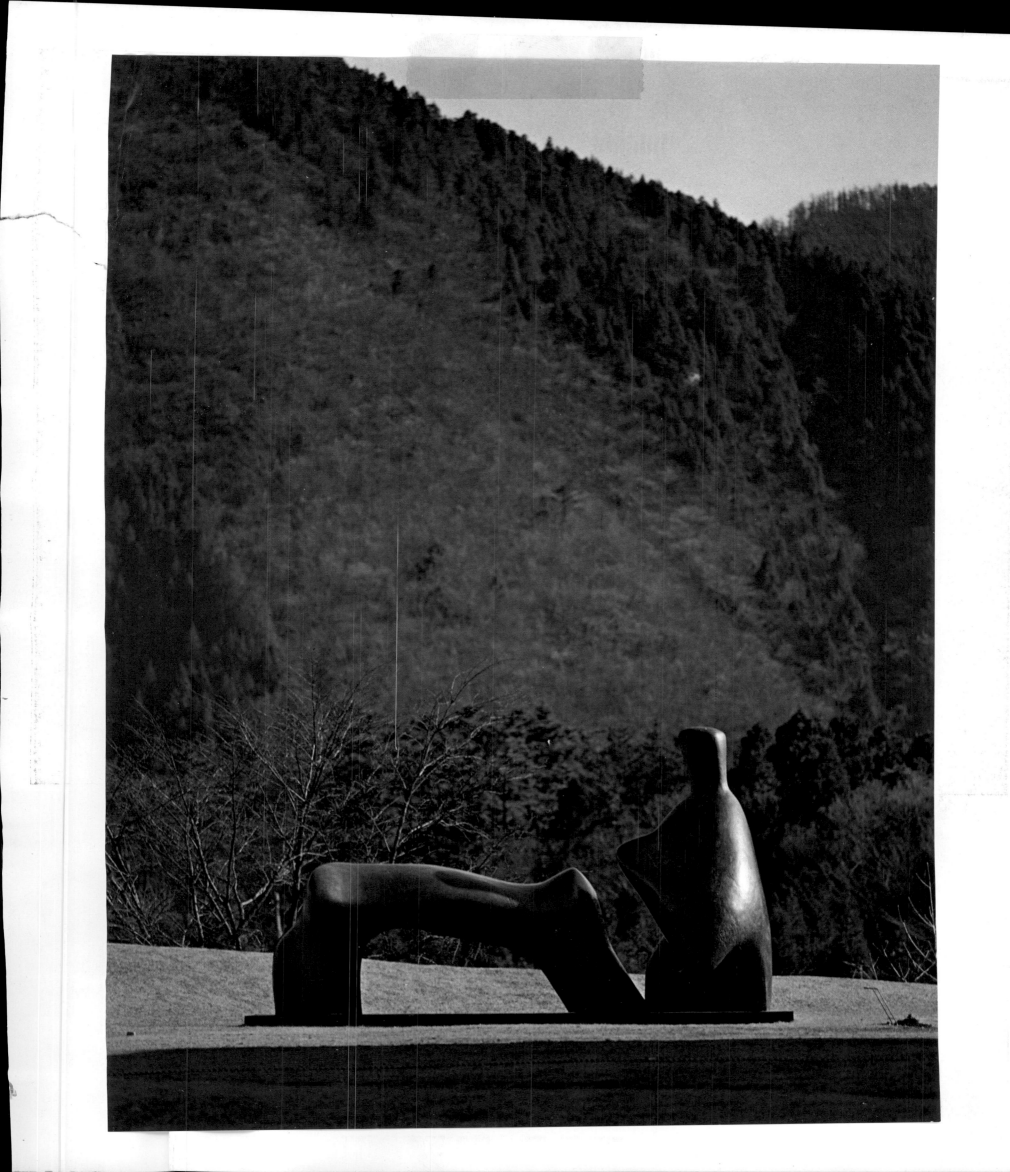

UPRIGHT MOTIVE 8

1955–56. BRONZE, H. 78". CHIYODA INSURANCE CO., TOKYO

This cast of *Upright Motive #8* is located in front of a remarkable building in a suburb of Tokyo (another cast of the same work is in Rochester, New York; see pp. 390–95). Beautifully designed, the building provides an ideal setting for sculpture. There is a lovely Emilio Greco sculpture in the lobby; and in a broad, open area outside, in what appears to be a place of honor, is this Moore *Upright Motive*. A plaque explains that the sculpture was a gift from the contractor of the building to the company—an act of generosity characteristic of the Japanese. A large stone

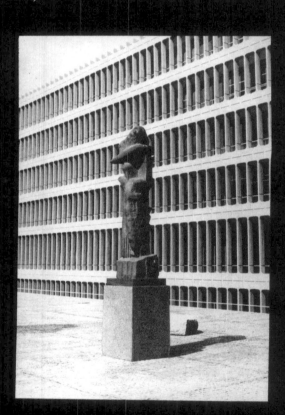

has been carefully placed on the pavement nearby as part of the setting.

My first impression when I saw the sculpture was that it was in a beautiful location but would be extremely difficult to photograph because of the intricate design of the building. I was wrong. The photographs came out quite well, and the site turned out to be visually stimulating, endowing—at least to my eyes—something of an Oriental character to the work and adding a new dimension to its symbolism.

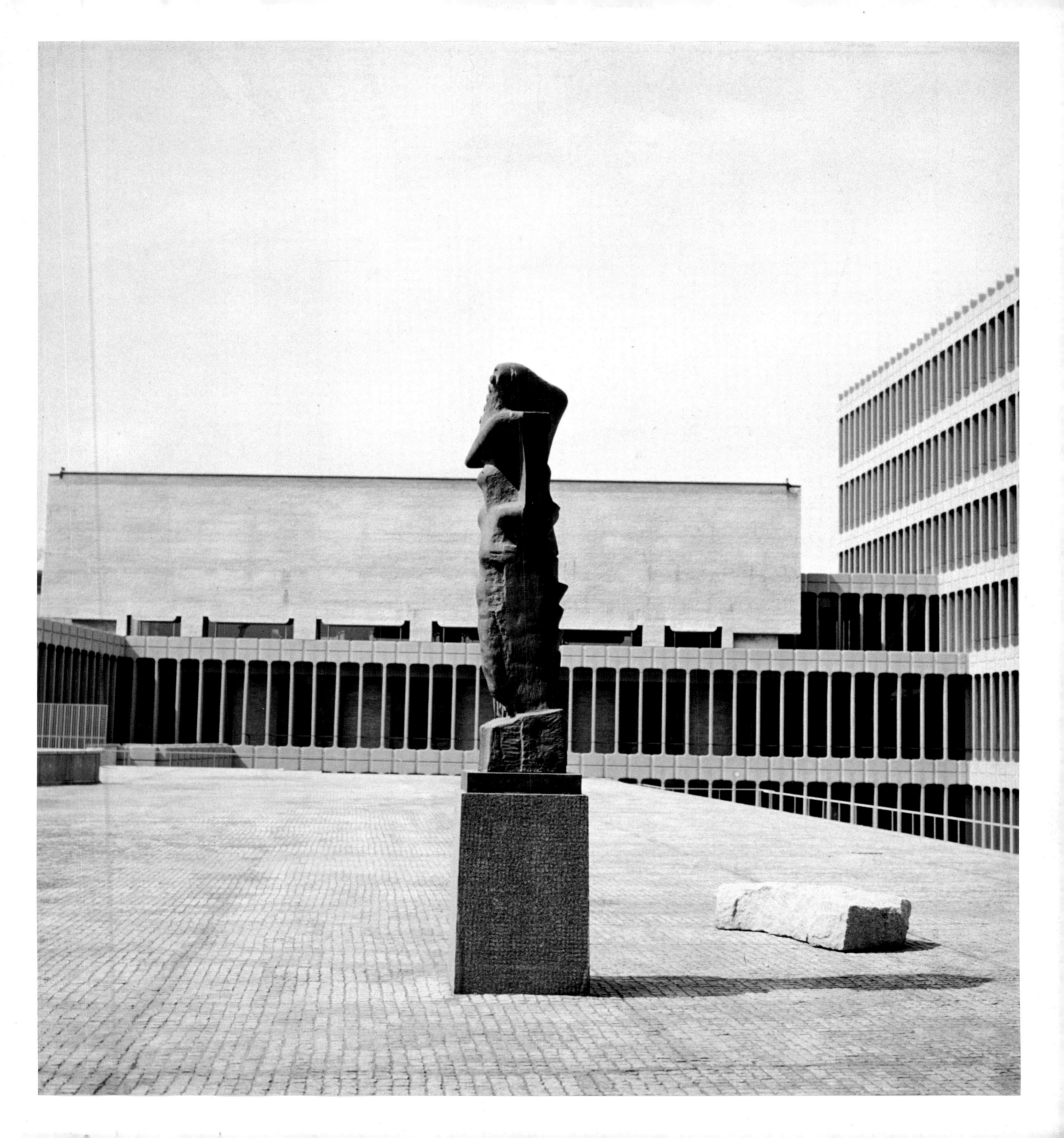

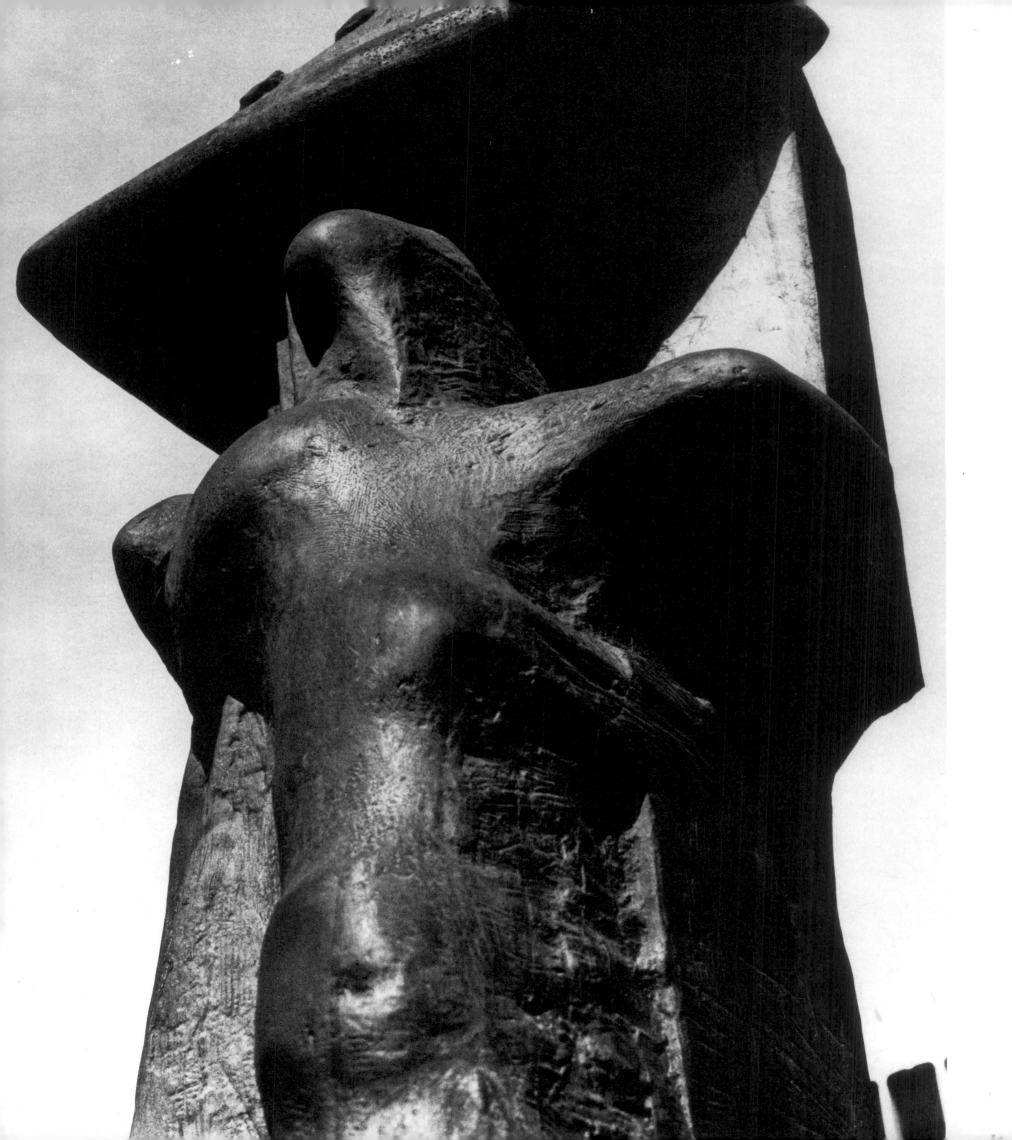

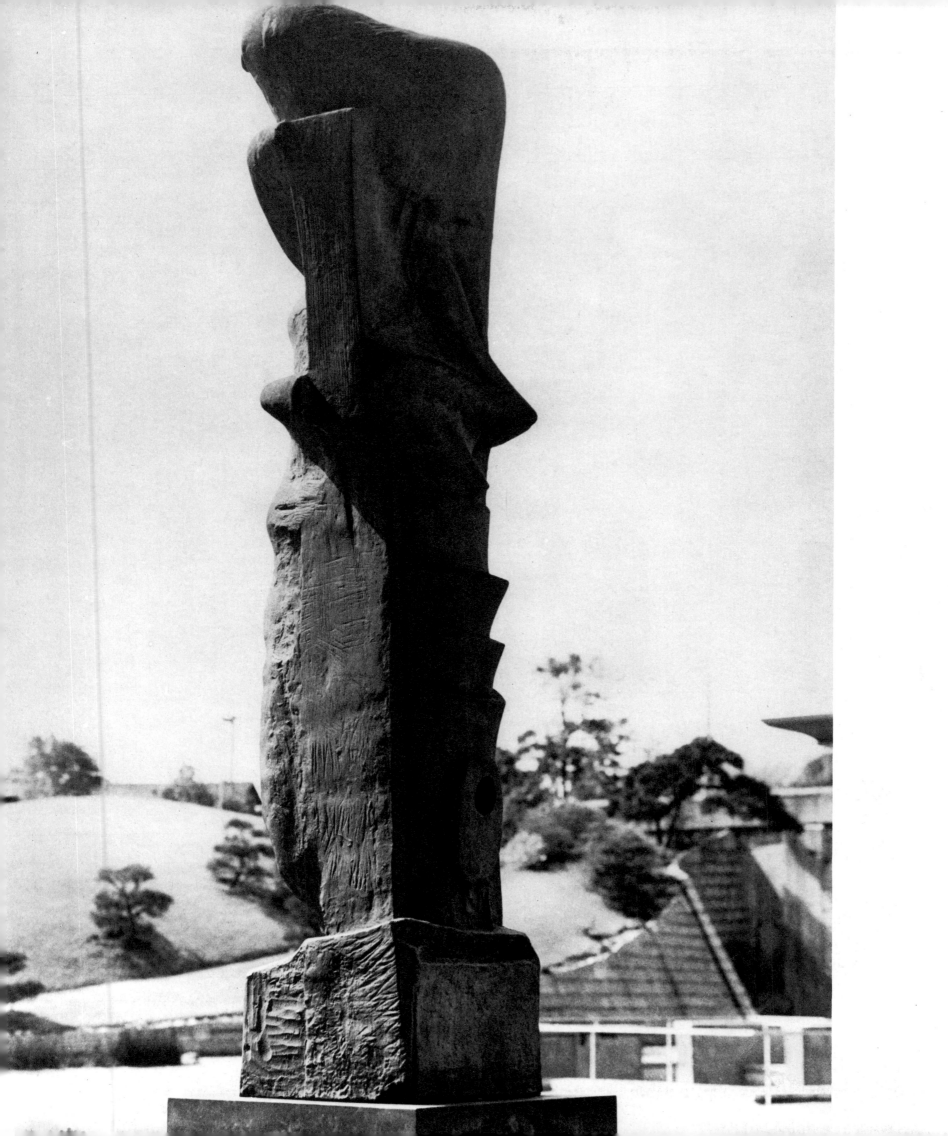

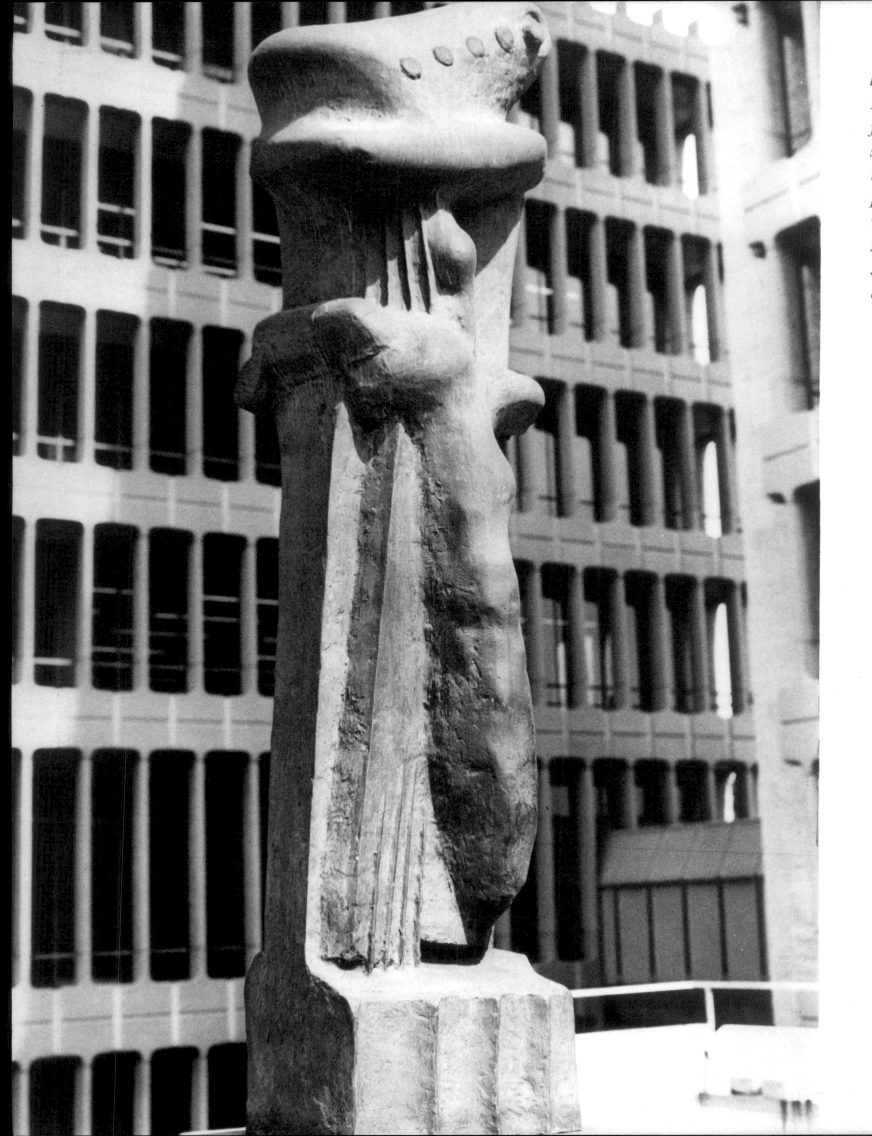

That, I dare say, looks like the leaning tower of Pisa. That's one of the few sites where the sculpture goes well with the architecture. These photographs are wonderful. . . . The sculpture looks Japanese—like a pagoda on top.

—Henry Moore

AUSTRALIA

DRAPED SEATED WOMAN

1957–58. BRONZE, H. 73″. NATIONAL GALLERY OF VICTORIA, MELBOURNE, AUSTRALIA

This sculpture is in the courtyard of the art museum in Melbourne, an impressive—and somewhat controversial—building whose glass front is covered with streams of water flowing down the surface. The museum's courtyard is rather small, with a few major sculptures placed in the area. Virtually without foliage, it is dominated by severe architectural forms and somewhat stark gray stone. Although the chunky pedestal of the Moore sculpture is ungainly, its austere background is quite handsome.

I liked the museum and its collection—especially because one of its treasures is the magnificent *Ince Hall Madonna,* attributed to Jan van Eyck, which I have loved (in

reproduction) for thirty-five years. In general, I also liked the museum's method of displaying works of art. Indeed the only part of the museum that did not impress me was the courtyard, and I thought the Moore sculpture in that location looked walled-in. (I photographed four other casts of the sculpture—see pp. 90–94; 244–45; 400–403; and p. 492.) To my surprise, Kenneth Clark and Henry Moore reacted with enthusiasm to the Melbourne photographs and considered the site successful. I do see what they like about the site as it appears in the photographs. Either I was wrong in my initial impression, or the photographs look better than the actual setting.

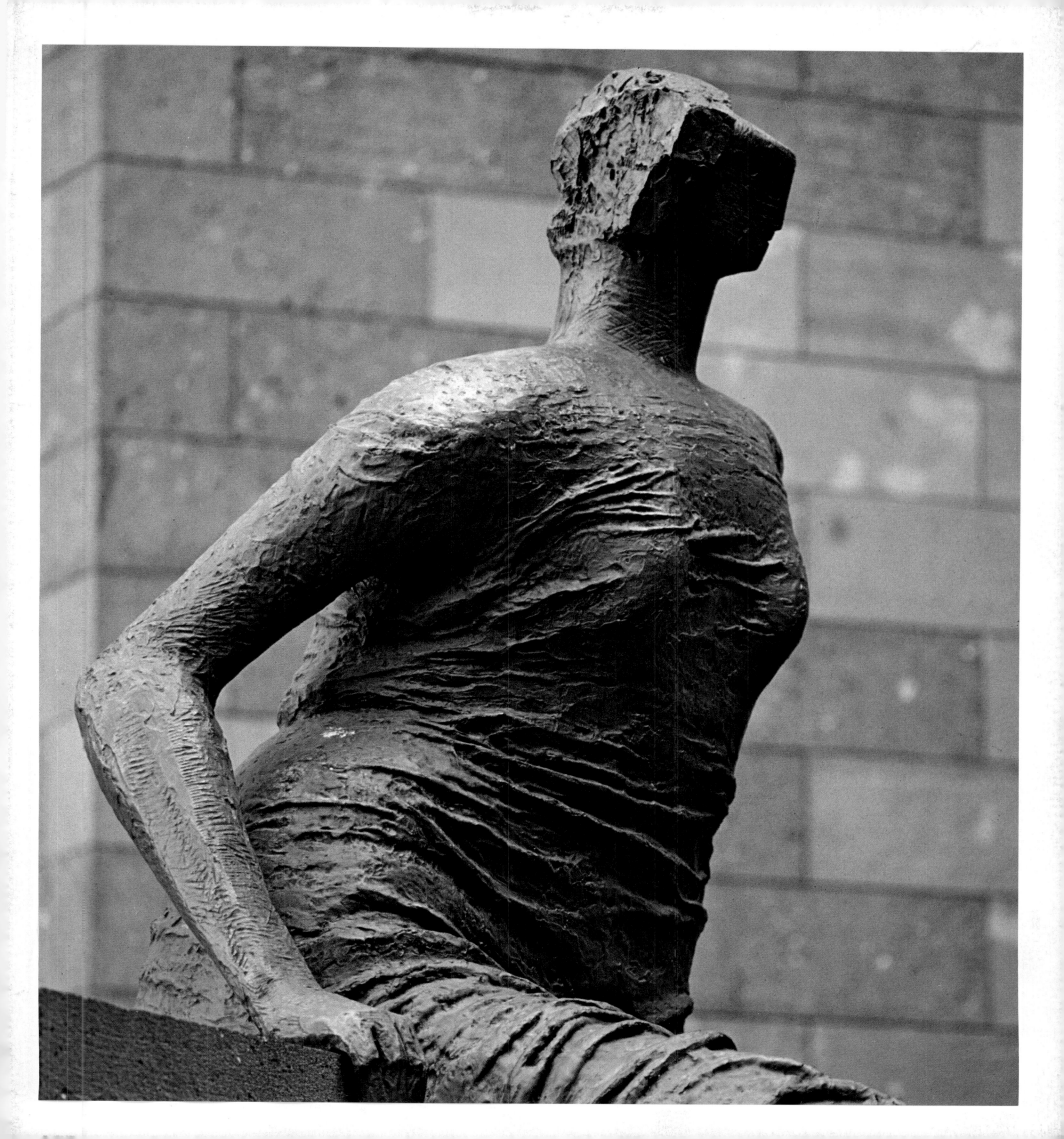

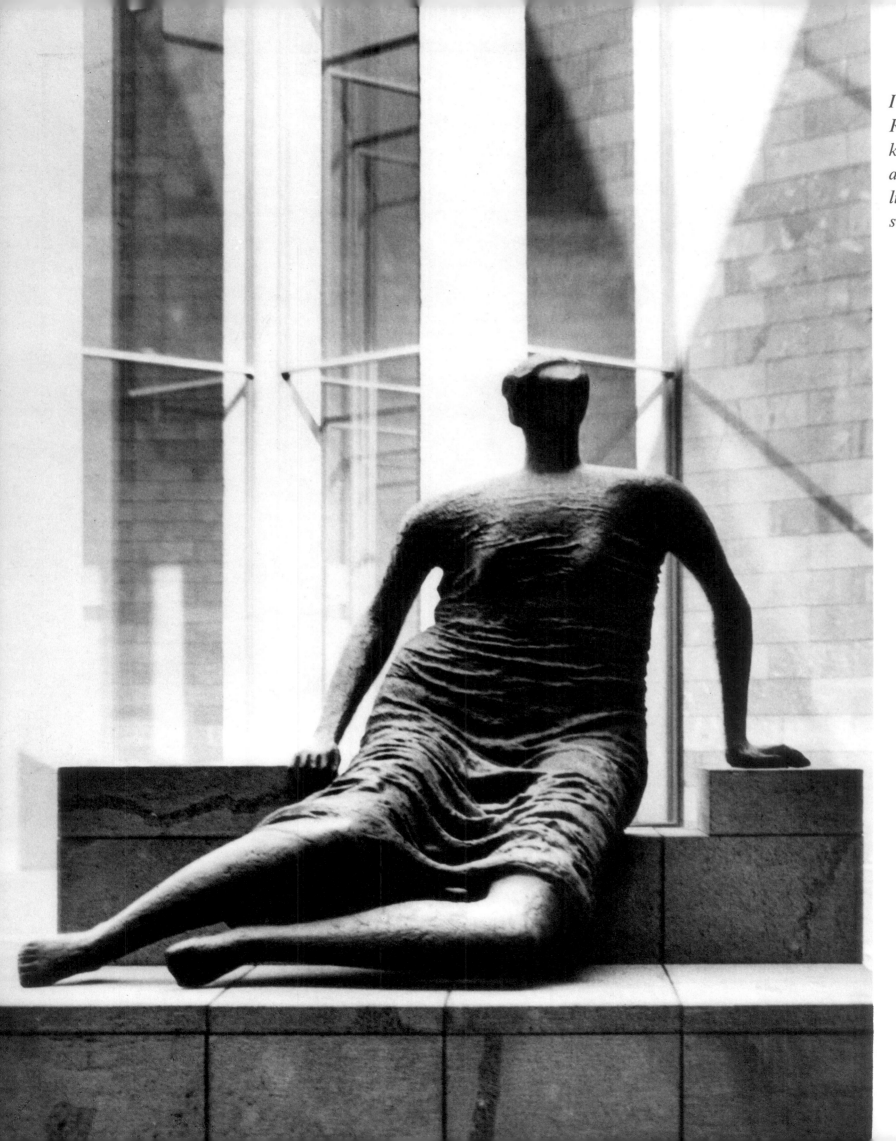

I think that is very
Renaissance. I don't
know if it is the
architecture or the
light, but the setting
seems very fine to me.

—Henry Moore

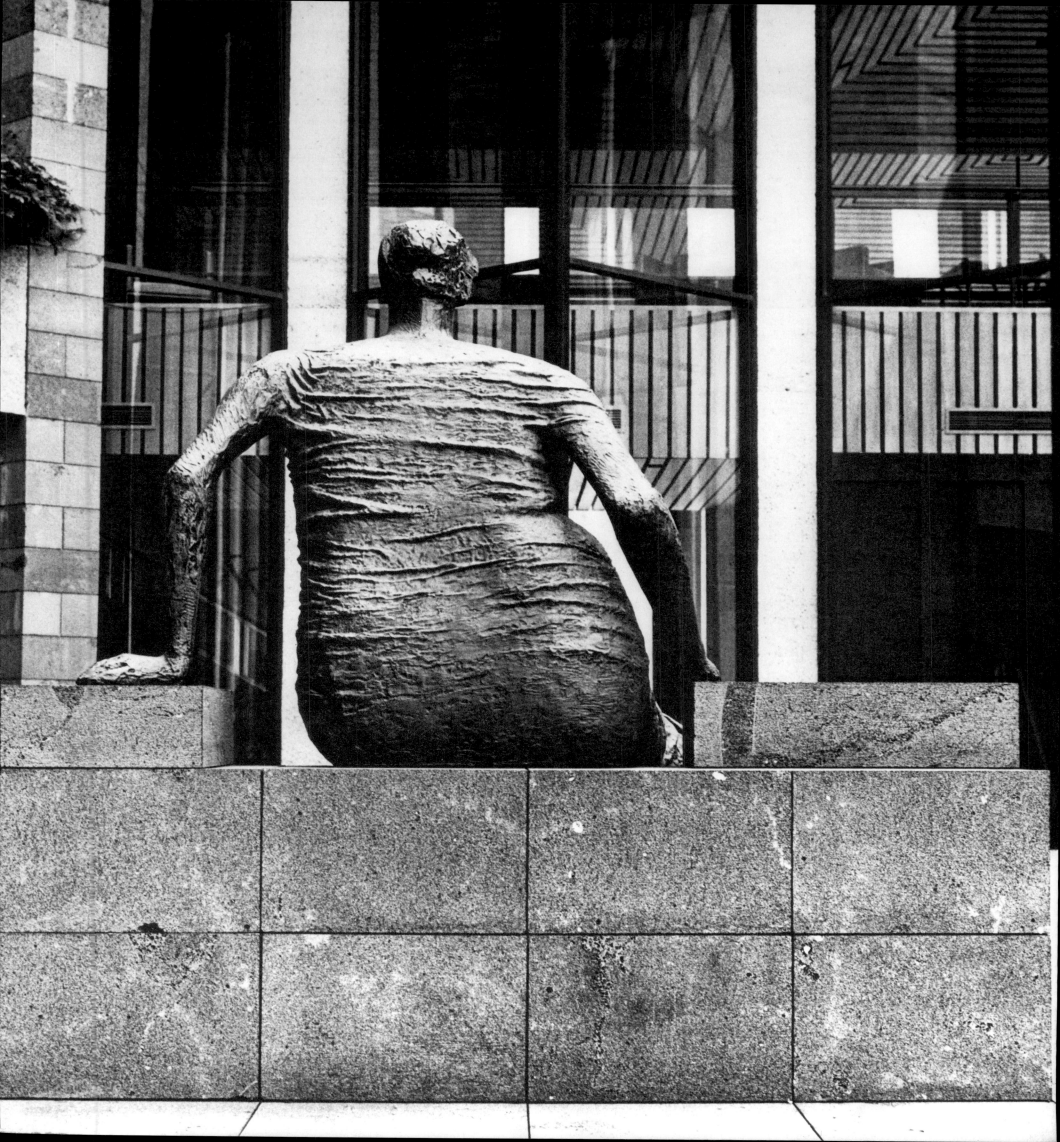

RECLINING CONNECTED FORMS

1969. BRONZE, L. 84″. UNIVERSITY OF ADELAIDE, AUSTRALIA

Although this sculpture was done about three years after the *Reclining Mother and Child* on Birdcage Walk in London (see pp. 240–43), there is a close resemblance between the two pieces. The title of this work does not describe it as a mother-and-child motif, but the basic concept of an outer form embracing an inner organic entity is here.

In Adelaide care has been taken to create a proper setting for the sculpture. A solid concrete wall has been erected behind the piece to give it a clean and simple background, and a pool in front of the sculpture is close enough to show reflections of the figure. A striking Gothic building off to one side also works very well with the forms of the sculpture.

My trip to Adelaide was actually made by mistake—a mistake for which I was most grateful. When I was in Australia, I knew that there was one Moore sculpture in Canberra

and one in Adelaide. Since I had time to visit only one of the cities and Canberra was the capital, I decided to make it my destination. Somehow the flight schedules were confused, and when I arrived at the airport for the trip to Canberra, I discovered that the plane had already left. There was still a flight to Adelaide, however, so off I went to that city instead.

Adelaide turned out to be a lovely university town, and the weather was glorious for photographing. The blue sky was spotted with extraordinary fluffs of clouds, and I thought the sculpture looked especially beautiful against such an unusual and fresh background (although I understand and respect Moore's warning not to make the sky too important when it is the sculpture one wants to concentrate on in the photograph).

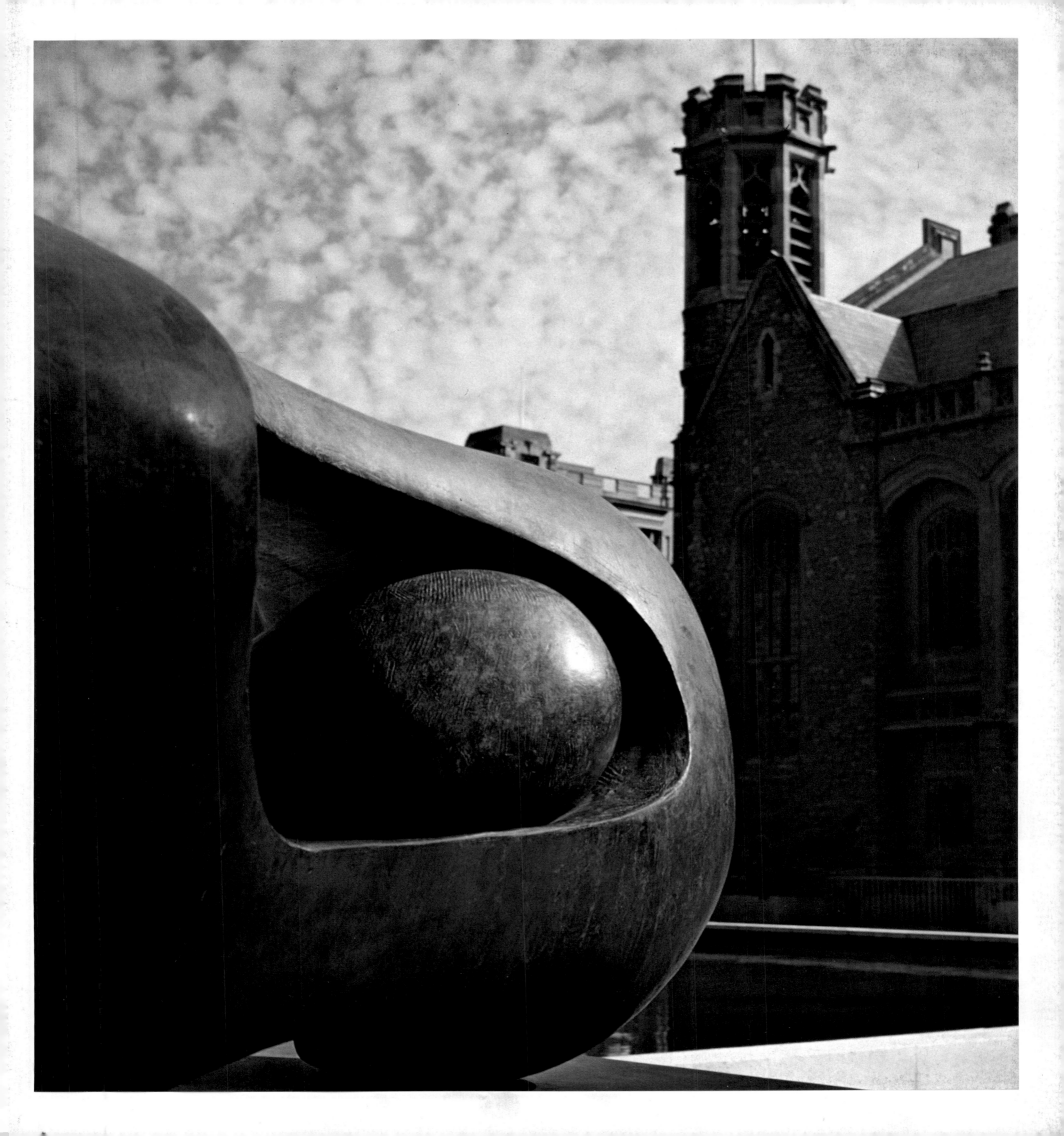

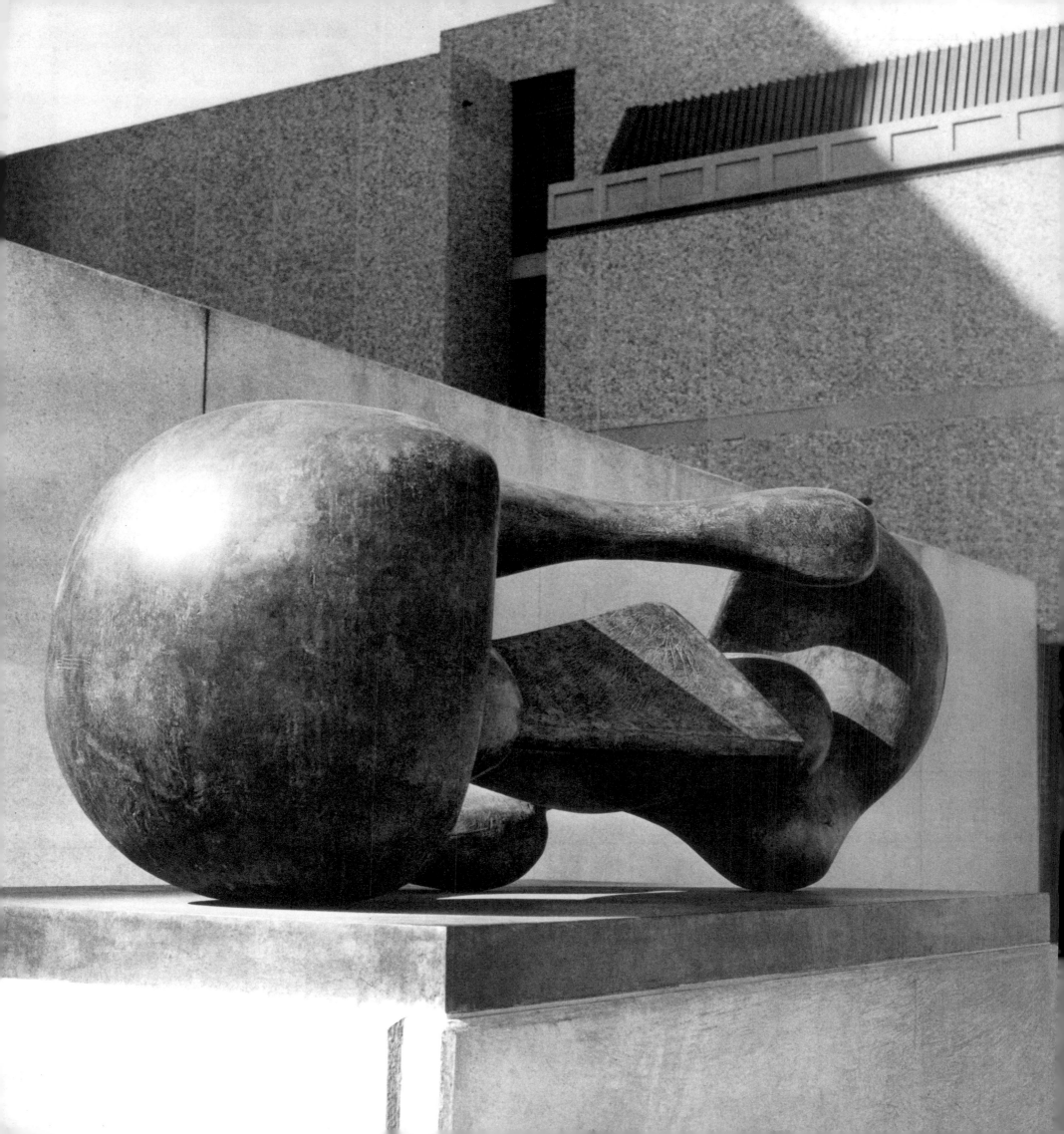

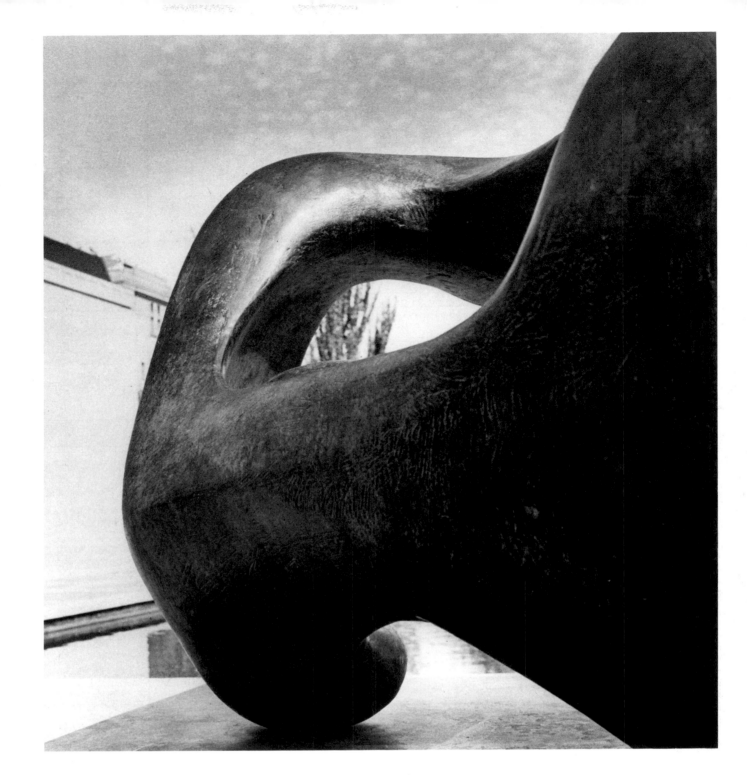

A nice sky. One has to be careful in such photographs that the sky is not what you look at rather than the sculpture.

—Henry Moore

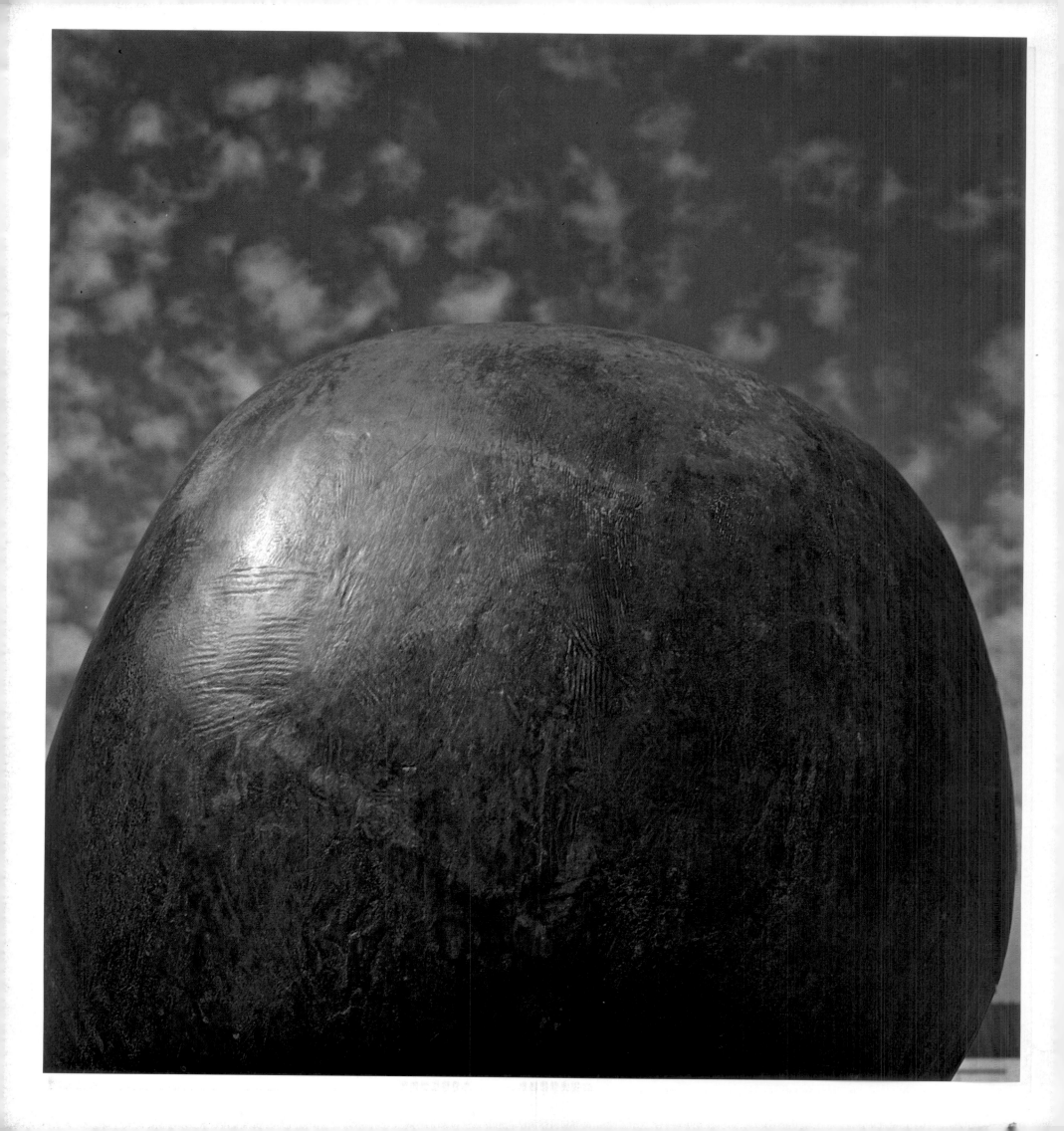

ISRAEL

RECLINING FIGURE

1969–70. BRONZE, L. 13'. TEL AVIV MUSEUM, ISRAEL

This work made its first public appearance at the historic Marlborough-Knoedler show in 1970 where it was the largest piece in the exhibition, occupying a whole gallery by itself. In fact the sculpture was too large to go through the doors or fit in the elevator, and it had to be lifted outside the building and brought into the Marlborough Gallery through a window. This cast of the work is located in a large plaza in front of the Tel Aviv Museum and has been reproduced often as its symbol.

The *Reclining Figure* happens to be one of my favorites among all Moore's works. I loved it from the moment I first saw it and recognized its extraordinary combination of voluptuous forms, flowing and rippling across the top, and its cavelike structures at the bottom. The incredible variety of markings all over the sculpture is also remarkable,

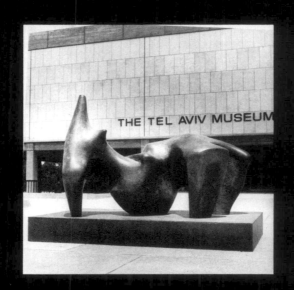

and I have thought that one day I might photograph these and compile a book of Moore "drawings" as seen on the surface of this one work of sculpture. Kenneth Clark shared my enthusiasm for the sculpture when I showed him these photographs; he thinks it is one of Moore's greatest works.

When I photographed the piece in Tel Aviv, I was delighted at all the open space around the work, which gave me a chance to photograph it comfortably from all sides. In this placement the view I like least is the one facing the museum itself, where the horizontal lines of the entranceway and the overlarge lettering on the front of the building interfere with the forms of the sculpture. I was especially grateful for the lovely cloud formations in the Tel Aviv sky, which work so beautifully with the lines of the piece.

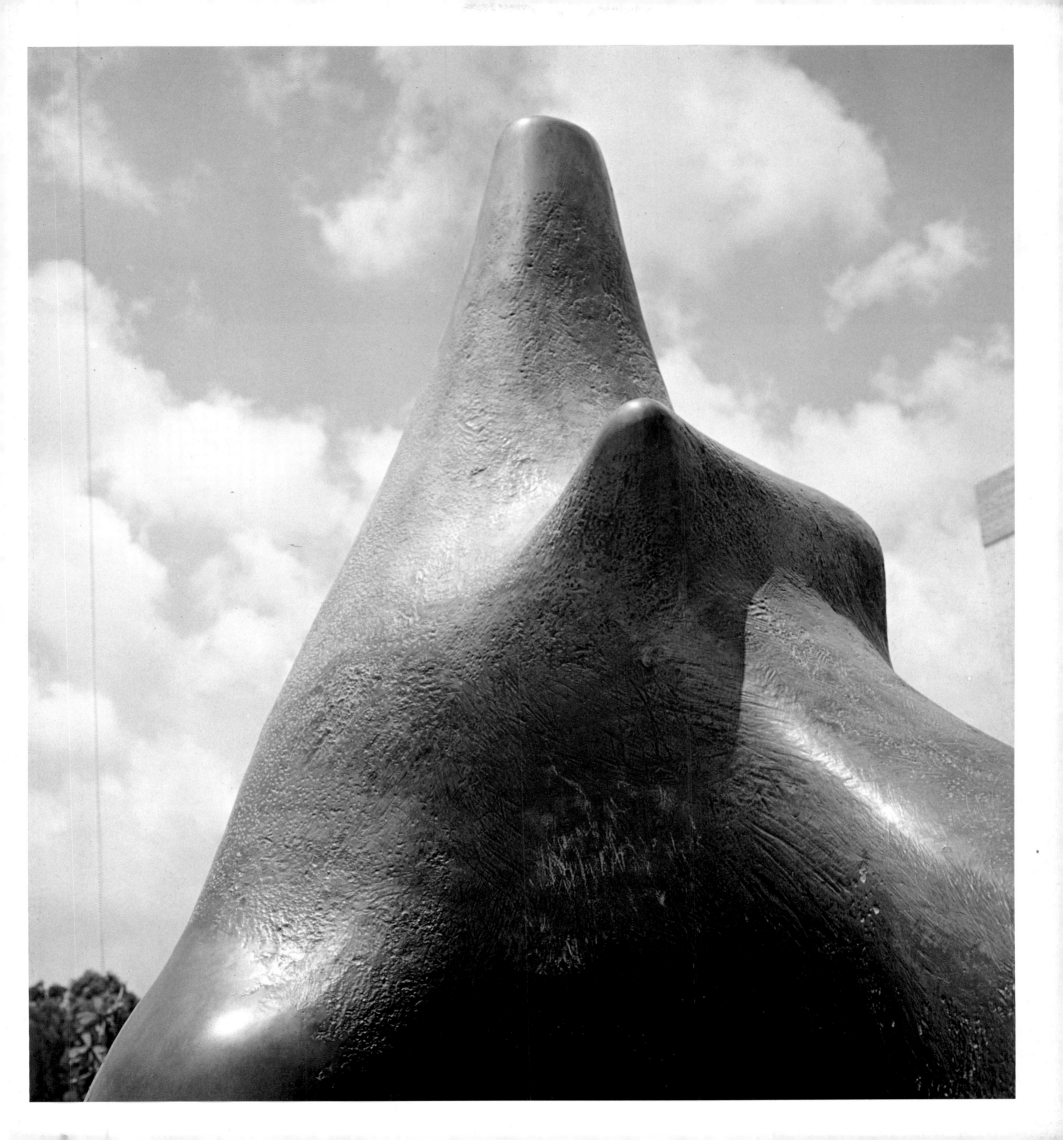

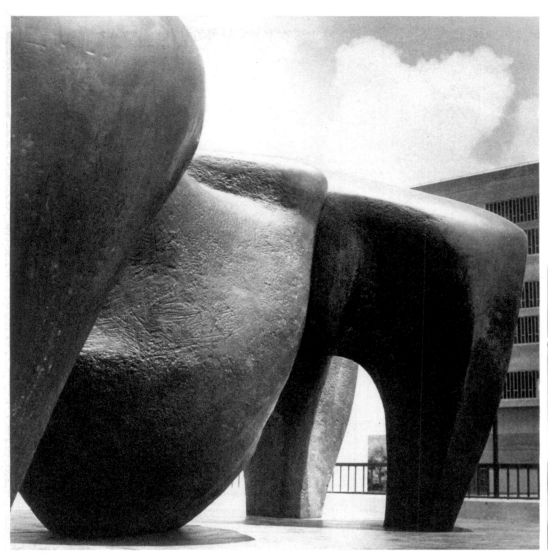

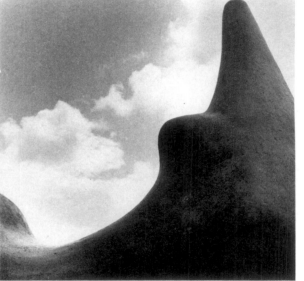

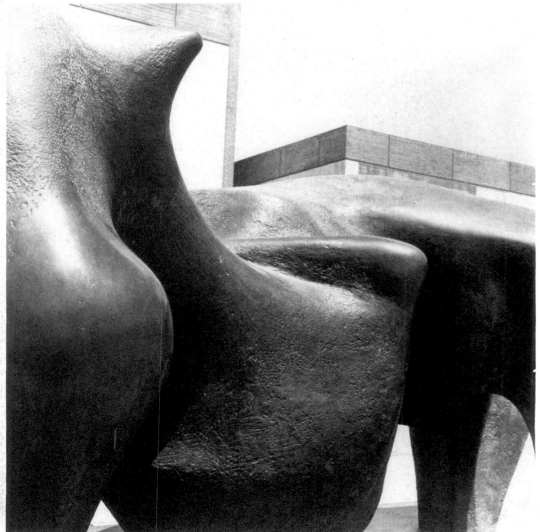

I have been once to Israel, for four days in November 1966, when the British Council sent an exhibition of my work to Jerusalem and Tel Aviv. This Reclining Figure *had not then been acquired by the Tel Aviv Museum. This is a good location, judging from the photographs. In one photograph it looks like some big arch; in another you can see a mountain peak. Jolly good.*

—Henry Moore

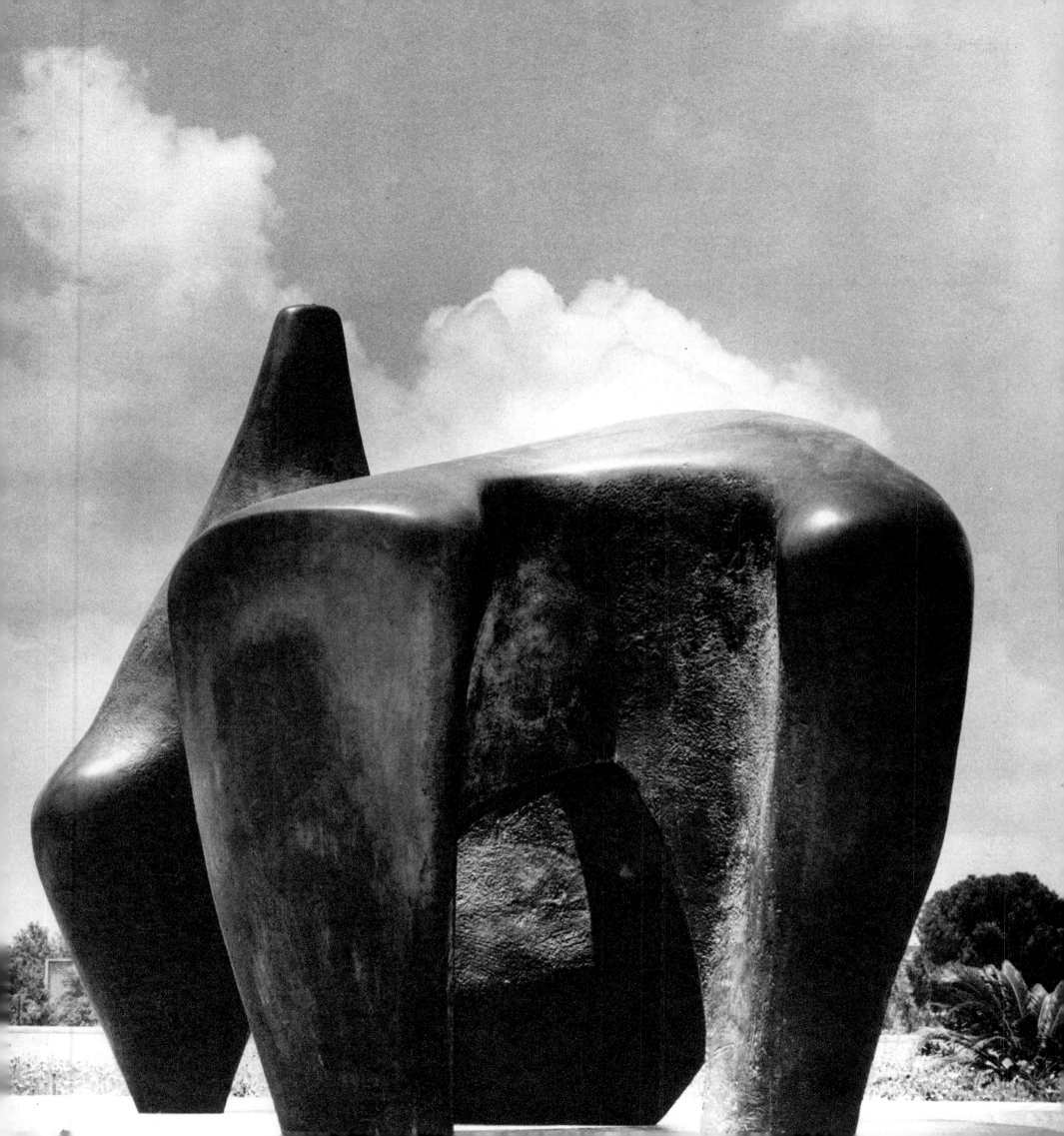

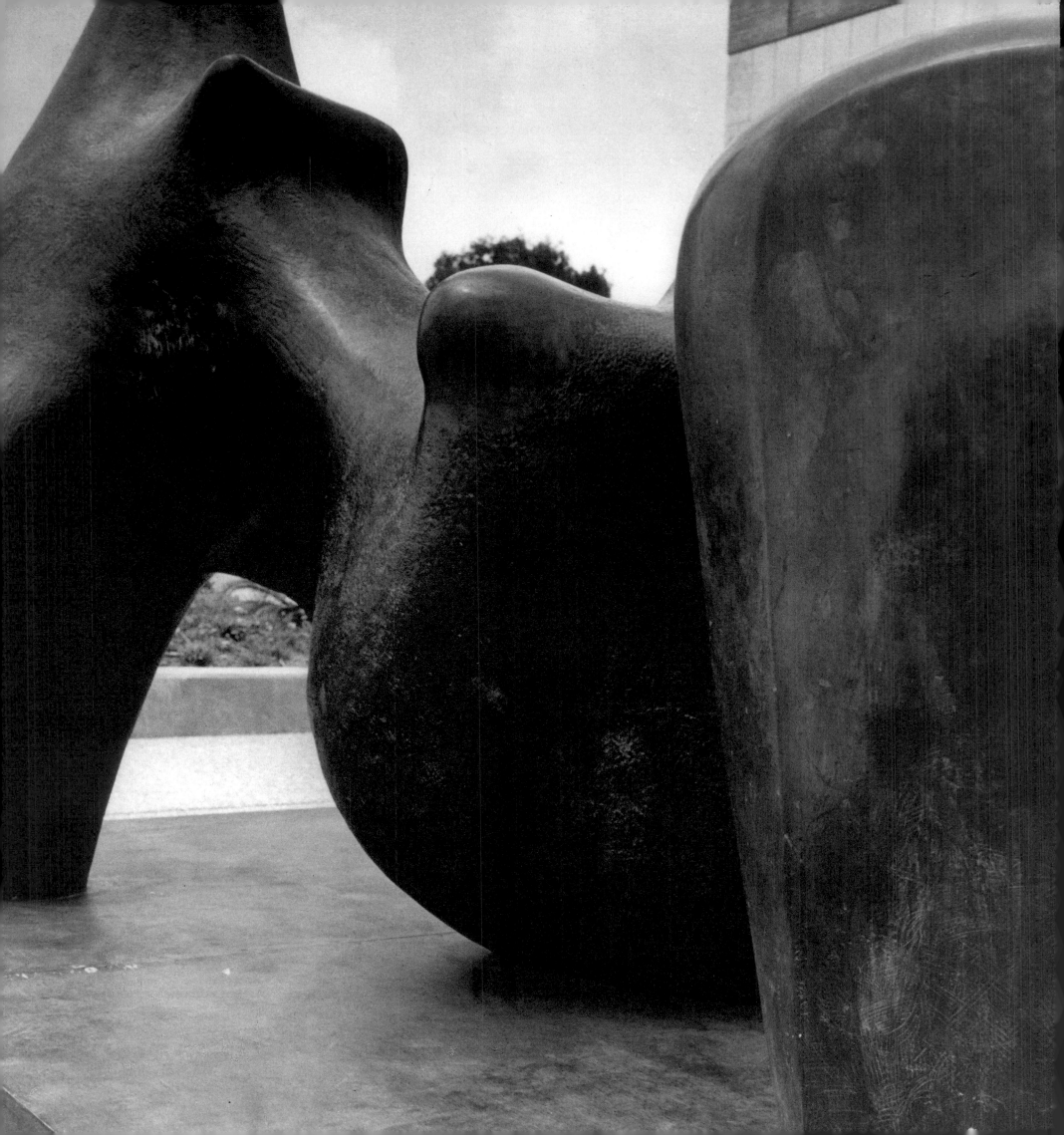

THREE-PIECE 3, VERTEBRAE

1968–70. BRONZE, L. 10′. ISRAEL MUSEUM, JERUSALEM

This monumental work was first exhibited at the Florence exhibition in 1972 and was quickly recognized as a new Henry Moore masterpiece. Subsequently, it went to the Billy Rose Art Garden of the Israel Museum, where it was first located in an area that happened to be available for a work of this size. Soon thereafter, James Johnson Sweeney, an old friend of Moore's who had installed the sculptor's first exhibition at the Museum of Modern Art in New York, became advisor to the Israel Museum. He decided that the *Vertebrae* had to be moved to a spot where it could be seen against the sky, and its present position was chosen by Sweeney, who also designed the pedestal.

I initially photographed this piece in

Florence, where it was not in such a choice location as this; in that exhibition its background was rather dull, and the sculpture was on a slope, which made it difficult to get many varied details. In Jerusalem it is in a perfect setting, and one could photograph it all day long and still discover new combinations of forms. Although it resembles the *Locking Piece* in some respects (see pp. 144–47; 190–94; 216–21; 364–67; and p. 487), there are elements in this work that I have never seen before in a Moore sculpture—the triangular head, like a cowl; the arm jutting overhead; and the distinctive intertwining of forms.

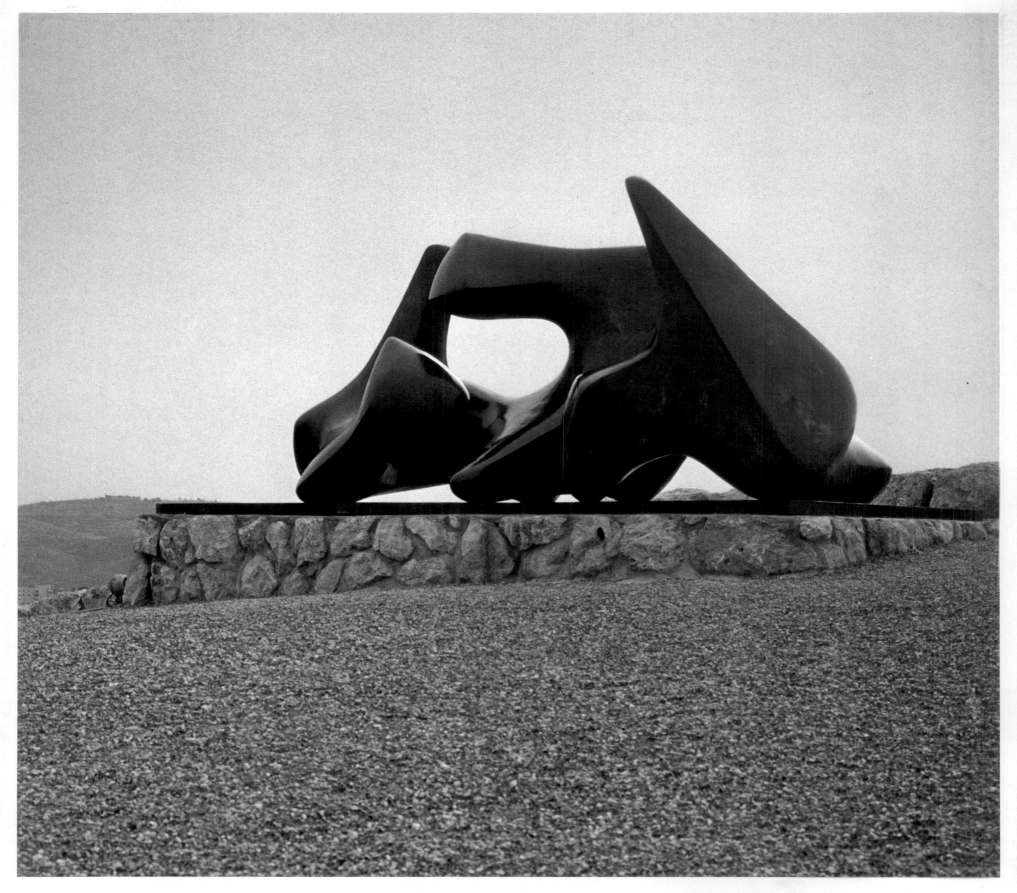

I know Jim Sweeney helped find this fine location. The stone base is good, although it would have been nice if they could have found a darker stone—dark granite perhaps. The detail that looks like a locking piece is very good, but I think the one with a hole is a bit obvious. Too much the general idea of a Henry Moore hole. One has got to be careful of photographing those holes. I especially don't like it when they put my face showing through the hole.

—Henry Moore

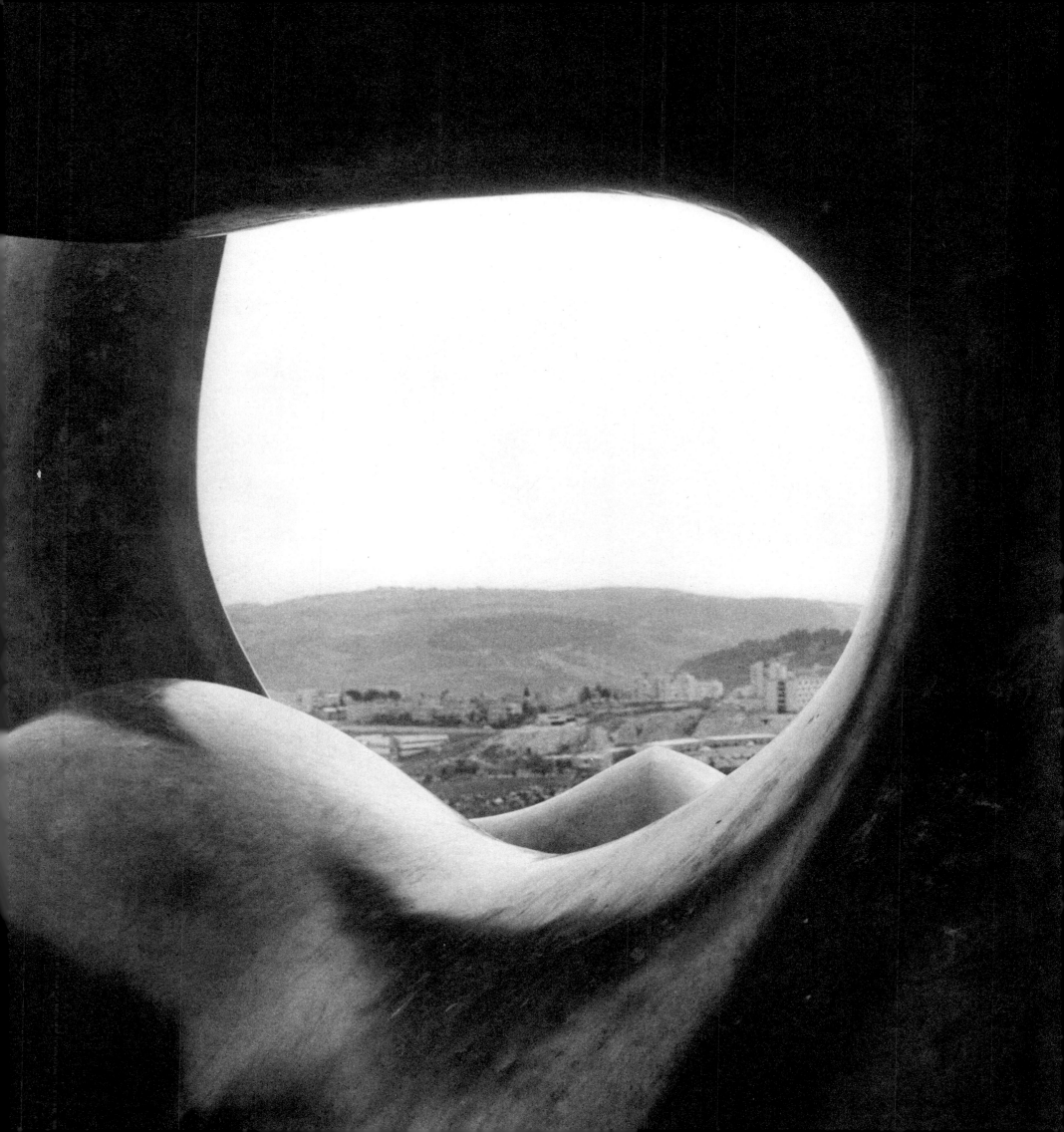

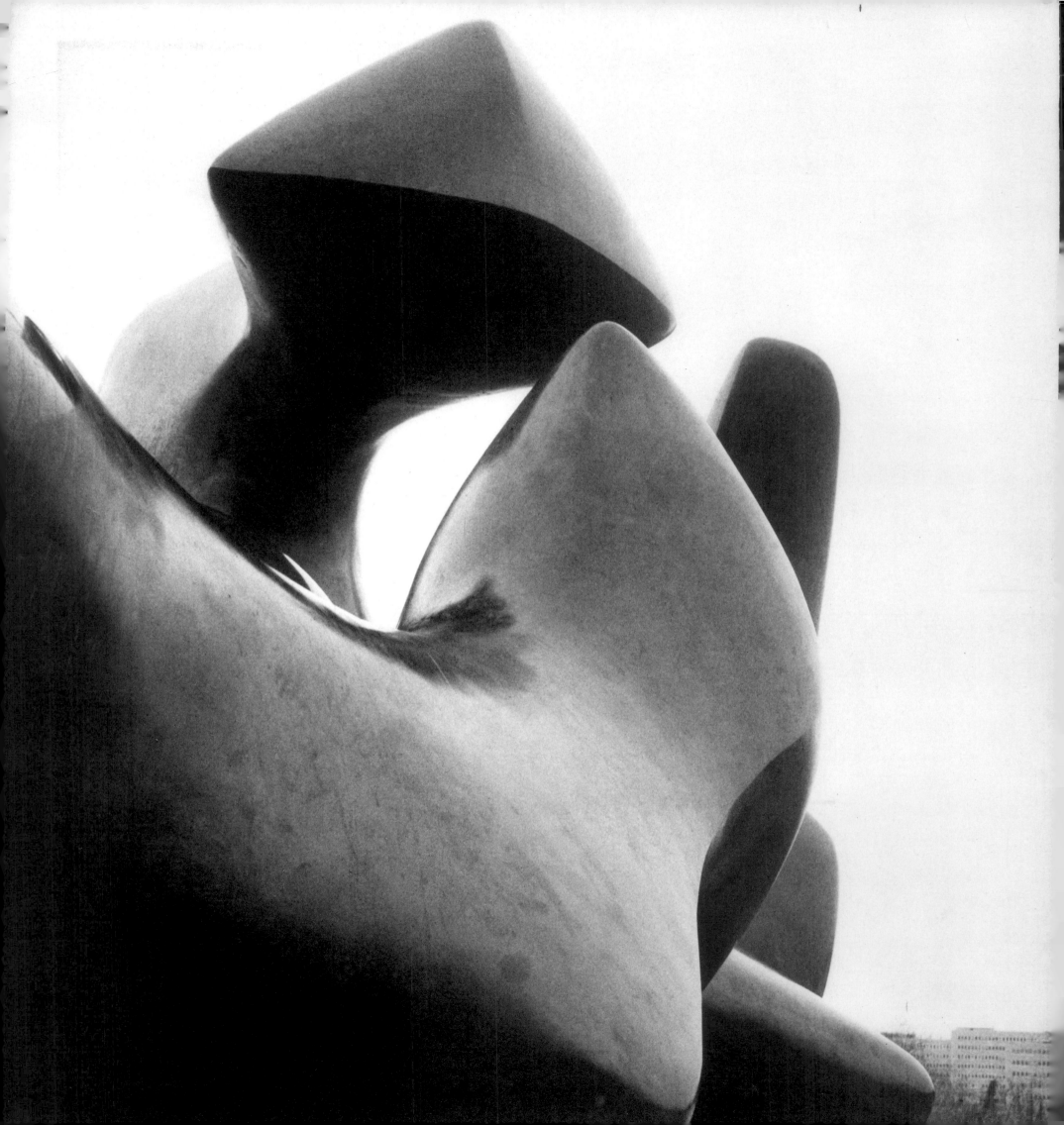

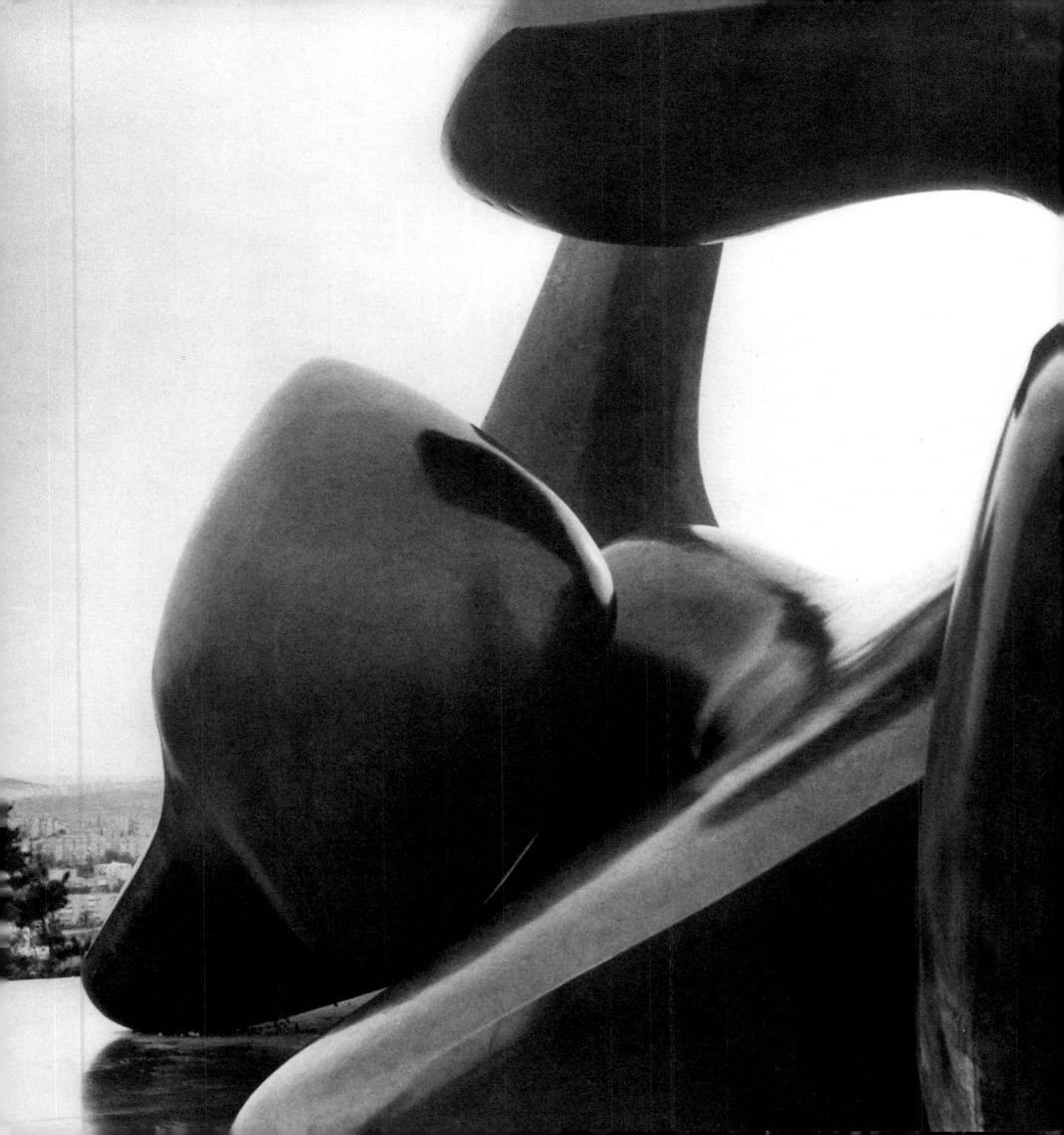

UPRIGHT MOTIVE 7

1955–56. BRONZE, H. 12′6″. ISRAEL MUSEUM, JERUSALEM

This *Upright Motive,* of which there are other casts in Otterlo, the Netherlands, and Fort Worth, Texas (see pp. 168–73; 456–61), can be seen more fully in this location, where it is isolated and silhouetted against the Jerusalem sky and hills. Actually, these photographs were taken when the sculpture was in its original setting, which was exceptionally fine (the plate below shows the work in its present, less dramatic position). It is, perhaps, a little more difficult to perceive in this figure the great variety of themes evoked by some of the other Uprights, but its sinuous forms are beautifully composed and possess great inner strength. Kenneth Clark thought the figure sinister, terrifying, in the photographs—a tremendous, brooding goblin with a tall cap and folded hands.

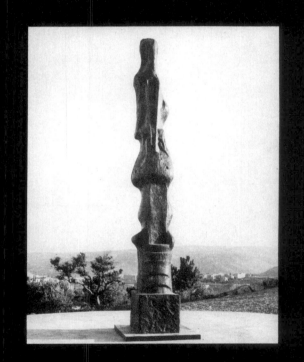

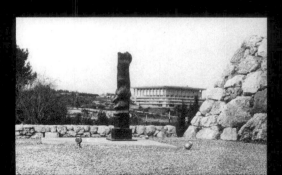

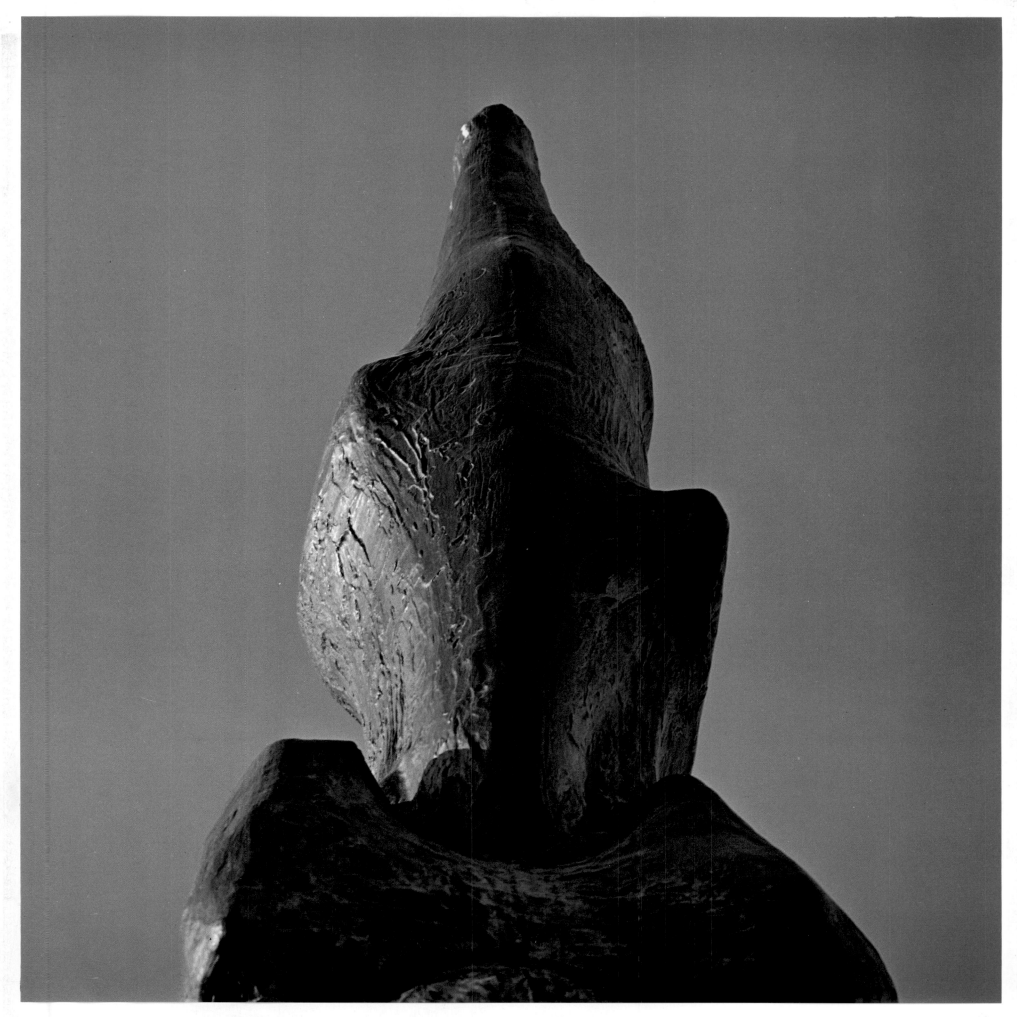

The views of the details are suprising. They're excellent.
The light is so good, it makes the form real and focuses the eye right on it.

—Henry Moore

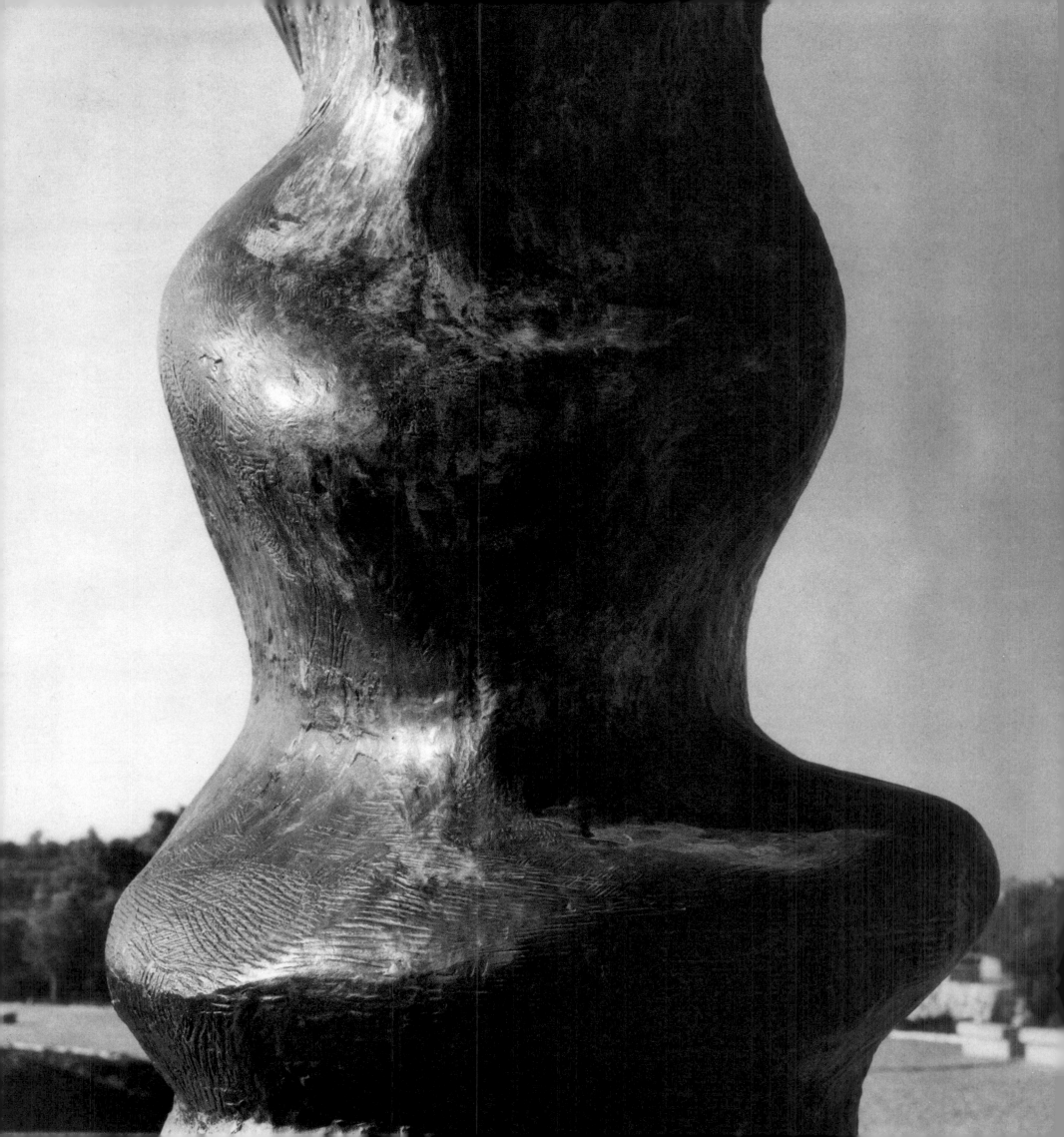

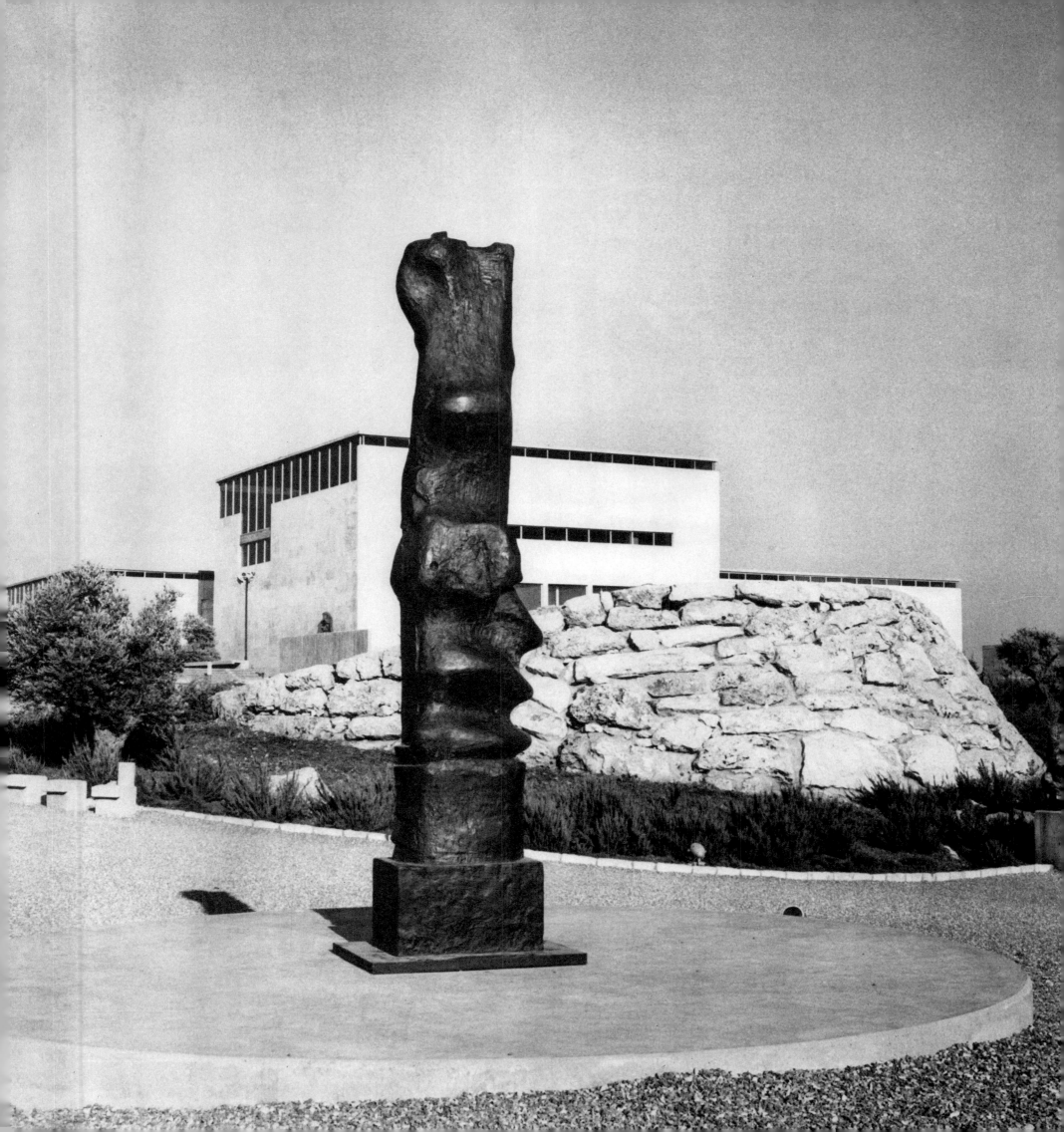

The Billy Rose Art Garden, designed by Isamu Noguchi, is located outside the Israel Museum and overlooks the beautiful Jerusalem hills. Like most sculpture gardens, it has become rather overpopulated, and some pieces are not displayed as well as they might be. When it was first installed, *Reclining Figure: External Form* was given a place of honor on a small rise at the edge of the garden with a view of the hills in the background. It was later moved to a much less satisfying location and *Three Piece #3, Vertebrae* was put in its place (see pp. 73–77).

I first photographed *External Form* its more prominent position (only the lo photograph on this page shows the work new location). In the original setting on eyes were drawn to the gaping holes an brilliant interplay of spaces as one look through the rings to the hills beyond. In new location one looks down on the pie and it tends to become merely an intere form on the ground, rather than a start invention dramatically juxtaposed again the sky.

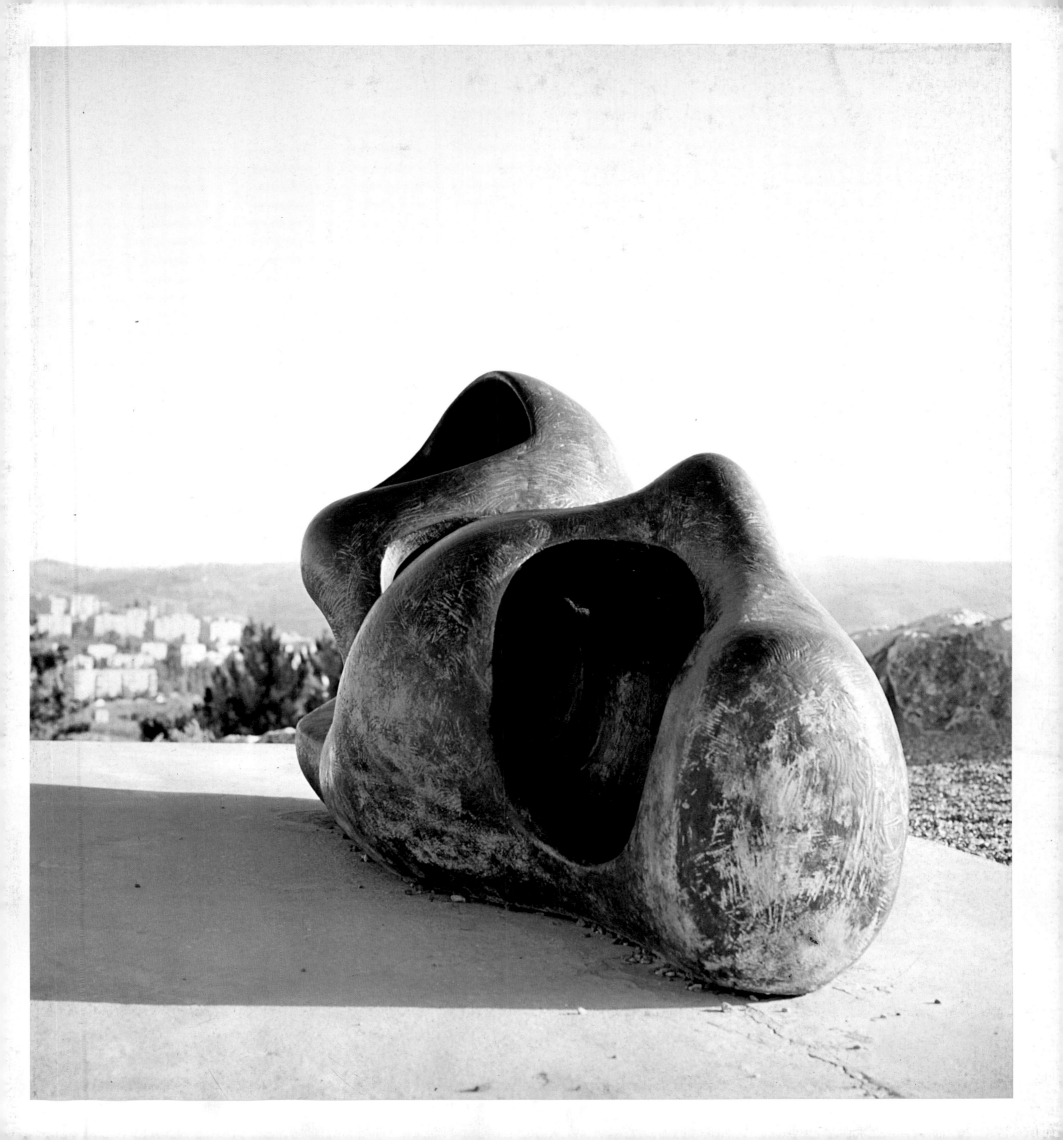

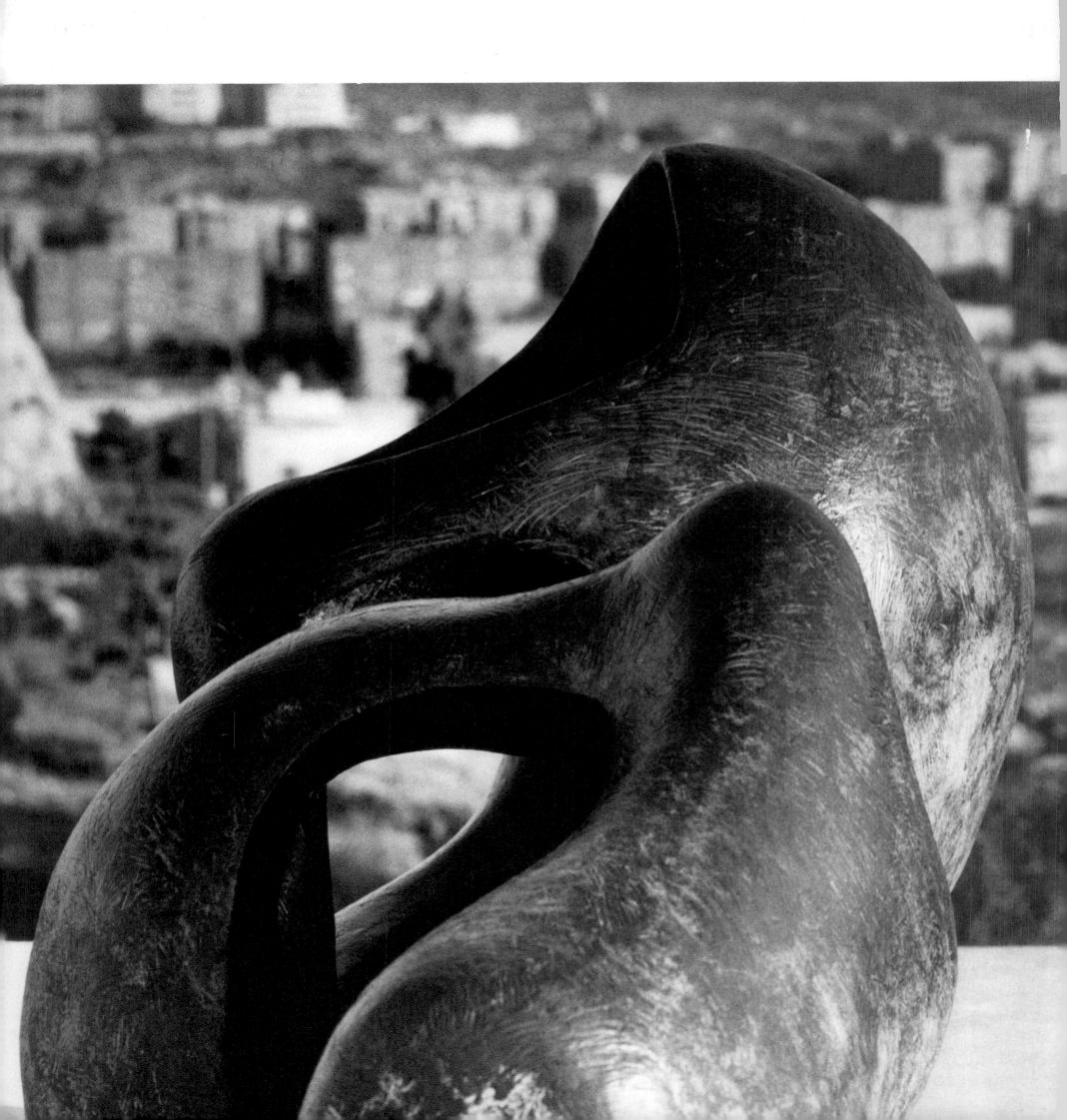

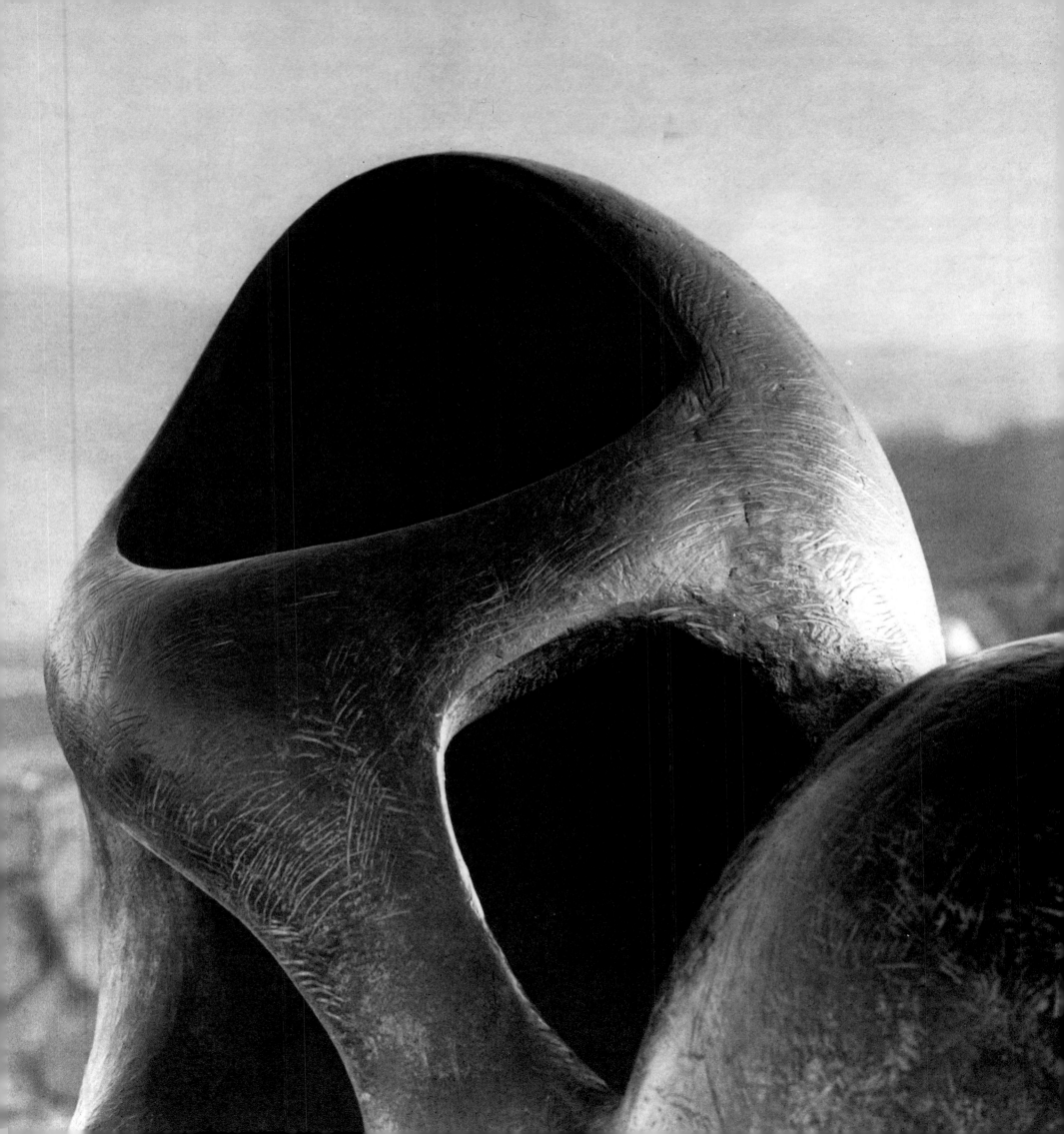

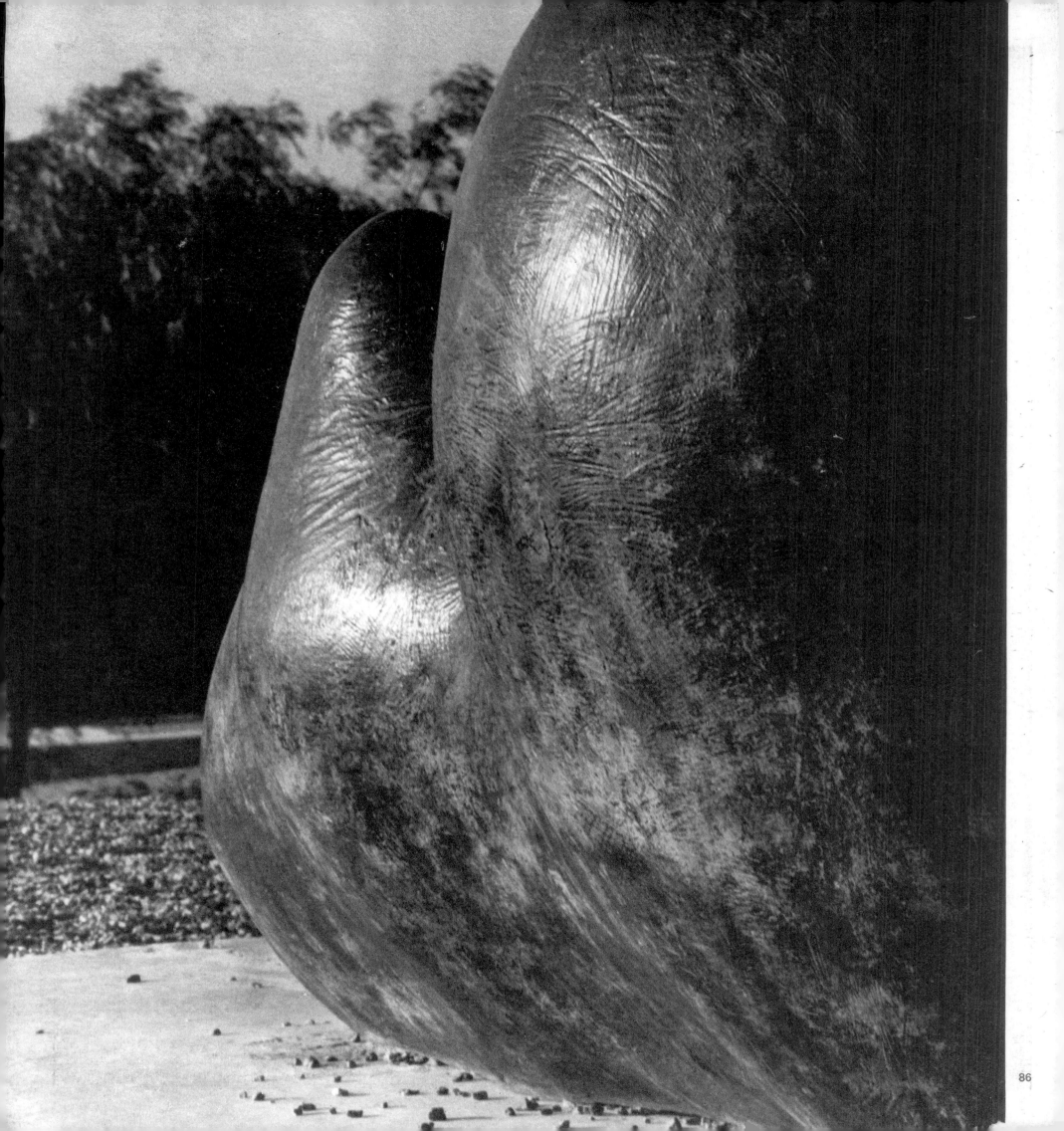

A cast of this upright relief is located in Moore's grounds in Much Hadham, England, where he has placed it in the middle of a broad lawn (see p. 490). Thus one can walk around the sculpture as if it were a figure in the round. It is difficult to get the same feeling with the cast of the piece that hangs on the side of the Israel Museum, especially since most viewers of the work see it from only a slight distance and do not have an opportunity to look at it from different angles. The relief itself is, however, a remarkably vigorous work, with its fascinating grouping of forms that weave in and out of each other. I was fortunate in being able to photograph the piece in full sunlight, when the strong highlights and

shadows emphasized the sinuous shapes, creating lovely patterns.

I don't like sculpture used as costume jewelry, which is what happens when it is pinned onto a building. It knocks out for me what is the main difference between sculpture and painting. In painting you have only one view, from directly in front. I like sculpture to be three dimensional and able to be seen from all round, that is, from many points of view. If a relief is framed into a wall, it asks only to be viewed from directly in front and often looks as if it is stuck on the wall—as if it is going to fall down.

—Henry Moore

DRAPED SEATED WOMAN

1957–58. BRONZE, H. 73". HEBREW UNIVERSITY, JERUSALEM

This is one of the best placements of a Moore sculpture on a university campus. The setting has the virtue of a large, open space with an expanse of green lawn around it and some foliage in the distance, and the buildings nearby are compatible with the piece, both in terms of proportion and design. The *Draped Seated Woman* is located near the entrance to the main building of the university and is seen daily by practically all students, members of the faculty, and visitors. Furthermore, the lawn on which it is situated is a natural congregating place for students, and one almost always sees them sitting or lying on the grass around the sculpture. Thus Moore's work has become part of the life of the university, enriching the experience of virtually all who live or study there.

This is one of five sites at which I photographed casts of this sculpture (see pp. 58–61; 244–45; 400–403; and p. 492).

Looking at the photographs, one sees clearly, I believe, how the setting of a sculpture draws one's eyes to different views and details of the piece, proving Moore's contention that our perception of a sculpture changes in different settings. I did not consciously photograph each cast from different angles but followed my instincts, as I always do. The variations in the photographs thus reveal the effect the sculpture had on me in each setting.

I have photographed this piece in Israel on several occasions. The light there is ideal, creating wonderful highlights and shadows and revealing the richness of the patina. The base is exciting, although I'm not sure that the shaping of the rock is as successful as it might have been, for there is something a little artificial about it. Nevertheless, it is one of the most successful placements of this work that I photographed.

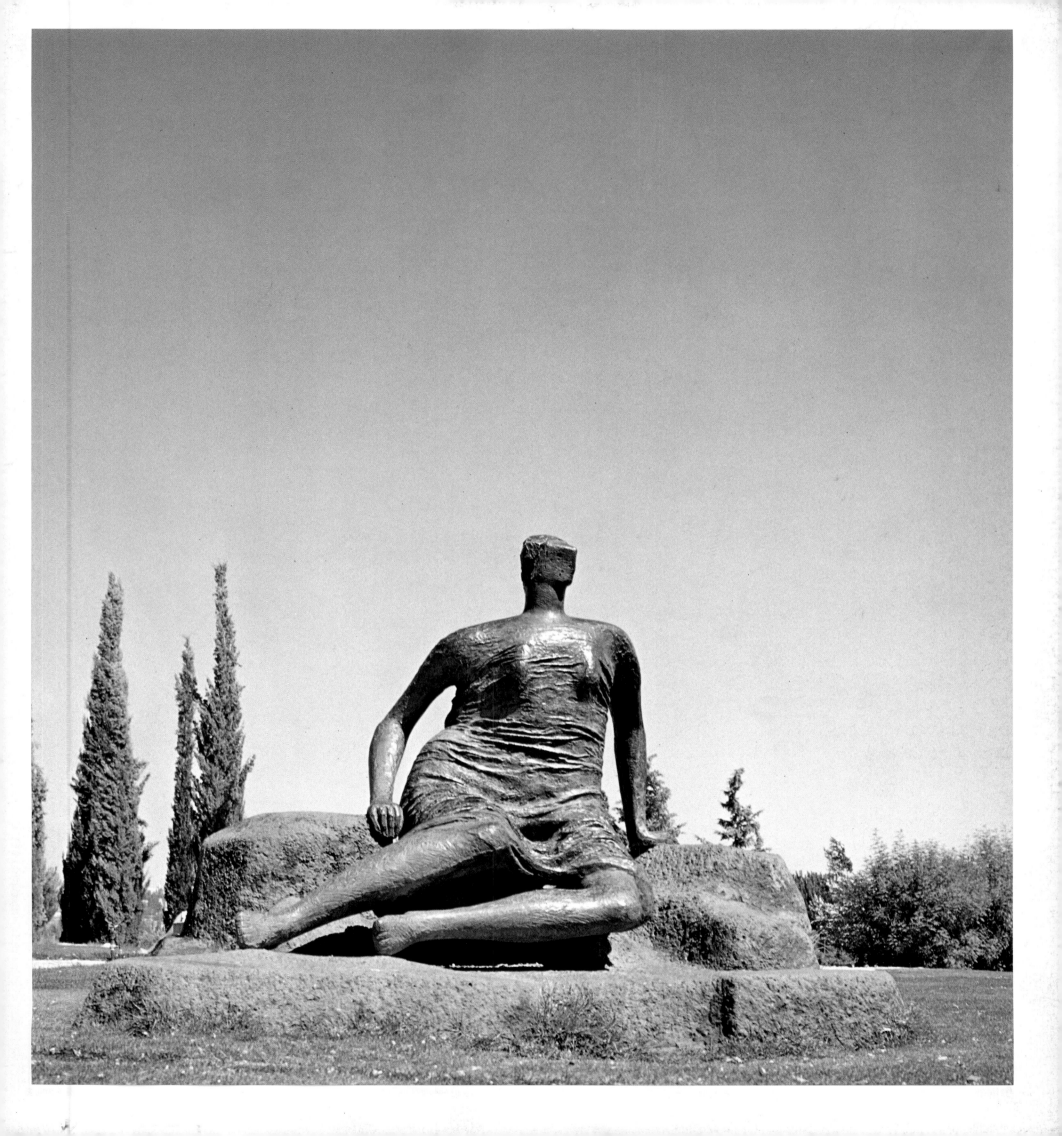

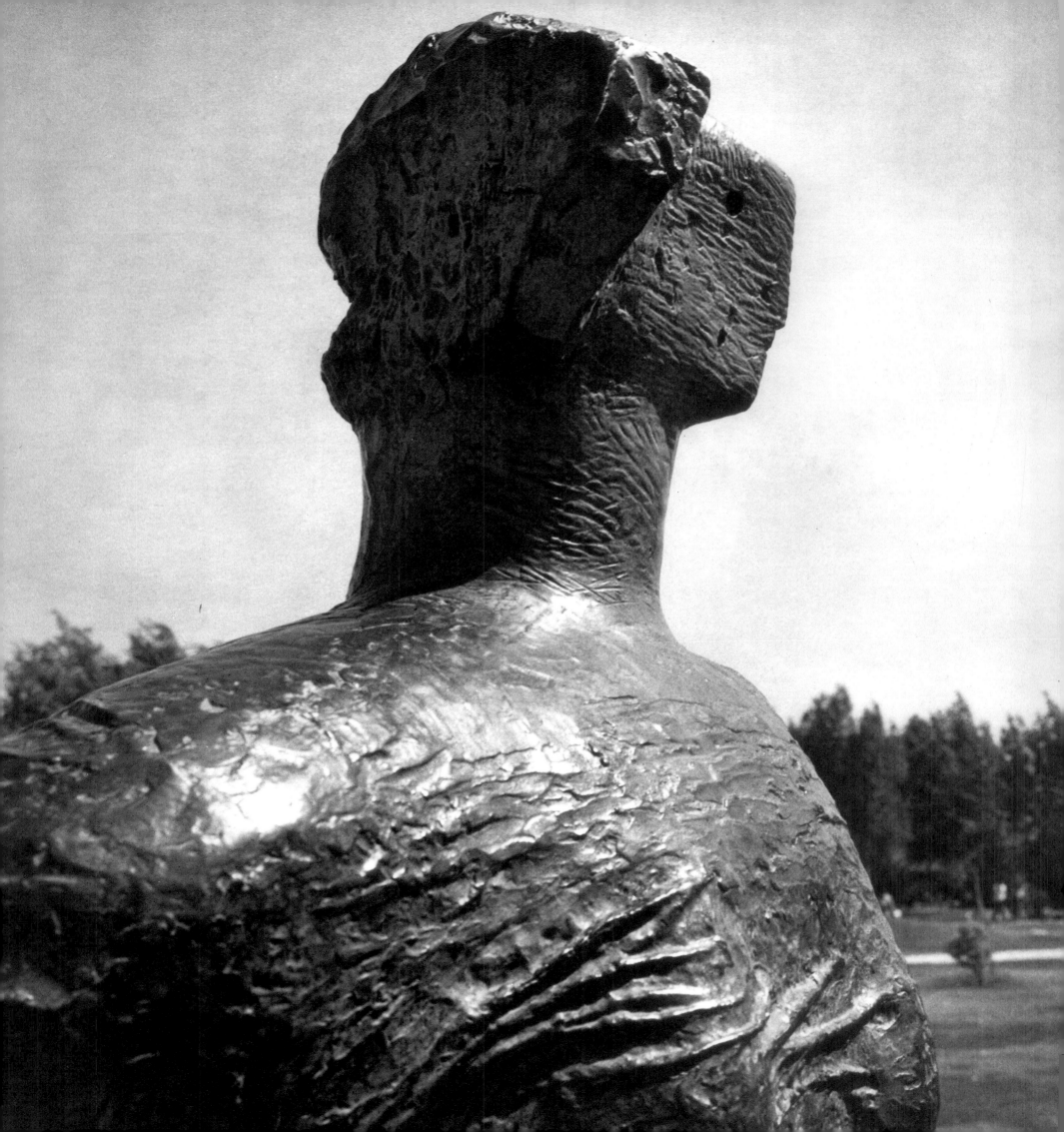

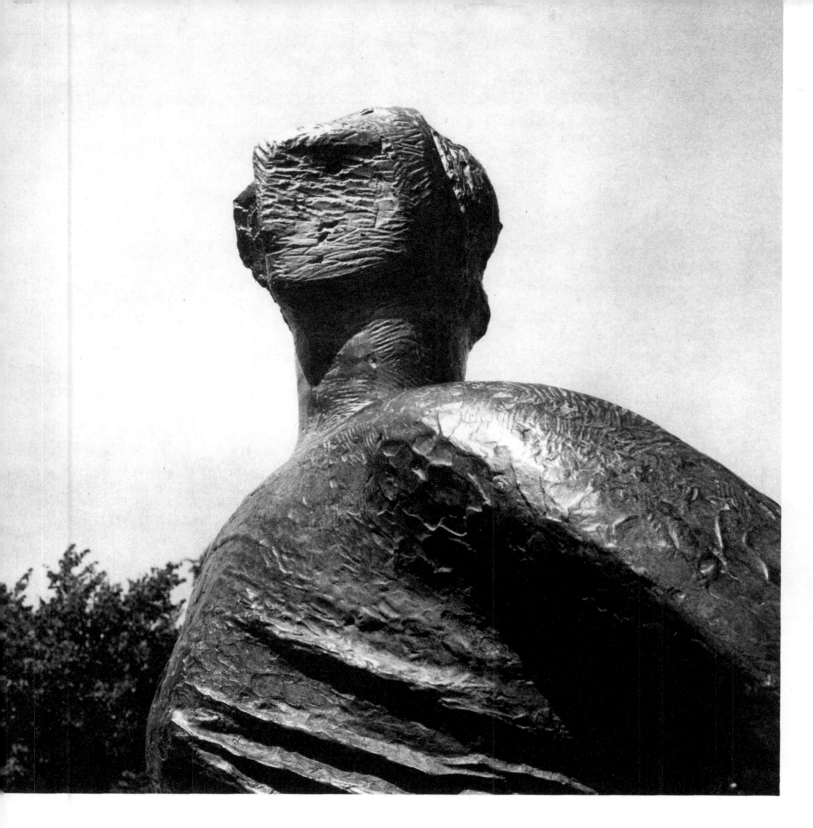

In the alert pose of this seated figure each hand rests at a slightly different level. Also, the feet touch down at different heights, and the buttocks are not on the same height—so all these points had to be correct when its stone base was made.

I suggested that they might use a local stone for the base. As it was not possible for me to go to Jerusalem, I gave them a rough model, a little maquette showing them how the heights must come out right. These photographs are awfully good. You see, there's good light. In photography, it's the light that counts, always.

The figure stands up against the sky. That's fine.

—Henry Moore

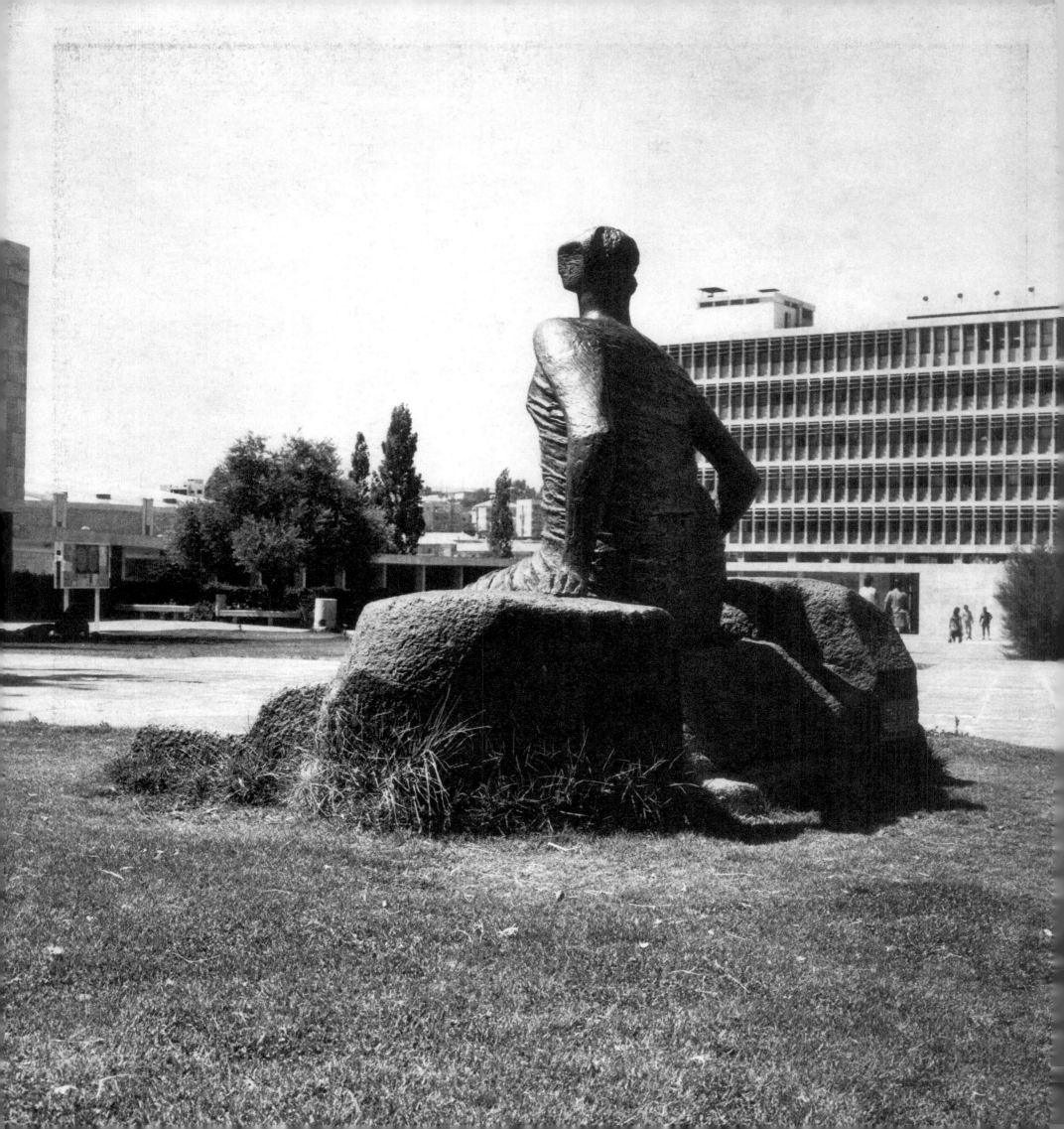

FRANCE

RECLINING FIGURE

1957–58. ROMAN TRAVERTINE, L. 16'8". UNESCO BUILDING, F

arly appropriate for this
e travertine marble with
that adds character to
he figure looks
nst the smaller building
skyline, but it is
ing when seen against
ing.
omplex is extremely
rchitecture, both interior
ent. Furthermore, the
ulptures in the area are
beautifully integrated
nt. No visitor to
to see and appreciate

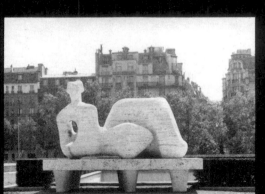

the works
of the com

I love
light hits i
beautiful g
marble tha
of the wor
by the gra
of surface
version in
116–19). V
long, swee
are majest
erect and
UNESCO

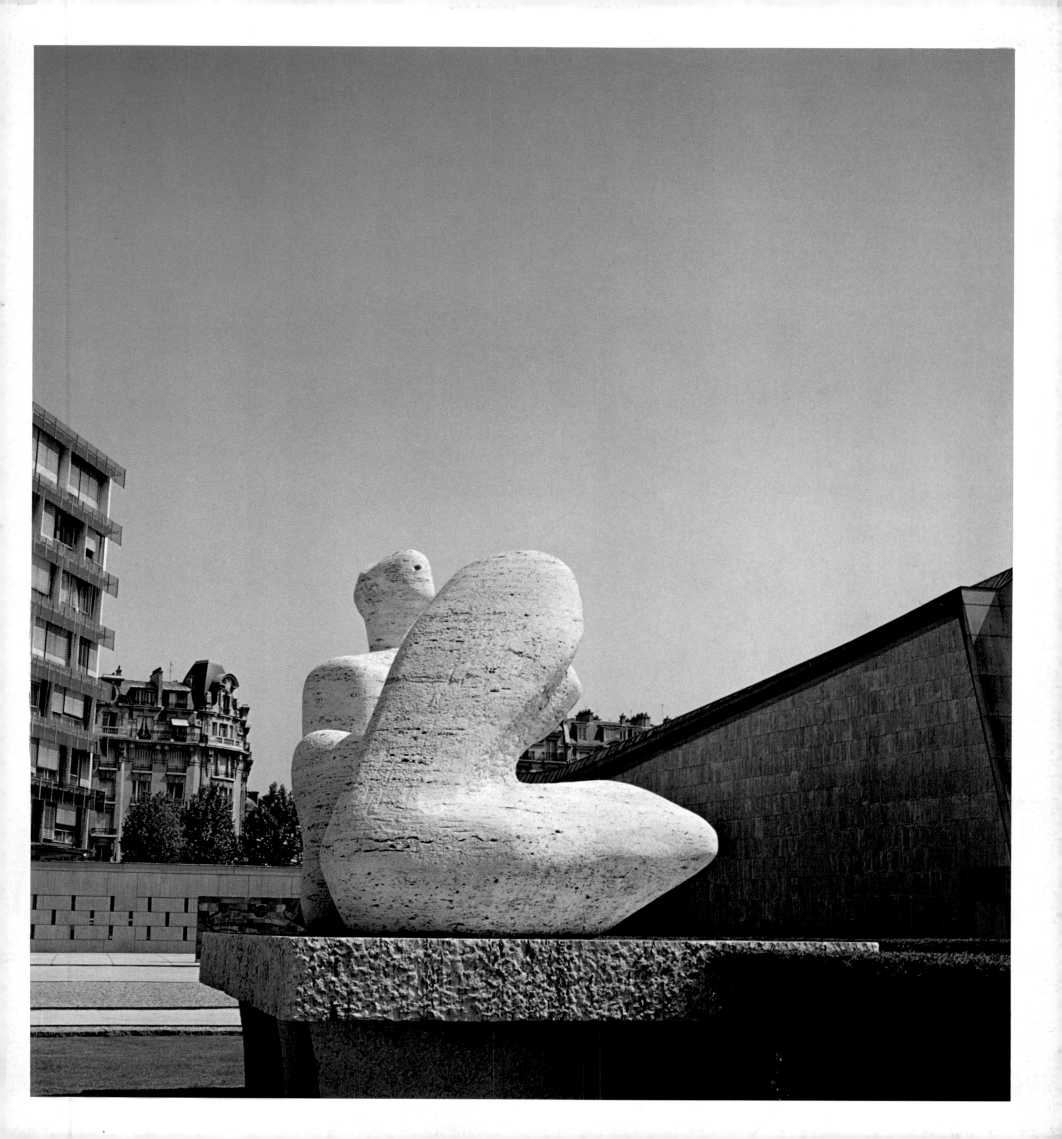

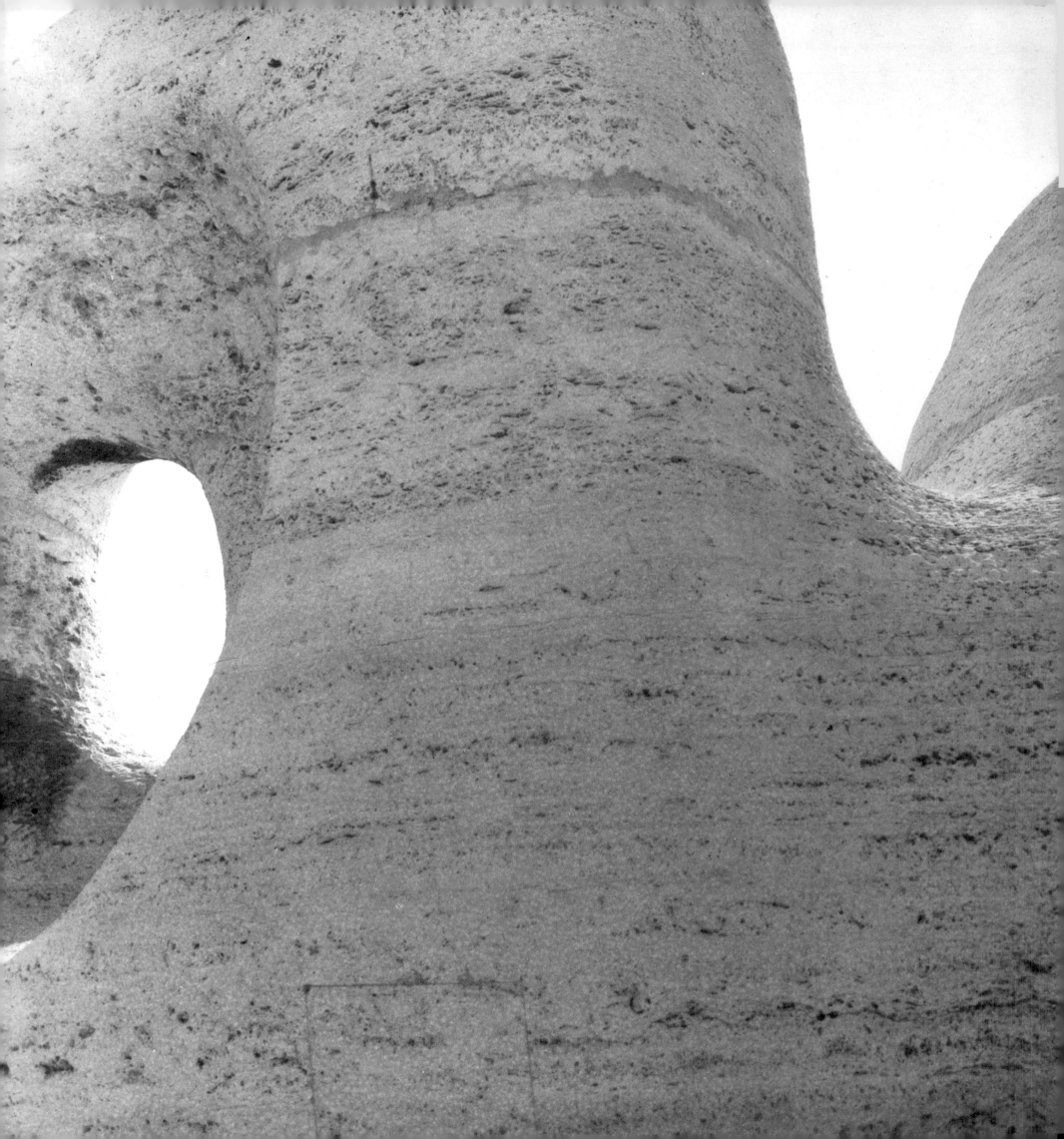

*There was an international team of three architects for the UNESCO Building,
and together we chose the position for the sculpture. I made a small maquette,
only 6 inches long, photographed it, and then made an enlarged photograph,
5 meters in length, as you would enlarge the head of Gregory Peck in front of the
cinema. We set up this large photograph on the site. The building was only half
done, and there were heaps of builder's rubbish and other things around, but the
photograph gave us a sense of scale. The architects thought the sculpture should
be 7 meters long. At that time, I had never done a sculpture anywhere near that
size. I was a little nervous about making something bigger than it should be,
blowing it up more than it deserved. I thought a sculpture 5 meters long was large
enough. It was a dull, misty day when we put the enlarged photograph in front of
the building, and from a distance it looked like a real sculpture. That was the way
we decided on both the site and the size, which we finally agreed should be 5 meters
in length.*

*The sculpture was done in two pieces of stone. You can see the joint if you
look carefully. It was the largest stone carving—or sculpture of any kind—I had
done. It enabled me to overcome my lack of confidence in doing large sculptures.
From then on I've had no fear about size.*

—Henry Moore

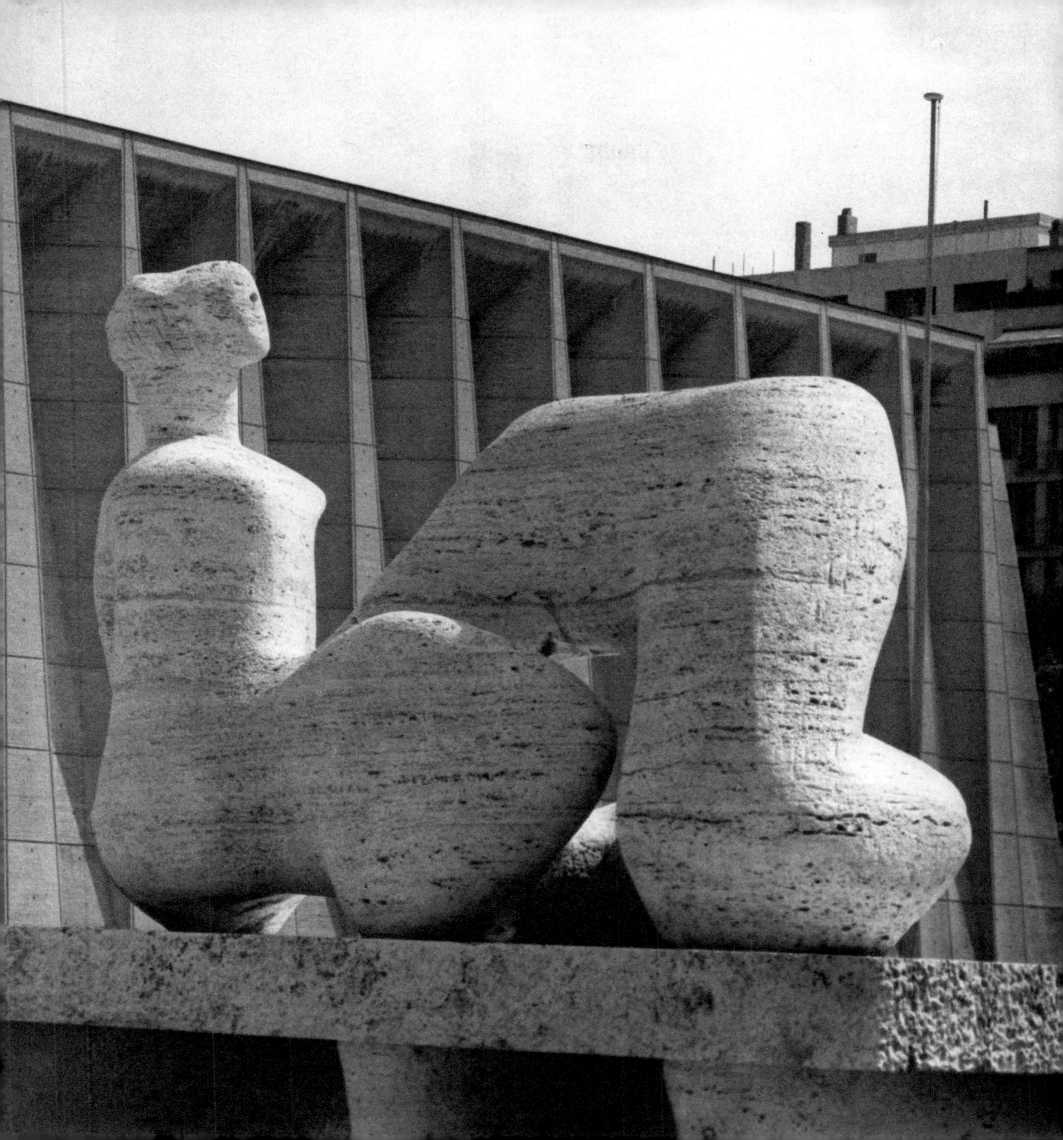

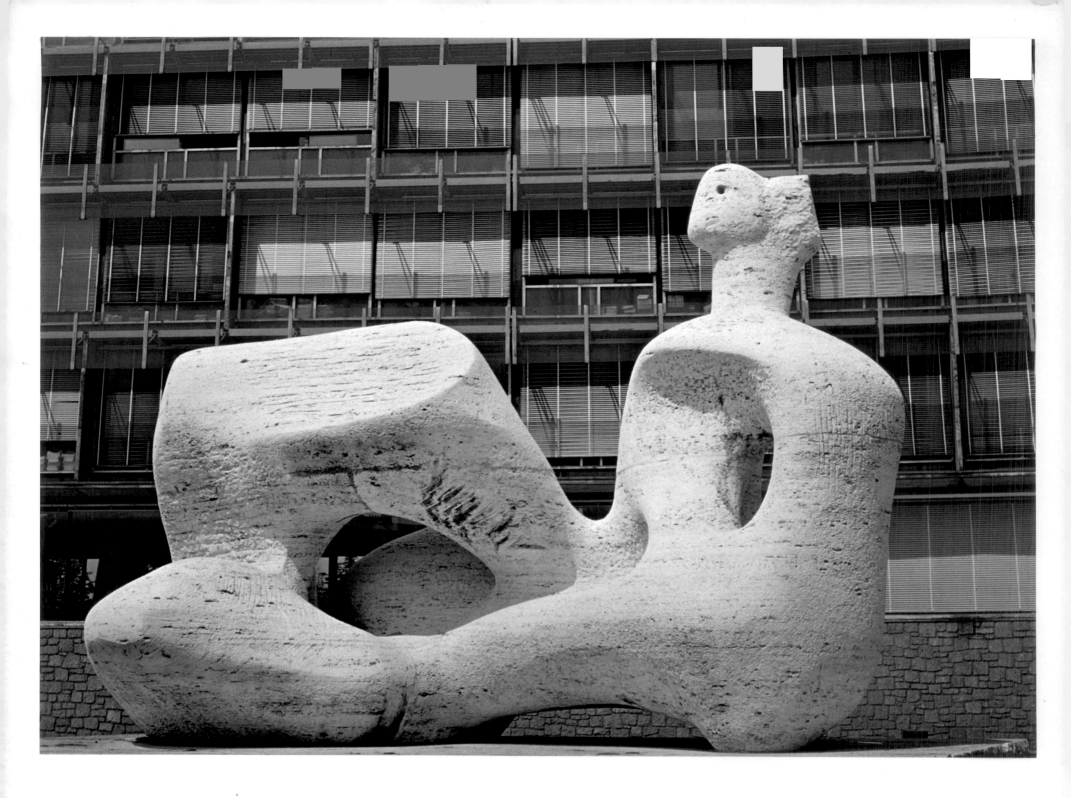

ITALY

TWO-PIECE
RECLINING
FIGURE
5

1963–64. BRONZE, L. 12′3″. SOCIETÀ ASSICURATRICE INDUSTRIALE, TURIN, ITALY

in effect, the courtyard
orporate office building,
t easily be seen from the
y low pedestal that is
ly to the building, and
ly views of the work
of the building. In the
he courtyard and by the
, the foliage provides a
d, but the sculpture is
by the overhanging

n walk around the piece
timate surroundings,
re drawn to details than
Also, the background is
ne from all sides, so
vas not influenced by

landscape considerations. T
been photographed in two
pp. 152–56; 196–202).

I wanted them to push the s
central area of the building
an open patio, and it would
some light. As it is now, it
canopy. This is very bad, es
you approach it from the d
could easily have built out
it—they have the space. It
much better.

In these details the figu
open-mouthed nipper. That'
that.

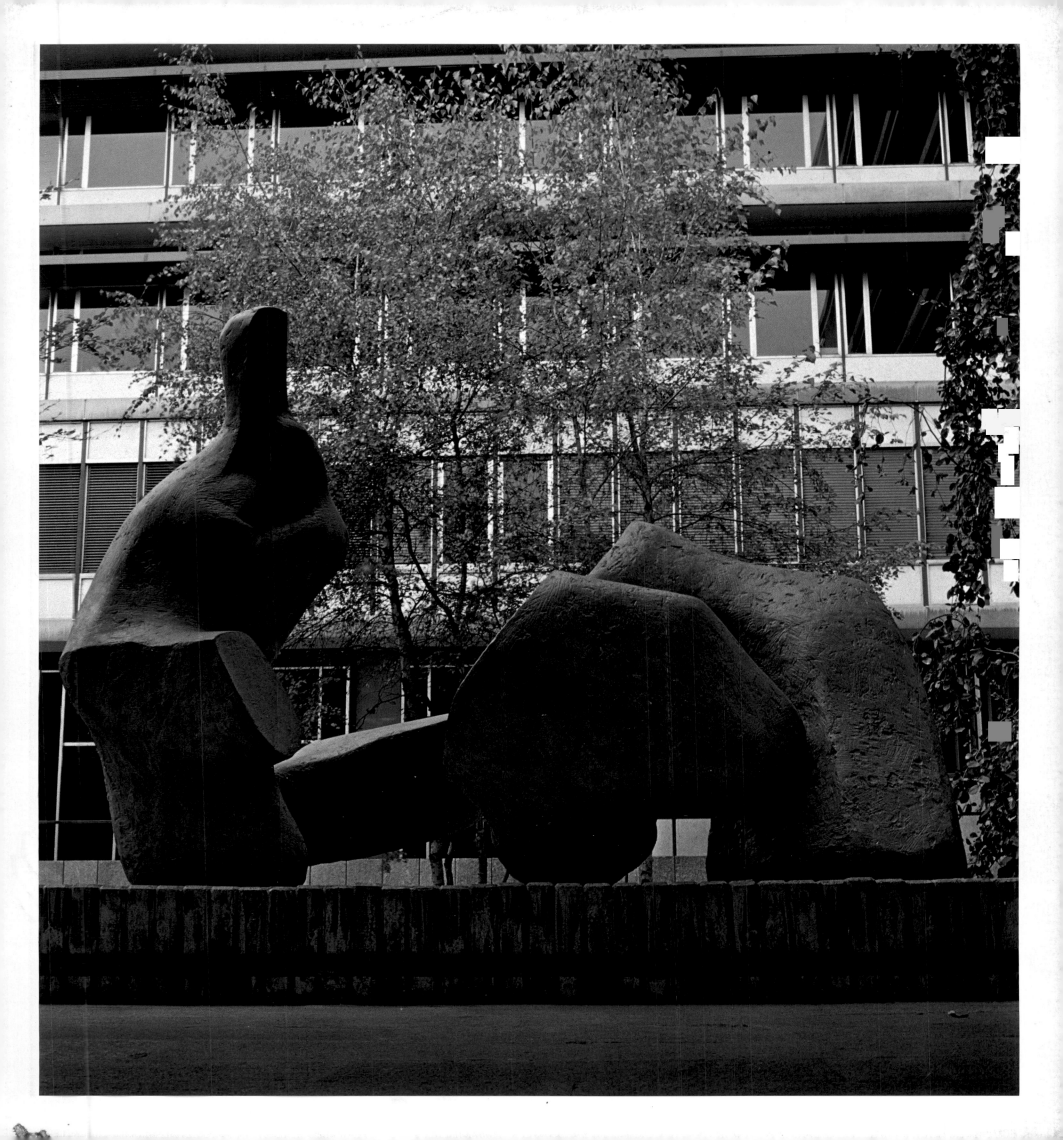

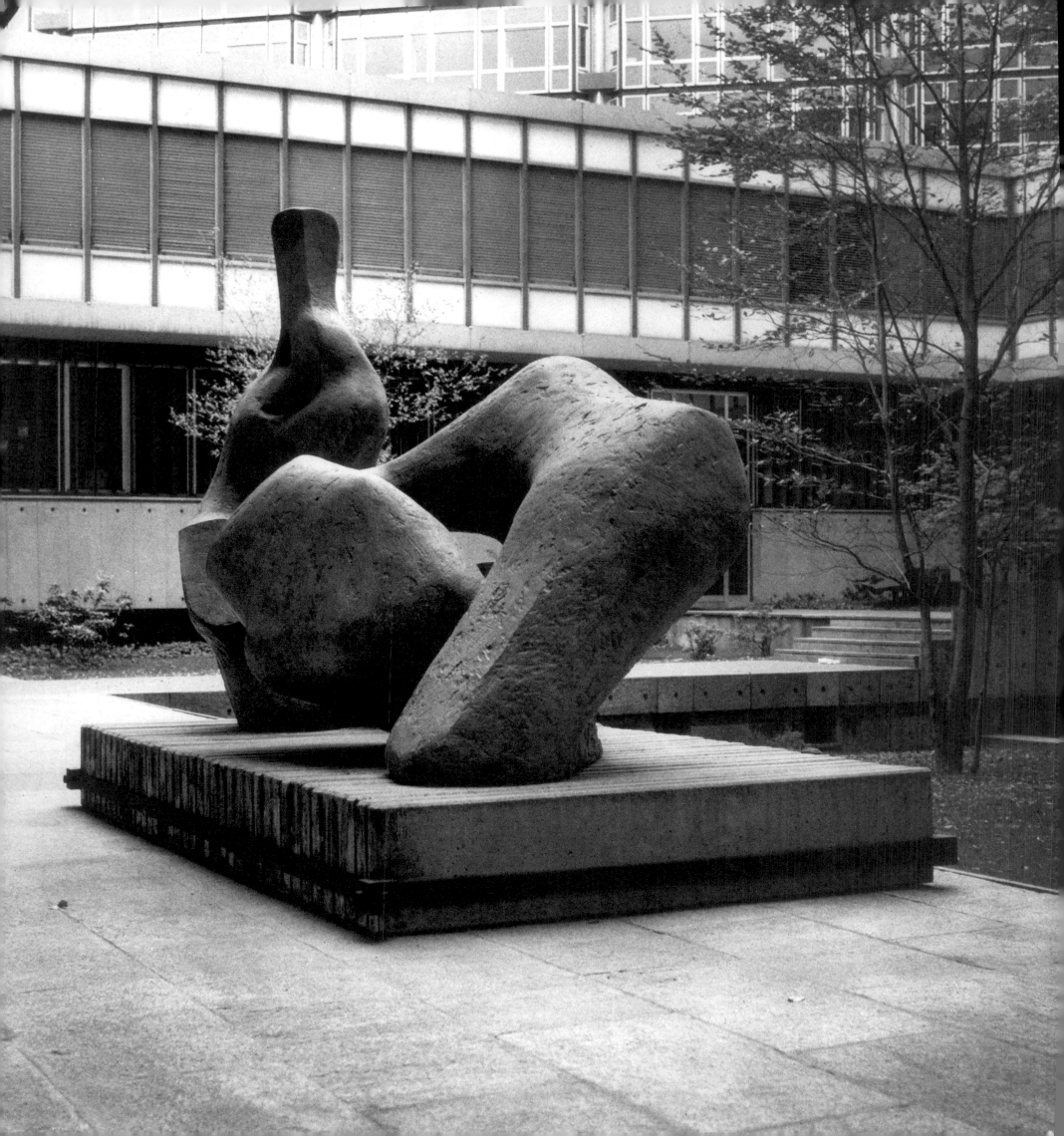

SQUARE FORM WITH CUT

1969–70. MARBLE, H. 55 1/4″. PRATO, ITALY

This sculpture, carved in rio-serra marble, is one of Moore's most remarkable achievements. It was initially shown at the Florence exhibition (see p. 477) and was recognized as a magnificent work, carrying out Moore's sculptural ideas in marble on a scale never before realized. Ingeniously designed in levels, the sculpture consists of slices of marble laid horizontally, one on top of another. The straight, parallel lines of their edges can easily be seen, adding to the viewer's appreciation of the sinuously curving surfaces of the work.

Unfortunately, there was no place for Moore's sculpture in the old and beautiful center of Prato, so it was placed in a large square on the outskirts of the town, where it is surrounded by commercial traffic and relatively unattractive modern buildings— jarring elements when viewing a great sculpture. Still, it is marvelous to see the work permanently placed in the open air, and a large expanse of lawn surrounding the piece sets it off nicely. Perhaps the aesthetic

deficiencies of the surrounding buildings are compensated for by the respite afforded those who can rest a few moments on this green island with its magnificent marble carving.

Although my wife and I were fortunate enough to acquire a cast of the maquette for *Square Form with Cut* and we later saw the full-size Styrofoam model Moore erected in Much Hadham, England, we were overwhelmed when we saw the final work in Florence, with its beautiful whiteness juxtaposed against the clear blue sky. As the surfaces curved gently from light into shadow, the subtle shadings of the marble were breathtaking. The basic shape of the piece is simple, and at first glance one doesn't expect to find much variety as one walks around the work. But this is deceptive, and it is truly startling to discover how many different shapes one can discover in this apparently uncomplicated form.

I was especially lucky the day I photographed *Square Form* in Prato. The previous day had been cloudy and gray, but

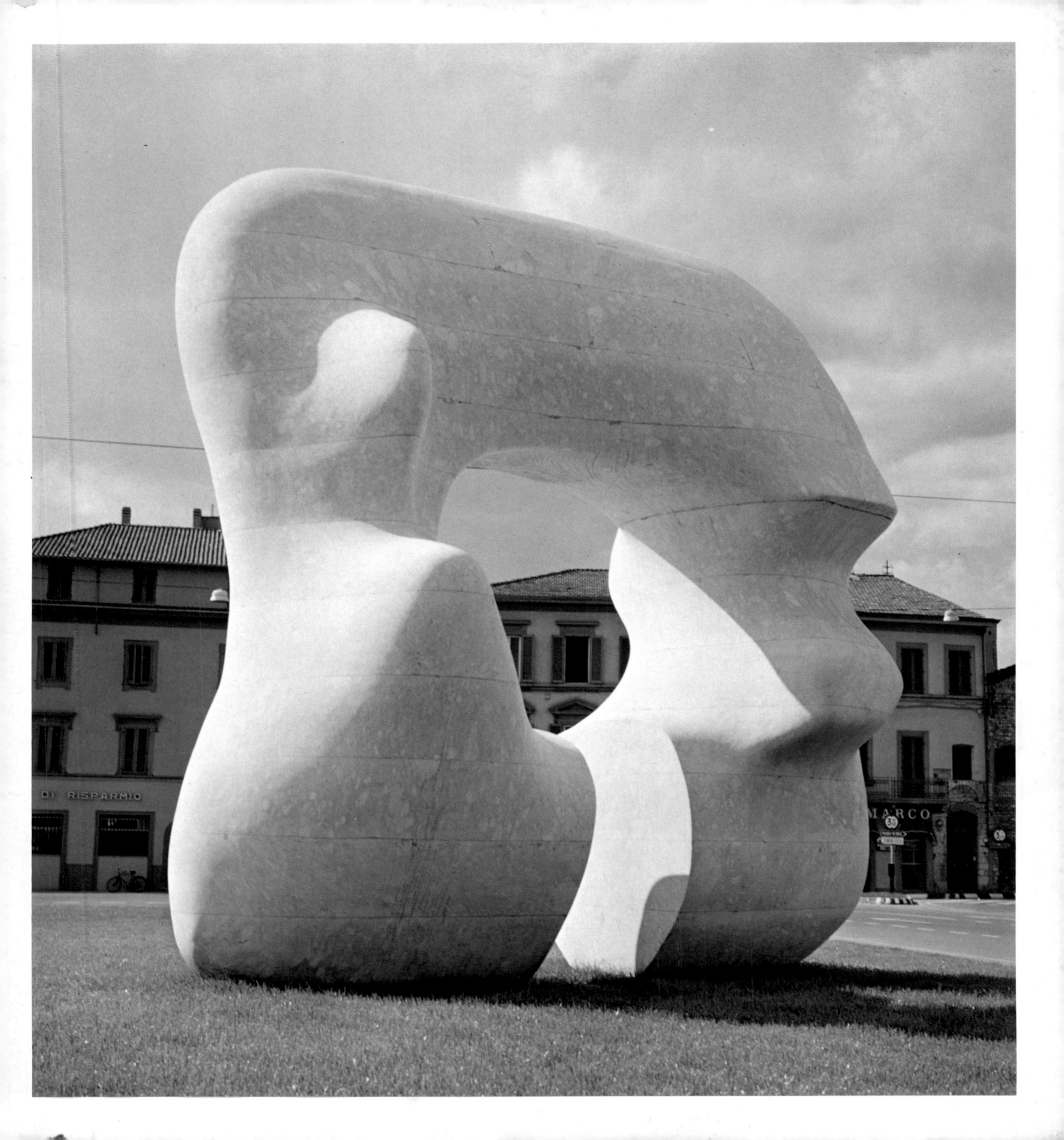

the weather had completely cleared by morning. After waiting a few hours until some clouds appeared in the sky, I drove there from Florence, where we were staying. On the way, I became nervous because the clouds suddenly began to accumulate; I feared I had been foolish and waited too long. Increasingly panicky as I drove into Prato, I wondered if I would find the sculpture before the sun disappeared. Fortunately, I happened on the square on the way into town. I hastily parked the car and started photographing frantically (the sun on the marble was especially brilliant, and I didn't want to miss it). Everything worked out beautifully, and I was able to take advantage of the sun and also make the most of some fine cloud formations in the sky. Just as I finished, the sun went behind

the clouds for the afternoon. It couldn't have been better timing.

When I showed the photographs to Moore he was especially pleased with the details of the sculpture shown against the interesting cloud formations. To my surprise, he wondered about the curious lines in the marble just under the crown of the arch; I had assumed that Moore had selected those pieces of marble on purpose. He hadn't. He finally figured out that the lines were caused by rain, which had produced a sort of patina on the sculpture that he found pleasing. I had the gratifying feeling that in showing him these photographs I was bringing news about the state of his sculpture and that he appreciated being brought up-to-date as much as if I had given him the latest news on world events.

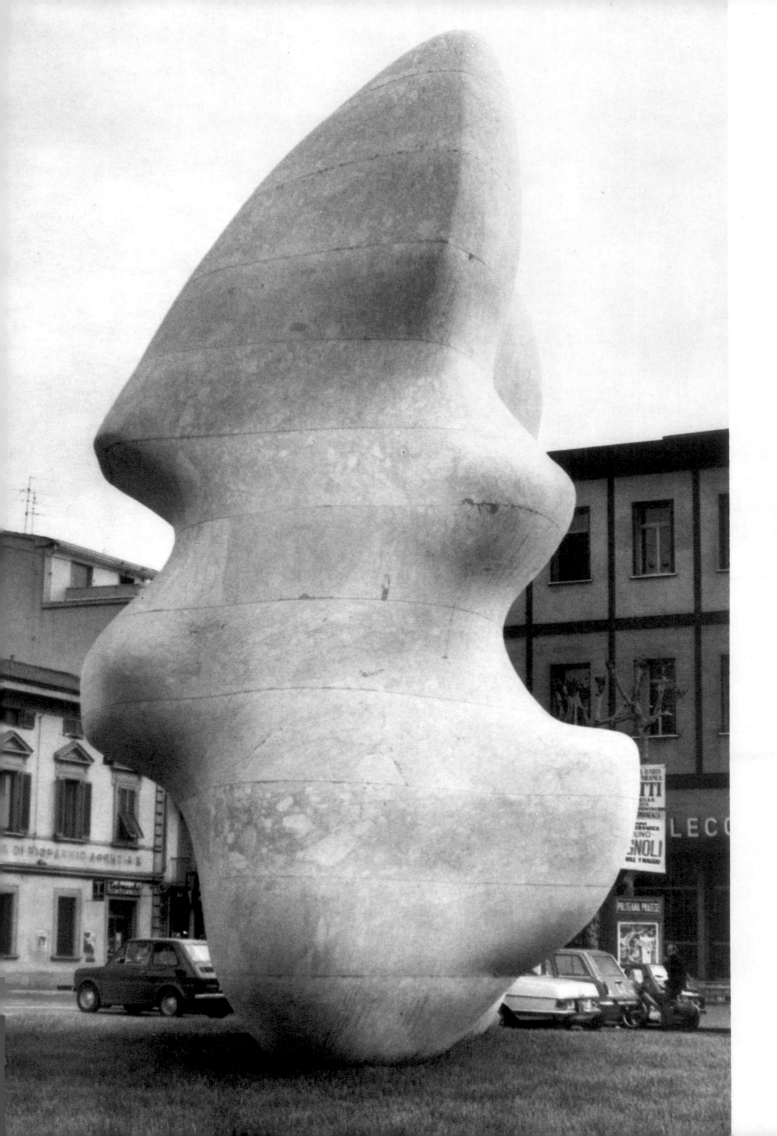

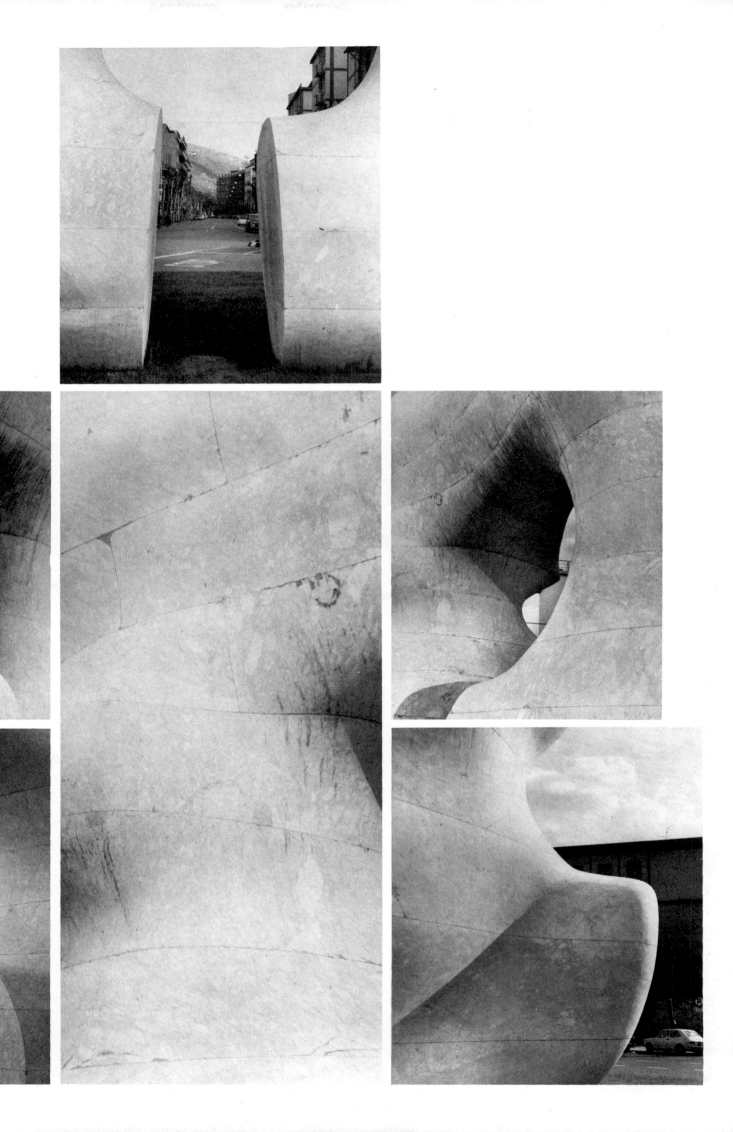

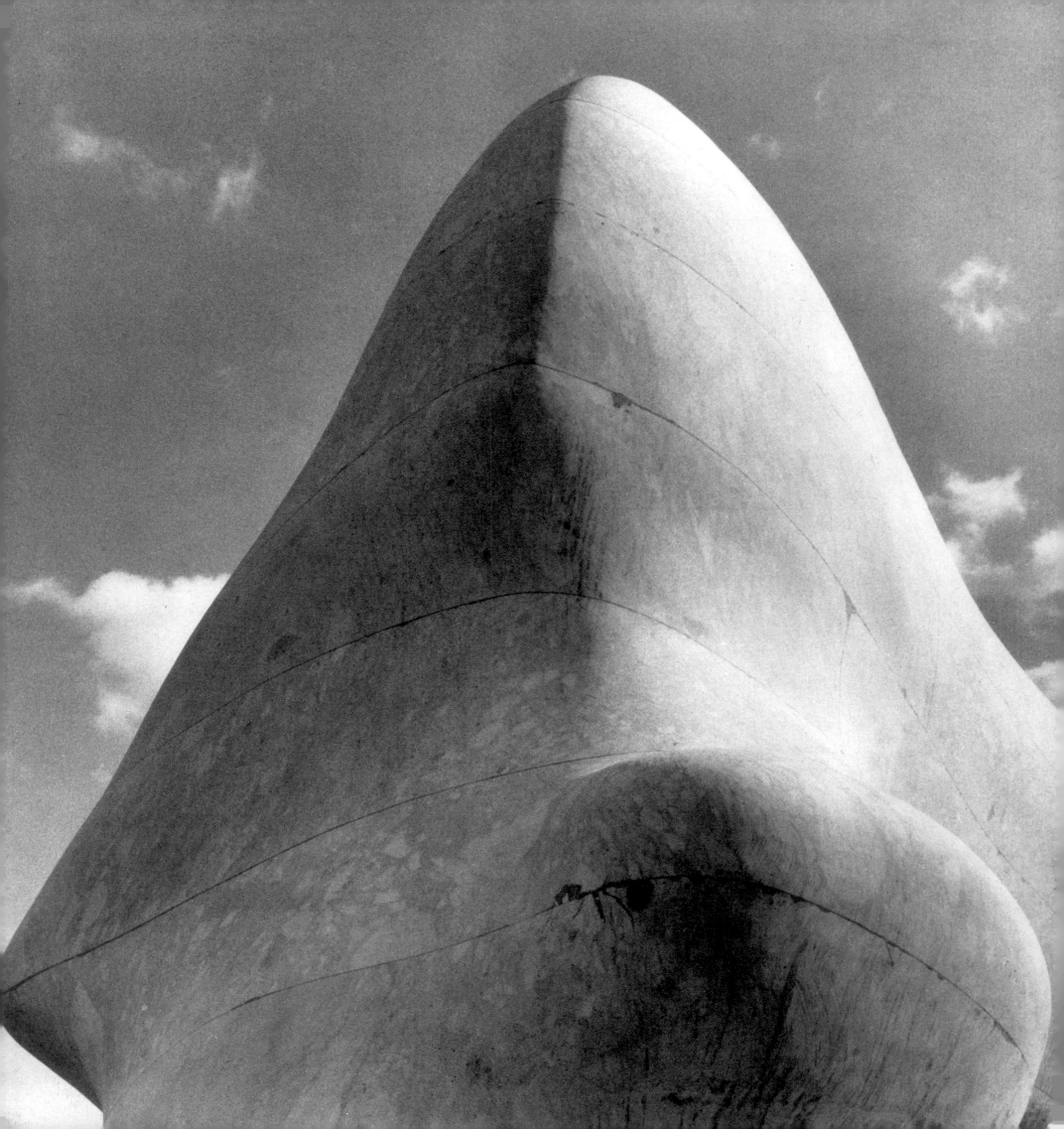

SWITZERLAND

WORKING MODEL FOR UNESCO RECLINING FIGURE

1957. BRONZE, L. 94″. KUNSTHAUS, ZURICH, SWITZERLAND

This Moore sculpture is the major work in front of the Kunsthaus. As one faces the building, a Lipchitz and a Rodin are on the left, and on the right is a Marini horse and rider. Through a glass wall one can see a Maillol figure inside the museum itself. The configuration suggests, perhaps unconsciously, a judgment on the relative importance of the monumental sculptors of the twentieth century, placing Moore in the center. The building itself is a well-designed structure, admirably suited for the placement of sculpture in front of it.

Although the *Reclining Figure* is a strong work, with characteristic Moore forms and

spaces, I did not find it as powerful as other Moore sculptures. I enjoyed photographing it in the pleasant Zurich surroundings and in front of the well-designed museum building, but somehow I did not feel the monumentality that I usually associate with his work. I felt that the large-scale UNESCO travertine version in Paris (see pp. 96–102) was considerably more successful than the bronze. Perhaps if I had seen the working model before the UNESCO version I would not have been inclined to compare them in a way that tended to put the smaller bronze cast in Zurich at a disadvantage.

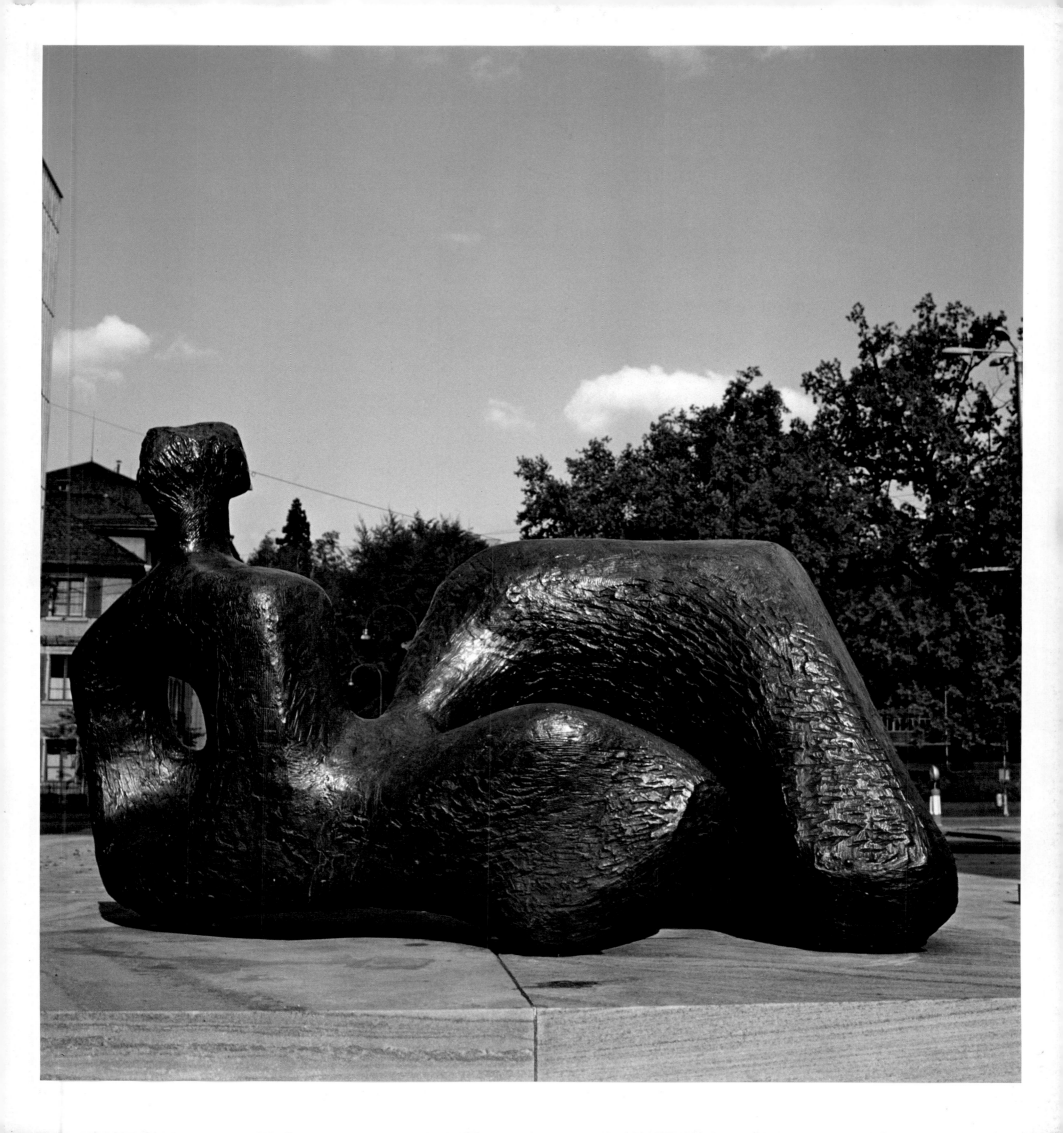

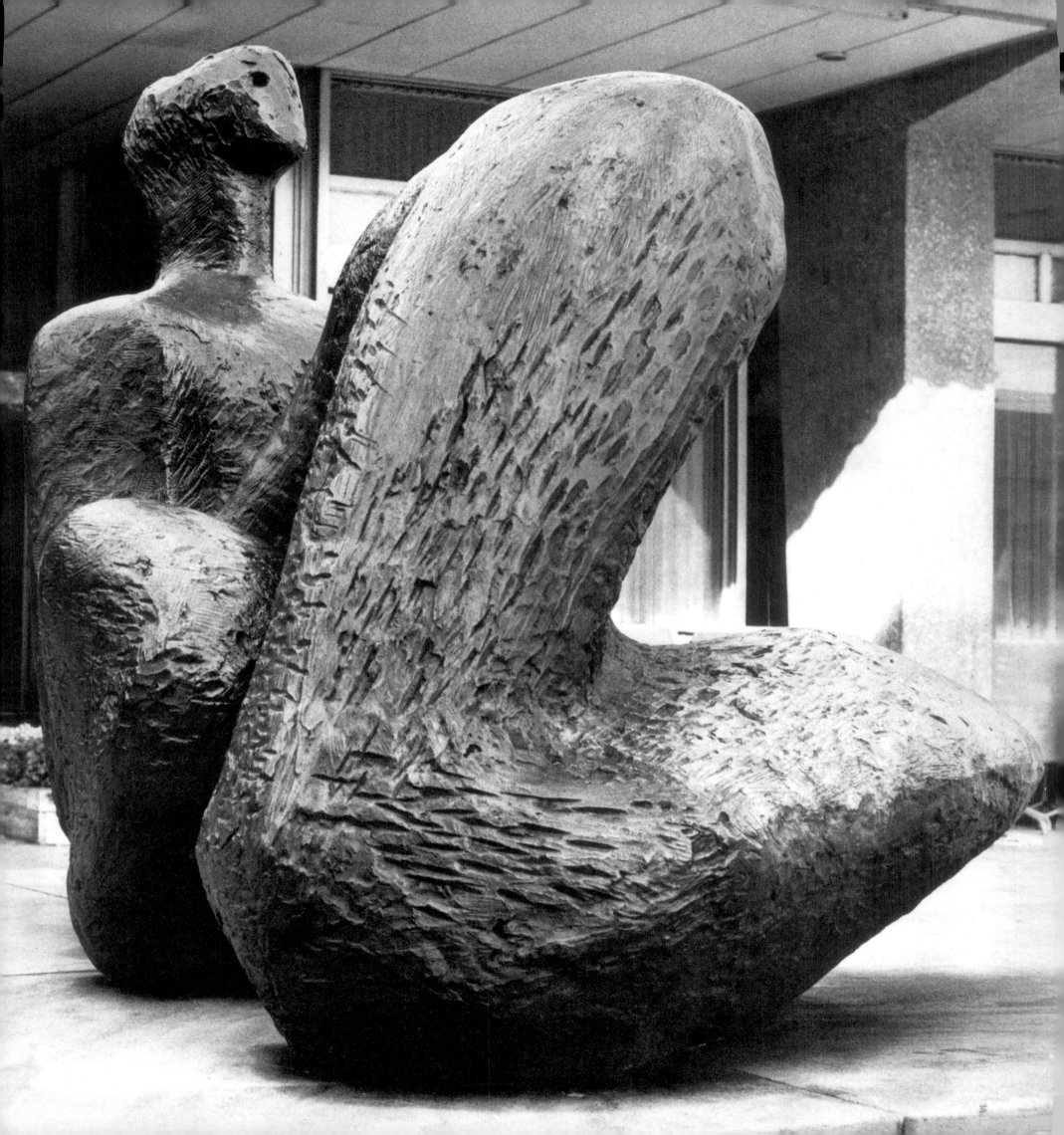

Max Bill and I together placed this sculpture in front of the museum. I remember well the two of us trying to decide the exact placing. I would have preferred a single block of stone for the pedestal; one is distracted by the divisions across the middle. But we couldn't get one block large enough, so we had to use four.

This was the working model for the stone carving at the UNESCO Building, Paris (see pp. 96–102).

—*Henry Moore*

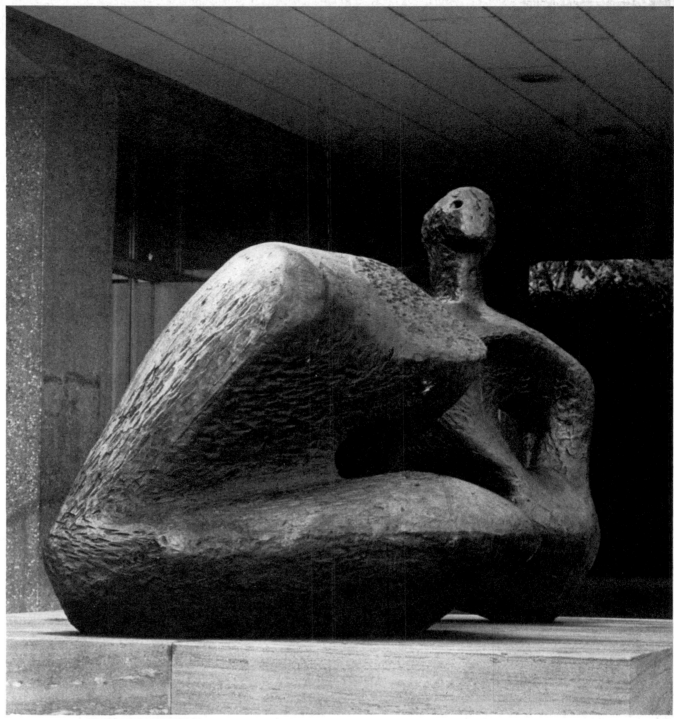

FALLING WARRIOR

1956–57. BRONZE, L. 58″. ZOLLIKON, SWITZERLAND

Zollikon is a small residential community just outside Zurich. There is a narrow park on the shore of Lake Zurich, and *Falling Warrior* is located in a small paved area along with a plaque that identifies it as a commemorative monument. The sculpture is on a high pedestal that brings it almost to eye level, enabling one to see all the elements of the figure in full detail. As pointed out by Kenneth Clark in his *Henry Moore Drawings* (New York, 1974), the origins of this work have more to do with Moore's drawings of coal miners working on their backs than with any study of warlike figures. Resting on only three points—the shield, the right hand, and the left foot, the sculpture is a remarkable depiction of a figure in descent,

I have never seen this location, but I know the sculpture was placed there as a memorial.

The photographs are awfully good. When I did this sculpture, I had the idea for a falling warrior but I did not have a destination in mind. I never make my sculptures to fit a particular place. Each one is made for its own sake, as an individual piece of sculpture. Nor was there any topical connection with anything happening at the time. This is a nice view at sunset with the lake behind it.

I always like sculpture against water.

—Henry Moore

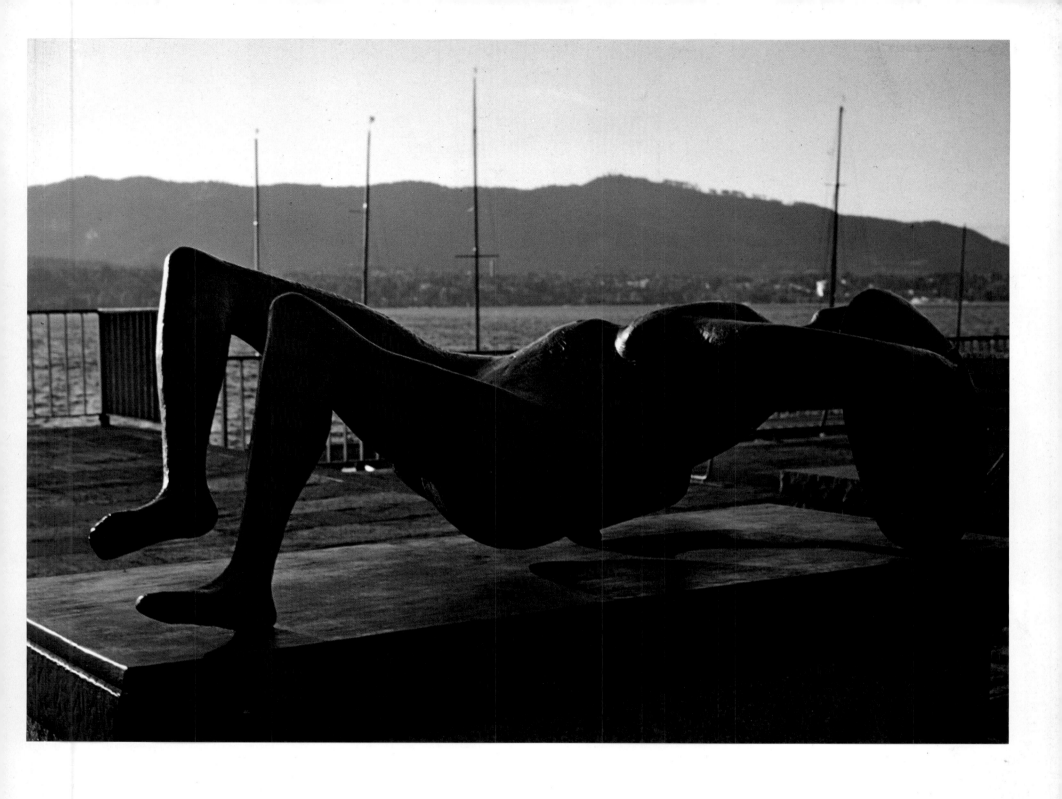

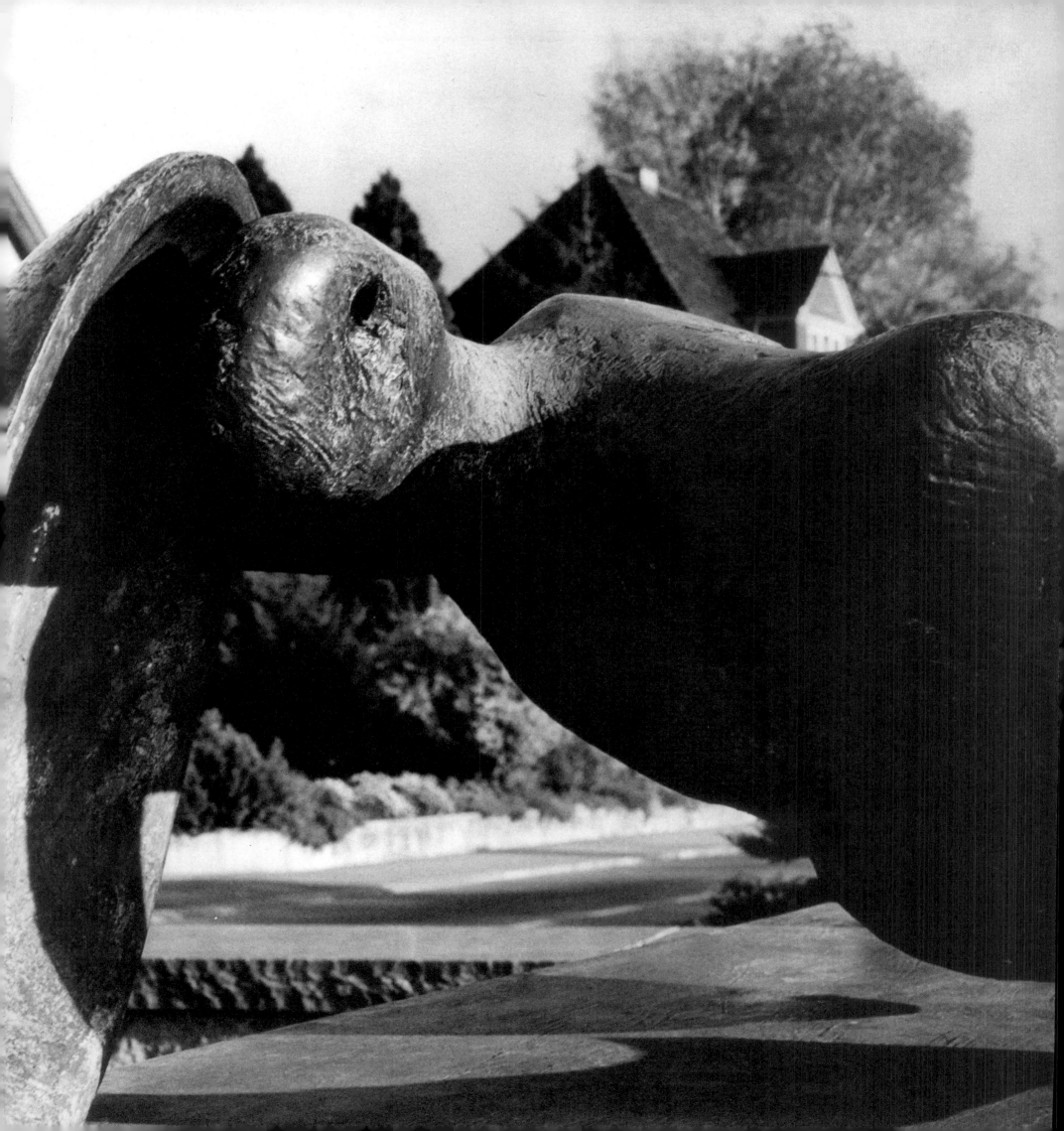

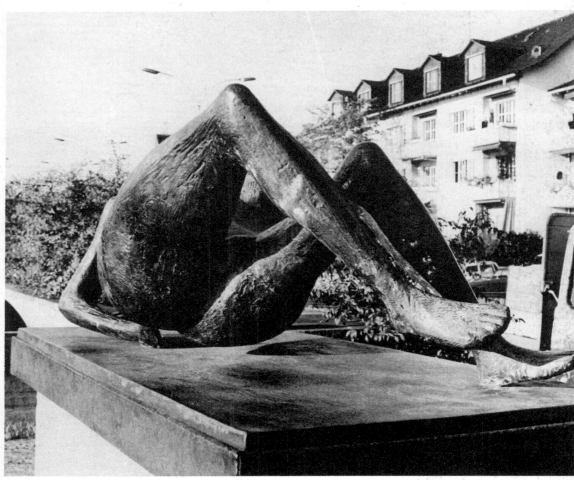

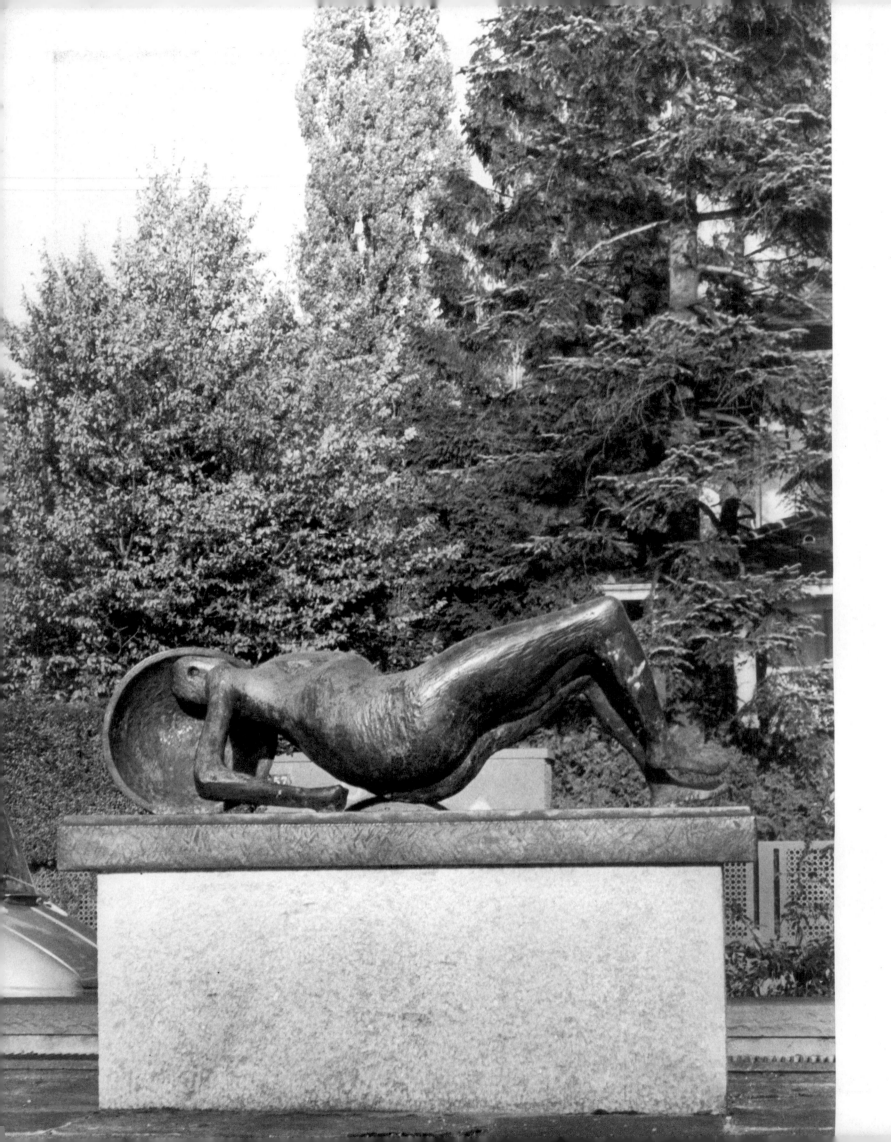

GERMANY

RECLINING FIGURE: EXTERNAL FORM

1953–54. BRONZE, L. 84". UNIVERSITY OF FREIBURG, GERMANY

Freiburg is a lovely little university town. A large part of it was destroyed during World War II, so there are many contemporary buildings in the town. But somehow the character of the old city has been saved, and it is a remarkably clean and cheerful place. This cast of *Reclining Figure: External Form* is located in front of the administration building of the university. A good-sized pedestal raises the piece high enough to silhouette its forms against the distant skyline, and there is some foliage in the area, which helps to create a pleasant atmosphere.

When my wife and I arrived in Freiburg, we felt a sense of gratitude to Moore for giving us a reason to visit the town. The streets were delightful—many of them

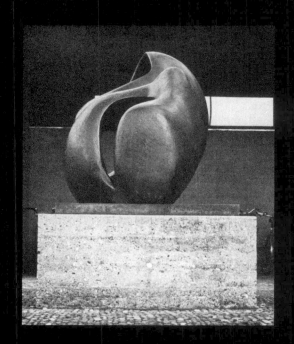

without cars. Swiftly running water flowed in small channels in the middle of the walkways, presumably to help keep the place clean. Many college students were on the walks and in the shops, contributing to the general cheerfulness of the atmosphere.

Although the site for this sculpture does not compare to that of the cast of the same work in Jerusalem (see pp. 82–86), one can see interesting views of the piece in this location. That from the rear, in which one can see the skyline in the distance, is quite good. The view against the university building is less satisfying, however, even though I did manage to photograph the sculpture without showing the many bicycles that are usually parked in the area.

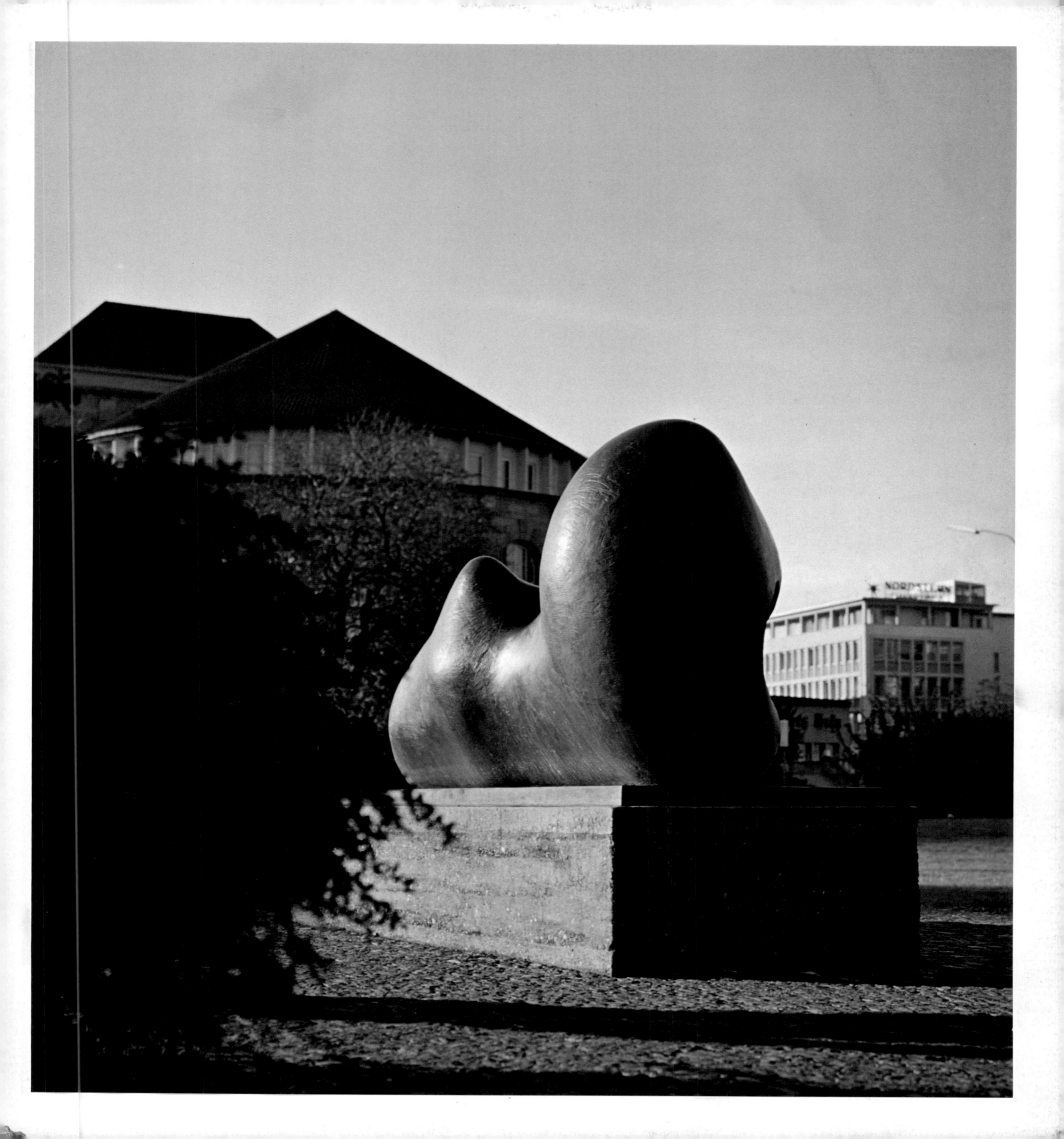

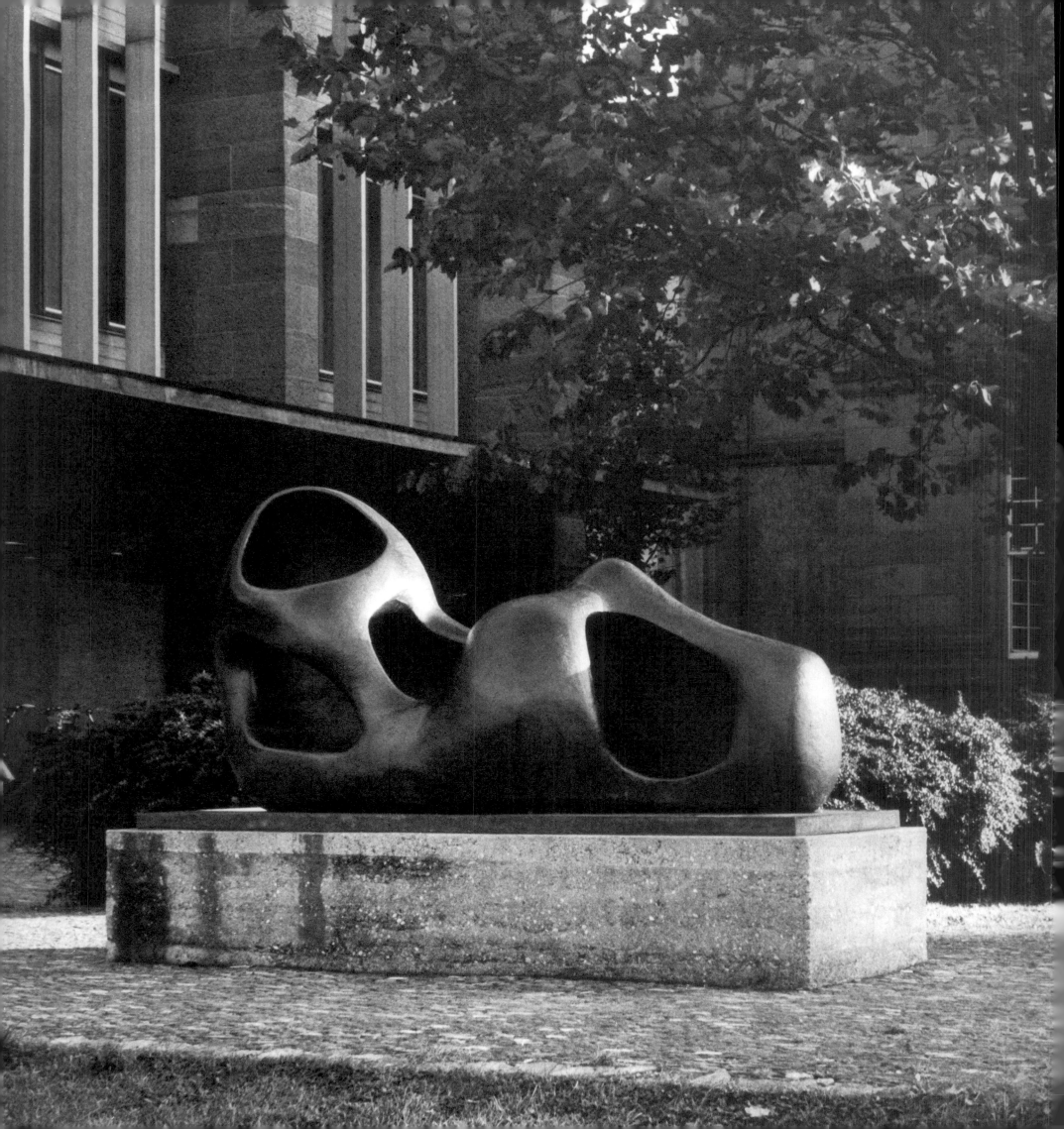

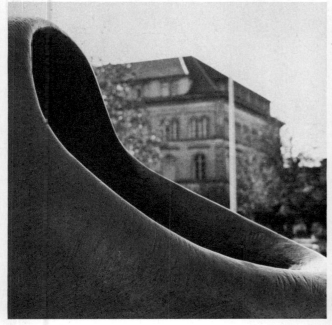

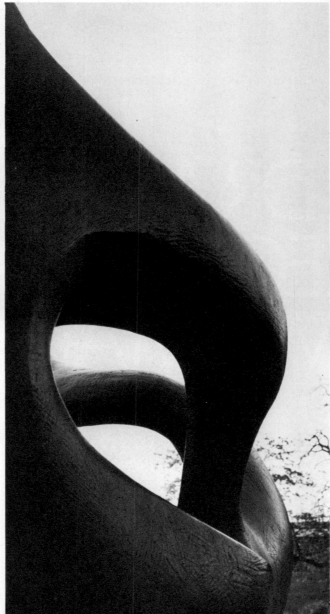

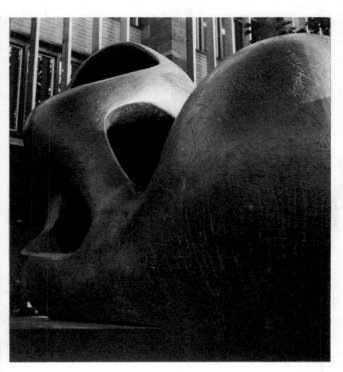

*This was apparently
photographed a bit late in the
day—perhaps too late. But it has
a monumental look with the
buildings in the distance. This is
one case where the sculpture and
the buildings seem all right
together.*

—Henry Moore

DRAPED RECLINING WOMAN

1957–58. BRONZE, L. 82″. KUNSTGEBÄUDE, STUTTGART, GERMANY

Like other German cities destroyed during World War II, Stuttgart is not particularly attractive, but it has a fine museum, the Kunstgebäude, with an excellent collection. The museum is located in a lovely park near the center of town, and to one side of the building, in a small cluster of trees, is this noble figure of a reclining woman. The Moore sculpture is probably overlooked by many of the museum's visitors, since it is not visible from the front of the building, nor would many strollers in the park be apt to notice it in its almost secret location. But the sculpture is so sensitively placed that one feels compensated for any difficulty

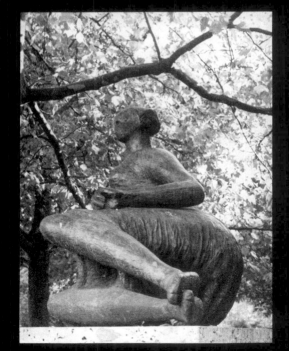

have heard of it—not even the museum staff) that the sun was setting behind the building when we finally located it. I was afraid that the views showing speckled sun on the sculpture would not turn out well because of the strong contrast between light and shadow. Perhaps the fall colors helped somewhat (the day was October 20th—I remember it because it was our wedding anniversary), for the sunlight effect proved to be extremely lovely. Also, the marvelous way in which the tree relates to the sculpture helped to create a most satisfying composition for some of the details. After the sun passed behind the building, I took

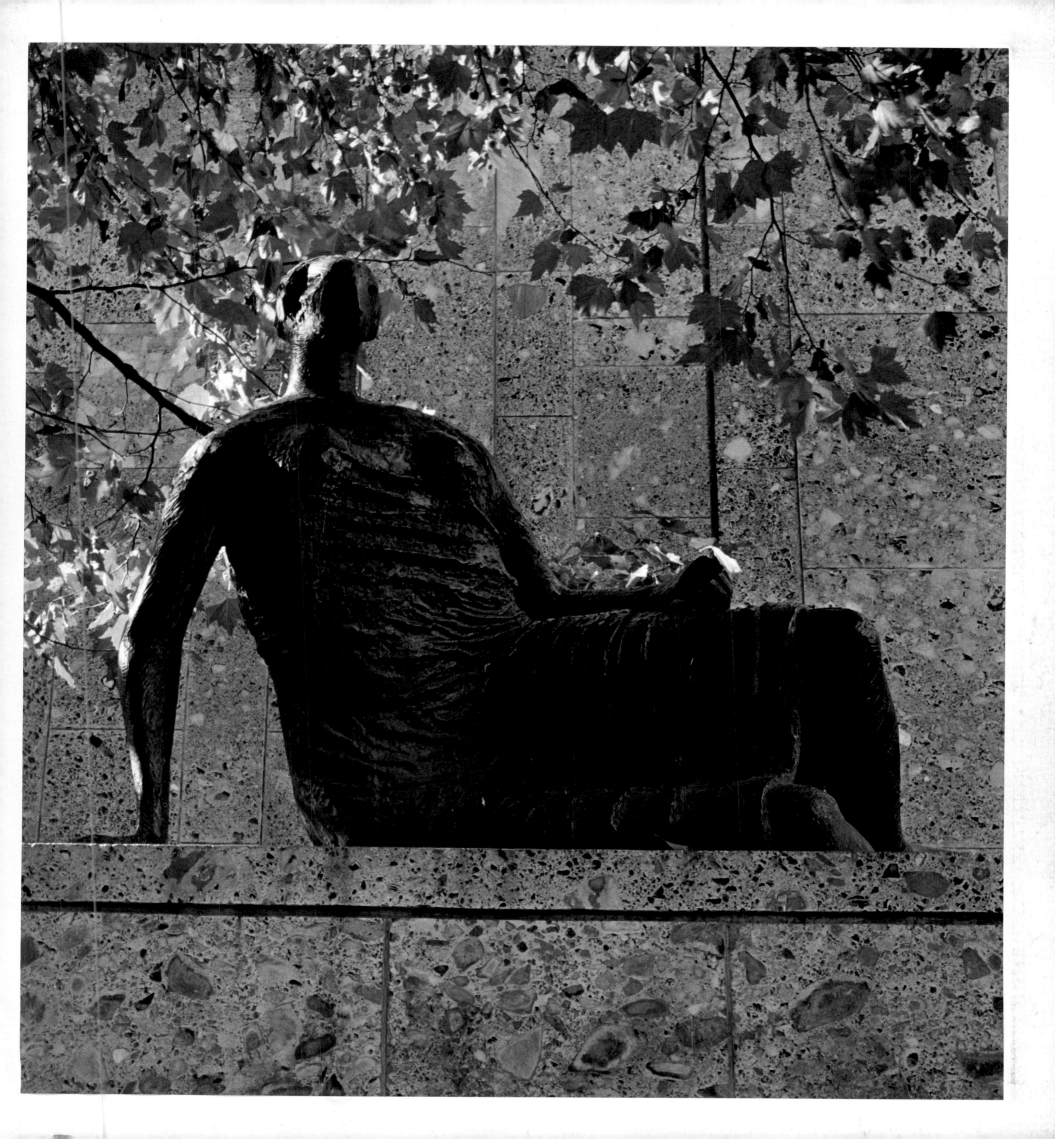

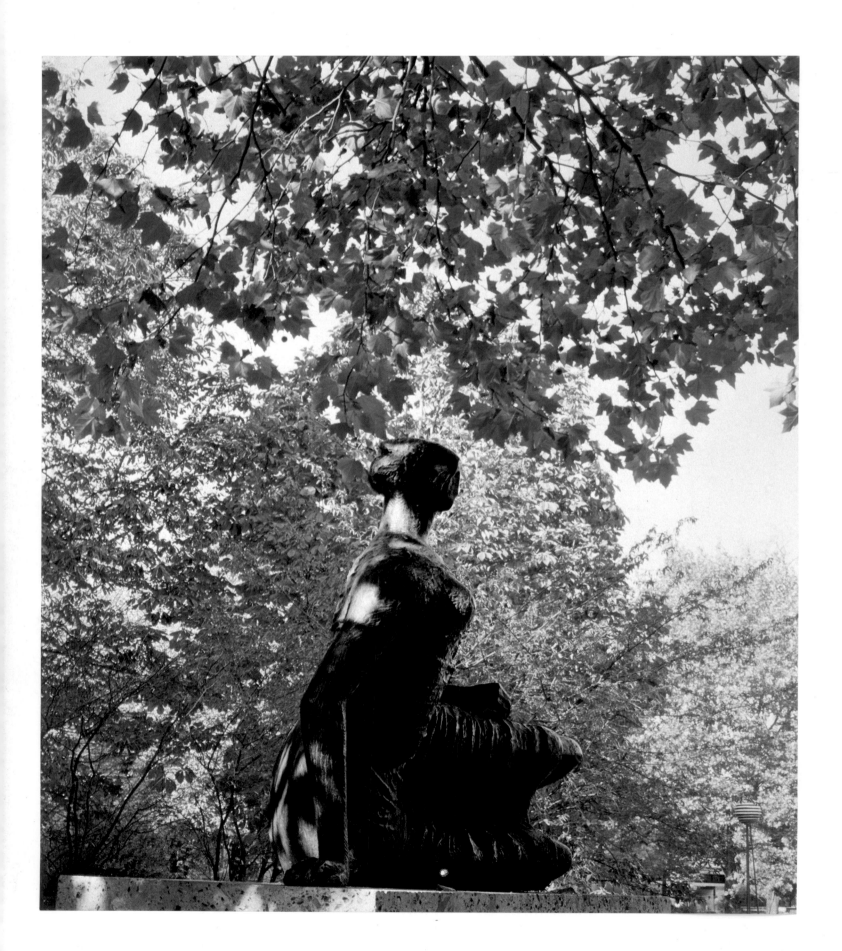

That's charming. I've never seen photographs of this location before. It's a nice base. The autumn leaves are a lovely color, and I like the sunlight patches in the trees.

—Henry Moore

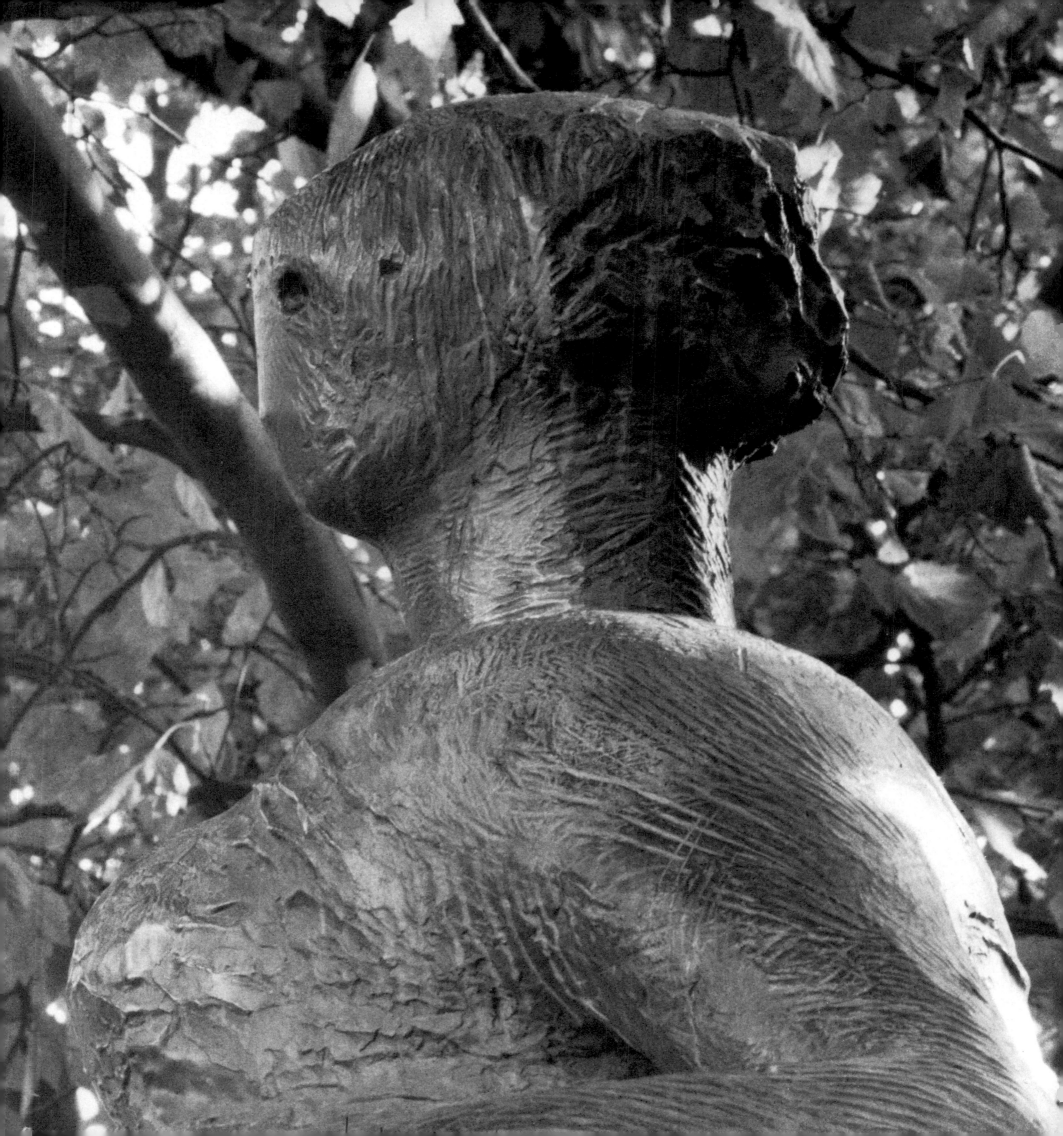

DRAPED RECLINING FIGURE

1952–53. BRONZE, L. 62″. WALLRAF-RICHARTZ-MUSEUM, COLOGNE, GERMANY

This is a cast of the same *Reclining Figure* that is on the terrace of the Time/Life Building in London (see pp. 230–32). Although both casts are in enclosed areas, there is a striking difference in the way the sculpture appears to the viewer in each location because of variations in the backgrounds, the nature of the space around each sculpture, and the distinctive design of the two pedestals.

Cologne is another of those German cities that has been almost completely rebuilt since World War II (although its magnificent cathedral, by some miracle, is still standing). For the most part, the new city is undistinguished architecturally—including the famous shopping mall, which stretches over a vast part of the city's central area.

The museum, however, is a beautiful structure and has a fine collection that includes one of the best representations of the art of the 1960s I have seen anywhere.

It also has a fine group of German Expressionist paintings and a choice selection of sixteenth- through nineteenth-century paintings.

The Moore sculpture is located in the courtyard of the museum, and there is no doubt that the crowded shapes seen through the glass façade of the museum make it difficult to enjoy the piece. An old church with fine architectural lines forms another side of the courtyard, and this provides an attractive view. The pedestal, however, is a disaster. I don't think I've ever seen a Moore sculpture so disoriented from the block on which it stands.

Because the lighting and background of the casts of the *Draped Reclining Figure* in London and Cologne are so dissimilar, one's eye is attracted to different sides of the sculpture at each site, which is why the two sets of photographs focus on different details.

Here the pedestal is poor, and the background is confusing because it is too busy.

This is one of the first draped figures I did in sculpture. It was in making the wartime shelter drawings that I became especially aware of the form function of drapery. Having to draw sleeping people covered with blankets or with coats and odd garments scattered over them gave me an interest in drapery and its relationship to the figure.

Drapery can emphasize the tension in a figure, for where the form pushes outward, as at the shoulders, the thighs, the breasts, etc., the drapery can be pulled tight across the form (almost like a bandage), and, by contrast with the crumpled slackness of the drapery which lies between the salient points, the pressure from inside is intensified. Drapery can also, by its direction over the form, make each section more obvious—that is, show shape. It need not be just a decorative addition, but can serve to stress the sculptural idea of the figure.

—Henry Moore

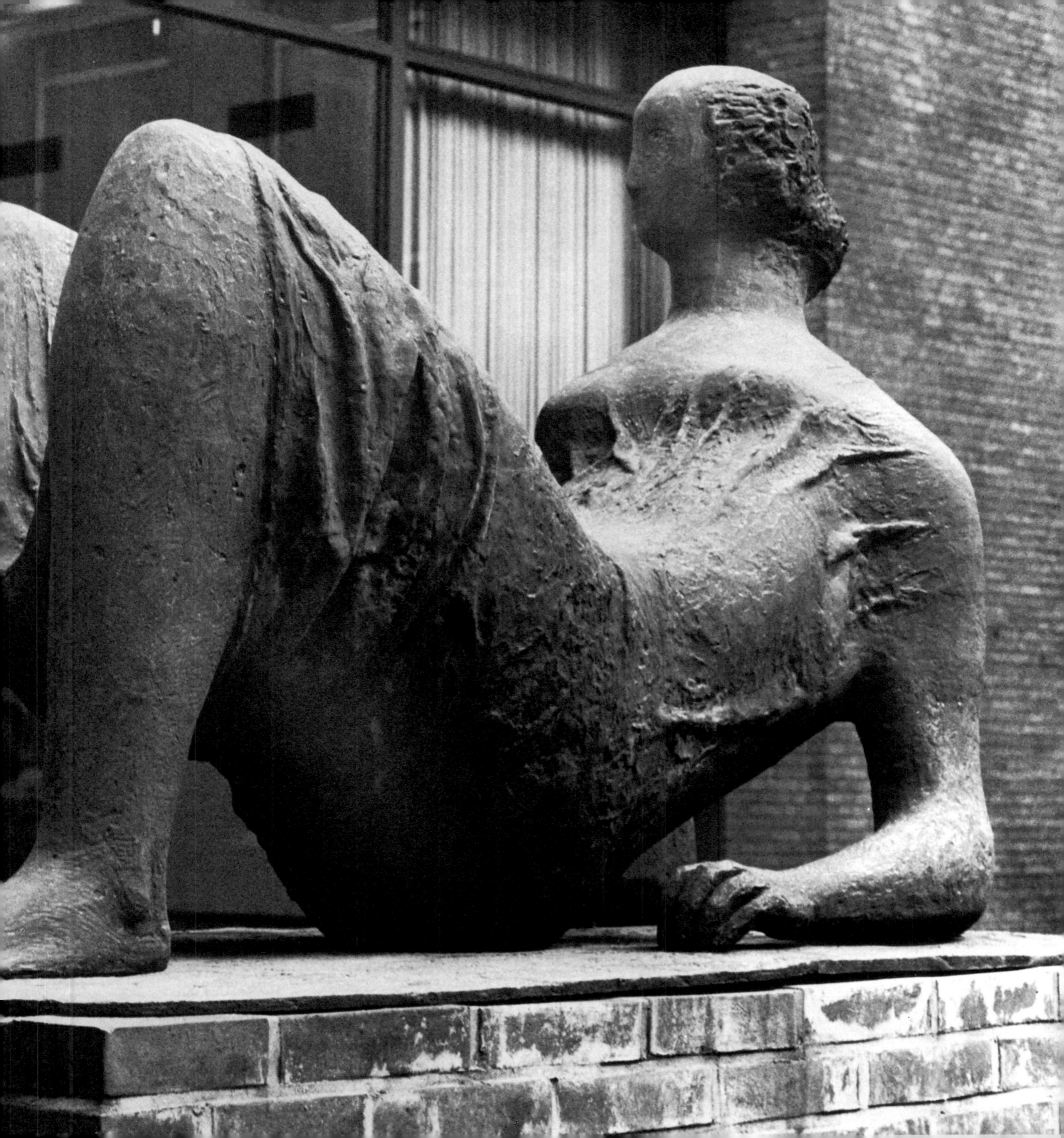

TWO-PIECE RECLINING FIGURE 1

1959. BRONZE, L. 76''. LEHMBRUCK MUSEUM, DUISBURG, GERMANY

The Lehmbruck Museum has a superb collection of Wilhelm Lehmbruck's sculptures, drawings, and paintings that enables one to appreciate the creative output of this remarkable artist, most of whose work was done in a ten-year span that terminated with his tragic suicide at an early age. The building is beautifully designed and is part of a lovely park in the center of town. There is an excellent outdoor area for sculpture, and besides the two Moores there are works by Laurens, Lipchitz, Richier, Butler, Chadwick, Giacometti, Julio Gonzales, Brancusi, and Marini. Moore's *Reclining Figure* has been given the most prominent position in the collection. It is set on a grassy terrace so that from one side it seems to rest on the ground, with no pedestal at all, while from another one sees the sculpture several feet above ground level, with its forms outlined against the sky.

This is one of four casts of the sculpture that I photographed; the others are in London; Glenkiln, Scotland; and Buffalo, New York (see pp. 248–51; 308–12; 396–99). The figure seems more domesticated here than in Scotland, where it has a wild, rugged look. In Duisburg, instead of being noble and self-confident, it seems serene and self-possessed, as is appropriate in a cultivated urban environment.

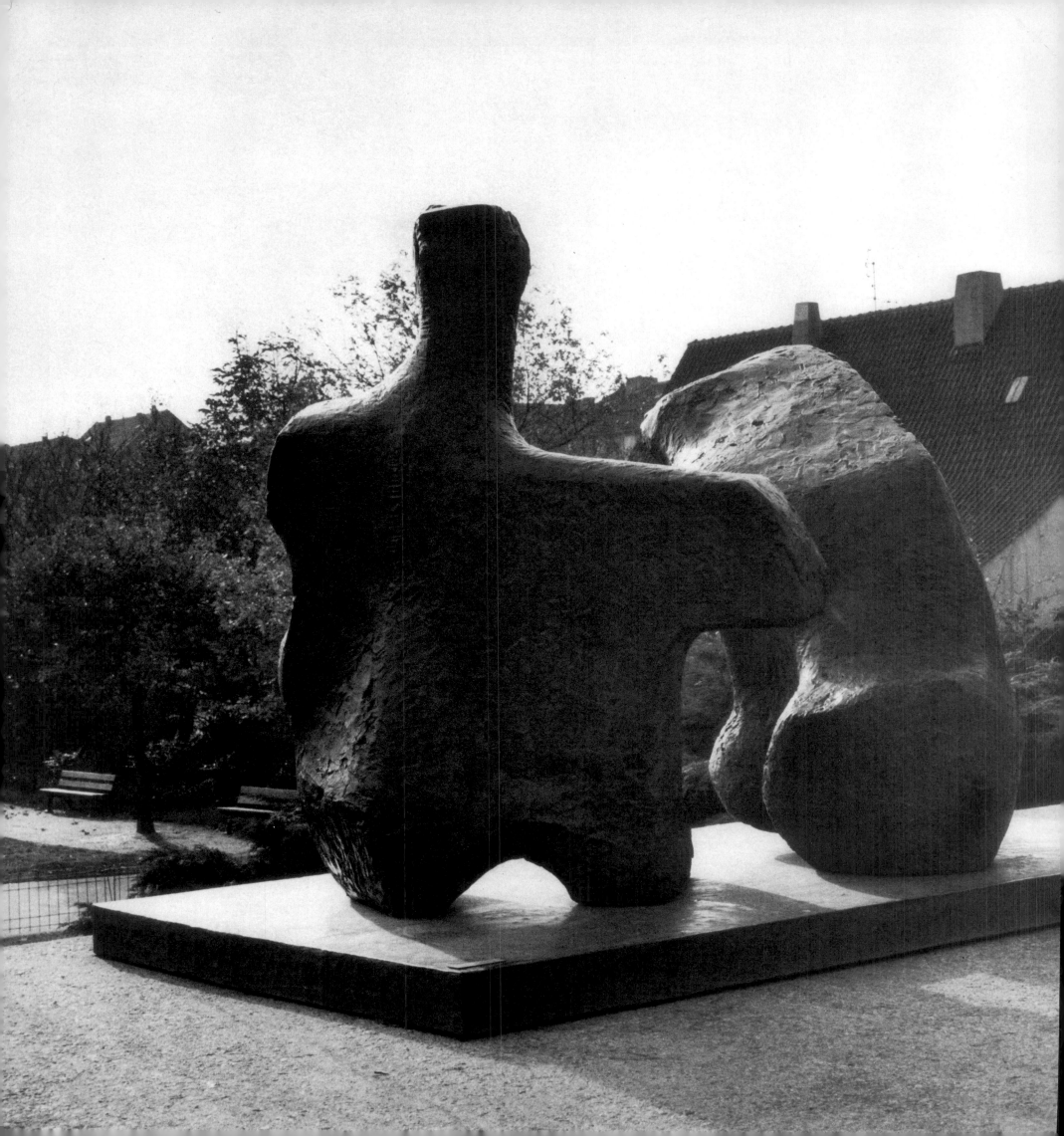

I helped place this piece in the park in the Lehmbruck Museum. This was some years ago, and I see from the photographs that the surrounding foliage has grown up a bit.
It looks a little different now from what I remember.

You can see the Seurat Le Bec du Hoc *rock clearly in photographs showing the leg-end detail of the sculpture.*

—Henry Moore

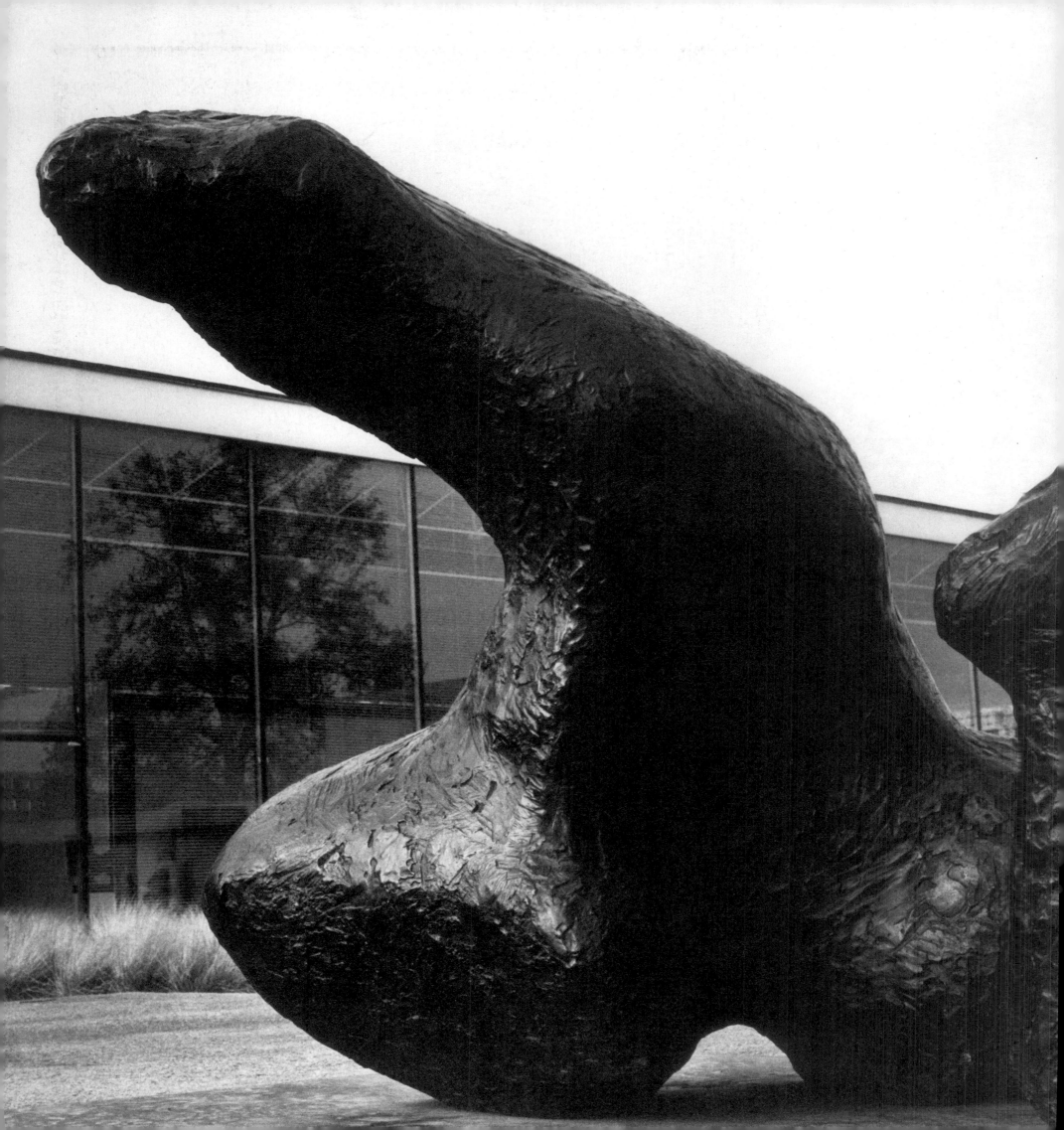

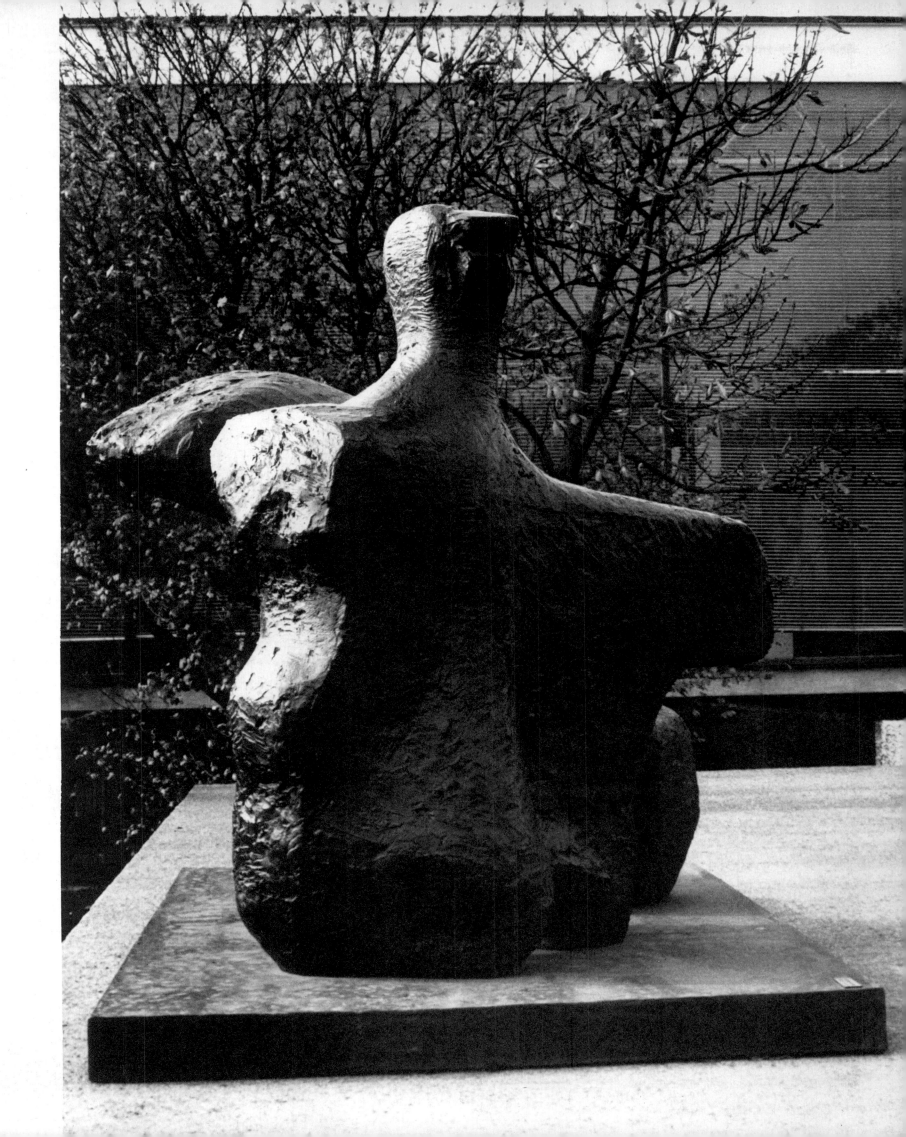

WORKING MODEL FOR LOCKING PIECE

1962. BRONZE, H. 42″. LEHMBRUCK MUSEUM, DUISBURG, GERMANY

Located in the small sculpture garden outside the Lehmbruck Museum, this working model of the *Locking Piece* can be seen against trees and bushes that echo its graceful shapes. With its dark brown patina, it looks more like an organic form that one might find in a forest than a complex, man-made puzzle. It is tastefully placed, and even the lines on the pavement help to set off the well-proportioned pedestal.

This location brings out something special in the sculpture. It shows the same work can have a different effect on you in a different setting.

—Henry Moore

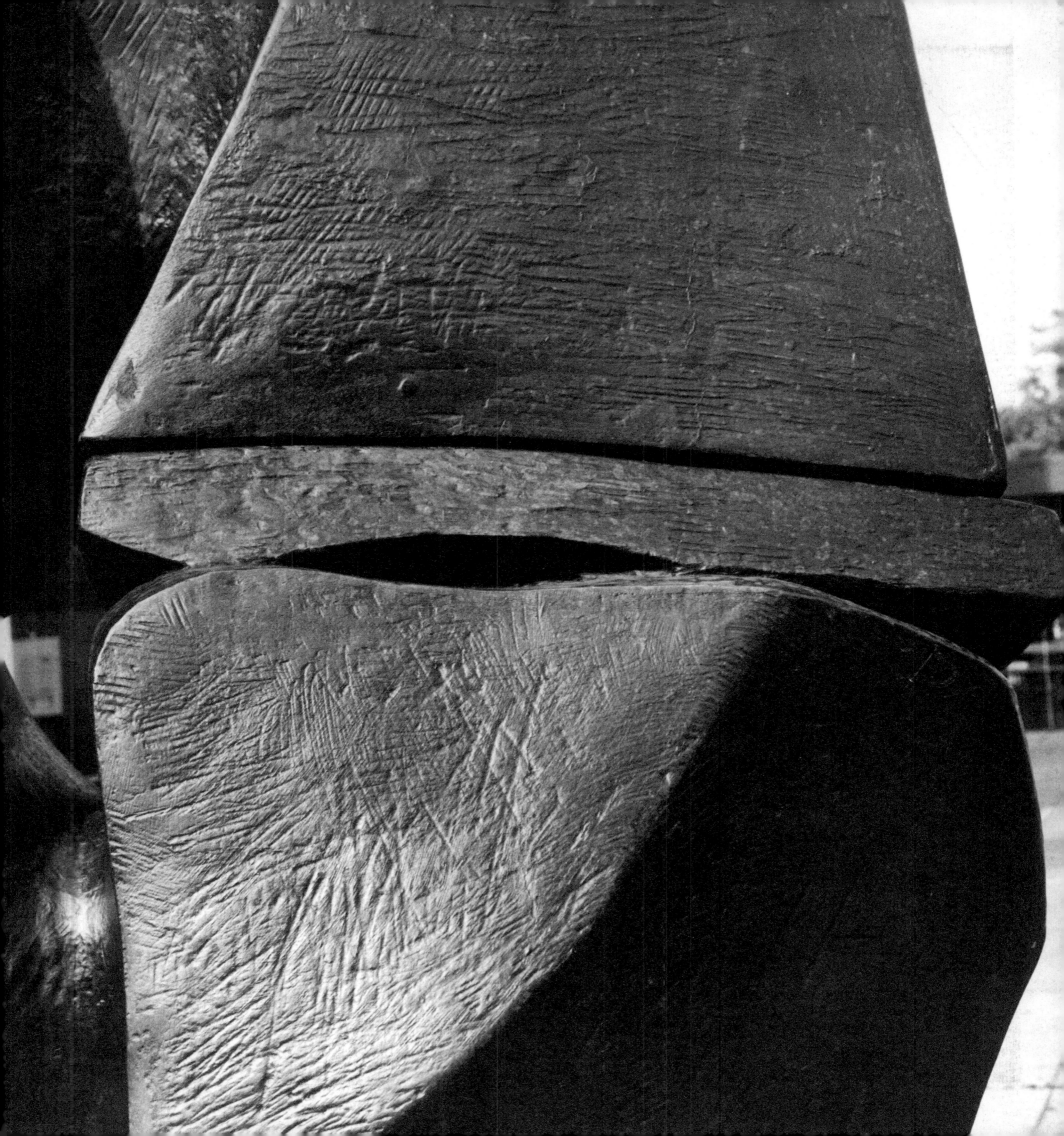

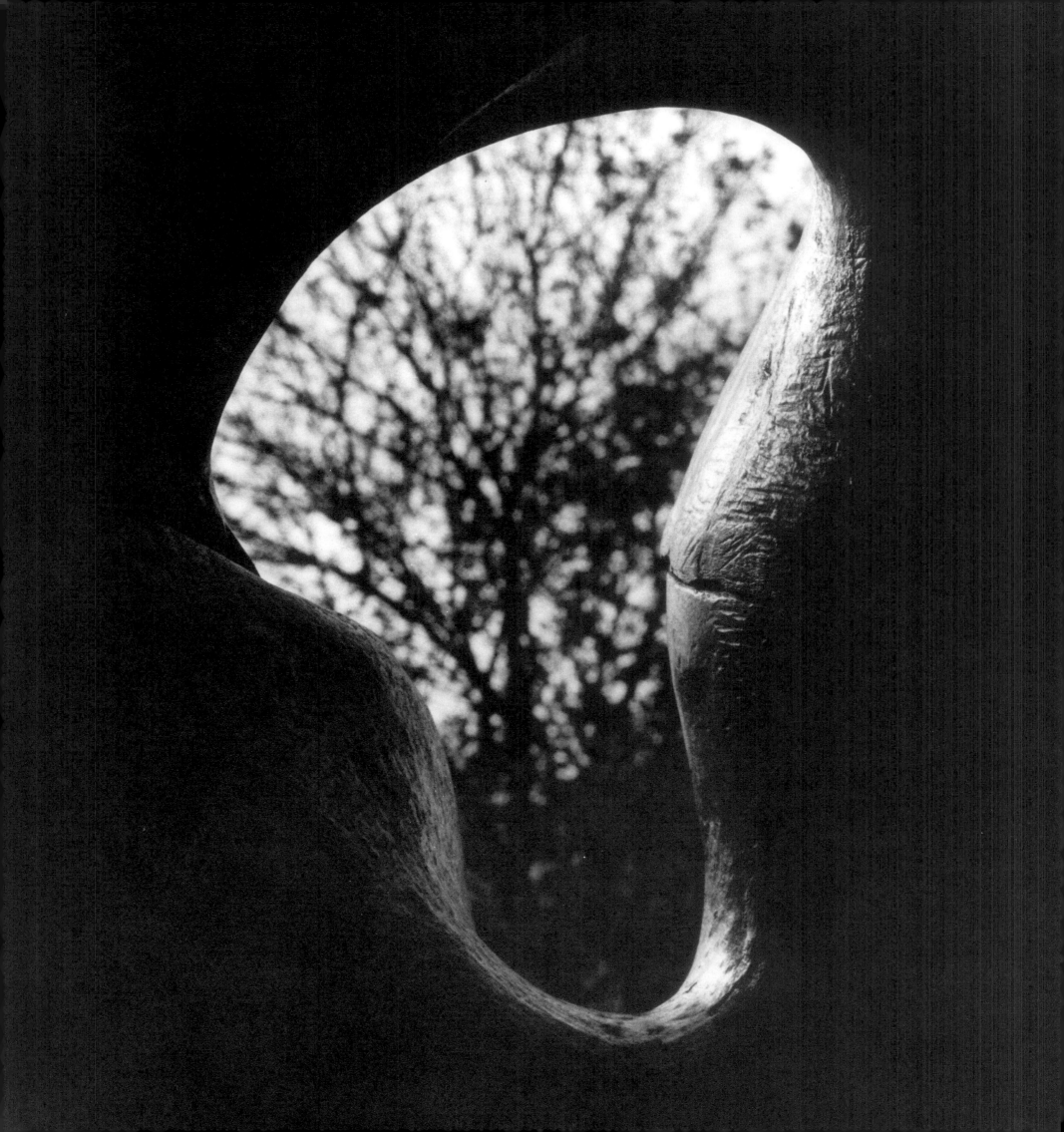

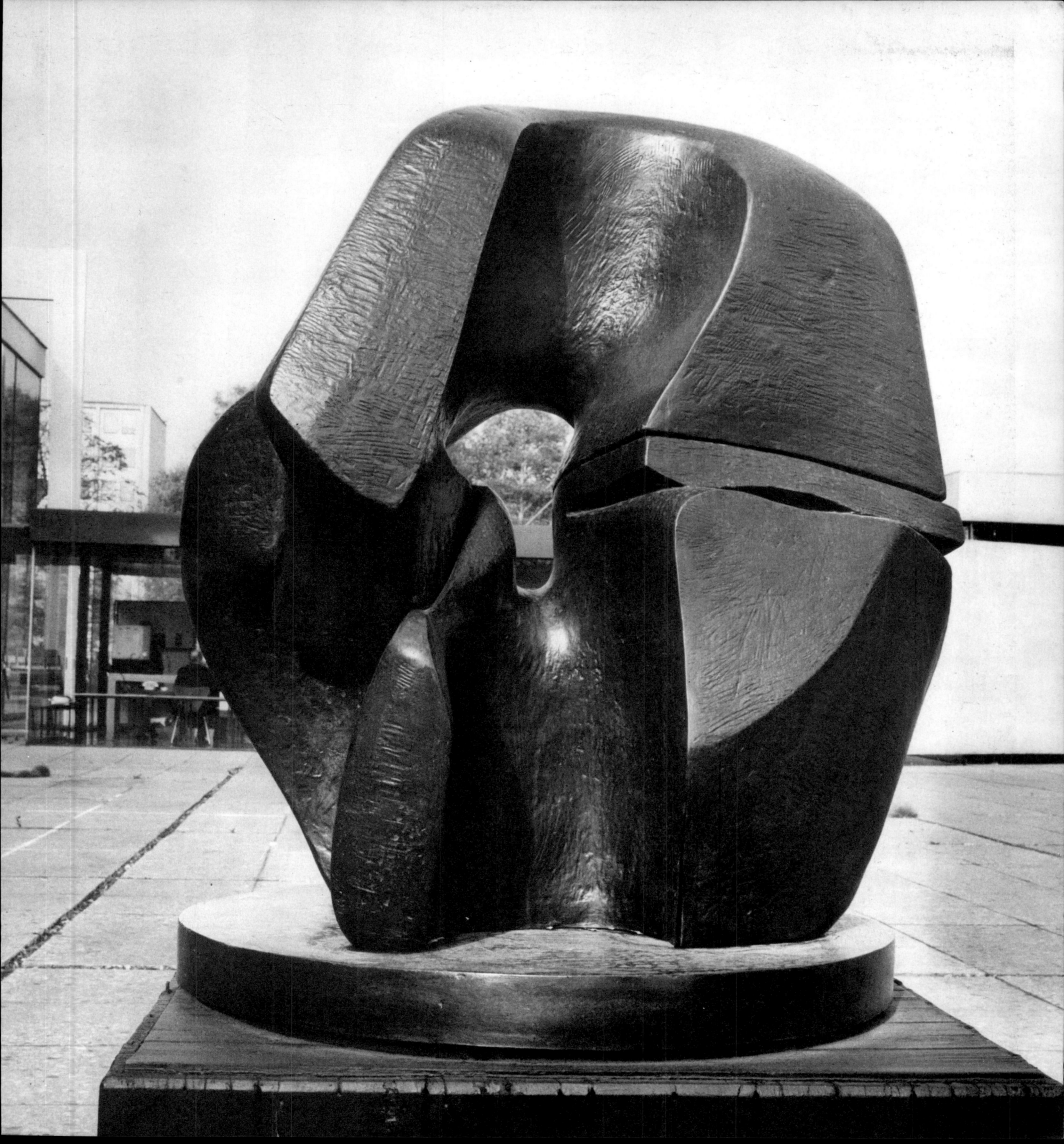

UPRIGHT MOTIVE 1: GLENKILN CROSS

1955–56. BRONZE, H. 11′. FOLKWANG MUSEUM, ESSEN, GERMANY

In this location, the *Glenkiln Cross* almost looks like a different sculpture from the cast in Scotland (see pp. 306–7). Here it is erected on a very high pedestal, which is stained with what appear to be rust marks, and situated in the courtyard of a museum that has a rather dull exterior. Although it is nice to see the forms of the sculpture against the sky, the piece seems incompatible with the residential buildings across the street.

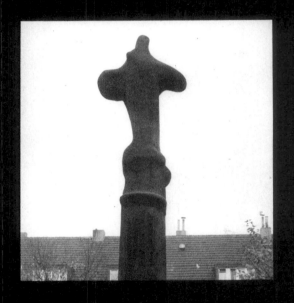

There is only one view in which the work can be seen against foliage, and it is quite lovely, but otherwise this is not a very felicitous setting.

This has the problem of buildings cutting into the sculpture.

—Henry Moore

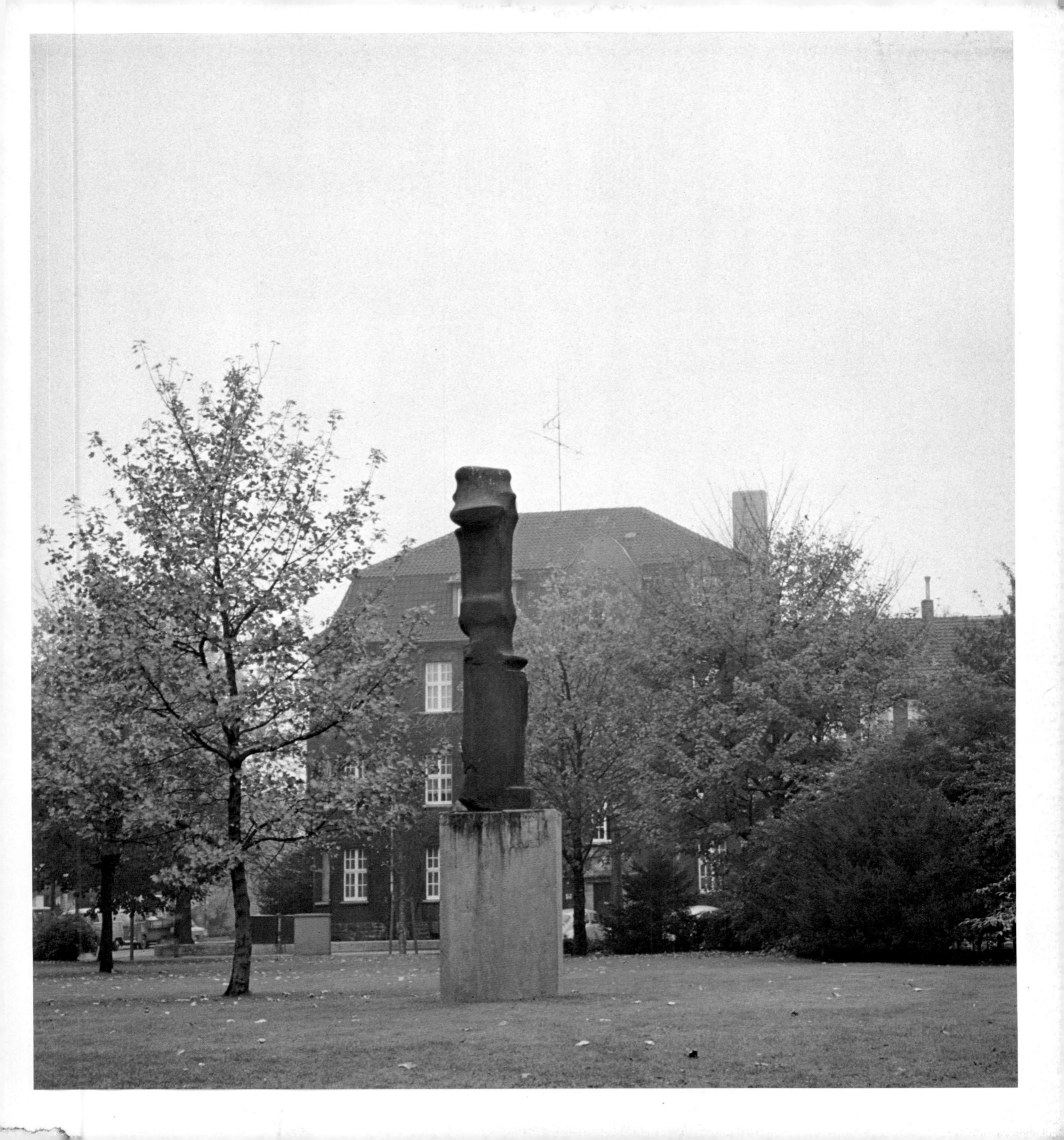

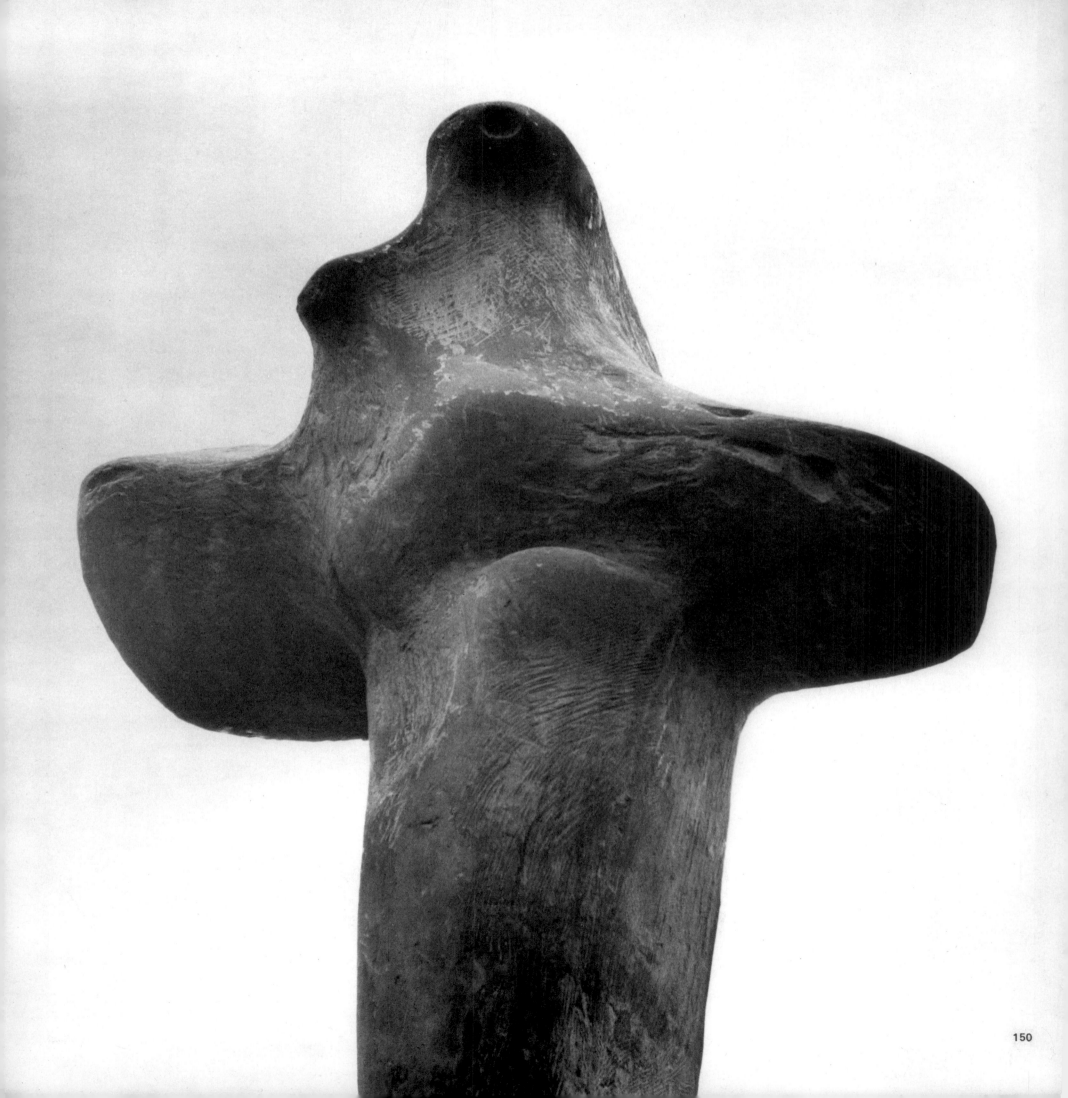

150

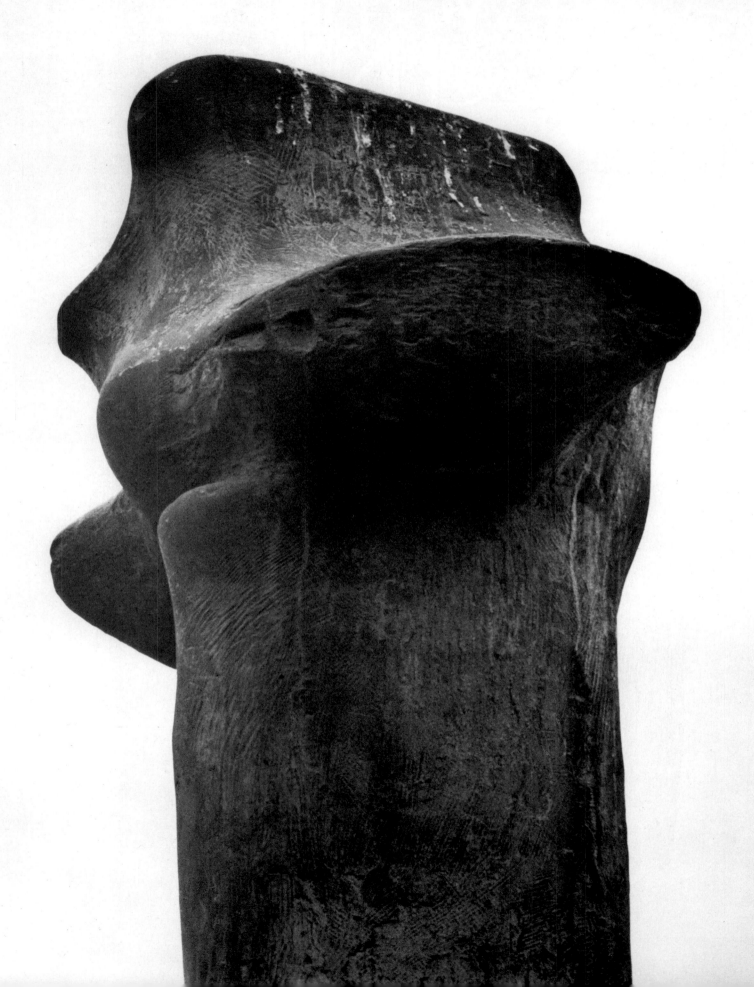

TWO-PIECE RECLINING FIGURE 5

1963–64. BRONZE, L. 12′3″. FESTSPIELHAUS, RECKLINGHAUSEN, GERMANY

The Festspielhaus, a giant festival hall located near Essen, Germany, is a magnificent building in a lovely wooded setting that provides a fine background for Moore's sculpture. The position of the work, away from the building in the midst of a wide expanse of pavement, works very well, and one can easily view the piece in its entirety from all directions.

The total effect of the figure's placement —it is set on a high pedestal in the midst of a grand open space, facing the majestic

Festspielhaus on one side and an unspoiled natural setting on the other—is to make the sculpture seem considerably larger than the casts in Turin, Italy, and at Louisiana, Denmark (see pp. 104–7; 196–202). Indeed, at the time that I photographed the Recklinghausen cast I actually thought it was a larger version of one of those works and found my camera eye drawn to details that gave the sculpture a more monumental feeling.

I didn't choose that location, but I did help place the piece after it had been selected for the site. I wanted it to be away from the building, which is where it is now. It seems quite good in these photographs.

—Henry Moore

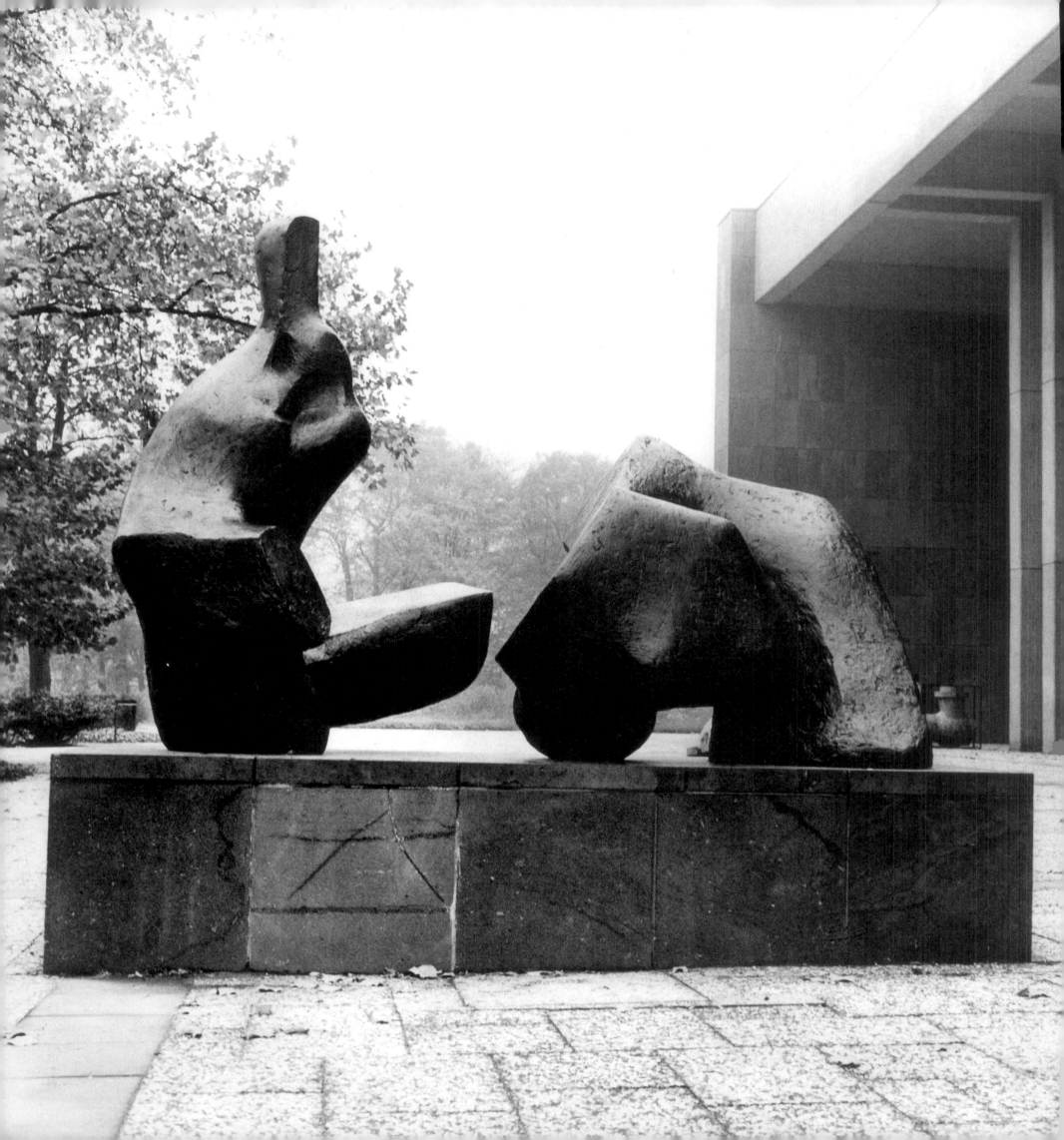

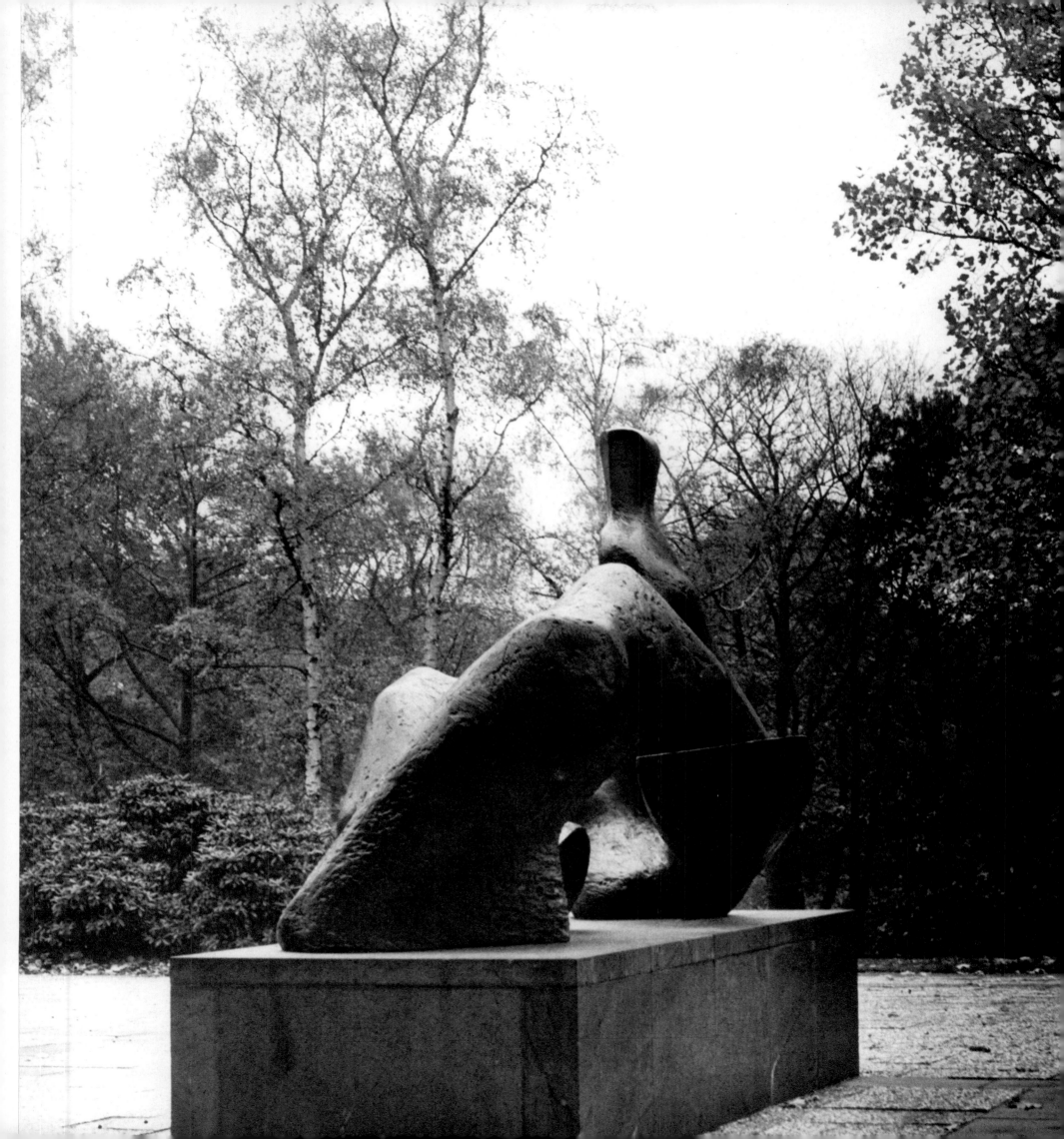

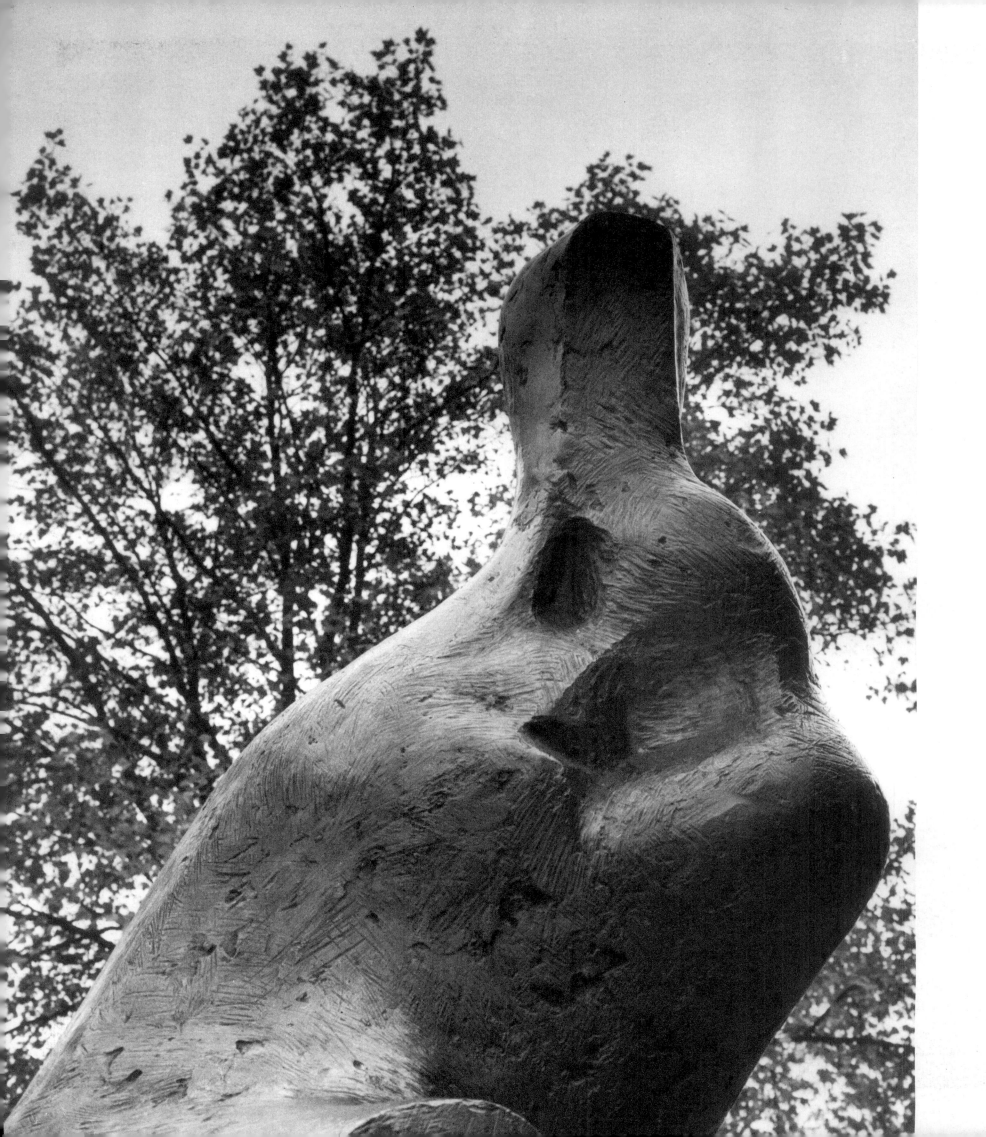

THE
ARCHER

1964–65. BRONZE, L. 10'8". NATIONAL MUSEUM, WEST BERLIN

Located in front of a handsome museum
structure, this cast of *The Archer* has a
strikingly different appearance from the one
in Toronto (see pp. 322–26). The building
behind the cast in West Berlin is smaller
and invites the viewer to discover inter-
relationships between the geometric
forms in the background and the sweeping,
organic shapes of the sculpture. However, the
placement of the work is not altogether a
happy one, partly because the area around
the museum is rather uninteresting and also
because the sculpture looks somewhat like
an afterthought to an architectural plan
that did not include provisions for important
works of art outside the building. Also, it
does not have a wide expanse of space
around it, which means that one cannot easily
view the sculpture from a distance.

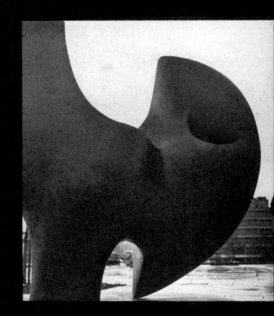

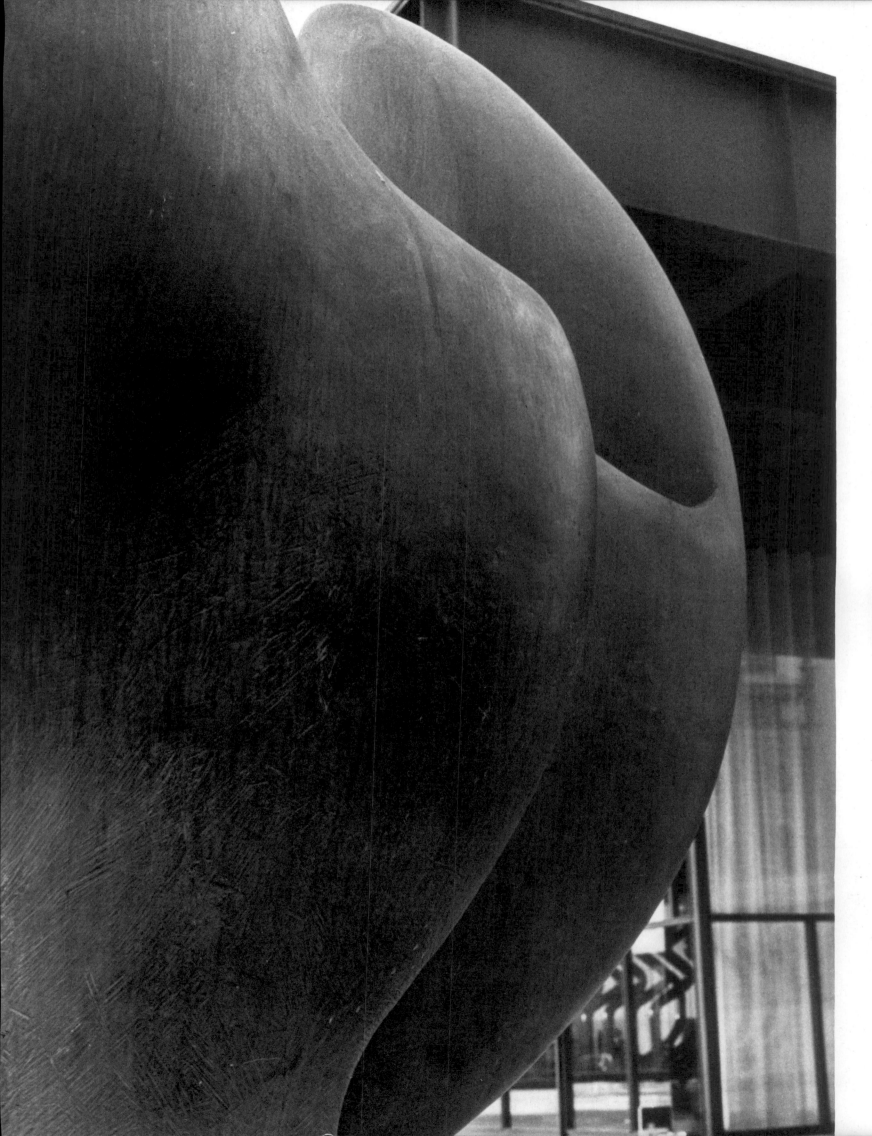

The patina of this sculpture in Berlin has now gone absolutely black. These photographs were taken before this happened.

This location is a little too architectural; it's very different from the Toronto location (see pp. 322–26). These are good examples of how the same sculpture changes when put in a different setting.

I like the photograph that looks like a big ear of an African elephant.

—Henry Moore

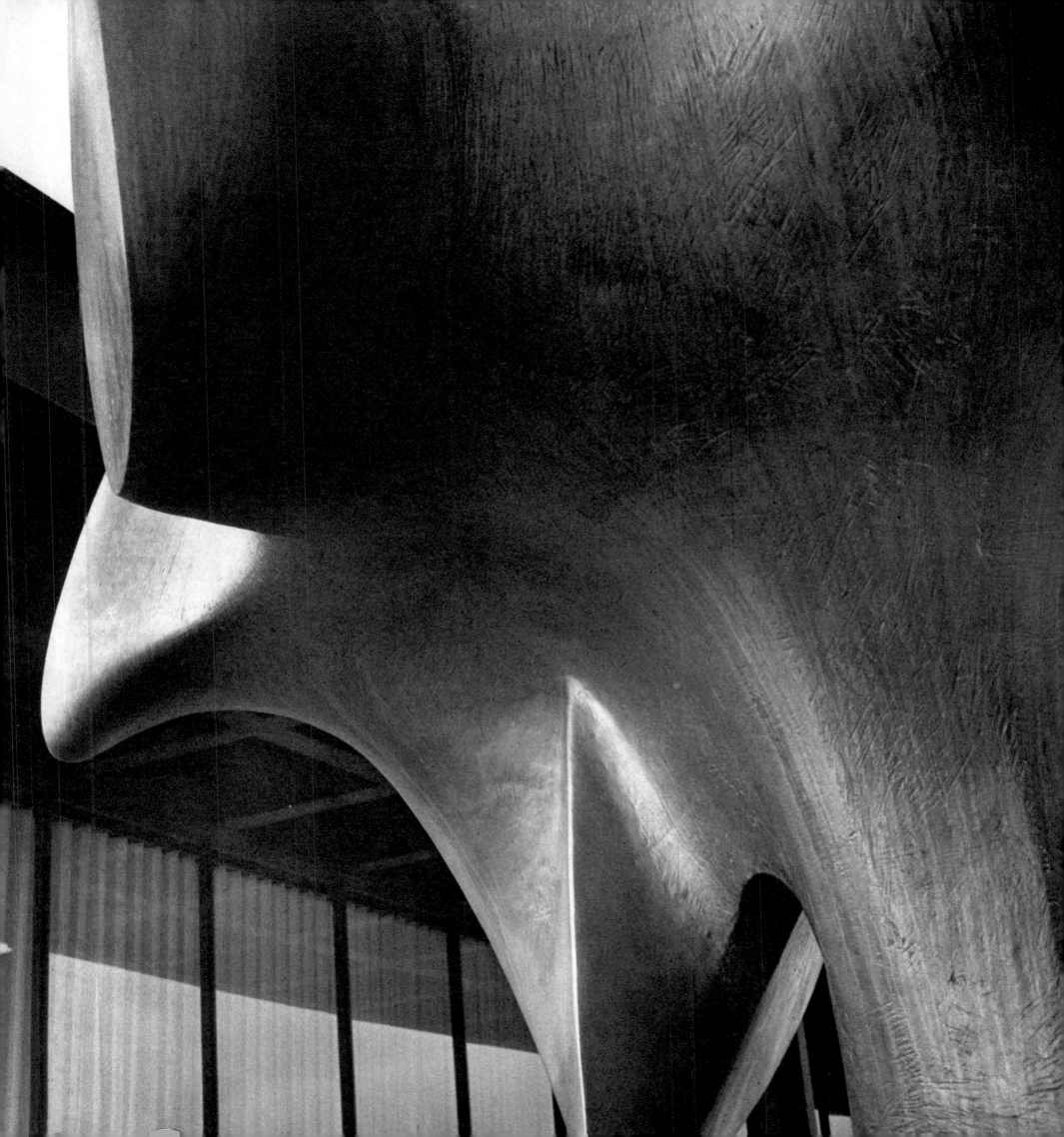

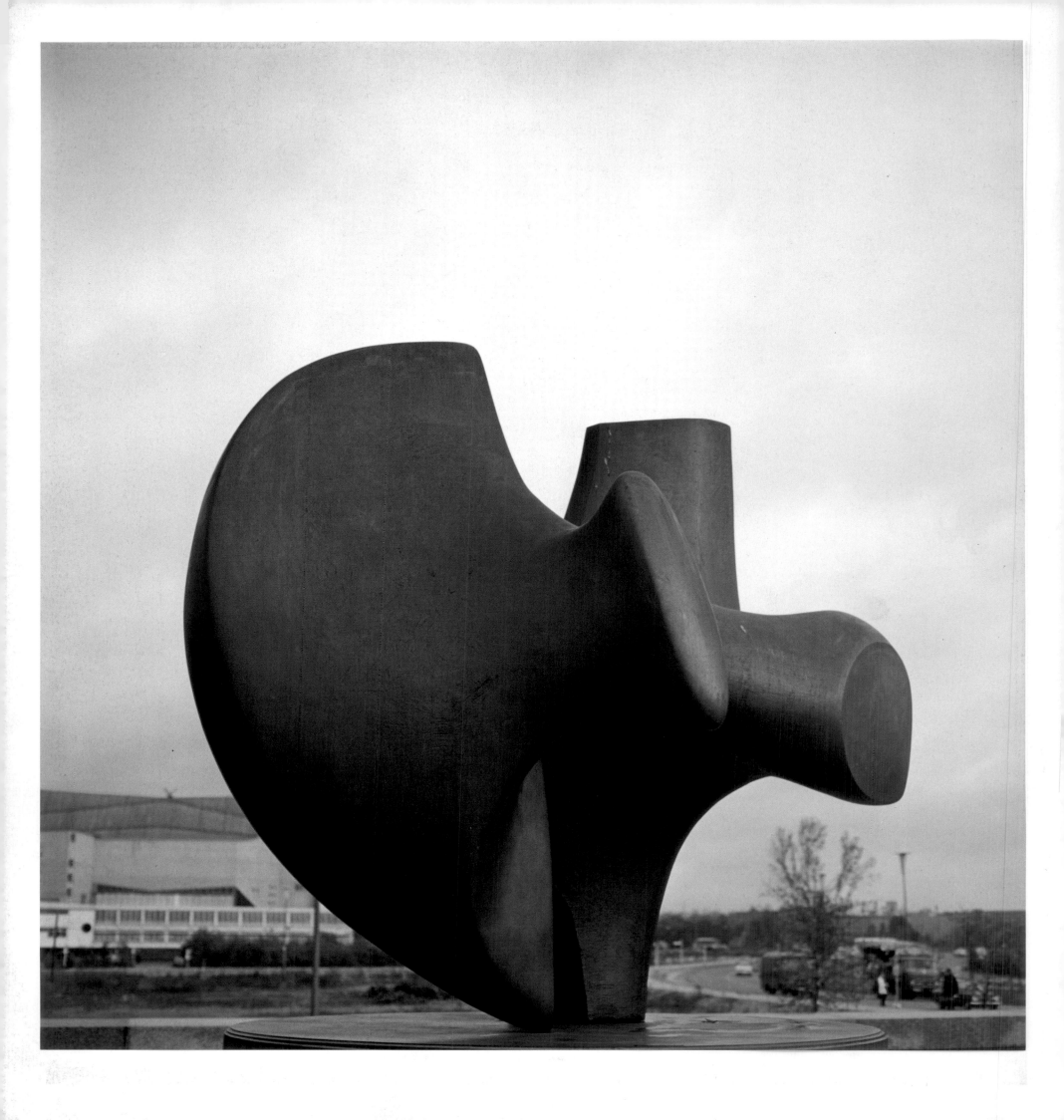

THE NETHERLANDS

WARRIOR WITH SHIELD

1953–54. BRONZE, H. 60". ARNHEM, THE NETHERLANDS

The most difficult aspect of photographing this sculpture was locating it. As with so many other Henry Moores that we inquired about, no one knew about this figure, even though it was right in the center of town! The *Warrior with Shield* is located in a large open area next to the cathedral and the municipality, and practically everybody in town must pass it every day. It is a very lovely setting for the sculpture, with fine architectural structures and street views all around it. And yet it has become so familiar to passers-by that even the museum personnel—to say nothing of hotel managers from whom we sought help—did not know that there was an important Moore sculpture in Arnhem.

We were so discouraged by the difficulty of locating the sculpture that we almost left without finding it. There was a heavy fog

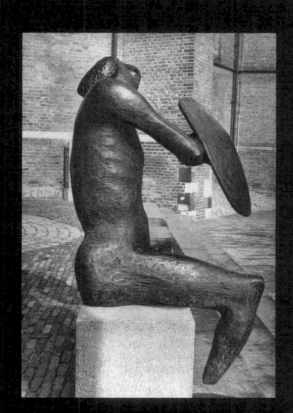

over the area on the morning that we made our last tour of Arnhem before giving up our quest. Then, to our delight—and amazement—we saw the familiar Moore shapes emerging from the mists right in the center of town. It was an early Sunday morning, and there was hardly a soul on the streets as we got out of our car and I proceeded to photograph the sculpture.

My wife and I thought the *Warrior with Shield* looked especially beautiful in this setting. During the hour or so that I spent photographing the work, the fog slowly lifted, and it became a bright, sunny morning. Clearly there is something wrong with the location, since nobody knows the sculpture is there, but I was especially pleased with the photographs which, I think, show the work in a most advantageous way.

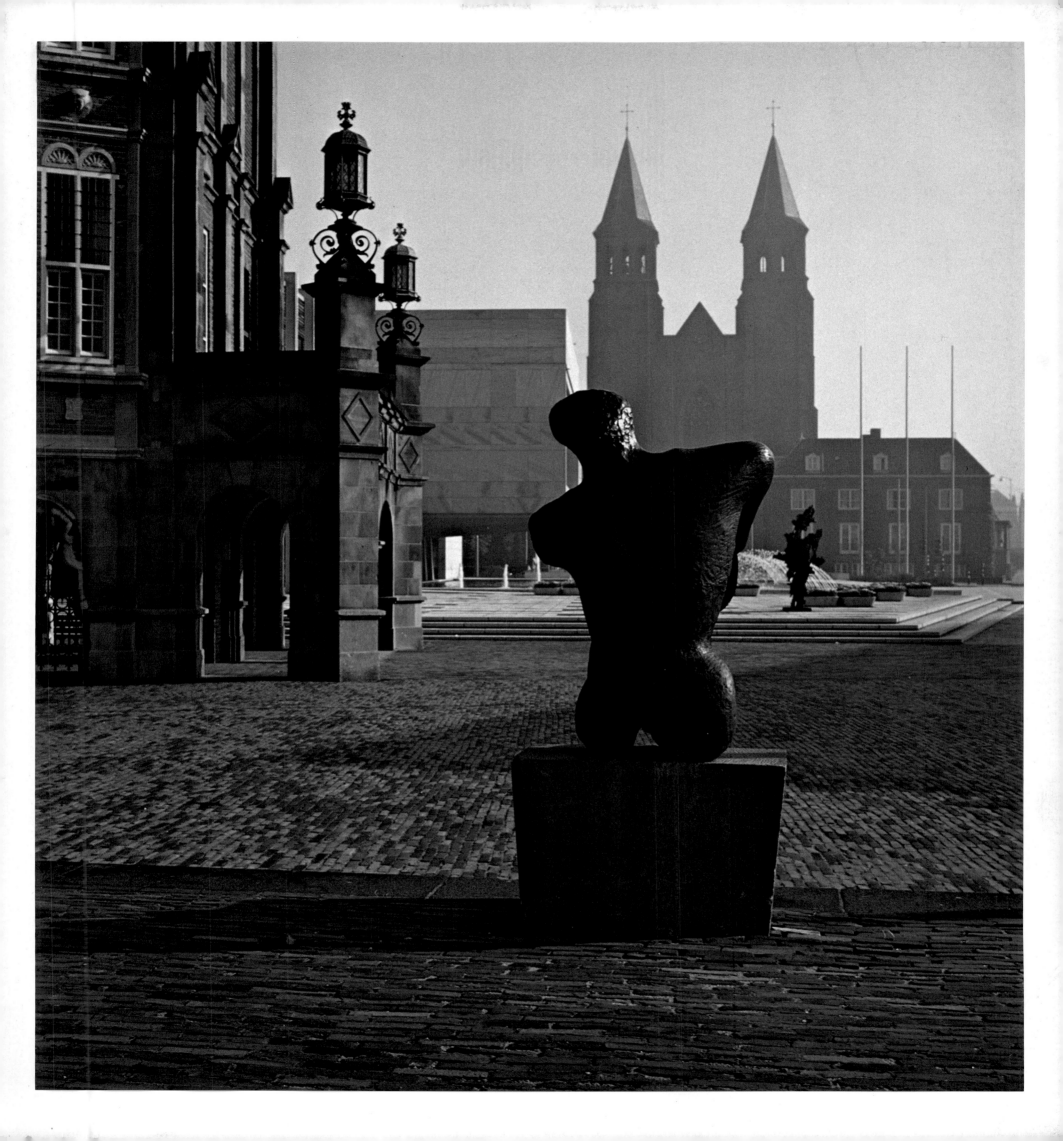

Sometimes people say, "Let's put a sculpture in a part of a city where there are hundreds of people every day"—like this one, which is in the center of town. This very rarely works. Most people are there because it is a busy place. If you put a sculpture in the middle of a crossing or a roundabout, where people are passing by in cars, would they stop and look at it? They can't. It is a silly idea. One of the best sculptures in London is the equestrian statue of Charles I which is in the middle of Trafalgar Square. I always stop and look at it because I like it, but I've never seen anybody else stop and look at it. For one thing, people risk their lives crossing the street. For another, when they get there, they have to stand below the sculpture and get only an underbelly, worm's-eye view. This is an example of where the siting wastes a beautiful sculpture. I have another criticism of the setting of the Warrior With Shield—the pedestal block should be darker. Why did they make the block white when the figure is so black? The pedestal, being whiter than the pavement, is too prominent.

—Henry Moore

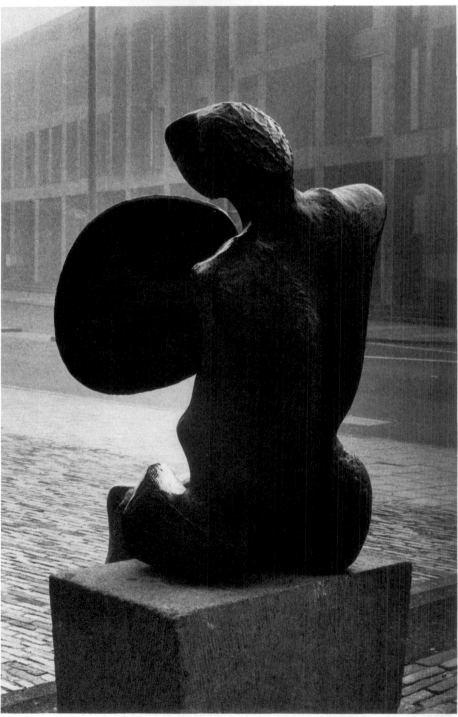

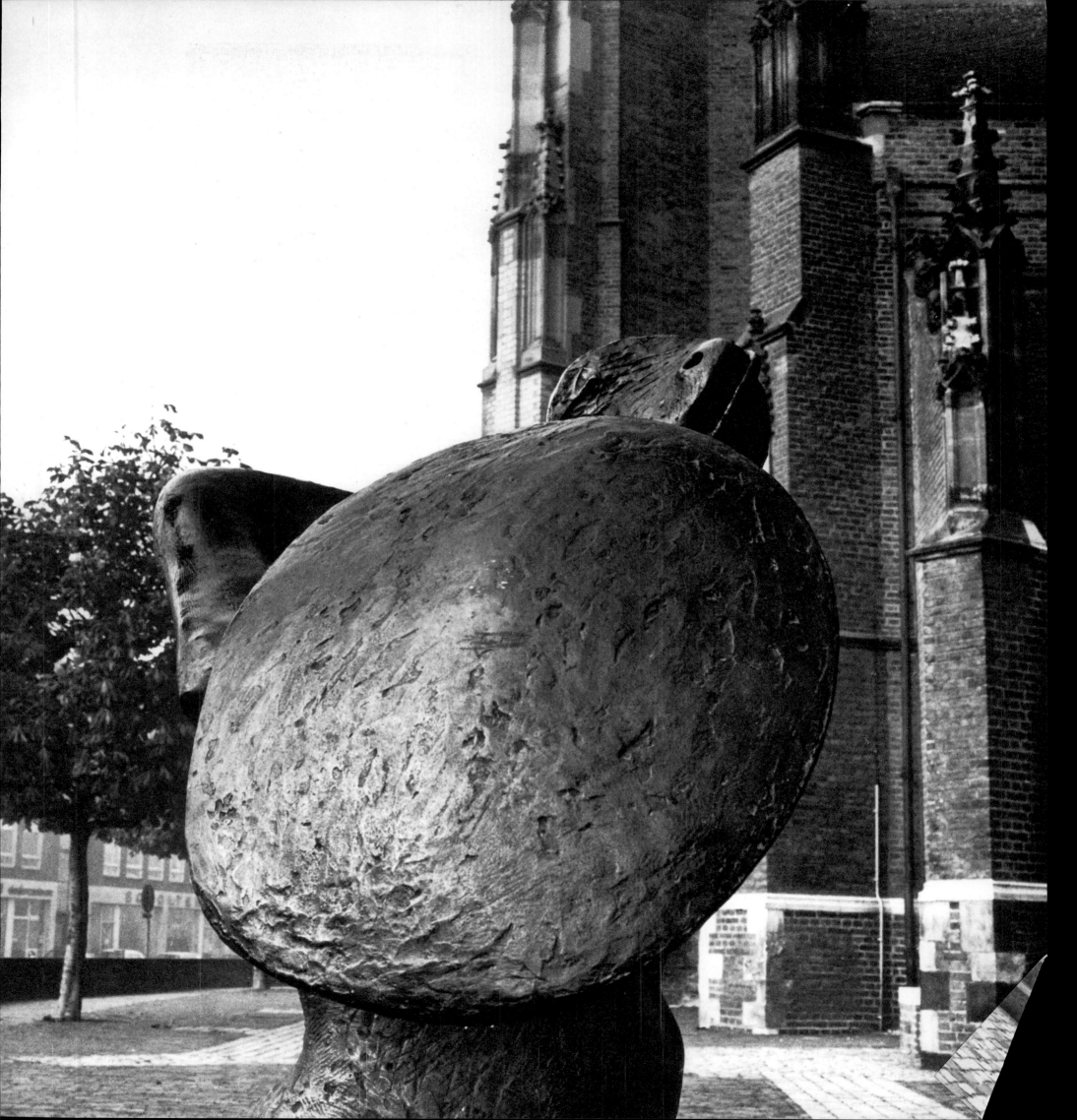

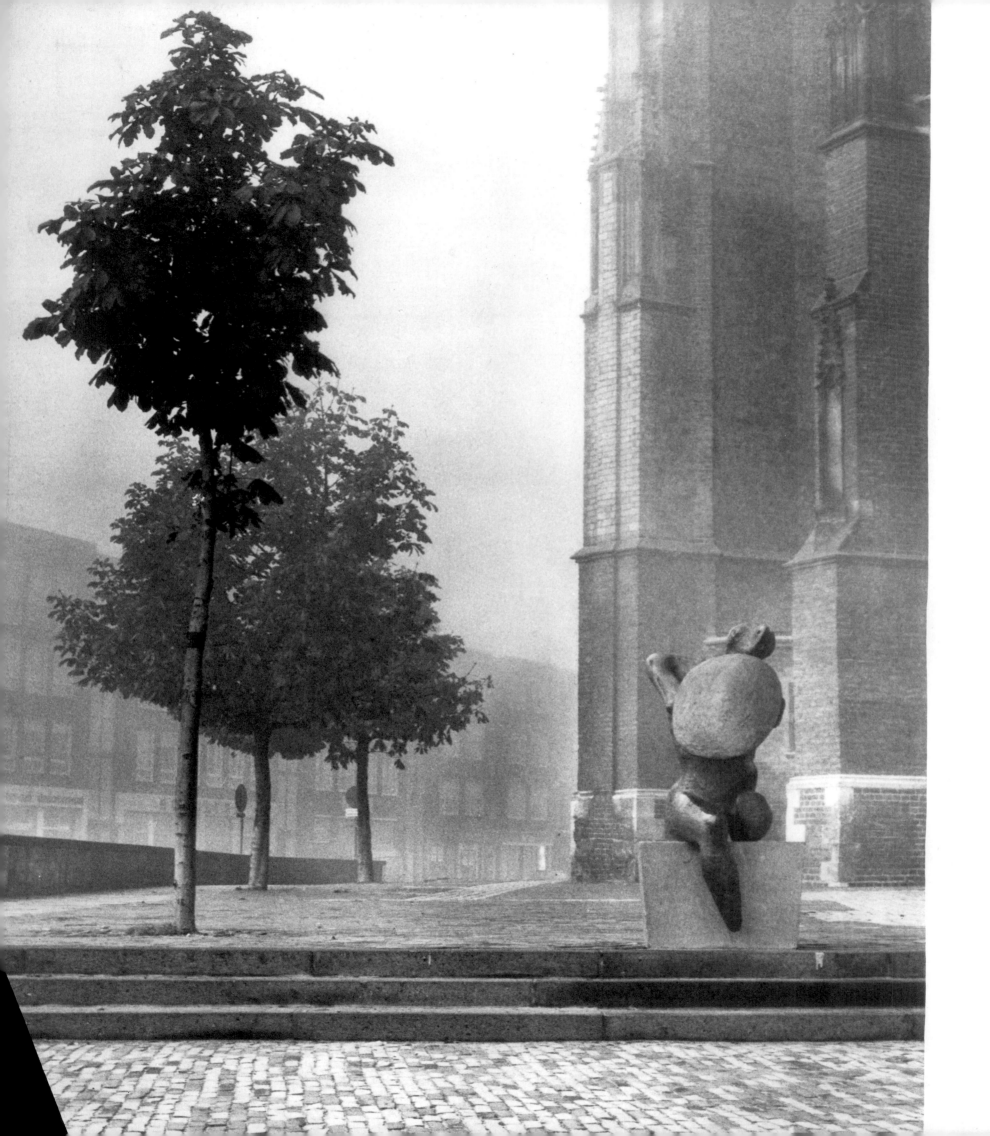

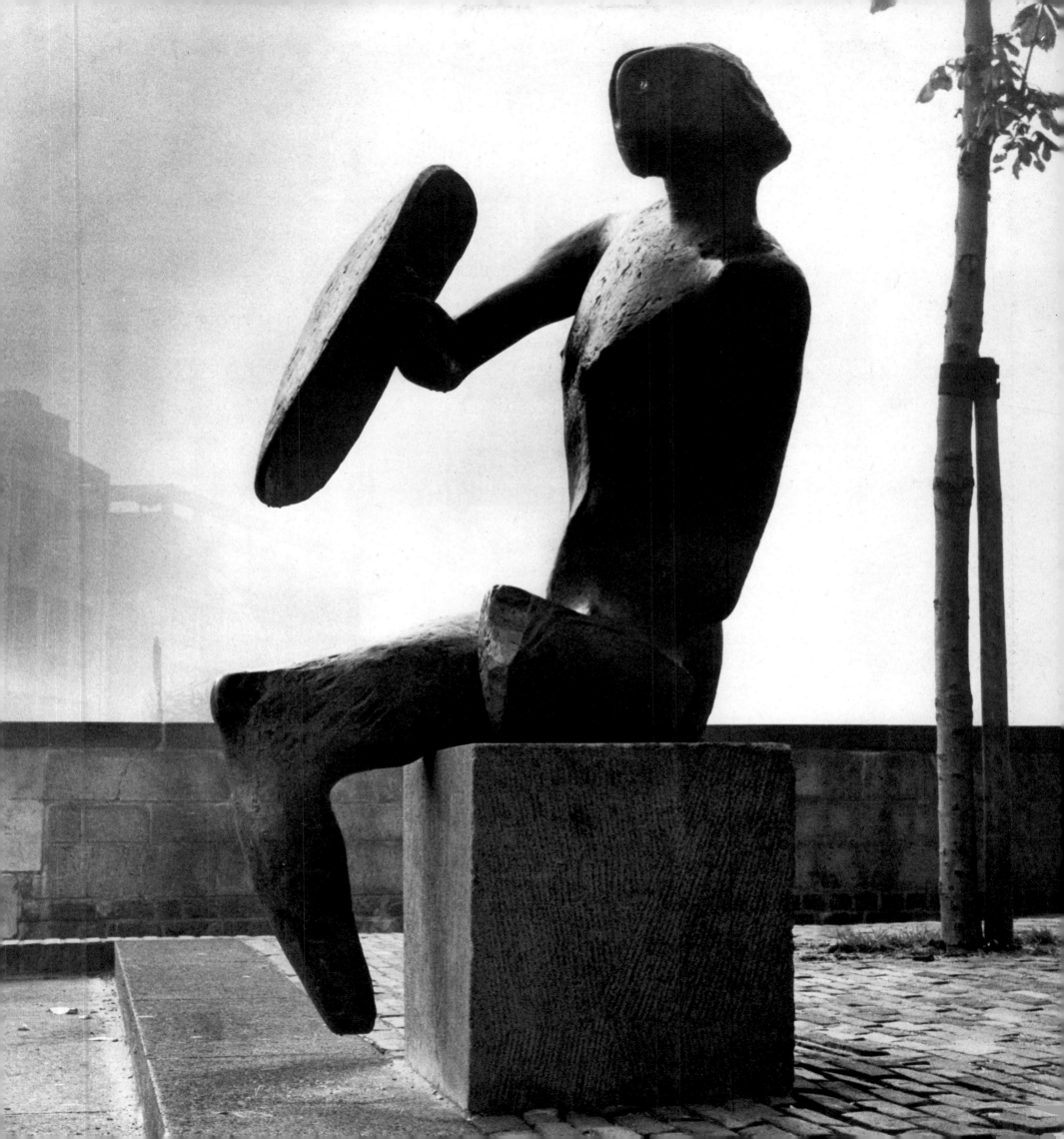

UPRIGHT MOTIVES 1, 2, 7

1955–56. BRONZE, H. 11'; 10'6"; 12'6". KRÖLLER-MÜLLER MUSEUM, OTTERLO, THE NETHERLANDS

The Kröller-Müller Museum is located in a beautiful park a few miles outside of Otterlo. The outdoor sculpture park is beautifully landscaped, with a winding path that takes one through groves of trees and open fields and around a lovely pond, with sculptures spotted here and there throughout.

These *Upright Motives* stand in a place of their own on a slight, sandy hill, with foliage in the background, that is separated somewhat from the rest of the sculpture garden at the Kröller-Müller. It is a dramatic setting, and almost everyone who visits the area stops to look at the sculptures. Children like to climb up the base of the Moore piece,

the work in that spot, and by such a measure this site would get a very high rating.

The Upright figures have always fascinated me: Although they lack the sweep and monumentality of other Moore sculptures, I find that their enigmatic forms evoke strange images and sensations. I have the feeling that, like James Joyce's *Finnegan's Wake*, they embody the folklore of the human race and that their mysterious passages incorporate all sorts of allusions— some erotic, some religious, some commonplace—forming a sort of visual encyclopedia of archetypal symbols. They are strange objects, particularly striking in their

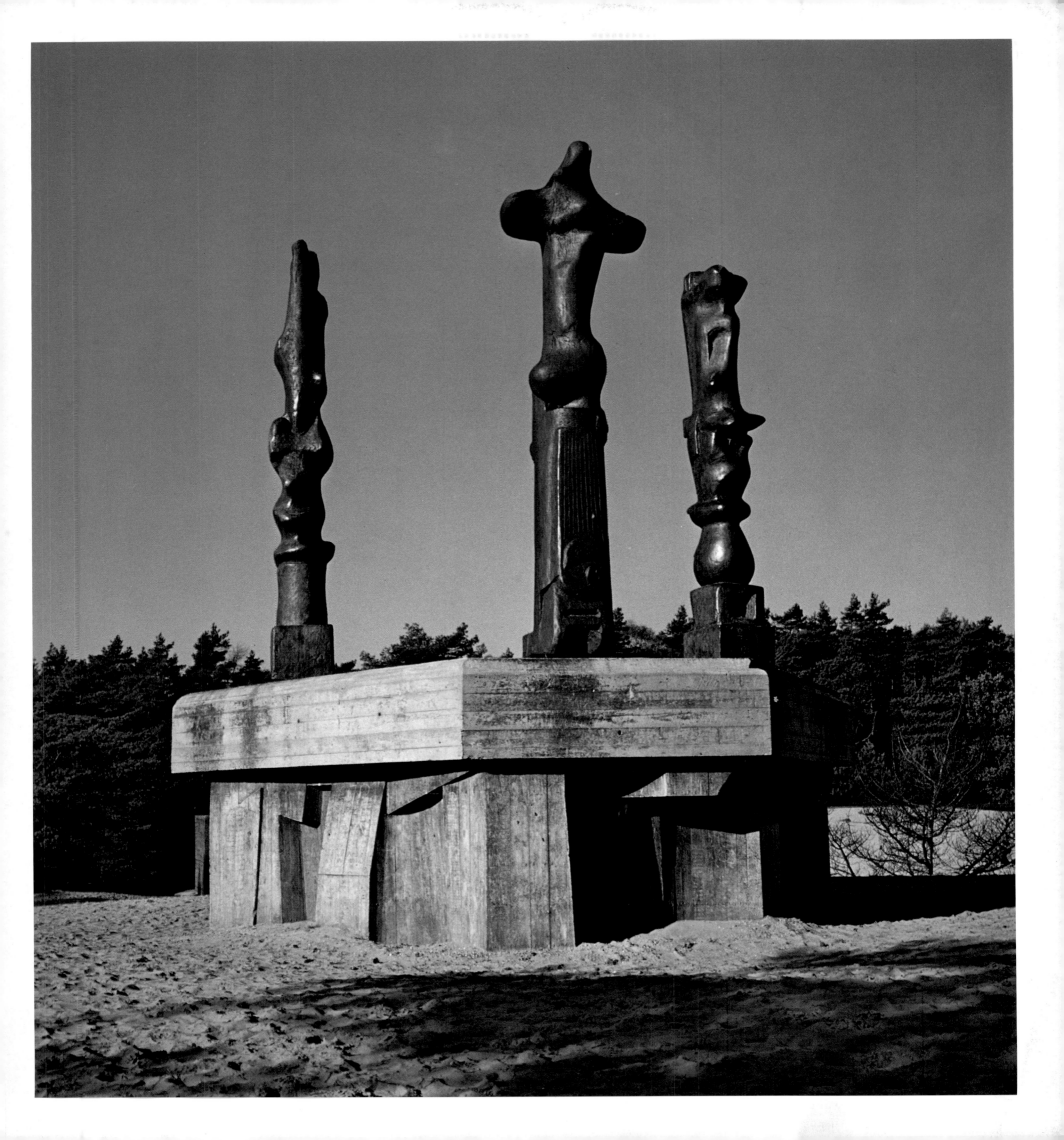

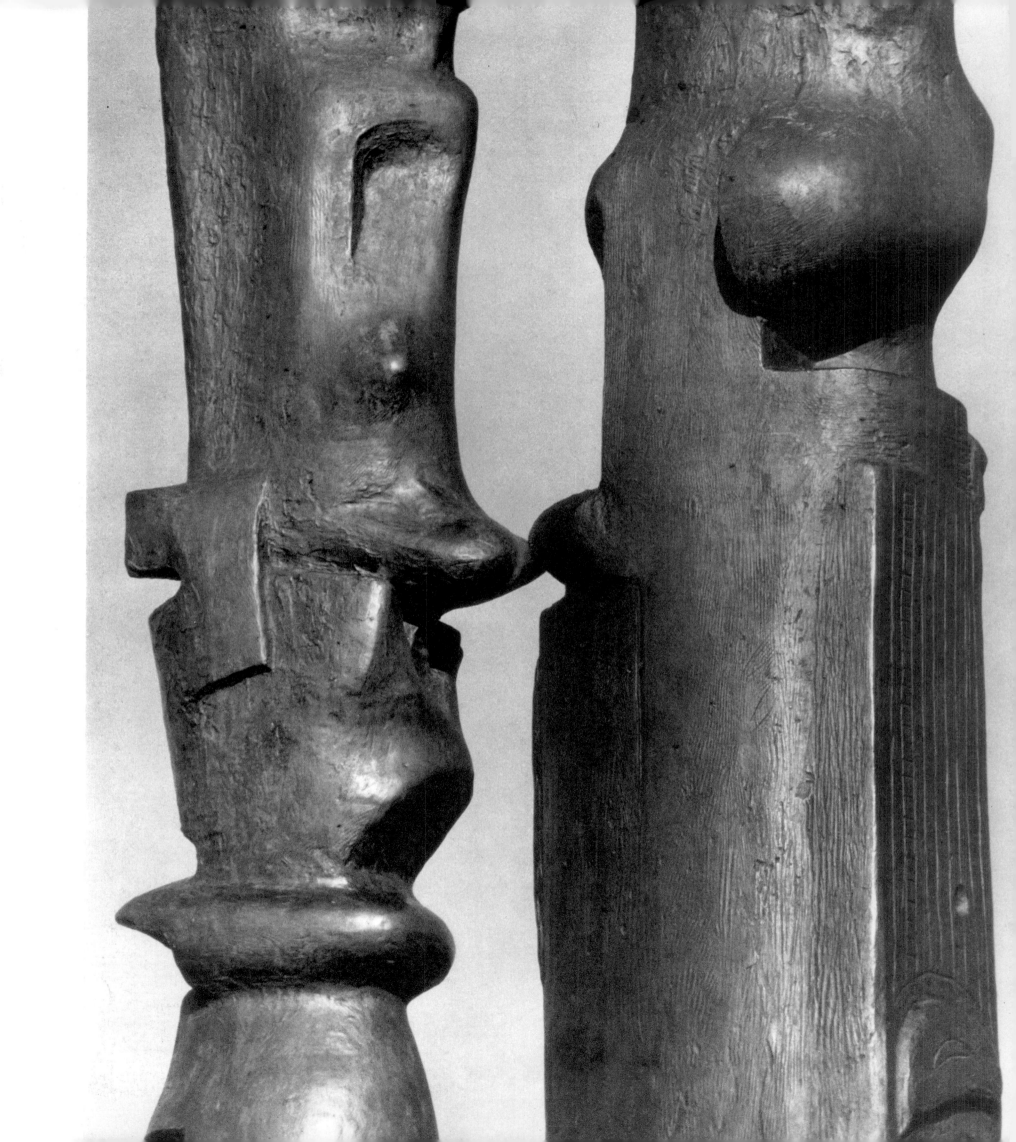

The Kröller-Müller Museum
was originally built only as a
temporary building. The family,
which was giving its art collection
to the nation, engaged one of the
best Belgian architects, Henry
van de Velde, to design a huge
monumental building. But it was
never built. The Kröller-Müller
family lost its fortune, and only
the foundations for the museum
were started, so you find these
rudimentary beginnings scattered
about the area. When I saw them,
I thought some of them would
make a good base for the three
upright figures . . . that's how
that particular base happened.

—Henry Moore

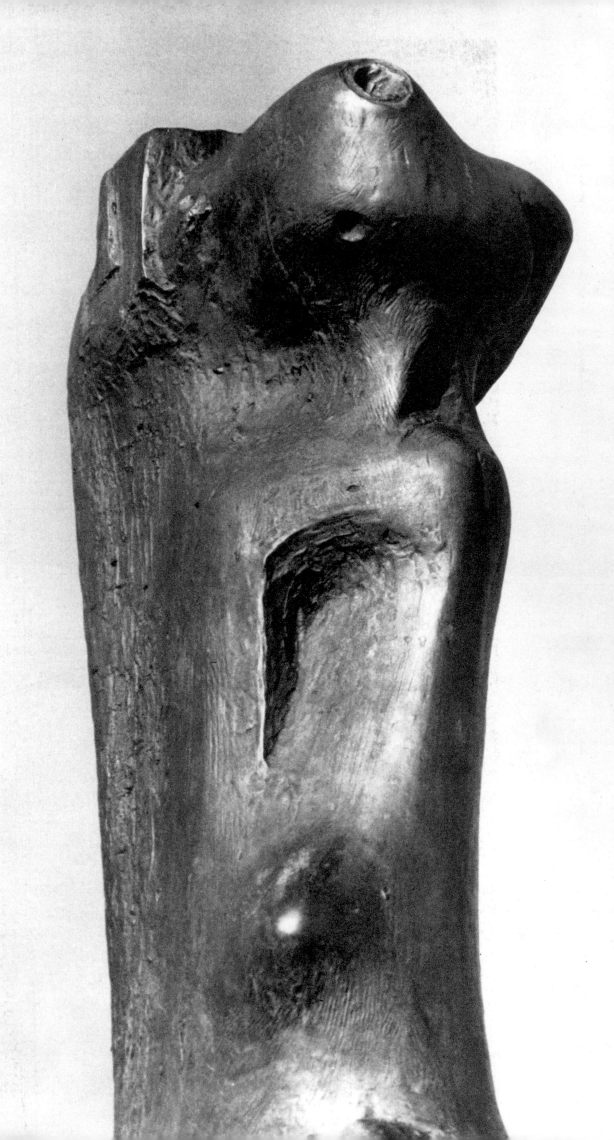

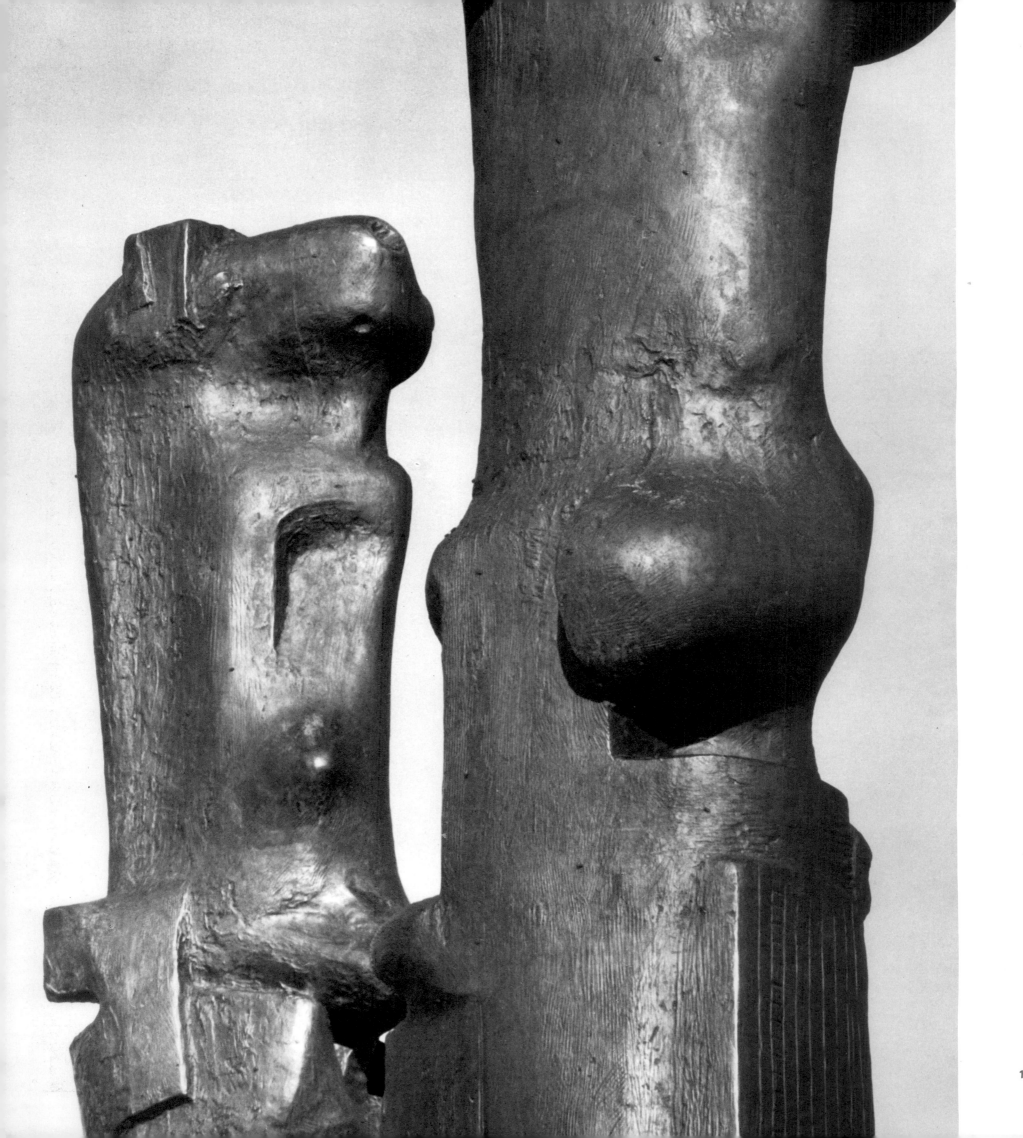

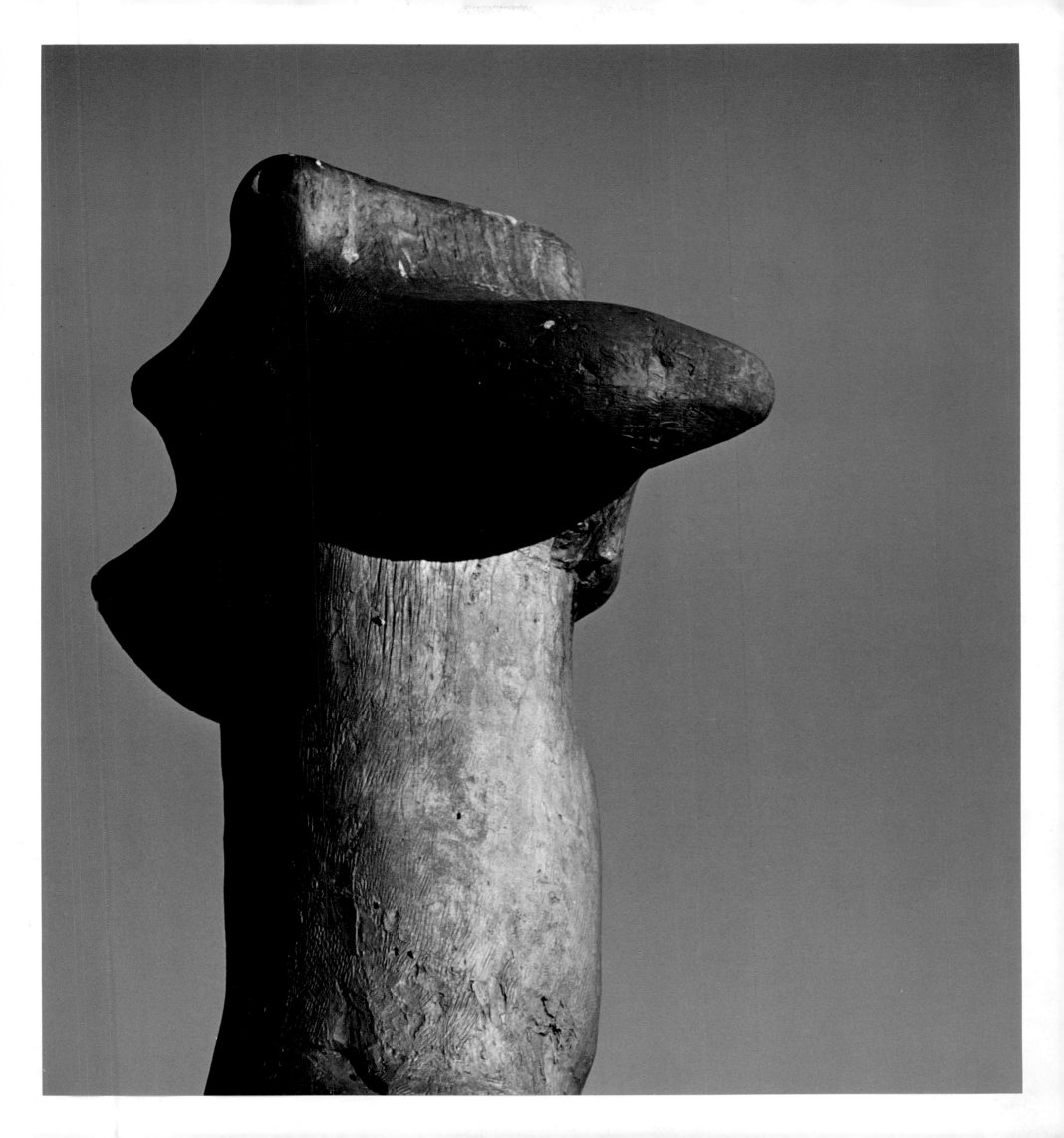

TWO-PIECE RECLINING FIGURE 2

1960. BRONZE, L. 8'6". KRÖLLER-MÜLLER MUSEUM, OTTERLO, THE NETHERLANDS

Moore's *Two-Piece Reclining Figure #2* is placed in a clump of trees, the kind of setting he has often talked about in the past. It seems to stand in the midst of a primeval forest, and, coming upon the sculpture, one feels that it has been there for centuries. I found it quite exciting to discover the sculpture there, hidden from the rest of the world, even though it was difficult to view the whole work and to photograph it properly because of the overhanging trees.

It's a pity the trees are not trimmed back a bit to let a little more light in. The shadows of the trees, leaves, and branches make it difficult to read the form and true modeling of the figure. Nevertheless, one of your detail photographs has the look of a mountain.

—Henry Moore

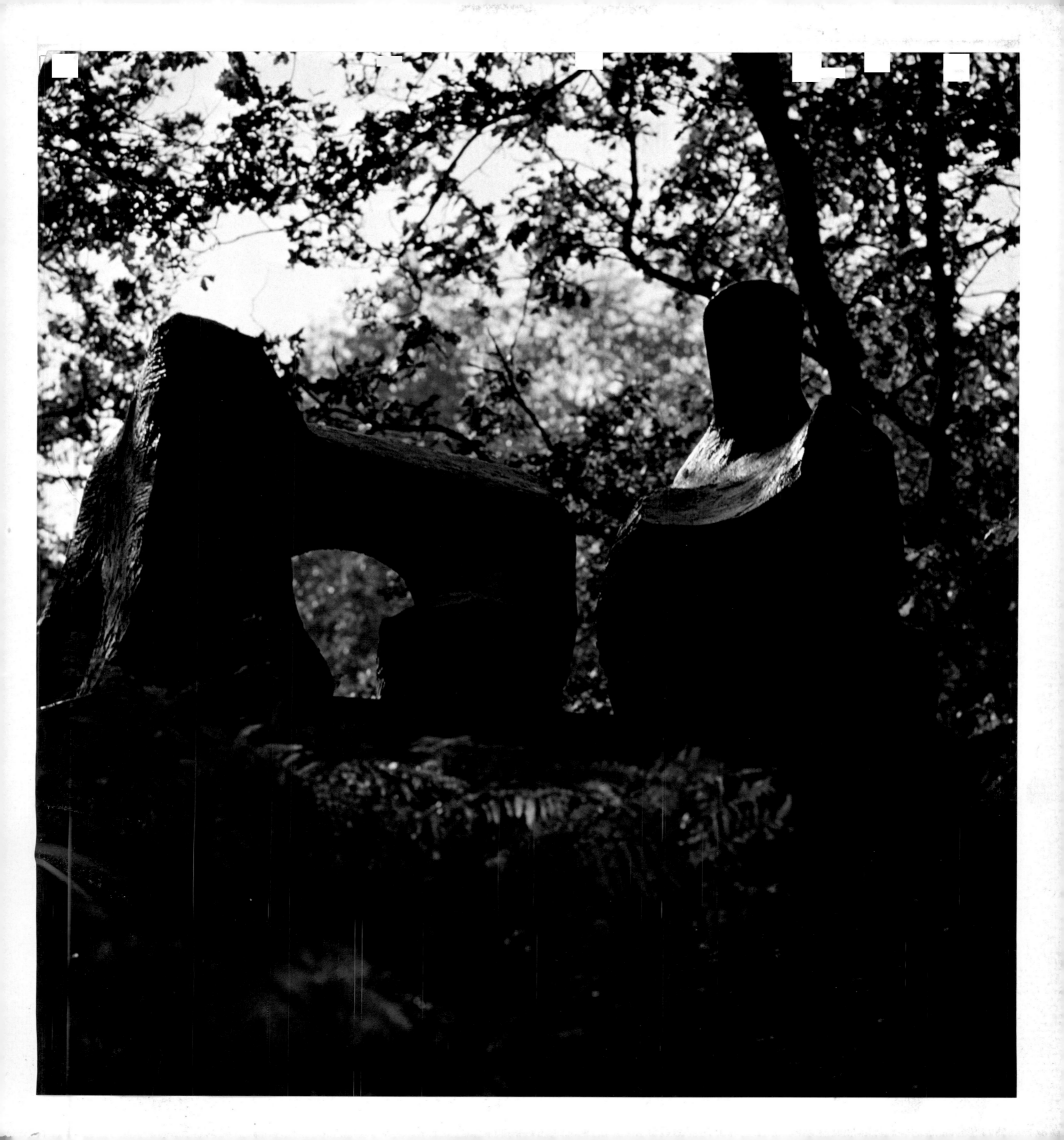

ANIMAL HEAD

1956. BRONZE, L. 21 5/8″. KRÖLLER-MÜLLER MUSEUM, OTTERLO, THE NETHERLANDS

Although Moore has done many human figures with animal heads, this sculpture of only the animal head is most unusual. It is a very strong figure, with characteristic Moore forms in the shape of the skull and the gaping eyeholes and nostrils. My wife and I have a strong personal association with the piece, because we once almost bought it at an auction, but in the split second during which we had to make up our minds we felt insecure about how we might mount it. We have regretted that uncertainty ever since. Here at the Kröller-Müller, it is handsomely mounted alongside a footpath in the sculpture garden. It looks especially fine under the trees, almost as if the animal has just stuck its head out from behind the bushes.

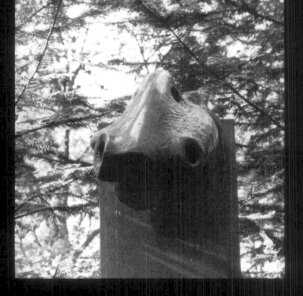

I think it's all right just mounted at the top of the upright board. It looks like a big signpost.

—Henry Moore

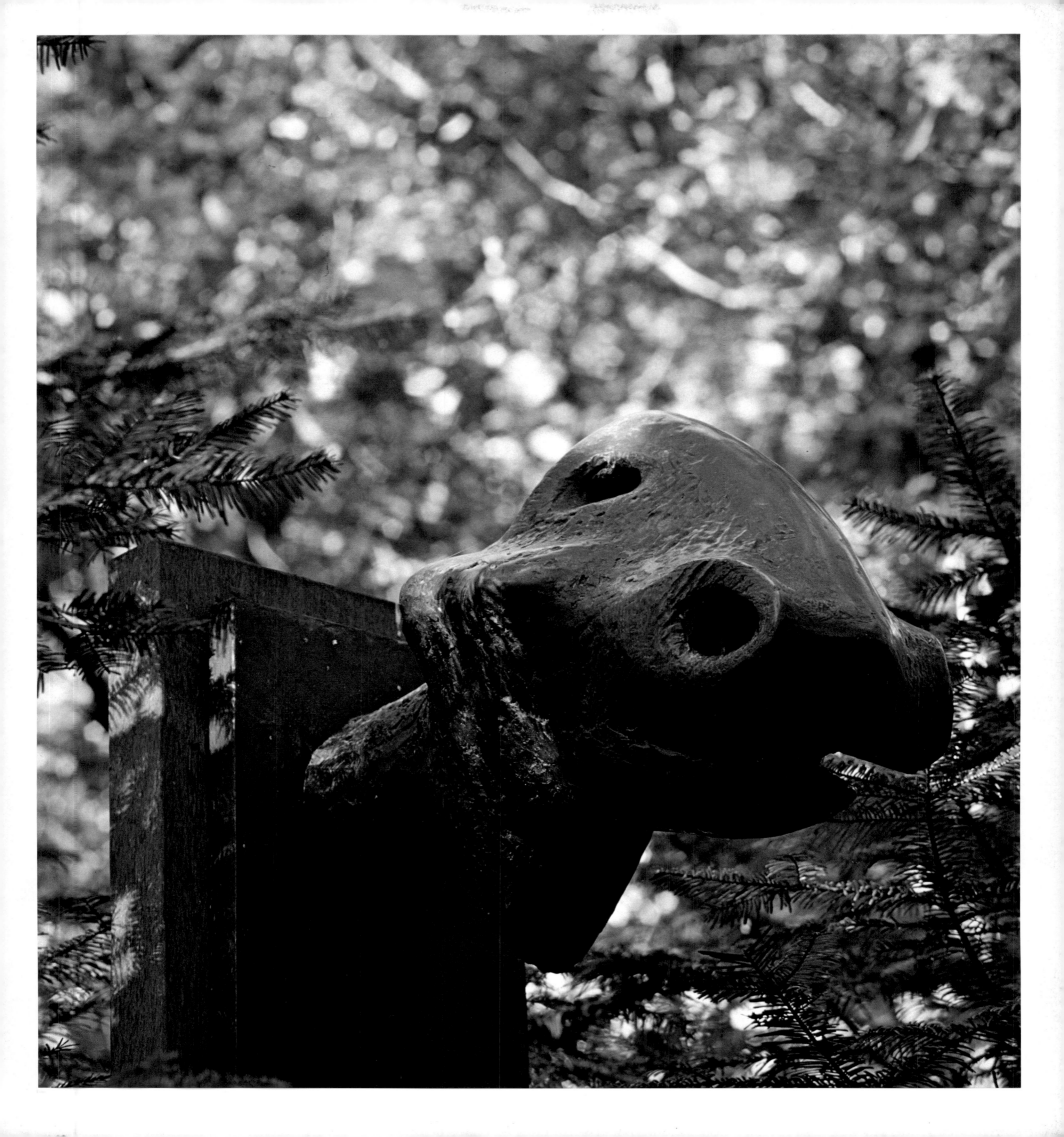

WALL RELIEF

1955. BRICK, 28'6" × 63'. BOUWCENTRUM, ROTTERDAM, THE NETHERLANDS

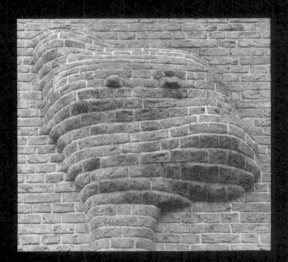

Bouwcentrum is a large store located on one of the main streets of Rotterdam. This relief is on a side wall of the store that faces a rather narrow street. As with the Time/Life Screen in London (see pp. 222–29), one has the feeling that the work is generally overlooked by passers-by, which is a pity because the relief is an especially engaging piece and seems very much in tune with the spirit of enterprise and innovation one feels in Rotterdam. The city was almost completely destroyed in World War II, and its reconstruction incorporated some of the most advanced urban ideas of postwar architects—streets designed for pedestrian shopping, islands of stores in the middle of malls, monumental public sculptures.

Although Moore has said that the forms in this relief are related to earlier sketches and sculptures, when I saw this work I had the feeling that it was different from any other Moore I had seen. Perhaps the strangeness of brick as a material for sculpture contributed to this sense of uniqueness, but in addition, there is something anthropomorphic about the goblin-like forms, which look half animal and half human. (The sculpture consists of the entire wall and includes abstract lines and shapes as well as the figures.) The relief is also witty and spritely, as if Moore were having fun in a city that invited a light touch and a bright sense of humor.

The *Wall Relief* was completed just prior to the Upright Motives, and there does seem to be a resemblance to the unusual inventions found in those totem-like works. But I feel that the Bouwcentrum relief stands alone as one of Moore's most ingenious experiments. It was a sort of excursion along a side road that offered the sculptor a refreshing diversion from the primary forms with which he is concerned in most of his other work.

Relief sculptures tell best when they get a side light. This relief is, unhappily, on a wall facing north and is best photographed only in the summertime—either early in the morning or in late evening when, for short spells, it catches the sun.

This leads me to say that architects often forget about the sun when choosing a site for a sculpture. I think it is because they design their building indoors and often choose what looks like the right spot for a sculpture only from their plans, forgetting the existence and direction of outdoor sunshine.

I made the design for this wall sculpture to be built in brick, but not being a practiced bricklayer, I did not myself build it. Holland having little stone of its own, the traditional building material is brick, and Dutch bricklayers are very highly skilled. (The ornamental brickwork on much of their early architecture is marvelous.)

I was told not to feel restricted in designing the relief by considerations of the technique of bricklaying, since Dutch bricklayers can build almost anything.

Some of the figures are animal forms with eyes and heads and gave the bricklayers a chance to show what they could do. . . . It was a most interesting experience for me. I had fun. I enjoyed it.

—Henry Moore

BELGIUM

KING AND QUEEN

1952–53. BRONZE, H. 64 1/2". MIDDELHEIM OPEN-AIR MUSEUM, ANTWERP

Middelheim was the first of the modern outdoor sculpture parks to be established. Located in Antwerp in a pleasant wooded area away from the center of the city, the park has become a well-known landmark and provides a large number of people with an opportunity to see outstanding sculpture in a natural setting. Over the years the number of works has grown so large that it is beginning to seem crowded, and the quantity of sculptures takes away somewhat from the quality of the experience.

The *King and Queen* is in a prominent position near the entrance to the park and has a large stretch of lawn all to itself. The

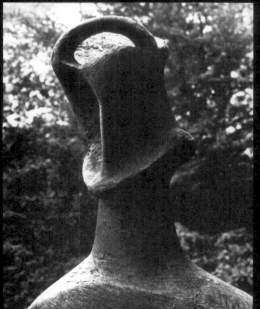

landscape, in which the sculpture is seen against a background of trees, is well suited for photographing. Although the general area has none of the breathtaking qualities of Glenkiln, Scotland (see pp. 298–305), this setting draws one's attention to the details of the work. I found the hands particularly fascinating—as expressive of the regal character of the subjects as the heads. I was also struck by the gracefulness of the drapery and the rhythm of the forms which, when seen from the side, seemed to anticipate many of the more abstract shapes Moore developed in later pieces.

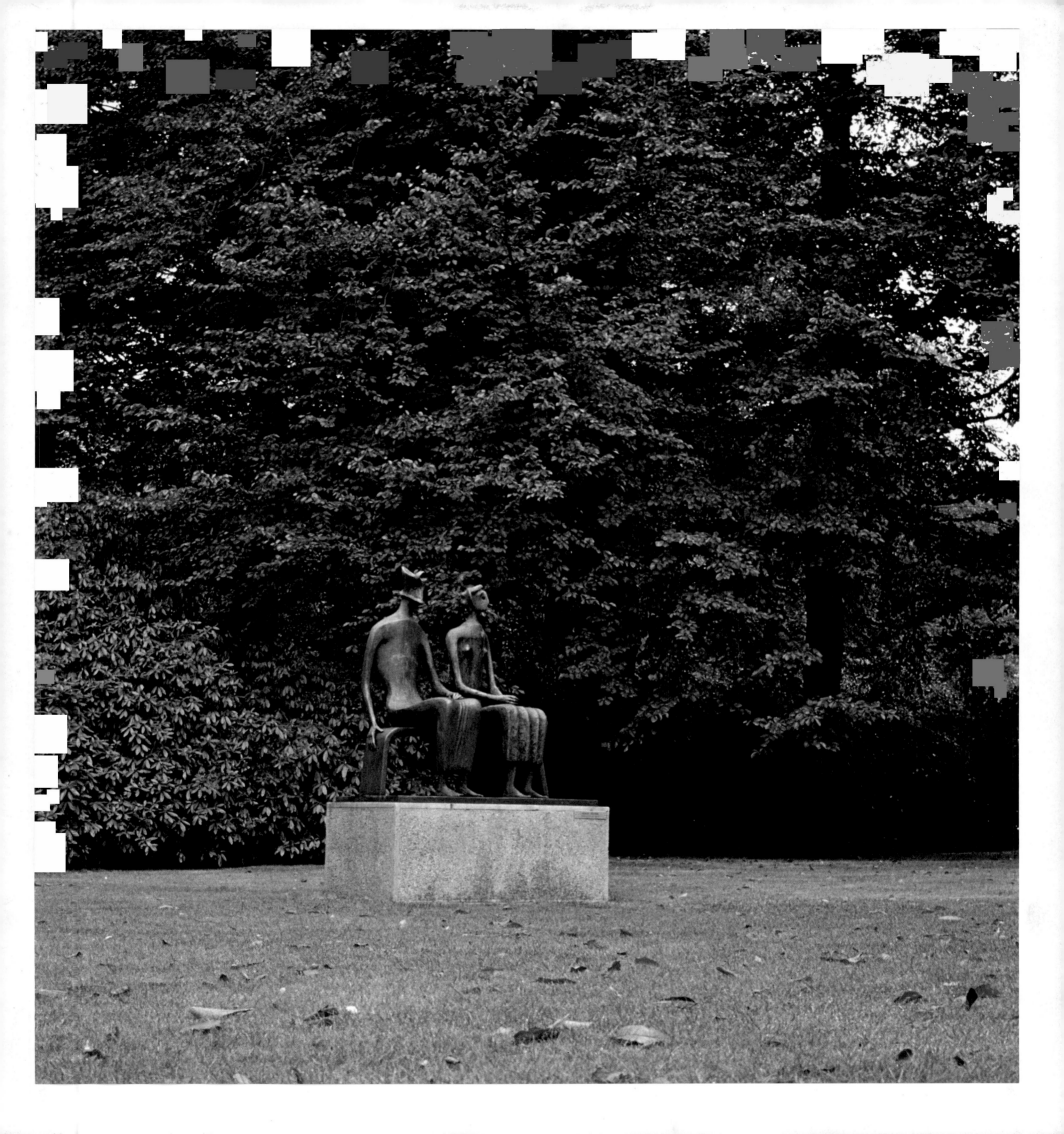

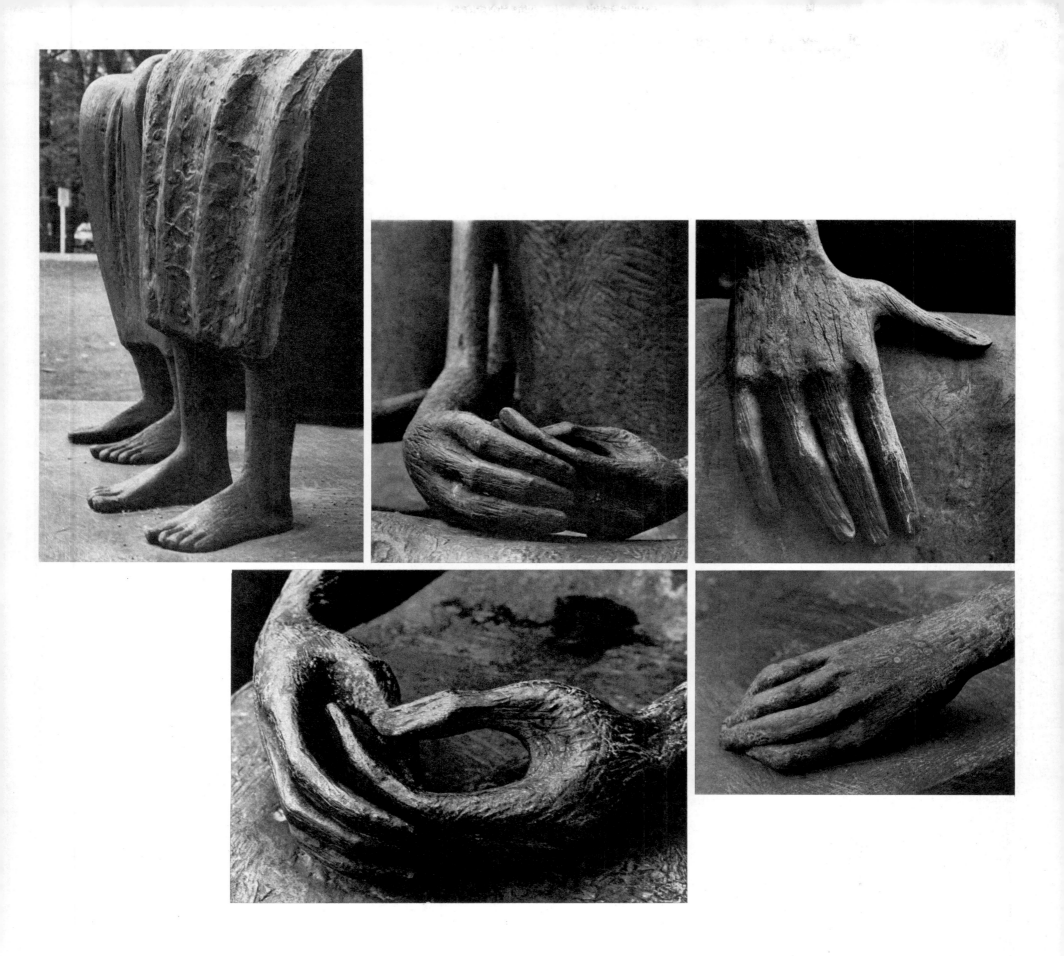

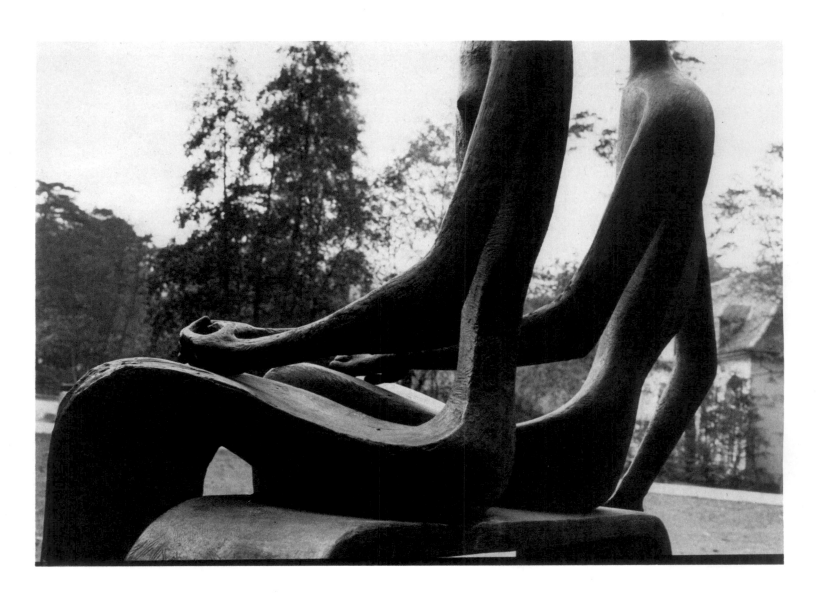

This is quite a good site for the
King and Queen *sculpture, even*
though not as dramatic as in
Scotland at Glenkiln (see pp.
298–305).

—Henry Moore

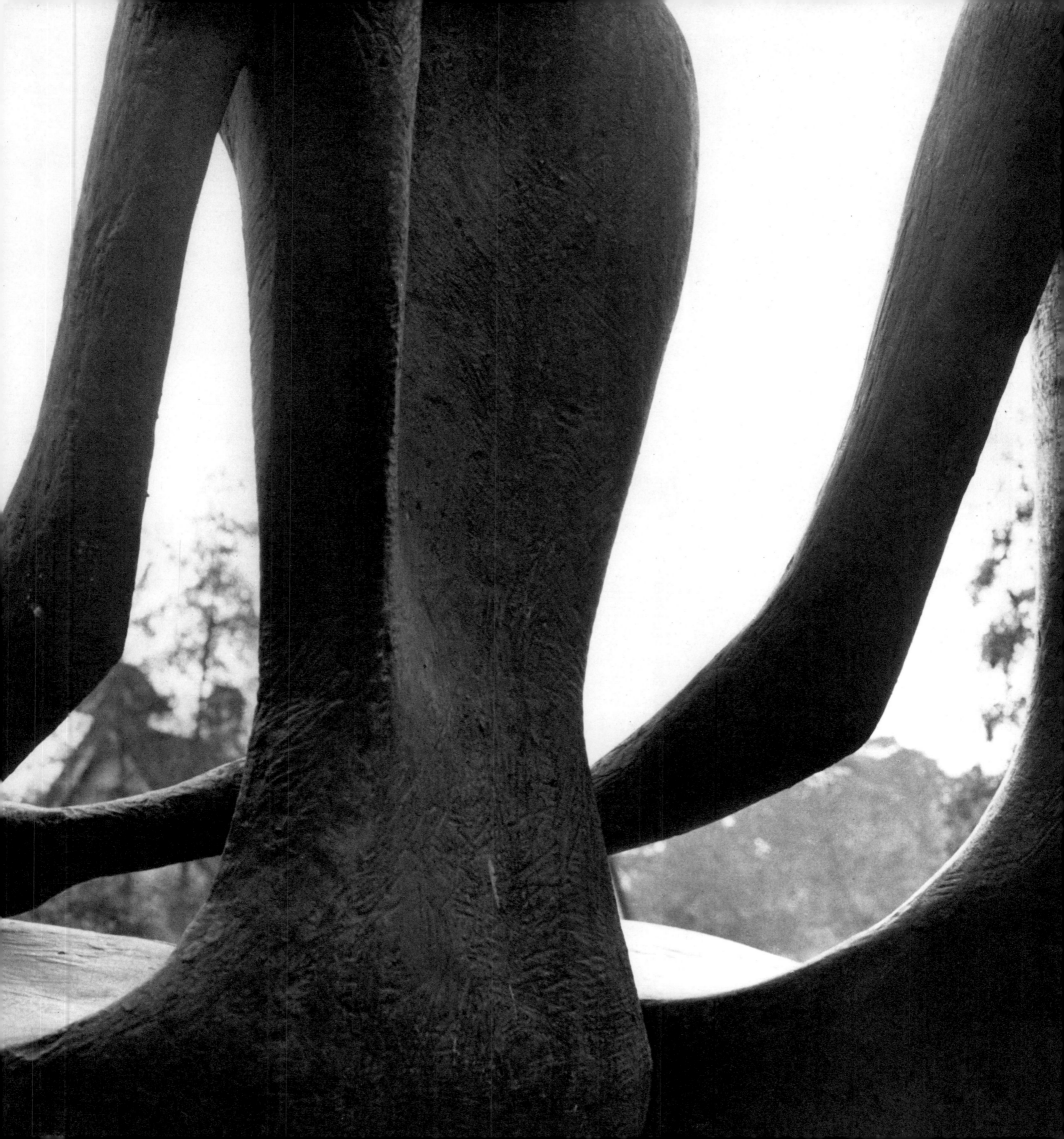

LOCKING PIECE

1963–64. BRONZE, H. 9′7 1/2″. BANQUE LAMBERT, BRUSSELS

Located on a main thoroughfare in Brussels, this cast of *Locking Piece* is placed in front of a fine building designed by the architect Gordon Bunshaft. Although one cannot see as many views of the piece as on The Embankment in London (see pp. 216–21), the relationship between the forms of the sculpture and the building is especially felicitous. Indeed there is such a close resemblance between the linked detail in the building and the linked aspect of the sculpture that it looks as if one inspired the other, which is not the case.

Fortunately, it was a Sunday when I photographed the piece, and because the offices were closed, I didn't have to worry about crowds in front of the building. I was struck by the differences between this cast of the *Locking Piece* and the one on The Embankment. The patina here is darker, and one doesn't get the gold brilliance of the London cast. Also, I didn't have the sense of infinite variety in the work that I experienced in London. Perhaps this was because one cannot see the sculpture against the sky as easily in the Brussels location, so one loses the advantage of an ever-changing background. A fairly wide expanse of pavement in front of the building creates space in which to view the work from all sides, however, and because the pedestal is lower here, there is a greater sense of intimacy about the sculpture *in place* of the grandeur one feels when looking up at the cast that is on The Embankment.

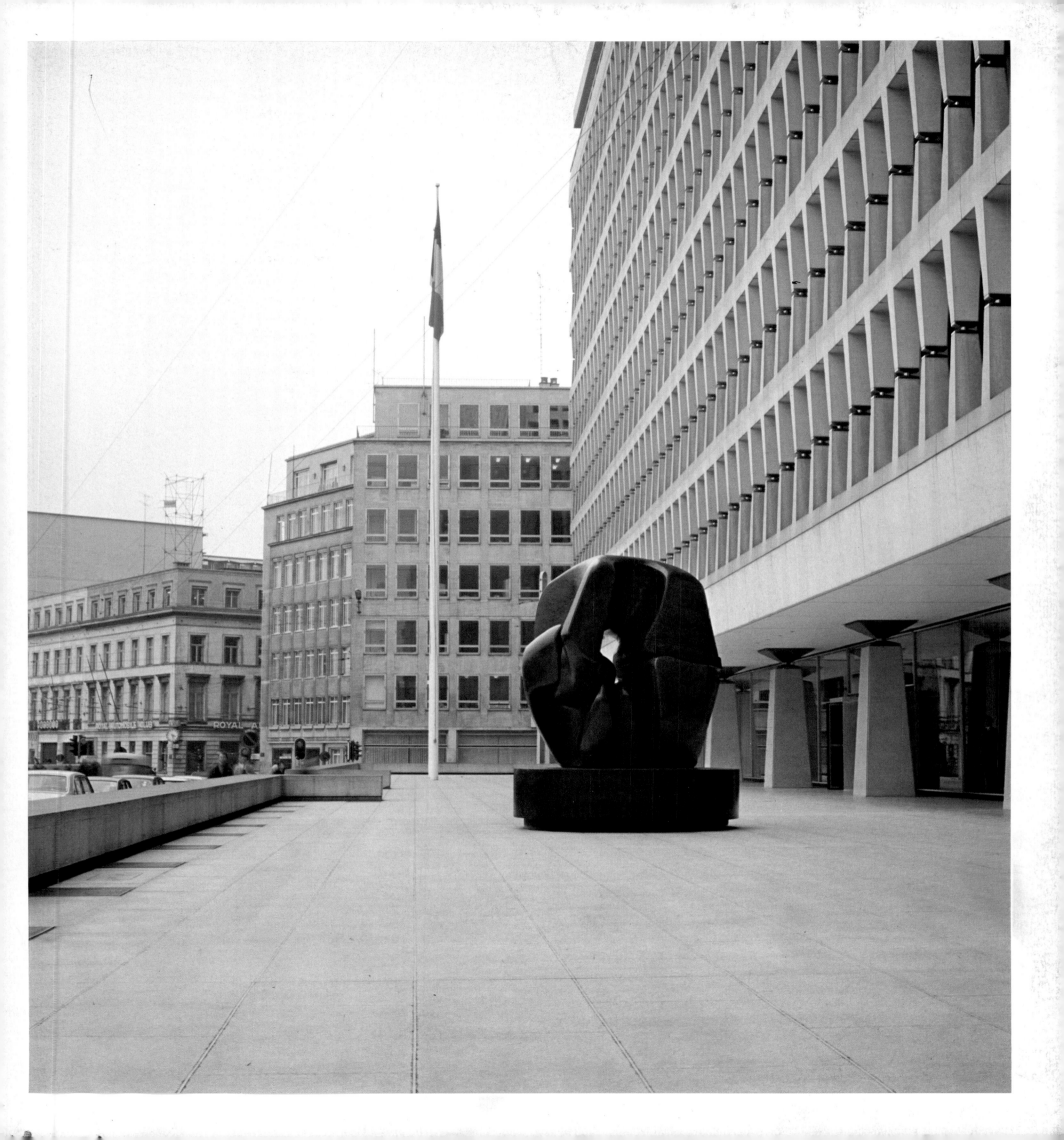

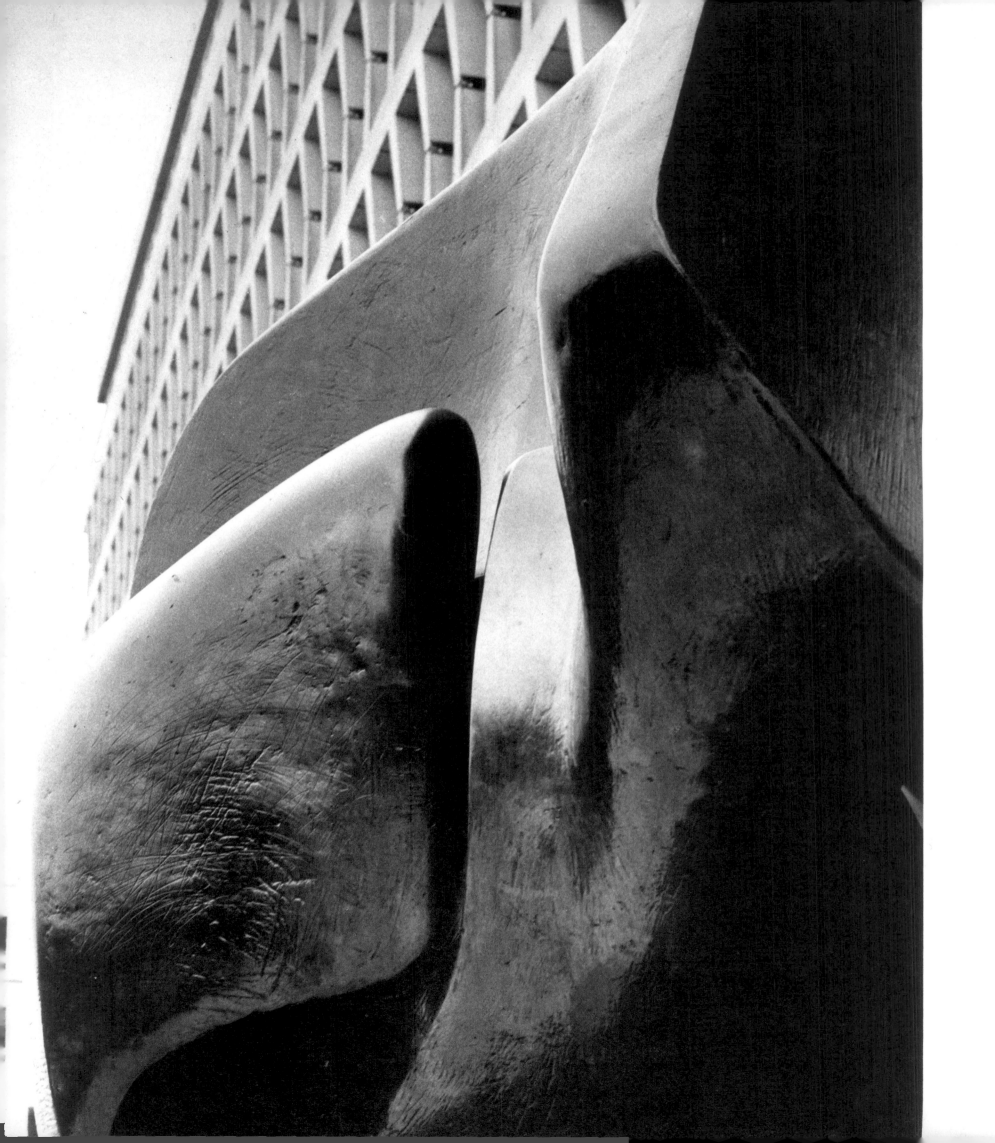

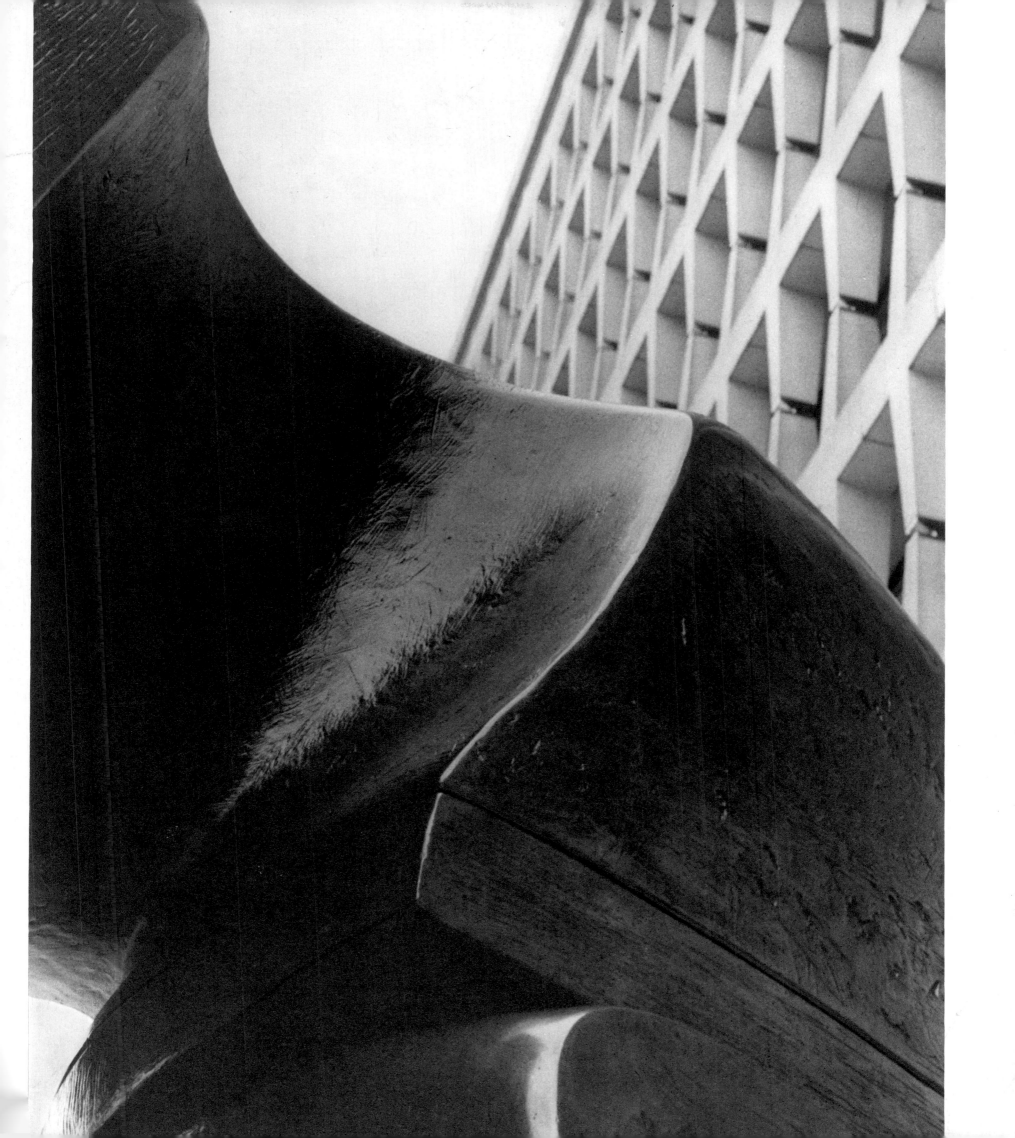

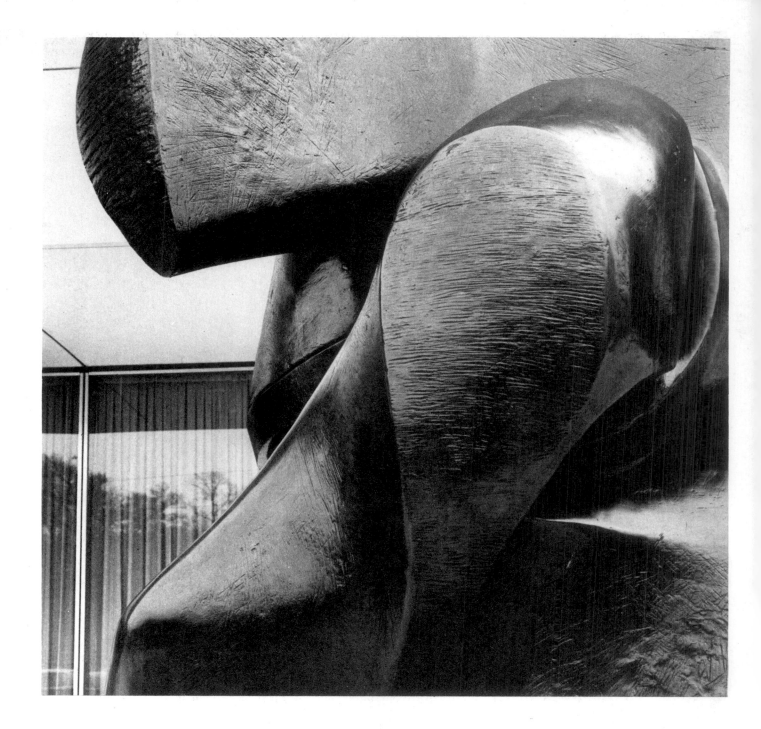

Gordon Bunshaft, the architect, and I chose this site, in the sense that we moved the sculpture a bit one way or another to find its exact position in front of the building.

The locking motif of the sculpture is similar to the locking features of the building's façade, but neither Gordon nor I had that in mind. I dislike the idea of making a work for a particular place and did not do so here. I think you should make something that is right anywhere—and then find a happy place for it.

Perhaps these photographs are not as satisfactory as those of the Locking Piece on The Embankment where the sculpture has more space (see pp. 216–21).

—Henry Moore

DENMARK

TWO-PIECE RECLINING FIGURE 5

1963–64. BRONZE, L. 12'3". LOUISIANA MUSEUM, HUMBLEBAEK, DENMARK

Louisiana is a lovely museum just north of Copenhagen. It has a fine collection of twentieth-century art and a beautiful sculpture garden overlooking the sea that separates Denmark and Sweden. The Moore sculpture is sensitively placed at the edge of a long stretch of lawn with trees at both ends and a bank that slopes into the water on the far side. The figure itself is one of Moore's finest, extraordinarily graceful in the positioning of the crossed legs and in

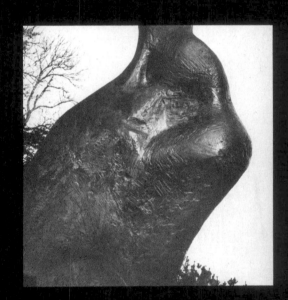

their relationship to the jutting form of the chest and head.

I photographed three casts of this piece—this cast in Denmark, one in Turin, Italy, and one in Recklinghausen, Germany (see pp. 104–7; 152–56). This is by far my favorite of the three settings, and I especially like the placement of this sculpture so close to the ground. This seems just the right height at which to view the vigorous forms against the trees, the sky, and the water.

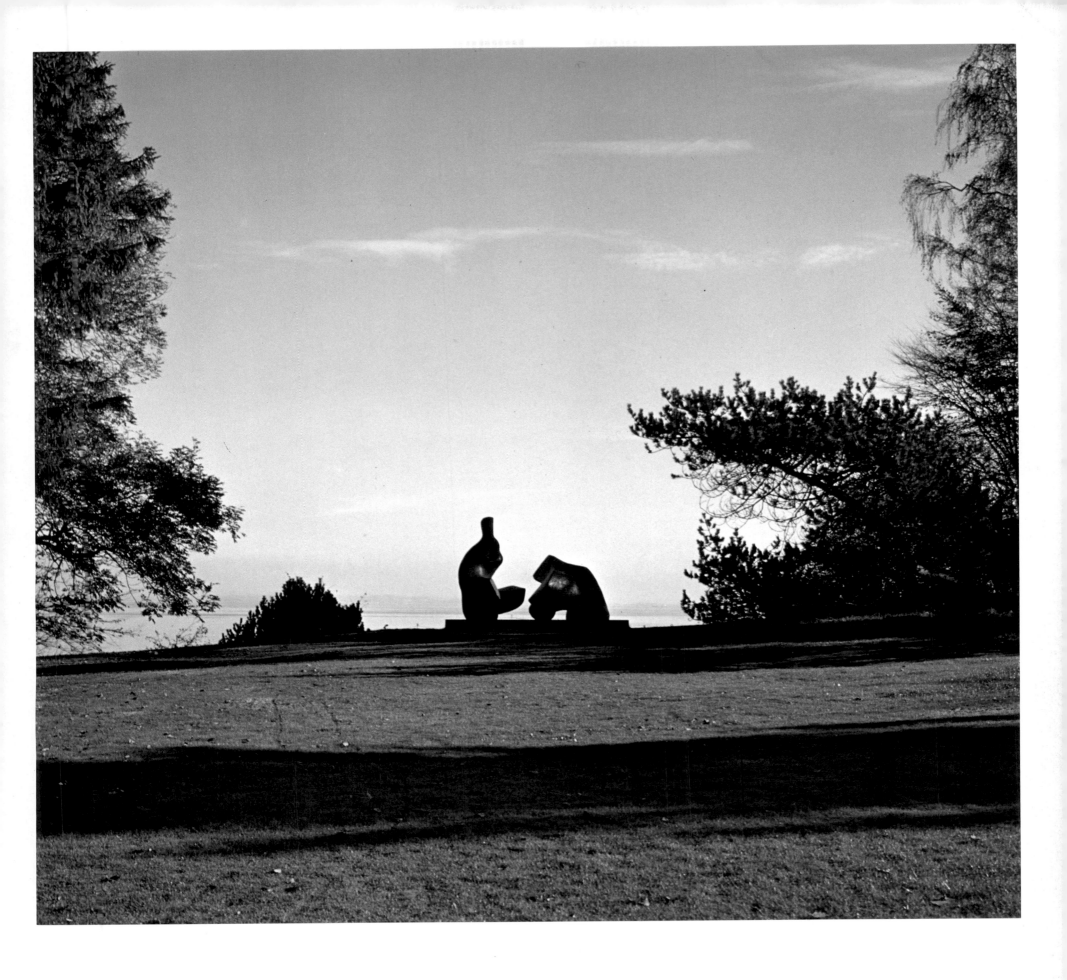

That's beautiful. It is one of the nicest sites I've been given for a sculpture. I was able to choose it myself. We cleared away some of the trees around it so one could see the water behind it. I think there are too many sculptures in that park now, but this figure still looks good there.

—Henry Moore

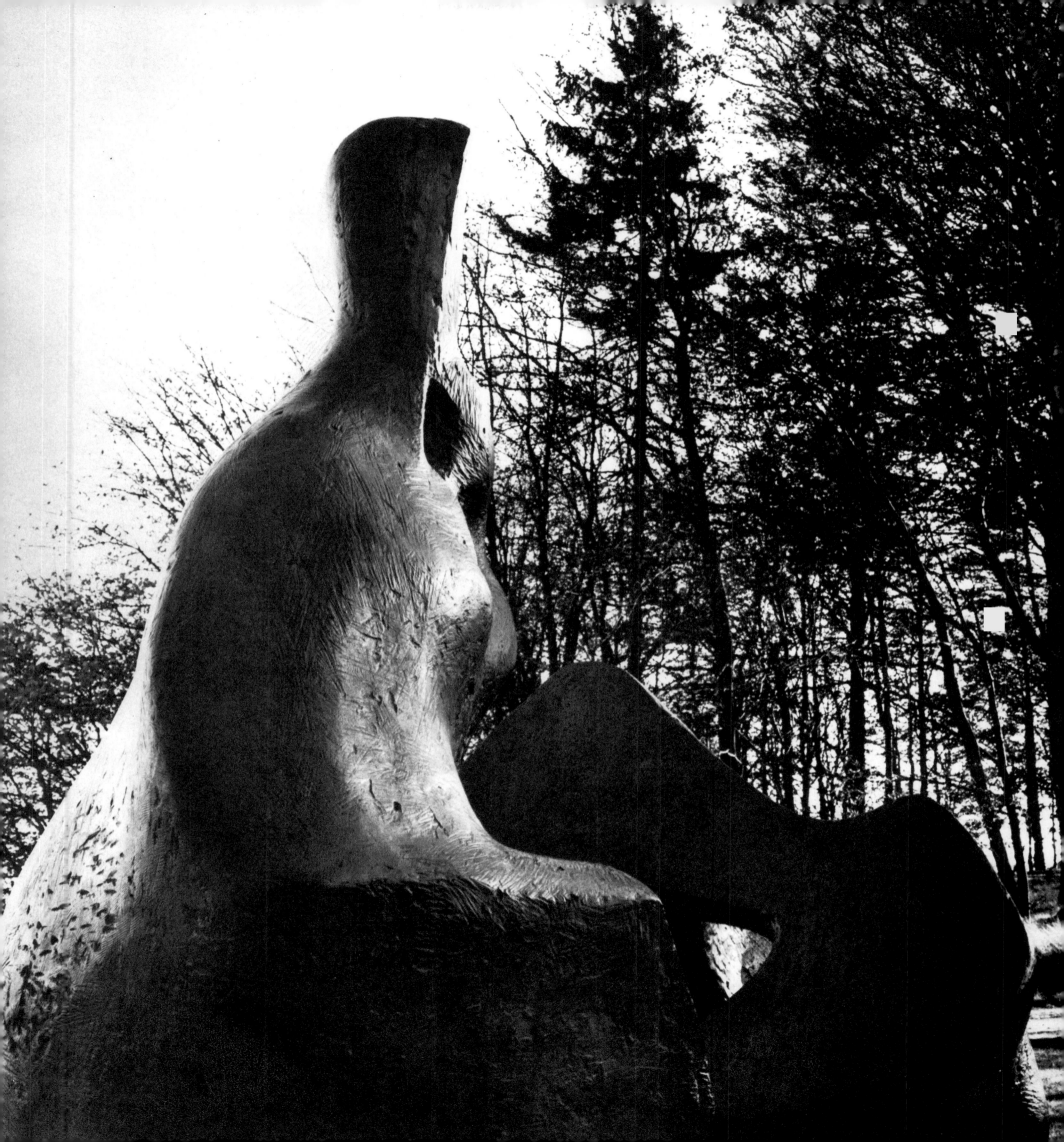

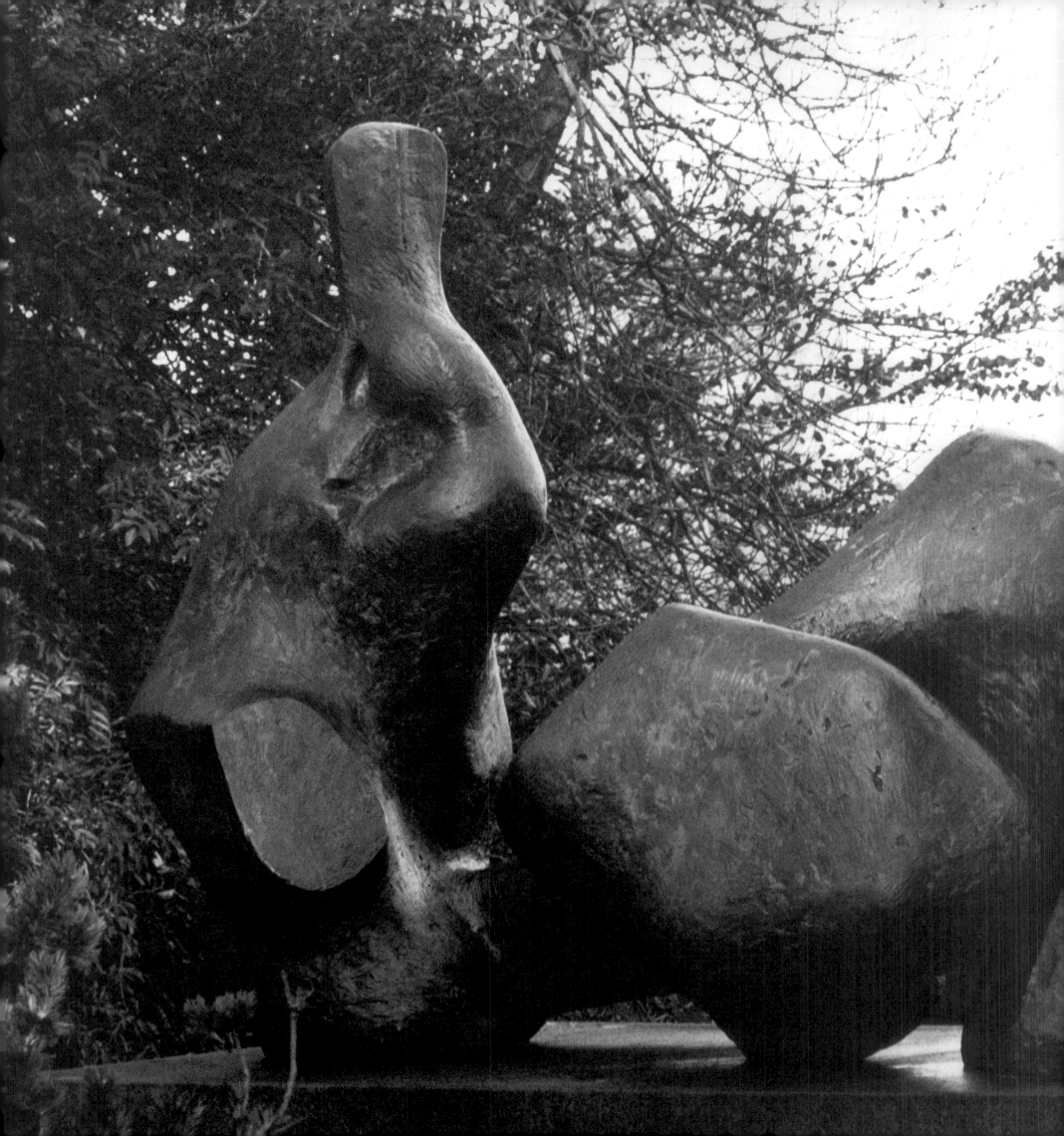

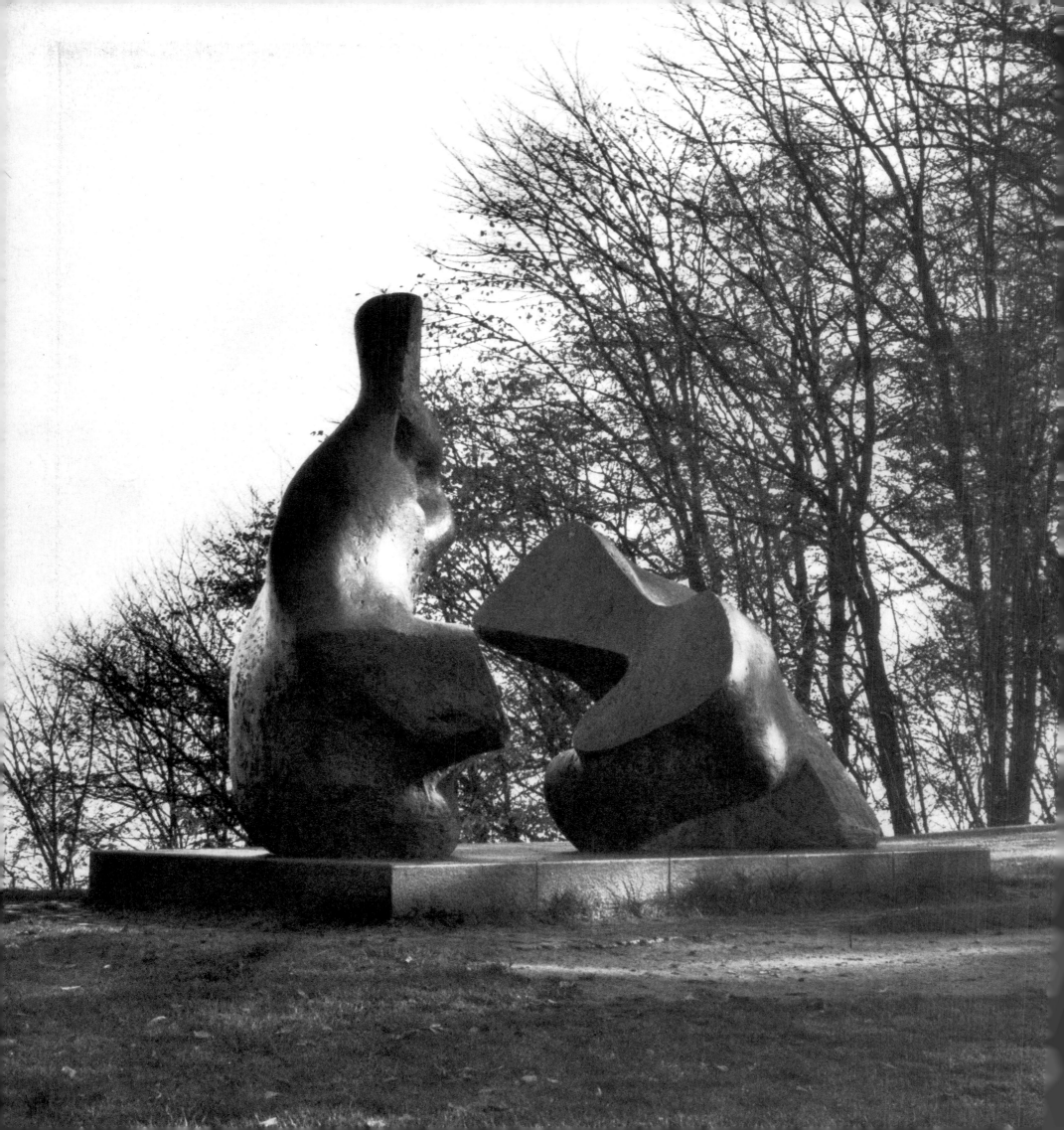

SWEDEN

TWO-PIECE RECLINING FIGURE 3

1961. BRONZE, L. 94". GOTEBORG, SWEDEN

This is the first of three casts of the *Two-Piece Reclining Figure #3* photographed at three different locations (see pp. 246–47; 470–72). This cast, in Goteborg, Sweden, is located in a lovely park, Slottskogen, that is about fifteen minutes by taxi from the center of town. Just outside the park there is a large square, Linne Platsen, with a map that shows the location of the sculpture next to Lilladammer Pond, just a short walk from the park entrance.

The setting is quiet and unpretentious. The sculpture sits on the slope of a small hill and faces the pond, in which ducks swim quietly back and forth. The base is a little too prominent (it probably should be a darker color), and, apparently, little thought was given to siting the sculpture in relation to the surrounding trees. The park itself is so attractive, however, that one can get fine views of the work.

I could not help noticing the resemblance between the piece and the rock formations of Sweden that I had observed from the air as I flew to Goteborg from Copenhagen. As soon as I saw the Moore sculpture —particularly the cliff-like formation at the foot of the piece—I almost felt that it was carved out of local stone. The sculpture seemed an ideal choice for that part of the country.

The director of the museum in Goteborg told me that when the idea of purchasing a Moore sculpture was suggested, a committee was formed to call on the sculptor. He believed that Moore had chosen another site for the work, but that the committee did not go along with his recommendation and picked the present location instead. The director thought Moore might be unhappy about the final decision, but when I showed him the photographs, Moore seemed very pleased.

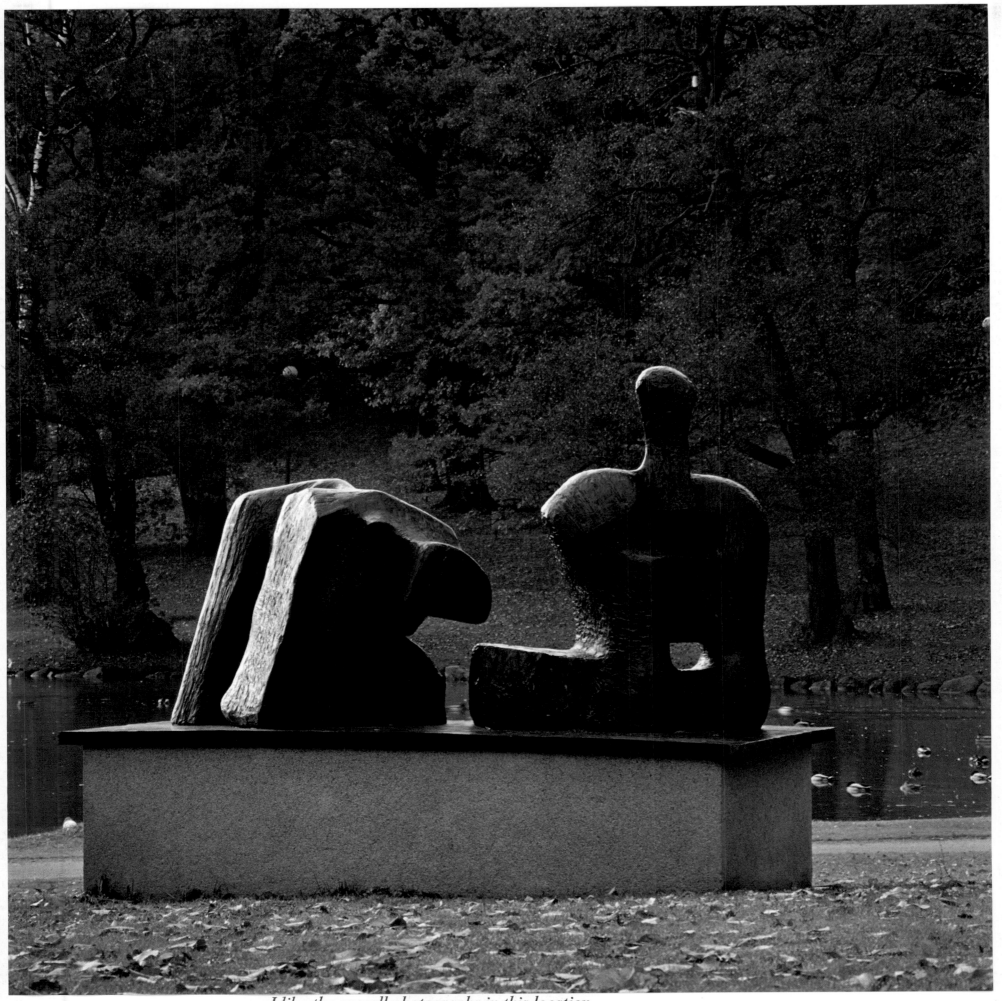

I like the overall photographs in this location.
Some of the details are good too, especially that kind of fan chest.

—Henry Moore

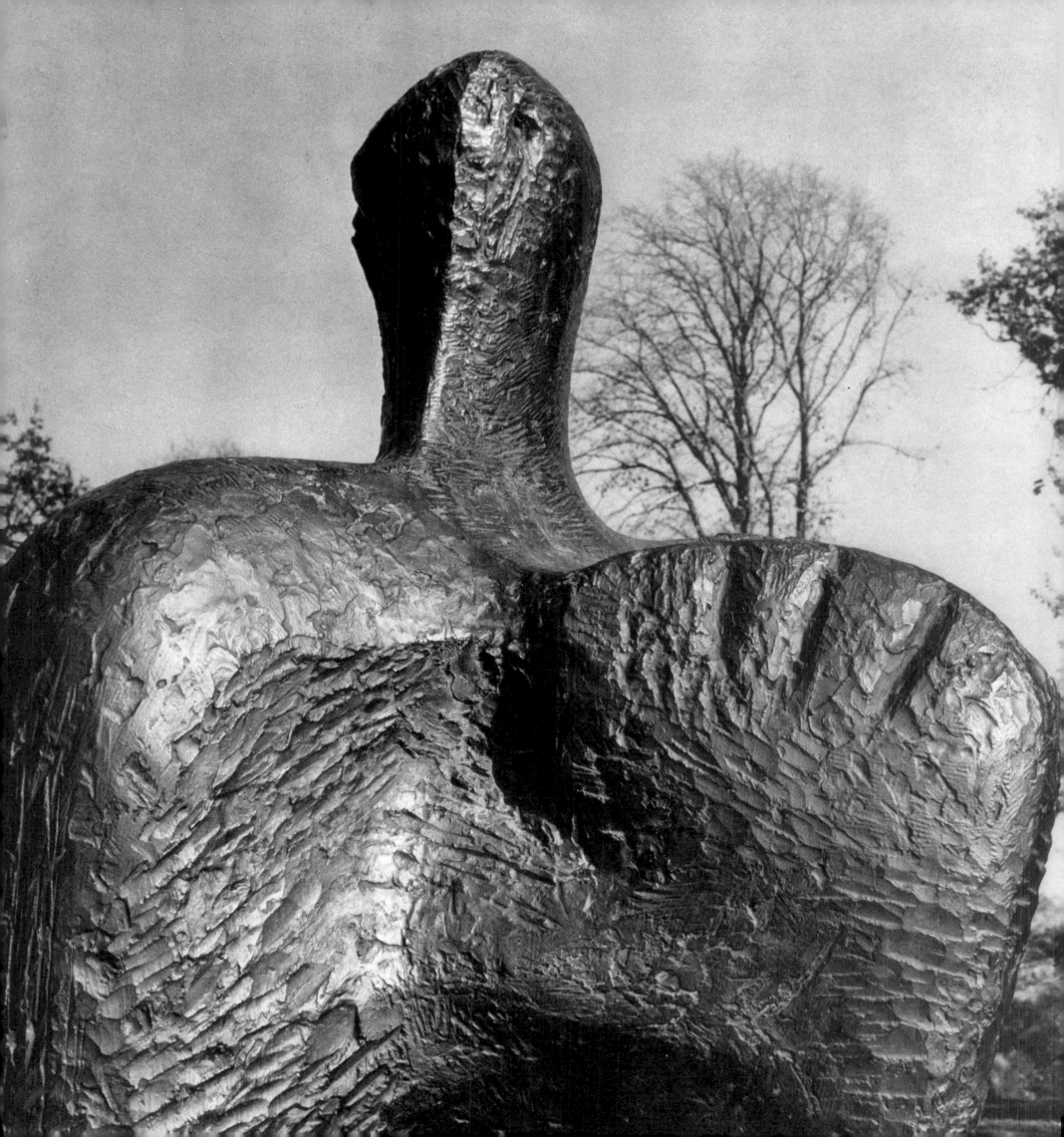

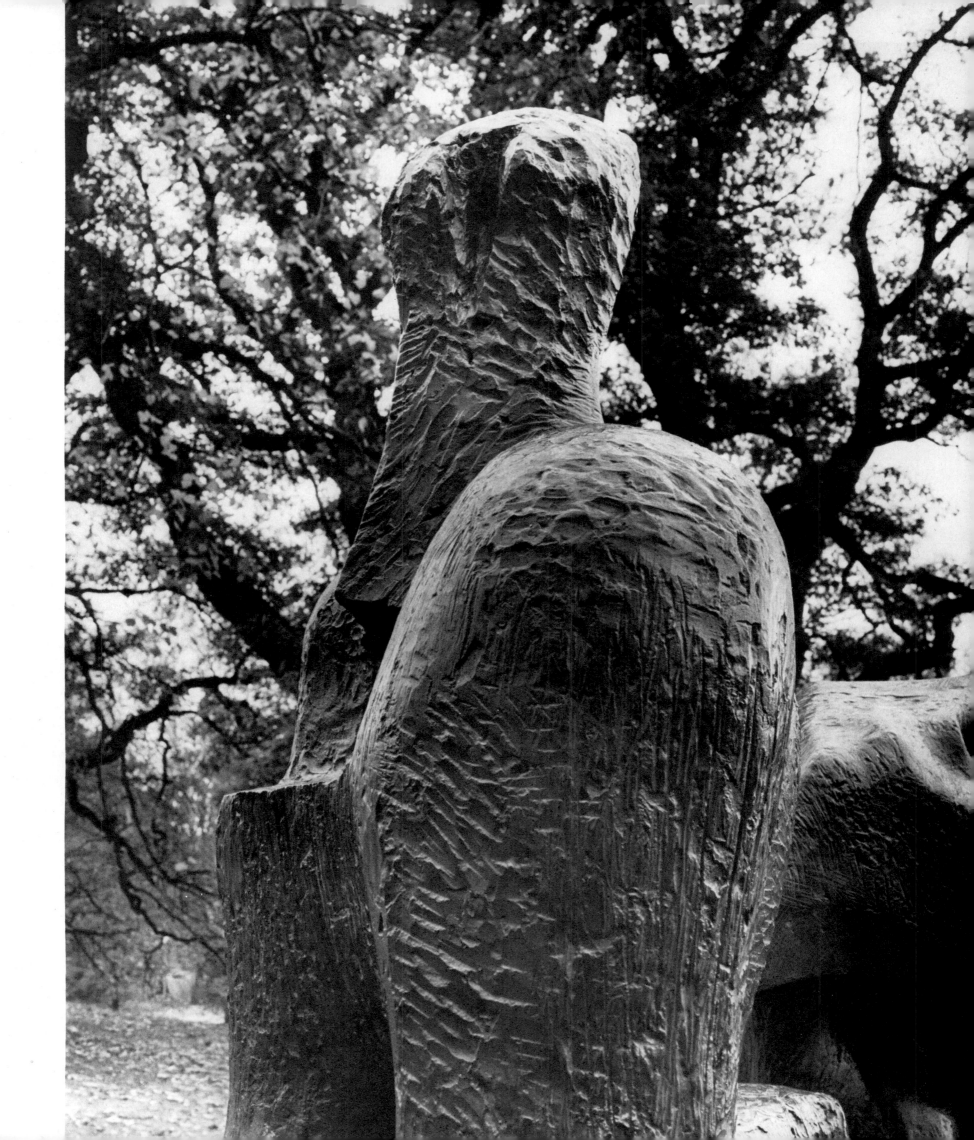

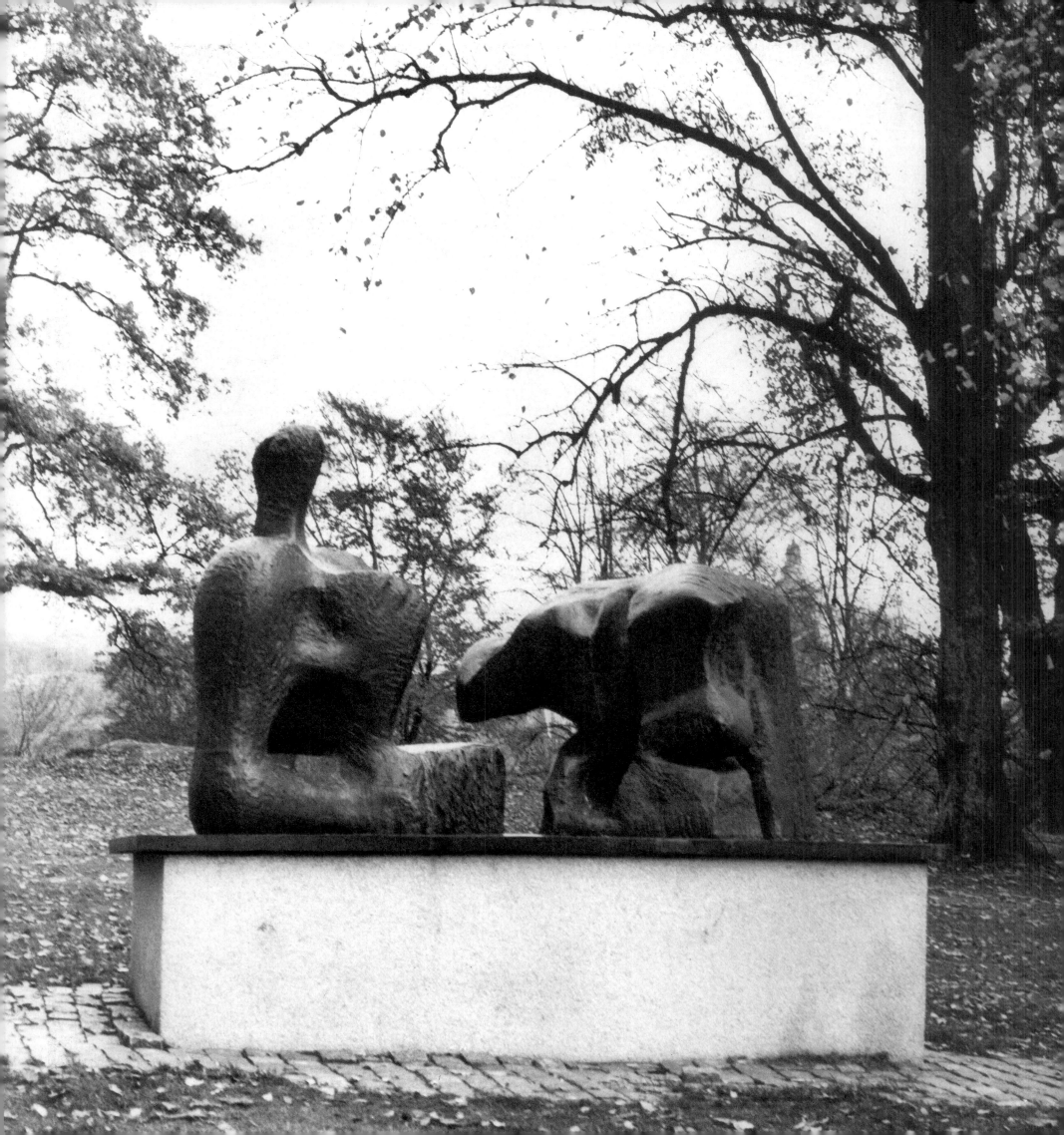

ENGLAND

KNIFE-EDGE: TWO PIECE

1962–65. BRONZE, L. 12′. THE HOUSE OF LORDS, LONDON

Located on a small stretch of green opposite the Houses of Parliament, these two knife-edge forms are a twentieth-century echo of the Gothic buildings in the background. The sculpture is in a highly traveled area (right next to a bus stop), which as Moore has pointed out may not be the best type of setting for a work of art. People are often too busy going about their business to notice the work as they pass by. But if they do take the time to look at it and to examine the interaction between one of Moore's most elegant works and the beautiful architecture of the House of Lords, they will enjoy a rewarding experience.

A policeman on duty chided me when I stopped to take photographs of *Knife-edge: Two Piece*. First he was annoyed that I was walking on the grass, which I had to do in order to get close-up shots. When I explained

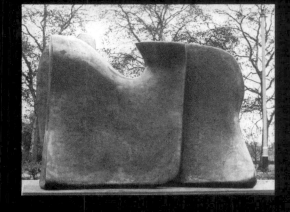

that I was taking these photographs for a book, he scornfully assured me that that a waste of time. "You have to admit it's just a pile of junk," he insisted. "If peopl didn't know it was by someone called He Moore, they wouldn't even bother to stop and look at it." I said that if we had the time, I was sure I could show him what w beautiful about the sculpture. "Not in a million years," he replied. He was very kind, however, as I lingered for over an hour, discovering all the amazing shapes and around the piece. This is certainly no an ideal site in terms of traffic (I had to w many minutes to get a shot without buses idling in the background), but one can get stunning views by relating the strong, curv shapes to the grand architecture in the distance.

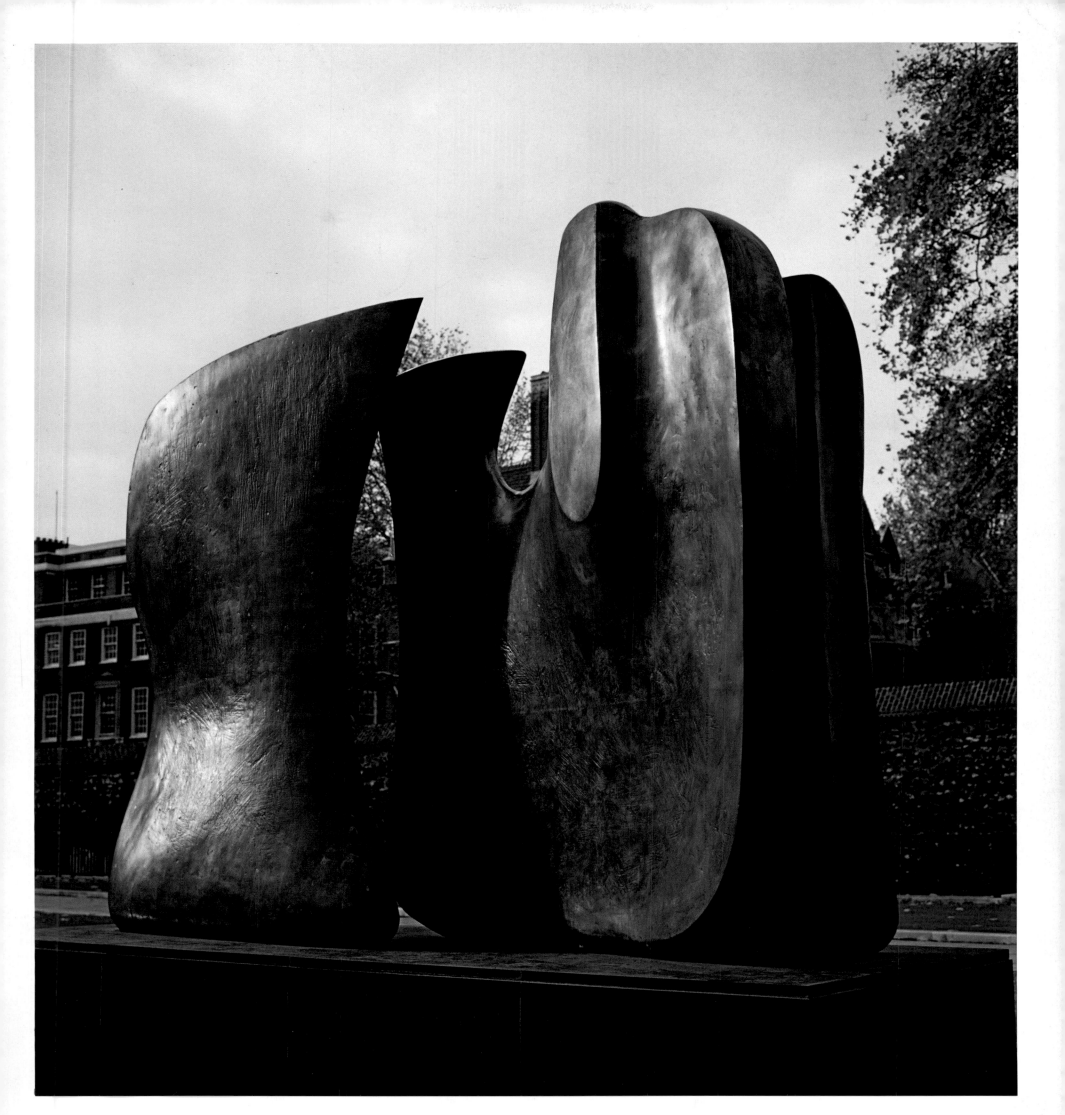

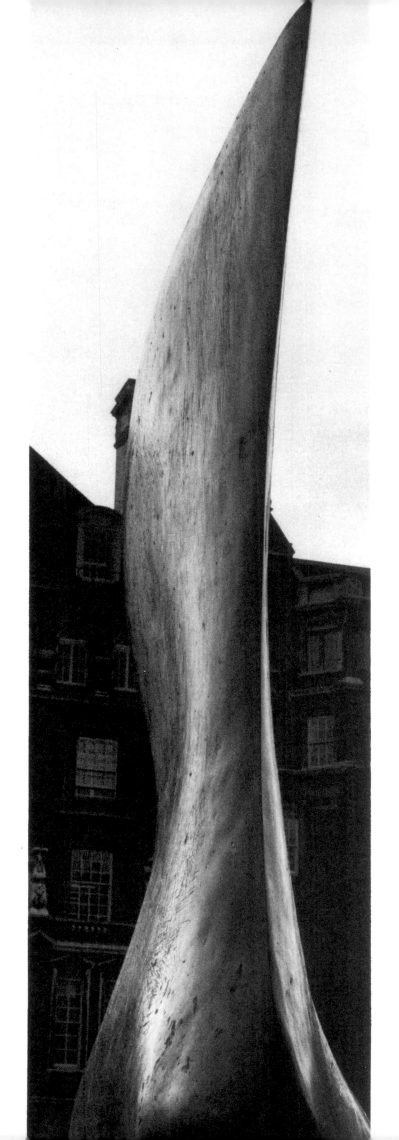

There were two sites considered for this sculpture. Neither site was my ideal. One was in Hyde Park, beside the road on Park Lane, and the other one was in front of the Houses of Parliament. I chose the Houses of Parliament. I like the view of the sculpture with the House of Lords in the background.

I think there are some good photographs of details here, especially the one that is like a question mark, with the forms bent over—also the photograph in which the spaces between the two forms are shown.

—Henry Moore

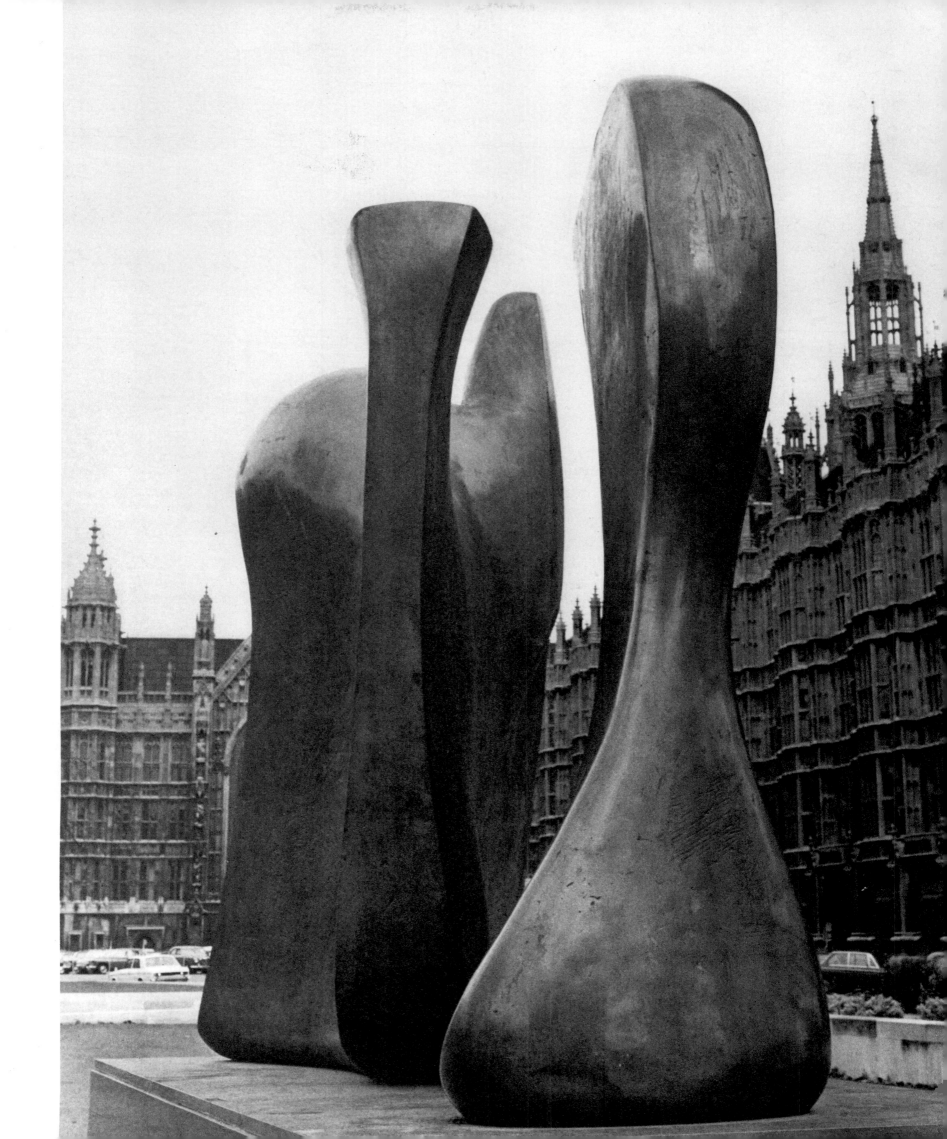

214

LOCKING PIECE

1963–64. BRONZE, H. 9'7 1/2". TATE GALLERY, THE EMBANKMENT, LONDON

This is one of four casts of the same work illustrated in this book. These include two large casts, those in London and in Brussels (see pp. 190–94), and two smaller versions, one in Duisburg, Germany, and one in Purchase, New York (see pp. 144–47; 364–67).

This cast of the *Locking Piece* is located in a specially designed setting on the bank of the river Thames, not far from the Tate Gallery. The sculpture is on a high pedestal, which makes it possible to see the piece against the sky and skyline. Furthermore, there are different levels in the area surrounding the sculpture, enabling one to see the work from a great variety of angles. It is a successful placement in other ways as well: children like to play around the sculpture, and it has become a favorite place in the neighborhood to sit and enjoy the general view.

There are some disadvantages to the setting. A fountain in the area is unfortunate in that it doesn't relate to the sculpture. It is also a pity that the street has such heavy traffic.

I've photographed *Locking Piece* on The Embankment many times, returning again and again to see how the many fascinating planes and shapes look at different times of the day and under changing skies. I like the work best in bright sunlight when the bright gold patina glistens so beautifully and one can see the fine dark lines of the textured areas most clearly. It is almost unbelievable to see how many different shapes one can discover as one moves around the sculpture.

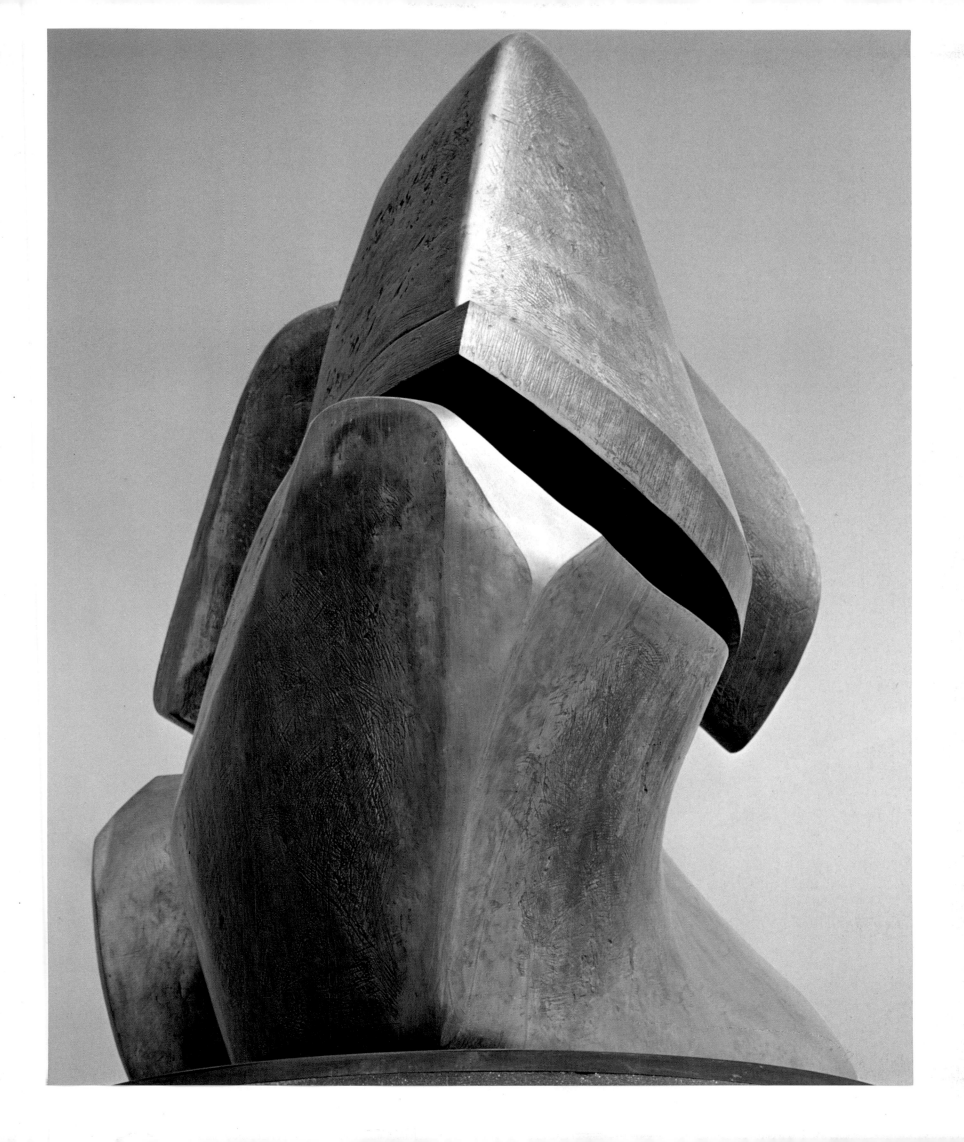

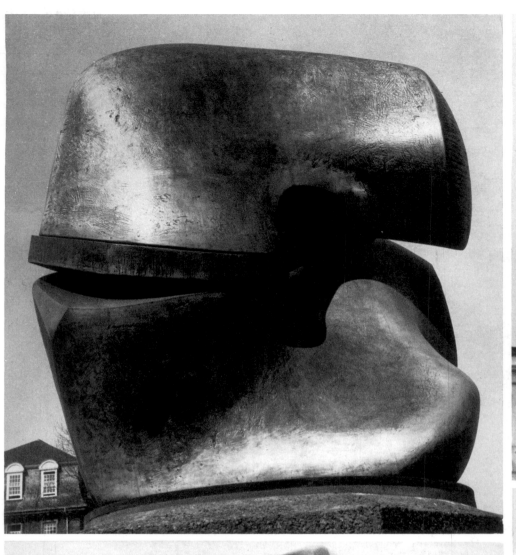 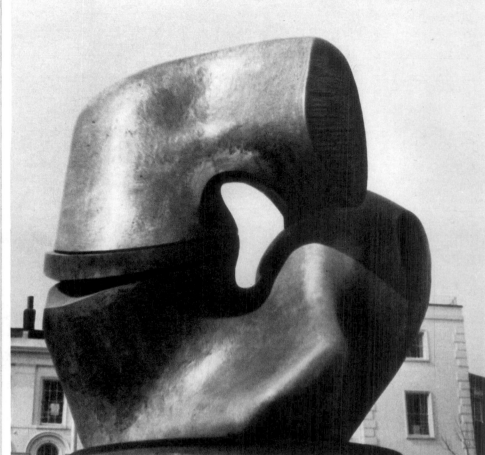

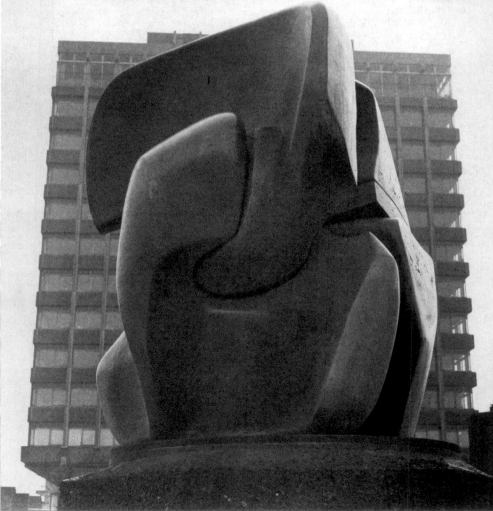 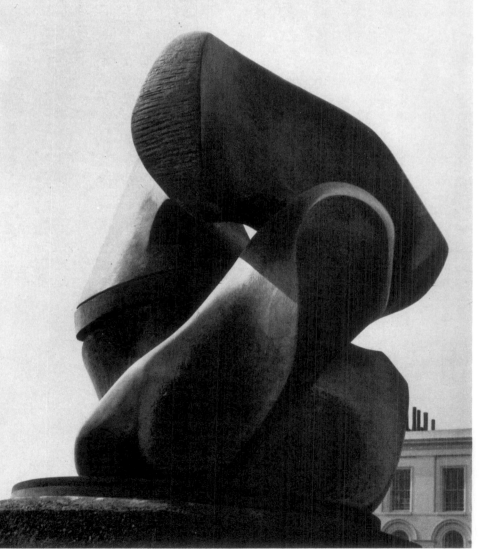

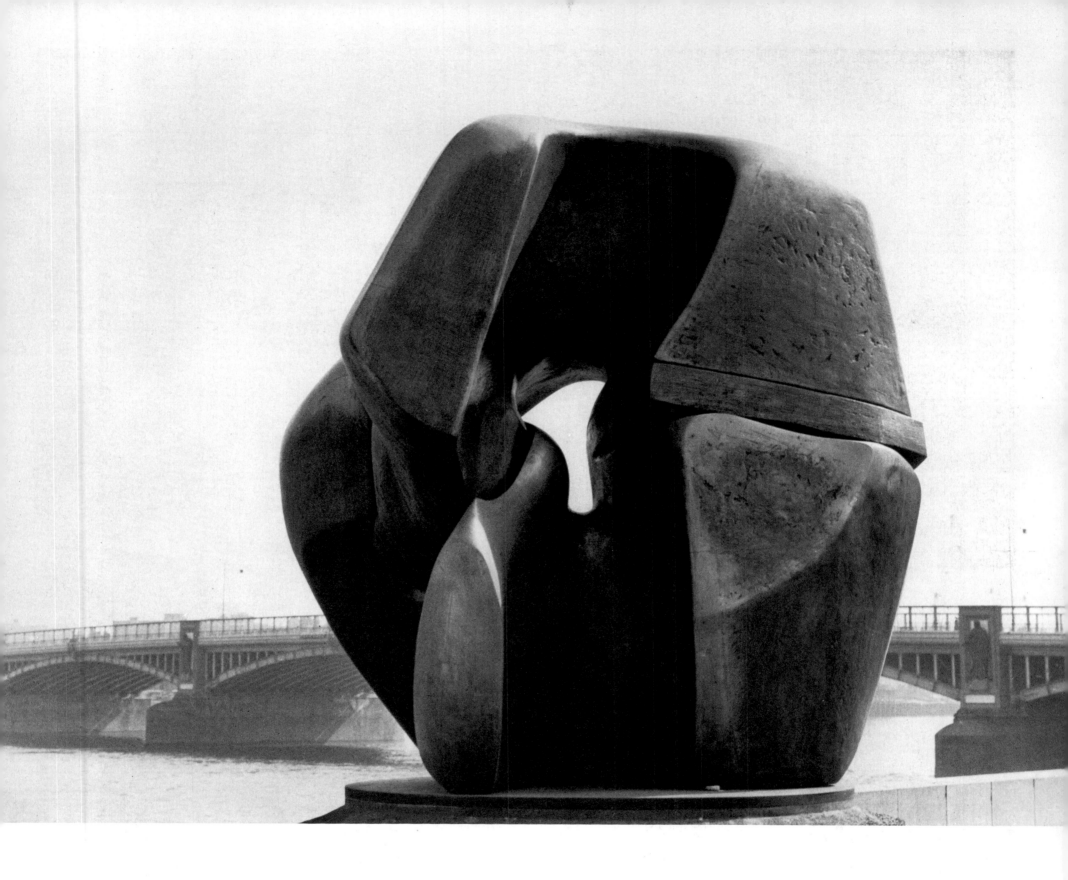

*The location isn't bad, but I don't like the idea of the fountain—
nor that great big thing the sculpture is standing on, its pedestal.
It is too powerful for the sculpture; it knocks strength out of the
sculpture. When the building was in progress, the architect asked
if I would lend a piece of sculpture for placement on The
Embankment. This may not be the sculpture's permanent site, as it
will eventually be given to the Tate Gallery. It might remain in a
public place, agreed upon by the Tate Gallery.*

*I like the different photographs of the whole work. They show
a kind of twisted knot. The sculpture is called* Locking Piece. *When
I made it, I was reminded of puzzles I played with as a child in
which there were pieces that fitted together but were more difficult
to take apart. To make two parts fit you had to put them together
in a certain way and then turn them so they would lock. That is
why it is called* Locking Piece.

*You see different shapes as you go around the sculpture. This
is the result of trying to make a sculpture have a lot of variety
even though it has the same unity throughout.*

*Unity in a work is easily achieved if all the forms are
repetitious and the same. Also, it is easy to create variety if all
the forms are consciously different. What is difficult is unity with
variety.*

—Henry Moore

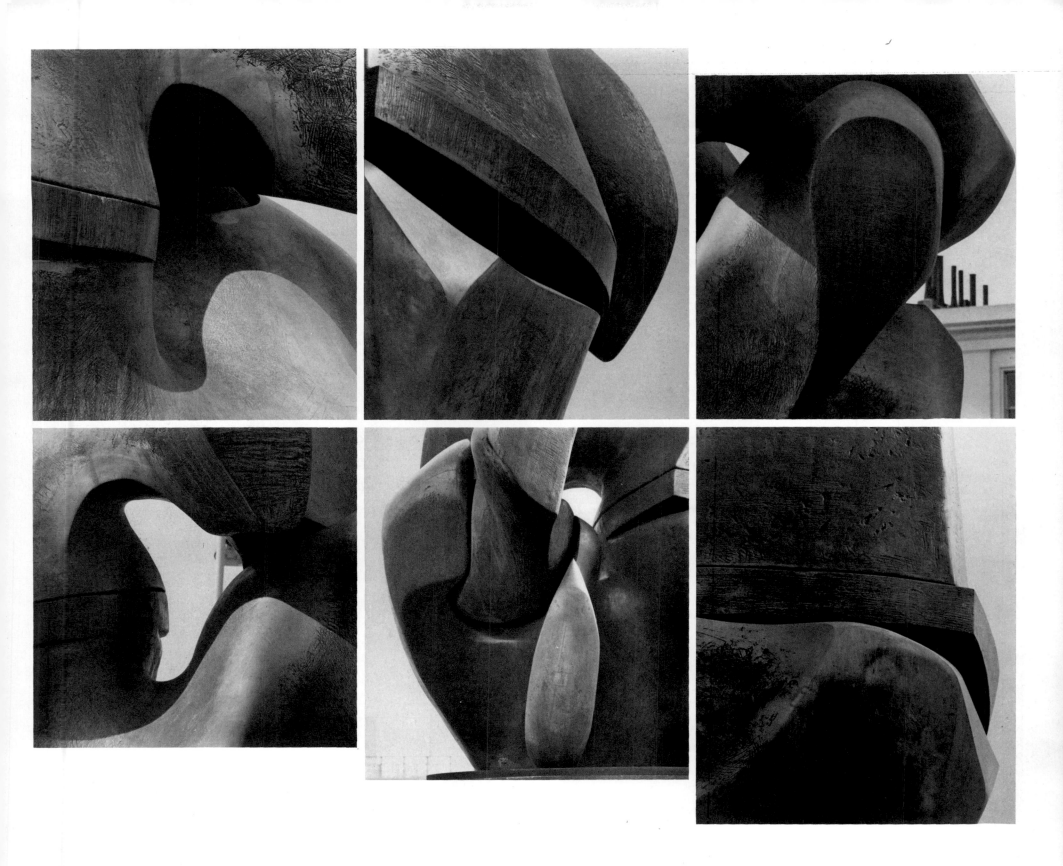

TIME/LIFE SCREEN

1952–53. PORTLAND STONE, 10′ × 26′6″. TIME/LIFE BUILDING, LONDON

Located above street level on top of the Time/Life Building, these four relief sculptures face outward on the narrow Old Bond Street. Even those Londoners who work in the neighborhood, or who frequently walk down what is certainly one of the most popular streets in the West End, are probably not aware that a major work by Moore has been in this spot for years. Yet this is one of Moore's earliest monumental sculptures and one of the very few works that he created for a specific location.

For years I was one of those who walked down Old Bond Street without realizing there was a Henry Moore above me. I did not see the piece until, having learned that one of his sculptures was on the Time/Life Building, I went there specifically to find it. People stopped as I set up my tripod and long lens to photograph the figures from directly below and from across the street, and I was amused at their perplexity as they followed the angle

of my camera and noticed for the first time that there was a work of sculpture on top of the building.

Moore thinks that the work can be seen best when there is sunlight on the piece, but because the street is so narrow, there is only a short time when this is possible (in winter, 9–9:30 A.M.; somewhat longer in summer). Also, during part of that time an unfortunate vertical sign to the left of the work throws a shadow over it. I was particularly anxious to photograph the piece from the front and the back (which can be seen from a rooftop terrace on the Time/Life Building), and the photographs on these pages show each relief from both sides.

The work has many of Moore's early motifs and, as I think can be seen from some of these photographs, the individual sculptures reveal an extraordinary strength. In another location, and properly maintained, this piece would stand up well against Moore's other major works.

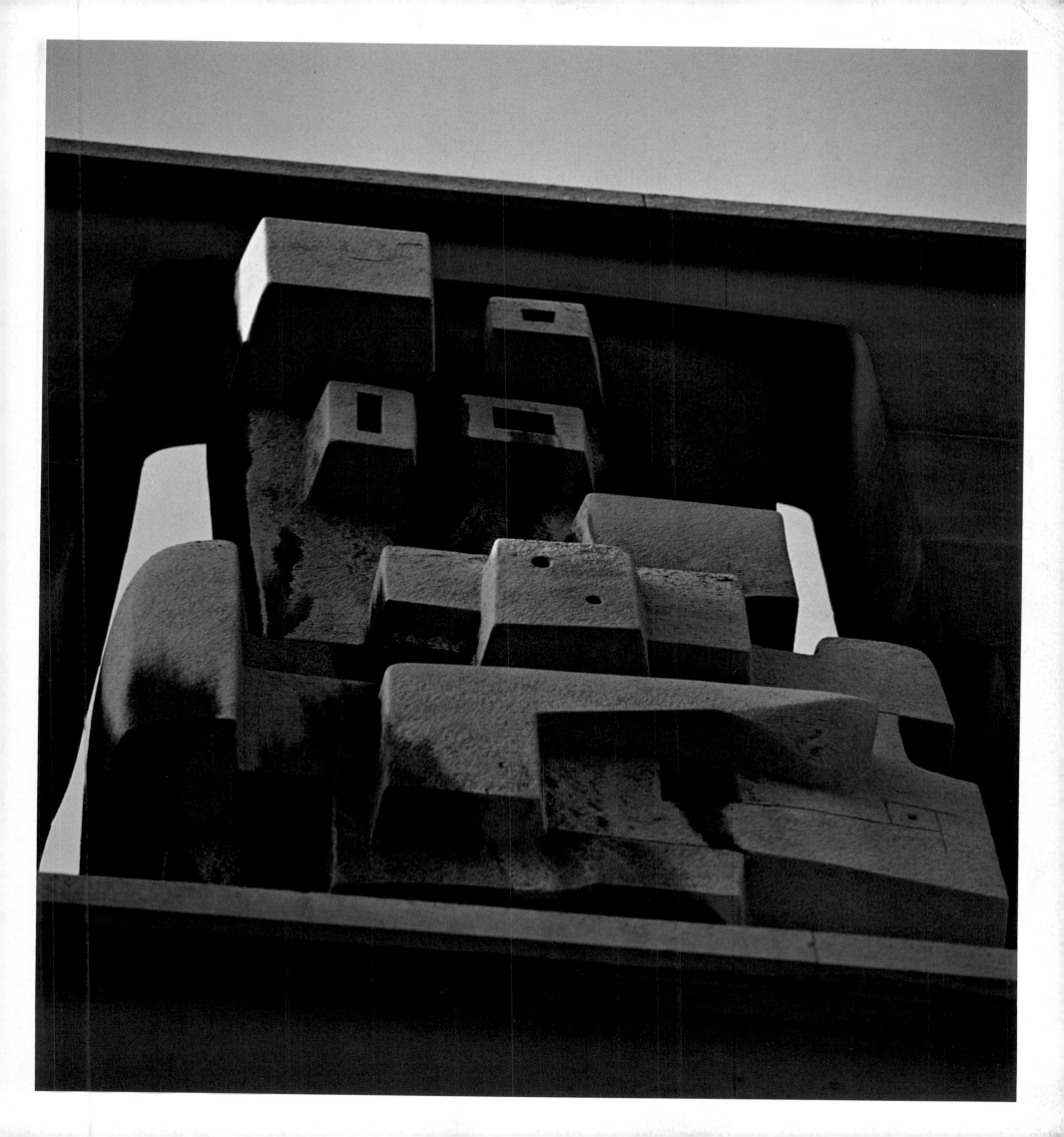

The photographs give a wonderful coverage of the sculptures and could almost make a book on their own. Some of them have sunlight on them, and I like that.

The story behind this particular sculpture is a long one. The architect of the building told me that he was having a problem with a sculpture that he wanted for this building. He had asked four or five sculptors to produce ideas for it, and he wondered if I would look at their drawings and models and tell him which I thought was the best. I didn't think any of them was especially good.

The sculpture was to be part of a retaining wall behind which there would be a small roof terrace. Most of the sculptors had treated the area as a solid wall with part of the real building behind it. They had done things such as a relief along the wall of a speeding Mercury carrying the news (the building houses the offices of Time/Life). My thought was that the wall should be pierced in places to show that there was nothing behind it. The architect asked me to show him what I meant. That weekend in my studio I played with the idea and made some small maquettes with sculptures in open alcoves, as it were, but fitted so that each could be turned to be seen at different angles—full views, three-quarter views, side views, and so on.

They might be turned on the first of every month. This would become an event in the Time/Life offices. And it would show that the sculptures were meant to be seen from all around. The architect then asked me to do the sculptures myself.

When it came to the practical problem of making the sculptures turn, the architect couldn't satisfy the official safety regulations. Some of these blocks were eight or nine feet high and weighed ten to fifteen tons. If they were to turn, they could have only one pivot. In fifty years' time, fixings could deteriorate, and the blocks might fall on the street. This was too much of a risk to take. The idea was good but not practical.

So the sculptures do not turn, and this takes away to some degree the pleasure I derived from the original idea.

As it developed, I also realize the sculptures were placed in too narrow a street, where nobody looks above the ground level. So in a way they're wasted. I wish I had retained them for myself and put them up as I wanted them, to be seen from all around. And I would rather have them seen at ground level.

I think that every sculpture should be interesting from a worm's-eye view, a bird's-eye view, a man's-eye view—and from every angle.

—Henry Moore

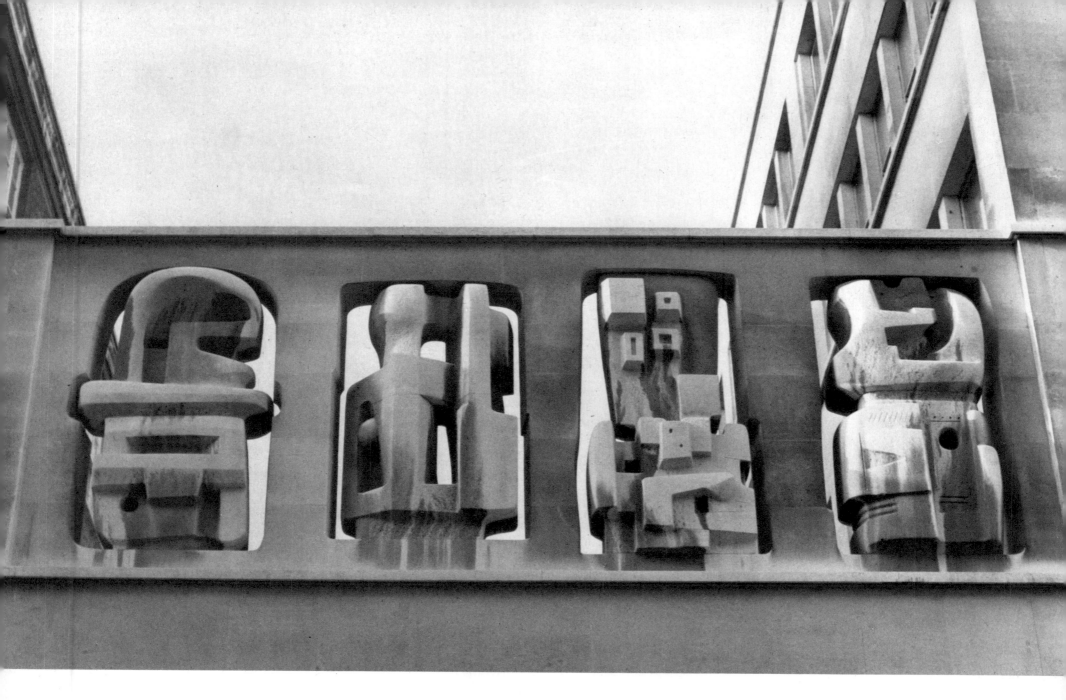

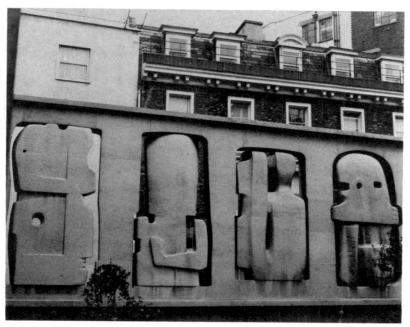

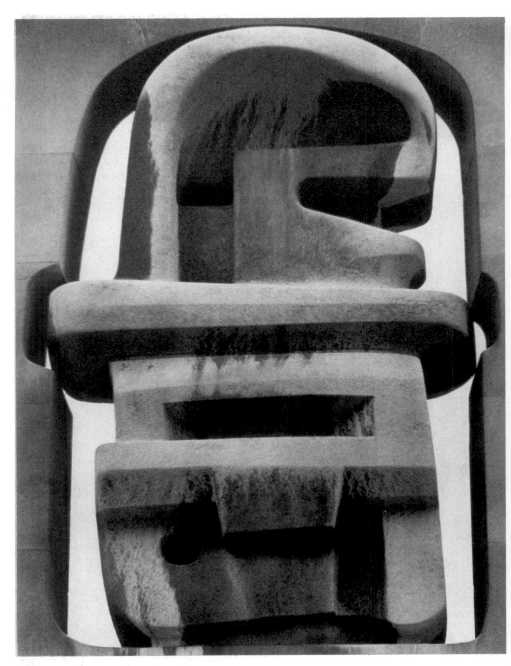

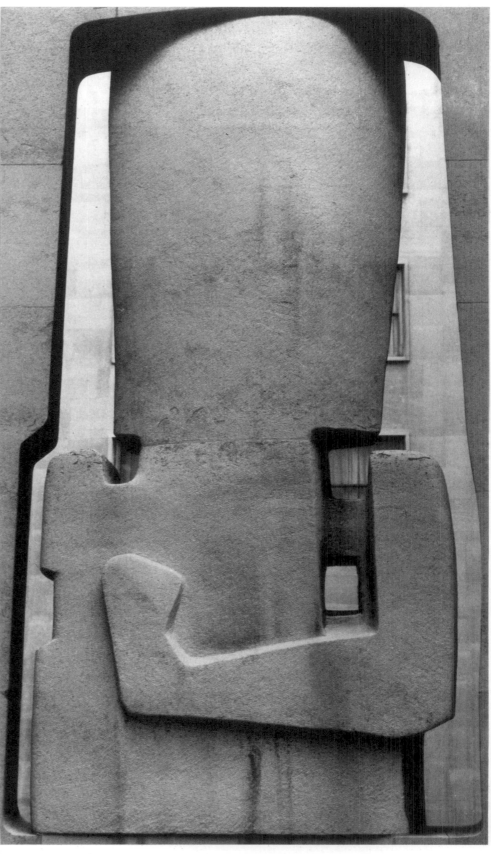

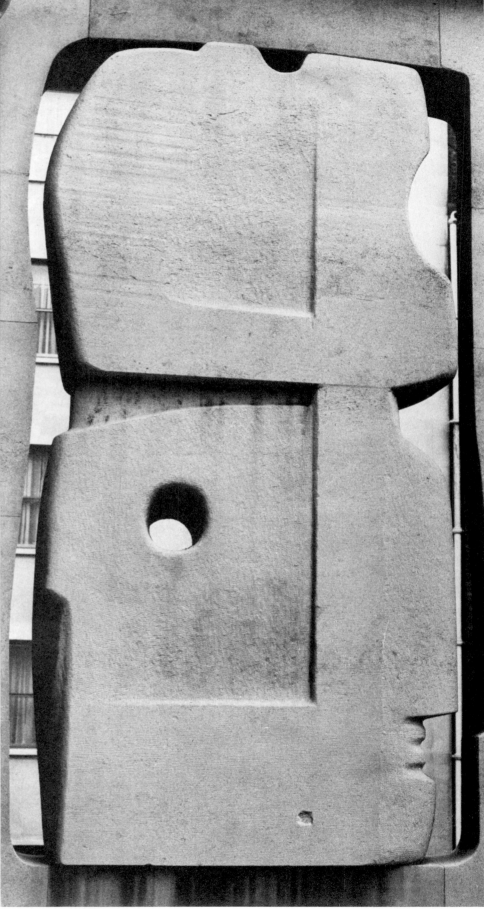

DRAPED RECLINING FIGURE

1952–53. BRONZE, L. 62". TIME/LIFE BUILDING, LONDON

Behind the Time/Life Screen (see pp. 222–29) there is a terrace open to the public that can be reached through the lobby of the building. The terrace—a handsomely designed area with an interesting combination of wood textures, stonework, glass windows, trellises, and greenery—is the only position from which the back of the screen sculptures can be seen. A welcome, quiet haven, it is just a stone's throw from busy Old Bond Street.

I have visited the Time/Life terrace many times because I find it so attractive, and I have always considered the placement of the

Draped Reclining Figure, with its rather unusual and well-proportioned pedestal, most attractive. I do, of course, recognize the problems referred to by Moore, such as the various lines in the background that cut into the work, but if one is going to have a sculpture in a city environment, this is one of the loveliest settings I have seen. The piece is a particularly graceful one (I have always admired the cast of this piece that Moore has on his grounds in Much Hadham, England), and I feel that in this location one has a sense of intimacy with the work and can view its details easily and fully.

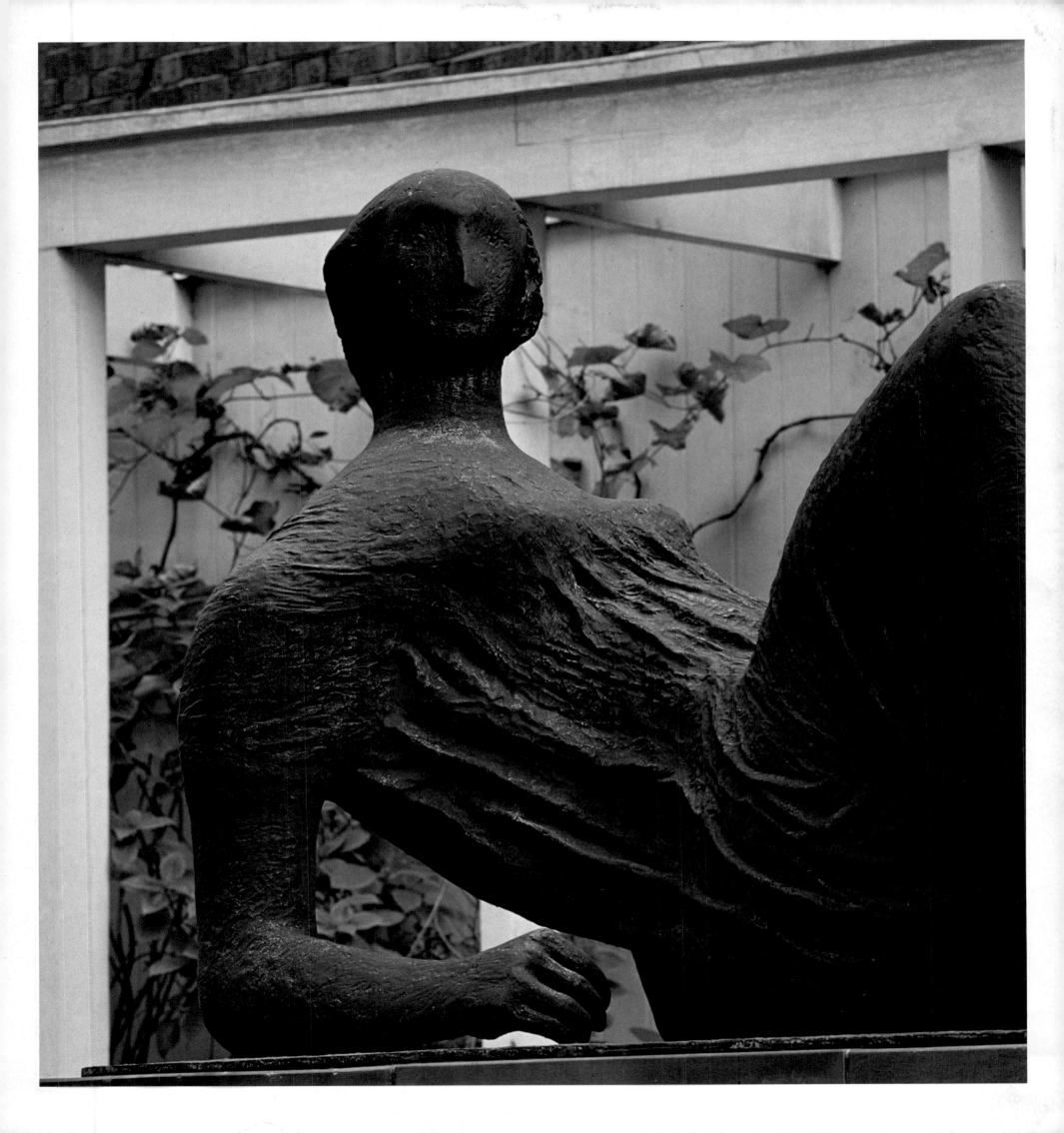

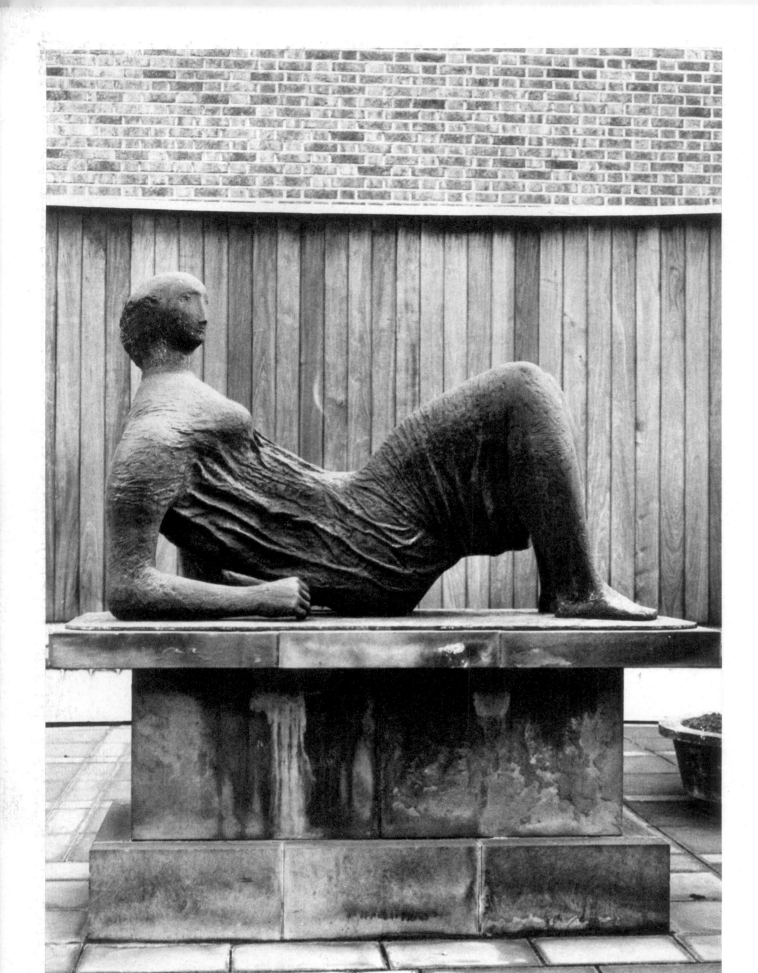

This sculpture was done at the same time as the Time/Life Screen (see pp. 222–29), but it wasn't done especially for there. It was just one of my Reclining Figures, and the architect acquired it for the terrace.

The location of the sculpture on the terrace is all right, but I feel there is too much distraction in the background. That's what I often dislike about architectural backgrounds, and why generally I would rather have my sculptures in nature. Sky, trees, grass, hills, and water are the best settings for my sculptures. With architectural backgrounds there's always a likelihood of horizontal or vertical lines cutting awkwardly across the figure.

—Henry Moore

THREE STANDING FIGURES

1947–48. DARLEY DALE STONE, H. 84″. BATTERSEA PARK, LONDON

Battersea Park is a short distance from the West End of London, and it is a lovely place to stroll. *Three Standing Figures* overlooks a quiet pond near one of the walkways in the park. It is not likely that people visit this section of the park to see the sculpture, for there is no way of knowing that it is there—one simply comes upon it while walking through the area. When I first saw the sculpture in this beautiful location, I was deeply affected by its haunting gracefulness.

The slope of the ground and the surrounding trees work beautifully to set off the figures, and I found both the overall views and the details most satisfying to photograph. For some reason Moore's name is carved in oversize letters on the pedestal, and I had to be careful to avoid showing them in some of the views. But I found the forms flowing within and around the sculpture, particularly the spaces between the figures, especially fascinating.

This sculpture was shown in the first big international outdoor sculpture exhibition in Battersea Park, London. This was the parent of all the outdoor sculpture parks which have grown up since—Kröller-Müller, Middelheim, and all the rest. I think the idea for the exhibition came from Mrs. Pat Strauss, then an influential member of the London County Council. She and her husband, Russell Strauss, the Labor M.P., were collectors (they have two small sculptures of mine). She got the L.C.C. to use Battersea Park for this exhibition. The Arts Council was asked to organize it. I was a member of the Arts Council at the time and was asked to help set up the exhibition. I welcomed the idea because I have always believed that, whereas painting is mainly an indoor art, sculpture, in its great periods, has been an art of the open air.

Since my early sculpture days I've liked working in the open air, and from 1930 until the present time my larger sculptures were thought of and worked upon out-of-doors, not in the constricted space and directional light of a studio. . . . And so, though one or two other sculptors helped with the installation, the placing and setting up of the exhibition became my project, and it was mainly I who put up the Battersea Park exhibition. I enjoyed it enormously and learned a lot.

It was some years after Battersea Park that the mayor of Antwerp started Middelheim Park as an open-air sculpture museum. Later, the Kröller-Müller began to exhibit sculptures out-of-doors, and the sculpture-park idea spread throughout the world. I therefore think that the first Battersea Park open-air sculpture exhibition was a very important event. I did not do the Three Standing Figures *for Battersea Park, but I was finishing the sculpture at the time, and I knew that it would be shown in the exhibition. At the end of the exhibition it was suggested that the sculpture should remain permanently in the park.*

I think it is now in a lovely spot. I put it there between those two big trees and on a slight rise. You see it from a little bit below when you approach it. Sculptures that can be seen against the sky often have a more monumental look—one reason why I chose that position.

This sculpture was to some extent influenced by the experience of the war. It is as though the three women are standing there, expecting something to happen from the sky. . . . Maybe this wasn't done consciously. You don't always do things consciously. I don't anyhow.

—Henry Moore

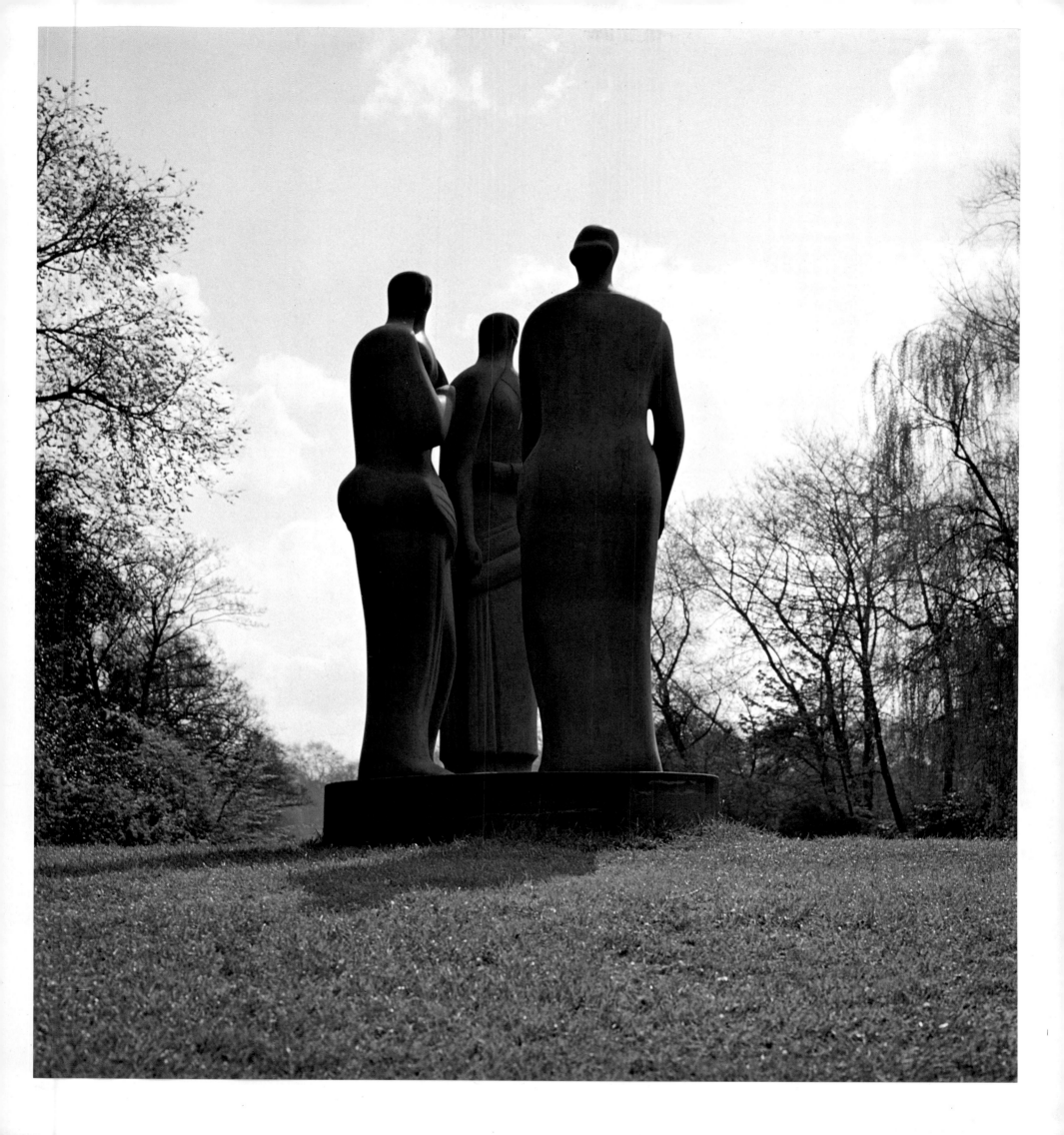

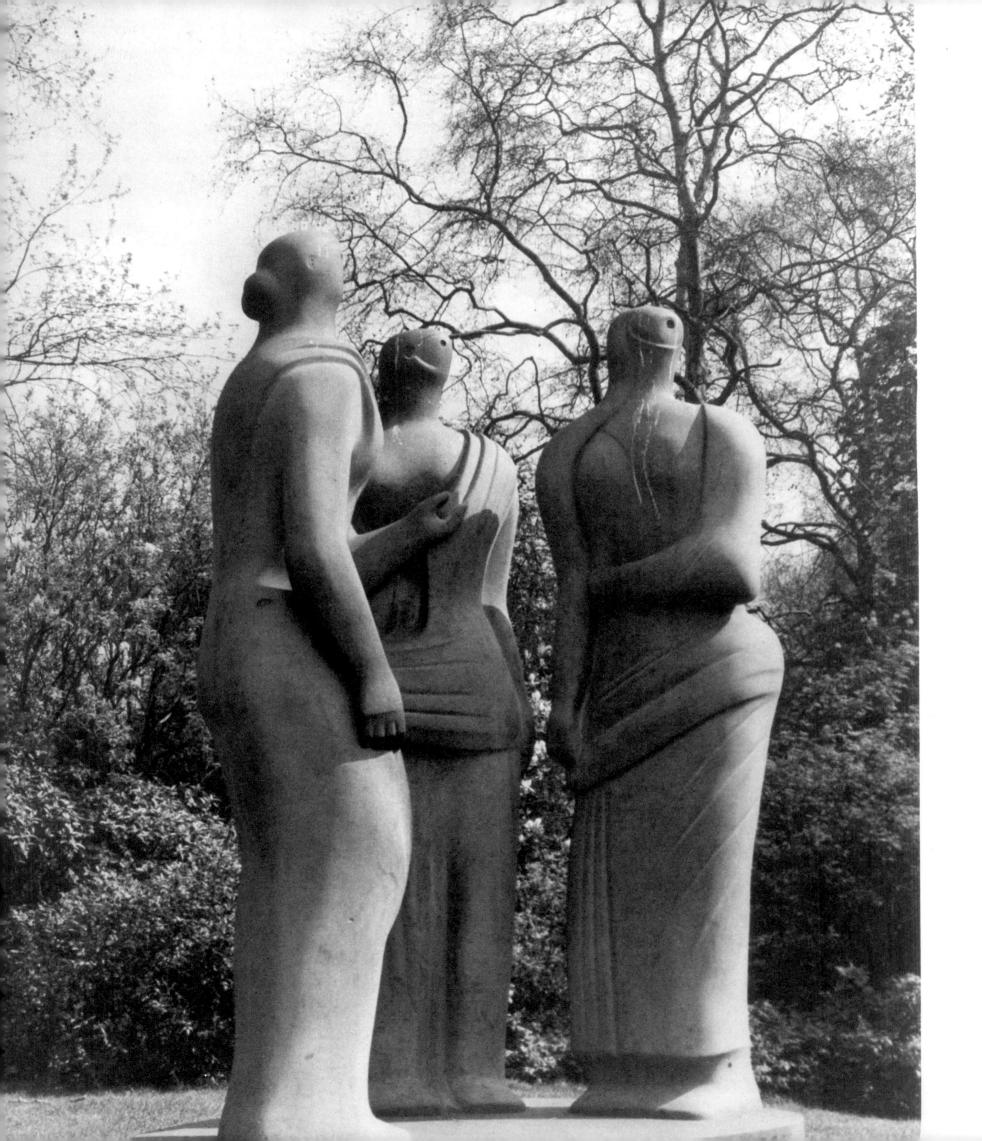

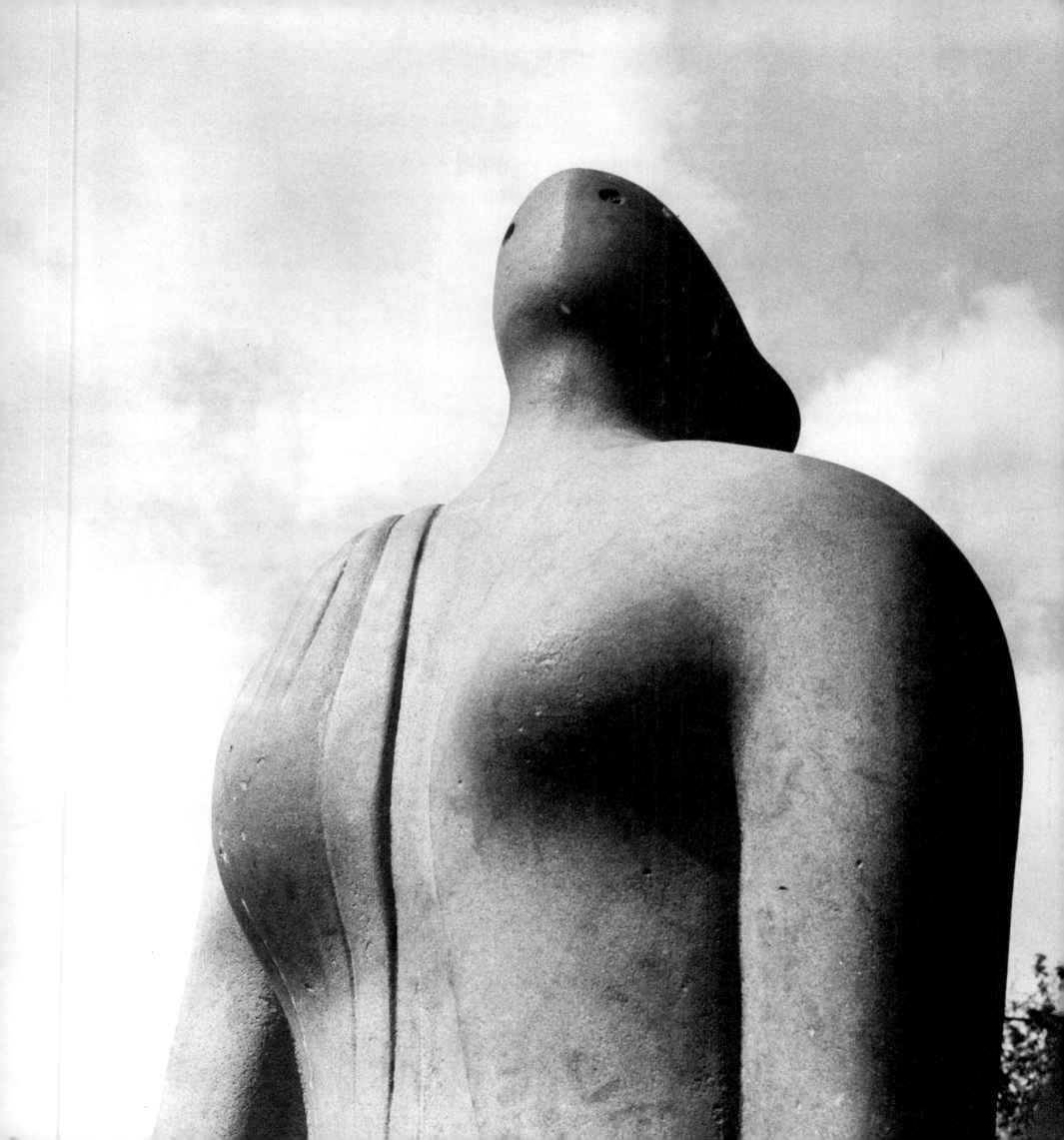

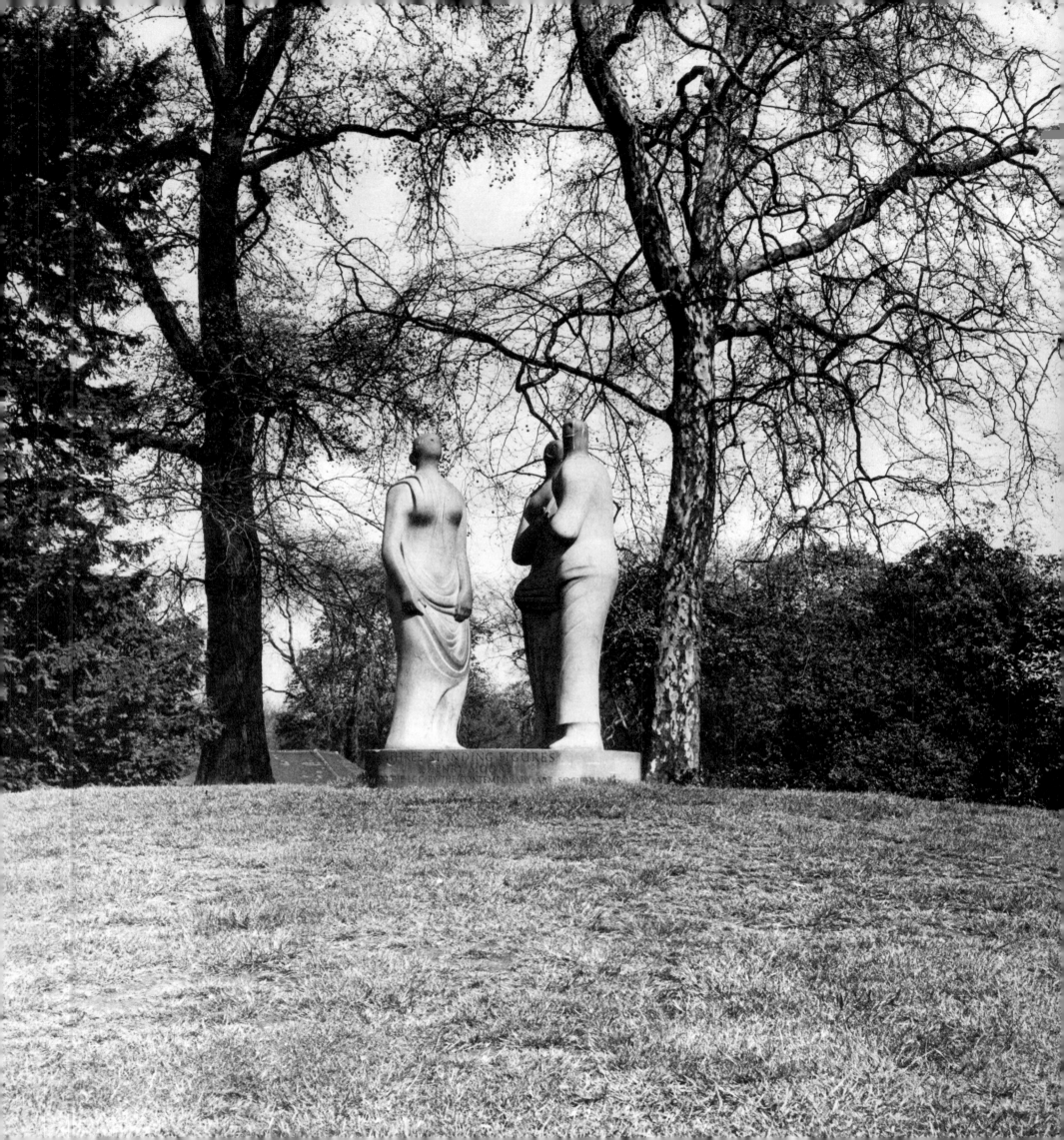

RECLINING MOTHER AND CHILD

1960–61. BRONZE, L. 86 1/2″. MINERALS SEPARATION BUILDING, LONDON

Birdcage Walk is a heavily trafficked thoroughfare of London, and people who drive by every day may never have noticed this Moore sculpture. It's quite a lovely setting, an unusual one to find in the middle of the city. The sculpture sits on a gentle slope in the center of a garden with well-planted foliage at its edges. An iron gate separates the garden from the public thoroughfare so that one cannot enter from Birdcage Walk directly. In order to gain access to the area, one must go around to a side street and go through the main lobby of the building.

I had glimpsed this Moore sculpture several times while driving on Birdcage Walk, but it wasn't until I went to the site

especially to photograph the piece that I looked at it carefully. The busyness of some of the background views when one faces the street was somewhat of a problem in framing overall photographs, but I had no difficulty getting good detail shots.

This is one of the more intricate of Henry Moore's sculptures, filled with evocative symbols of the mother-child relationship. There is, for instance, a sense of an enclosed interior, a womb-like space; there are some shapes that evoke the act of giving birth, while others suggest an infant feeding at the mother's breast. In the rear view, one has a sense of an egg being protected by a large organic form. It is a remarkable work.

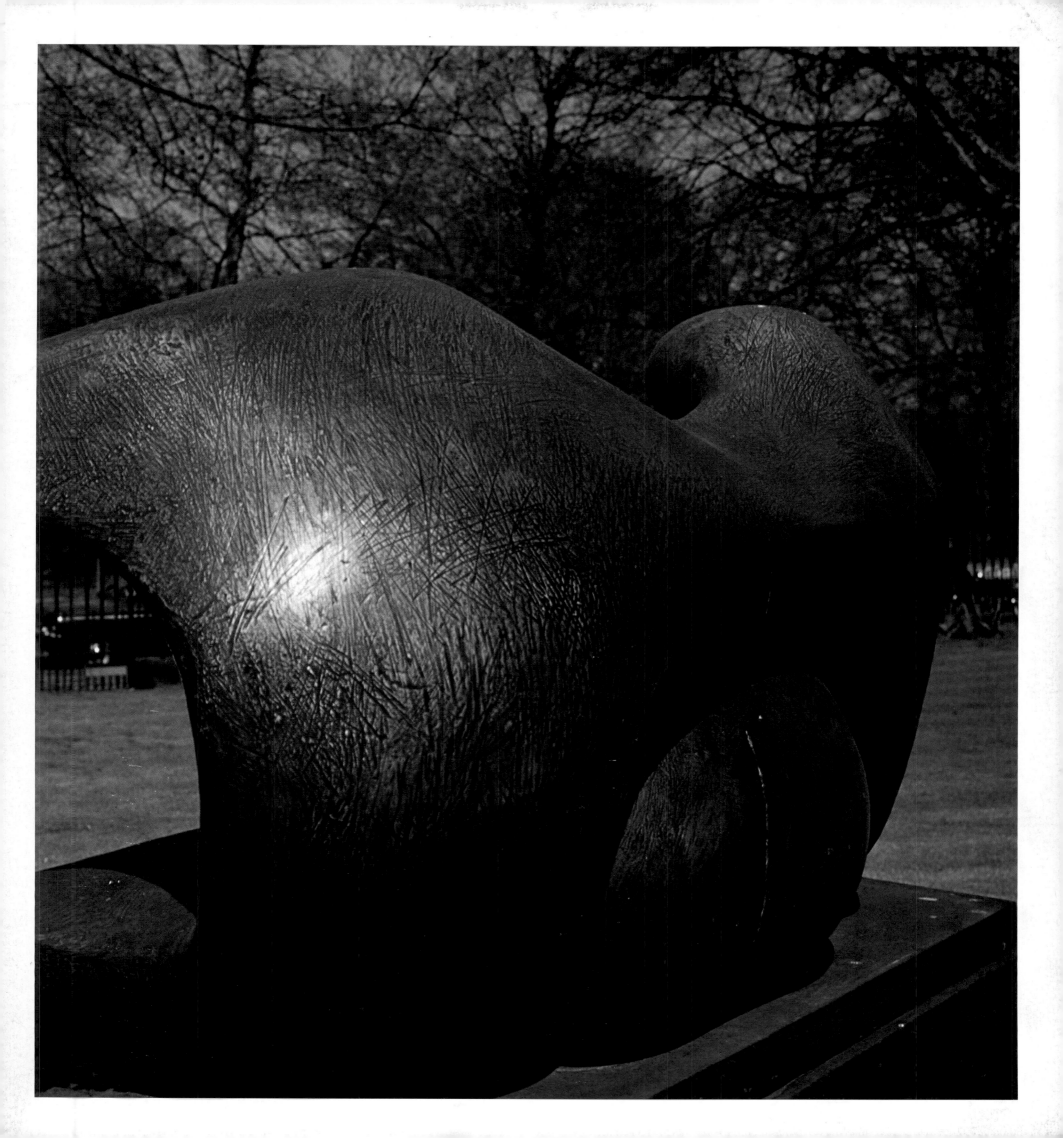

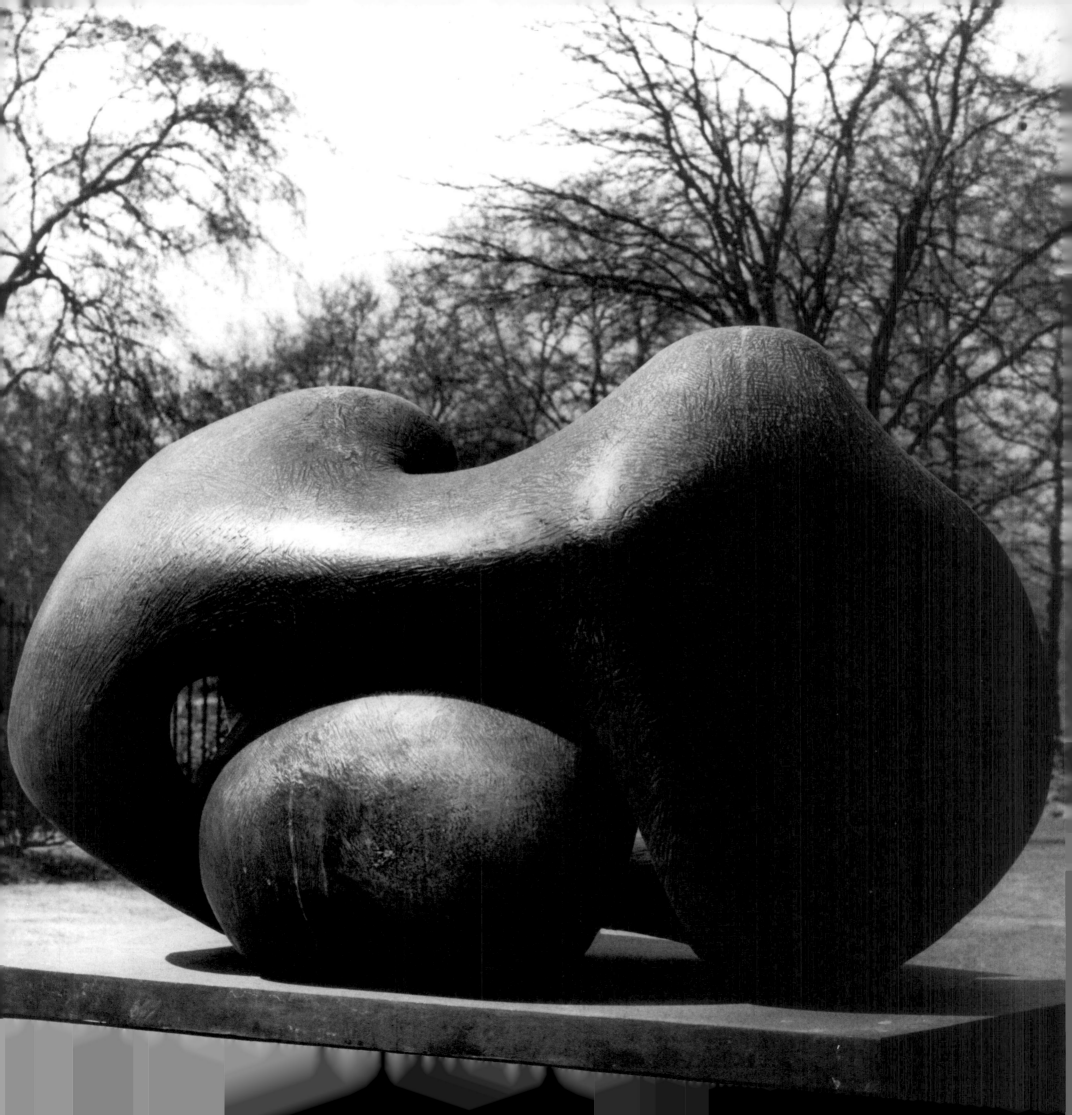

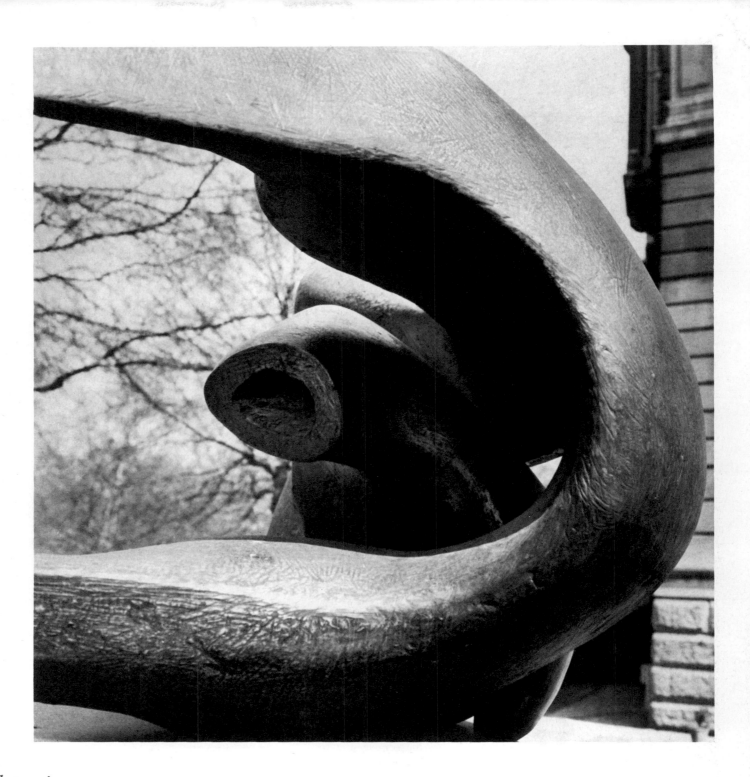

I helped with placing this sculpture in
that small garden. It was an odd little
problem—from Birdcage Walk you
only see it through railings. I put it
halfway up the lawn, which I thought
was best.

　　These photographs are done very
well. The sculpture comes out at you.
You feel you could touch the surfaces.

　　　　　　　　　—Henry Moore

DRAPED SEATED WOMAN

1957–58. BRONZE, H. 73". LONDON COUNTY COUNCIL (STIFFORD ESTATE), STEPNEY

This is located about twenty minutes by taxi from the London West End. It is one of two major Moores on the grounds of the London County Council Houses (see also pp. 246–47), and it is quite surprising to find these remarkable works placed with what appears to be little concern for their surroundings. One does not have the feeling that the sculptures are looked upon as rare and valuable works of art, but rather as objects that just happen to be there, as fixtures of the community.

I photographed this *Seated Woman* rather late in the afternoon, just before shadows covered the piece. While I was there, I did not notice any passers-by or occupants of the buildings stopping to look at the sculpture, which strengthened my feeling that it is not likely to make a deep impression on people in this location. It was also somewhat disconcerting to see the towering structures behind the sculpture,

which created a sense of total incongruity as I viewed the work through my camera lens. Moore's sculpture is no more appropriate to its setting than a Rembrandt would be in a drab lobby. This is certainly not a handsome setting for the work.

At the same time, I felt drawn to the idea of placing a Moore sculpture in the neighborhood of people who might not be likely to make a trip to the Tate Gallery to see his work. Given the fact that the buildings in the area are not very handsome, a frequent problem in urban locations, it is a constructive if not imaginative idea to bring a great work of art into the lives of the people who live there. The work might inspire a gifted child to explore his or her creative resources—with results that could more than justify placing the work in a Council House area. It is thus all the more pity that more care was not taken to give it a proper setting.

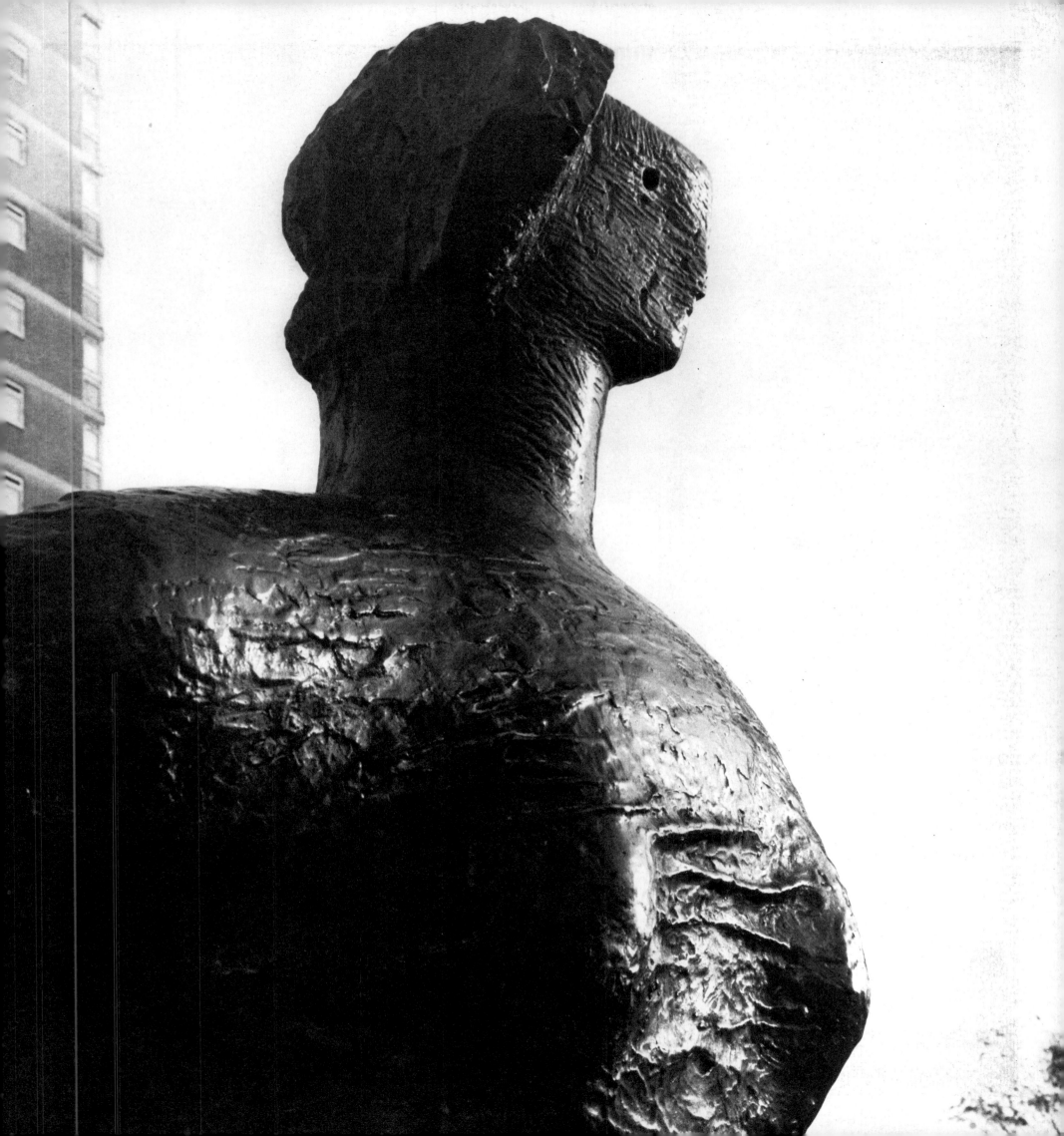

TWO-PIECE RECLINING FIGURE 3

1961. BRONZE, L. 94". LONDON COUNTY COUNCIL (BRANDON ESTATE), SOUTHWARK

The Brandon Estate London County Council House is located in one of the outlying districts of London. The pedestal for the sculpture is enormous, probably to keep children away, but the result is that the sculpture seems to be beyond the reach of the viewer. In the close-up photographs one has a sense of towering forms, and the sculptural shapes are almost a match for the high-rise structures in the background.

When I went to Southwark to photograph the piece, I was startled to find it in this lonely, almost barren, site. There is no foliage in the area to relieve the wide stretches of lawn and concrete, and it seems to be quite an

from the sky at random. Nevertheless was able to get some striking photogr by looking at the details against the s and if residents of the area look at th sculpture carefully—even in this desol location—they will be rewarded by ar inspiring and uplifting experience.

The three casts of this figure—th one and the casts in Goteborg, Swede and Los Angeles (see pp. 204–8; 470– —are mounted at three different level one sees the piece in a different way i each location.

Here the sculpture is well placed in tl can see it up against the sky.

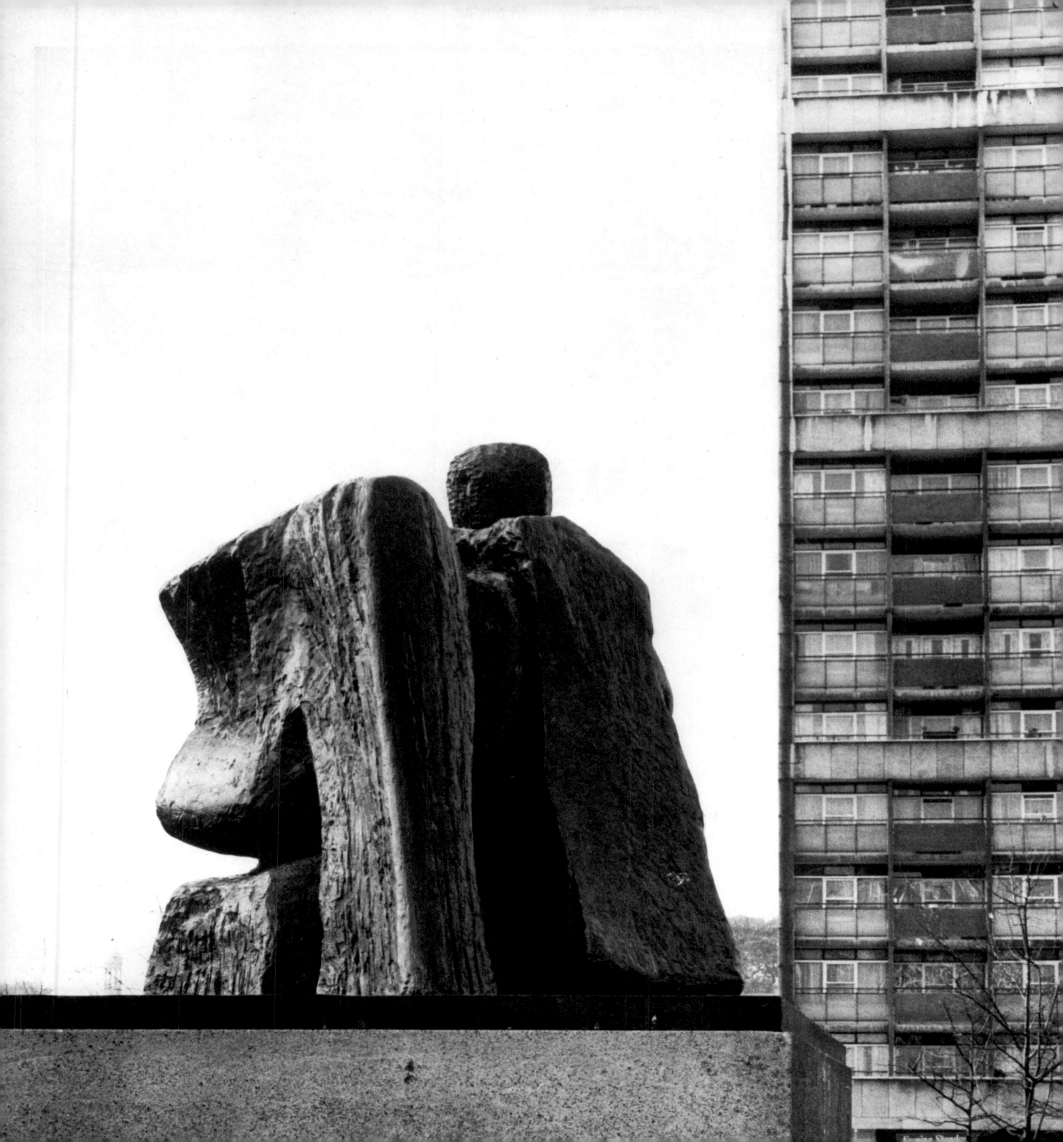

TWO-PIECE RECLINING FIGURE 1

1959. BRONZE, L. 76". CHELSEA SCHOOL OF ART, LONDON

This is the least successful of the four settings in which I photographed casts of this sculpture (see pp. 138–43; 308–12; 396–99). Neither the houses on the facing street nor the school provides a good background for the sculpture. The animal-like forms and forces seen in Glenkiln, Scotland, are here almost completely tamed. The round pedestal does give the viewer an opportunity to see the startling forms of the sculpture from different viewpoints, however, both because it gives ample space to walk around the piece, and because the proportions of the pedestal are well chosen to set off the sculpture handsomely. Also, one can see the work from different levels as one walks down the steps into the courtyard.

The work is probably seen by more people here than in Scotland, Germany, or

Buffalo, and in that sense the drawbacks of the cityscape as a background are somewhat compensated for by the availability of the sculpture to art students, who undoubtedly appreciate having it close by.

I designed the pedestal for this location. I wanted it to be turnable, though this proved to be not a good idea because the students played with it too much. Many sculptures could be made more interesting by putting them on a turntable. That way you wouldn't always see the same view. You could turn a piece if you wished to get a good light on a particular view. And a round base, where suitable, is a good idea because, not having a front, side, or back, it invites you to walk around it.

—Henry Moore

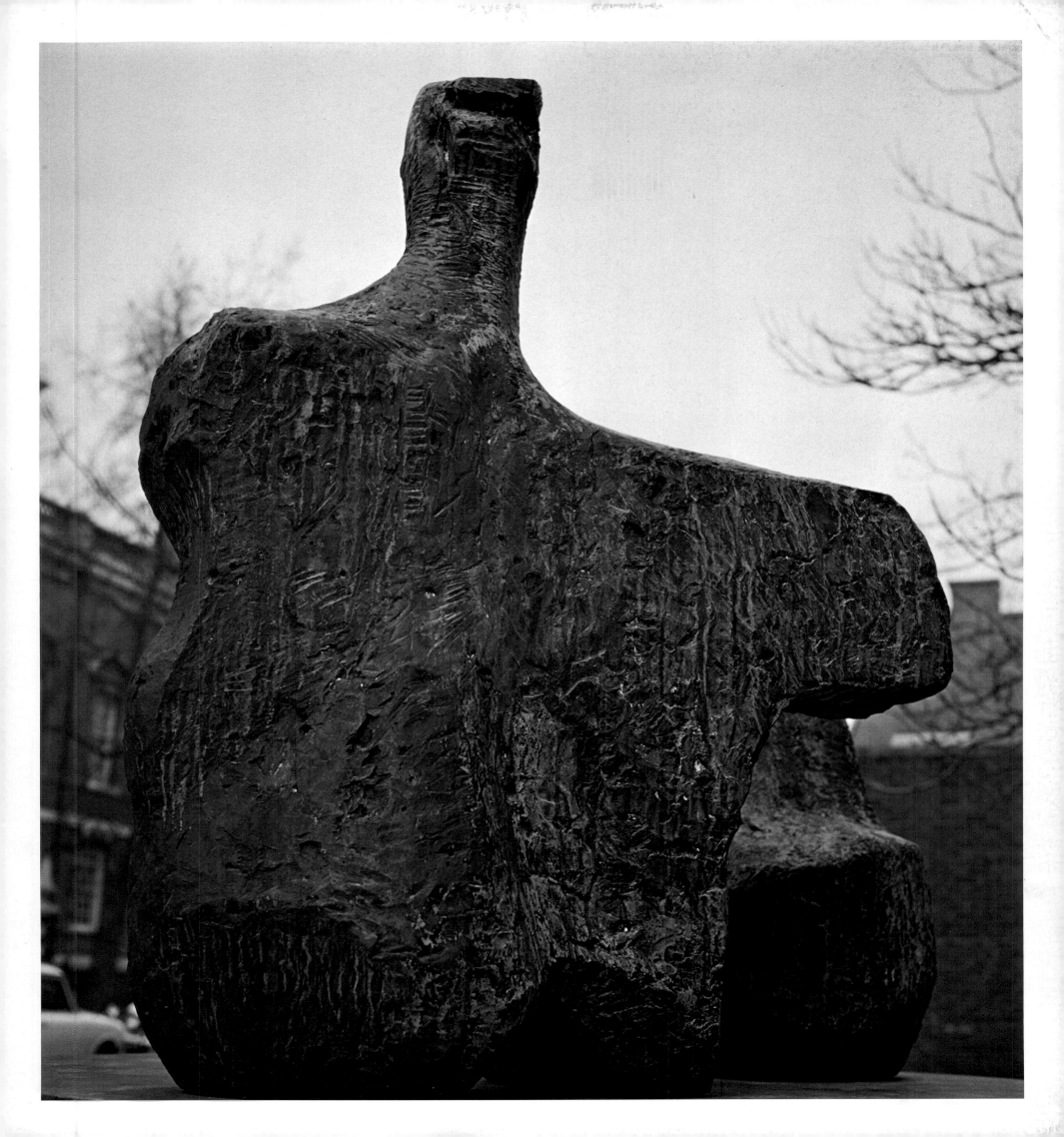

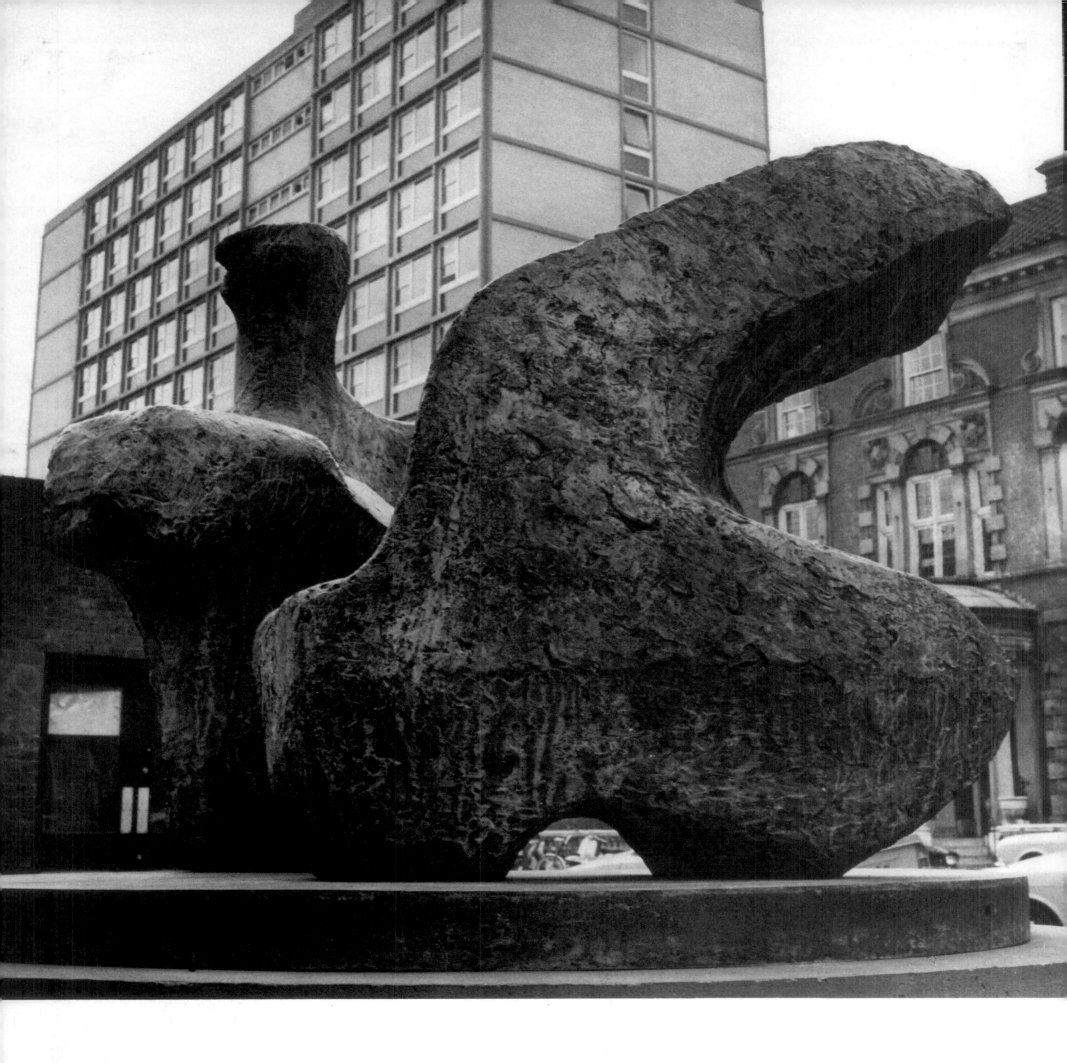

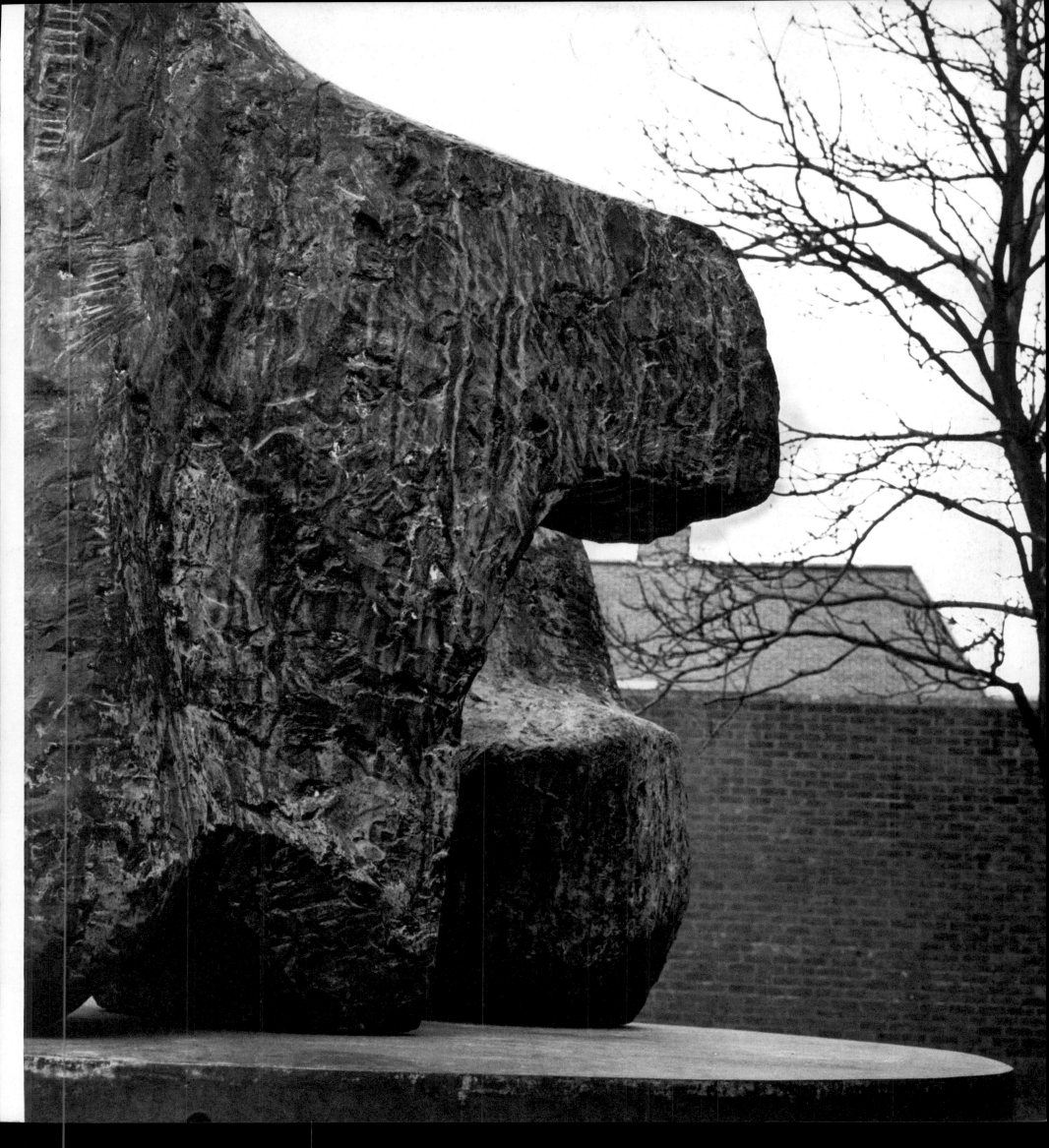

HARLOW FAMILY GROUP

1954–55. HADENE STONE. H. 64 1/2". HARLOW NEW TOWN, ESSEX, ENGLAND

Located about an hour and a half north of London, Harlow New Town is one of England's planned communities. It incorporates many advanced ideas of city planning—large malls, shopping areas, public greens, a variety of styles for its residential buildings, and carefully controlled traffic. To a visitor accustomed to the sense of history found in old English towns, however, Harlow New Town seems bland and uninteresting.

The *Family Group* is now placed on a high pedestal in the central square of the town and looks like a monument that people consider a landmark rather than a work of

art. But it is a fine sculpture and most appropriate to a community in which the family is clearly the central focus.

I particularly liked the photograph of the whole group with the irregularly spaced windows in the background, which suggest the patterns on the kind of screen that Moore has used behind some of his smaller figures. The faces are sensitive and unusually naturalistic for Moore. I found them very lovely. The characteristic Moore shapes can be found most clearly in the feet, both in the front and side views and in the solid shapes of the back.

This Family Group *is really an aftereffect of the first Family Group idea, connected with Henry Morris and Impington Village College (see pp. 258–63). The architect of the New Town of Harlow, together with a few people who lived in Harlow, thought that their New Town should not be, like other New Towns, completely bare of art, and they formed the Harlow Art Trust. The Art Trust asked me for a piece of sculpture—they hoped a family group. Harlow being so near my home in Much Hadham, and many of the Trust members being my friends, I wanted to help, so I carved this piece for them and helped to choose a most pleasant site for it—near the old church on a grassy slope with lots of open space—where it could be seen from a long distance as people approached the New Town.*

Unfortunately this sculpture has been moved from its original site, which proved to be too open, too countrified and unprotected. It was seriously damaged by vandalism—the child's head eventually was broken off. After I repaired the sculpture, it was decided to place it in the town's central square and on a high pedestal for protection.

—*Henry Moore*

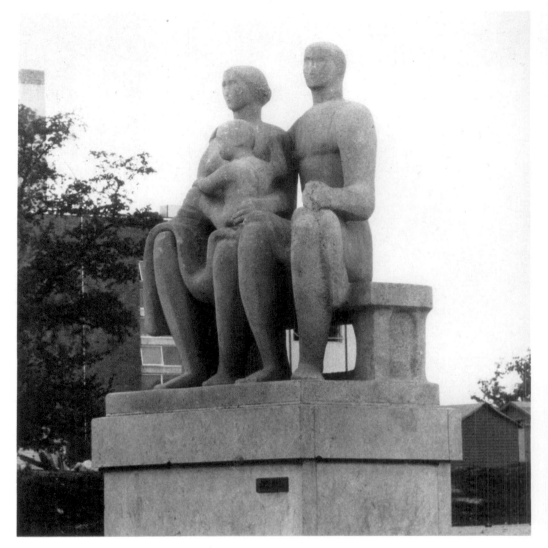

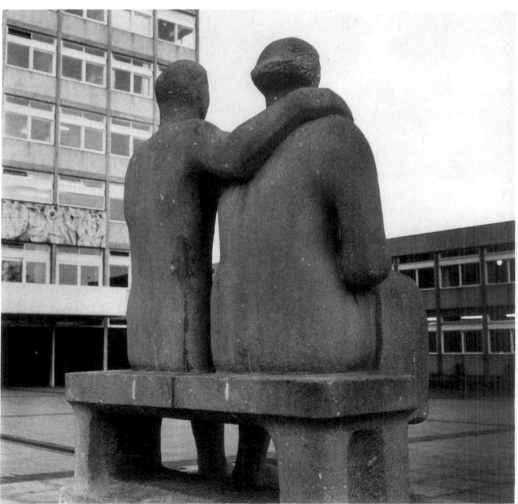

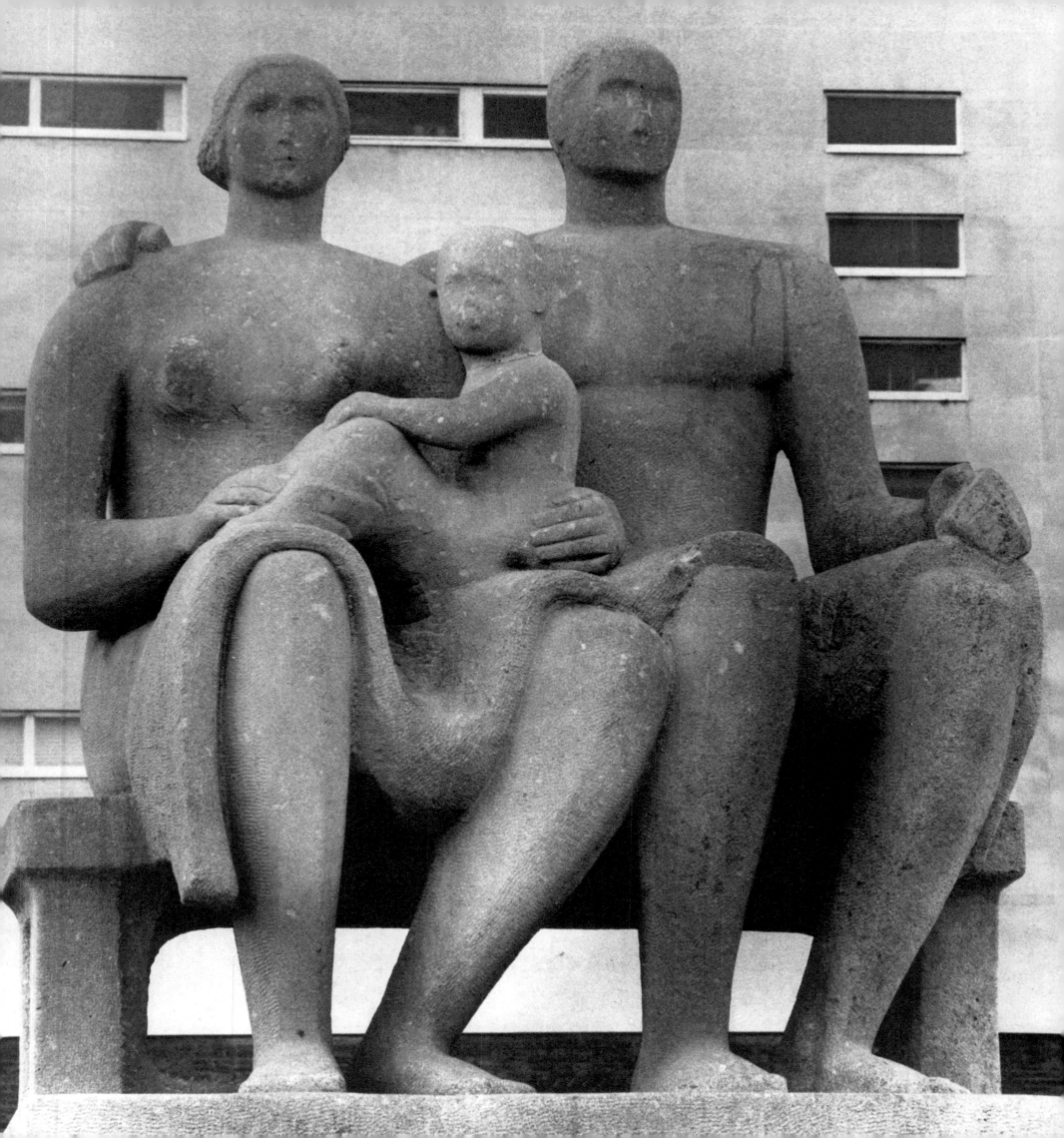

UPRIGHT MOTIVE 2

1955–56. BRONZE, H. 10'6". HARLOW NEW TOWN, ESSEX, ENGLAND

This sculpture is only a short distance from the *Family Group* at the edge of a beautiful green bordering Harlow New Town (see pp. 252–55). One of the Kröller-Müller group of Uprights (see pp. 168–73), it stands here in an especially lovely urban landscape. There is a pleasant garden in front of the work, with walks that lead up to the sculpture, and a long expanse of green on the other side that stretches out to clumps of buildings in the distance.

Because I arrived at the site late afternoon almost at sunset, it was too to photograph as many details as I w have liked. But this is a fine setting f sculpture, well worth a visit.

This looks lovely at sunset. I like the detail which looks like a vase.

—*Henry Moore*

FAMILY GROUP

1948–49. BRONZE, H. 60″. BARCLAY SCHOOL, STEVENAGE, HERTFORDSHIRE, ENGLAND

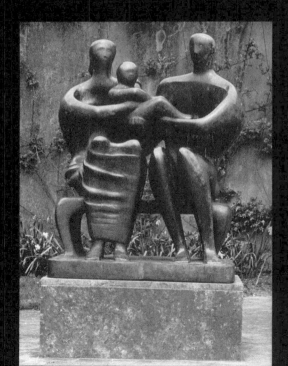

This is another of Henry Moore's well-known images. The figures are placed on the same kind of seat as are the *King and Queen*, but here it represents a bench rather than a throne. The faces are extremely simple and human, not animal-like as is the case with the *King and Queen*. In some respects there is more of the later Moore in the *Family Group*, with its scooped out cavity between the arms and thighs, the bulging shoulders and simple heads, than in the royal figures.

The site in front of the school is disappointingly casual, as if the work were not a particularly important one. Also, the sculpture is so close to the building that it is difficult to see the back view, and when it is looked at from the front, the lines of the building tend to cut into the figure awkwardly. When I photographed the *Family Group*, I happened to meet the headmaster of the school, and he was surprised that I had come all the way to Stevenage to photograph it, particularly since there is a cast of the same piece in the Museum of Modern Art in New York (see pp. 338–41). Having a world-famous work of art in front of this modest school seemed to strike the headmaster as curious, and I imagine that very few people who see it there realize how important a sculpture it is

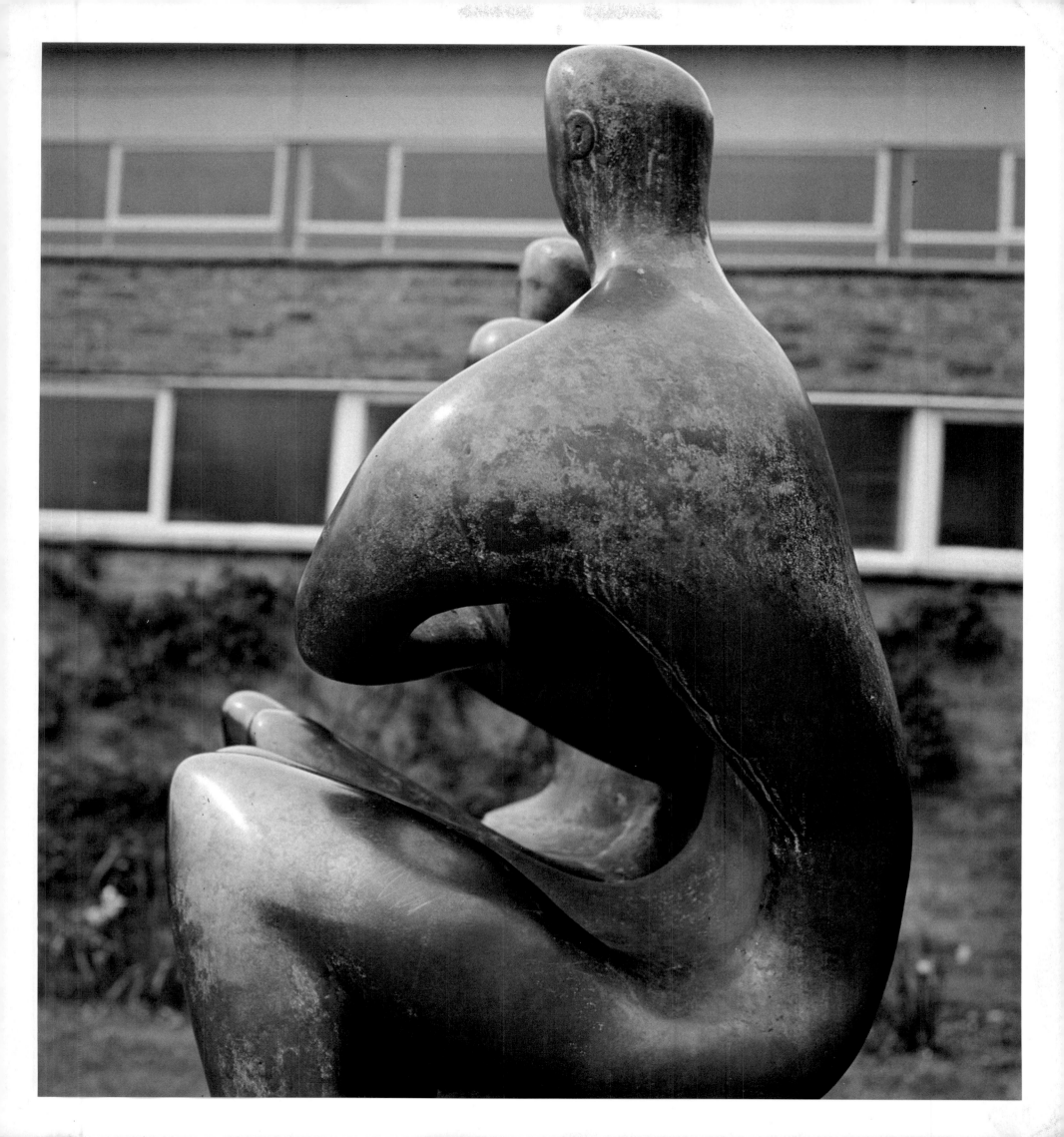

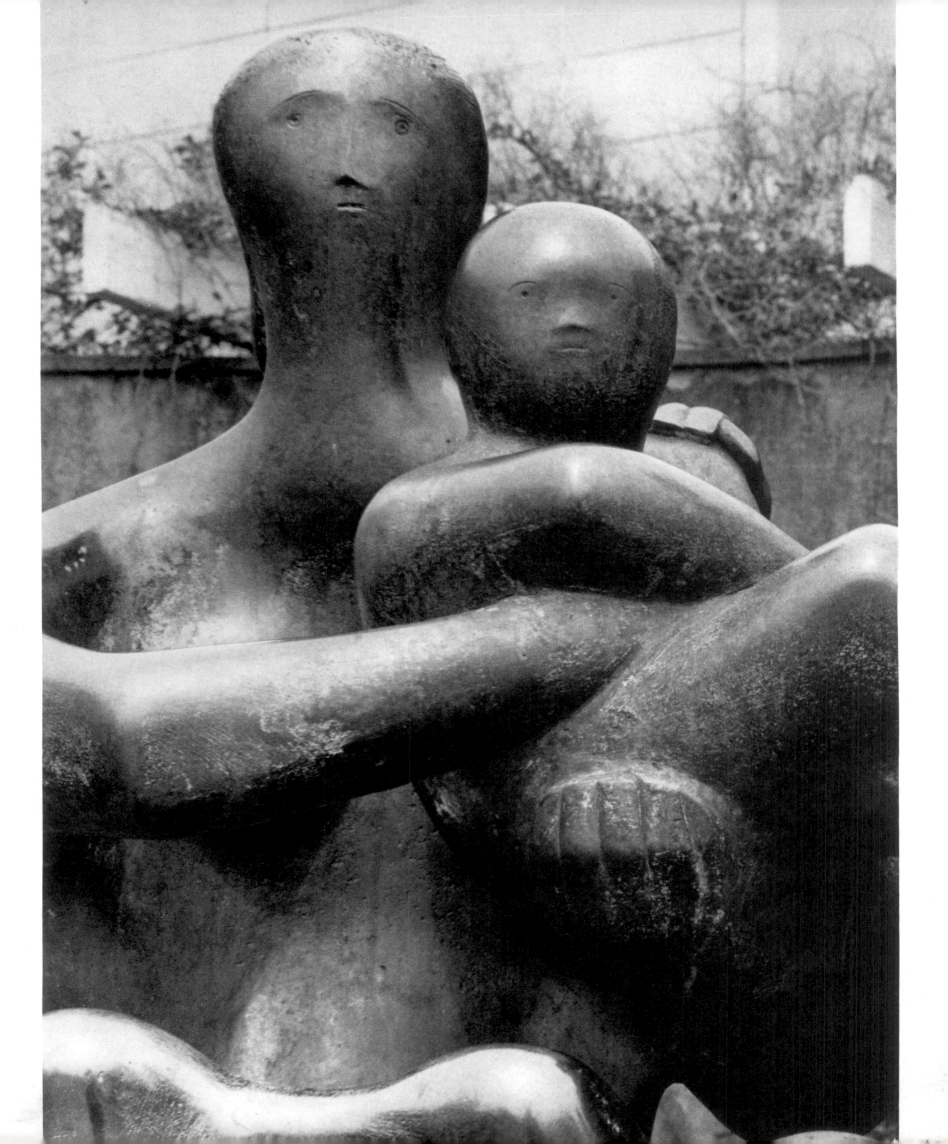

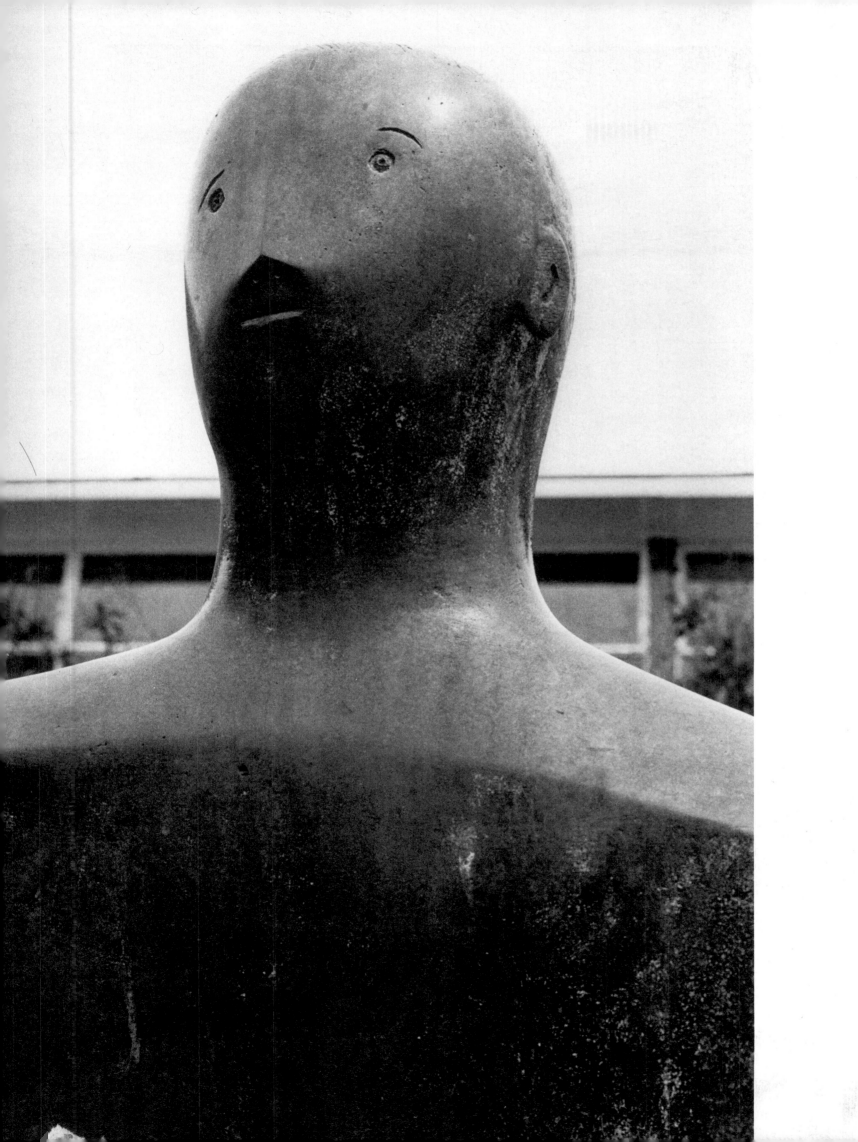

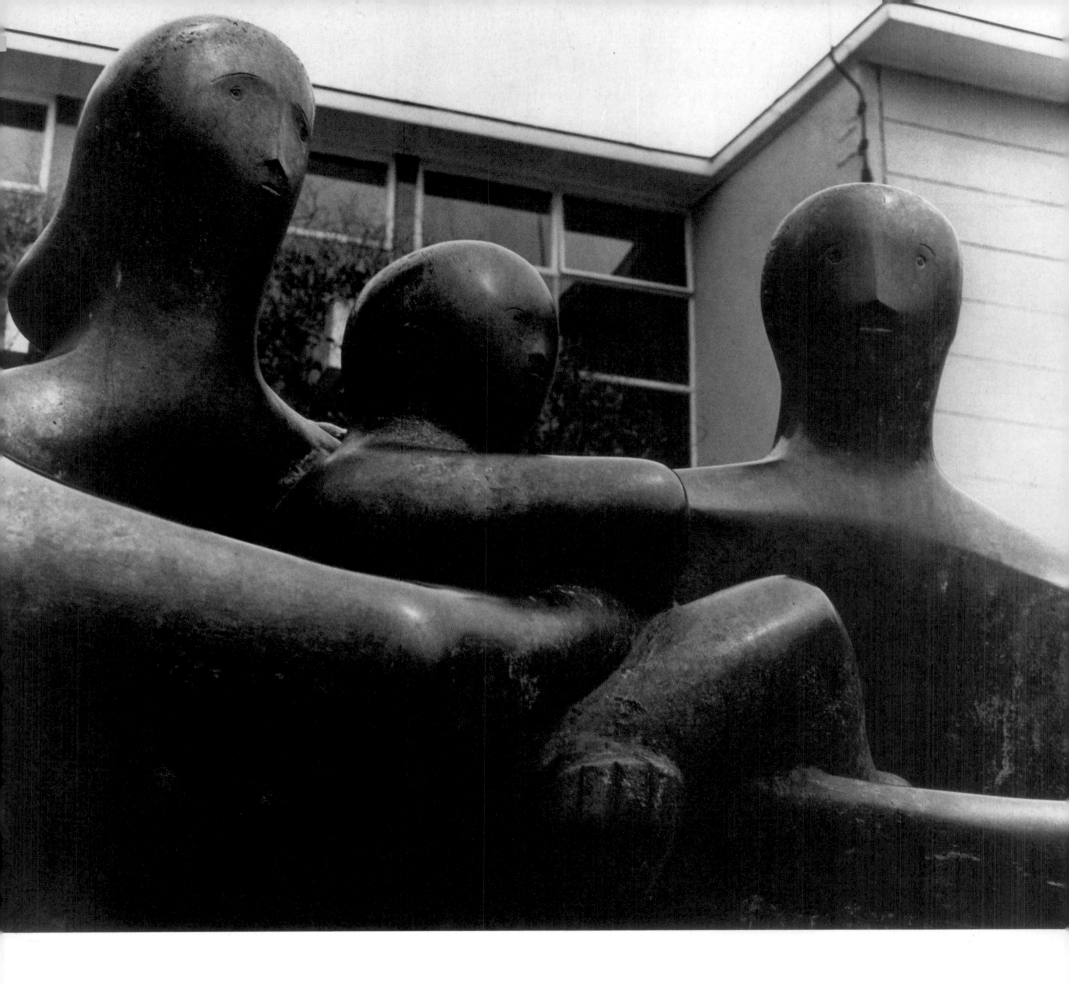

The idea for a Family Group *sculpture came out of a discussion I had around 1934 with Henry Morris, the pioneer of village college schools, together with Walter Gropius, the German architect engaged to design the first of these schools at Impington, a village near Cambridge, England. I was not often asked to do a special sculpture in those days. Usually I would do what I liked and if it sold, it sold. But I admired them both, Gropius as an architect and a past director of the Bauhaus and Henry Morris as a great educator. Henry Morris explained his hopes that by a full use of the school buildings and facilities in the evenings and also throughout the weekends parents would further their own education and, in consequence, there would be a better parent-student relationship with teachers and more community life in the village.*

After some thought, I came to the idea of the Family Group, *making the connection between family and school. Unfortunately, the money for the project ran short, and the sculpture never materialized. But Henry Morris had many young disciples in the educational world, and one of them, John Newsom, some years later became the director of education for the county of Hertfordshire. He remembered the unrealized Impington sculpture project, and he asked me if I was still interested in the* Family Group *as a subject. I was, and this is what led to the completed sculpture now in front of the Barclay School, Stevenage. The school was designed by a very good group of English architects.*

I would have preferred the sculpture to be placed out in front on the lawn and further away from the wall. But for security purposes and other reasons the school wanted it where it is.

In the sculpture the child is shown in the arms of his parents, as though the two arms come together and a knot is tied by the child. It is as though they are pulling with their arms and the knot that connects both parents is the child. This did not come into my mind at the time of doing it.

—Henry Moore

MEMORIAL FIGURE

1945–46. HORNTON STONE, L. 56". DARTINGTON HALL, TOTNES, DEVONSHIRE, ENGLAND

The Devon landscape in which this sculpture is located perfectly suits the mood of the work. The figure is surrounded by beautiful trees and is high up on a hill, with great expanses of space all around it. The stone has not weathered too well, and some of my photographs show certain delicate features of the work less clearly than earlier views taken when the sculpture was installed. The *Memorial Figure* was one of the earliest works that Moore created for an outdoor

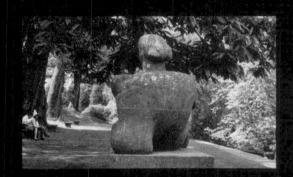

environment and is the oldest sculpture included in this book.

It was somewhat difficult to photograph the *Memorial Figure* because it was completely in the shadow of the trees, while the fields in the background were in bright sunlight. But as seen through my camera eye, the piece retains much of its tenderness and sensitivity, and I was delighted to have made the trip through such a beautiful part of the country to see this historic work.

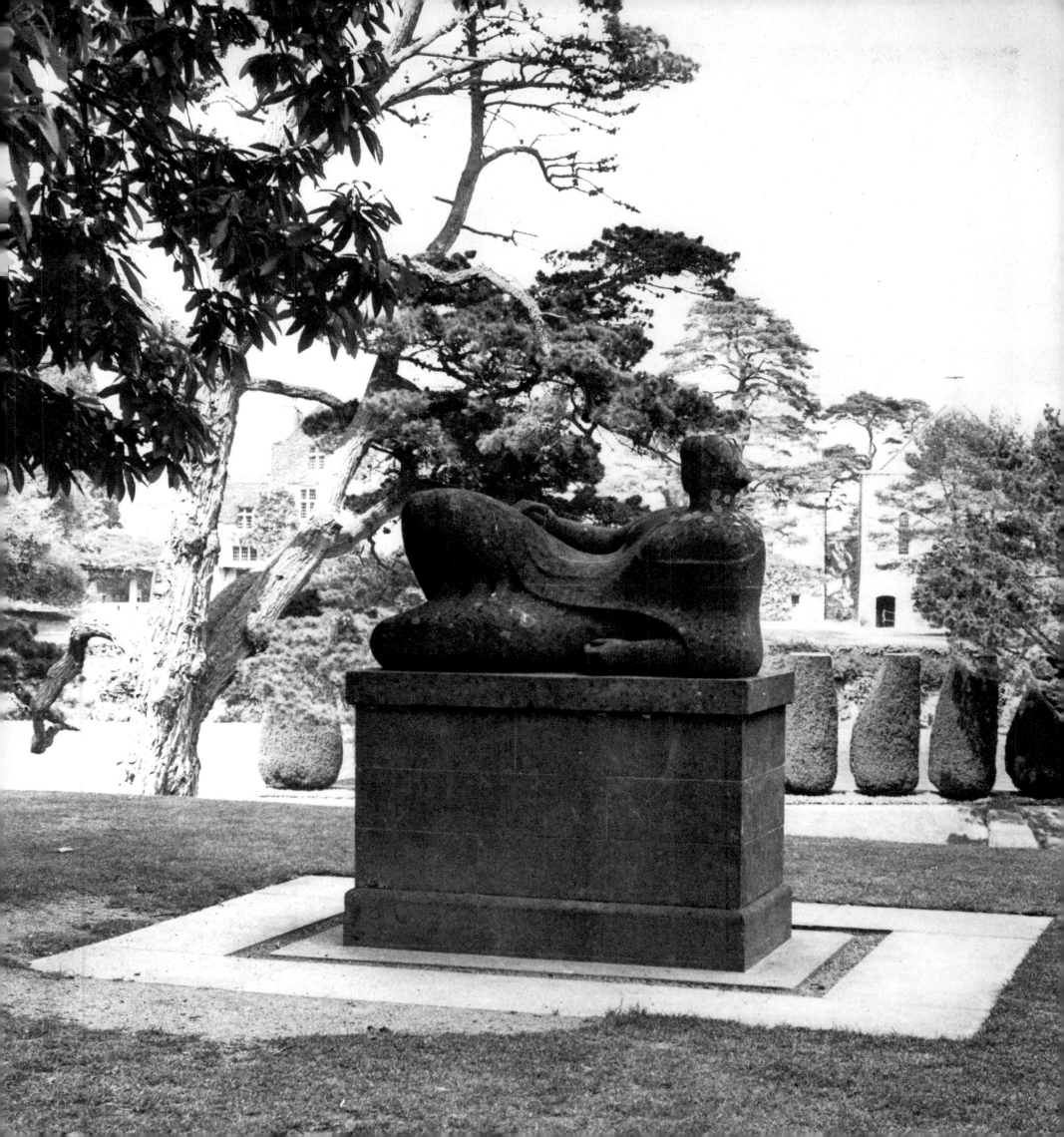

This *Reclining Figure*, carved in Hornton stone, was placed
here in 1945 by Dorothy and Leonard Elmhirst as a memorial
to Christopher Martin, first director of art at Dartington
Hall. The spacious gardens at Dartington are very beautiful.
In the last thirty years the trees around the sculpture have grown,
and the piece does not get as much sun as before.

　　Hornton stone is an English stone—not a very hard or very
durable stone—and over the years the rain dripping from the
overhanging trees has caused some erosion of the stone and
patches of lichen to appear in places.

　　I intended the Dartington sculpture to be calm, gentle,
and contemplative, in keeping with the character and personality
of Christopher Martin. In the same year I was carving a large
elmwood *Reclining Figure* (formerly in Cranbrook Academy of
Art) which is very different in feeling. Perhaps the two
sculptures express what some critics see as two opposing sides
in my work—the "tough" and the "tender." I am happy to
think I may have these two sides. To understand or feel anything
deeply, you must know its opposite.

<div align="right">

—Henry Moore

</div>

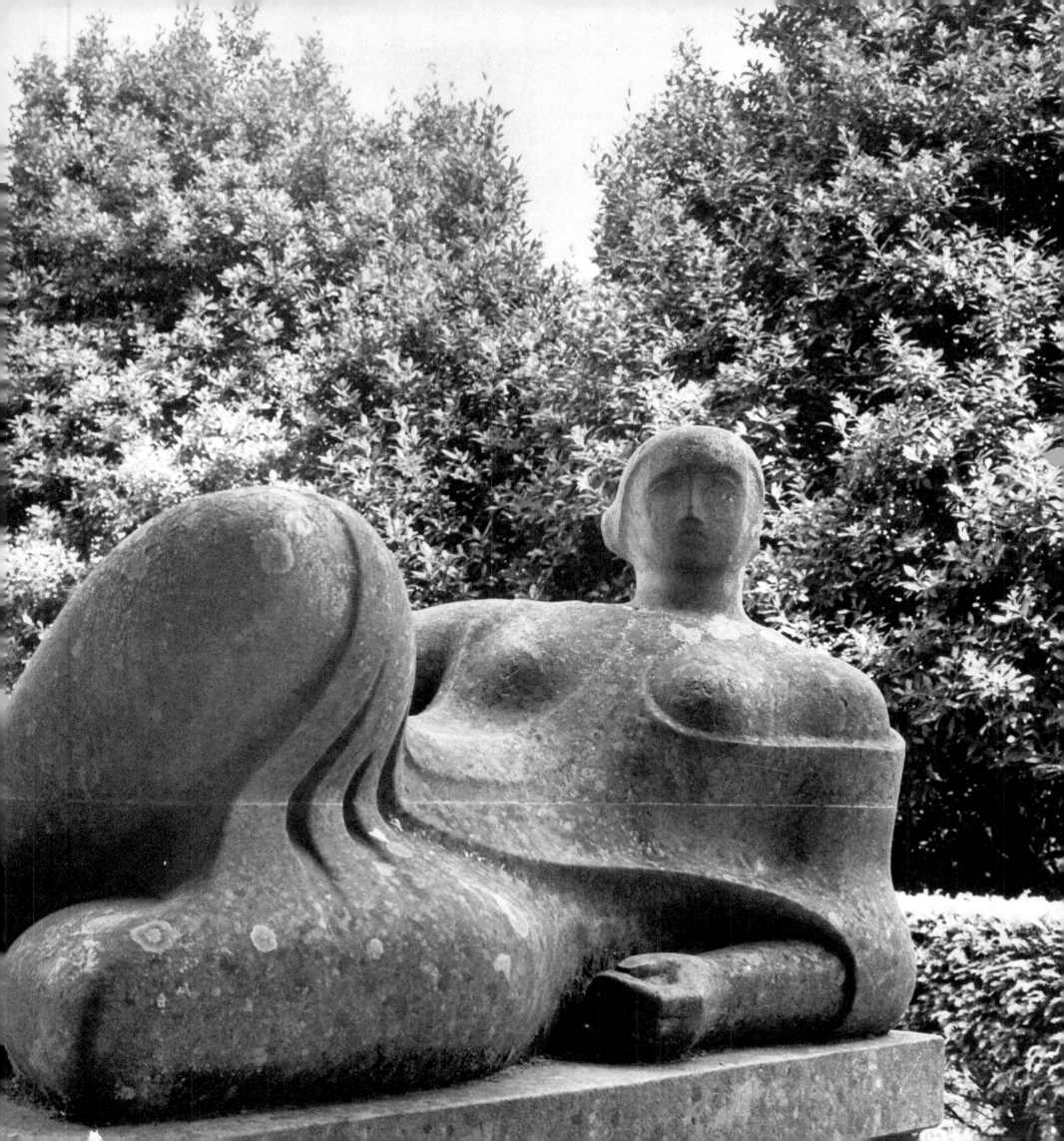

THREE-PIECE RECLINING FIGURE 1

1961–62. BRONZE, L. 9'5". CHURCHILL COLLEGE, CAMBRIDGE UNIVERSITY, ENGLAND

This is one of the few settings of a Moore sculpture that is very striking even though it does not have foliage around it. By a curious coincidence, another cast of the same work is located in a similar area on the campus of the Rochester Institute of Technology in New York (see pp. 380–85). Moore liked the photographs I took in Rochester, but I did not have a chance to show him the photographs of the Cambridge site, which I think is far superior. There is plenty of air around the sculpture at Churchill College, and there are no architectural lines that cut into the figure. Also, a solid brick wall immediately behind the sculpture sets off the figure rather well (although I still would prefer to see it against trees). In addition, I liked the architecture of Churchill College better than that of the Rochester Institute

of Technology and thought that it was more compatible with the quality of the sculpture.

I was particularly struck by the dramatic cavelike passages of this sculpture and by its marvelous rocky formations, for we had just spent a week in northern Scotland. There we had visited the giant Cave of Smoo near Cape Wrath and had seen the awesome cliffs on the island of Hoy in the Orkneys. I had photographed the extraordinary formations of those rocks and had been startled by their resemblance to some Moore sculptures. Of all his works, *Three-Piece Reclining Figure #1* is perhaps the most successful in capturing the essence of such ancient forms carved by the elements, and I was glad that I was able to photograph this cast in Cambridge with the Scottish scenes still fresh in my mind.

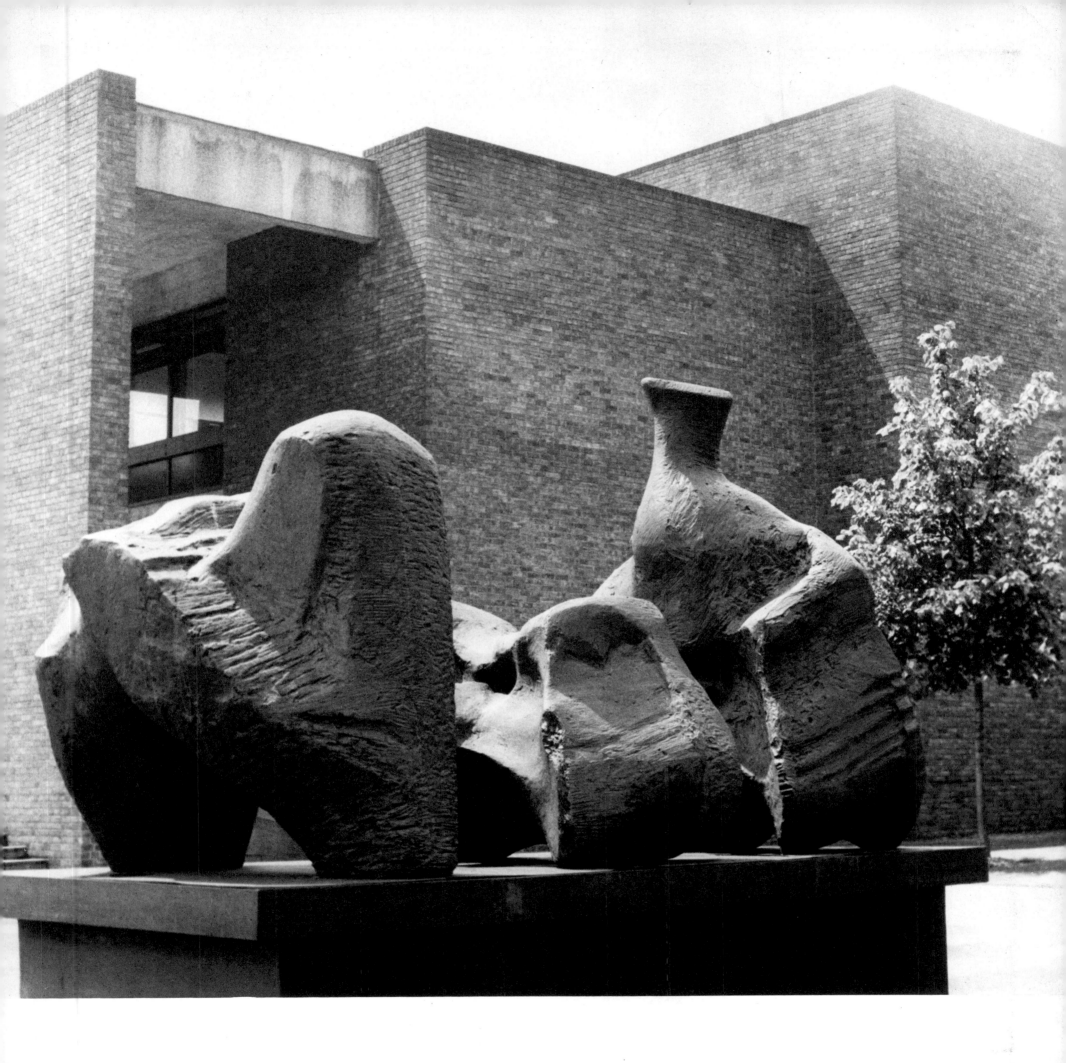

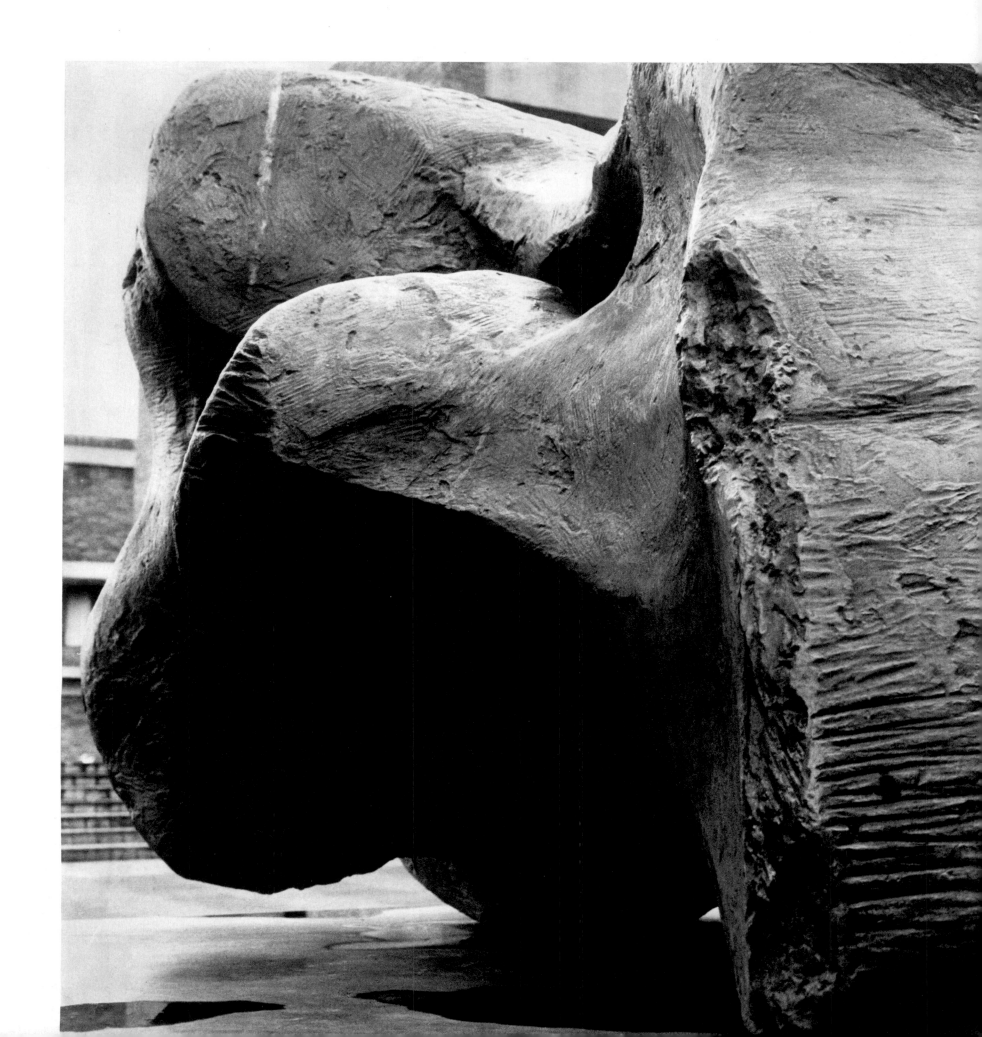

FALLING WARRIOR

1956–57. BRONZE, L. 58″. CLARE COLLEGE, CAMBRIDGE UNIVERSITY, ENGLAND

This casual placement of the *Falling Warrior* in the New Court of Clare College does not quite do justice to the sculpture. Although the court has a war memorial arch that seems an appropriate companion piece for the *Falling Warrior*, the setting doesn't compare to the placement of another cast of the same sculpture in Zollikon, Switzerland (see pp. 120–24). Moreover, the relatively uninteresting façade of the buildings in the background and the almost complete absence of foliage make it difficult to photograph the piece properly. I was able to get some good detail shots, however, and I particularly enjoyed the shadows that were created by the midday sun.

My daughter Amy, who was with us on our trip to Cambridge, commented on the similarity of the figure to the seated

pregnant woman (called *Seated Woman*) that Moore also completed in 1957. We have a cast of this sculpture in our collection, and I knew that Moore's wife, Irina, had been pregnant when he worked on it. Irina had told her husband about the baby moving back and forth, which is why the stomach of the sculpture is pushed to one side. I noticed that, indeed, the stomach of the *Falling Warrior* does have the same bulging character as that of the *Seated Woman*, and I made a mental note to ask Moore about it. Amy was right. Moore said that both sculptures had come from the same maquette. He had simply placed the figure on its back to do the *Falling Warrior*, intending in this case to represent the bloated stomach which might develop as a result of a fatal wound.

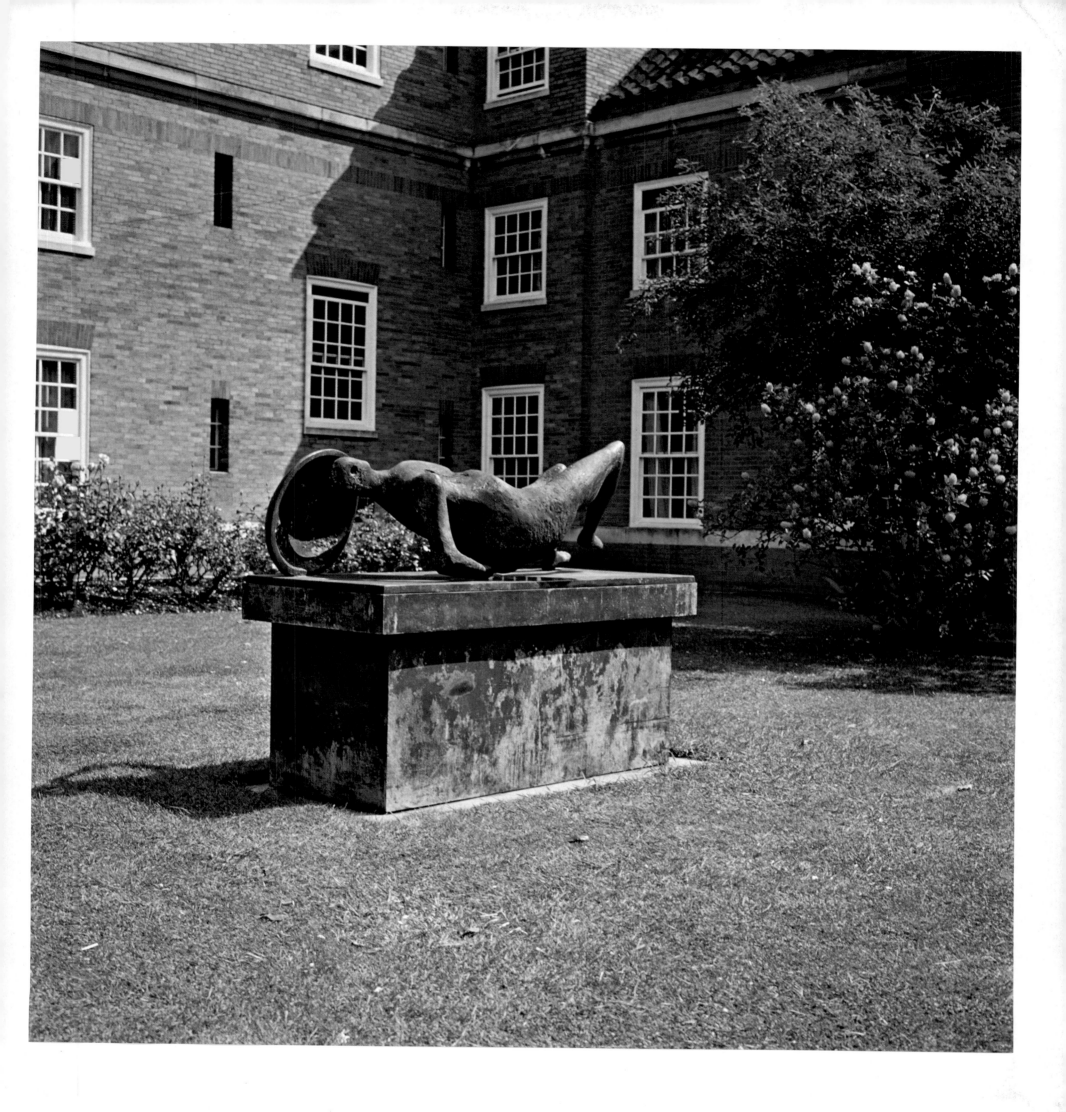

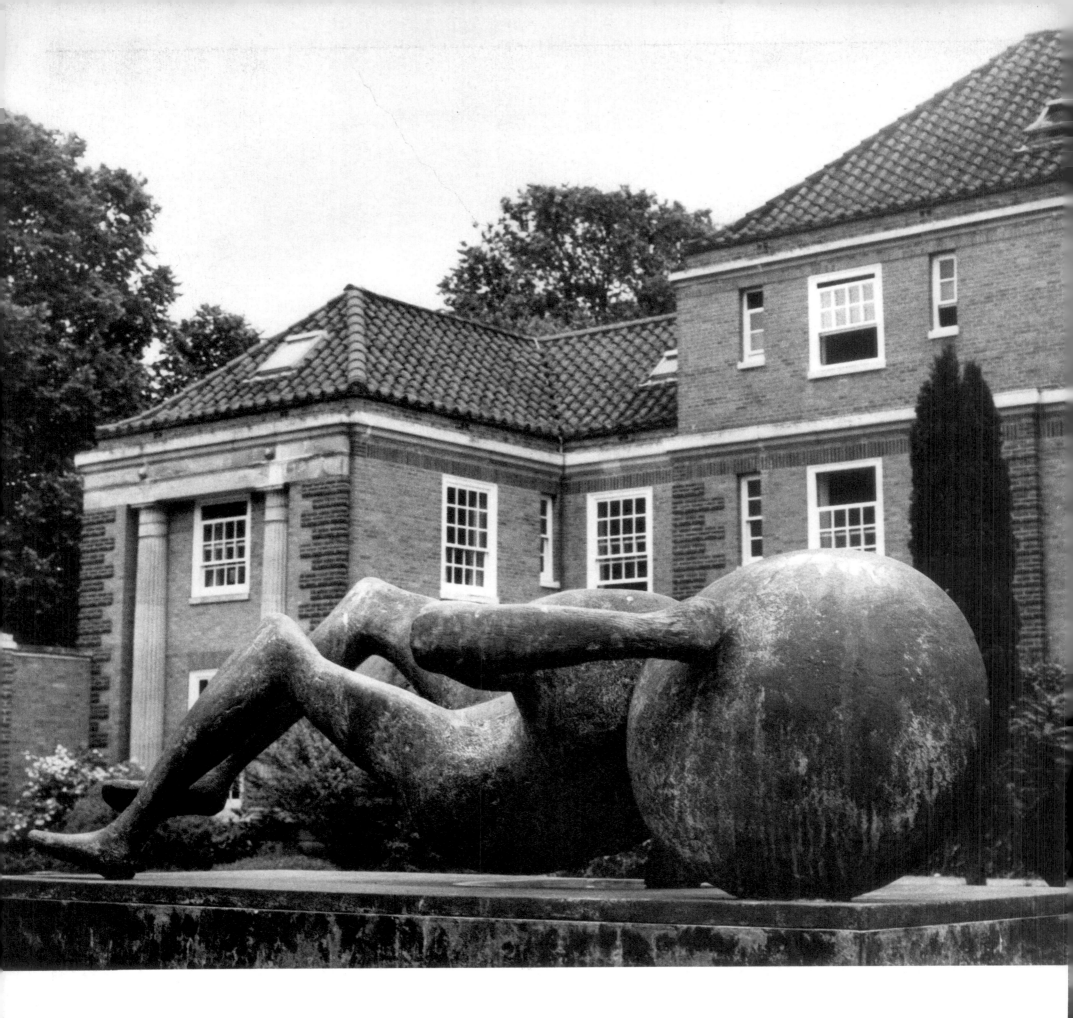

274

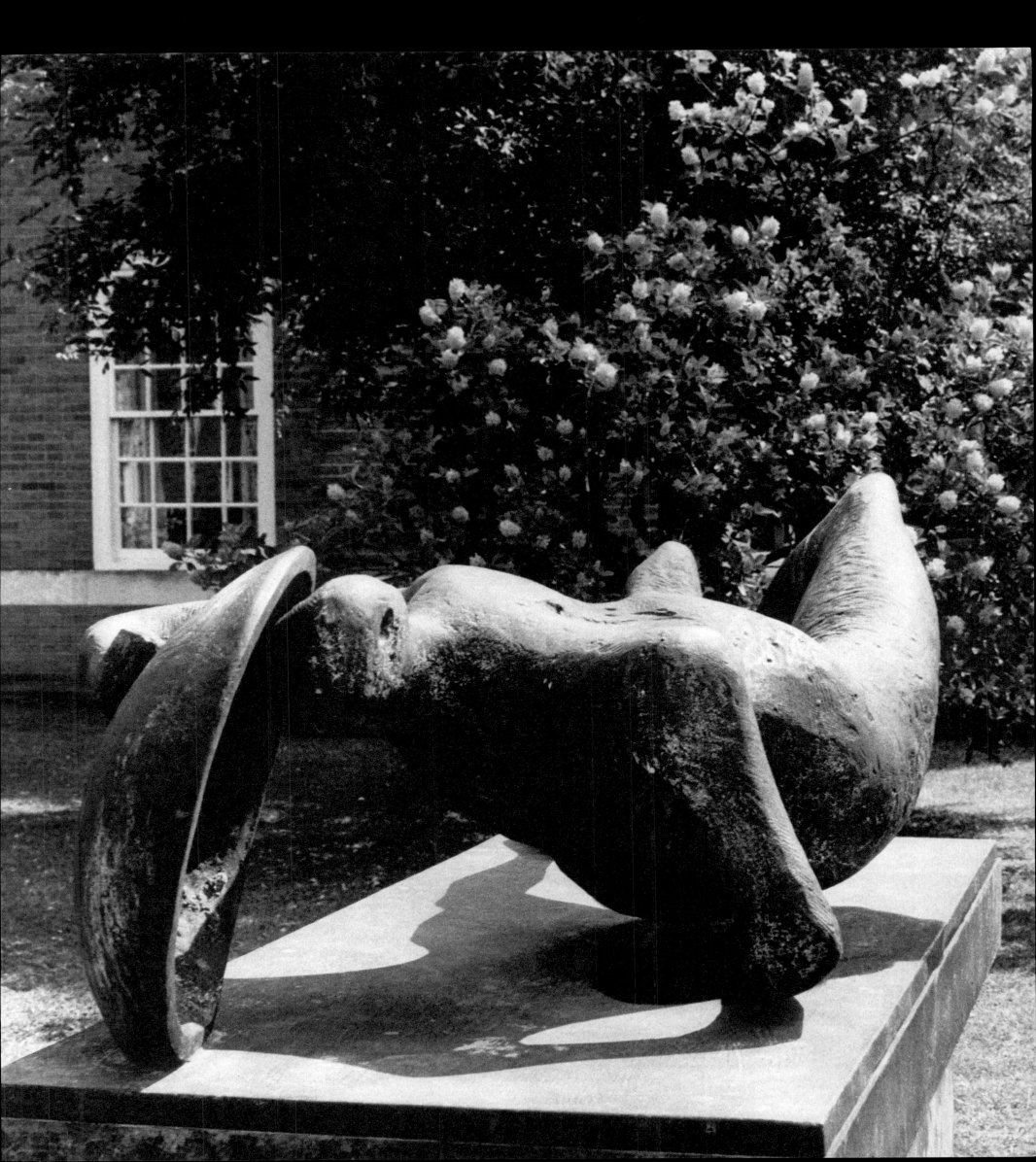

SEATED MAN

1964. BRONZE (PLASTER, 1949), H. 61″. LEKHAMPTON HOUSE, CAMBRIDGE UNIVERSITY, ENGLAND

This is a special cast, with some modifications, of the male figure of the *Family Group* in Harlow New Town and the Museum of Modern Art in New York (see pp. 252–55; 338–41). As a single figure, and with the new shapes created by the removal of the arms, the sculpture has a markedly different character than the father in the family piece. The hollow of the stomach cavity has become much more pronounced, anticipating many of the shapes in later Moore sculptures, and the figure has a lonely, brooding quality. The setting of the sculpture in this beautiful tree-shaded garden of Lekhampton House adds to this feeling, for it is quite a distance from the buildings in the area and is seated all alone at the end of the green near what appears to be the beginning of a forest.

I first saw a cast of this sculpture many years ago at Moore's home in Much Hadham, England. It was located on a long path through a cluster of trees, quite some distance from the house. One night some gypsies knocked the head off the sculpture, apparently thinking they could melt the metal and sell it for a good price. Moore was very amused at this misjudgment of value and has told the story many times with a twinkle in his eye.

Lekhampton House is a good long walk from the center of town, and I had some difficulty finding it. When I did spot the figure on the corner of the green and realized that it was a cast of the sculpture that I had never photographed before, I was quite excited. It was one of those days when the sun went in and out of the clouds, and I waited patiently to photograph the piece with and without the benefit of sunlight. As it turned out, the sun threw a sharp and distorting shadow over the figure, and the photographs in the shade turned out to be far more satisfactory.

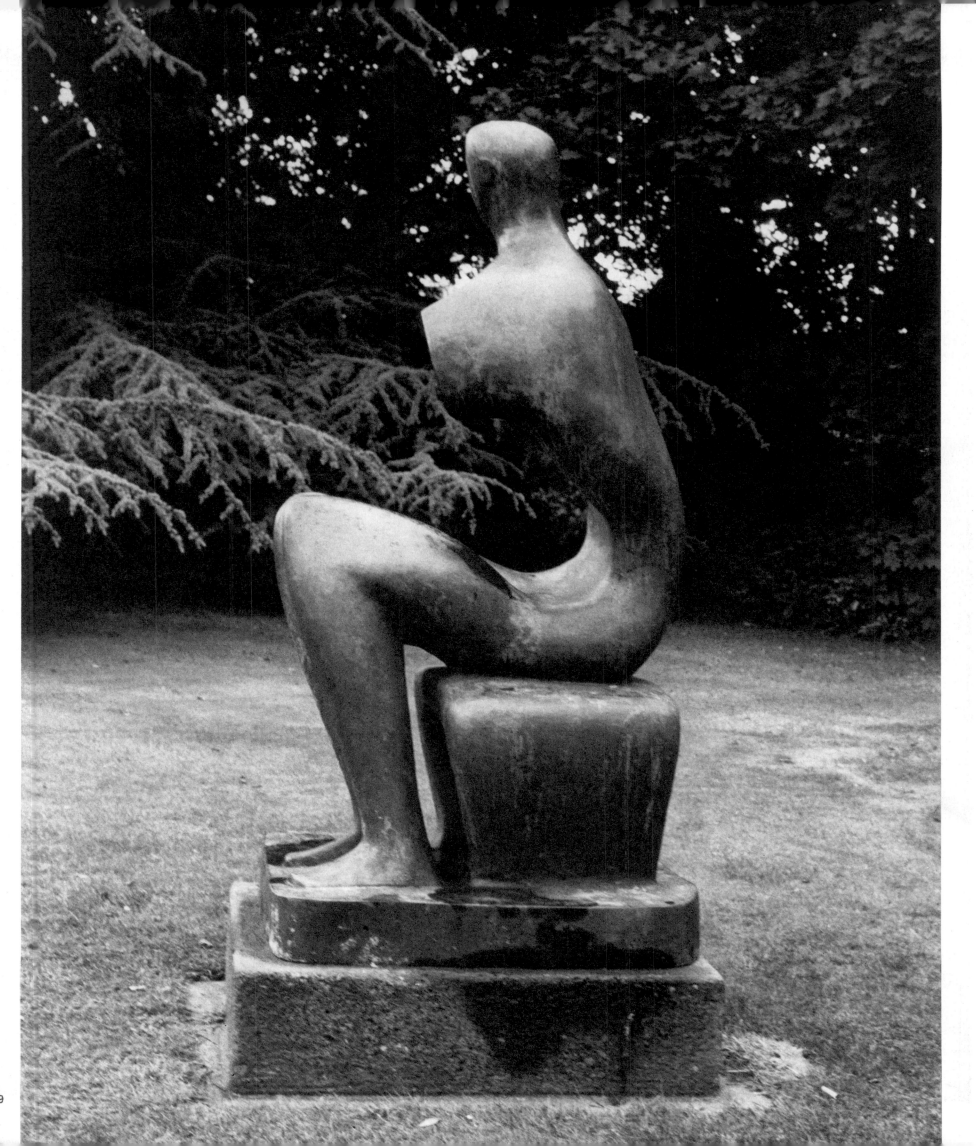

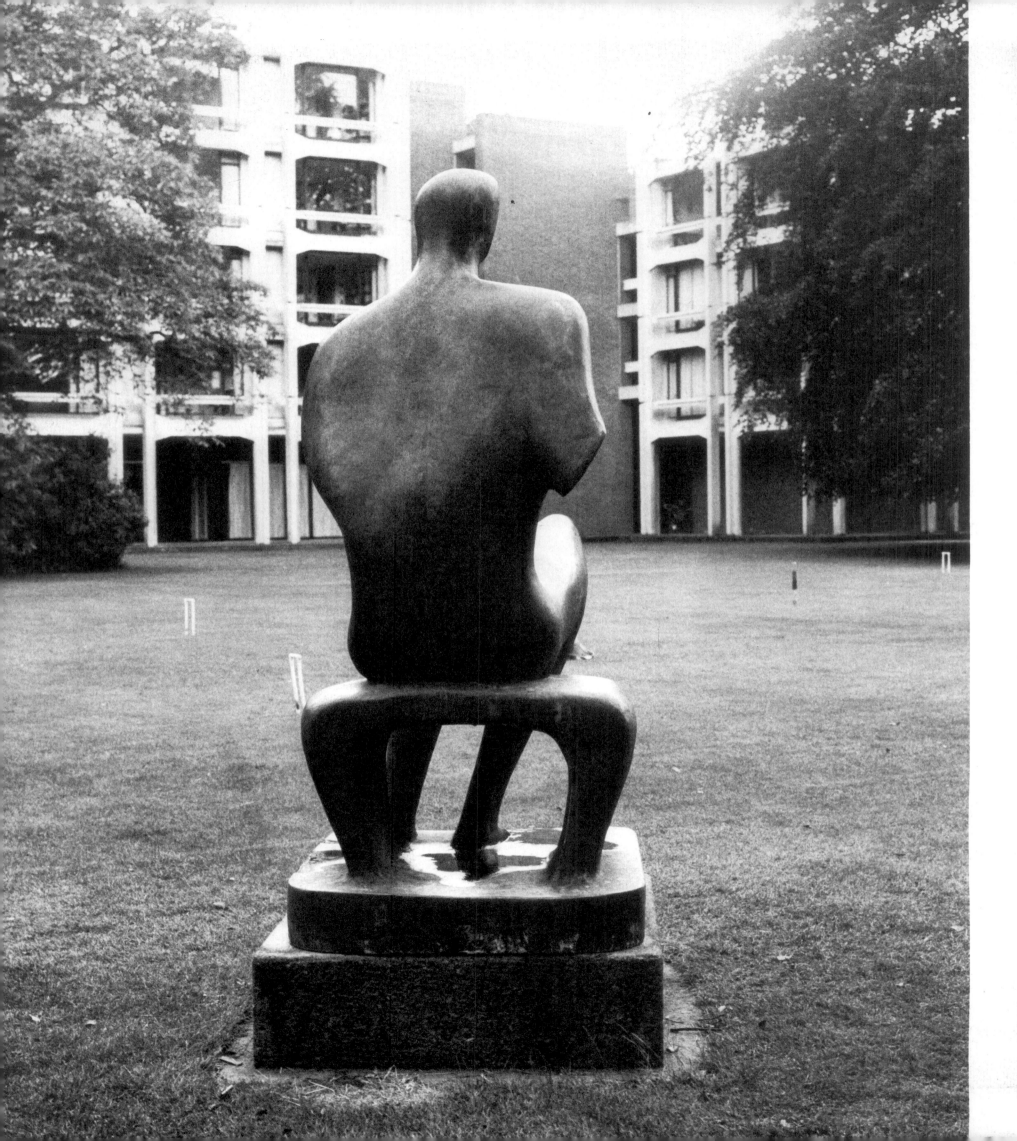

SCOTLAND

RECLINING FIGURE

1951. BRONZE, L. 90". SCOTTISH NATIONAL GALLERY OF MODERN ART, EDINBURGH

This sculpture is one of two Moores in a lovely, small museum located in the middle of Edinburgh's botanical gardens, which are on a hill overlooking the main part of the city. The permanent collection of the museum is quite limited, and there are several galleries available for traveling exhibitions. The *Reclining Figure* is one of a few choice sculptures in the garden outside the museum building.

The work itself is a masterpiece of

innovation. Although I think that other Moore sculptures may be stronger or more dramatic, one cannot escape the feeling of discovery in this particular piece. I was especially struck by the lines made by strings placed in the plaster, which when cast in bronze, seemed to give added strength to the space-form relationship. The *Reclining Figure* is a brilliant display of creative imagination, and this is a fine outdoor place to see it in its full glory.

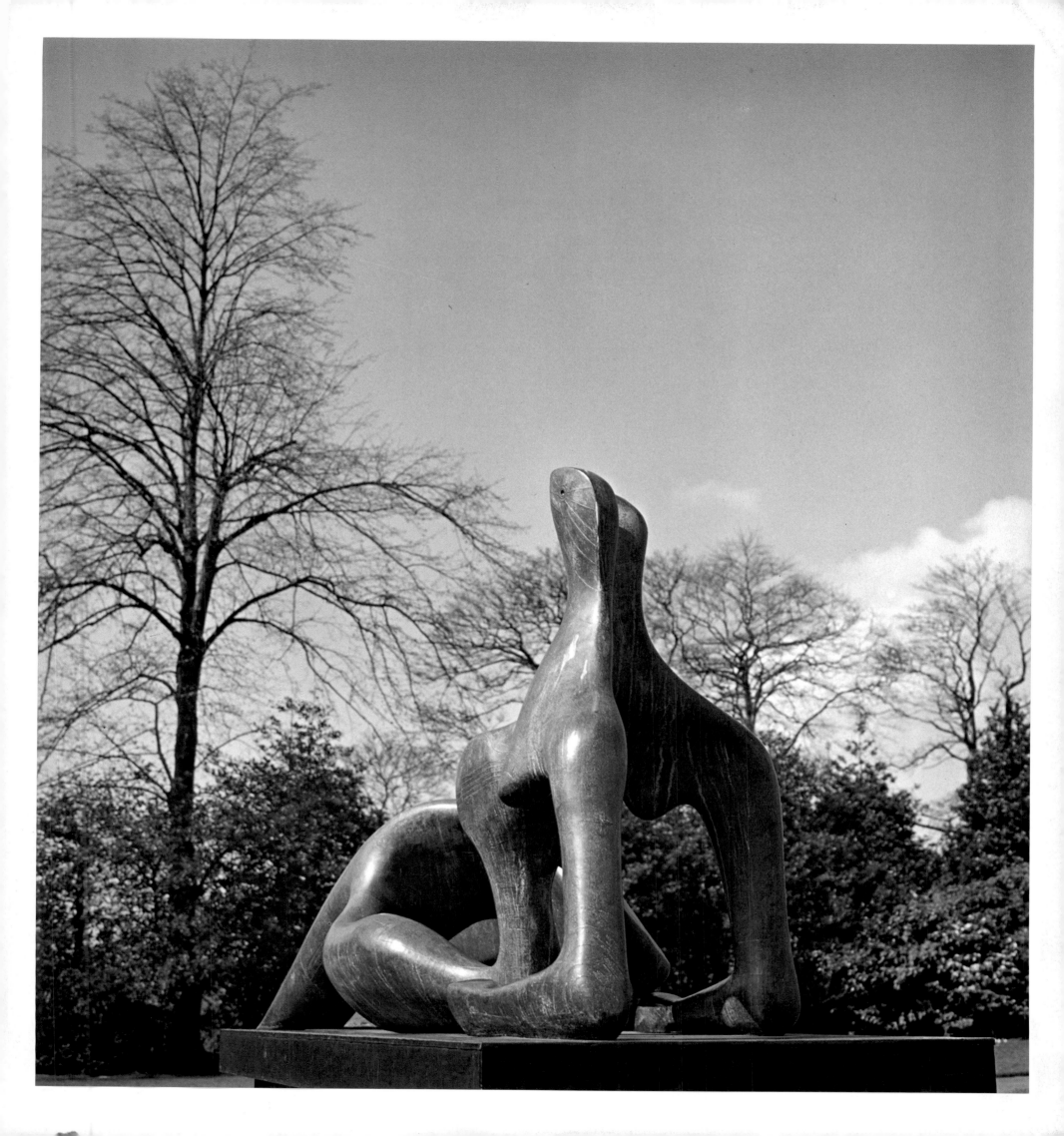

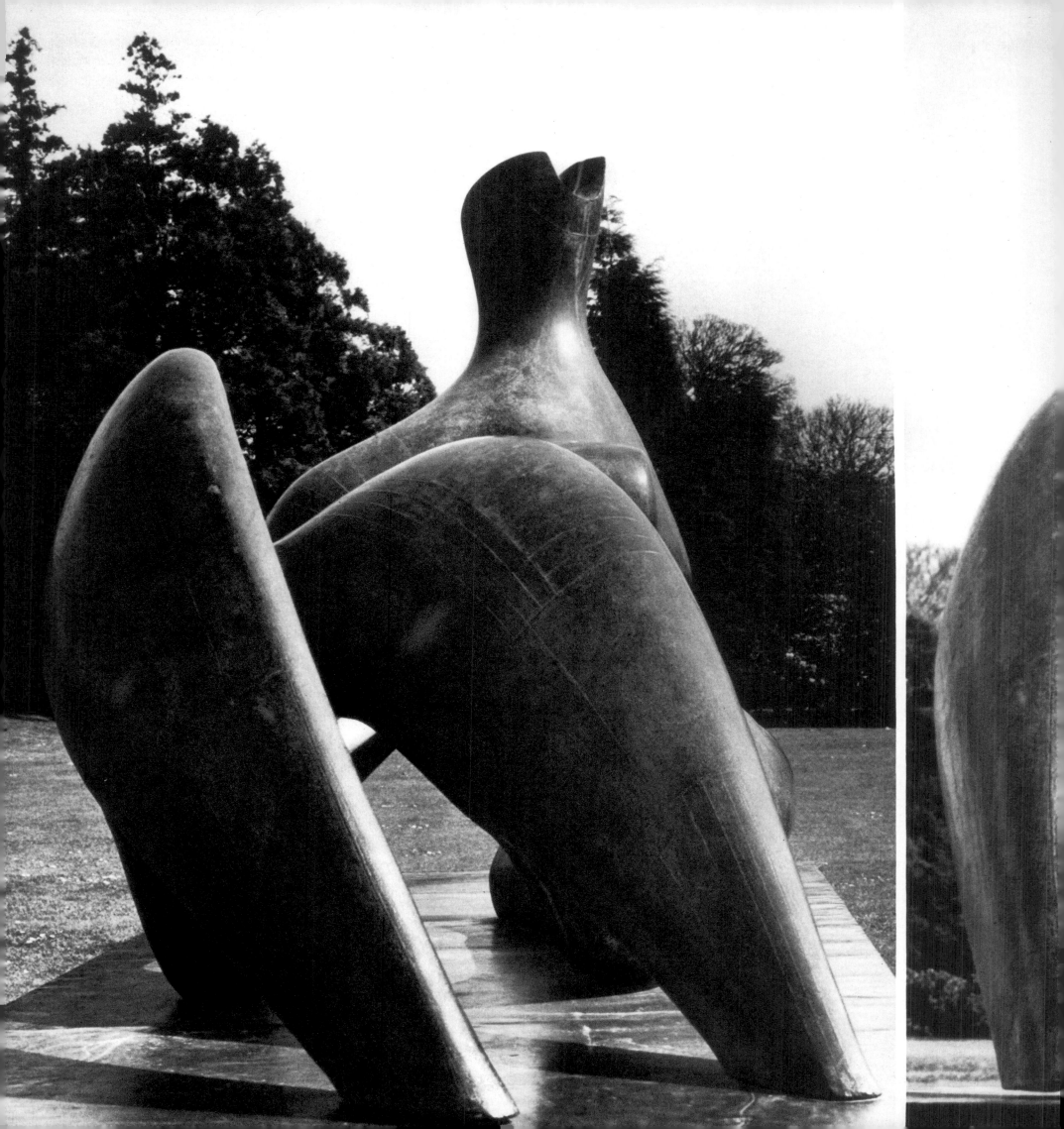

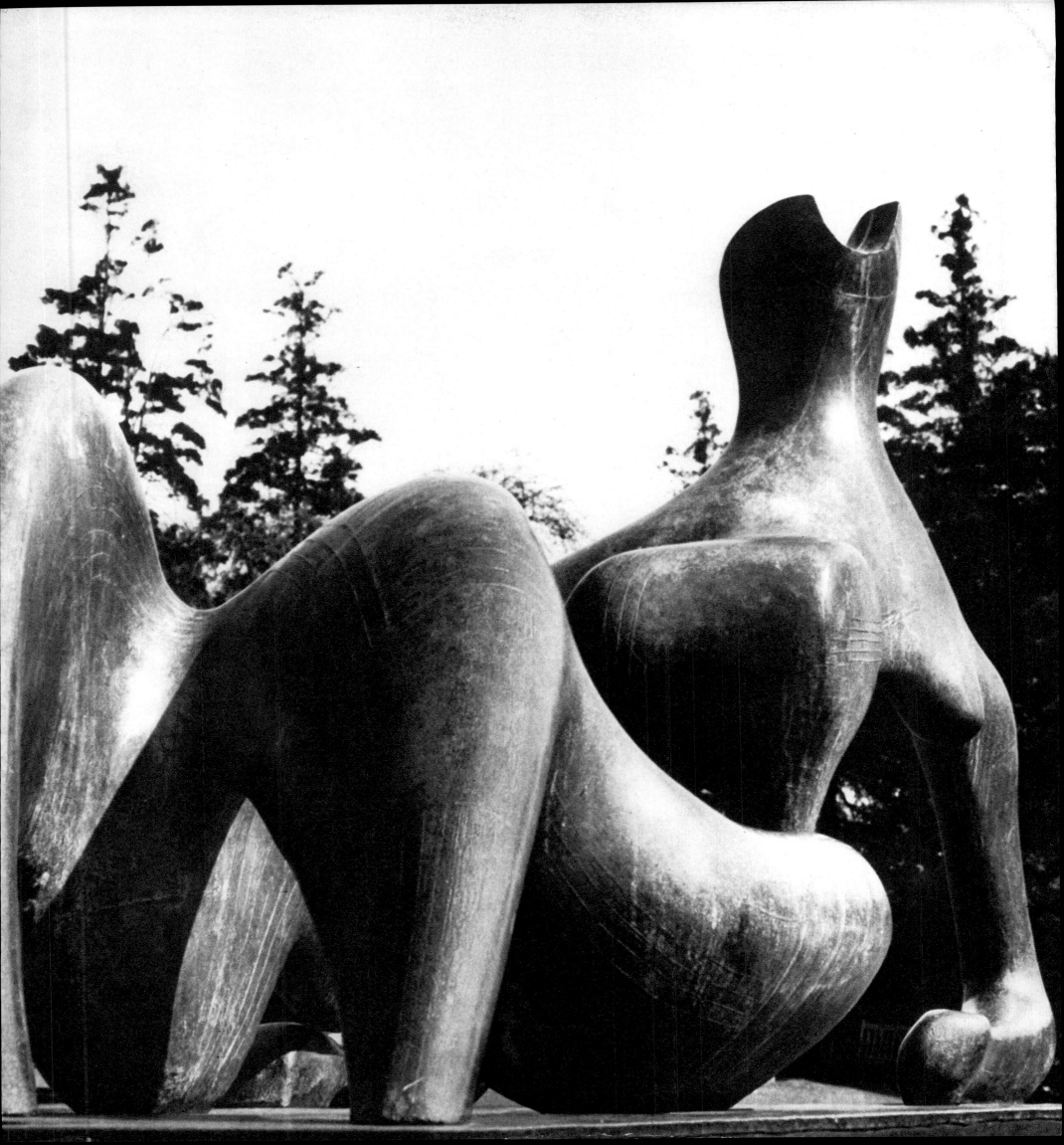

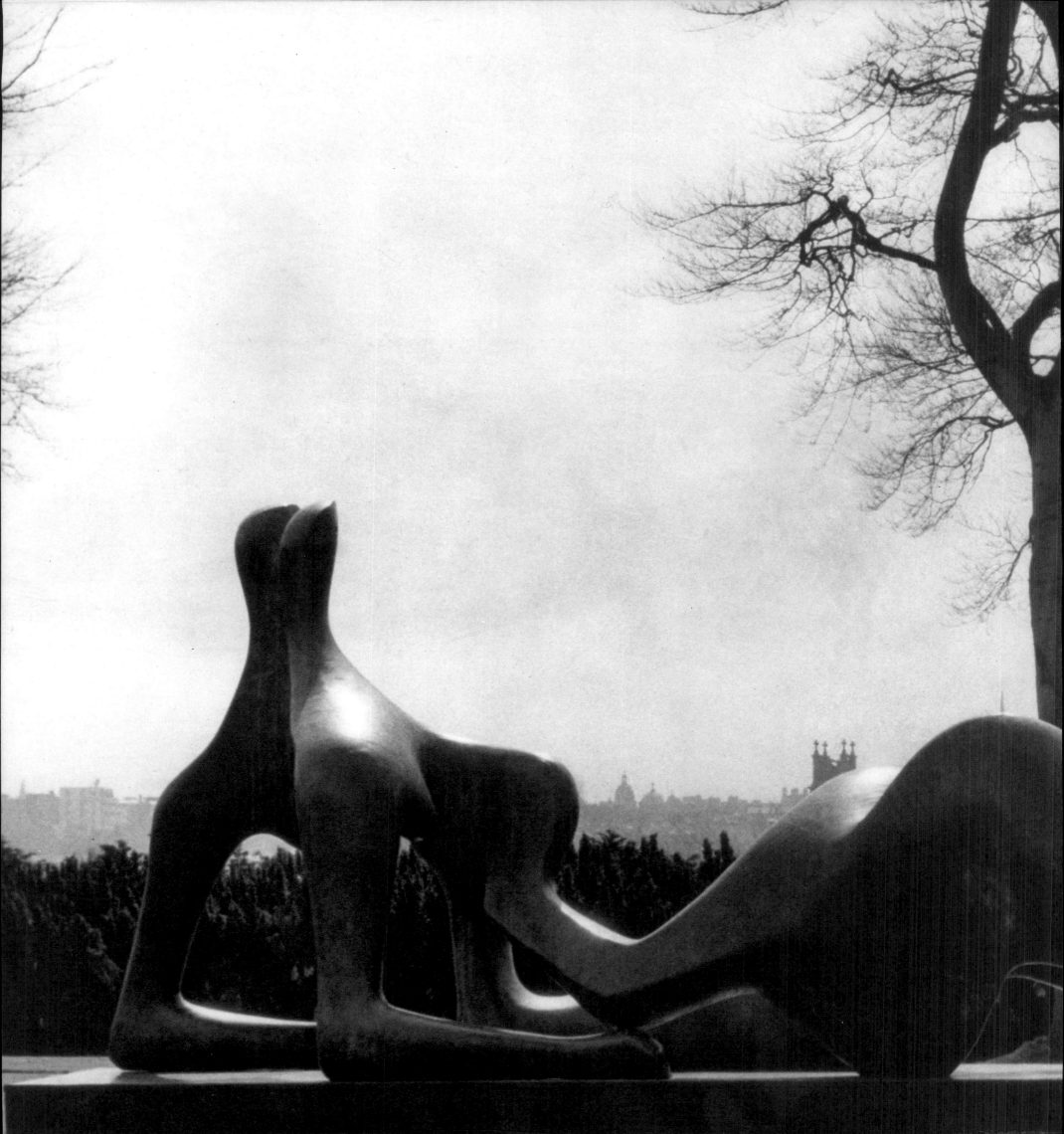

This sculpture is in bronze, though its original was made in plaster built up on an interior metal armature. A complex bronze sculpture cannot be produced by the sculptor shaping it from a solid lump of bronze. To produce a bronze sculpture, the sculptor usually makes his original in some other material (most often clay, wax, or plaster). A mould is made from this original, and into it the molten liquid is poured. The liquid is then allowed to cool and solidify into the bronze copy.

This figure was perhaps my first conscious effort to make space and form absolutely inseparable. I became conscious of this aim half-way through the sculpture. In earlier works, particularly in my carvings, when I wanted to make space in stone sculpture it had been more difficult. Making a hole in stone is such a willed thing, such a conscious effort, and often the holes became things in themselves. But then the solid stone around them sometimes suffers in its shape because its main purpose is to enclose the hole. This isn't a really true three-dimensional amalgamation between forms and space.

I think this is the first sculpture in which I succeeded in making form and space sculpturally inseparable.

—Henry Moore

TWO-PIECE RECLINING FIGURE 2

1960. BRONZE, L. 8'6". SCOTTISH NATIONAL GALLERY OF MODERN ART, EDINBURGH

Located in the same outdoor garden as the 1951 *Reclining Figure* (see pp. 282–87), this sculpture can be seen and studied more clearly here than in the wooded area surrounding the cast at the Kröller-Müller Museum in Otterlo, the Netherlands (see pp. 174–75). The site is less mysterious, and one misses the drama of the other setting, but it is much easier to photograph the work here and to show its details.

It is especially interesting to see the evolution of the sculptured spaces of the 1951 *Reclining Figure* into the cavernous openings of the 1960 *Two-Piece Reclining Figure #2*. The latter, which is one figure in

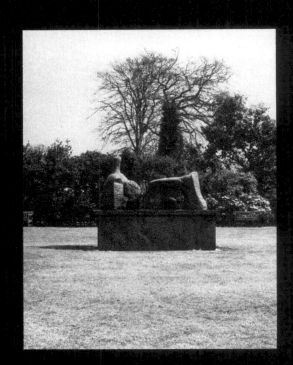

two parts, consists of interrelating broken forms and rocky cavities. I enjoyed photographing the interior spatial areas, which I felt anticipated some of the more developed forms in the *Reclining Figure* that was done shortly afterwards for Lincoln Center in New York (see pp. 328–37).

I like the photographs of this sculpture much better in this location than in the Kröller-Müller Museum (see pp. 174–75). The light is good and you can see the modelling of the figure very clearly.

—Henry Moore

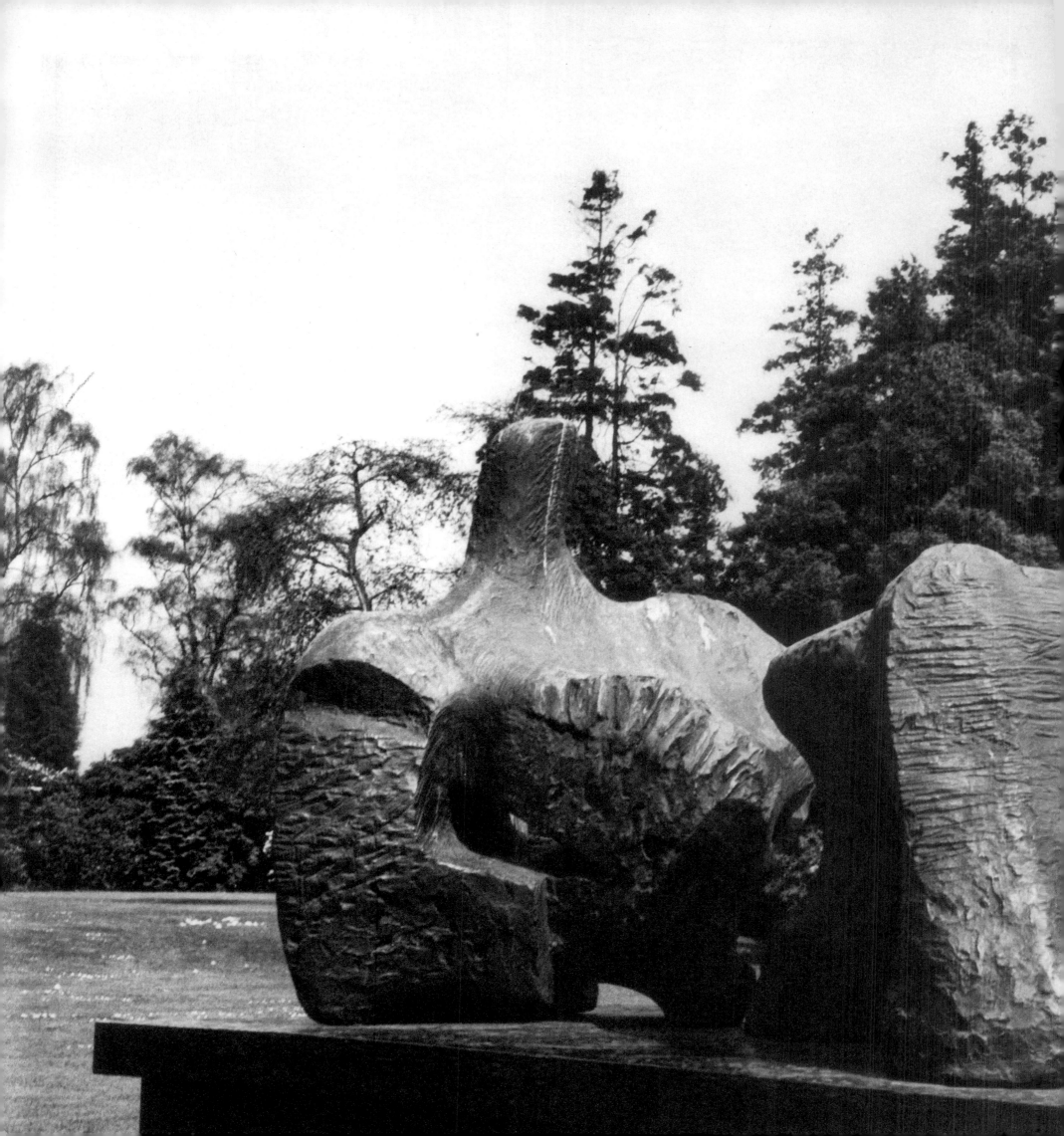

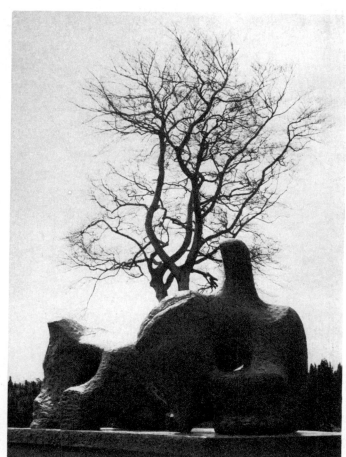

STANDING FIGURE

1950. BRONZE, H. 87". GLENKILN, SHAWHEAD, DUMFRIESSHIRE, SCOTLAND

This is one of the four extraordinary placements of Moore sculptures on the Keswick sheep farm near Dumfries, Scotland. Although it is privately owned, the farm, which is named Glenkiln, has become world famous as the magnificent setting of these sculptures. Public roads pass through Glenkiln, and in recent years there has been an increasing flow of visitors who drive by just to see the sculptures.

Unlike the other works at Glenkiln, this figure is not placed on a hill; it is quite near the public road, perched on a giant rock that is an ideal pedestal for the piece. One can see the sloping hills in the background, and as one walks around the sculpture, the unusual curves of the figure produce astonishing effects. The work does not lend itself to the kind of detail photographs one can take of most of Moore's other pieces; it is the whole figure that is so striking.

The shapes of the *Standing Figure* have

long been fascinating to Moore, and he has a carved marble copy of the piece in his studio, which he has worked on over a long period of time in a further private and personal exploration of its possibilities. The marble copy has proved to be a virtuoso piece of carving, since Moore has eliminated most of the supports that he at one time thought were necessary to bind its delicate strands together. In describing this carving, Moore has referred to the influence of Bernini. In his youth, Moore explains, Bernini had not been a favorite of his. Moore always believed that the material being carved should be respected and not be made to look like cloth or hair or some other substance, as Bernini sought to do. As he matured, however, Moore grasped an essential aspect of Bernini's control of his materials, the bold cutting away of supports that distracted from the figure itself, and was able to apply this to his own work.

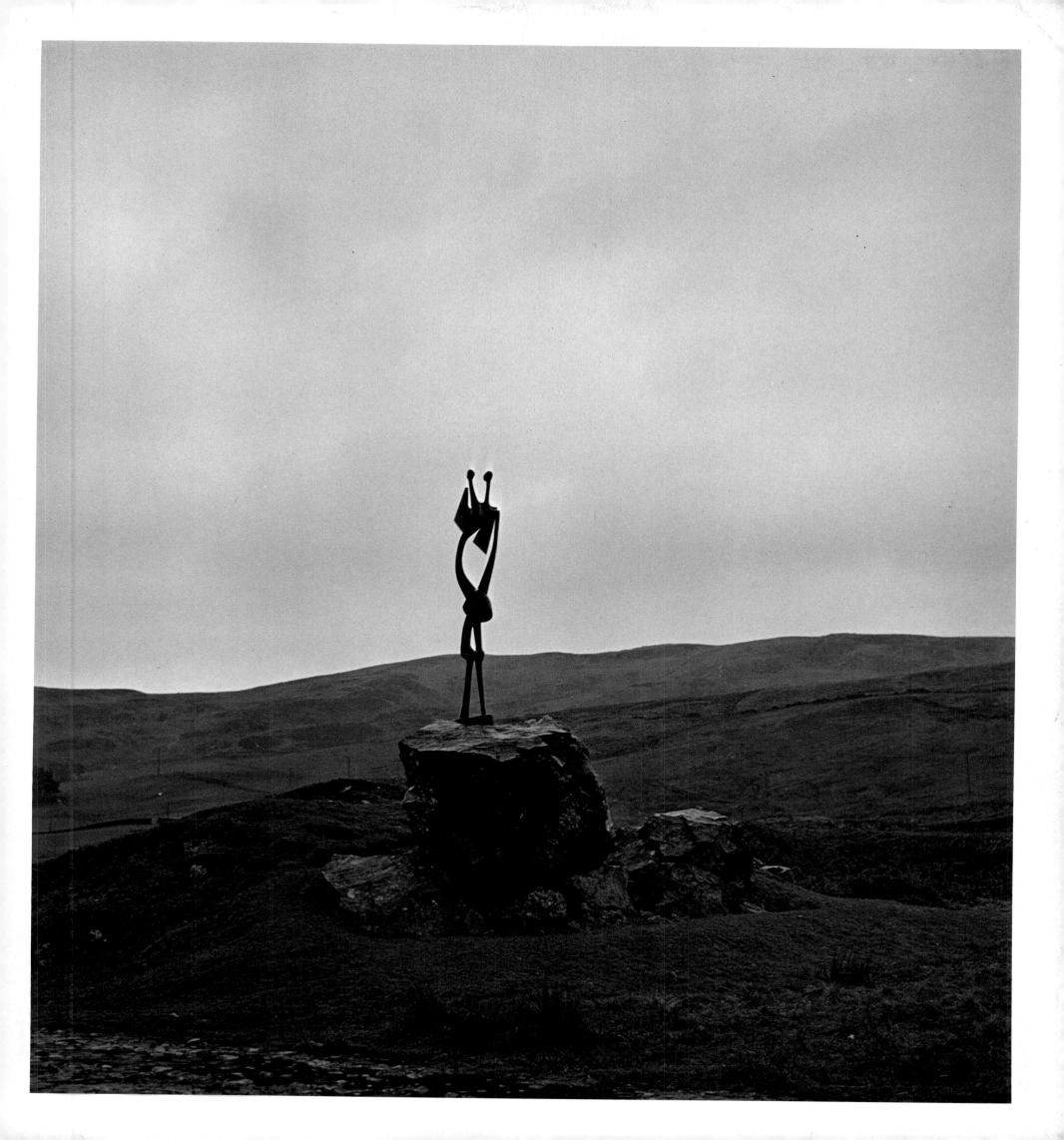

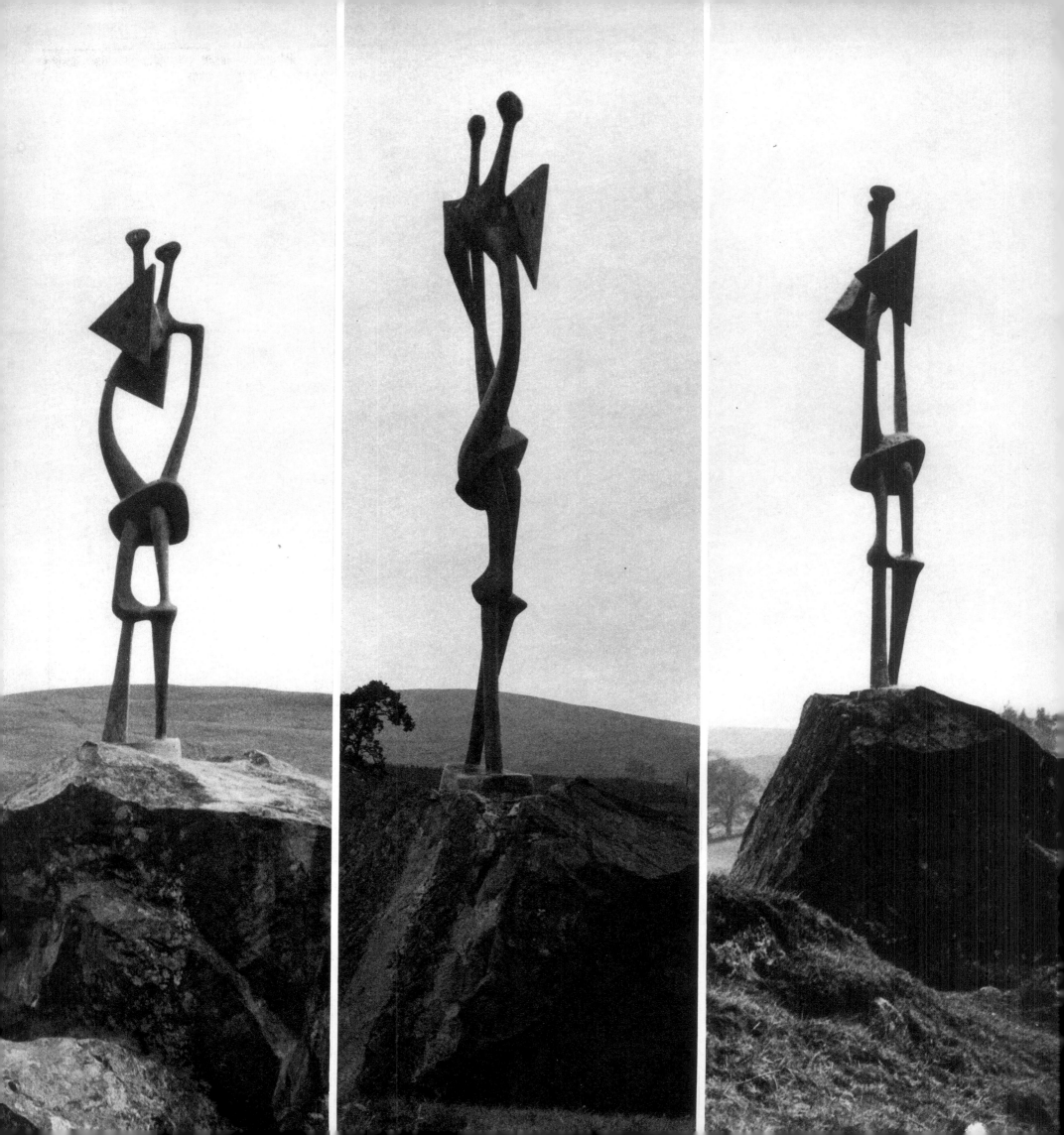

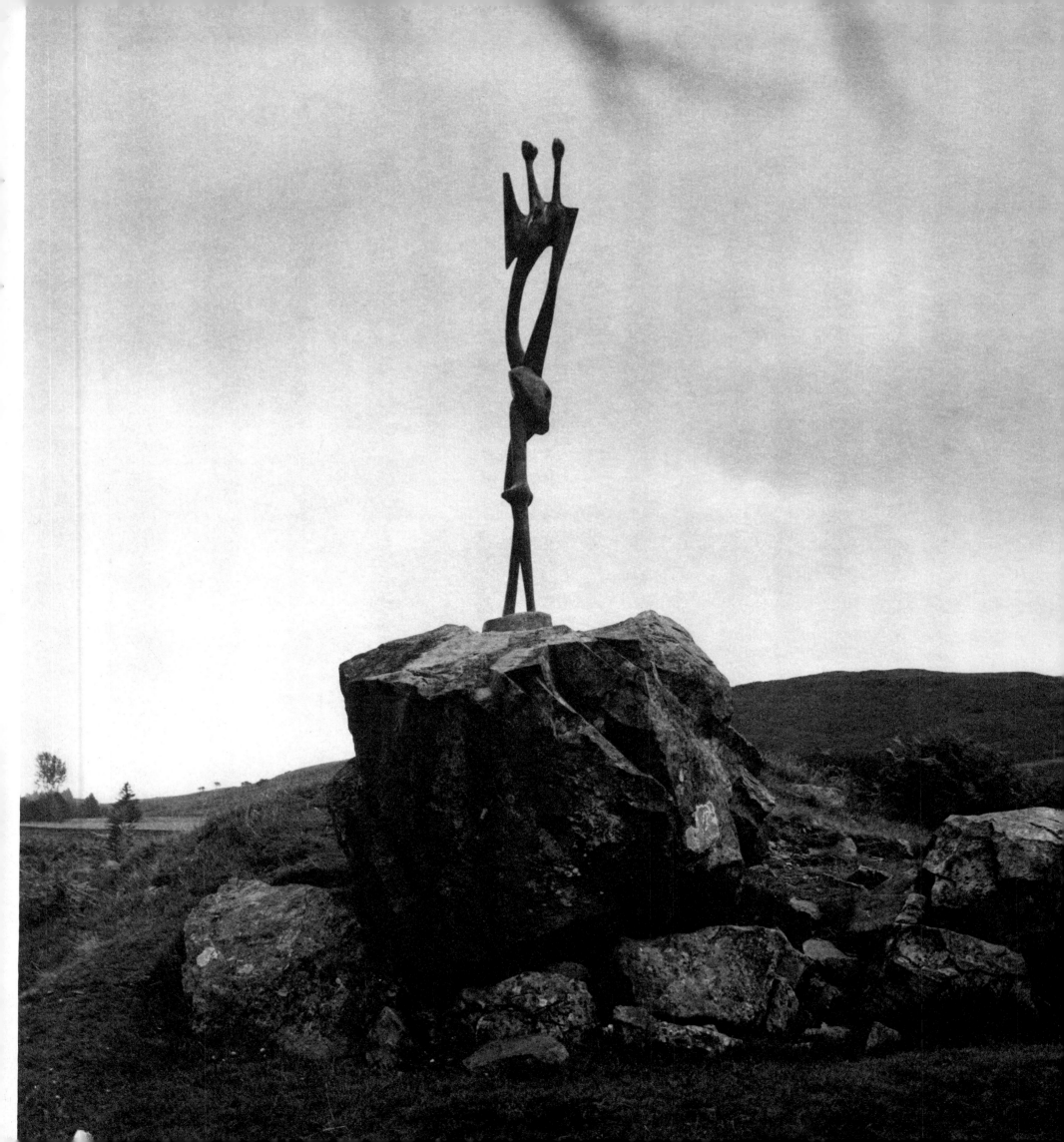

Sir William Keswick came to me after he had seen this piece in an exhibition (it may have been the second Battersea Park exhibition). He told me about his sheep farm in Dumfriesshire, Scotland, and said its large acreage was unsuitable for agricultural farming because the ground was too rocky. I don't know whether he got the idea to put sculpture on his sheep farm after he saw the Battersea Park open-air exhibition, or whether he was inspired by his experience in China, where he had lived for many years, and where, he said, there are many examples of monumental sculptures in the open air. In any case, he bought this piece to put on his farm in Scotland.

He placed the sculpture himself on an existing outcrop of rock. Later I went up there and was thrilled with the beautiful landscape and at how well he had sited "Yon Figure" (the sculpture's local name).

—Henry Moore

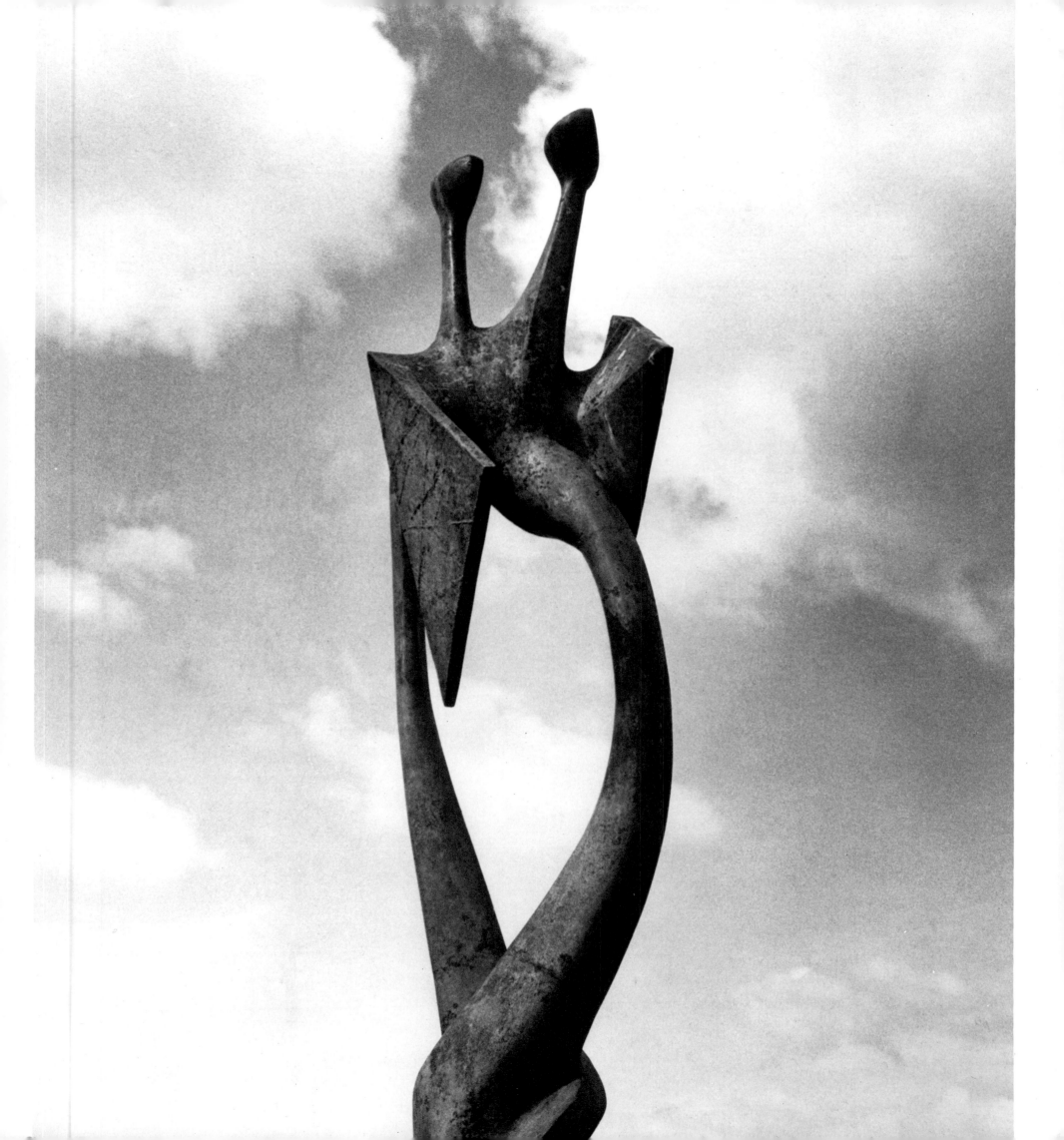

KING
AND
QUEEN

1952–53. BRONZE, H. 64 1/2". GLENKILN, SHAWHEAD, DUMFRIESSHIRE, SCOTLAND

The *King and Queen* is one of Henry Moore's most famous images, and Moore has always loved photographs showing the piece on the hills of Glenkiln. For years he has had a series of these photographs mounted on a board in one of his studios, as if the place— Glenkiln—were as much a work of art as the sculpture itself. It would be hard to imagine a more ideal setting for the work. The two regal figures sit on a high promontory overlooking their kingdom of lakes and moors, which stretches for miles in all directions, with sheep grazing peacefully throughout. Their primitive throne and animal-like heads identify the king and queen with man's earliest ancestors. The whole work is placed on a sensitively arranged pile of rocks. Nothing about the setting seems in the least bit artificial.

The road that passes below is sufficiently removed so as not to interfere with the

unspoiled landscape. The body of water at the foot of the hill is actually a reservoir but has the appearance of being a large natural lake. Indeed the only jarring element in the scene is a single telephone or electric wire that passes above the sculpture.

For me, the climb up the hill to the *King and Queen* has become something of a ritual experience. Approaching the work I experience a sense of awe, mystery, and reverence. It has somehow endowed the place with a profound meaning that can only be understood by being there. I once saw the two figures sitting on their throne in the midst of a driving rainstorm. Another time I saw them with a clear and sparkling blue sky above. I have seen them in gusty autumn weather and in the springtime, with unshorn sheep grazing at their feet. I think at any time of the year this is one of the most beautiful spots in the world.

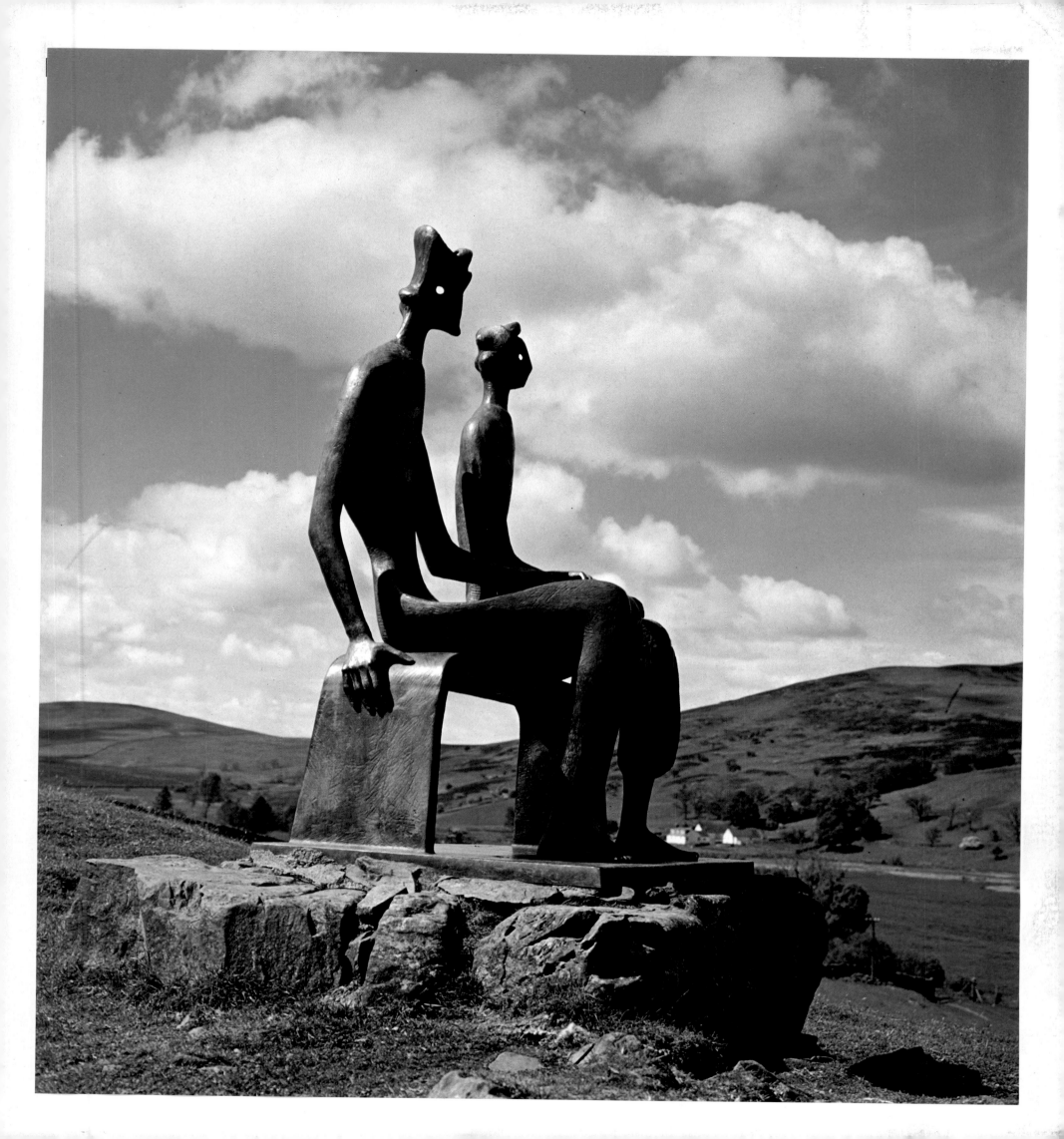

This is the second piece acquired by Sir William Keswick for Glenkiln. As with the others, he chose the location himself. This is the remarkable thing about Sir William. He spends three or four months every year on his farm in Scotland, and he loves the place. He also loves sculpture. So he married the two in a very real and profound way. If I had gone up there and told him where to put a sculpture, I would not have done as well as he did. To properly place a sculpture in nature, one should take a long time. If it is to be done right, one should know the locality, its changes throughout each hour of the day and throughout the seasons of the year. Here in Much Hadham I keep changing my mind about where I want to put certain pieces. I move them around until I feel they are right. But this you can't know in an afternoon. Sir William understands this, and that's why he found perfect places for his pieces.

I like the natural non-geometric rock pedestals at Glenkiln, but you can't use stone like that everywhere. In some places it would be quite inappropriate. At Glenkiln there are natural outcroppings of rock. Glenkiln hasn't been landscaped—the landscape is there.

—Henry Moore

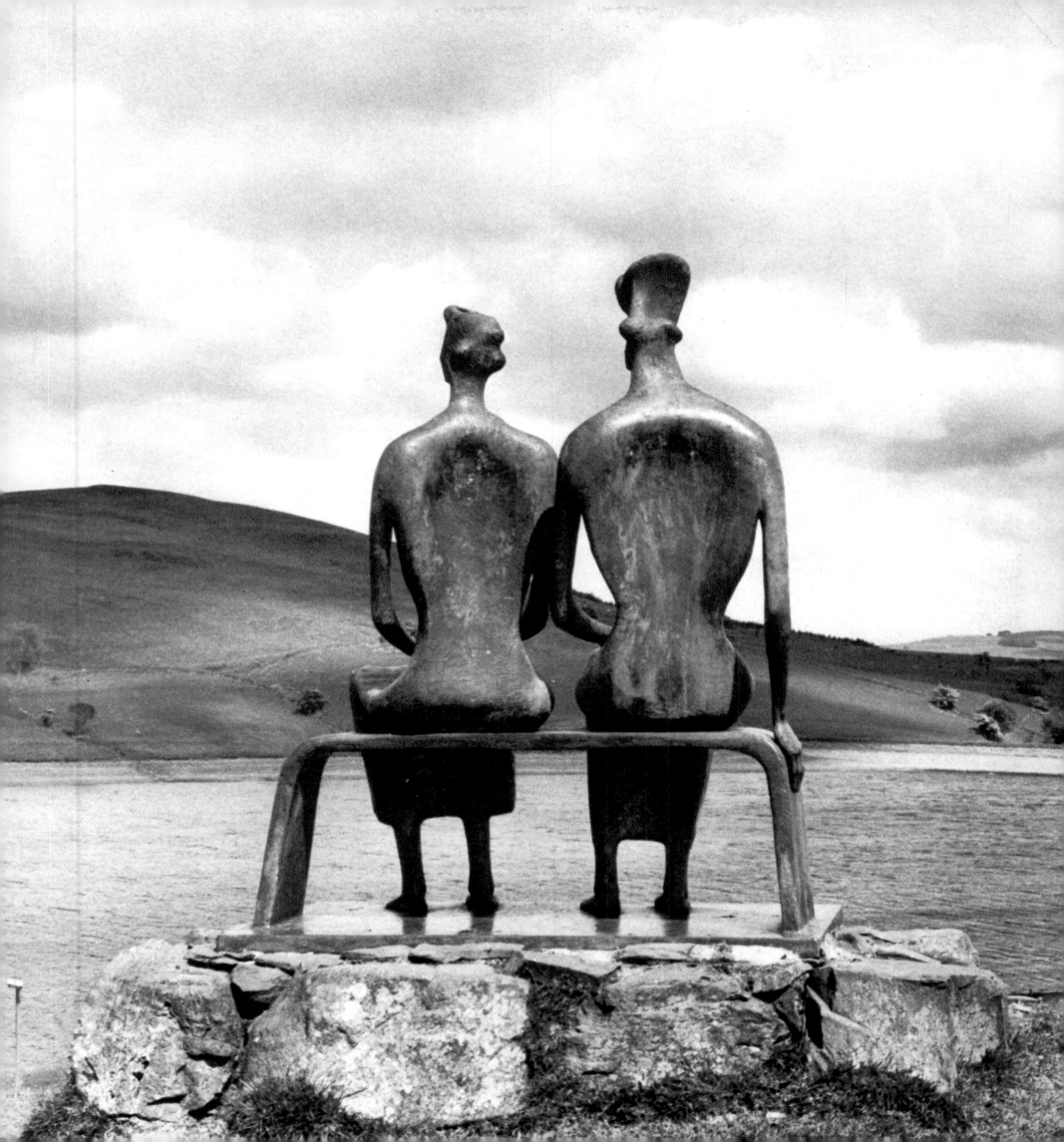

UPRIGHT MOTIVE 1: GLENKILN CROSS

1955–56. BRONZE, H. 11′. GLENKILN, SHAWHEAD, DUMFRIESSHIRE, SCOTLAND

The *Cross* is placed on one of the highest points of Glenkiln. It resembles a cross erected for religious purposes on a hilltop overlooking a town, and the setting is perfect for one of Moore's mysterious Upright figures. From the road below, which is where most people stand to view the piece, one appreciates its awesome character. Yet from that vantage point it is so remote that one cannot consider its finer sculptural qualities. If one climbs the hill and sees the sculpture at close range, the *Cross* becomes a mixture of fantastic forms. Moore has been stimulated by such close-up views of the sculpture and has recently made drawings of the work at Glenkiln.

It is almost always windy when one reaches the top of the hill where the

sculpture stands, but it is an exhilarating experience to see the *Cross* against the vast expanse below.

This sculpture got the name Glenkiln Cross *because it was first set up on Sir William Keswick's farm, which is called Glenkiln. I preferred it to any of the other* Upright Motives *for this spot because, even seen from a long distance away, it had the symbol of a cross on it. . . . You always notice a cross; it marks the spot, just as one says, "X marks the spot."*

Sir William chose this site, as he did the other sites.

—Henry Moore

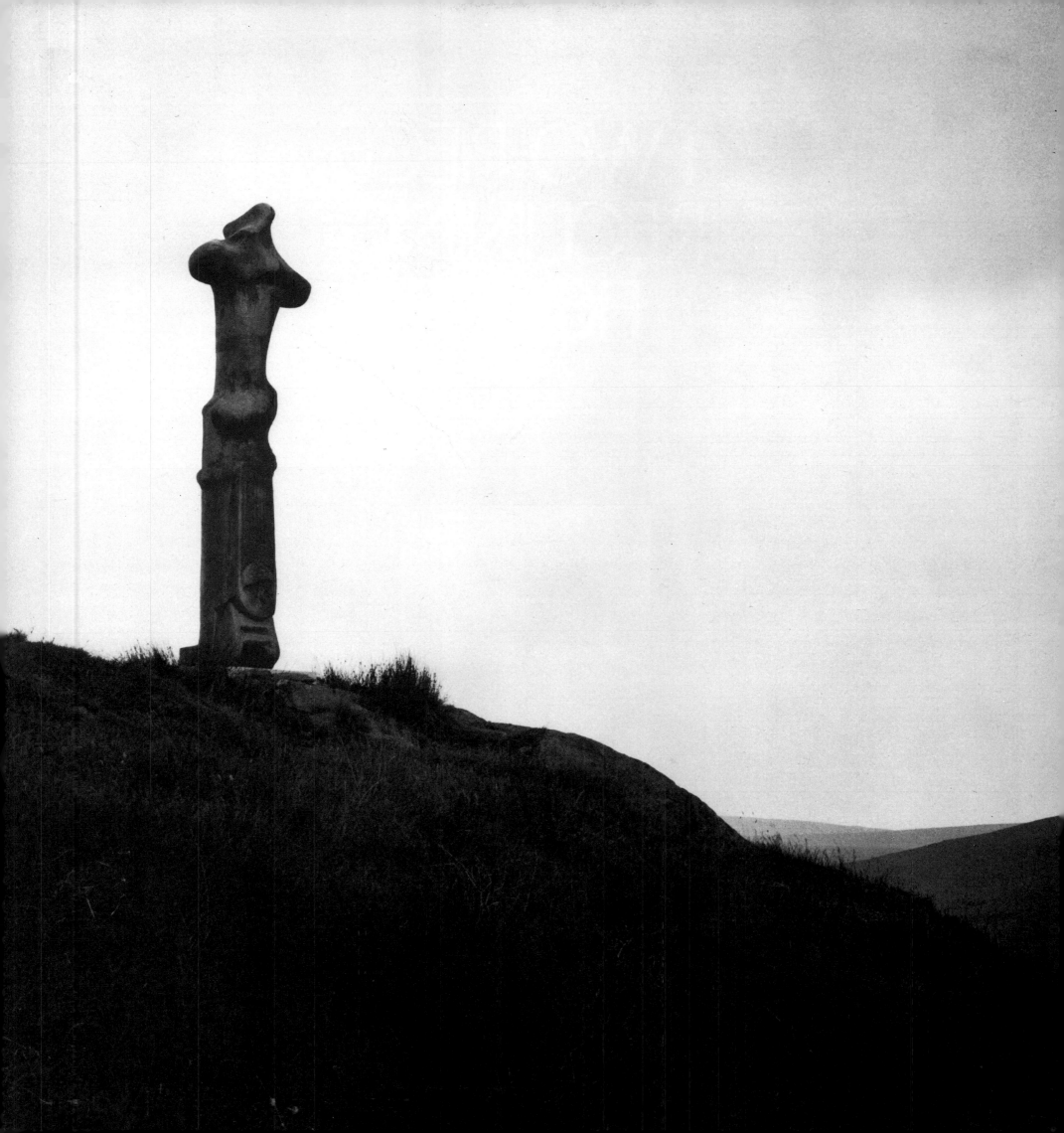

TWO-PIECE RECLINING FIGURE 1

1959. BRONZE, L. 76". GLENKILN, SHAWHEAD, DUMFRIESSHIRE, SCOTLAND

Two-Piece Reclining Figure #1 is the last sculpture to have been installed at Glenkiln. Located on a separate road from the others, it sits on top of a slope overlooking a ravine. There is a vast panorama of hills in the distance and a dark forest nearby, both of which provide a dramatic setting for the figure. A rough-hewn rock serves as the pedestal for the piece.

The figure is very strong. Its two elements are filled with energy and tension, and in some views the sweeping foot, which Moore likened to the rock in Seurat's painting *Le Bec du Hoc*, has a phallic shape. The bust is noble and self-confident, strong enough to confront the driving winds and rains of the moors. In the side views one feels a quality

like that of ancient rocks, filled with the mystery of time.

I have traveled to Glenkiln many times to see and photograph the Moore sculptures. The first time I was there I found myself in the midst of one of those heavy storms that blows like a hurricane across the open stretches of land, and I could hardly stand against the wind and rain to hold my camera in position. It was exhilarating to see this sculpture in the midst of such a storm, with the forces of nature contributing to the overall experience. These were not, however, the best circumstances for photographing the piece, and I was glad that the weather was clear on subsequent trips.

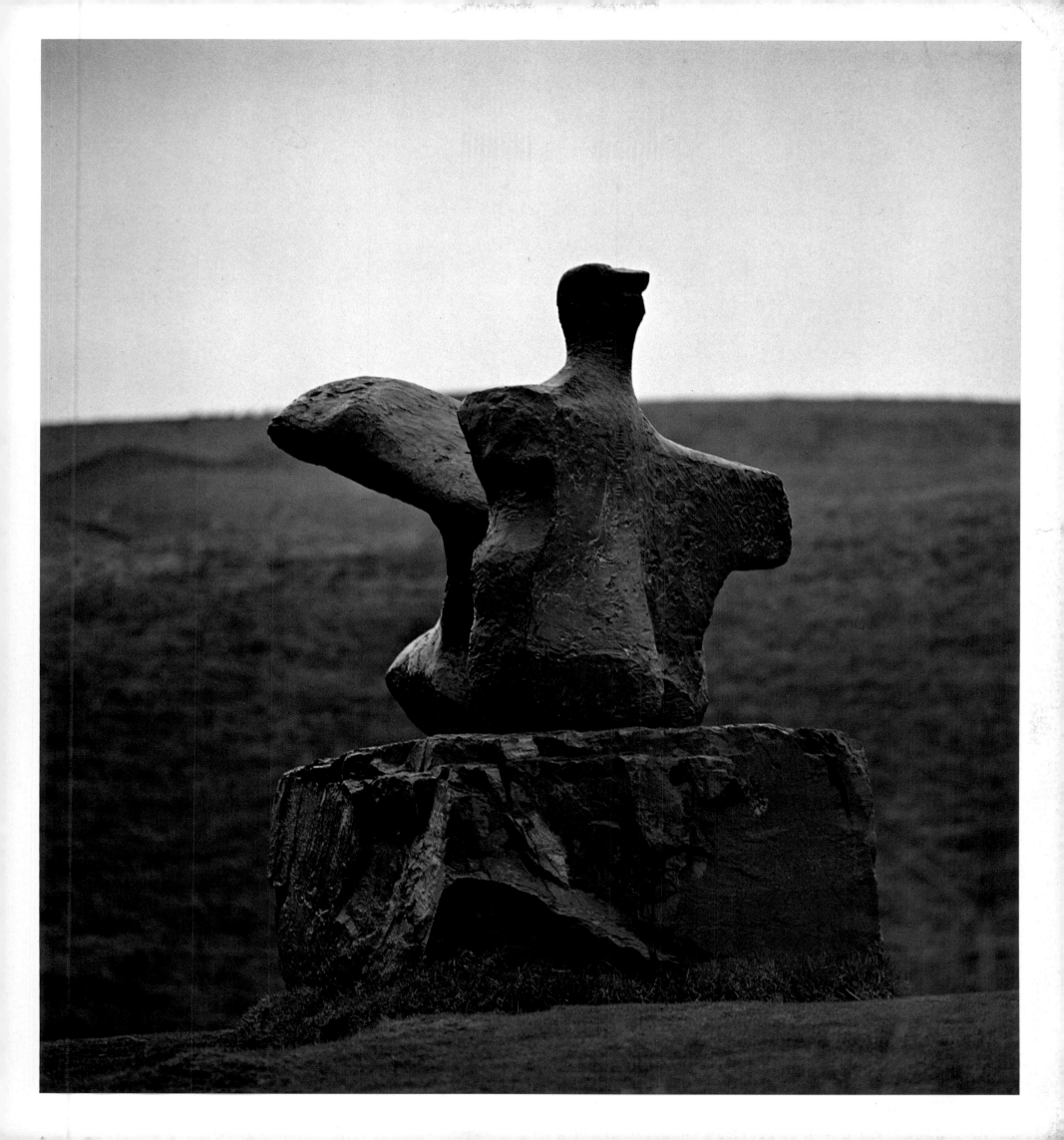

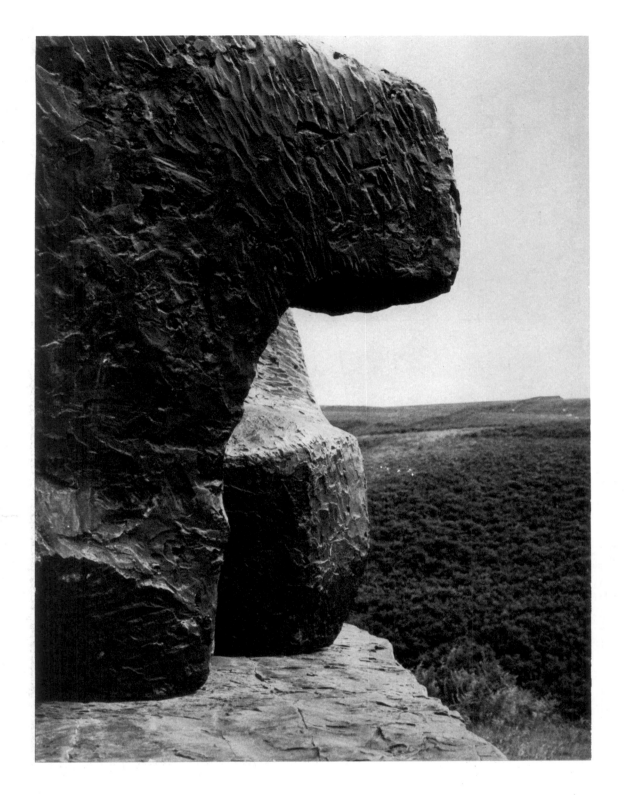

An awfully good site. Even if you're there on a misty
day it doesn't matter. It's a jolly good location. The
photographs are lovely.

You can see what I mean in saying the leg-end of
the sculpture reminds me of the rock in Le Bec du Hoc
(see p. 141).

<div align="right">

—Henry Moore

</div>

(see p. 141).

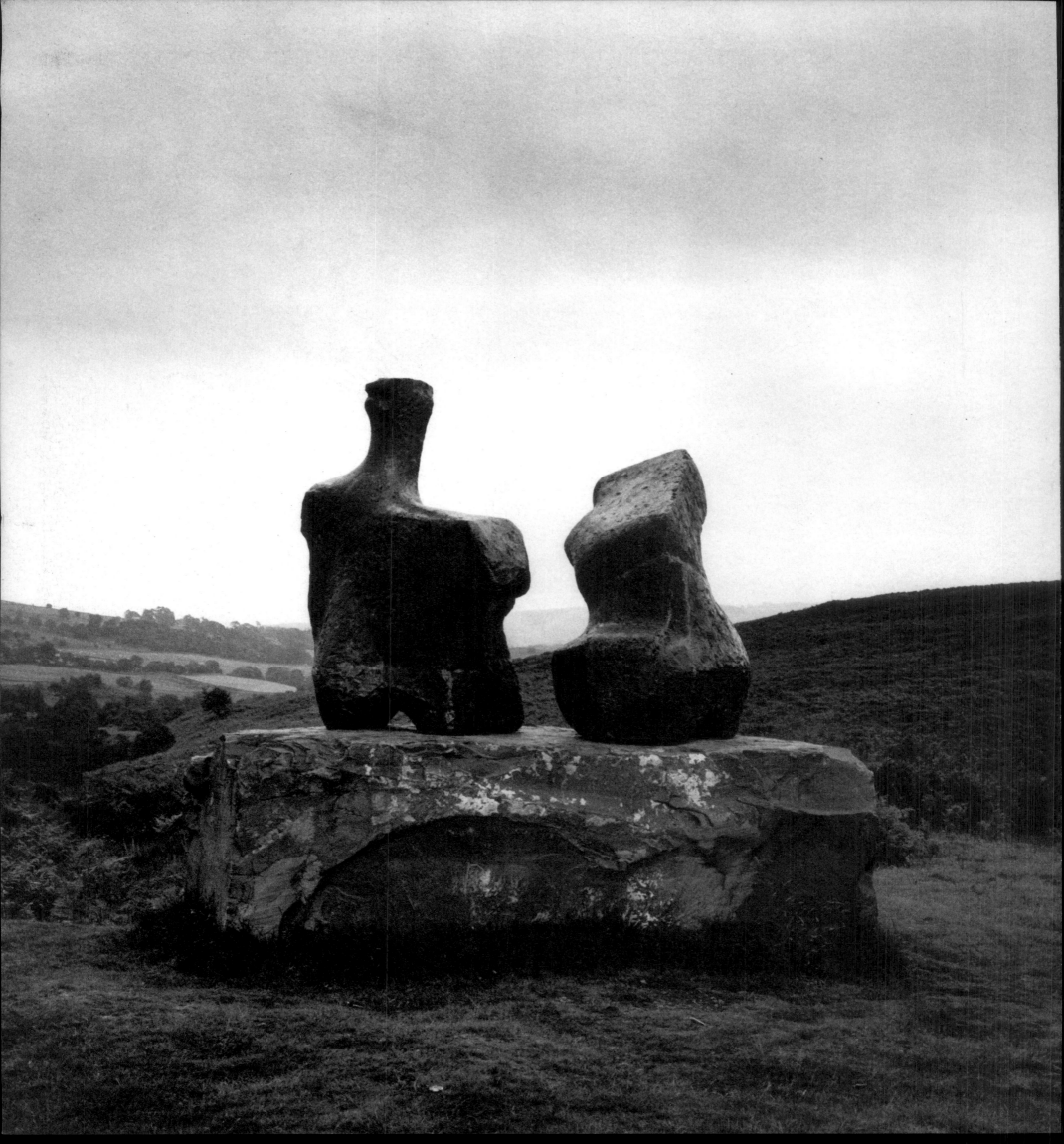

IRELAND

STANDING FIGURE: KNIFE-EDGE

1961. BRONZE, H. 9'4". ST. STEPHEN'S GREEN PARK, DUBLIN

One of Moore's simplest and most dramatic works, *Knife-edge* is a stunning example of how a sculpture can present entirely different shapes from each side and still retain its unity as a coherent work. The figure is replete with striking abstract forms on its flat, twisting surfaces and rises in a variety of graceful arcs that can be seen in the side views. By combining the sharp edges and large, undulating surfaces, Moore achieves a strong sculptural quality, introducing a theme that is repeated in many subsequent works.

This cast of *Knife-edge* was placed in St. Stephen's Green Park, the largest of Dublin's great squares, as a memorial to the poet William Butler Yeats. Surrounded by a grove of trees and centered in a well-designed series of terraces, the sculpture seems to be an

organic part of the landscape. A plaque on a nearby wall reads:

W. B. Yeats 1865–1939
A Tribute in Bronze by Henry Moore,
Erected By Admirers of the Poet
October 1967

My wife and I first saw a cast of *Standing Figure: Knife-edge* during one of our early trips to Moore's home in Much Hadham, England, and we have considered it one of our favorite Moores ever since. I photographed a cast of the same piece in Florence (see p. 479), but I feel the Dublin location is especially lovely. This may be partially because of its association with Yeats. I photographed the piece just after

314

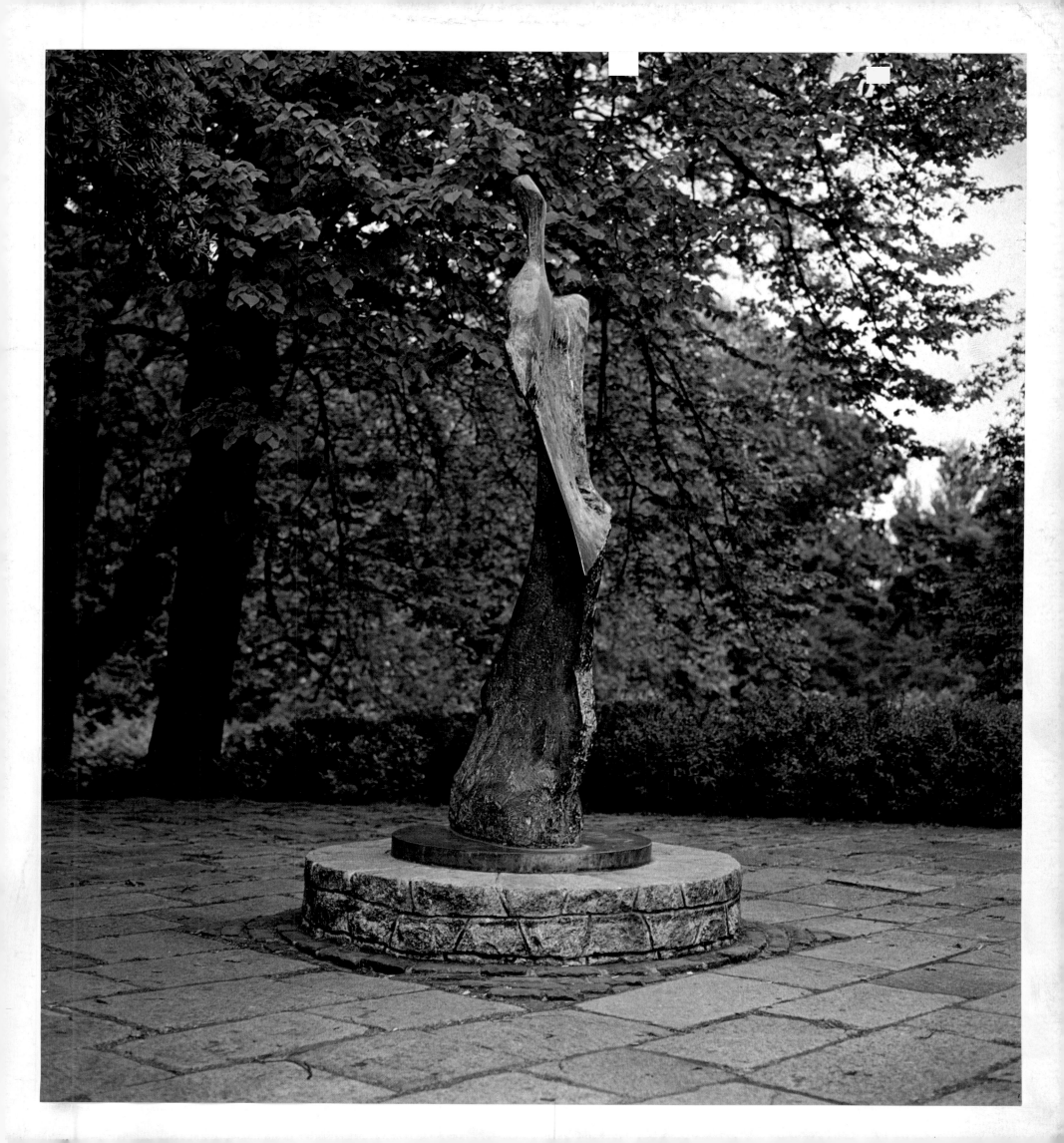

spending a few days in and around Sligo; there we saw many of the Yeats landmarks, including his grave in the small churchyard at Drumcliff, with the provocative lines on his tombstone from his poem "Under Ben Bulben":

> Cast a cold eye
> On life, on death.
> Horseman, pass by!

Also, the setting—in the middle of the city, yet intimate and natural, completely

surrounded by the lovely greens of the park—offers a combination of accessibility and remoteness that is unique.

Although we located the park without trouble, the sculpture was, as usual, not easy to find. Eventually an attendant took us into the heart of the park where it was placed. On the way he made disparaging remarks about the Moore sculpture, wondering why we were not more interested in the commemorative statue of Sir Arthur Guinness at the park's edge.

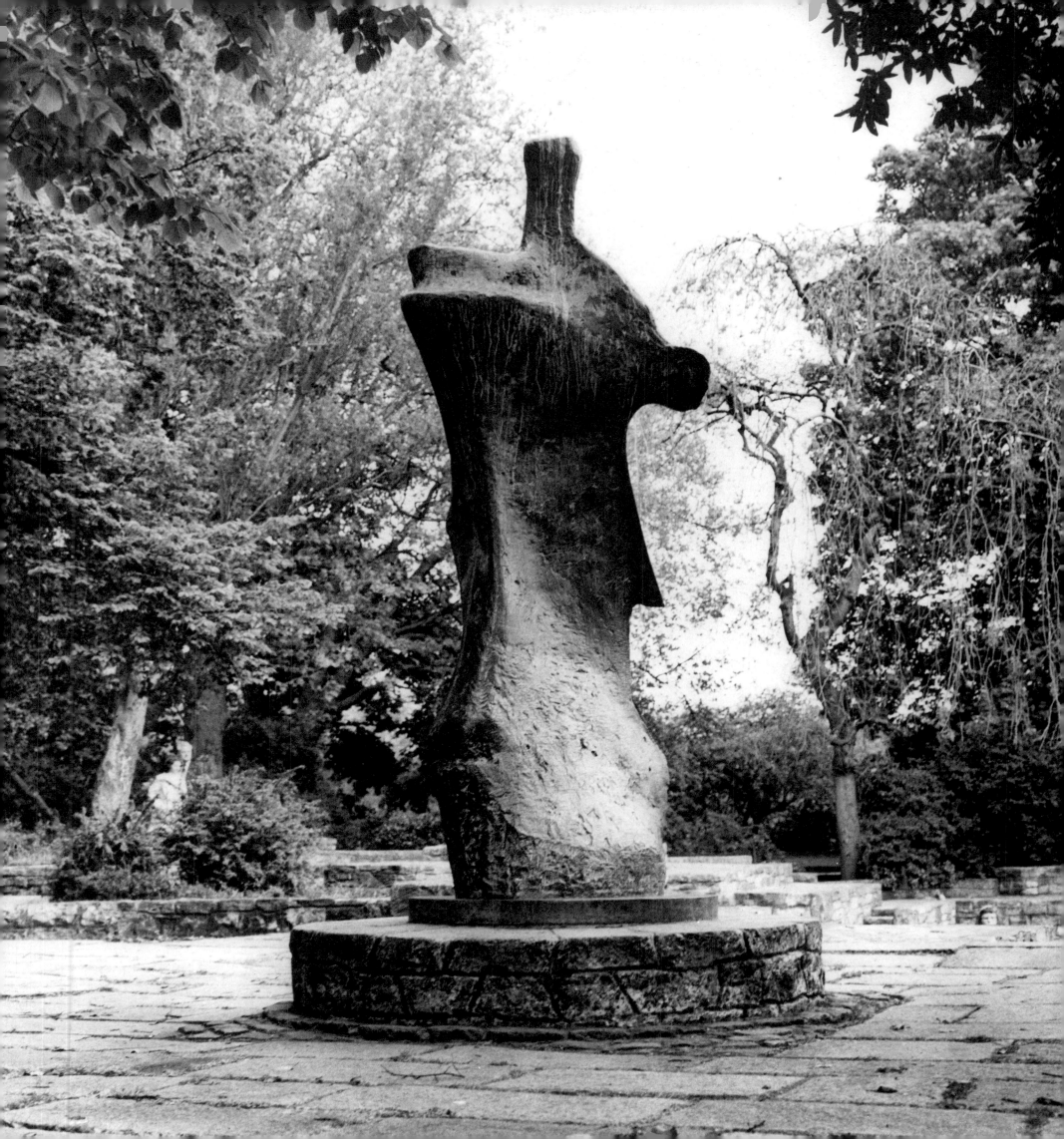

RECLINING CONNECTED FORMS

1969. BRONZE, L. 84″. TRINITY COLLEGE, DUBLIN

When I photographed this piece in the summer of 1975, this was the only contemporary sculpture on the grounds of Trinity College. It is placed under a large spreading tree near the famous library, which contains the magnificent *Book of Kells*. The surrounding buildings are quite lovely, and I don't think one could have found a more appropriate spot on the campus for the sculpture.

I photographed casts of this piece in Adelaide, Australia, and in New York, as

well as the large stone carving of the work in Baltimore (see pp. 62–66; 356–59; 422–29). In all of these locations the sculpture is placed in front of buildings without any trees or grass in the area. Dublin was the first location in which I saw the piece with elements of nature in the background, and although it was a dark, rainy day when I was there, I was very pleased to see the sculptural forms intermingle with those of the tree behind them.

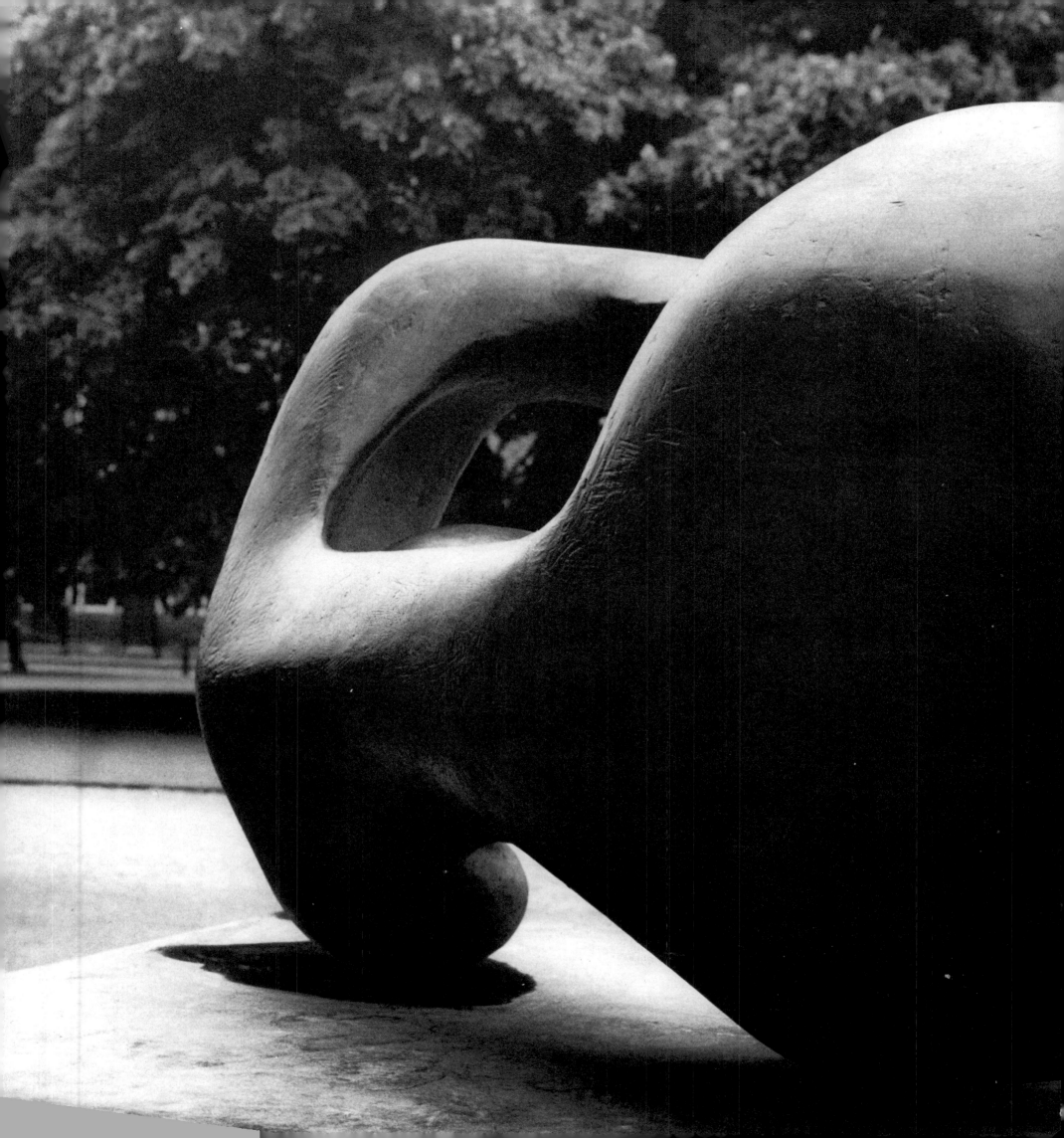

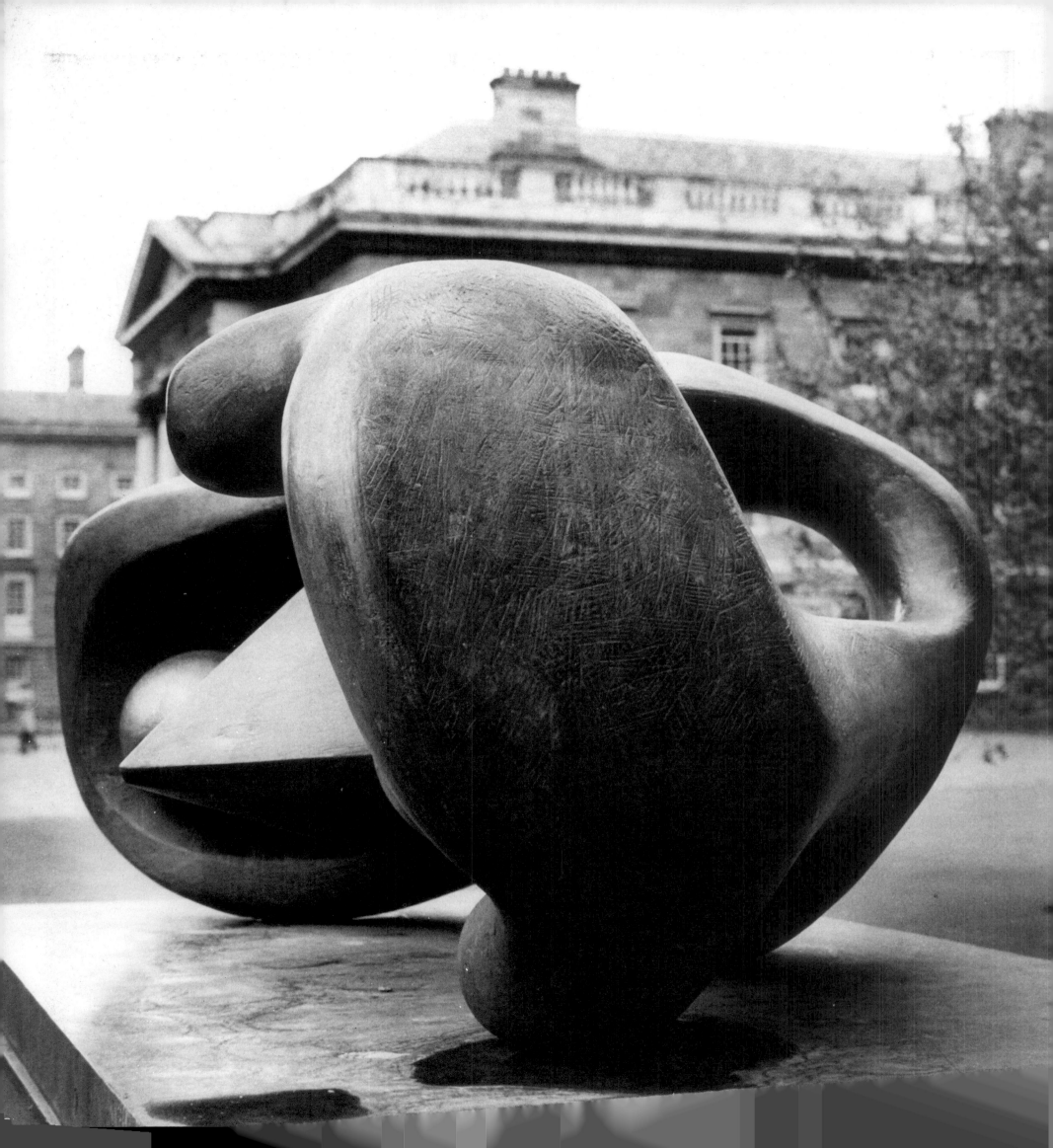

NADA

regular Sunday evening date with the same prostitute for years. After facing Justice Ó hUadhaigh, who at times sounds and looks as though he personally can invoke the wrath of the Almighty, the farmer spends Sundays away from Dublin now.

The women mostly have standard charges for standard sexual practises. Most will try and up the price if the lusting male has a beery breath and seems under the influence. But it ranges from as low as £8 to as much

tution. It's like trying to hold water in your hands. It should be legalised and controlled and maybe then a lot less people would be exploited."

A posting with the Anti-Vice Squad is among the least glamorous jobs in the Garda. One detective said it was just slightly better than walking up and down outside the Dáil all day looking like an idiot.

They work from 8 p.m. to 4 a.m., five shifts a week. Then they have to rise in time for their average dozen or so weekly court appearances which begin at 10.30

e ladies of to be found on nearby Hatch also. And they have invaded Leeson Street, much to the annoyance of the night club owners on "The Strip" who charge as much as £18 for a bottle of plonk.

But when the girls are actually providing their services in the office car parks, the maze of alleyways and cul de sacs in Dublin 2, they can be less than discreet.

THE ARCHER

1964–65. BRONZE, L. 10'8". NATHAN PHILLIPS SQUARE, TORONTO

Located in front of the architecturally fine and distinctive city hall in Toronto, *The Archer* has become one of the artistic landmarks of the city. The commission to design the building and the civic square was given to a Finnish architect, Viljo Revell, who won an international competititon for the assignment. The city hall has a sweeping, curvilinear quality that is quite remarkable in a large public building, and the sculpture seems to echo these forms, not only in its own sweeping shapes, but in its smooth, polished surfaces, which reflect the building that towers above it. The funds to purchase the Moore were raised by a group of civic and cultural leaders together with the mayor of Toronto, Philip Givens, who was running for reelection at the time. Unfortunately,

Givens lost the election, and it was widely believed that the controversial nature of this abstract sculpture was a major cause of his defeat. The details of the controversy are now forgotten, but there is a lingering awareness that the sculpture has a special history.

When I first saw *The Archer*, I wondered about the scale of the sculpture in front of such a large building. Although the work is monumental, it seemed dwarfed by the high-rise structure. But when one stands close to the sculpture and looks out from under it, the setting is most effective. The jutting horizontal and vertical shapes provide a dynamic frame for the city hall building as well as for the general cityscape that one sees in other directions.

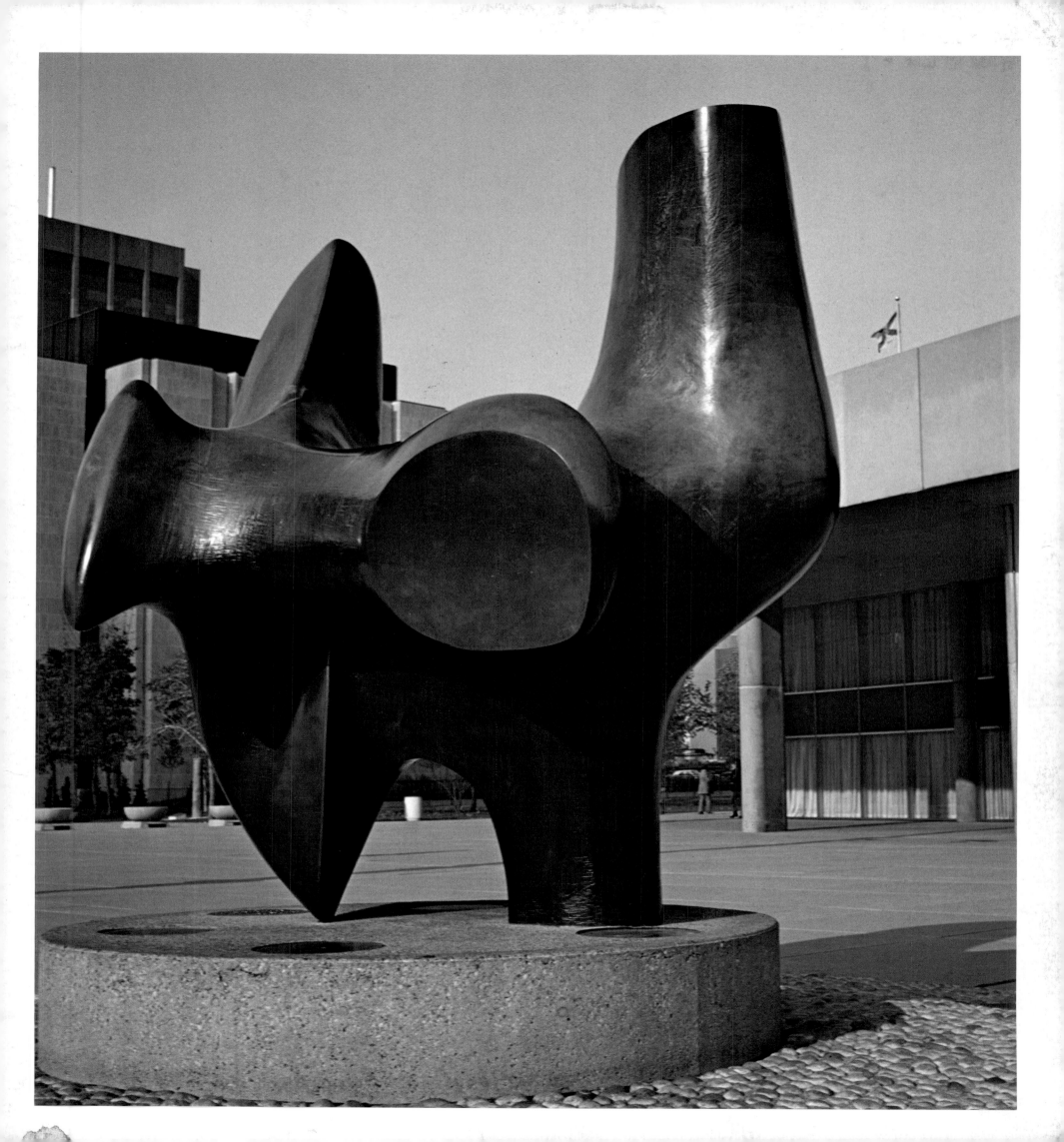

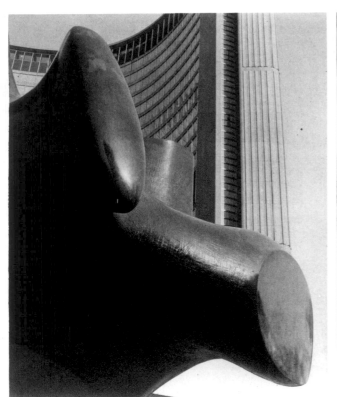

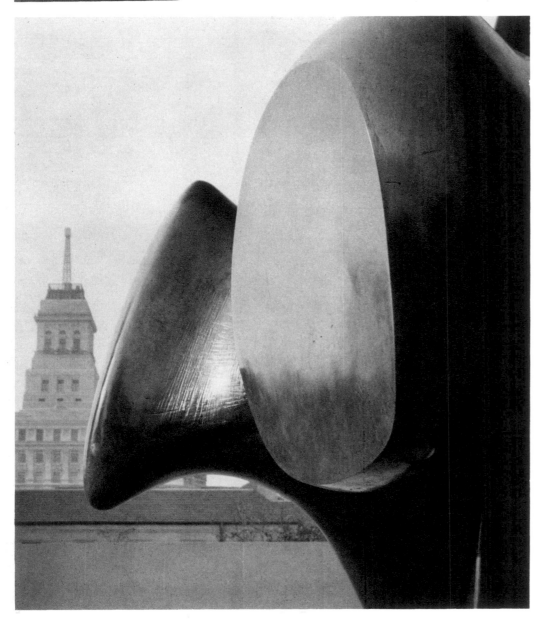

Although I had no say in its positioning, I think this placement is not a bad one. The sculpture from some views echoes the lines of the building.

—Henry Moore

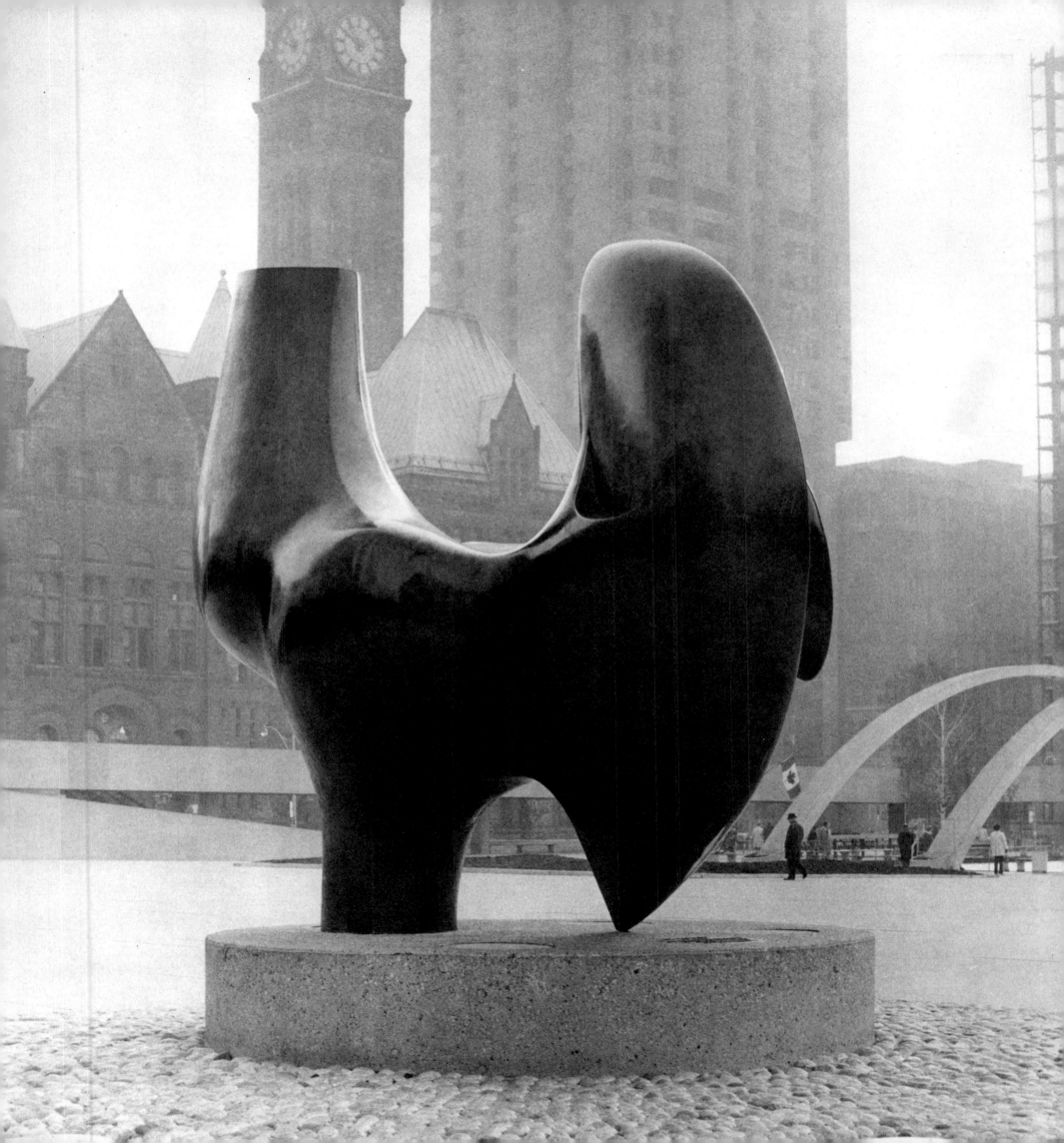

THE UNITED STATES

RECLINING FIGURE

1963–65. BRONZE, L. 30'. LINCOLN CENTER, NEW YORK

The largest sculpture yet created by Henry Moore, this work gains in monumentality by its placement in the middle of a reflecting pool. Although maintaining the water level designated by Moore has always been a problem, the reflections in the pool effectively carry out the sculptor's vision of a piece combining rocklike formations with their mirror images. Surrounded on four sides by fine architectural forms, the work is set in an ideal urban landscape, and the Vivian Beaumont Theater designed by Eero Saarinen and completed by Gordon Bunshaft is a particularly lovely background for the piece.

For a variety of reasons I feel a special closeness to the Lincoln Center piece. For one thing, Albert and Vera List, who gave the work to Lincoln Center, are old friends of mine. By chance, I happened to be meeting with Vera List in her apartment the day her husband came home and told her he had promised John D. Rockefeller, 3rd

(then chairman of the board of Lincoln Center), to contribute one million dollars to the center. At first Vera List had reservations about the idea, but then we discussed specific elements of the Lincoln Center project for which the List contribution might be earmarked. Because of Mrs. List's interest in the visual arts, we found ourselves discussing the possibility of acquiring a major sculpture for the center. Mrs. List was delighted with the idea, and after several meetings with the planners a substantial amount of the List contribution was allocated for that purpose. Subsequently, the arts committee, chaired by Frank Stanton, decided to acquire a Moore work with these funds, and I felt that I had played a part in bringing the sculpture to the spot.

I also remember the unveiling of the work. It so happened that I managed to be present for the occasion, although I had been in bed with pneumonia. For the occasion

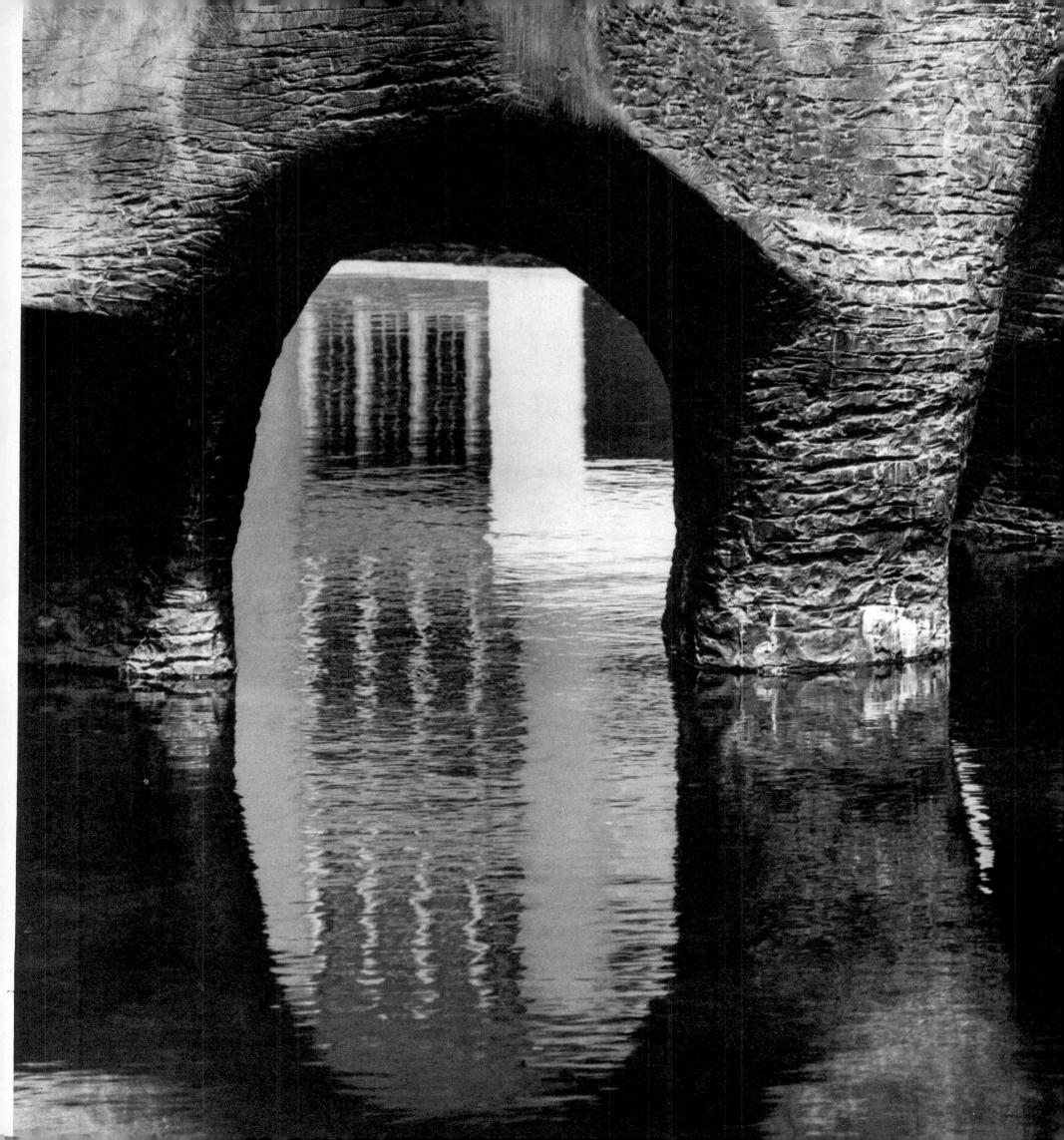

Moore, who had come to New York to oversee the installation of the piece, gave a remarkable speech. After introductions by various dignitaries, including an especially eloquent one by Frank Stanton, the sculptor stood up to the microphone: "Thank you all very much for being here," he said softly and sat down.

For anyone who visits Lincoln Center regularly, the Henry Moore sculpture can become a continuing source of enrichment. I never attend a performance there without spending some time walking around the piece. I never tire of seeing its gigantic, voluptuous, cavernous forms, set off dramatically by the handsome geometric shapes of the architectural background, and I find the ever-changing reflections in the pool fascinating—as much so when the water

is windblown as when it is still. And I have even enjoyed the times when the pool was empty and I could sneak a quick walk up to the sculpture to feel the magic of the forms close at hand.

I waited several years before photographing the piece, wondering how I would decide on the kind of day best suited to catch its finest qualities. And then finally I took my camera with me. I planned to return another day, but after I printed the negatives of my one exhaustive and exhausting session, I realized that I had far exceeded the amount of material that could be used in this book. Every time I visit Lincoln Center, I still feel I have captured only a small fraction of the work. There are volumes yet to be done.

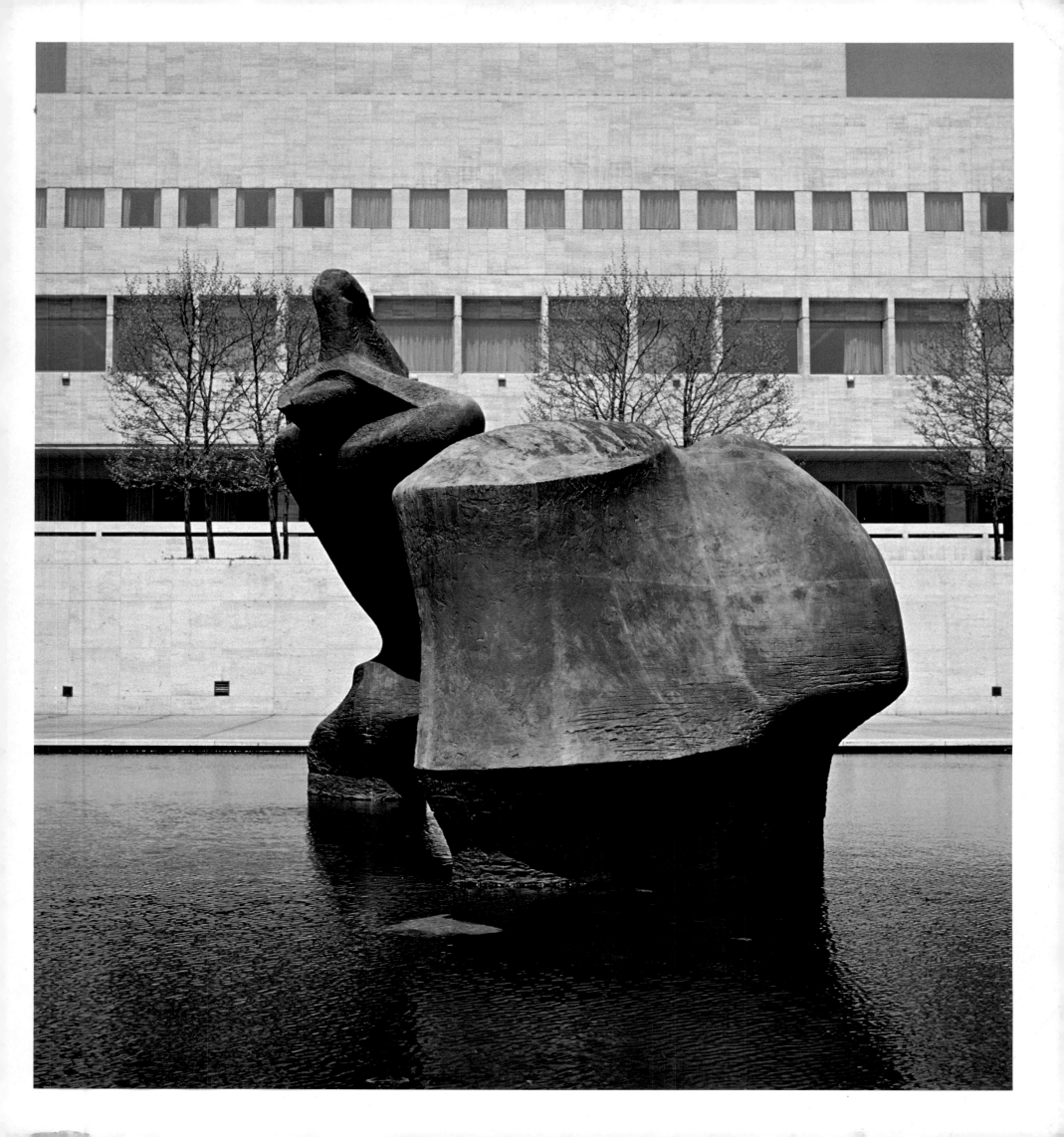

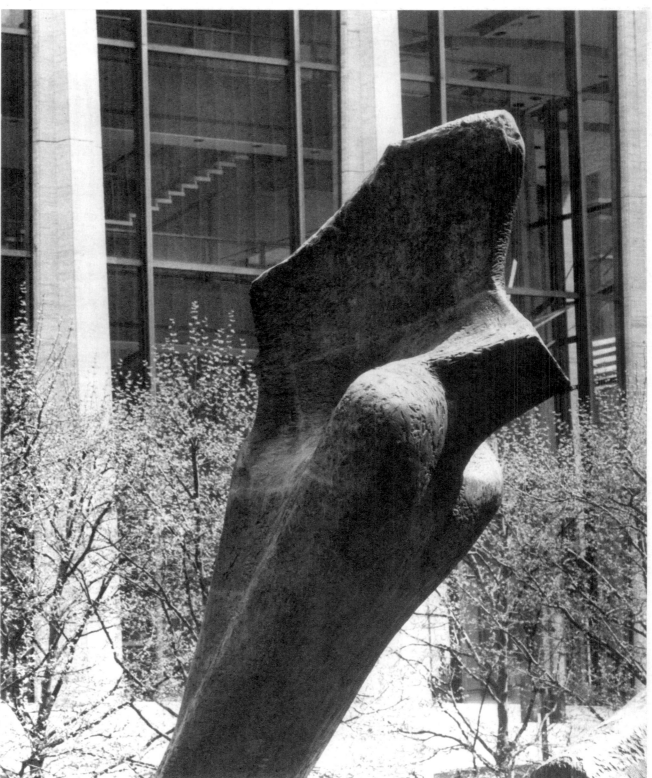

*I've been continually disappointed
over the Lincoln Center sculpture.
The water level has never been the
height I was told it would be, and
which I allowed for when making the
sculpture. The level is always too low;
sometimes the pool is nearly empty.
In consequence, too much is visible
of what was meant to be the
underwater part of the support-
ing "legs."*

 *This fault shows up badly in
many previous photographs I've
seen of this sculpture. But these
photographs of it are some of the
best I've seen. I especially like the
ones showing water reflections, like
a bridge in Venice, and for once
the piece seems properly presented.*

—Henry Moore

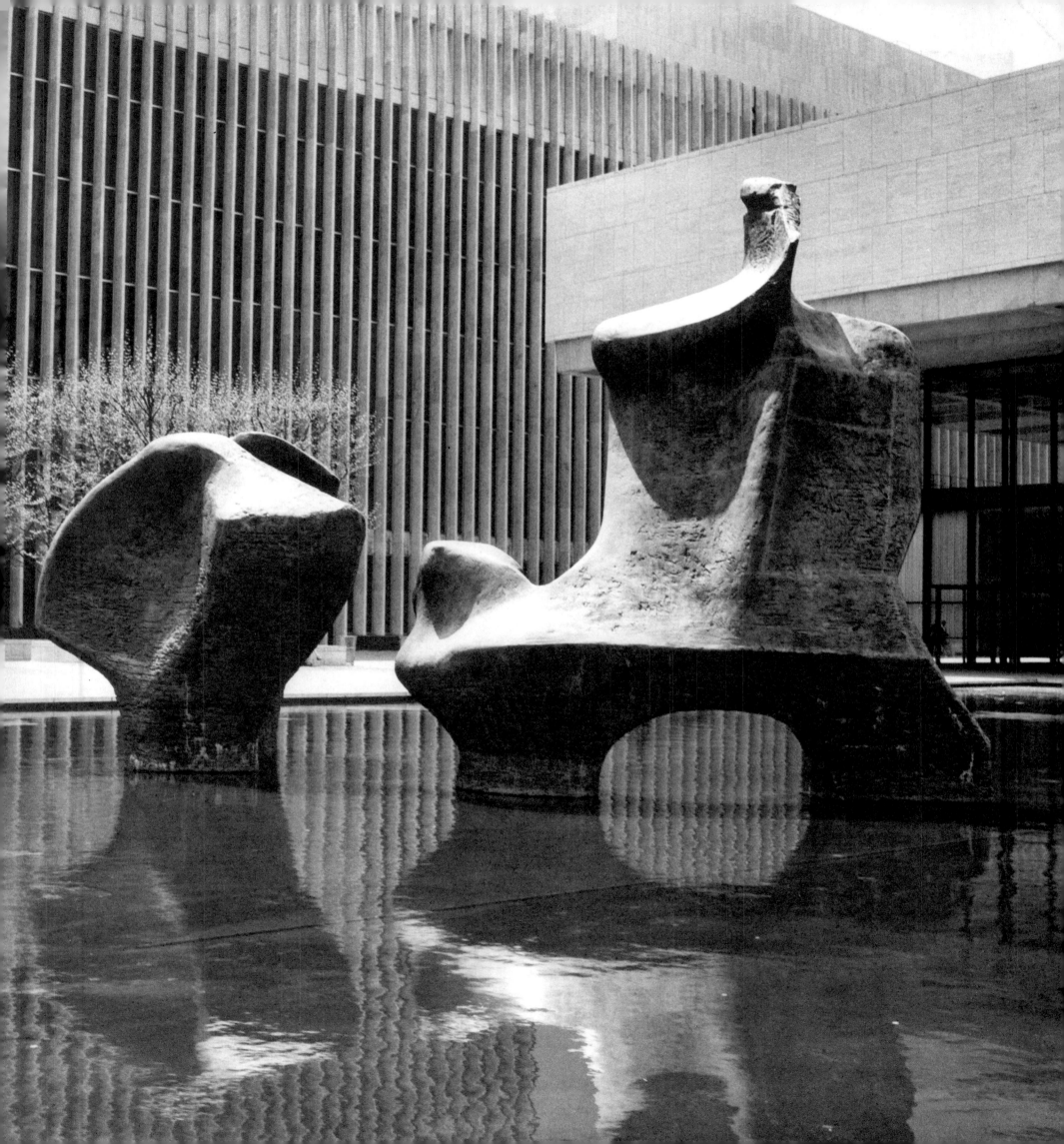

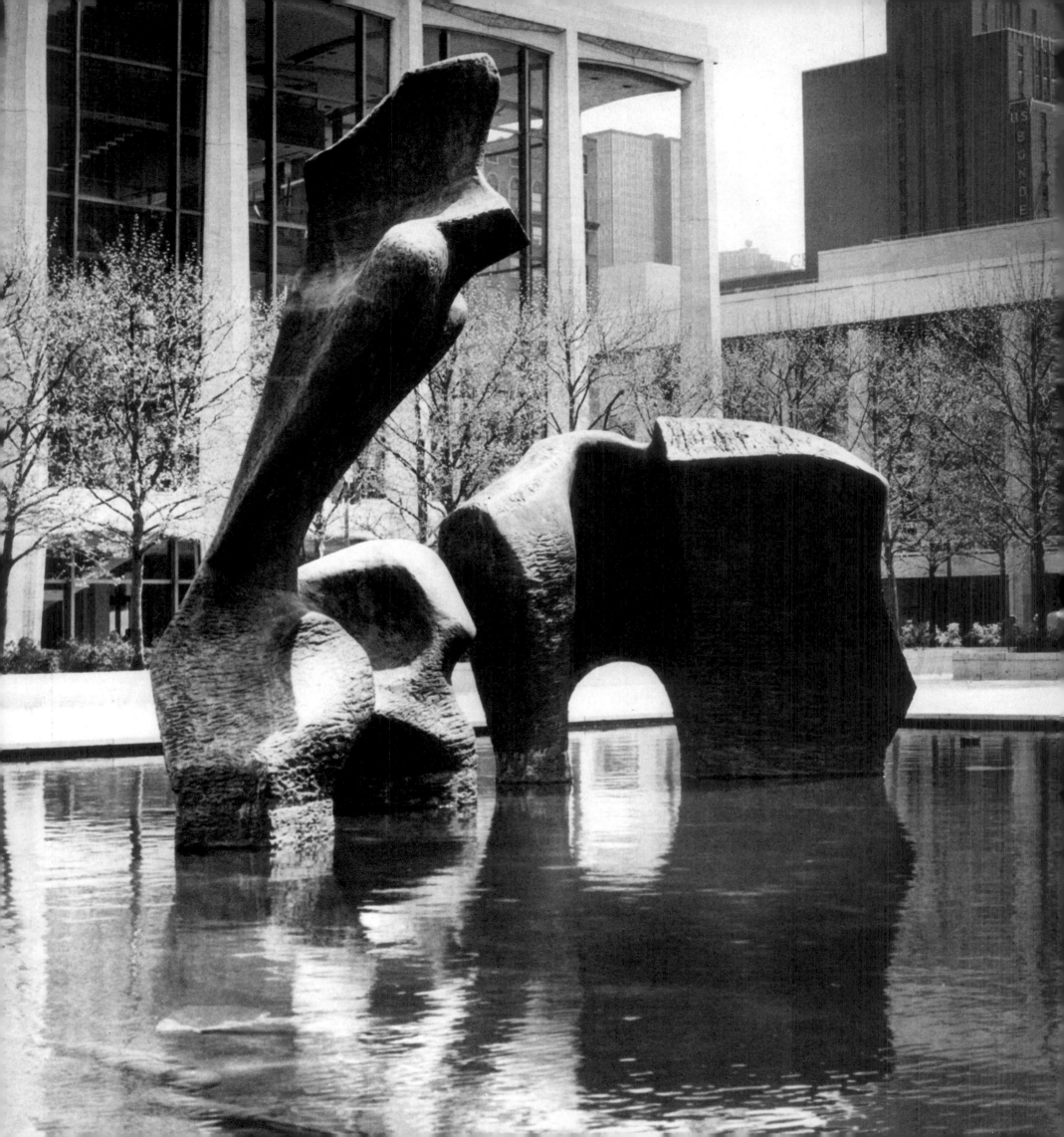

FAMILY GROUP

1948–49. BRONZE, H. 60″. THE MUSEUM OF MODERN ART, NEW YORK

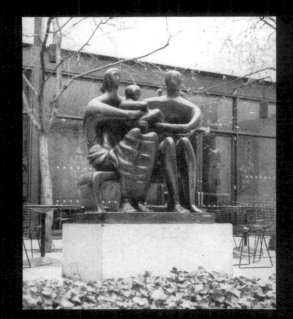

The *Family Group* has long been considered one of the most prized works of art in the Museum of Modern Art Sculpture Garden. In its present site, at the edge of a terrace that is a few steps above the central garden area, it is somewhat too high when viewed from the front. The sculpture is also set in the midst of tables and chairs, which are used as part of an outdoor restaurant during the summer months, and this is a disturbing element from the point of view of the photographer. Yet from some positions one can see the sculpture against both trees in the garden and the New York skyline, so that this is, in some ways a more interesting setting than that at Barclay School in Stevenage, England (see pp. 258–63).

This was probably the first Henry Moore sculpture I ever saw, and for many years it was the primary mental image I had of his work. I don't think that either the Stevenage or the Museum of Modern Art setting does it justice, and one day I hope a cast of this piece will be placed in a site similar to Glenkiln, Scotland, where its archetypal forms can be experienced in an appropriate landscape.

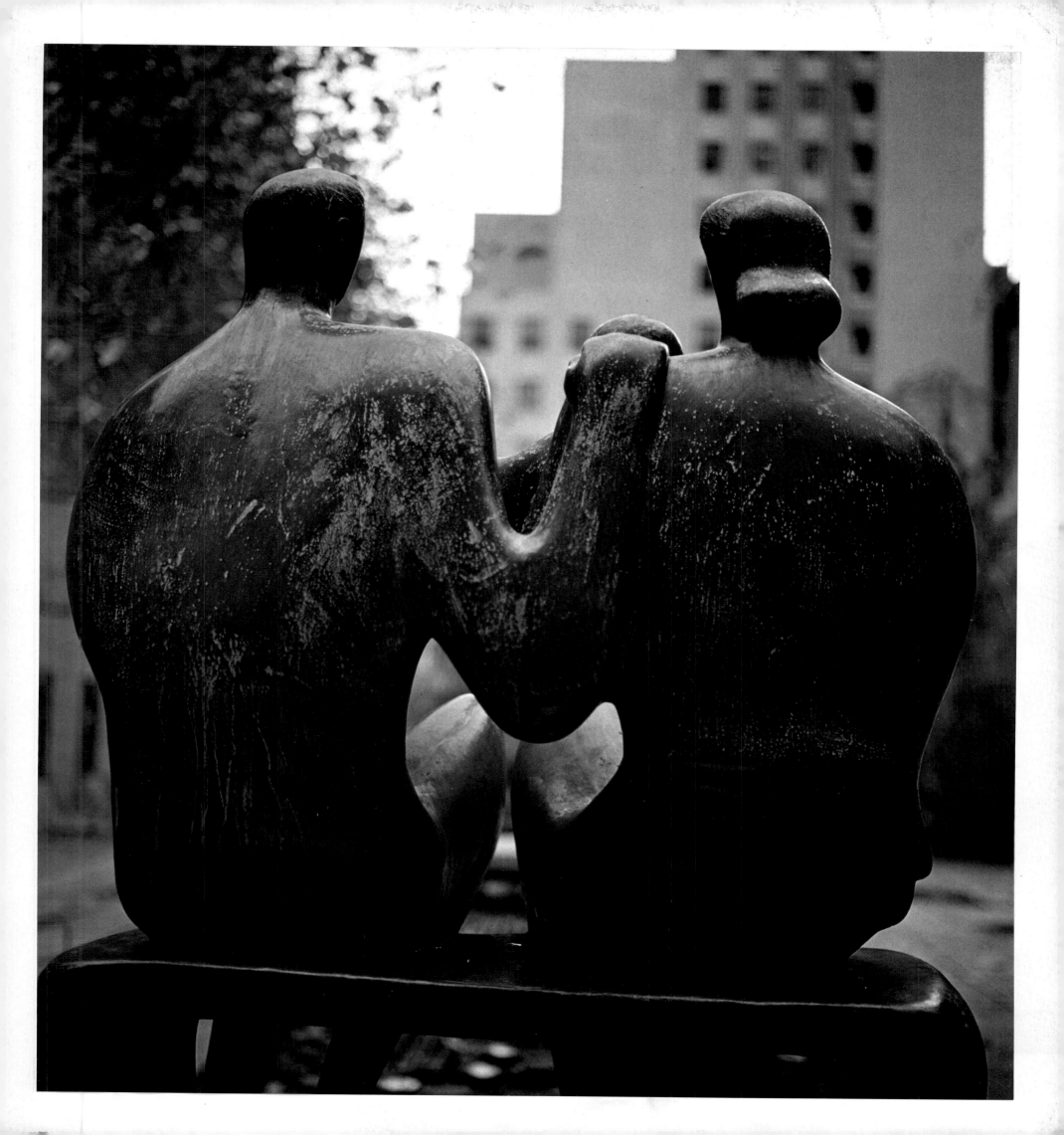

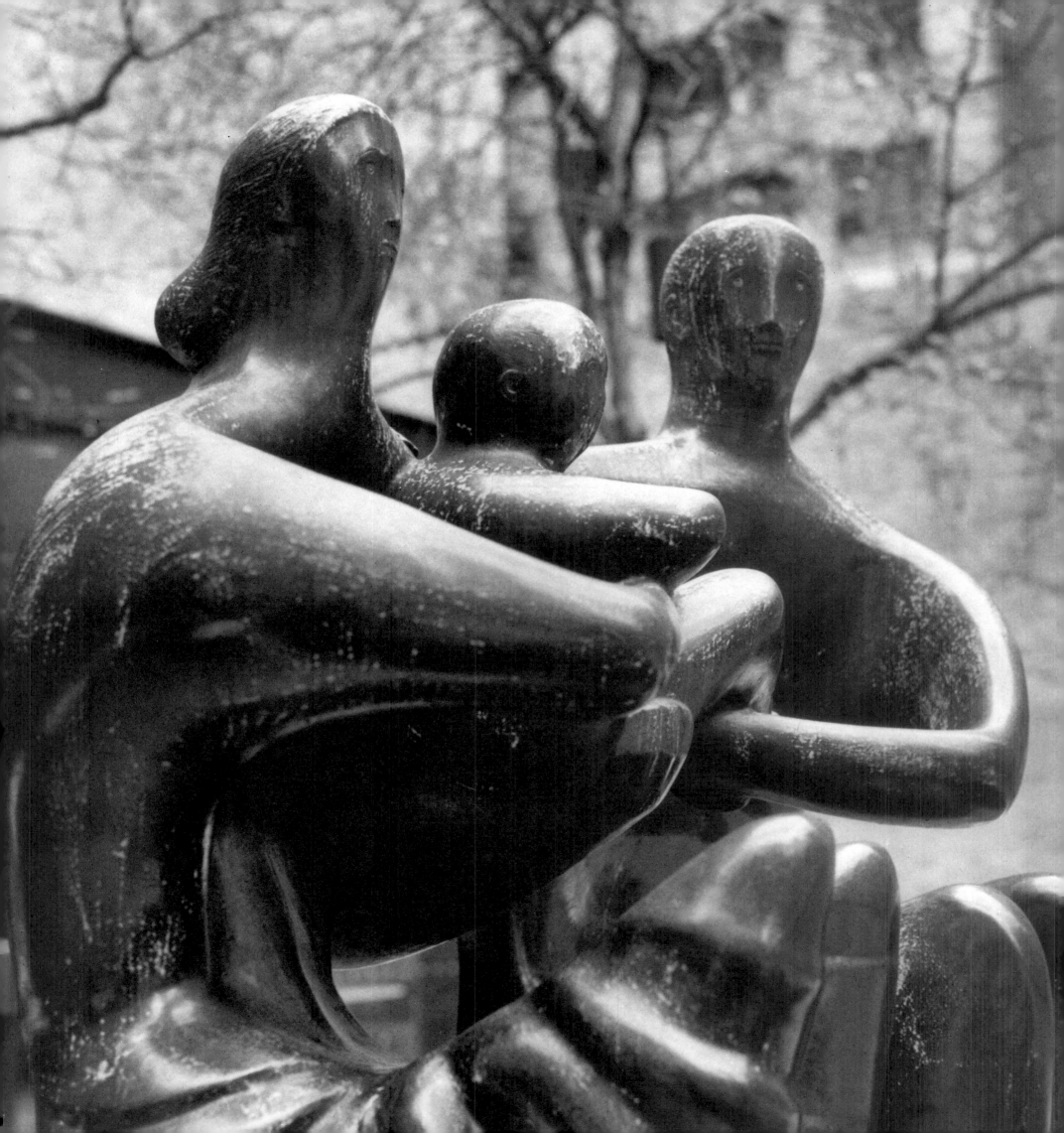

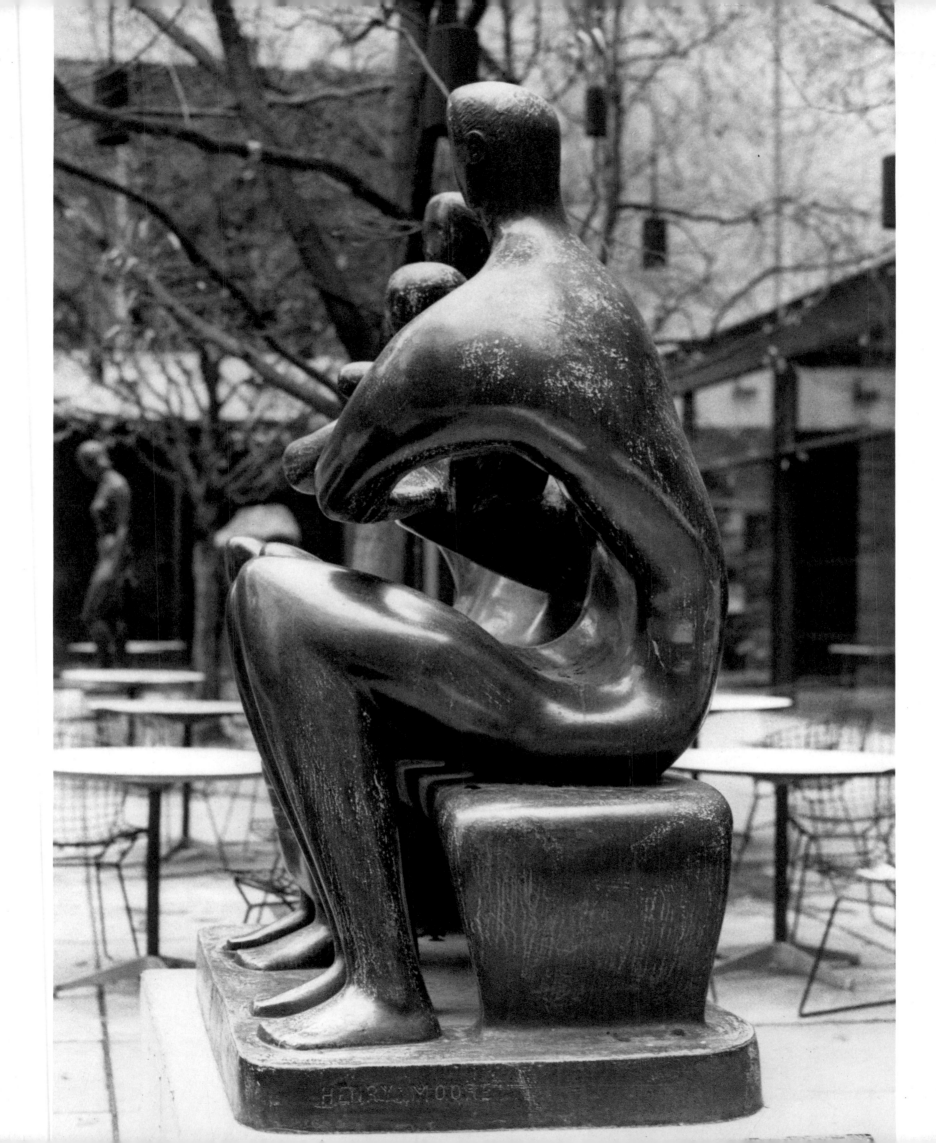

WORKING MODEL FOR THE ARCH

1962–63. BRONZE, H. 78". THE MUSEUM OF MODERN ART, NEW YORK

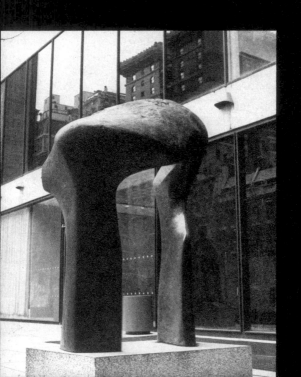

This cast of the working model for *The Arch* is placed rather ungraciously in the corner of the Museum of Modern Art Sculpture Garden (for other casts, see pp. 430–37; 462–63). With little space around it, and with the glass sides of the building providing a static background for the front and side views, the sculpture looks stunted and dwarfed. There is, however, one view from which one can see the surprising shapes of *The Arch* against the New York skyline with dramatic effect.

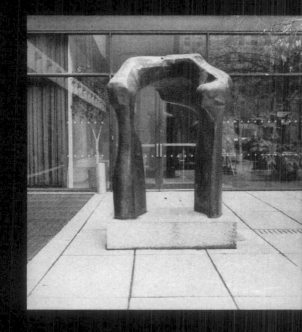

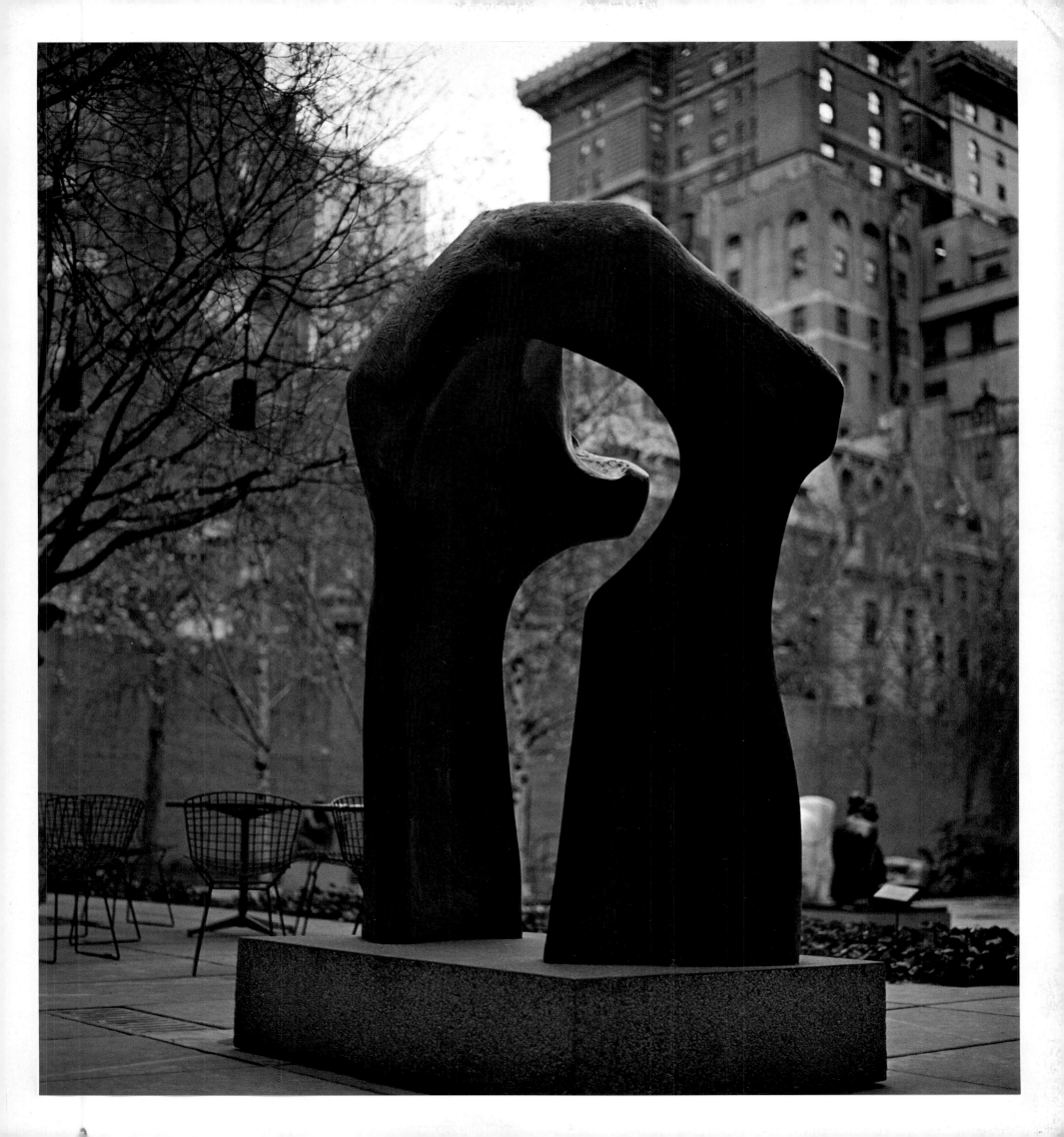

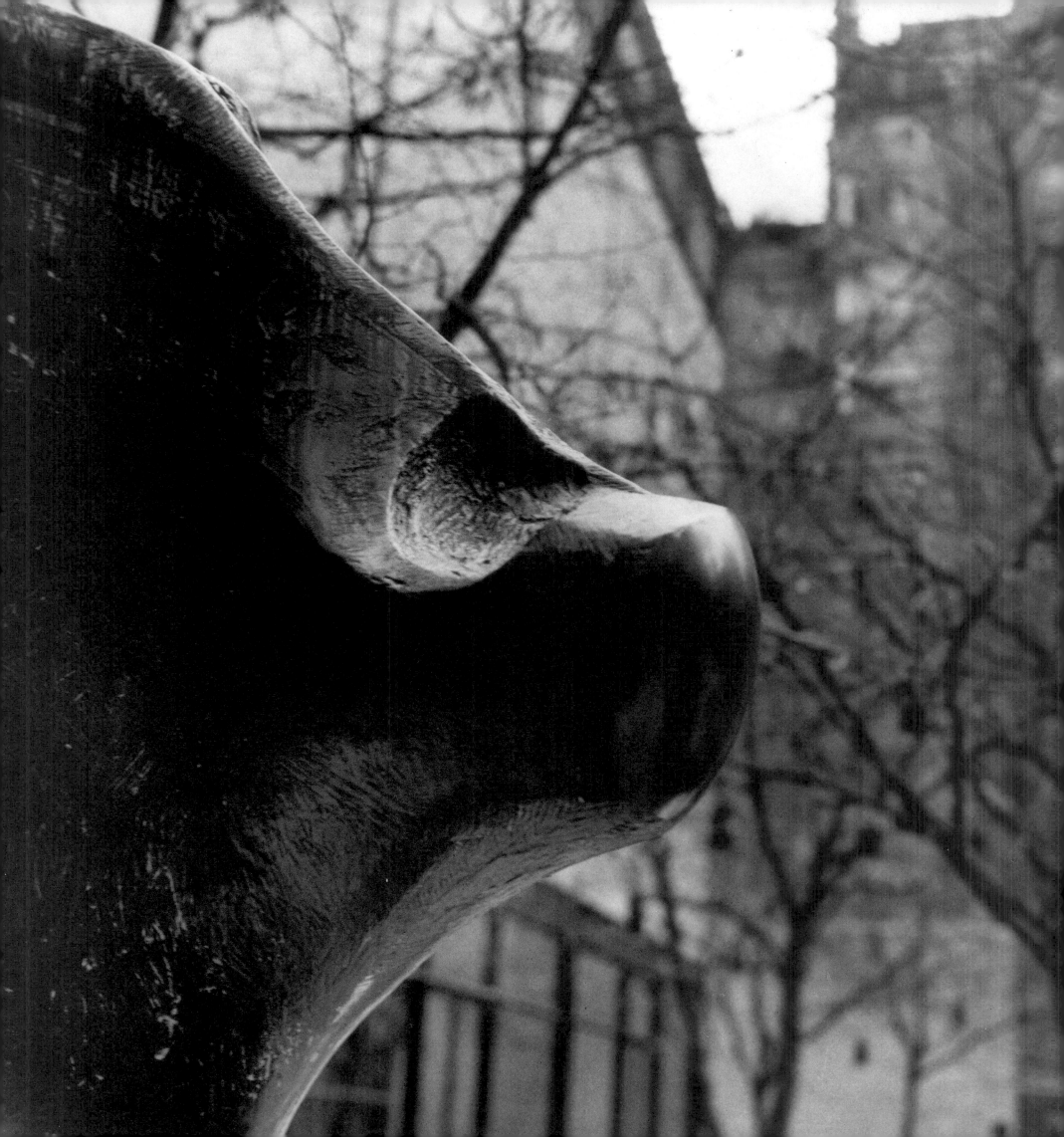

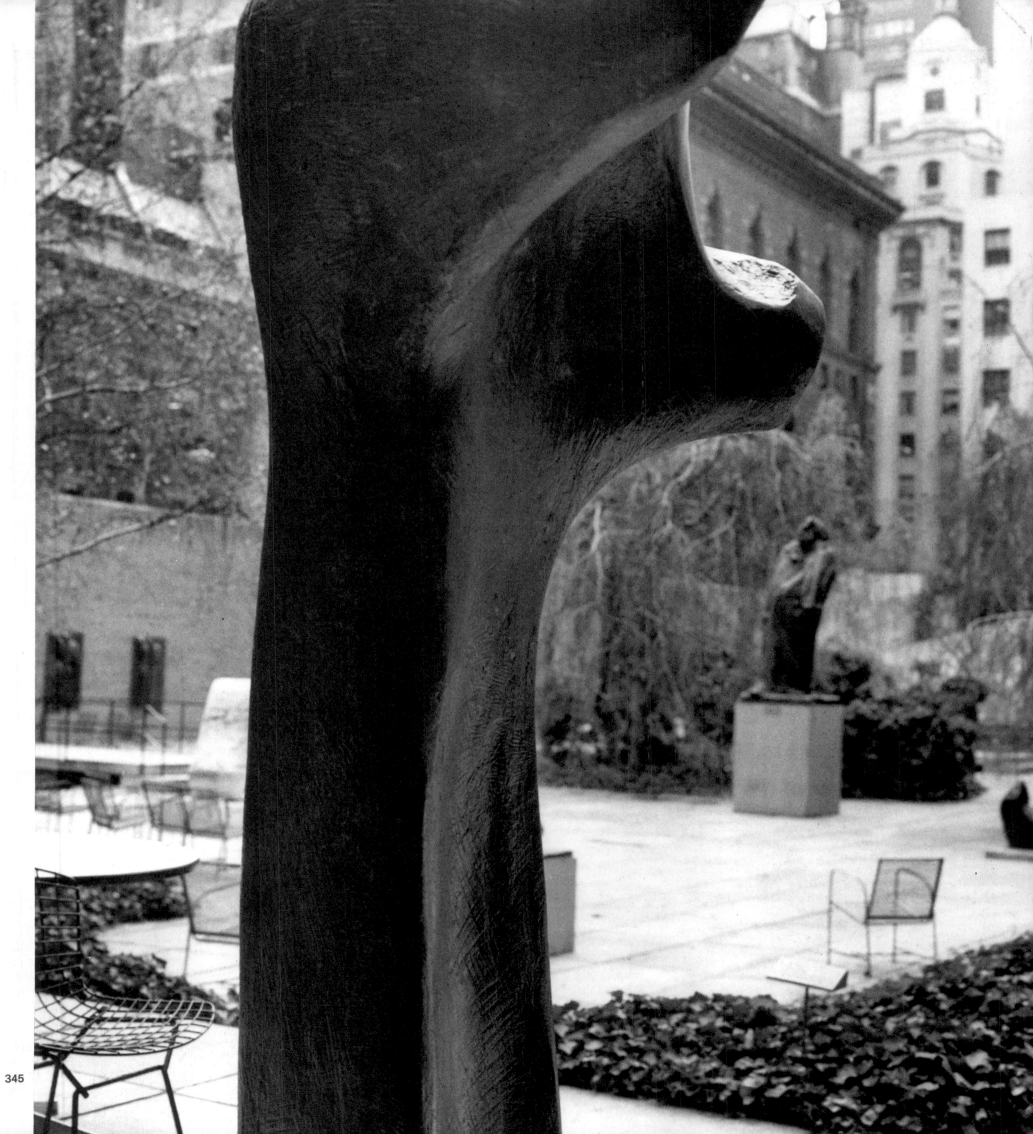

ANIMAL FORM

1969–70. ROMAN TRAVERTINE, L. 8′ 9 3/8″. THE MUSEUM OF MODERN ART, NEW YORK

For many years Moore has spent the summer in a cottage in Forte dei Marmi, Italy. Taking advantage of his proximity to marble quarries, he has devoted himself to stone carvings. Many of these are abstract forms in which the sculptor expresses his love of the material and at the same time explores new variations on the themes with which he is currently preoccupied.

Animal Form brilliantly combines a series of rounded forms that suggest the

shape of a hippopotamus. The head, hind legs, hump, and hanging belly are all recognizable once one knows the name of the sculpture, and there is a fascinating interplay of forms flowing in and out of each other as one moves around the figure.

Placed in the center of the museum's sculpture garden, *Animal Form* seems almost to have been created especially for that location.

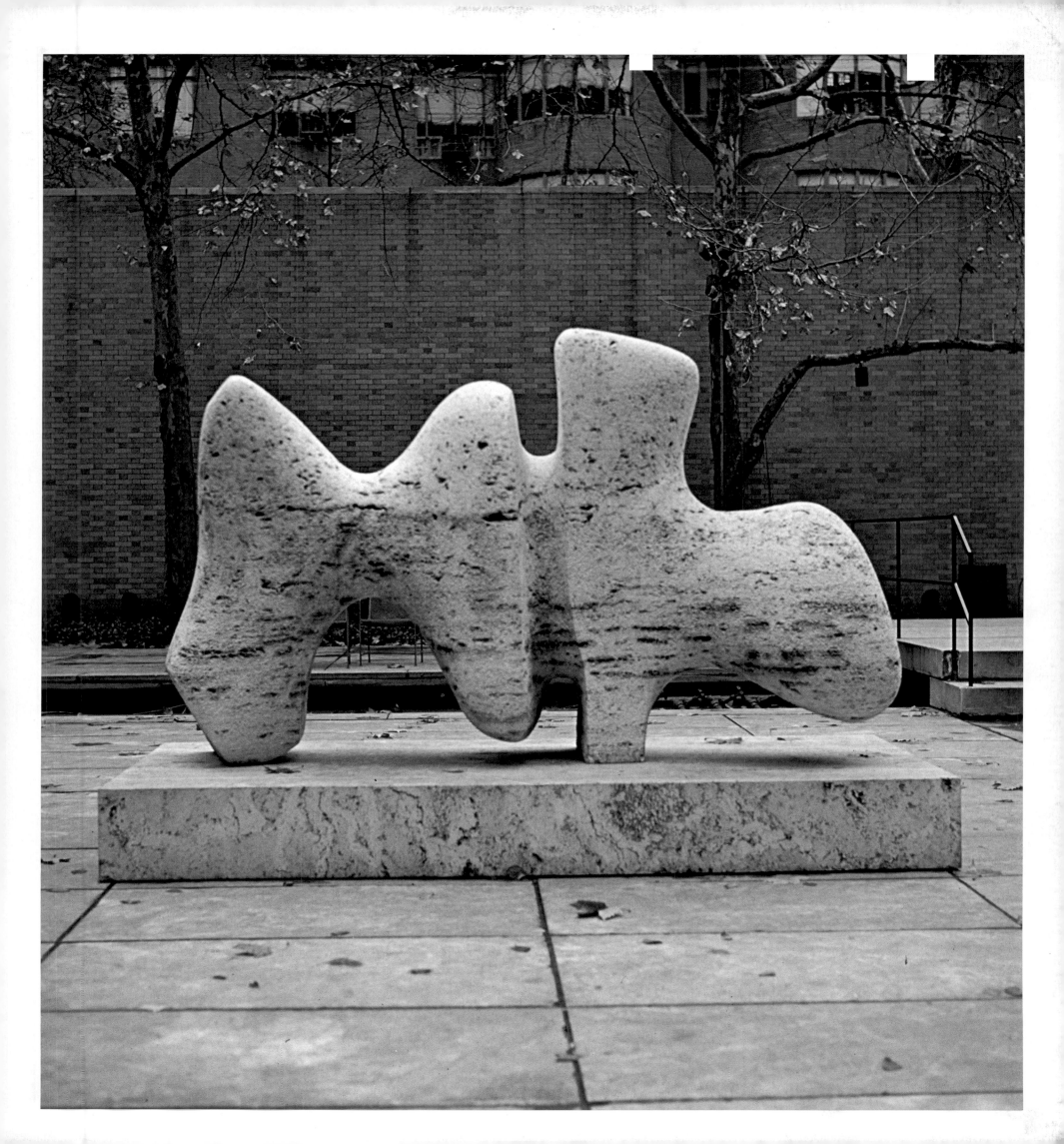

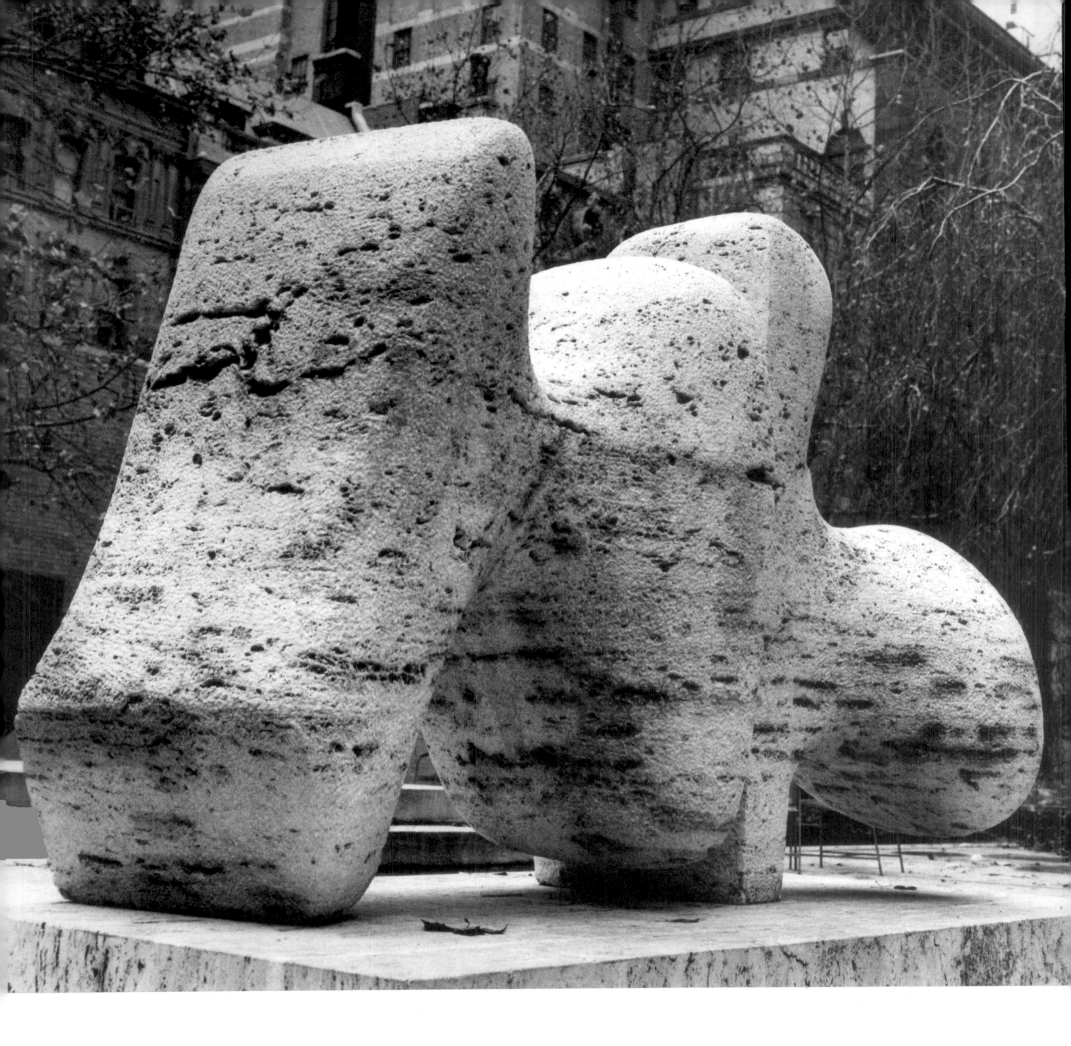

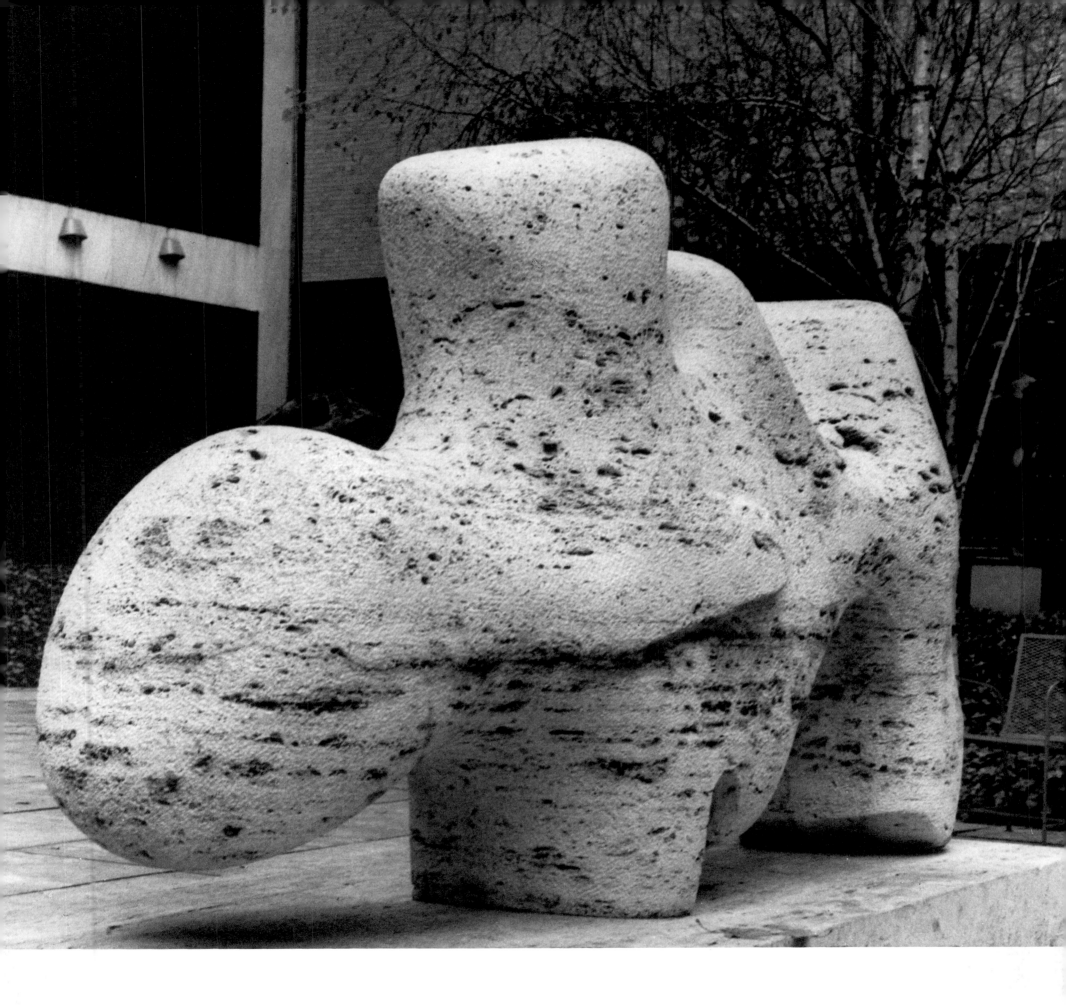

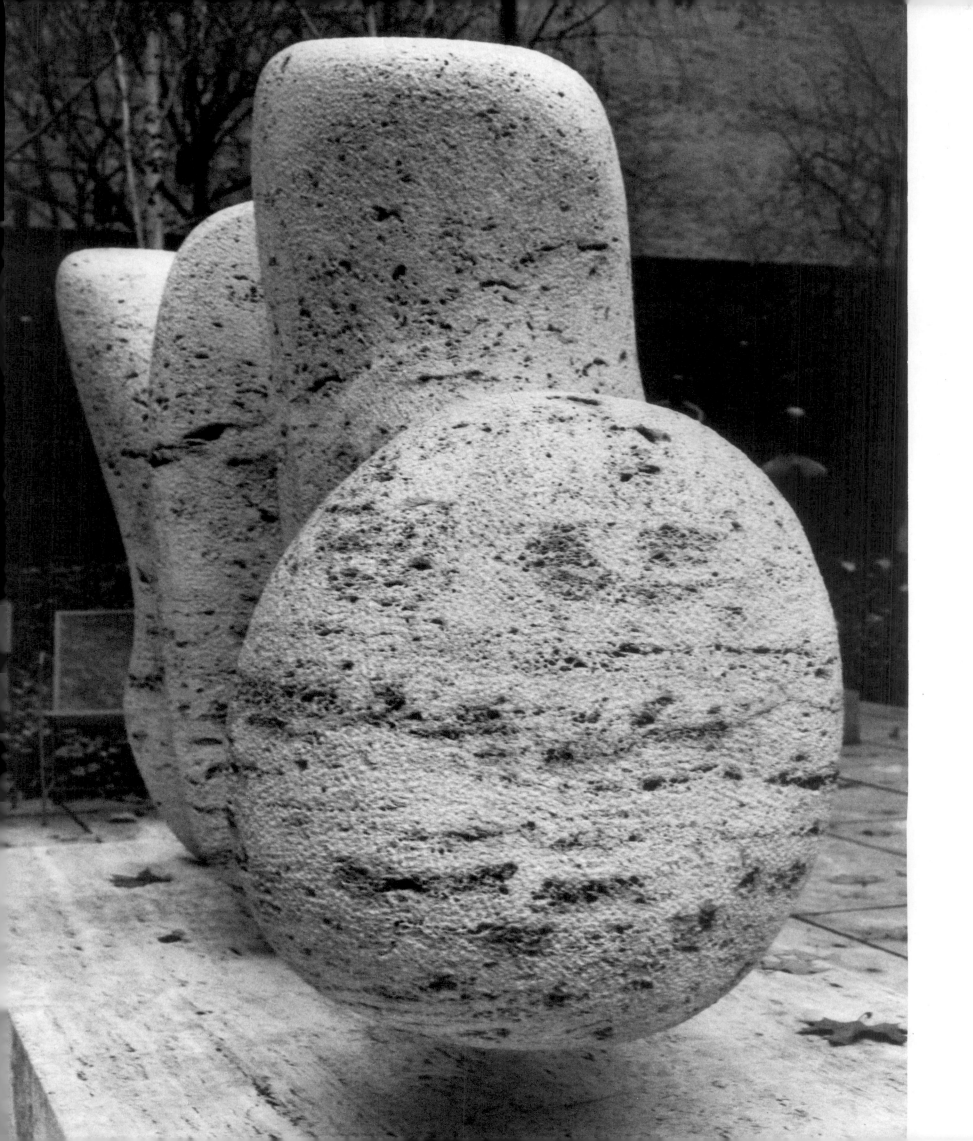

THREE-WAY PIECE 1: POINTS

1964. BRONZE, H. 76". COLUMBIA UNIVERSITY, NEW YORK

This work is situated on the campus of Columbia University, on a large terrace or platform that bridges Amsterdam Avenue, a main thoroughfare of the neighborhood. In this position it has the double advantage of being seen against the handsomely designed buildings of the university on one side, and the thoroughfare, stretching out to the distance, on the other. It is not located in a central position on the campus, and there is no foliage to set off the work. But the environment is attractive, and the large expanse of space on all sides enables one to get a good view of the work.

Although I have visited Columbia University many times and knew that Mr. and Mrs. Ira Wallach had contributed this work to the university, I did not see the piece until I went to the campus expressly to photograph it. The sculpture is located

in front of the School of Law, which is off to one side of the campus. Although it is unfortunate that the work is not in a more prominent position, I enjoyed photographing it in this setting, with its varied backgrounds. The round pedestal, which is a very good height, invites one to move around the sculpture and to discover its continually changing forms.

There wasn't much of a choice about where to put this sculpture. There aren't many ideal locations in cities. That's why I'd rather have my things placed in natural settings. But in some of these photographs it looks all right. It's like some big owl, some big bird brooding, with its wings spreading, just about to fly off.

—Henry Moore

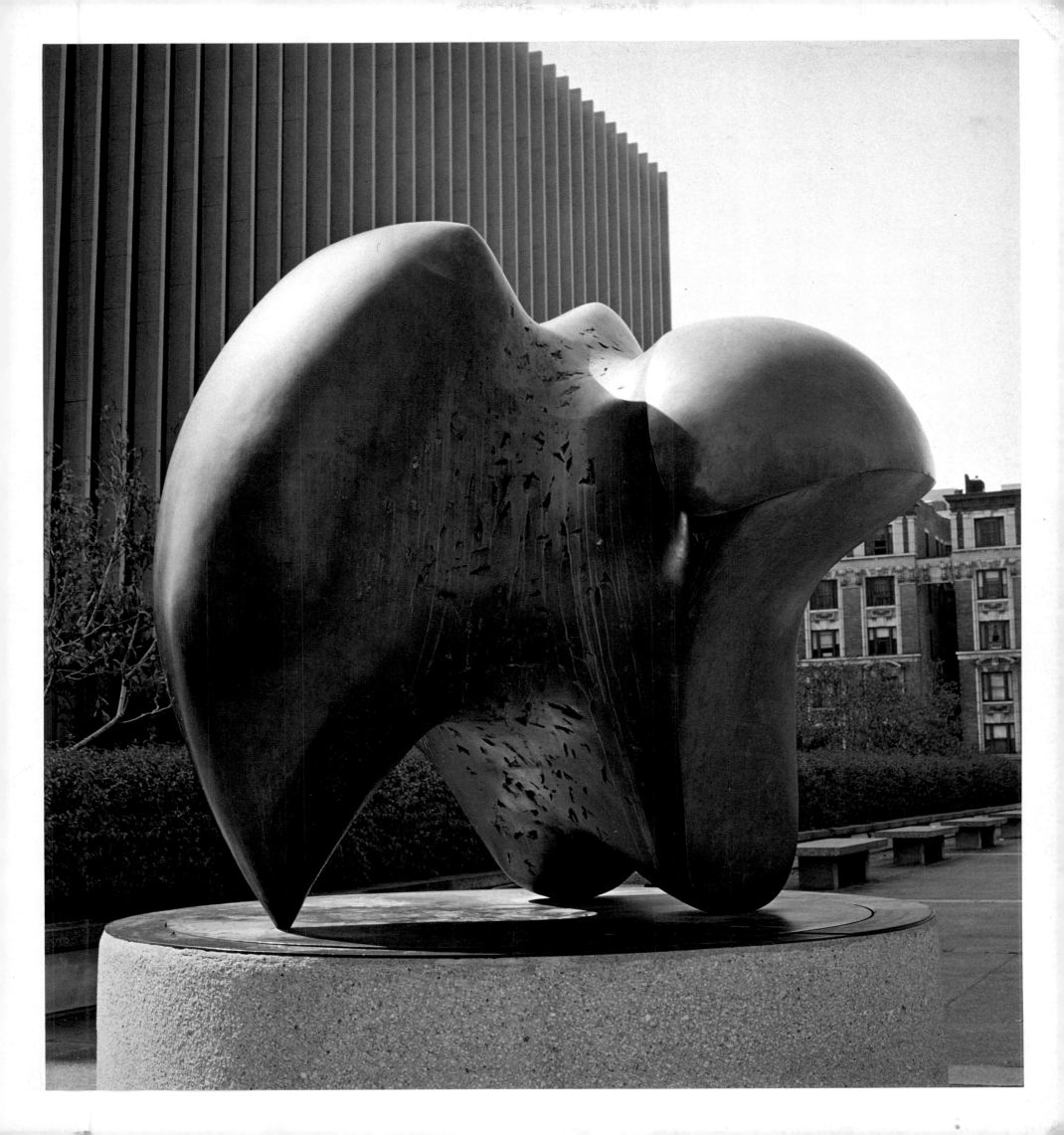

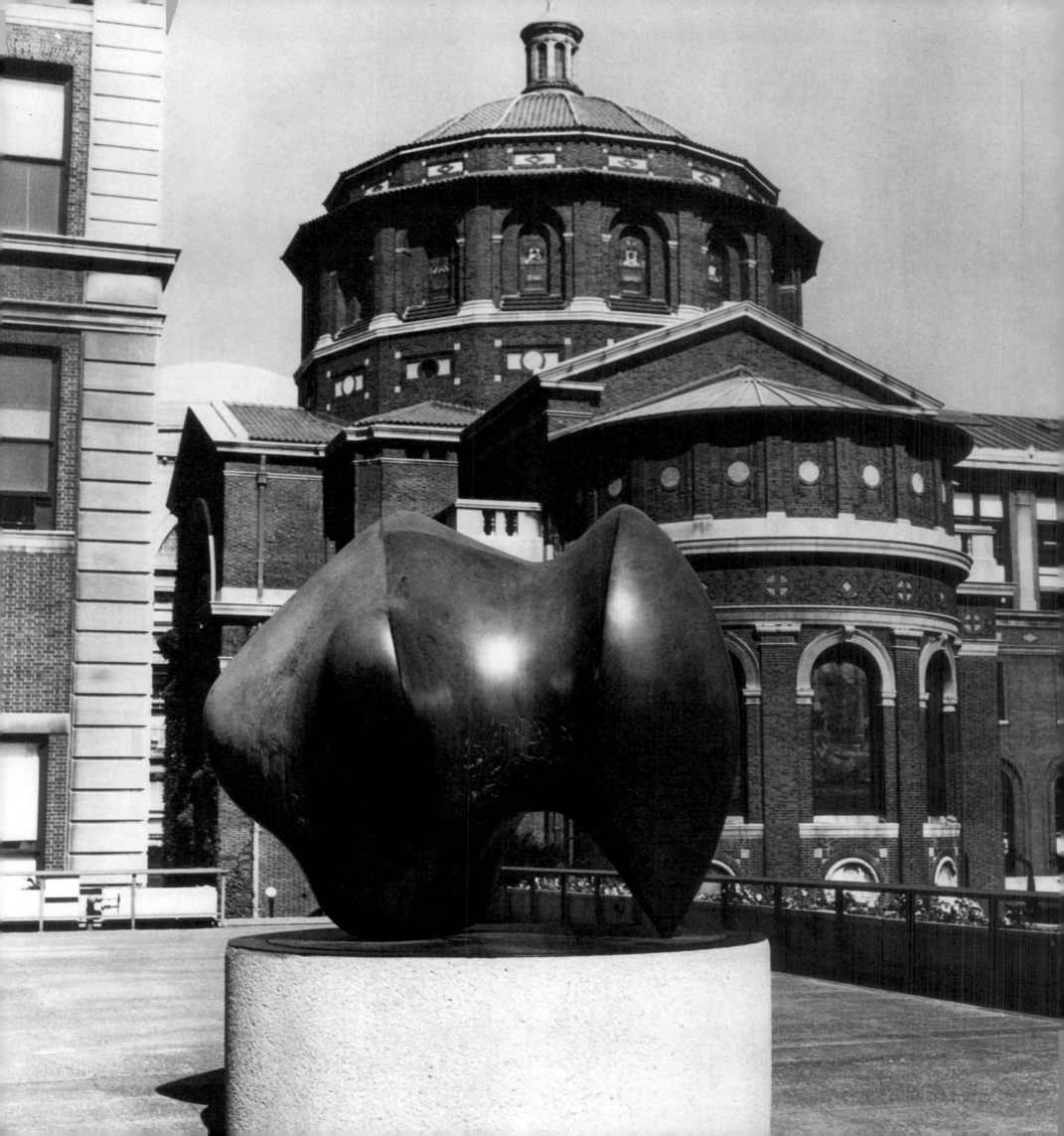

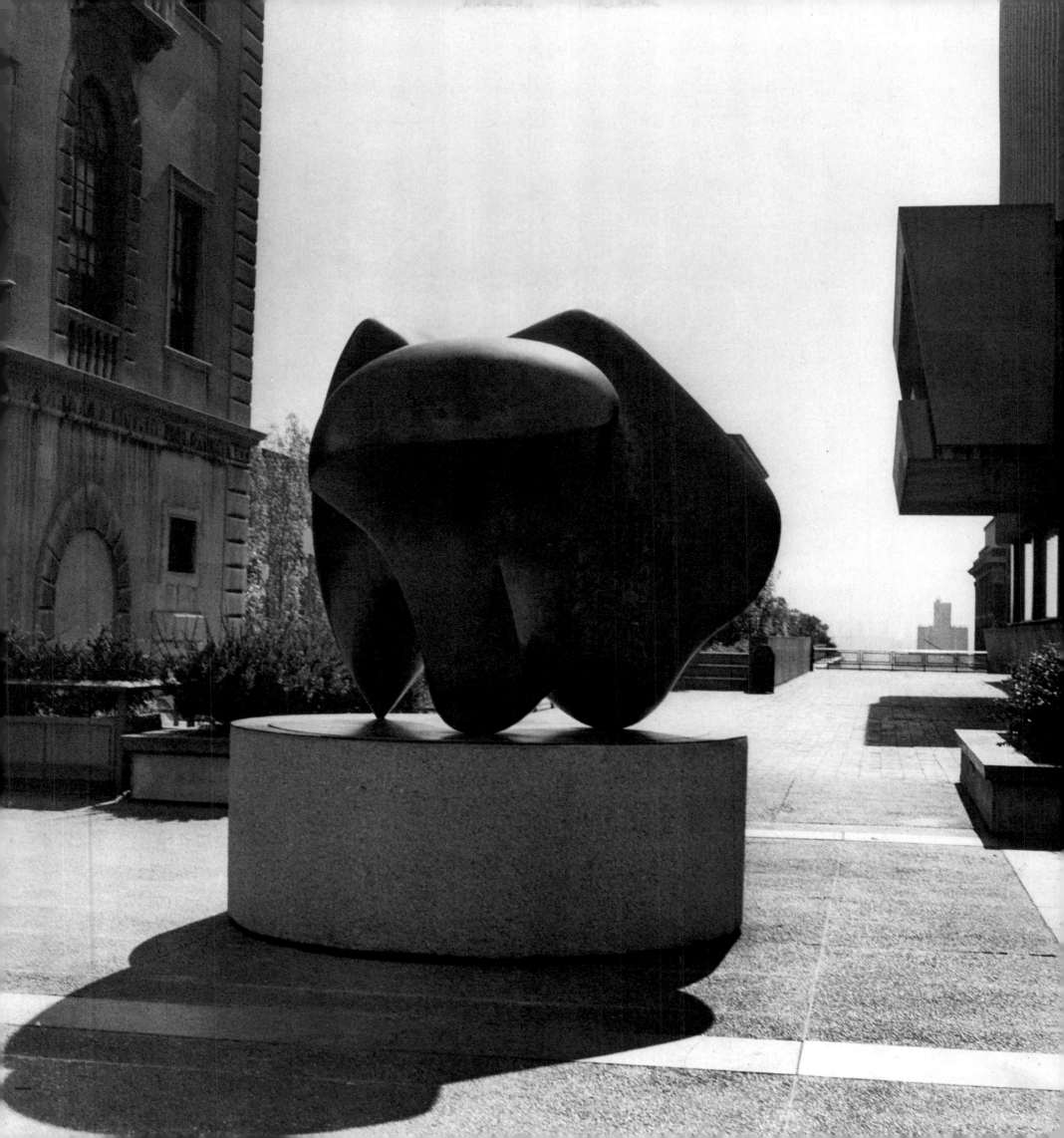

RECLINING CONNECTED FORMS

1969. BRONZE, L. 84". 900 PARK AVENUE, NEW YORK

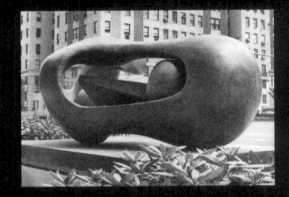

In the spring of 1974 this sculpture, which is on loan from a private collection, was installed in front of a new apartment house at the corner of Park Avenue and 79th Street in Manhattan. At that time an editorial in the *New York Times* expressed the city's gratitude for such an outstanding contribution to the people of New York, and the apartment house soon became known as "The Moore Apartments."

The sculpture is placed on a nicely planted island of shrubbery in front of the main entrance and rests on a specially designed pedestal that sets off the work handsomely, if a little too decoratively. The scale of the work in comparison to the high-rise buildings in the area is a problem, and unless passers-by look closely at the piece its inherent monumentality may be missed. But the location of the Moore in the midst of the East Side residential district of the city is a welcome addition to the community.

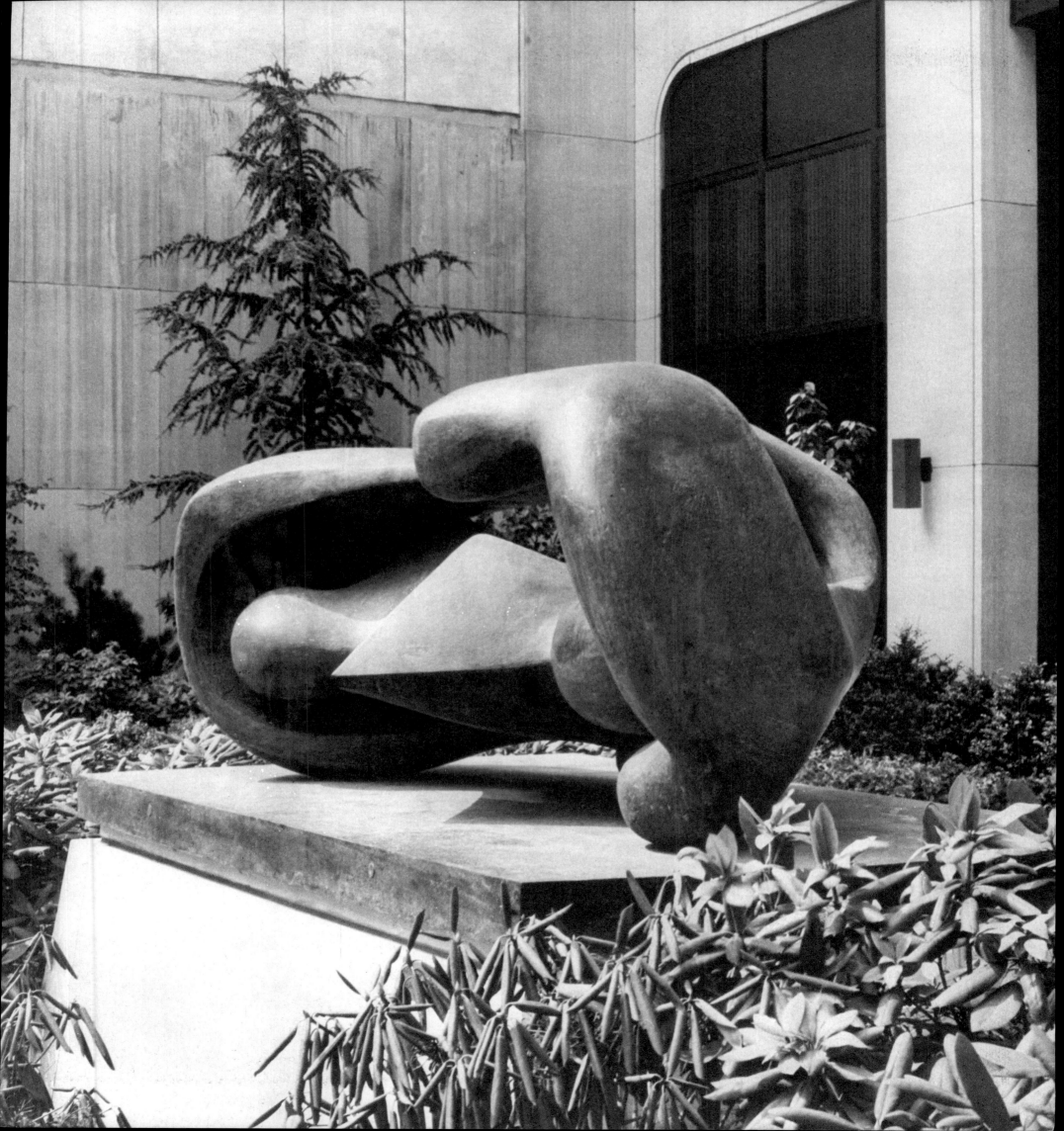

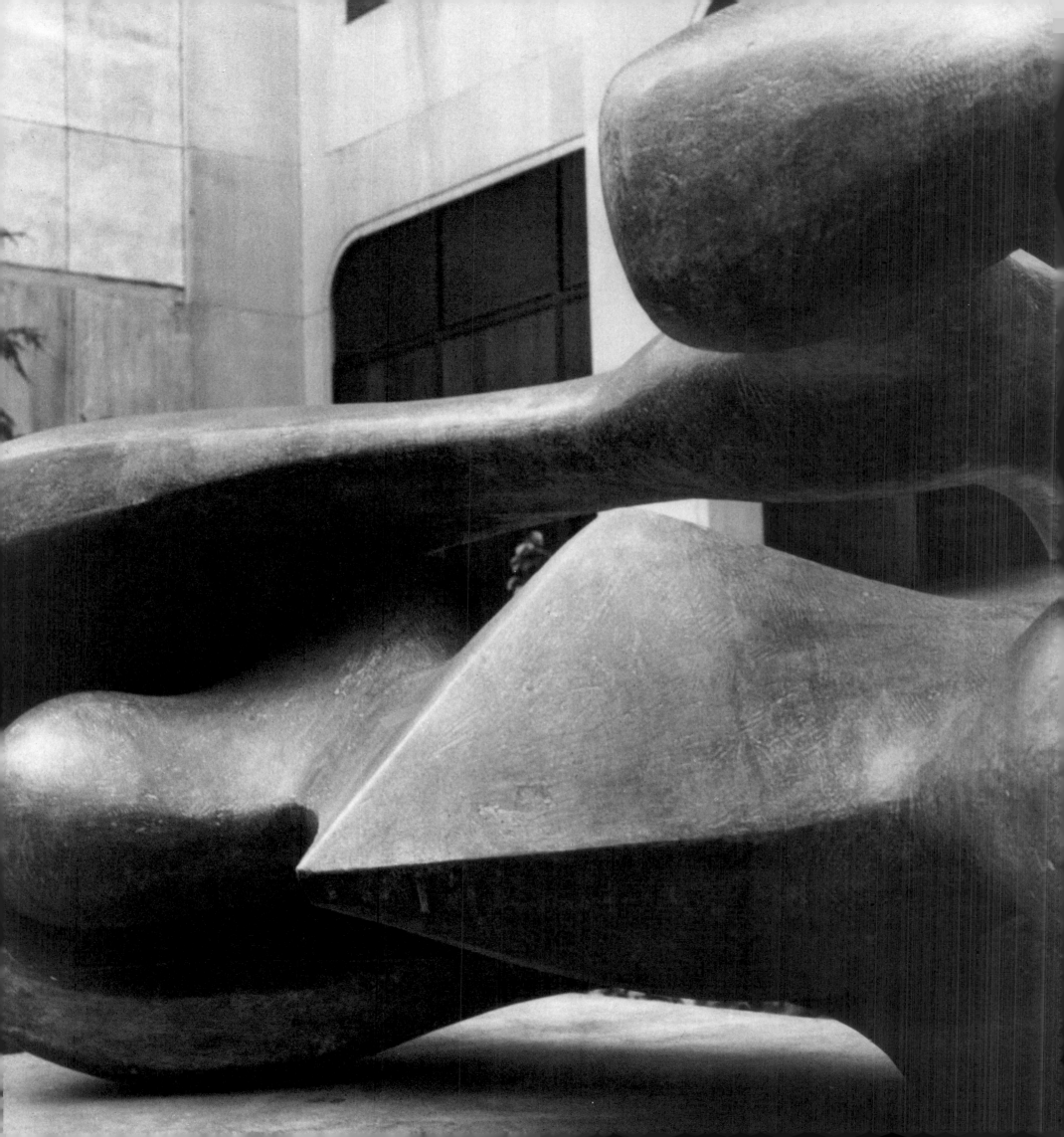

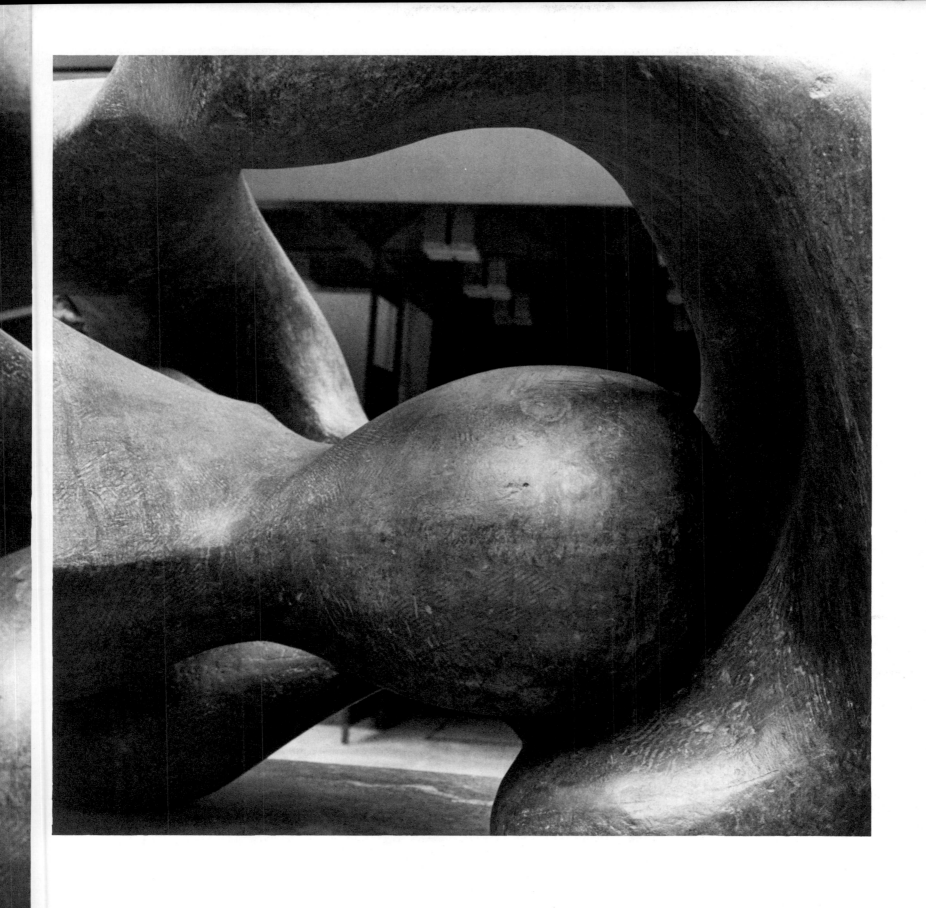

RECLINING FIGURE

1956. BRONZE, L. 96". PEPSICO, INC., WORLD HEADQUARTERS, PURCHASE, NEW YORK

Completed at about the same time as the *Falling Warrior* (see pp. 120–24; 272–75), this is another version of a reclining male figure. The unusual feature of arms and legs that are cut off, without hands or feet, further suggests a conceptual resemblance between the two sculptures. Unlike the *Falling Warrior*, however, this is a figure in repose. Yet from some positions its undulating forms are remarkably vigorous, as if the figure possesses an animal-like strength.

The site for the work in front of the Pepsico building is well chosen. It is in a spot that must be passed by employees and

visitors as they enter the building, and there is a wide expanse of lawn around the sculpture, so one can get a fine view of it from all directions. Also, the building is well designed and modest in size, so the sculpture is not overshadowed by a towering structure. The piece has long been a favorite of mine, and I enjoyed the opportunity to photograph it in this location.

That's quite lovely against the fountain. I like the pedestal.

—*Henry Moore*

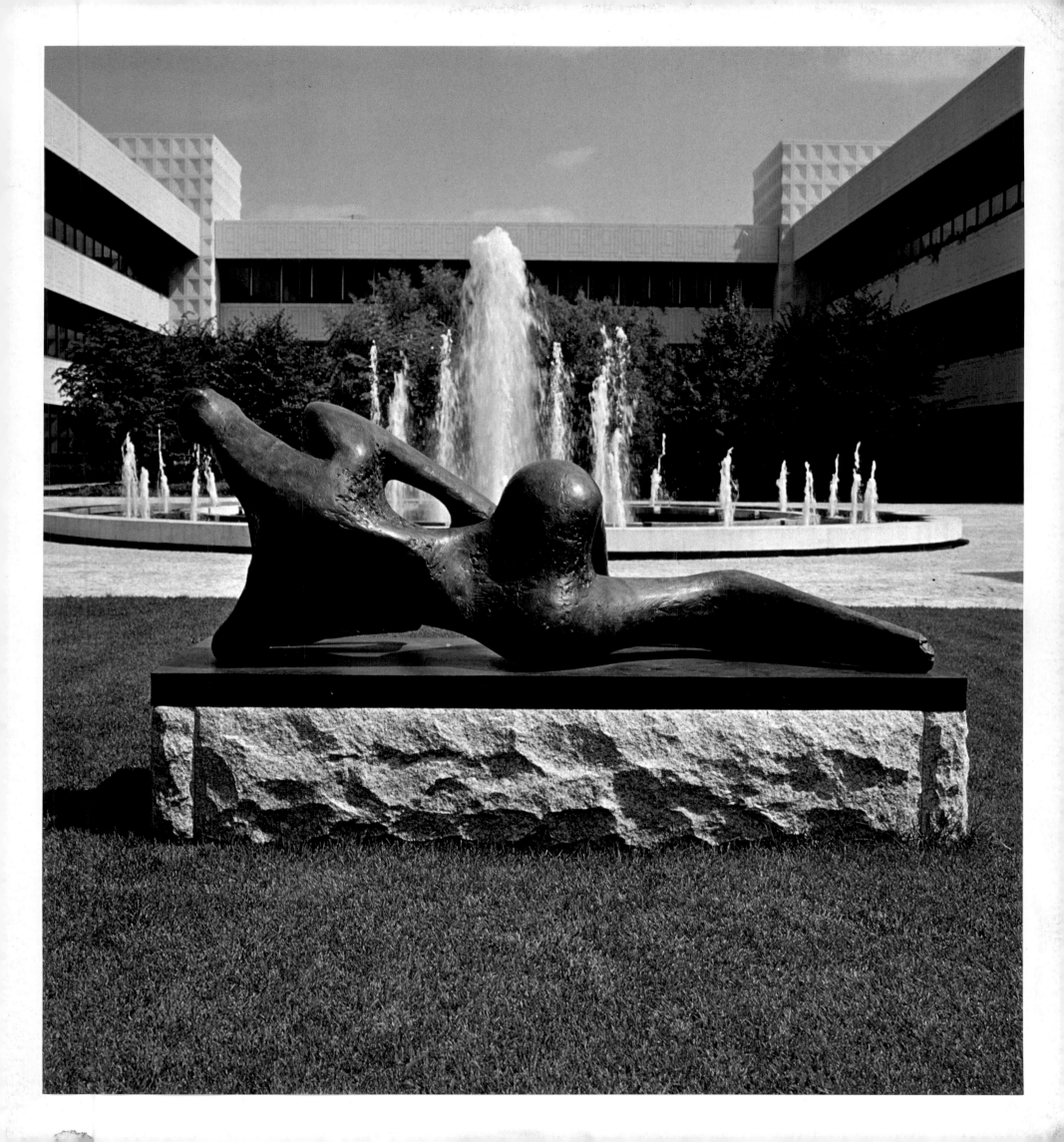

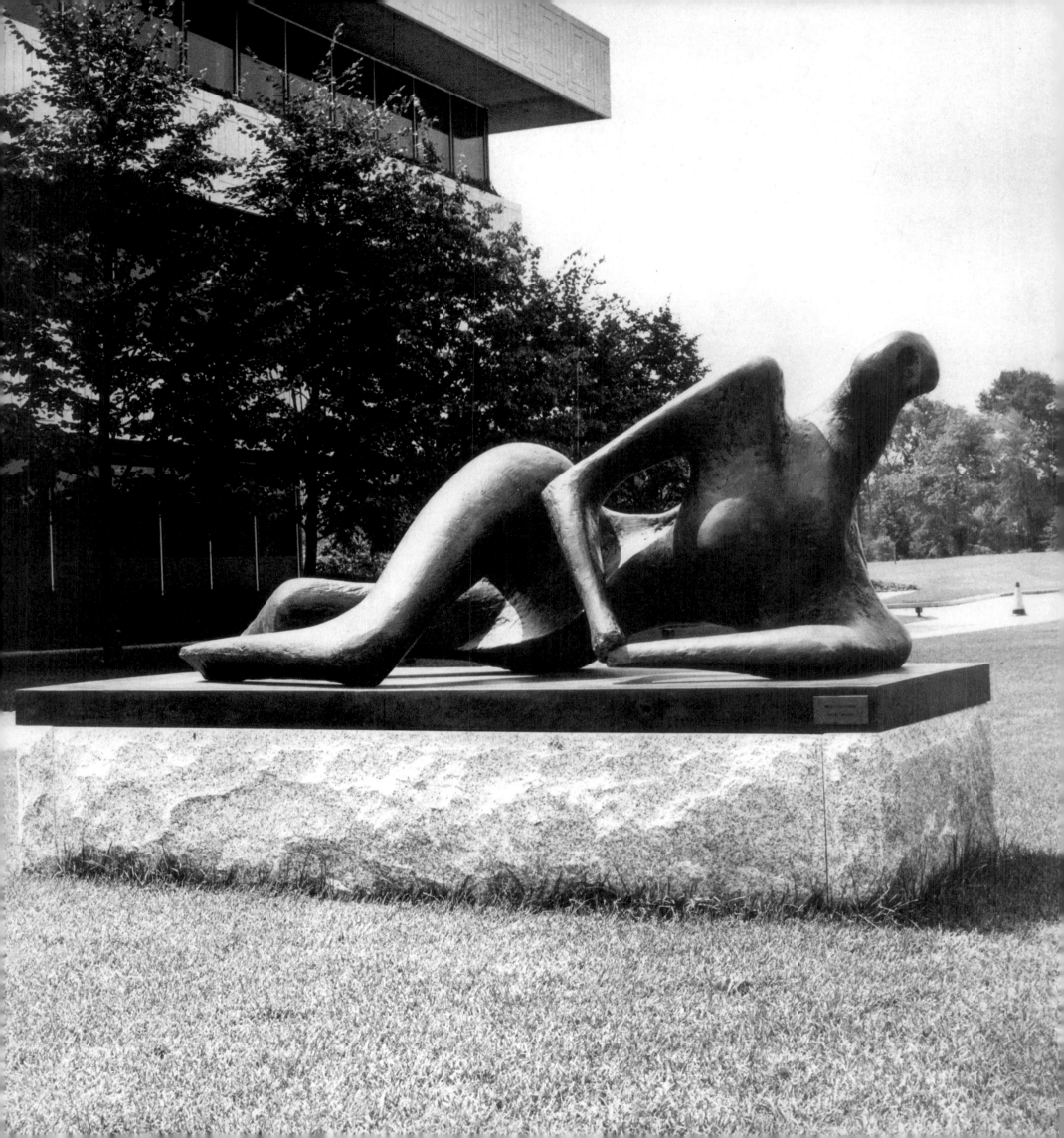

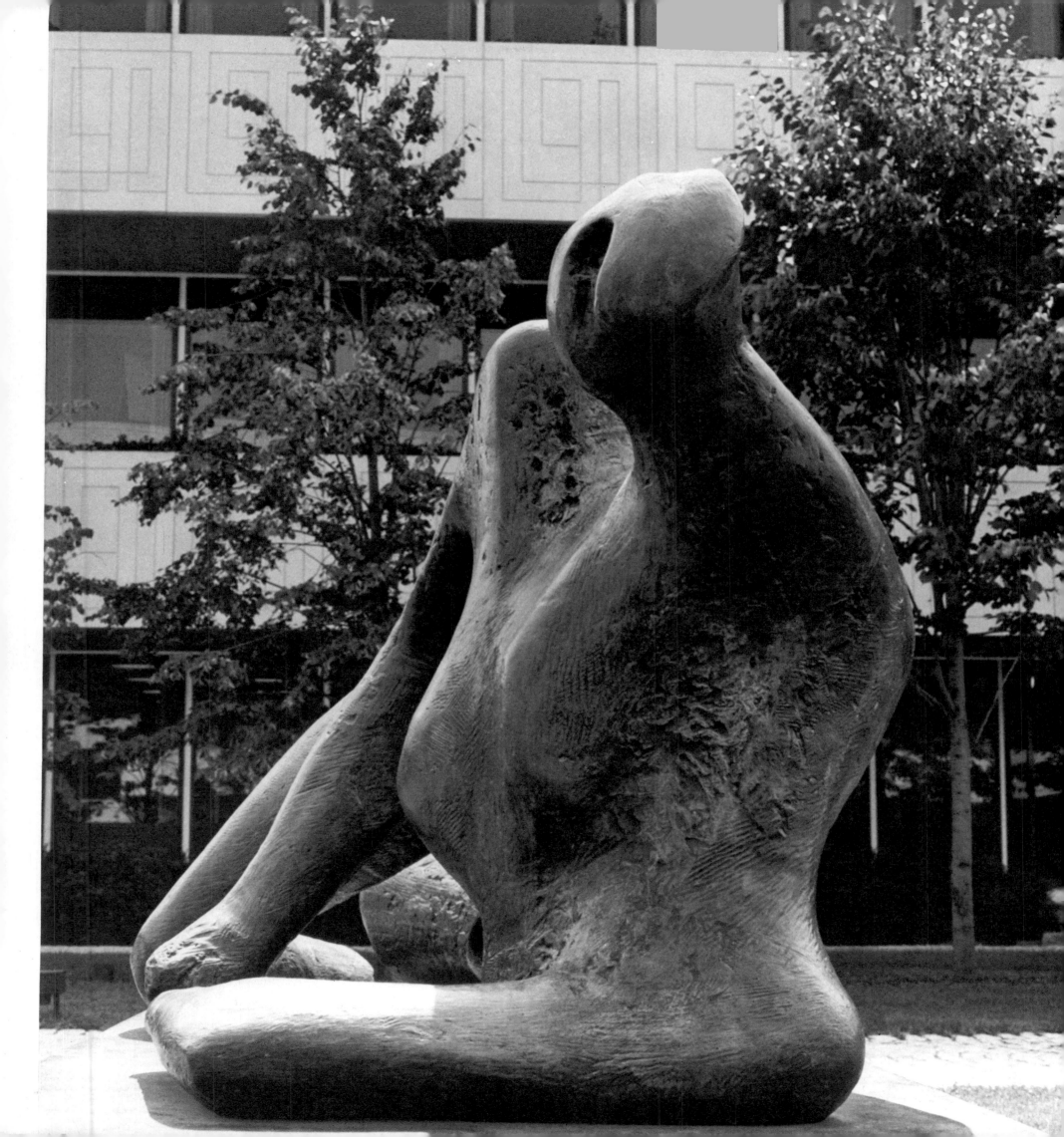

WORKING MODEL FOR LOCKING PIECE

1962. BRONZE, H. 42". PEPSICO, INC., WORLD HEADQUARTERS, PURCHASE, NEW YORK

This cast of the working model for the *Locking Piece* has a green patina and is located in a small garden in the central area of the Pepsico headquarters building. Although the design of the building and its surrounding area is outstanding, this particular setting seems too manicured for such a strong elemental piece. The pedestal is too delicate, and the pebbled area at the base, with the highly formalized squares of lawn and stone around it, gives the work a

decorative quality that is less striking than the effect produced in other locations.

These photographs have a better light than those in Germany (see pp. 144–47). But the pedestal block looks too massive, and the setting is not my idea of the right place. It looks too much like a cottage garden.

—Henry Moore

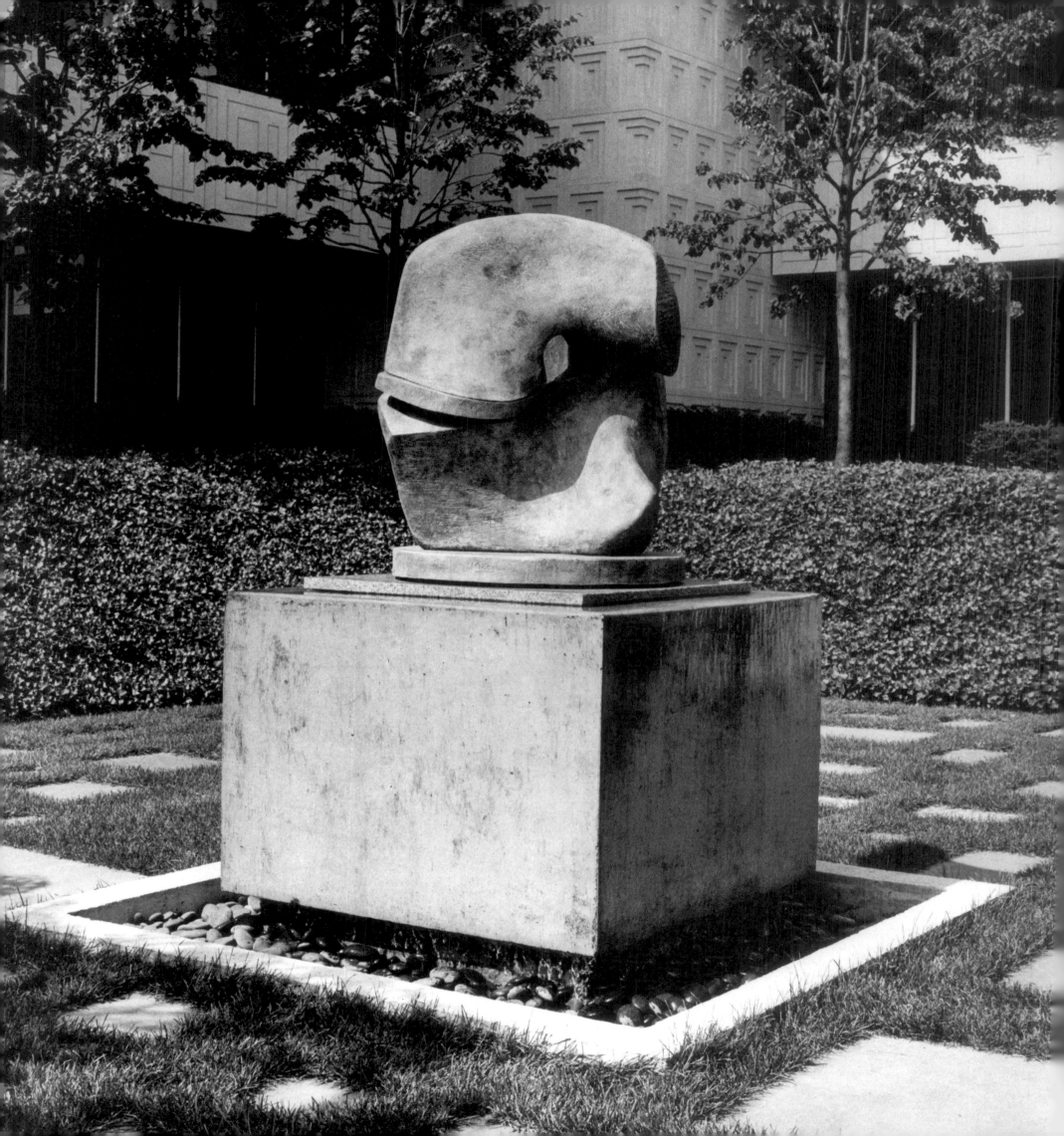

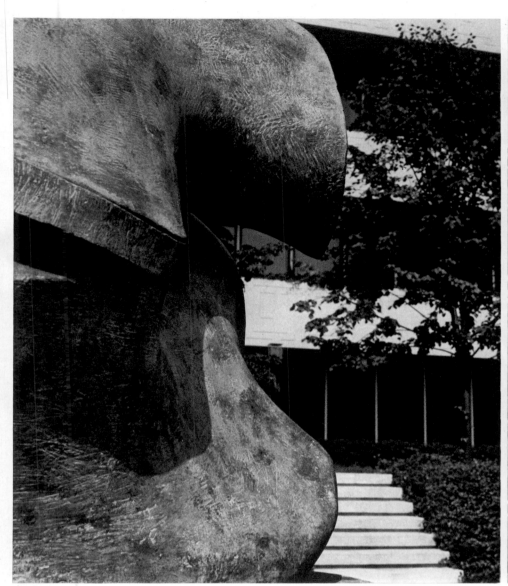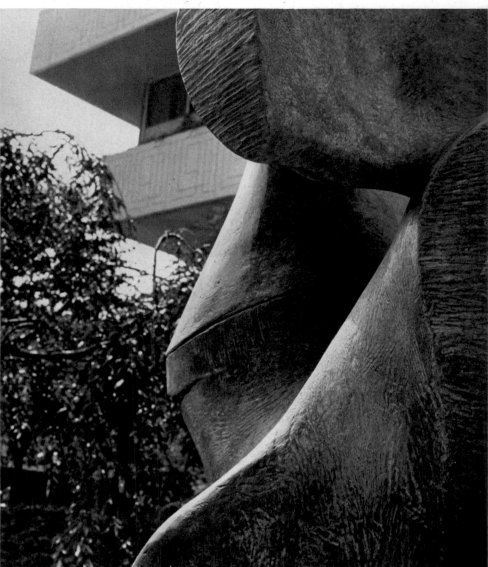

DOUBLE OVAL

1967. BRONZE, L. 17'8". PEPSICO, INC., WORLD HEADQUARTERS, PURCHASE, NEW YORK

One of Henry Moore's less familiar works, *Double Oval* was not included in the great Florence exhibition of 1972. And yet it is a wonderfully inventive piece, in which the interaction between the two rings enables one to discover a series of interrelated ovals. The work is placed in a fine location at the rear of the Pepsico building at Purchase, New York. The sculpture stands near a pond with a lovely fountain and has a wide expanse of green lawn and a good background of trees. A striking work by Alexander Calder, a major sculpture by David Smith, and an Arnaldo Pomodoro are also in the same general area.

The Pepsico building does not seem to interfere with the enjoyment of these works; indeed there seems to be a pleasant relationship among the shape of the building, the landscape of the general area, and this monumental sculpture. I spent several hours photographing *Double Oval* and enjoying its brilliant combination in the interior sections of sweeping lines and flesh-and-bone-like qualities. And, of course, I was delighted at the appearance of the goose, whose graceful lines seemed to echo the curves of the sculpture.

That's fine. Jolly good. I don't mind here that the architecture is so different from the sculpture.

—Henry Moore

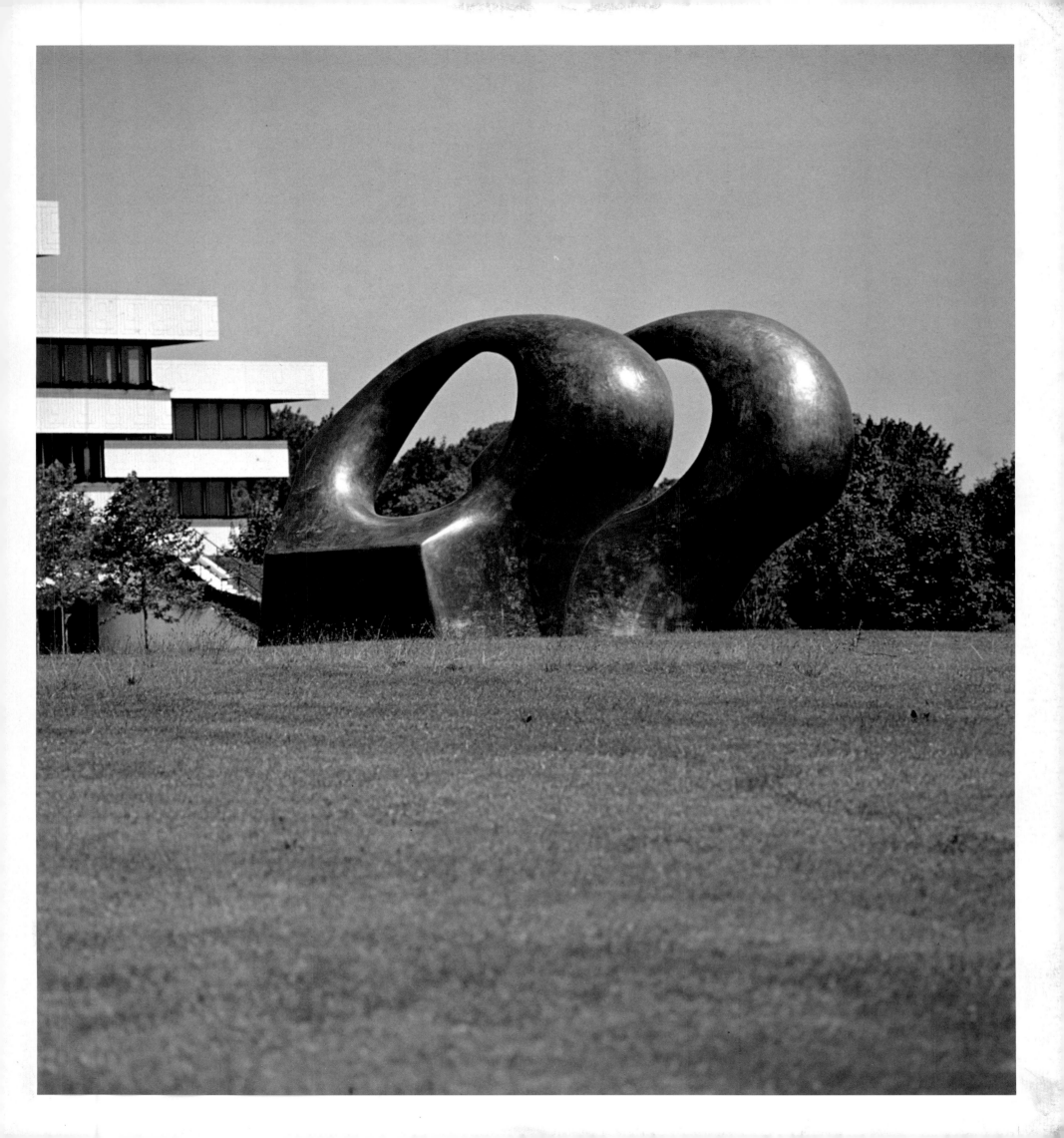

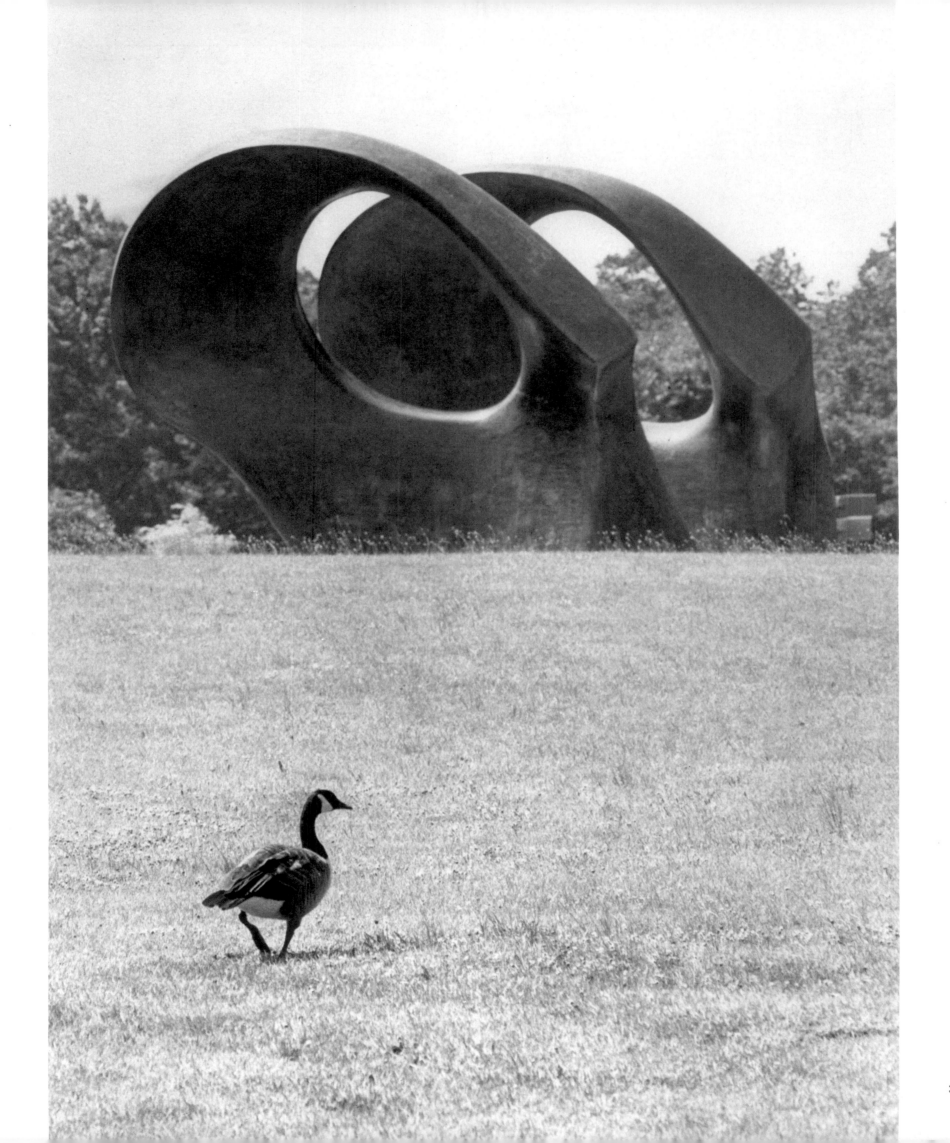

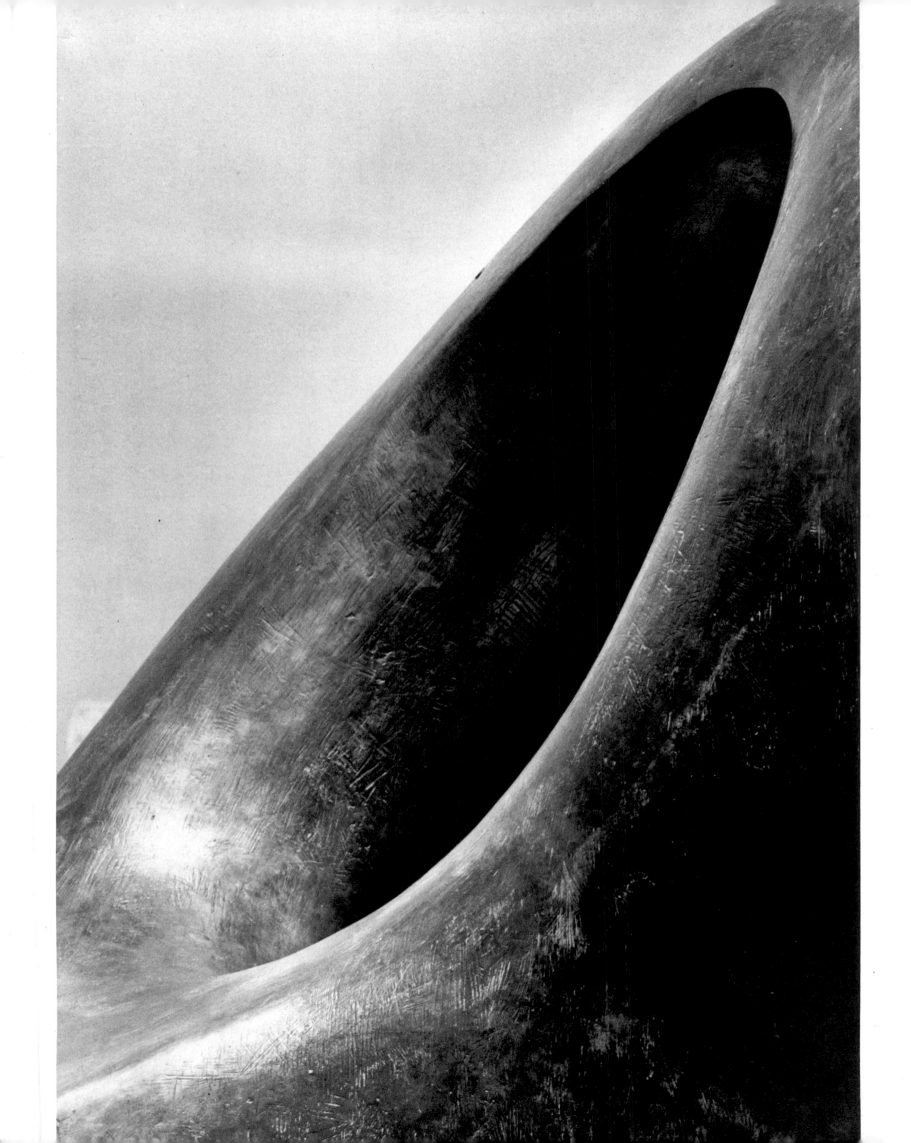

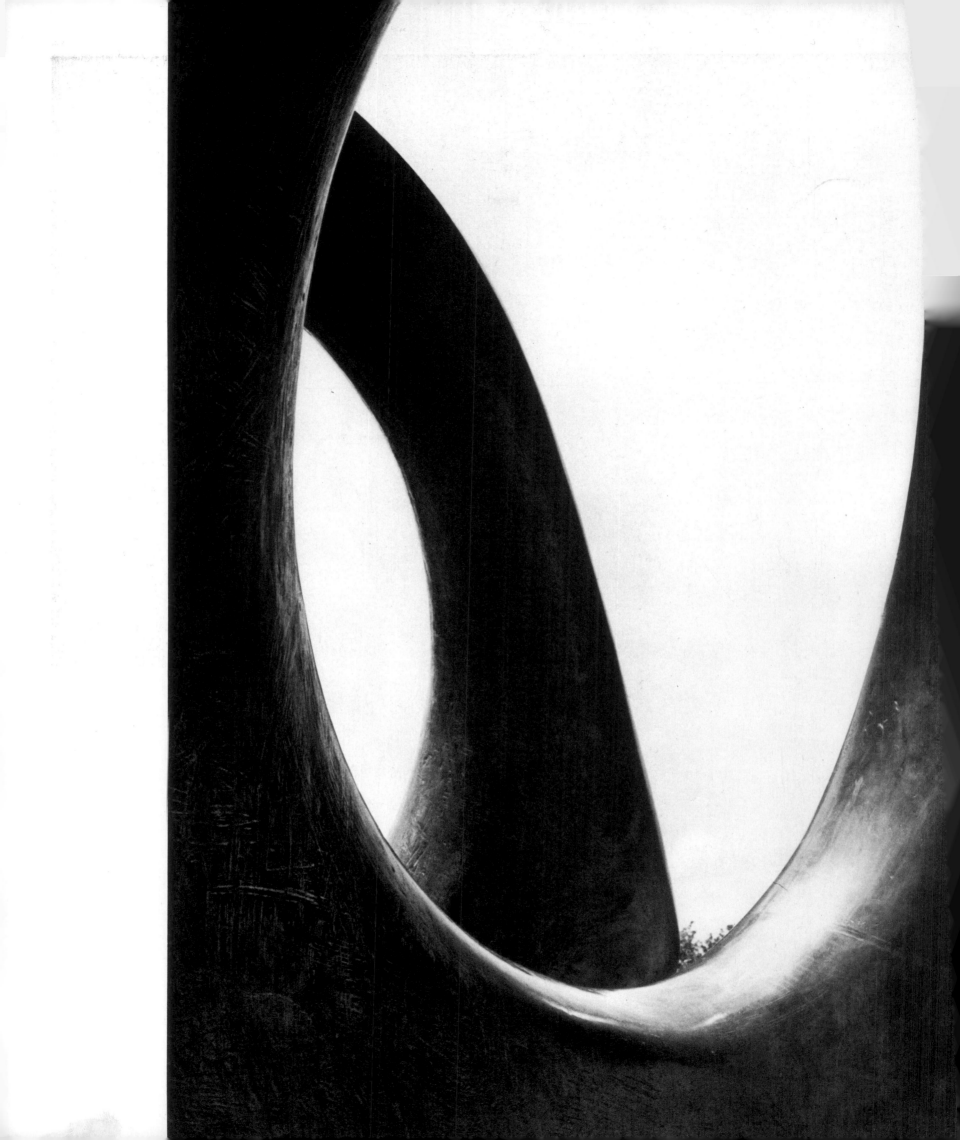

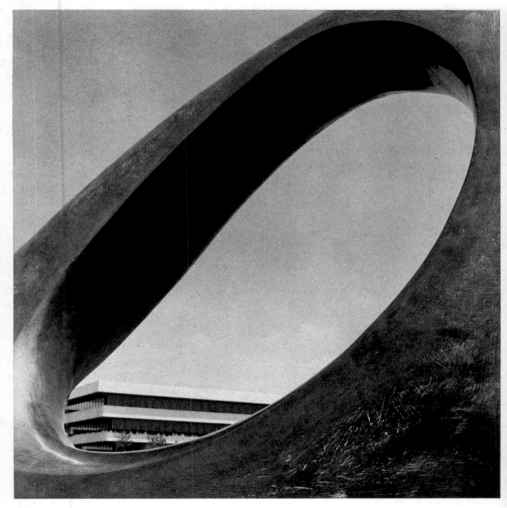

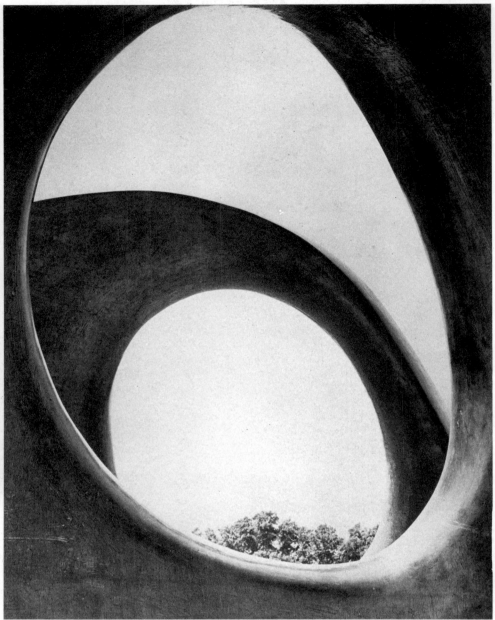

LARGE TWO FORMS

1966–69. BRONZE, L. 15'6". STATE UNIVERSITY OF NEW YORK, PURCHASE

This cast of *Large Two Forms*, one of Moore's most brilliant achievements, is located on the central mall of the State University campus at Purchase, New York. The scale of the piece is excellent in relation to the neighboring buildings, and there is a grand expanse of space around it that enables one to see the work equally well from all directions. Unfortunately, the architectural impression created by the campus in general is somewhat monotonous, and the sculpture might have looked far more beautiful if it had been located in the midst of the green field adjacent to the present mall. It is situated on one of the most heavily used walkways of the campus, however, which means that it is seen regularly by practically everybody attending the university. Thus, in spite of the disadvantages of the setting, the sculpture is a dominant feature of the environment and, as such, has become the artistic symbol of the institution.

I had first seen a fiberglass cast of *Large Two Forms* at the 1972 Florence exhibition (see p. 475). I thought then that it was a magnificent example of Moore's genius for creating forms that transform themselves through the variety of their shapes and relationships as one moves around them. But it wasn't until I spent a morning photographing the sculpture at Purchase that I realized how great the work truly is. Indeed I was so fascinated by the variety of magnificent lines, shapes, spaces, and shadows that I simply couldn't stop photographing, and I went on taking roll after roll until I ran out of film. There is an obvious sensuality about the piece in its thrusting, gaping, straining forms; there is also something noble and stately about it. One of its most remarkable qualities is the way it catches light and casts shadows, and I was very lucky to have photographed it on such a crystal-clear day.

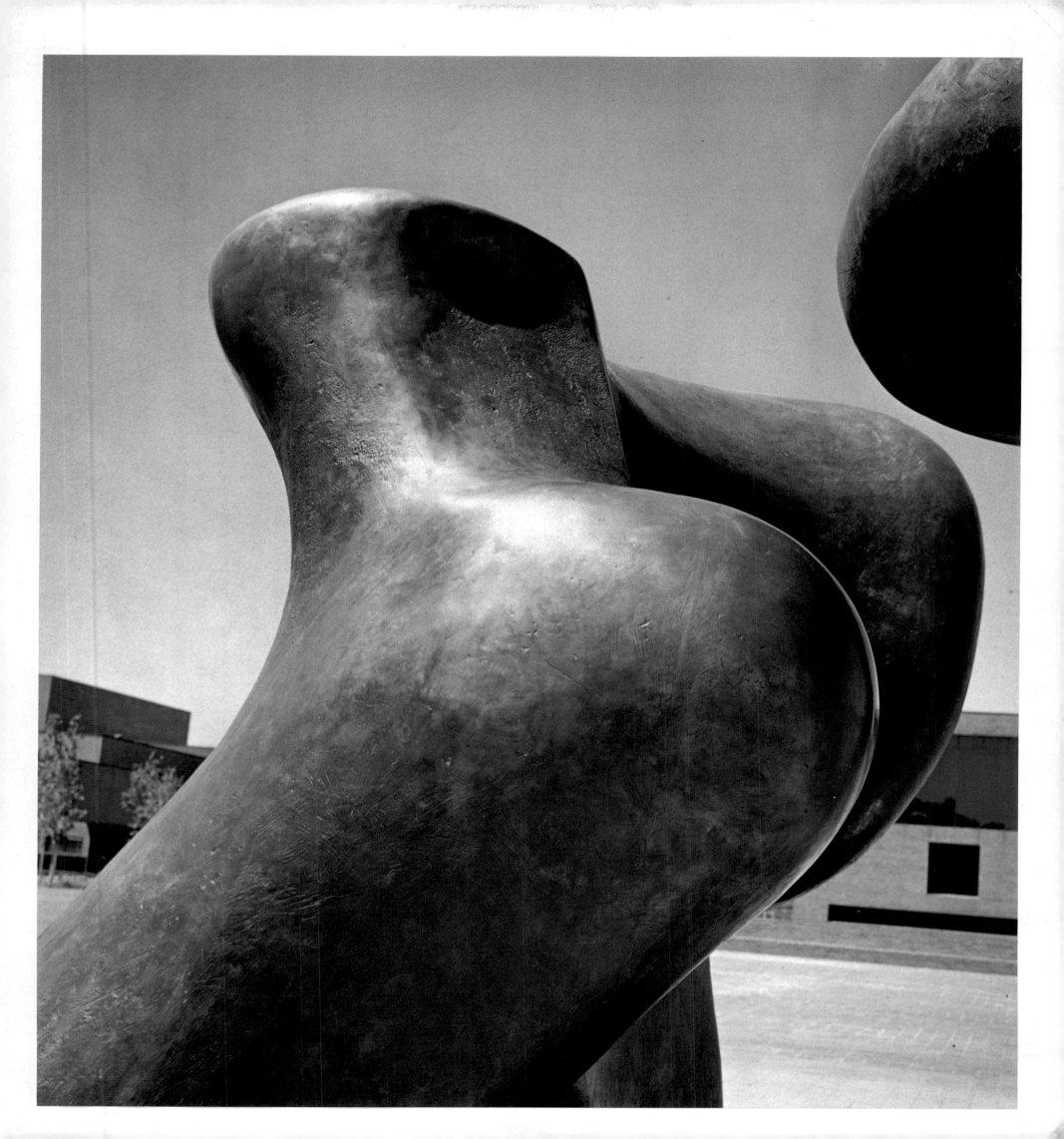

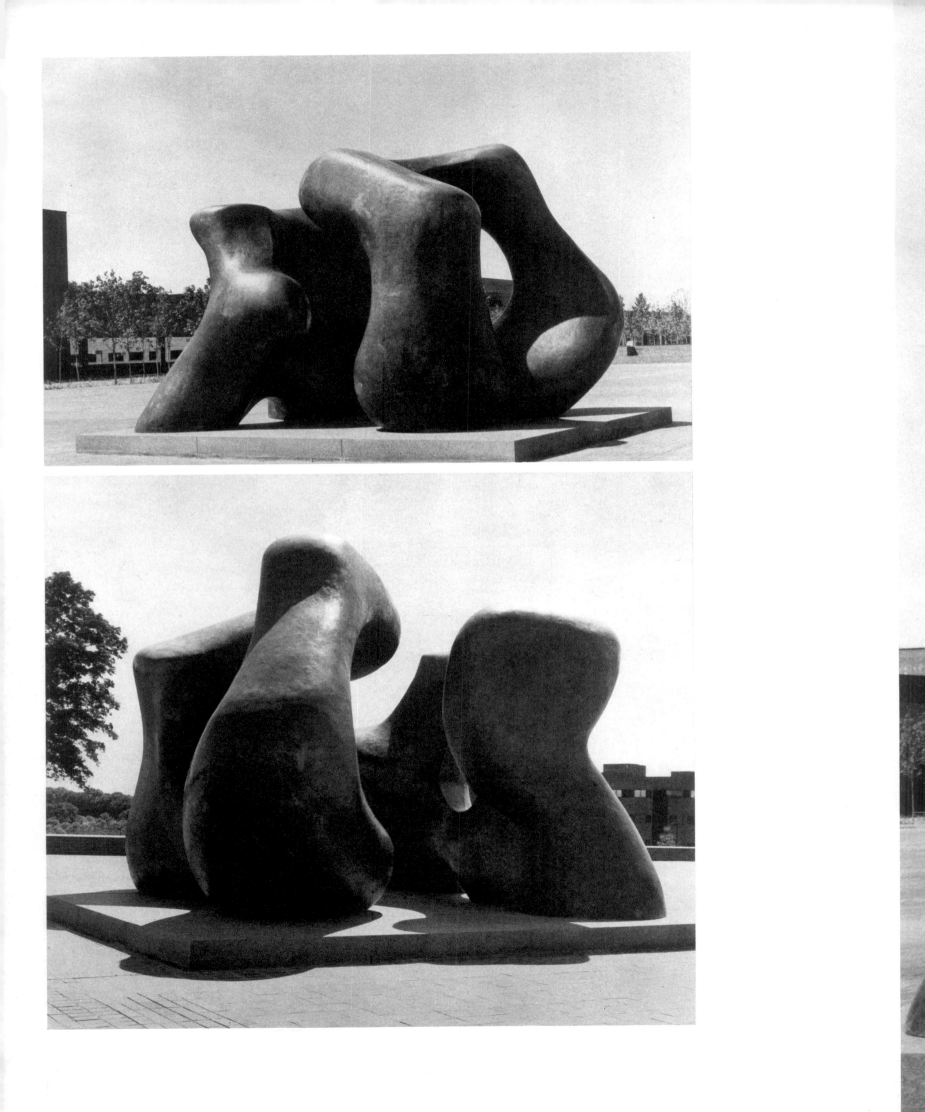

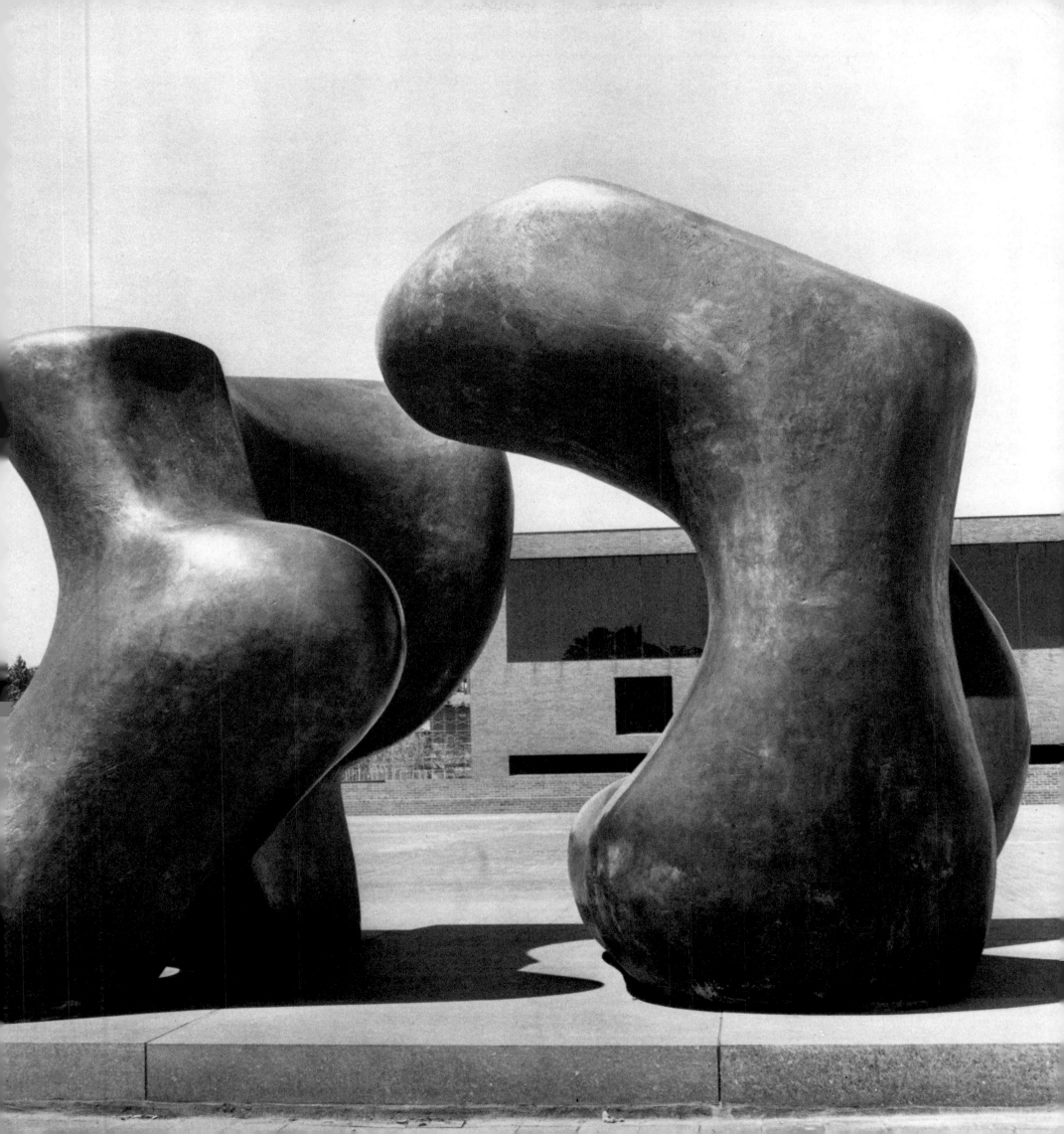

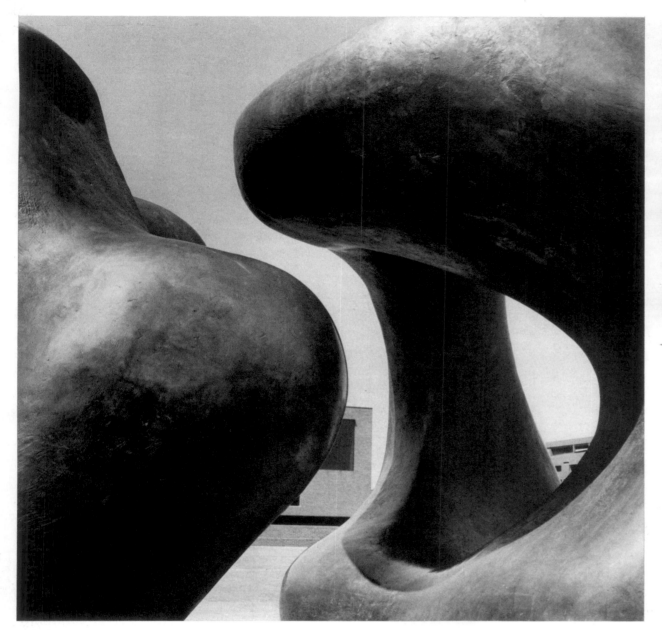

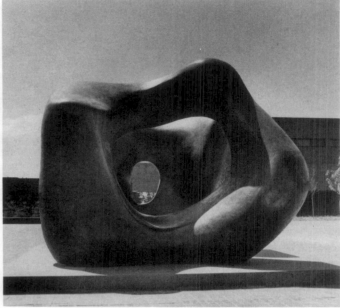

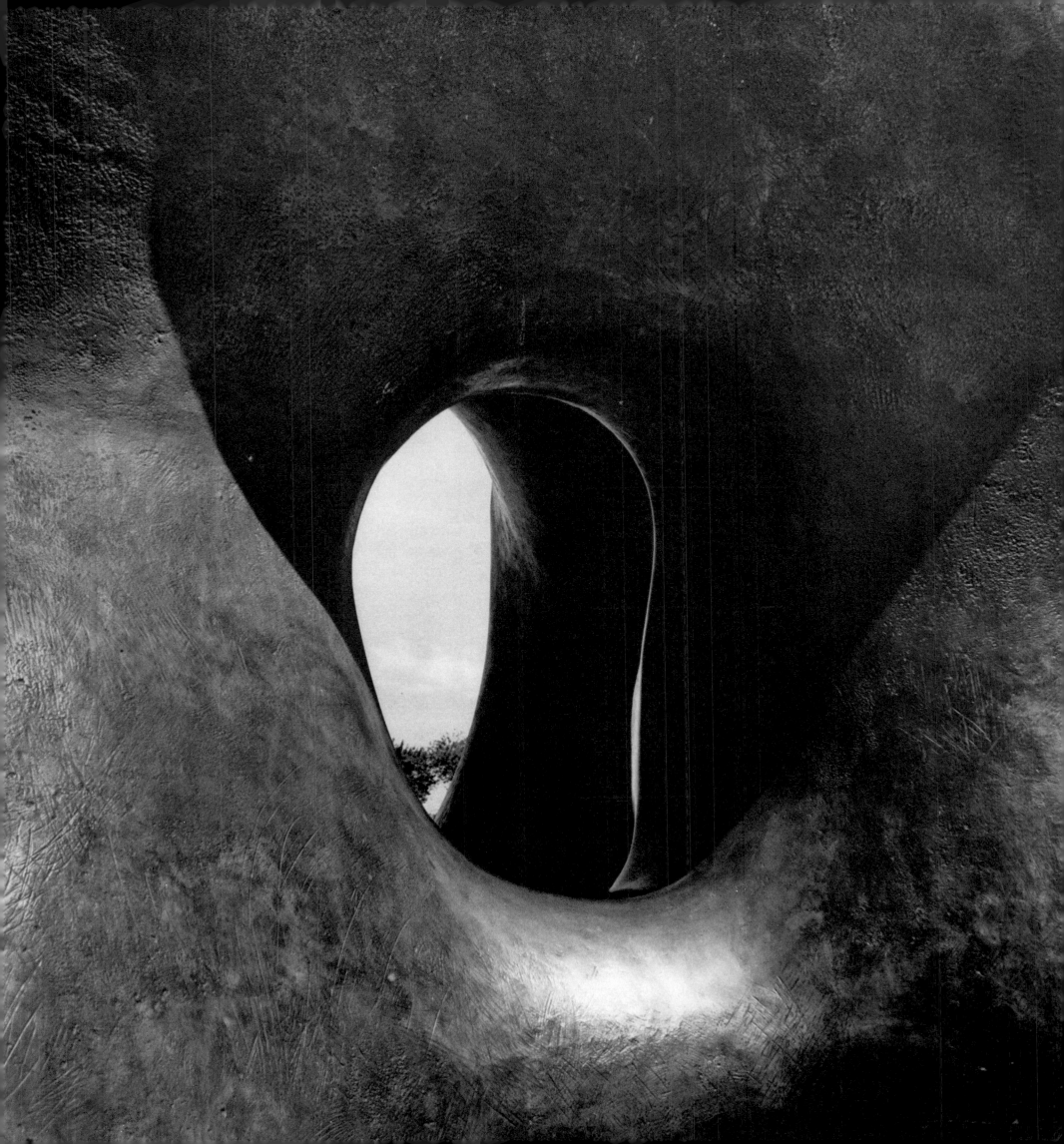

THREE-PIECE RECLINING FIGURE 1

1961–62. BRONZE, L. 9'5". ROCHESTER INSTITUTE OF TECHNOLOGY, NEW YORK

This work, which is on the campus of the Rochester Institute of Technology, is situated so close to a building that it almost seems to be part of the architecture. There are green areas of the campus that could have provided alternative settings, but there was clearly a conscious decision to put the sculpture in the midst of a stone environment in order to take advantage of the flat, geometric character of the architectural shapes.

The sculpture, which I also photographed in Cambridge, England, and Los Angeles (see pp. 268–71; 464–67), is an extremely beautiful one, and I am delighted that these photographs reveal its qualities

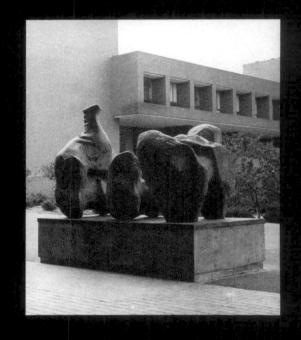

so well. But I found the almost unrelieved monotony of R.I.T.'s architecture disturbing. The placement of the work immediately in front of the building makes it appear cramped, and I keenly felt the absence of any greenery to set off the sculpture. I consciously tried to show views in my photographs that take advantage of a positive interrelationship between the architectural forms and the sculpture, and I'm glad Moore reacted well to these. But if he saw the sculpture in the setting itself, I think he would have many reservations about the way it is placed.

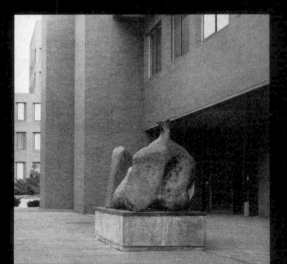

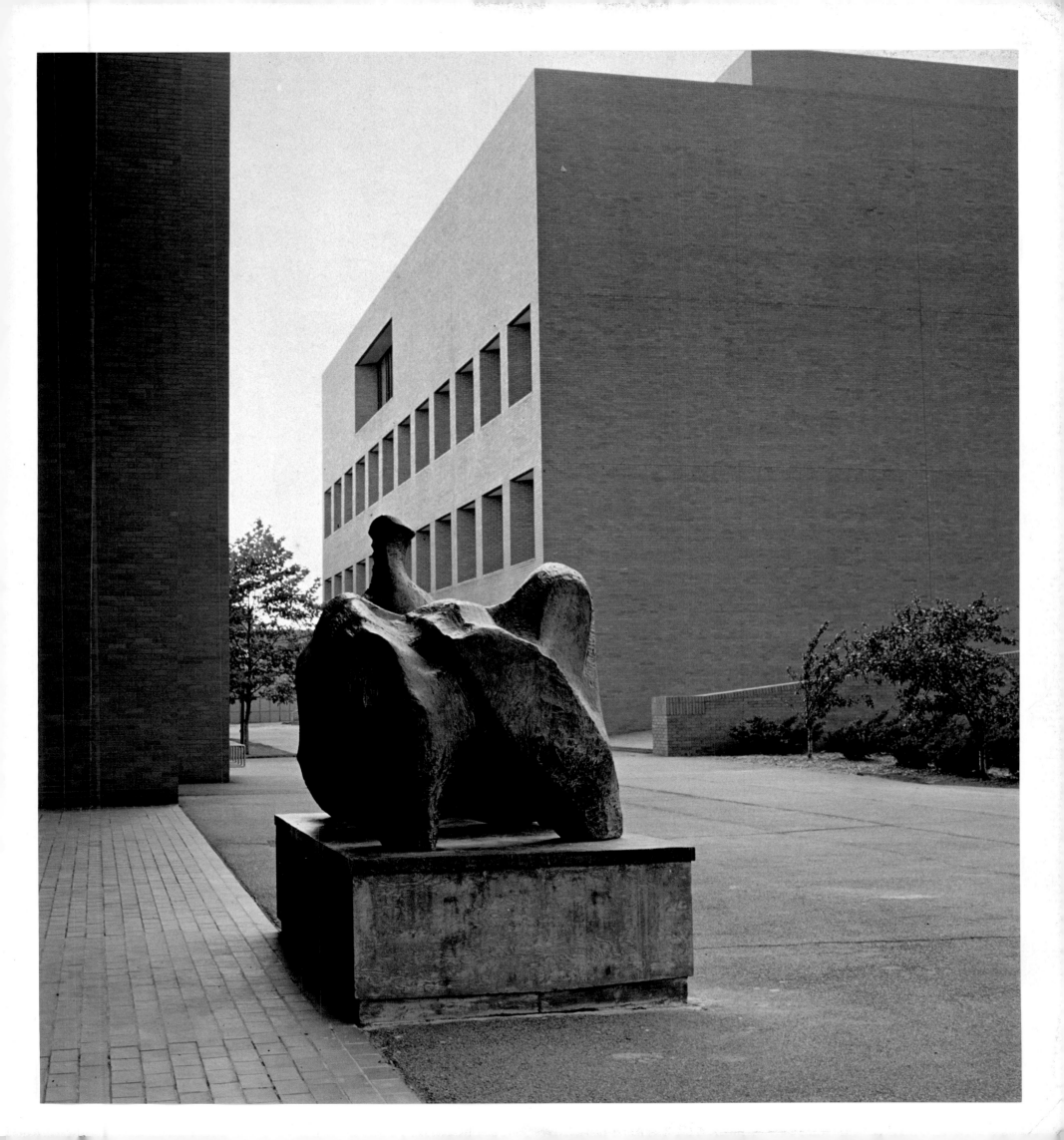

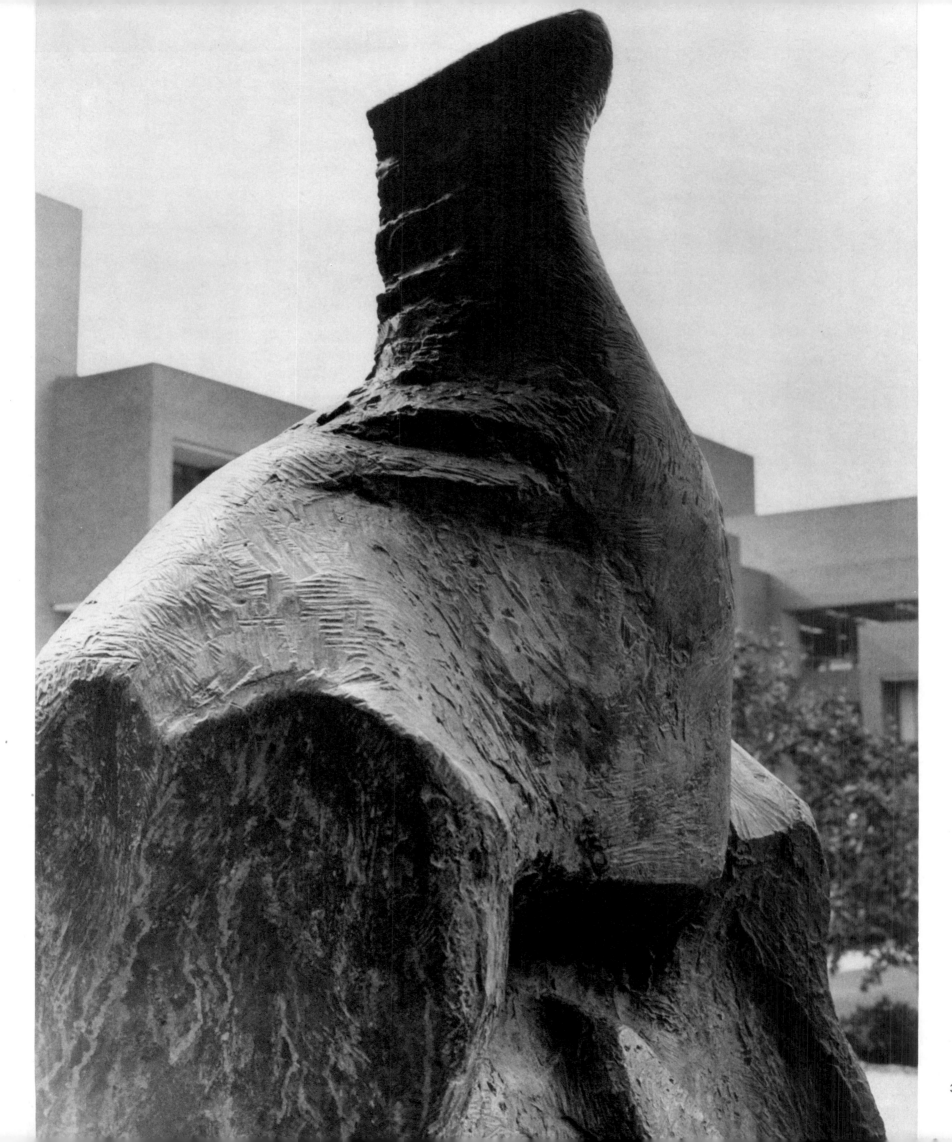

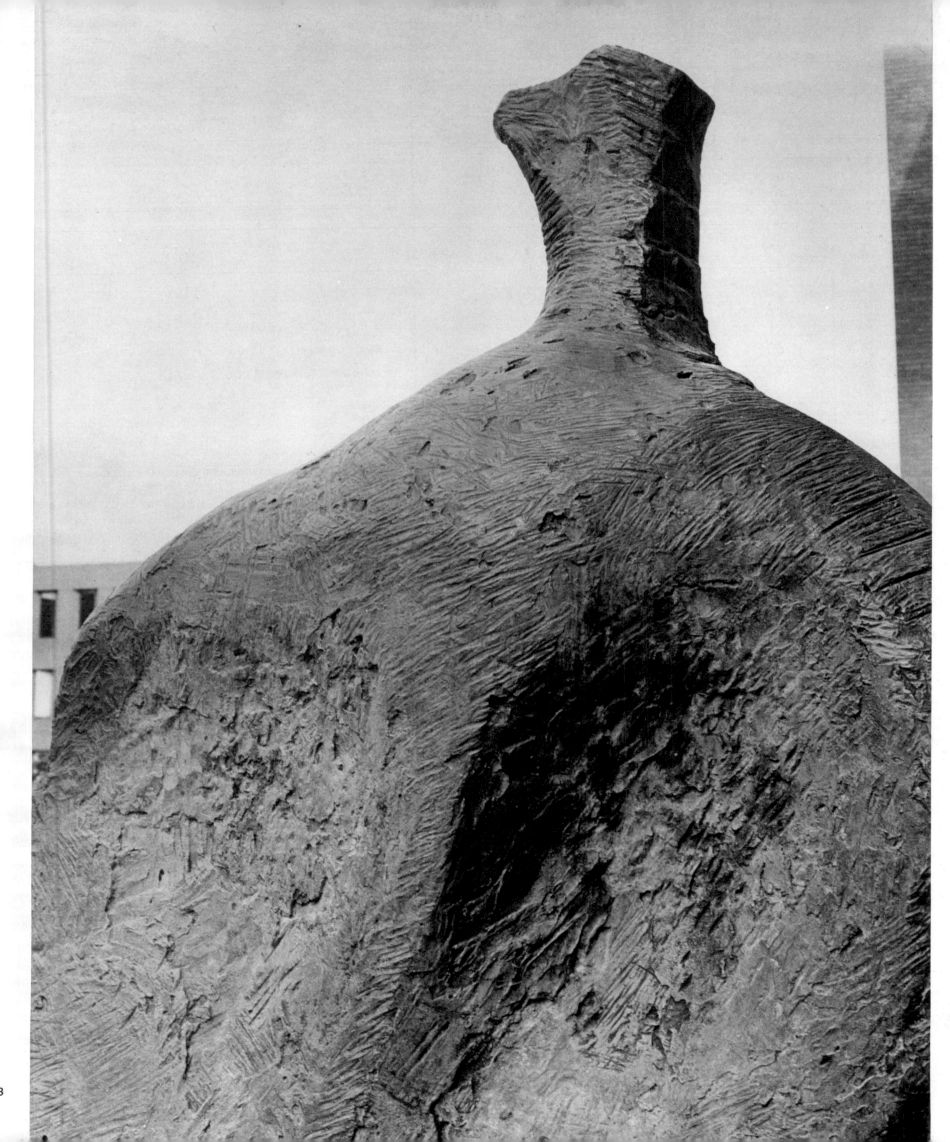

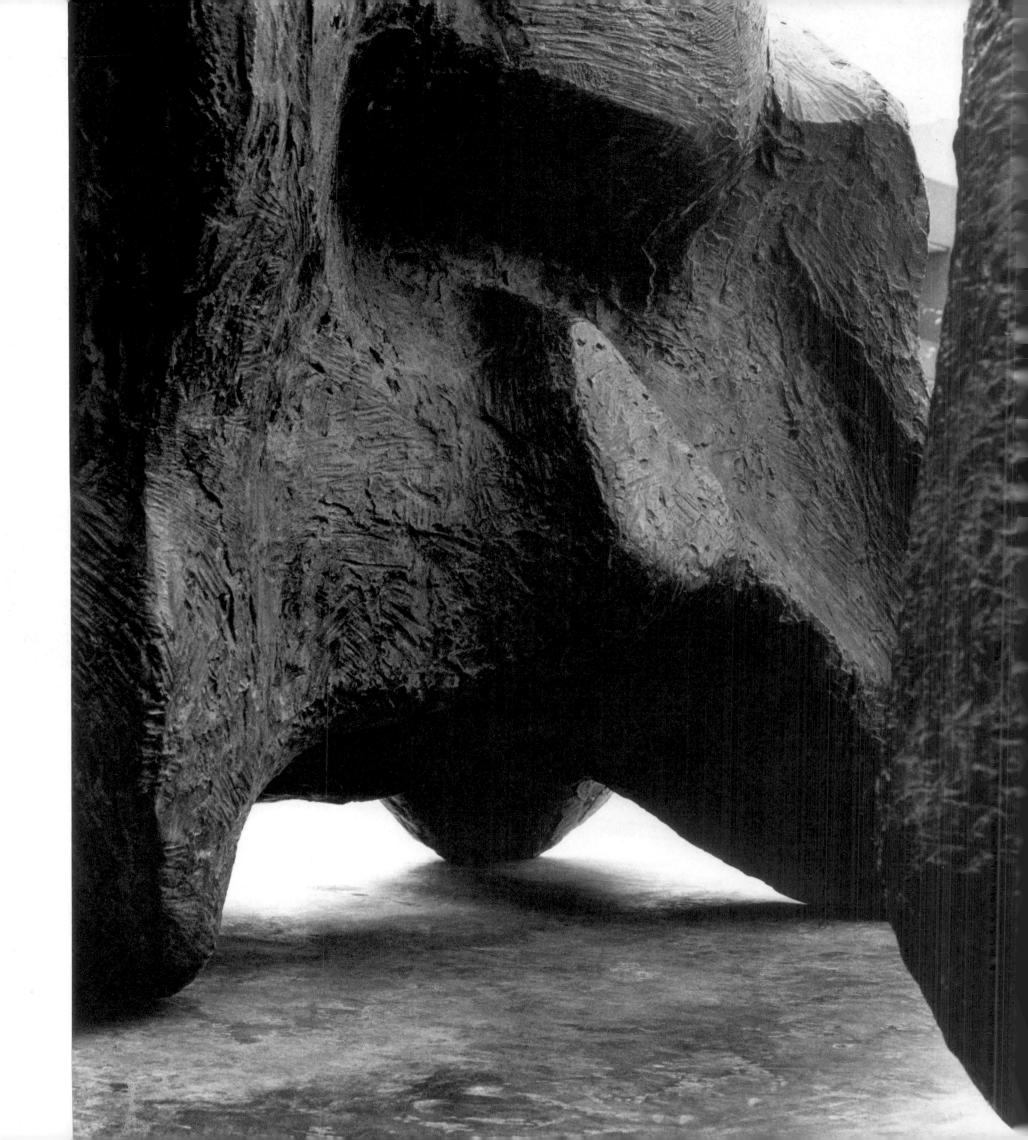

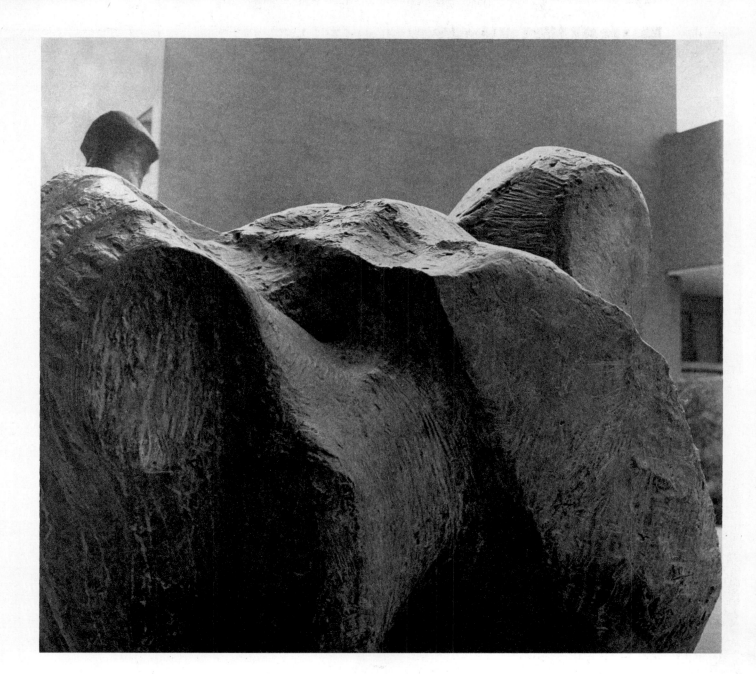

The photographs are excellent, some of the best photographs in the book. They show what the form really is, the boniness under the flesh. They explain and reveal the sculpture: that is what I like photographs to do. If I had to make the sculpture over again, these photographs would be enough to enable me to do it.

I have not seen my sculpture here at Rochester, and perhaps if I did, I might be critical and find that from many angles there would be unfortunate visual severances because of the powerful background architecture, i.e., knees cut off by cornices, the head cut into by window frames (see the Time/Life *Draped Reclining Figure, pp. 230–32). But I would like to make a special argument for sculpture being a contrast to the architecture it accompanies, rather than only an echo in miniature of the architecture.*

—Henry Moore

MOTIVE
5

1955–56. BRONZE, H. 84". FORMERLY ON LOAN, ROCHESTER MEMORIAL ART GALLERY
OF THE UNIVERSITY OF ROCHESTER, NEW YORK

wo Upright Motives that
ed loan from Charles R.
Rochester Memorial Art
Moore prosaically calls "the
in this sculpture could be
ly erotic. This interpretation
by the swelling form with
y in its center lower down on
he walnut shape seems like
cient symbol of fertility.
piece seems to be a collection

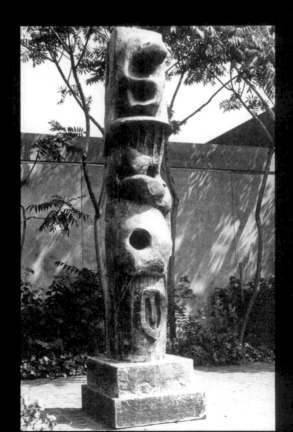

of organic forms so real that you
feel them pulsing with vitality.

I call this "the hole and lump." T
lump sticking out of the top and a
underneath it. I like the details in
photographs. One looks like a pr
woman, another like a deep cave.
spiral form is actually a sliced wa

—Henry Moore

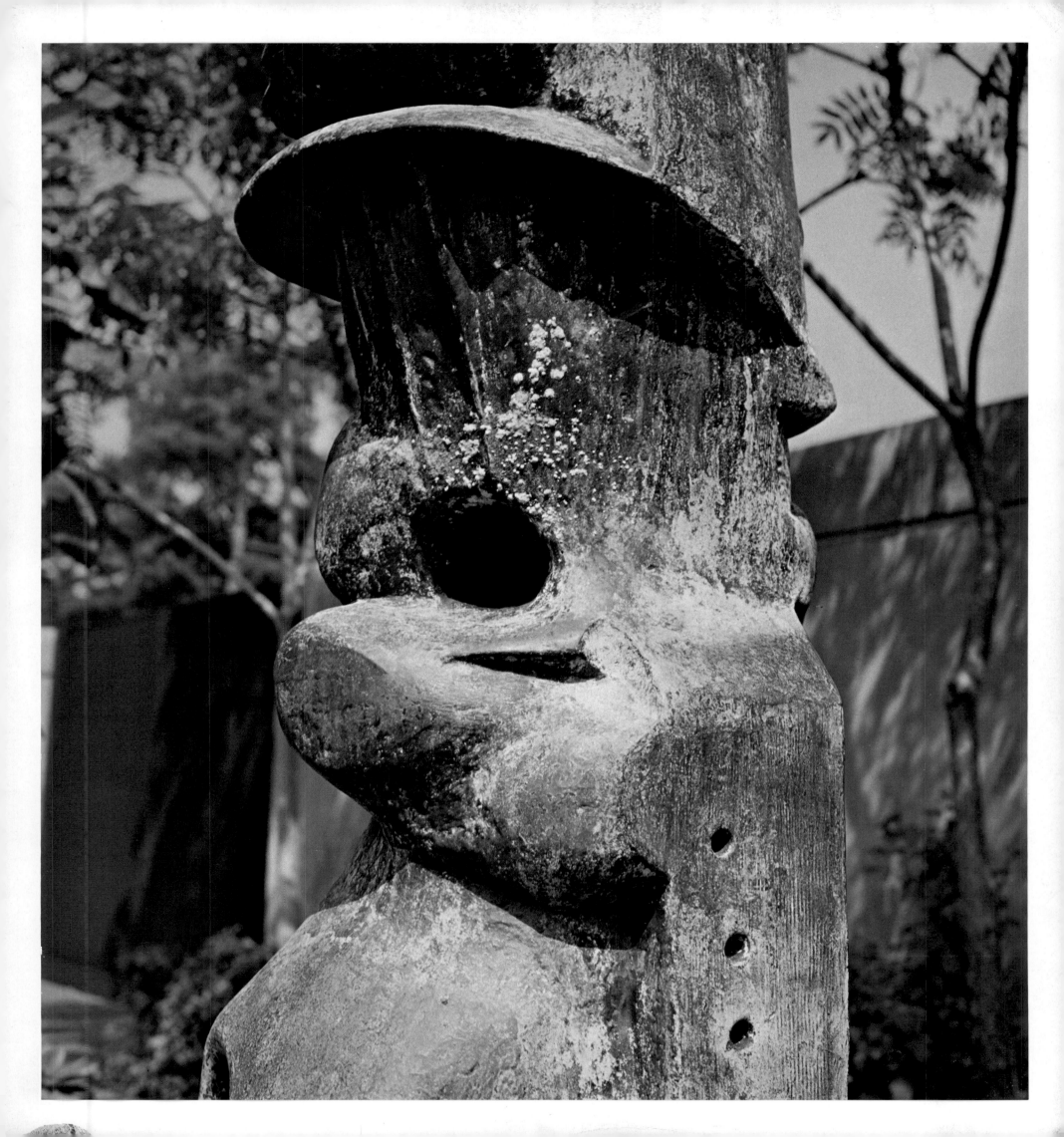

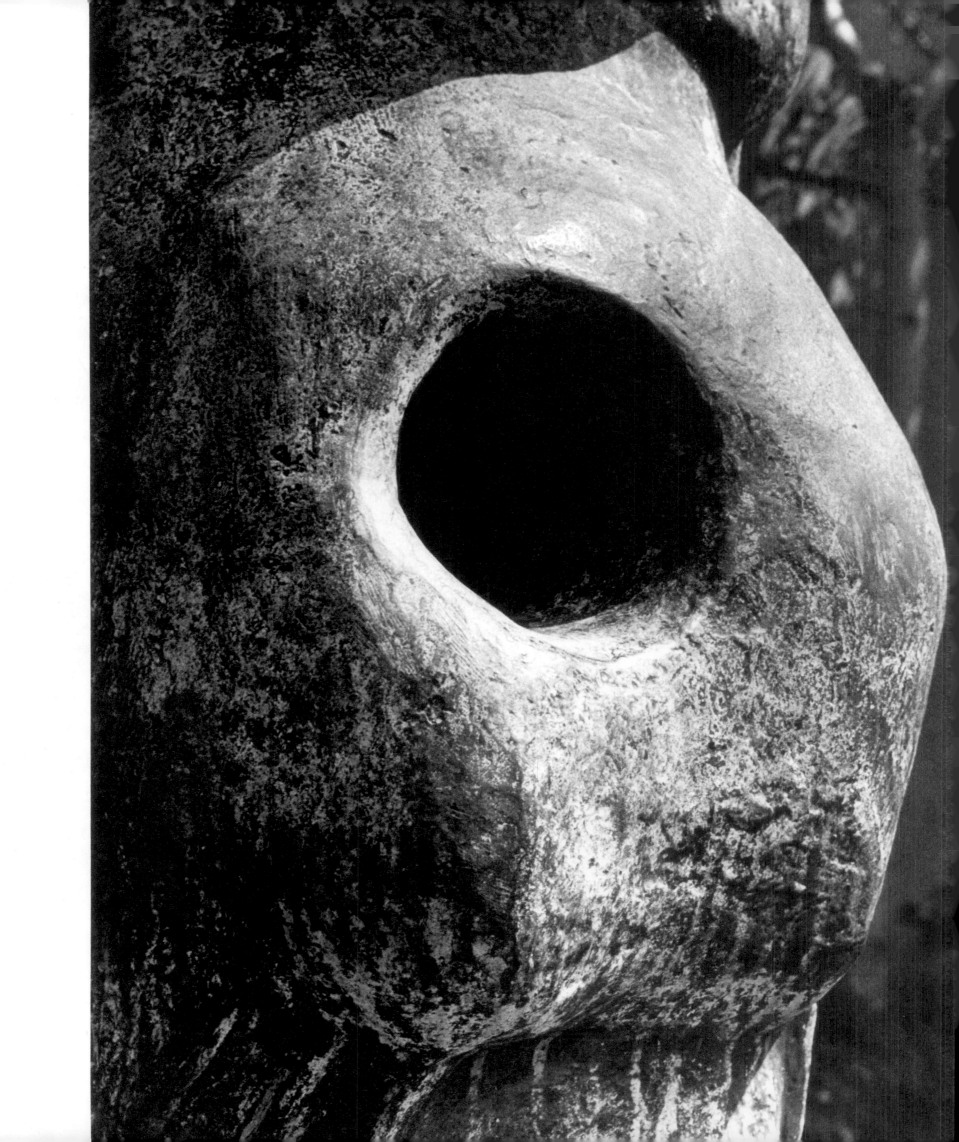

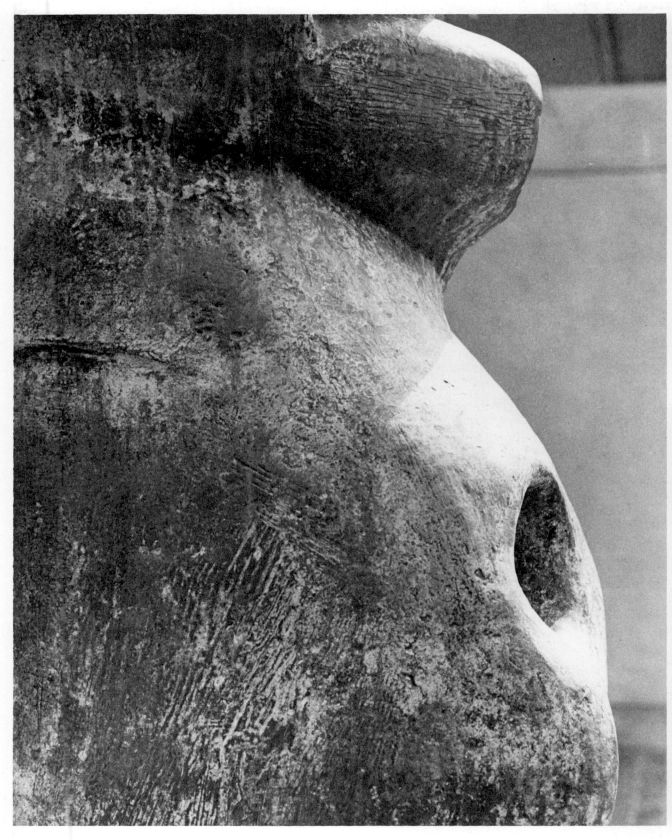
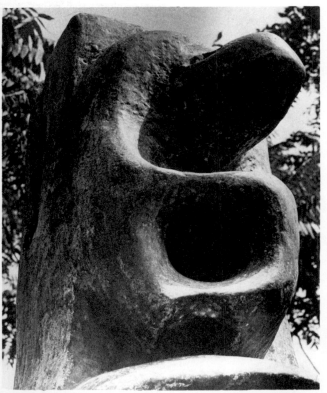

UPRIGHT MOTIVE 8

1955–56. BRONZE, H. 78″. FORMERLY ON LOAN, ROCHESTER MEMORIAL ART GALLERY
OF THE UNIVERSITY OF ROCHESTER, NEW YORK

When I photographed this sculpture, it was placed in the gallery's small but well-designed courtyard and could be enjoyed at close hand because it was on a low pedestal that allowed one to walk around it comfortably. There was some shrubbery in the yard that set off the work effectively, but the smallness of the space and the proximity of other sculptures made it a little difficult to get a proper feeling of the piece as a whole.

The work itself is quite extraordinary (see also the cast in Tokyo, pp. 52–56). There is a figure on a cross and, at the top, a form that to me resembles a jeweled crown, although apparently this was not Moore's intention. The side and back are abstract, and there are several enigmatic architectural shapes. This is not one of the three Uprights in Otterlo, the Netherlands (see pp. 168–73), but, like them, it is mysterious and evocative.

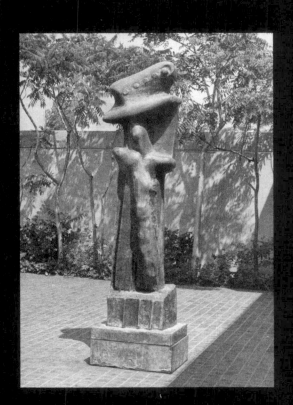

I did a series of Upright Motives around 1955. They came about because I was asked to do a sculpture to stand in front of Olivetti's new office building in Milan. I went to see the building—it was a low horizontal building which I thought needed a contrast. This led me to do a lot of variations on the Upright Motive theme, which I enjoyed doing as a contrast to the Reclining Figure rhythm. But I never carried out the commission. I lost the wish to do it as I realized the sculpture would always be surrounded by motor cars.

This sculpture has in it the idea of a cross (as in the Glenkiln Cross; *see pp. 306–7), but the silhouette of it from a distance does not read as a cross, and so would not have been right for the Glenkiln site. The top can be looked upon as a head—a face with eyes!*

—Henry Moore

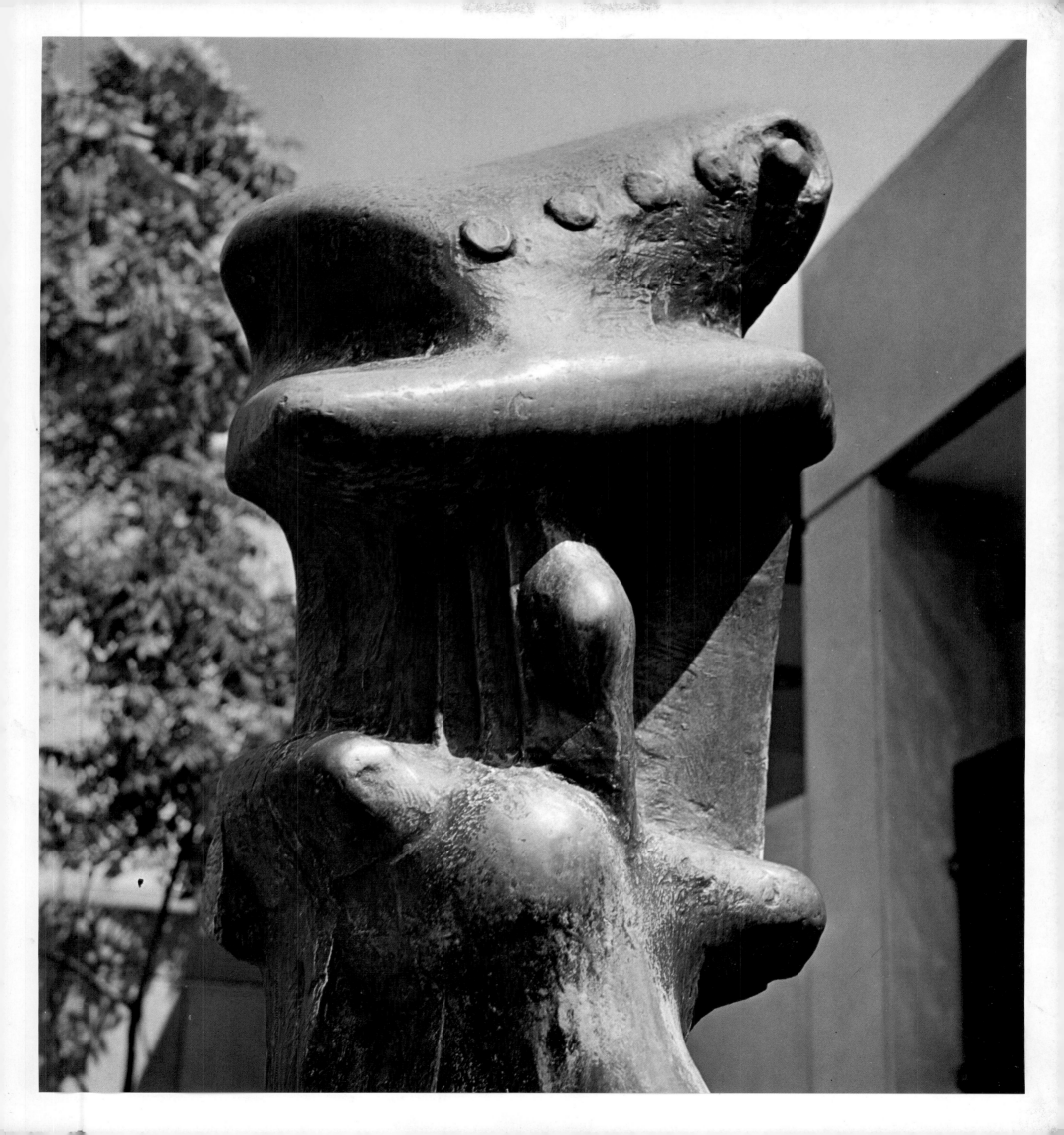

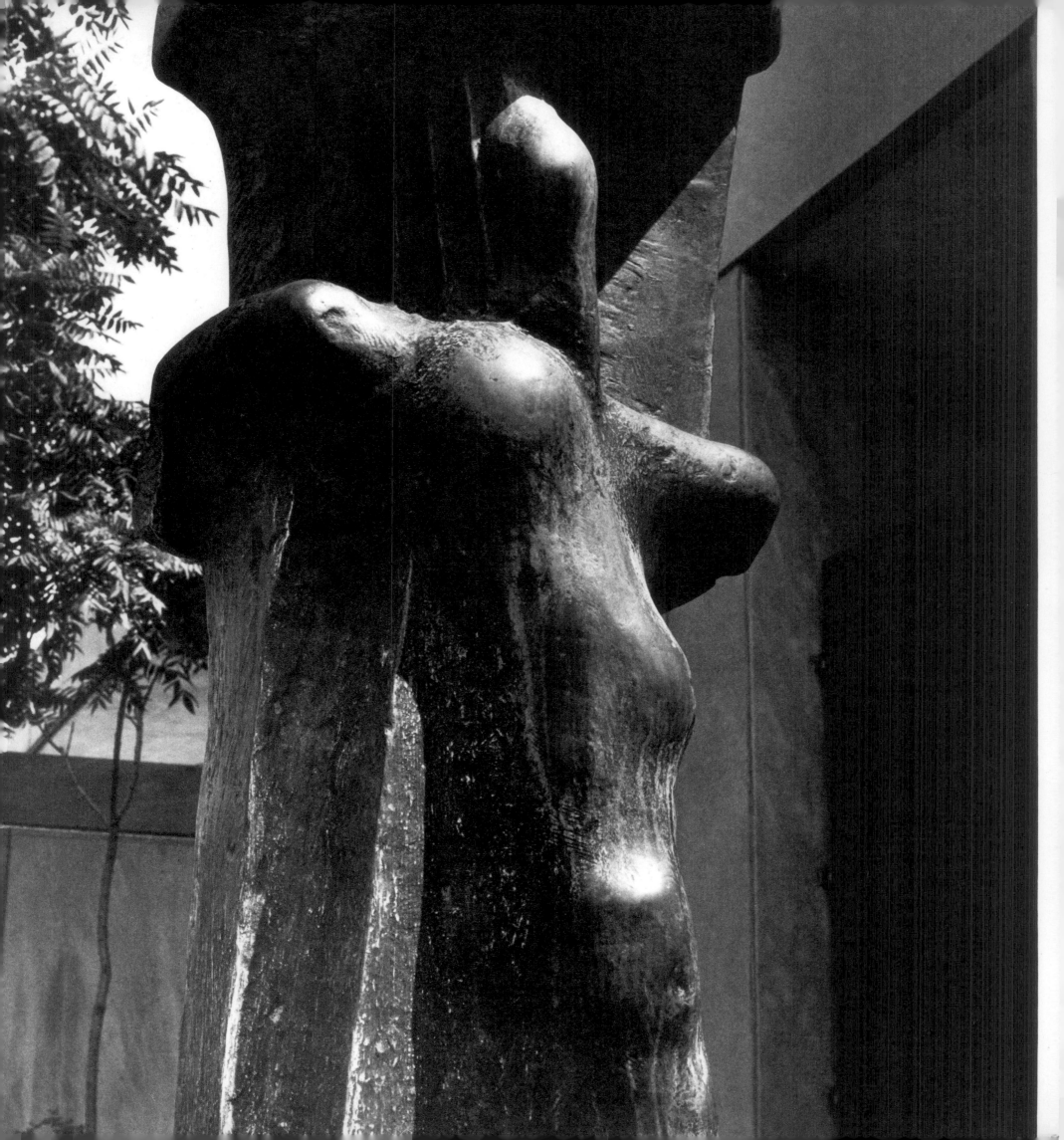

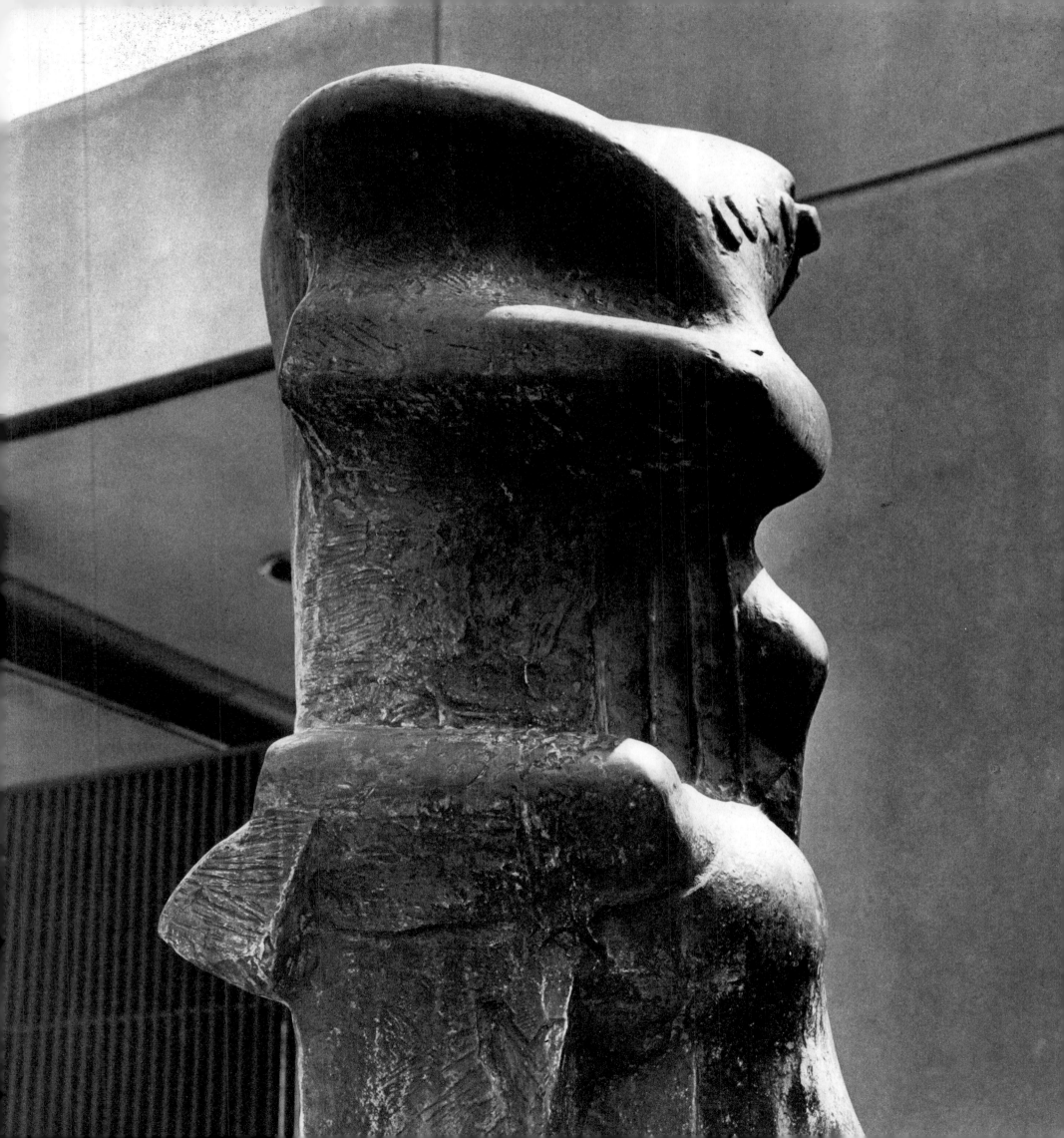

TWO-PIECE RECLINING FIGURE 1

1959. BRONZE, L. 76". ALBRIGHT-KNOX ART GALLERY, BUFFALO, NEW YORK

This is the fourth cast of this sculpture that I photographed. The others are in Duisburg, Germany; London; and Glenkiln, Scotland (see pp. 138–43; 248–51; 308–12). The location in Buffalo in front of the handsome museum building designed by Gordon Bunshaft is well chosen and the sculpture's dark pedestal is unobtrusive and at the right height for viewing the piece. The area is surrounded by foliage, providing a good background for the work, and the building is simple in its geometric forms, which contrast effectively with the organic shapes of the sculpture.

It was a gray, rainy day when I was in Buffalo to photograph the piece, and I was worried that I would not be able to do justice to the sculpture. I had the good fortune to meet Seymour Knox, a distinguished patron of the arts who, with his wife, had been responsible for the development of the museum and who was a good friend of Henry Moore's. We had lunch together, and afterward he took me through

the museum to see its fine collection. I was especially delighted to see a fine wood carving by Moore, an early work which I had heard much about in the past. Fortunately, the rain stopped when I began to photograph the *Reclining Figure*, and although the sky offered only a flat-white background, the light was good, and I was able to discover many details of the work that I hadn't seen before. This was particularly true in the breast area of the figure, where I found a face that I didn't remember seeing in any of the other casts. I pointed this out to Moore when I showed him the photographs, and he was delighted to see this unanticipated form. It was apparently a product of the particular way the patina had developed in this cast and of the light in which I photographed it on that particular day—another of the many surprises one experiences while exploring Henry Moore sculptures at different sites.

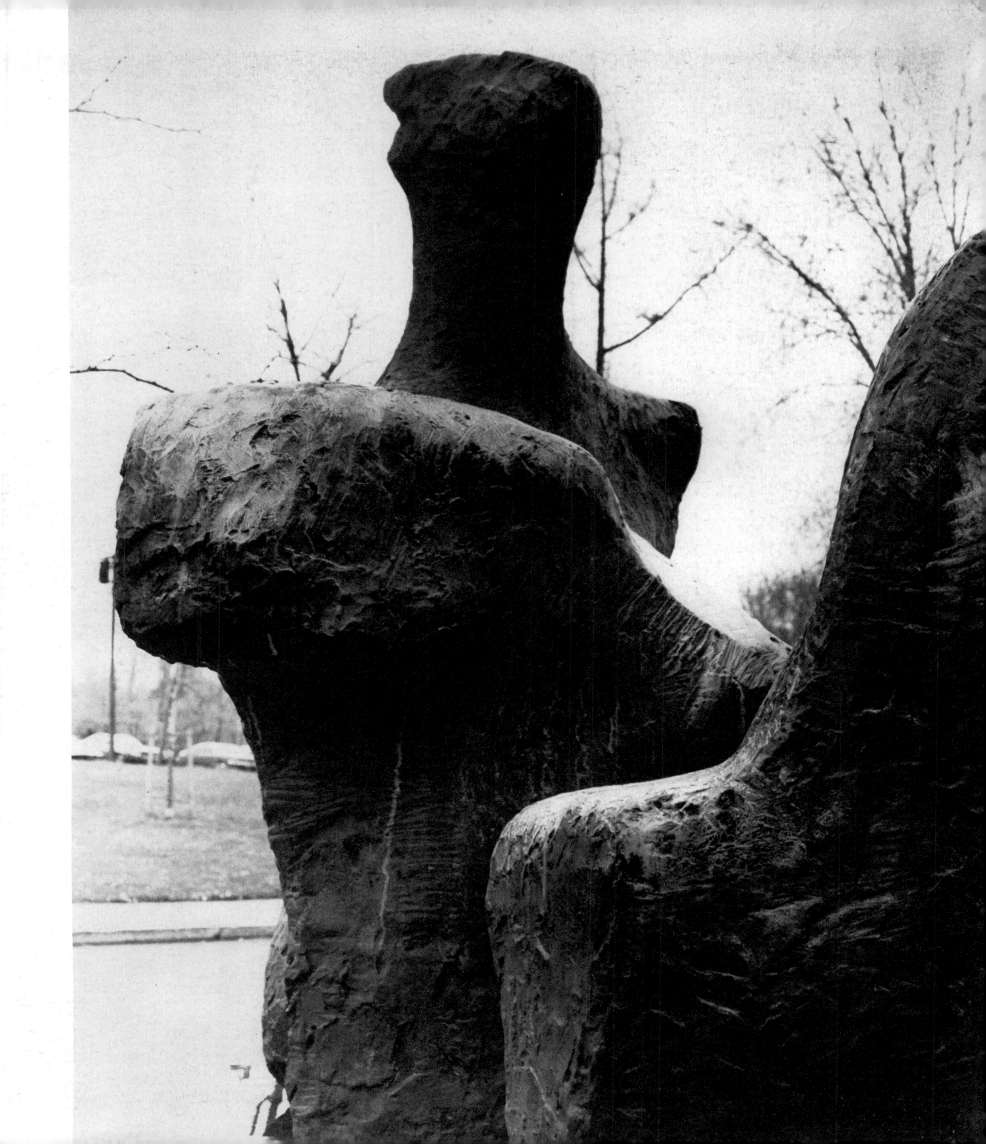

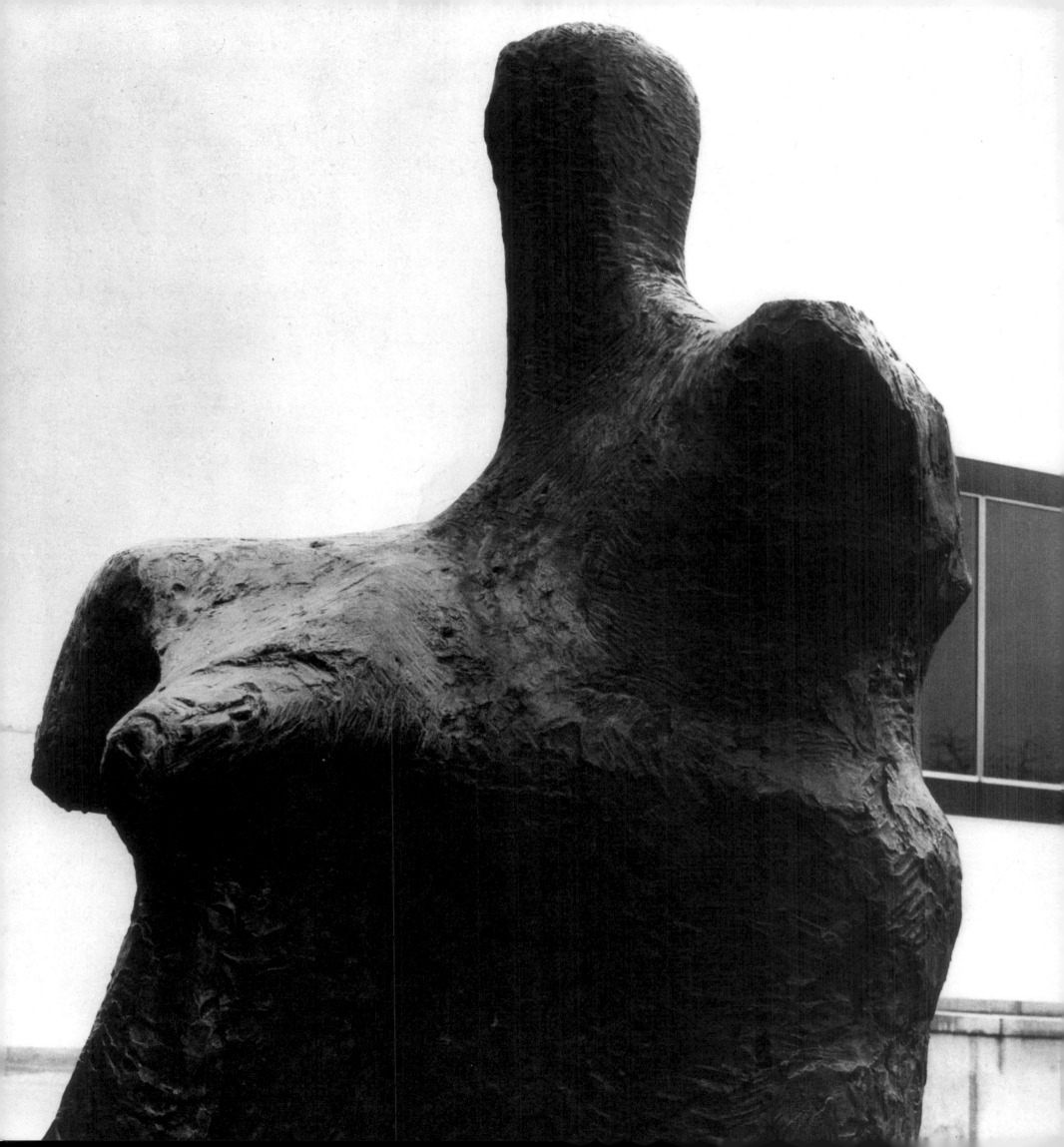

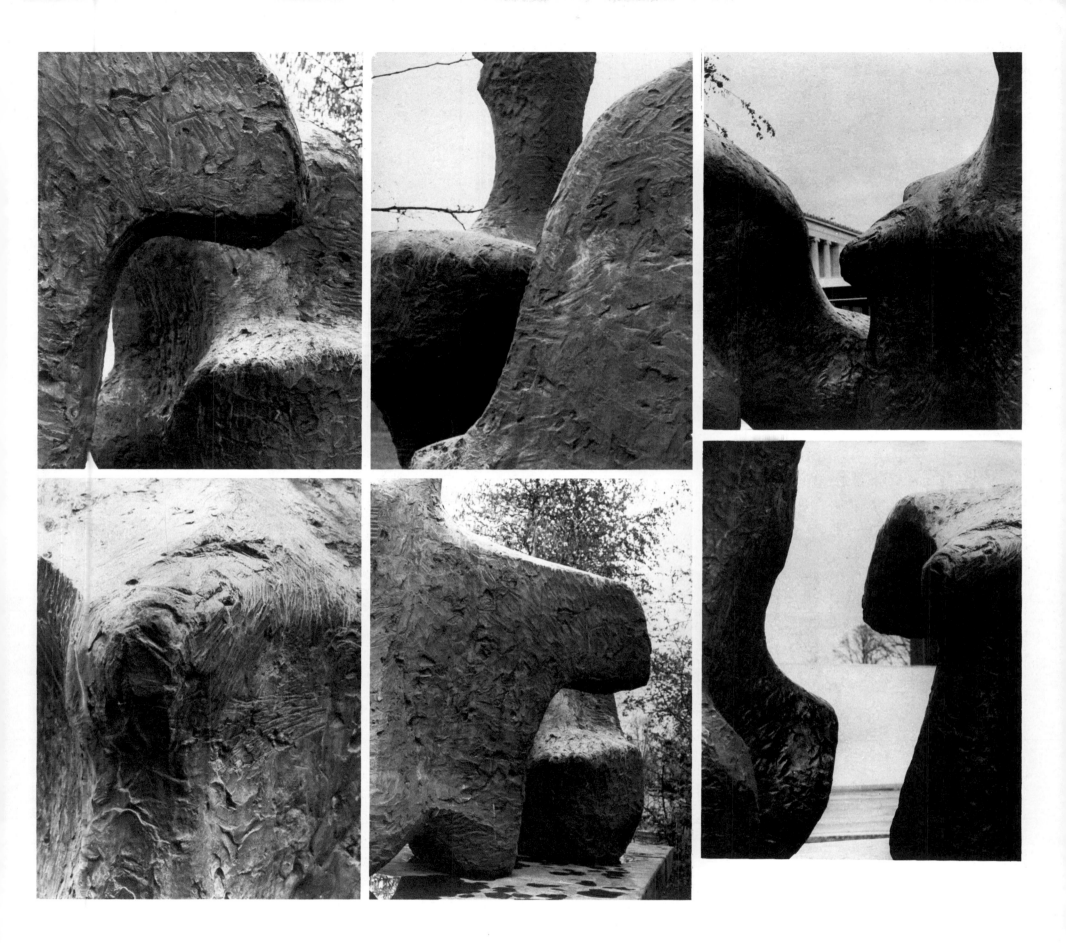

DRAPED SEATED WOMAN

1957–58. BRONZE, H. 73″. YALE UNIVERSITY, NEW HAVEN, CONNECTICUT

This cast has a multicolored patina, one of the richest surfaces of all the casts I photographed (see also pp. 58–61; 90–94; 244–45). It is beautifully placed, from a photographer's point of view, with a lovely green around it, a fine tree nearby, and some of the handsome university buildings in the background. The location is poor, however, in terms of the sculpture's total effect on the environment, for the work is in an almost hidden corner of the Berkeley College green, and it is probable that few students or visitors even know that it is there.

By chance, I visited Yale a week or so before this book was scheduled to go to the printer. I had heard that there was a Moore sculpture on the campus, and I took a camera, thinking that I would take some photographs for my own pleasure rather than for the book. Even so, I almost didn't photograph the piece. The grounds of Berkeley College are behind a locked gate, and I was discouraged by the apparently unimpressive site that had been selected for such a fine work. Moreover, the sculpture was resting on what seemed to be a temporary wooden base, one of the worst pedestals for a Moore sculpture that I had seen. But as I looked into the green, a student with a key came along, and I went in with my camera to see how the sculpture would appear in the lens.

To my delight, the combination of foliage (it was late April, a perfect time for photographing) and the buildings in the background provided some fine views of the sculpture. The following day I asked the designer of this book, Ulrich Ruchti, if there was time to add another section, and he kindly agreed to lay out the pages. I was especially pleased to see that some of the views in this spot were different in character from those taken at the other three locations, demonstrating once again that one's experience of a sculpture varies according to the environment in which it is placed.

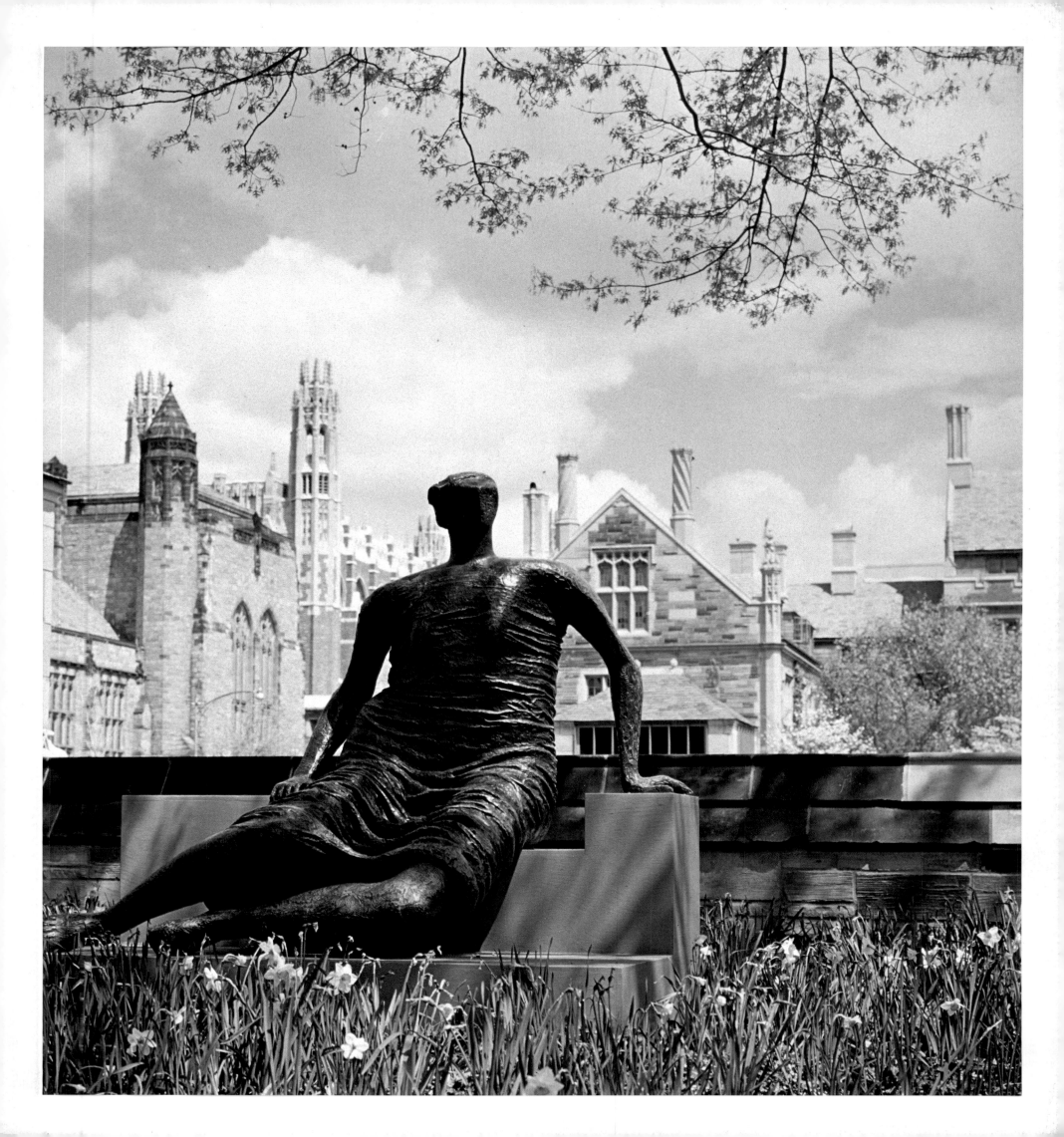

THREE-PIECE RECLINING FIGURE 2: BRIDGE PROP

1963. BRONZE, L. 99". BROWN UNIVERSITY, PROVIDENCE, RHODE ISLAND

This sculpture is placed on the College Green of Brown University. Most of the students pass by this spot daily, and they are almost always seen around the sculpture, which has become a familiar and popular feature of the Brown landscape.

Bridge Prop was located on my own family's grounds for many years, and I took literally hundreds of photographs of it while it was there. My two youngest children practically grew up with the sculpture, and yet felt that they appreciated it much more when they saw it on the Brown campus (they were both students at Brown when my wife and I gave the sculpture to the university). This was probably because there is more space around the piece at Brown, so they could see it more freely from all sides. Moore

visited Brown in the spring of 1974, just after the sculpture was installed, and he was very pleased with the location.

The sculpture is called *Bridge Prop* because one of the three pieces rests on another, reminding Moore of Waterloo Bridge in London, which he often passed as a young man. I think the sculpture is an amazing combination of graceful elegance and monumental strength created by the bony structures shown in the back and shoulder of the piece and the sweeping surfaces of the center and front sections. Living with it for so many years was a great privilege for our family, and we are delighted that it is now in a place where it can contribute to the lives of so many students.

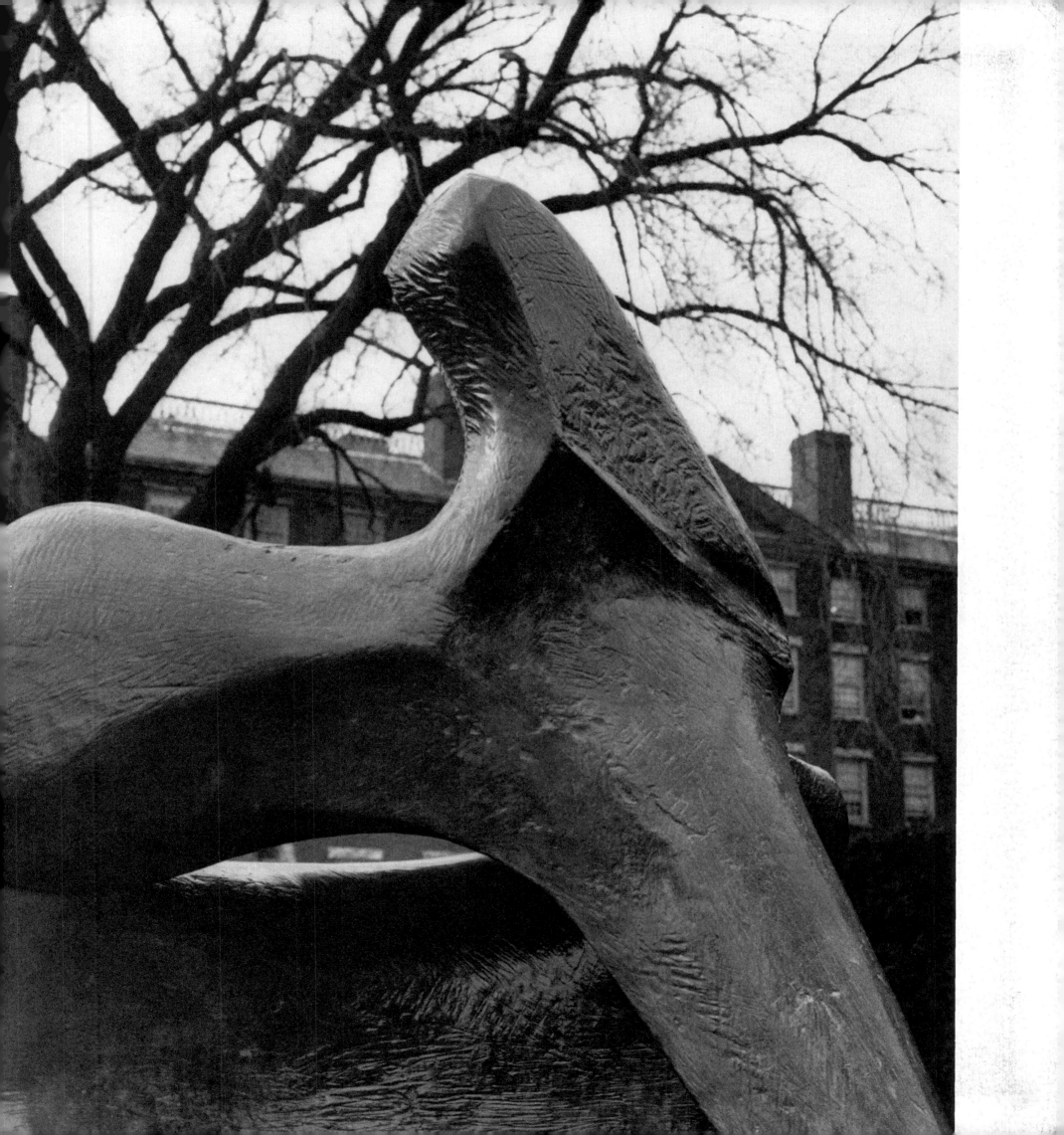

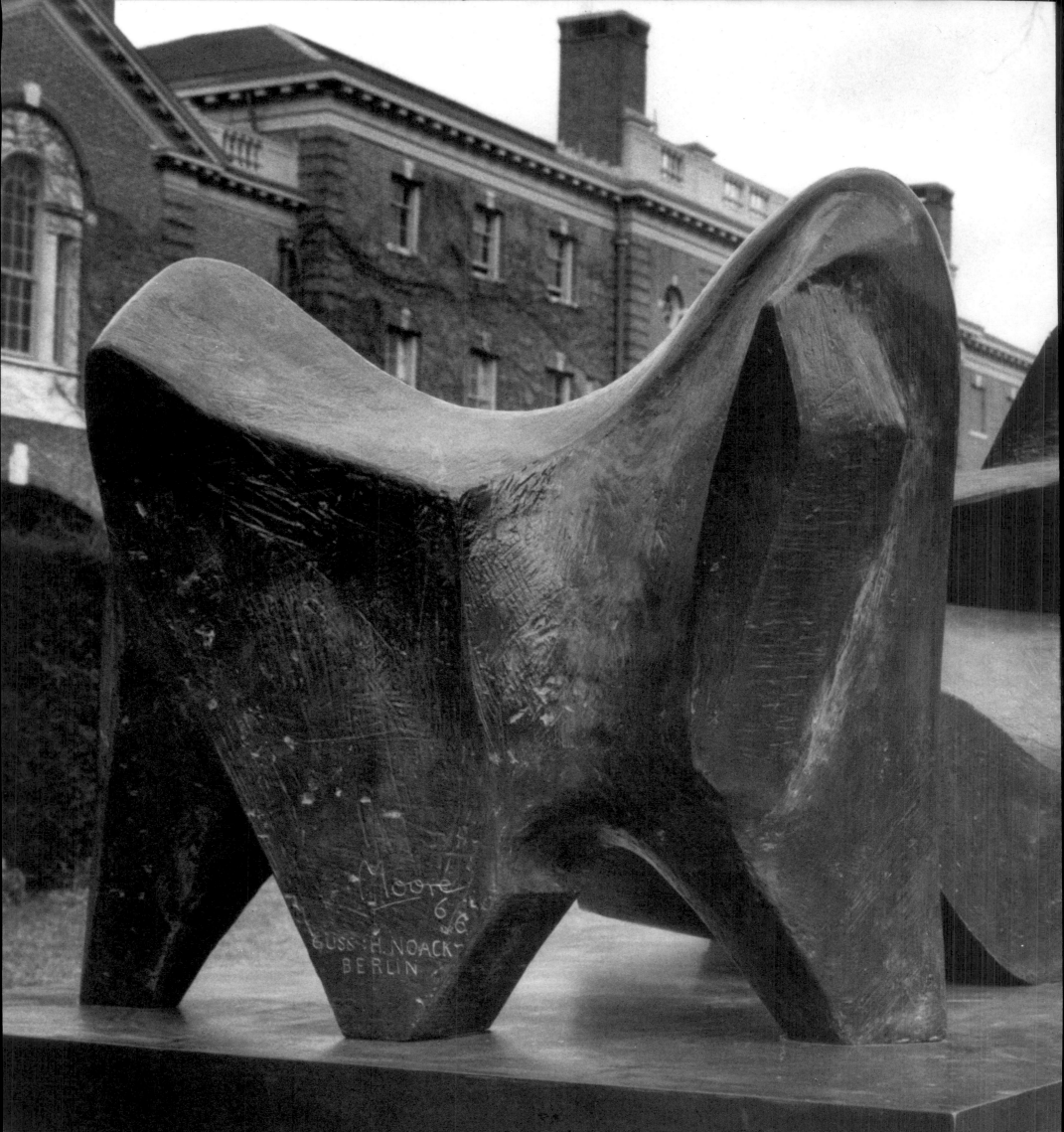

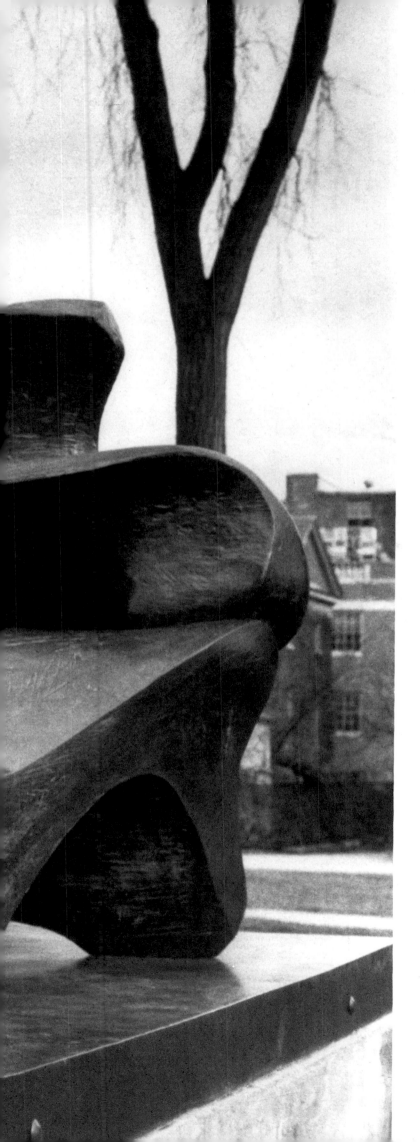

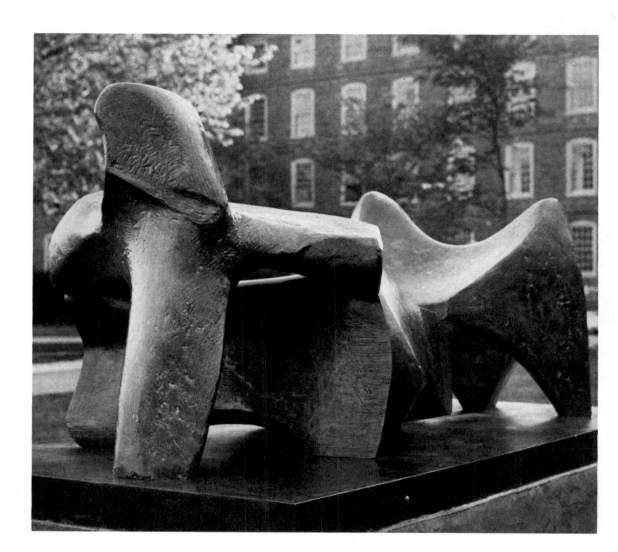

*When I saw this, I patted it like an old
friend, as I often do when looking at sculptures
of mine that I haven't seen for a long time. Of
course there is a whole book—As the Eye
Moves—on this sculpture. I think it's very nice
in that location on the campus. I would have
liked to see a few photographs taken of the
sculpture without the buildings behind it.*

—Henry Moore

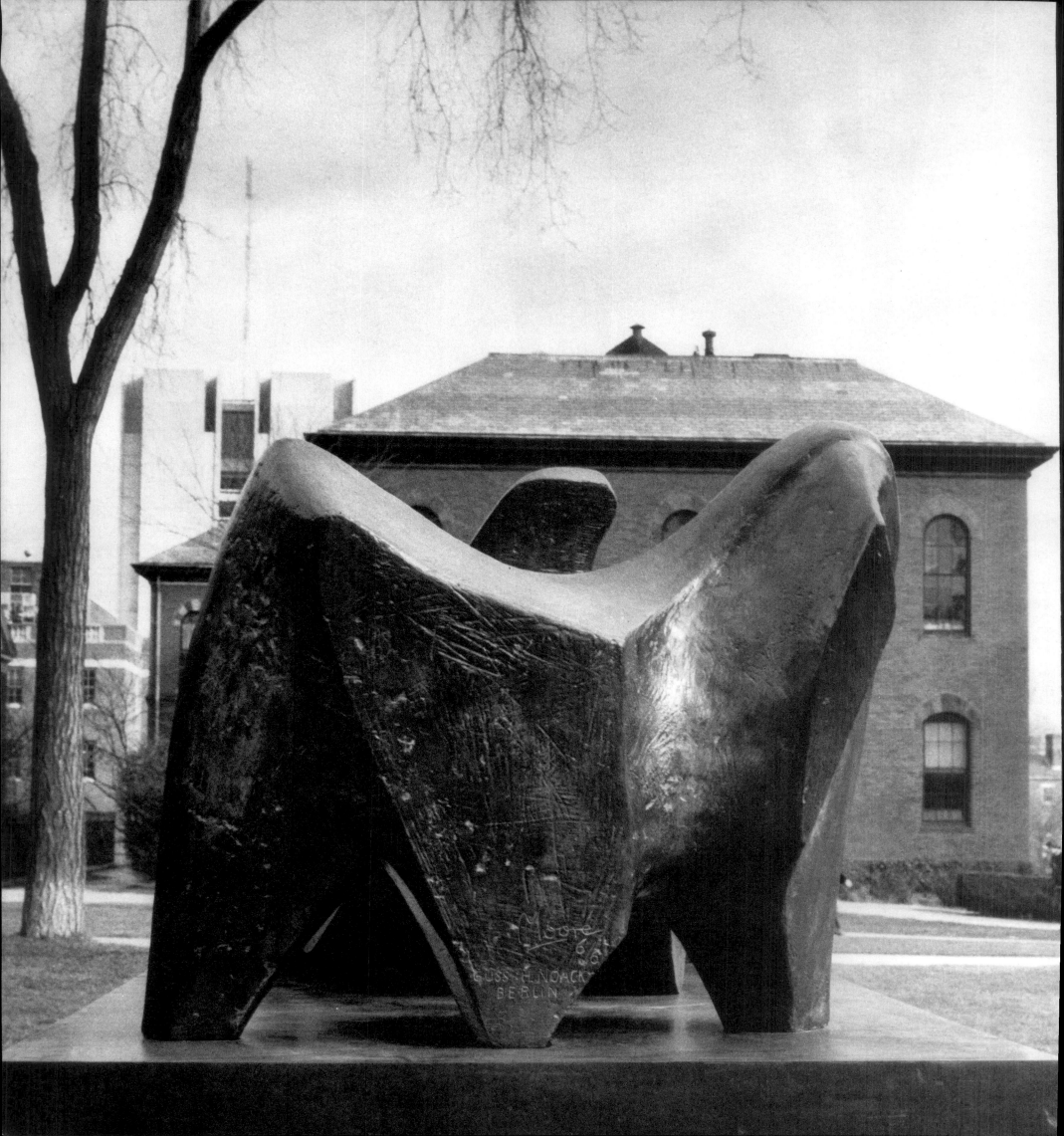

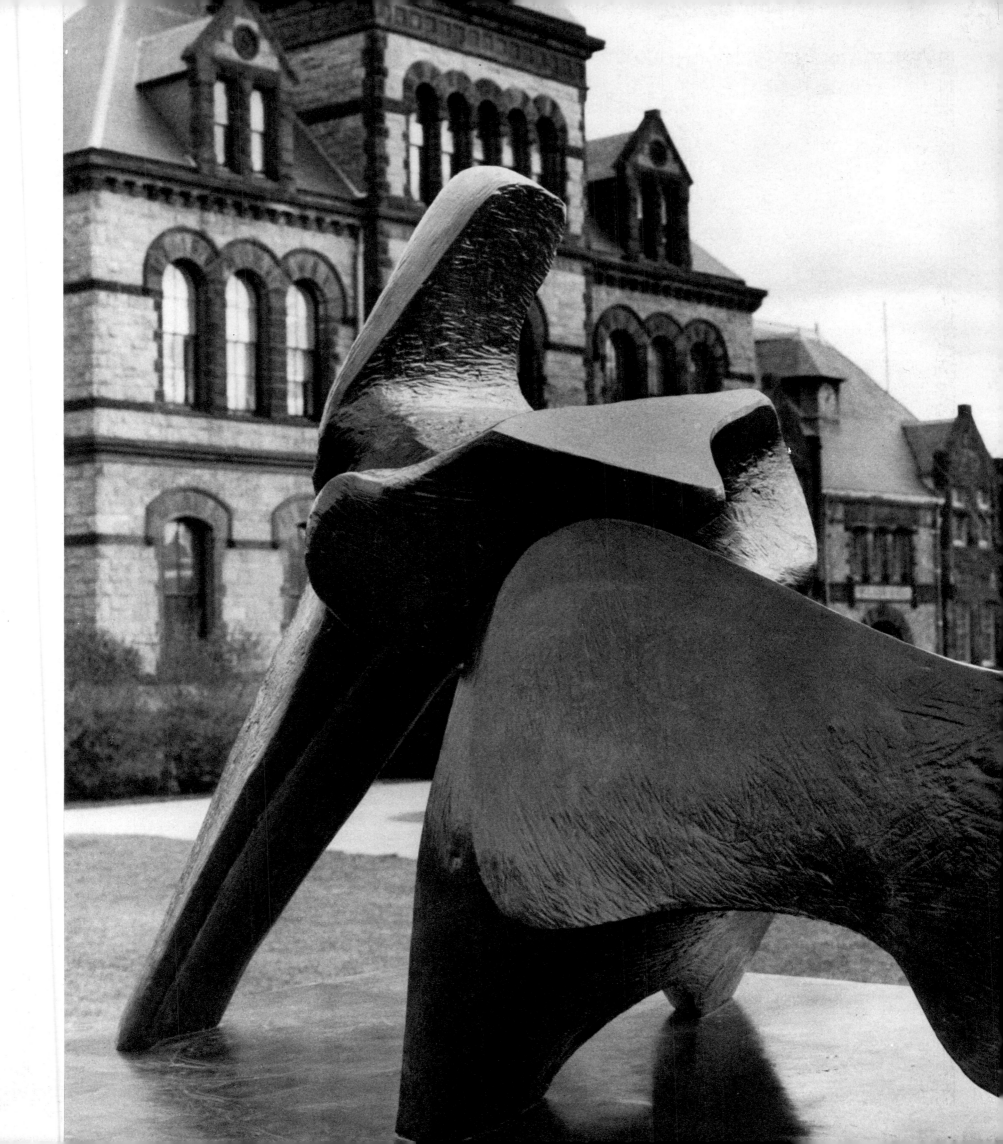

OVAL WITH POINTS

1969. BRONZE, H. 11'. PRINCETON UNIVERSITY, NEW JERSEY

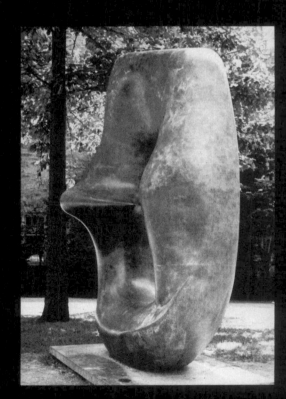

Some years ago an anonymous donor established a fund of one million dollars to purchase sculptures by major twentieth-century artists for the campus of Princeton University. This was to be known as the John B. Putnam Memorial Collection in memory of Lt. John B. Putnam, Jr., of the class of 1945, who was killed in World War II. Included among the works acquired are a Picasso, a Calder, a Lipchitz, and the Moore *Oval with Points*.

The sites for the sculptures have been chosen with taste and sensitivity. The Moore is located in a relatively open area, with foliage nearby and university buildings in the background. My one criticism might be that the placement seems almost too casual, causing students to take the work for granted. Although the informal setting is aesthetically appealing, it is not altogether successful as a means of integrating the work into the consciousness of the student population.

I had some difficulty photographing *Oval with Points*, partly because of the light (sections of the work were in shadow, others in sunlight) and also because some of the more interesting views had to contend with distracting backgrounds. It is a most unusual piece in that, at first glance, it looks quite simple, as if there were really only one or two overall shots worth taking and few opportunities for exciting details. As one looks at and through the piece carefully, however, one finds a surprising diversity of fleshy forms, with all the characteristic richness of Moore's evocative variations and convolutions, and the two points of the sculpture have an amazing magnetic pull between them.

When printing the photographs, I was drawn to the interesting pattern created by the shadows of leaves. I know that Moore thinks the shadows obscure the shape of the sculpture, but as photographs I must admit I find them pleasing.

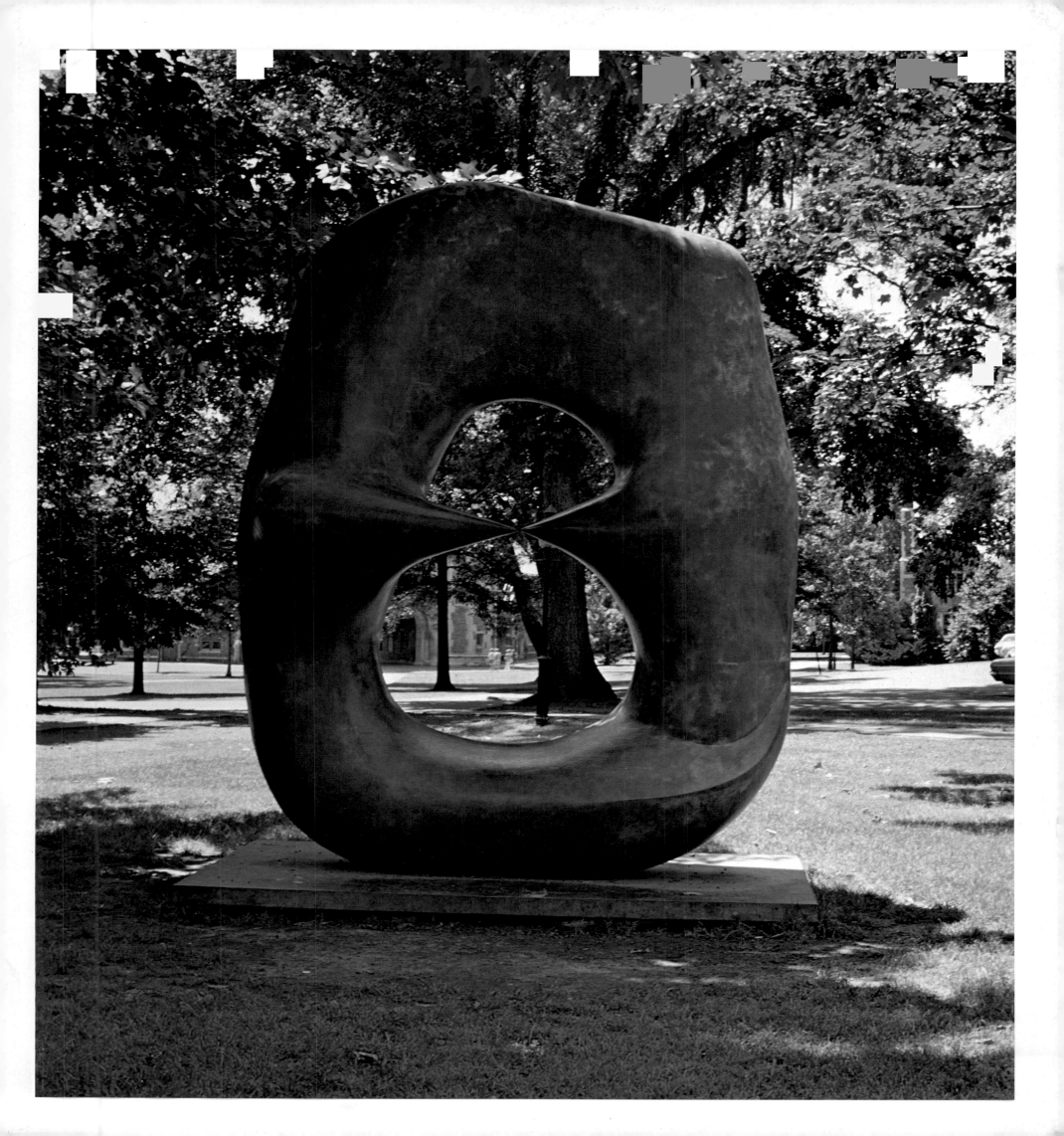

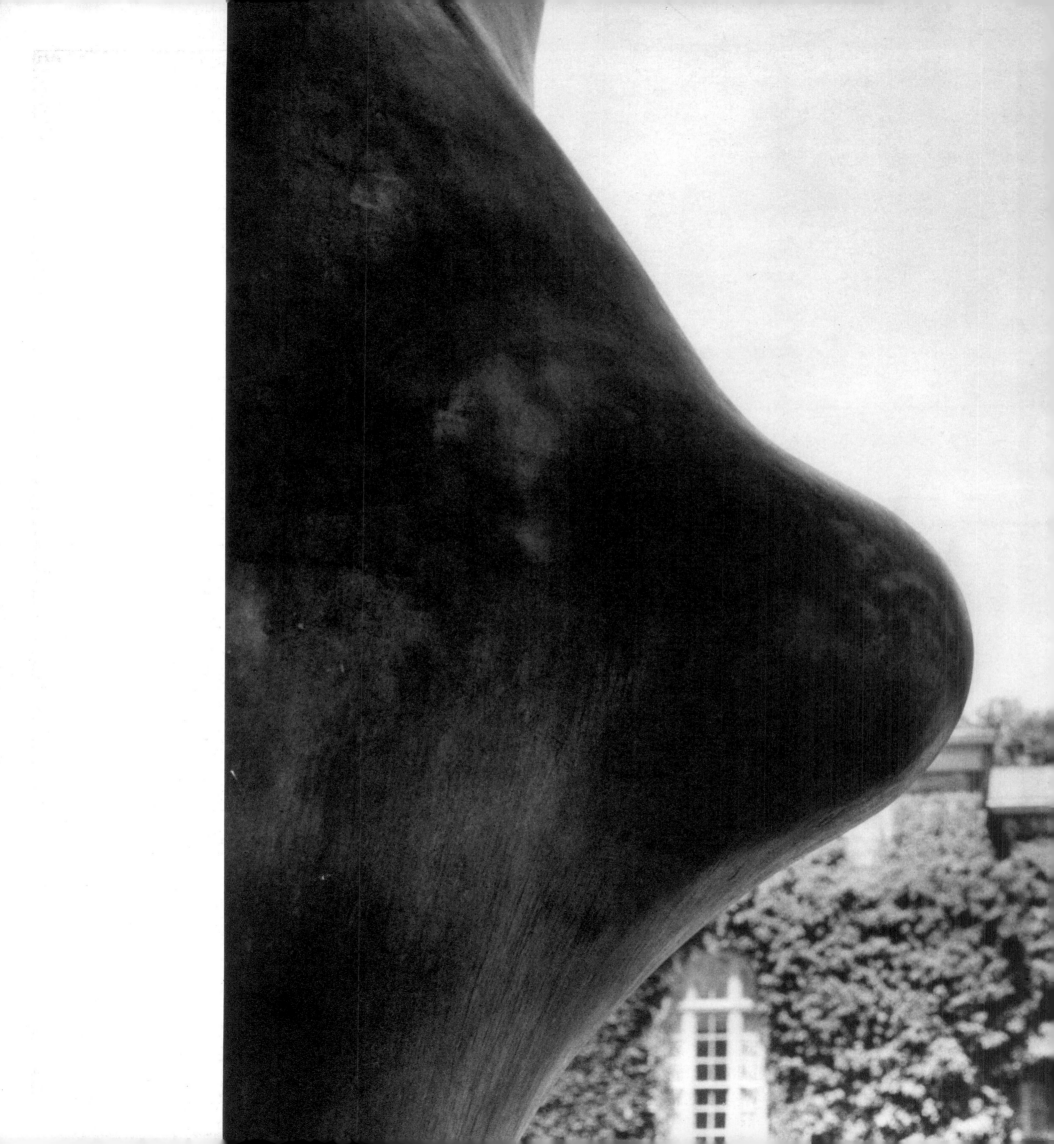

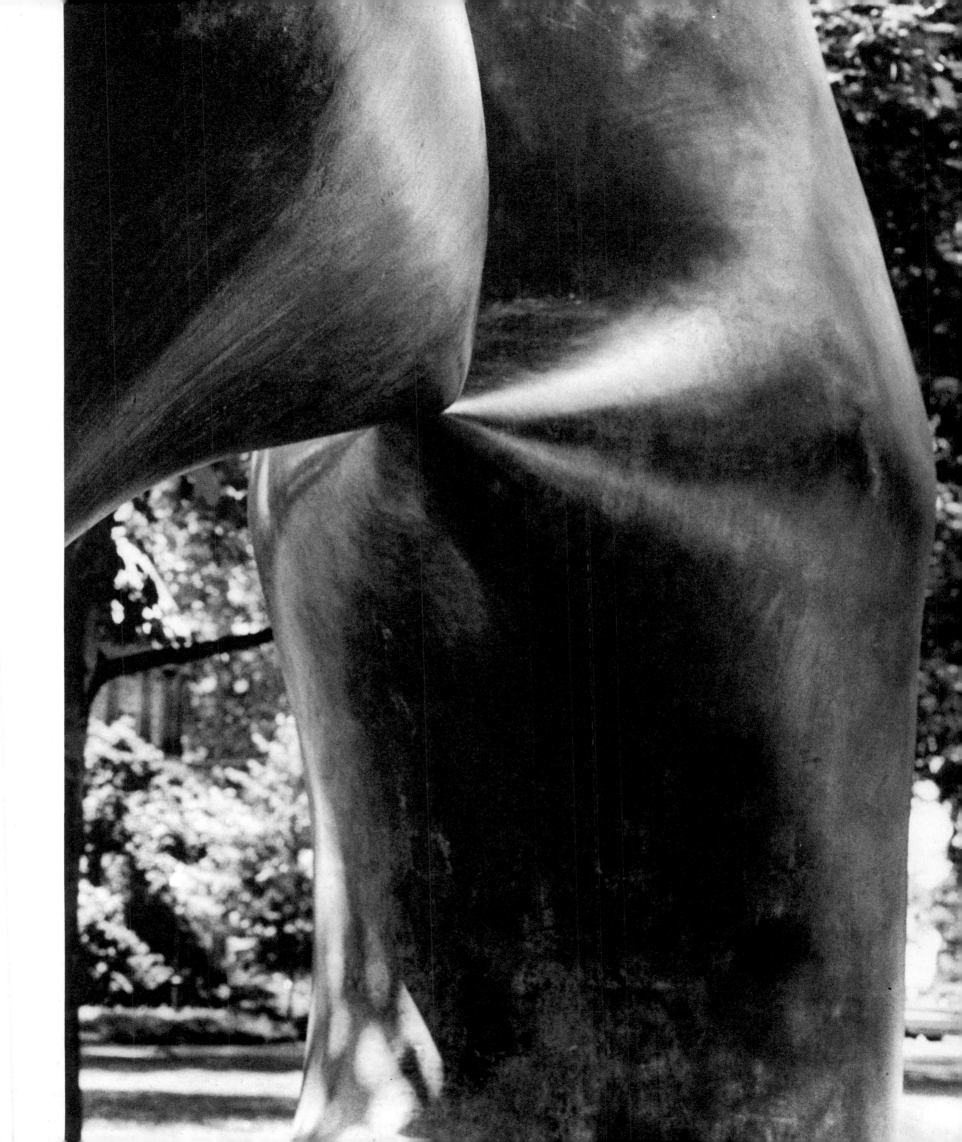

413

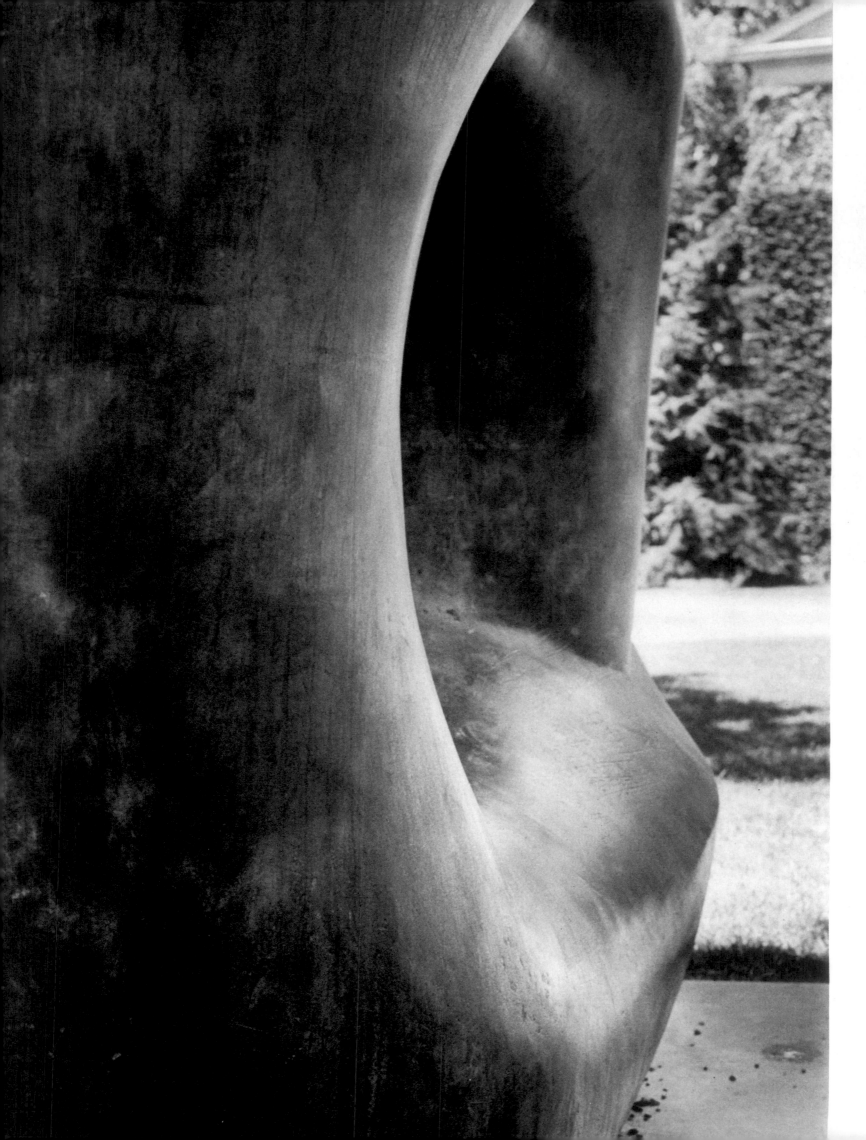

I have never seen this
location. It looks to be
a lovely place. . . .
What is sometimes
distracting in
photographs of
sculpture is when you
see the speckled
shadows of leaves on
the sculpture. Leaves
are not geometric, so
their shadows are
amorphous and
confuse one's reading
of the form. This is
not the same when the
sculpture is seen not
in photographs, but in
reality. Then the
physical focussing of
one's eyes, backward
and forward, can
itself give the sense of
three dimensions and
explain the form,
irrespective of light
and shade.

—Henry Moore

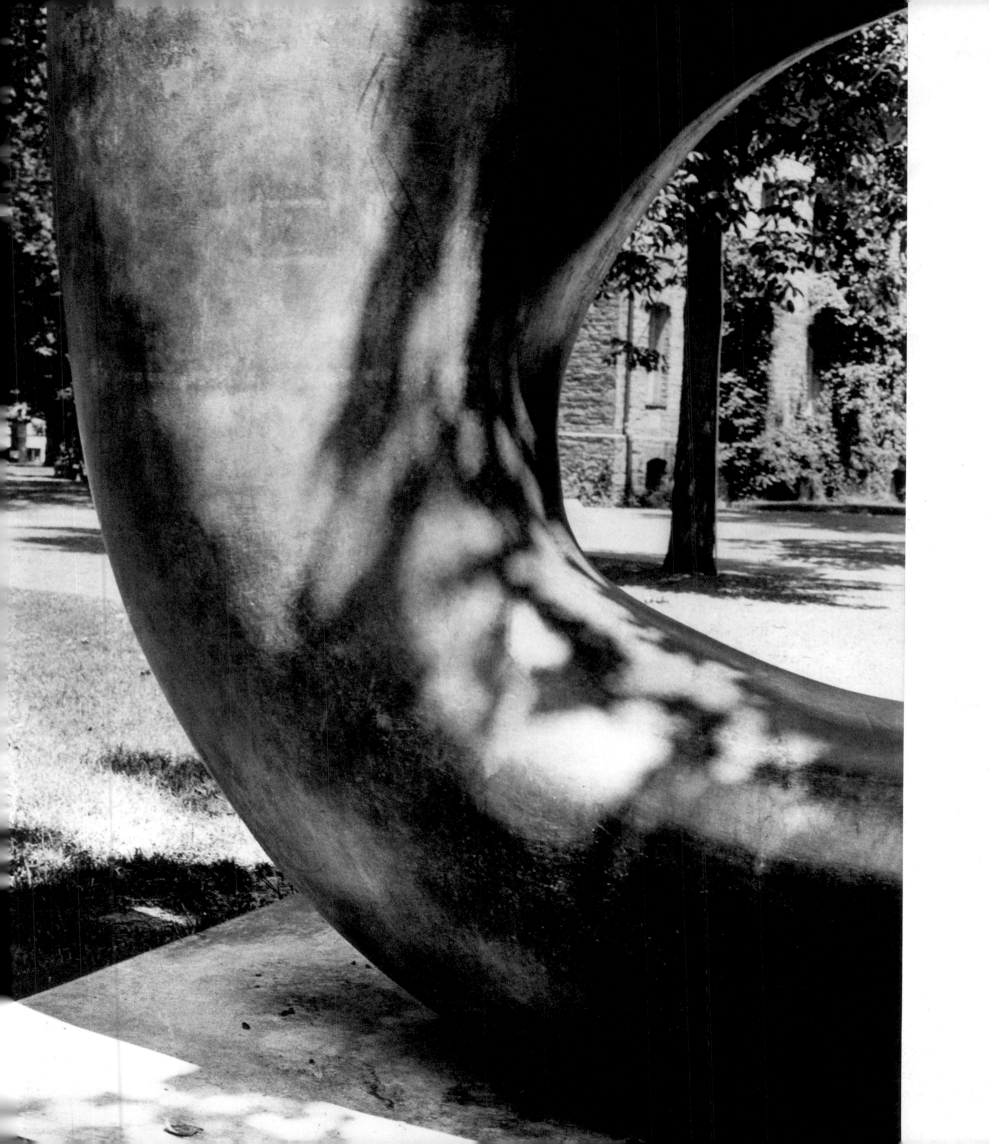

THREE-WAY PIECE 1: POINTS

1964. BRONZE, H. 76". FAIRMOUNT PARK, PHILADELPHIA

Located in a small park in the center of Philadelphia, this work, with its curving forms, provides a striking contrast to the massive office buildings in the vicinity. The sculpture, which I also photographed in New York (see pp. 352–55), is situated in the center of a walkway that is well traveled, but unfortunately most passers-by are in too much of a hurry to stop and look at it. The lamp posts mentioned by Moore are highly decorative and do not seem consistent with the character of his work.

I photographed the sculpture in Philadelphia on two separate occasions, once when it was raining and once when the sun was shining. The first time I photographed it, I noticed that there was writing on the surface, probably with a wax crayon since the words were clearly visible in the rain. I was amused by the effect and showed some details to Moore, but he didn't want me to include them in the book lest they encourage others to deface sculptures in this way. When I returned a few weeks later to photograph the piece again, this time in sunny weather, the sculpture had apparently been cleaned, and there was no evidence of the writing.

The street lamps being so near the sculpture is distracting. When the lamps are cut off from view, it's not a bad location. The photographs which show a reflection of the buildings in the sculpture are interesting.

—Henry Moore

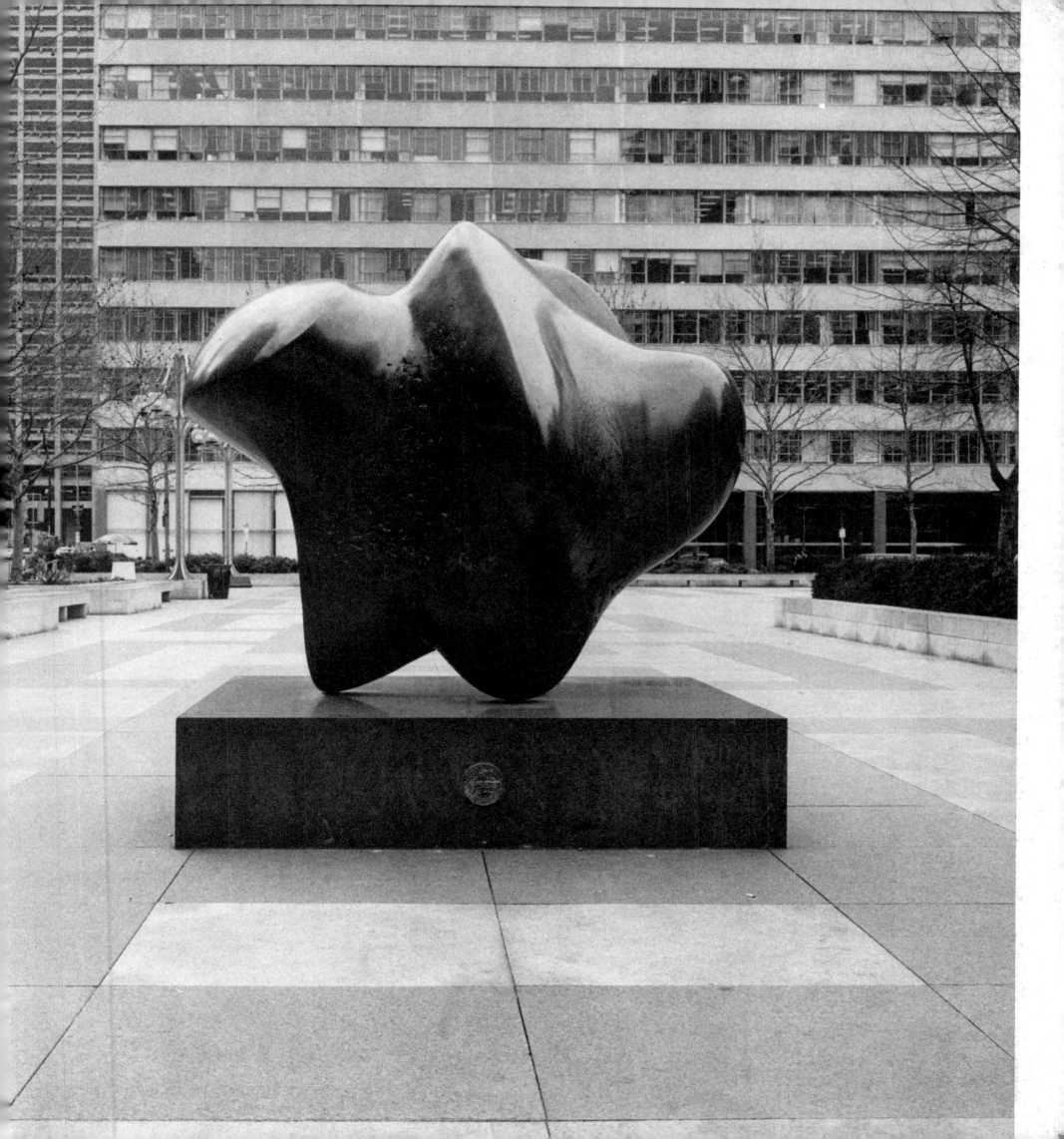

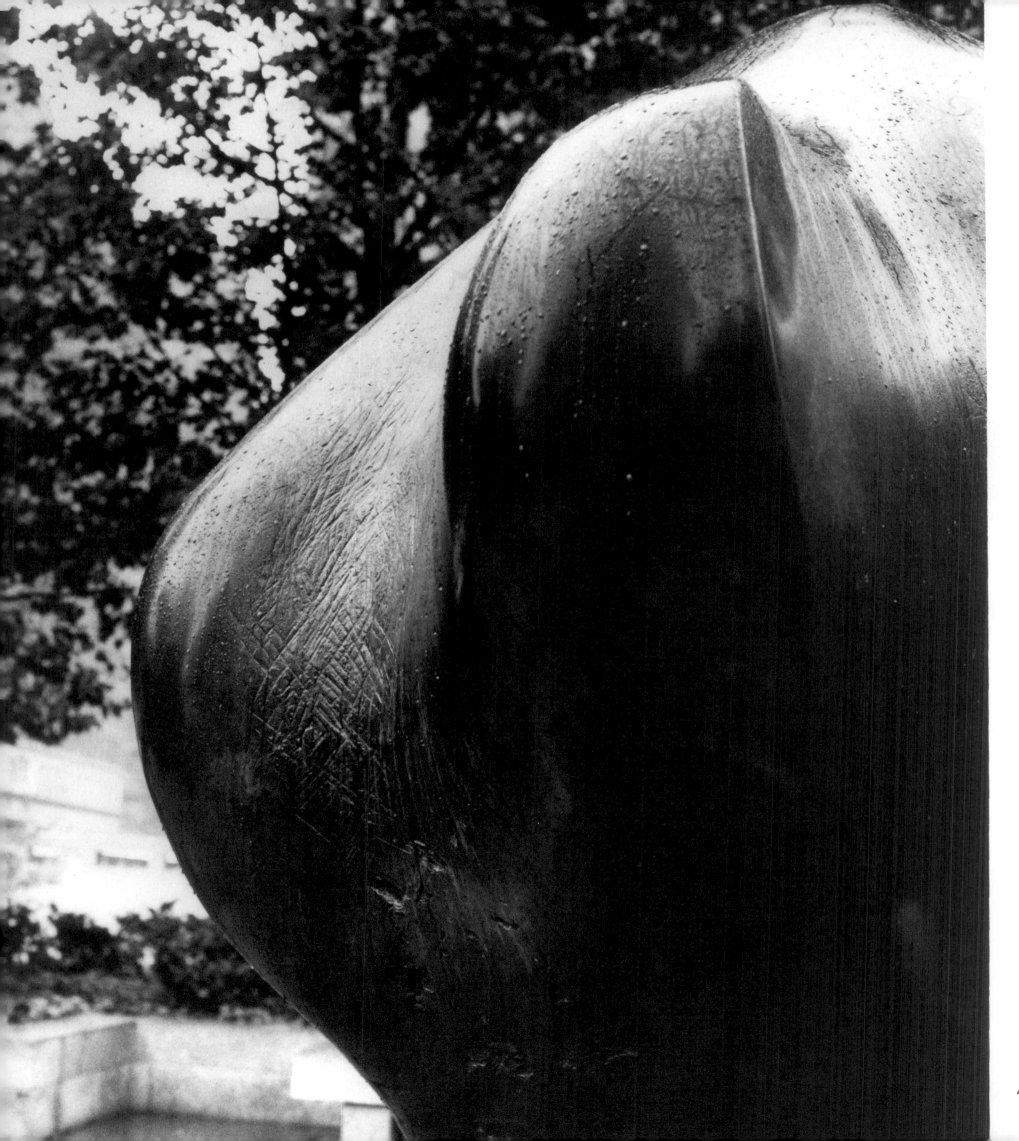

418

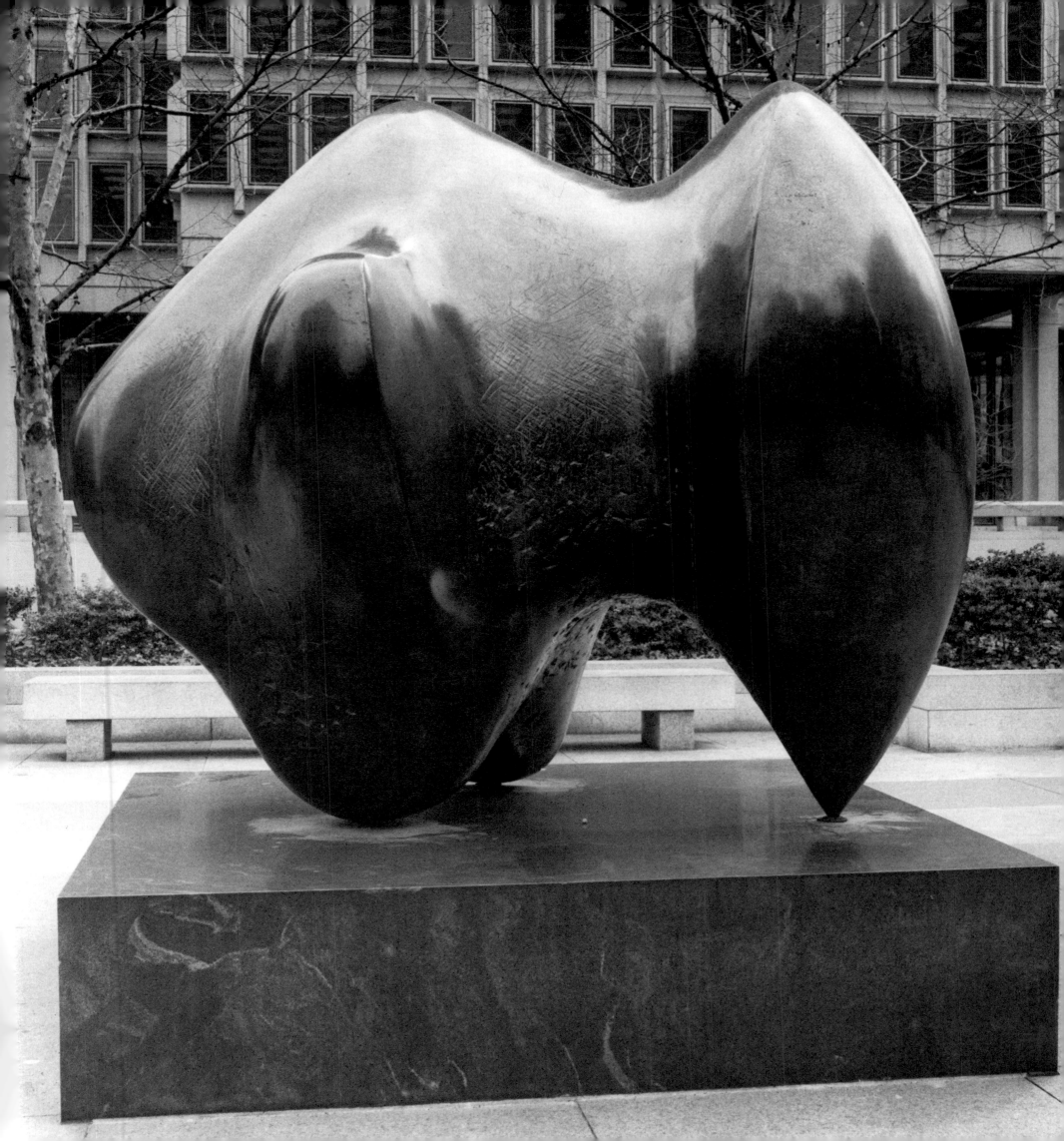

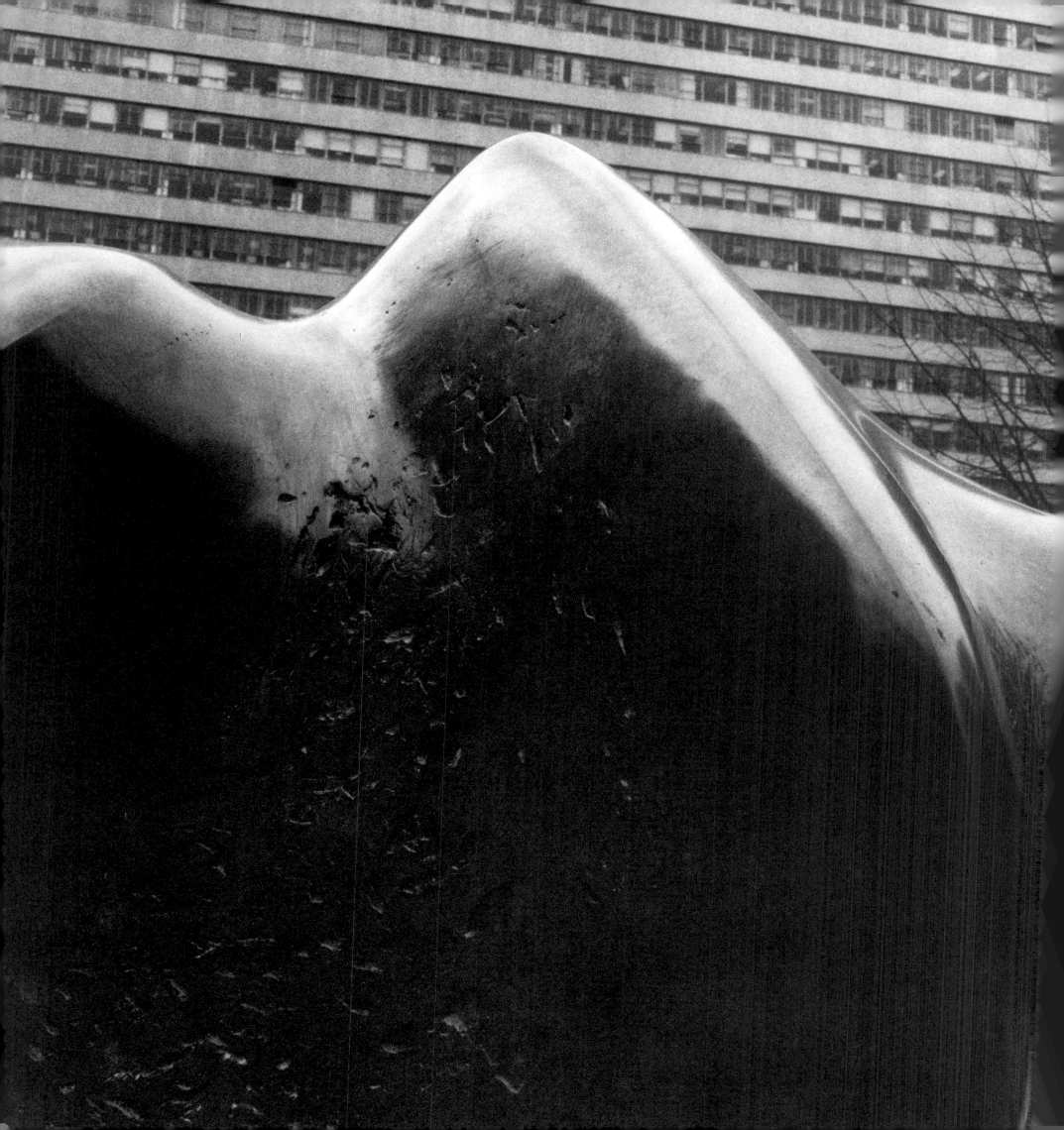

RECLINING CONNECTED FORMS

1969. BRONZE, L. 84". UNITED STATES FIDELITY AND GUARANTEE CO., BALTIMORE

This large travertine work, carved by Moore in the 1970s, is a later version of a sculpture that was completed in the 1960s. There are three bronze casts of the work included in this book, those in Adelaide, Australia; Dublin; and New York (see pp. 62–66; 318–20; 356–59). Although the shapes are virtually identical in the bronze and travertine, the latter has a brilliance that makes it almost seem to be a different work.

Reclining Connected Forms is located in the midst of an expansive terrace fronting a monumental building in central Baltimore. The space around the sculpture is well suited for viewing from all sides, but the building itself is so high that it dwarfs what is in fact a very large work of sculpture. The effect might have been improved if the sculpture had been set off with some green foliage. The small cylindrical forms under the sculpture were placed there, according to Henry Moore, in order to raise the work off the ground without having to construct a pedestal, which might have competed with the forms of the sculpture. This was an interesting idea, but the cylinders do not seem to accomplish their purpose since they themselves create shapes that are foreign to the sculpture.

I arrived in Baltimore to photograph the piece relatively early in the morning, only to find that the sun would not rise over the neighboring buildings until later in the day. I took some photographs of the sculpture in the shade and then waited a couple of hours in order to photograph the travertine surfaces illuminated by the sun. My patience was well rewarded, and the photographs taken in full sunlight were far more satisfactory than those taken earlier.

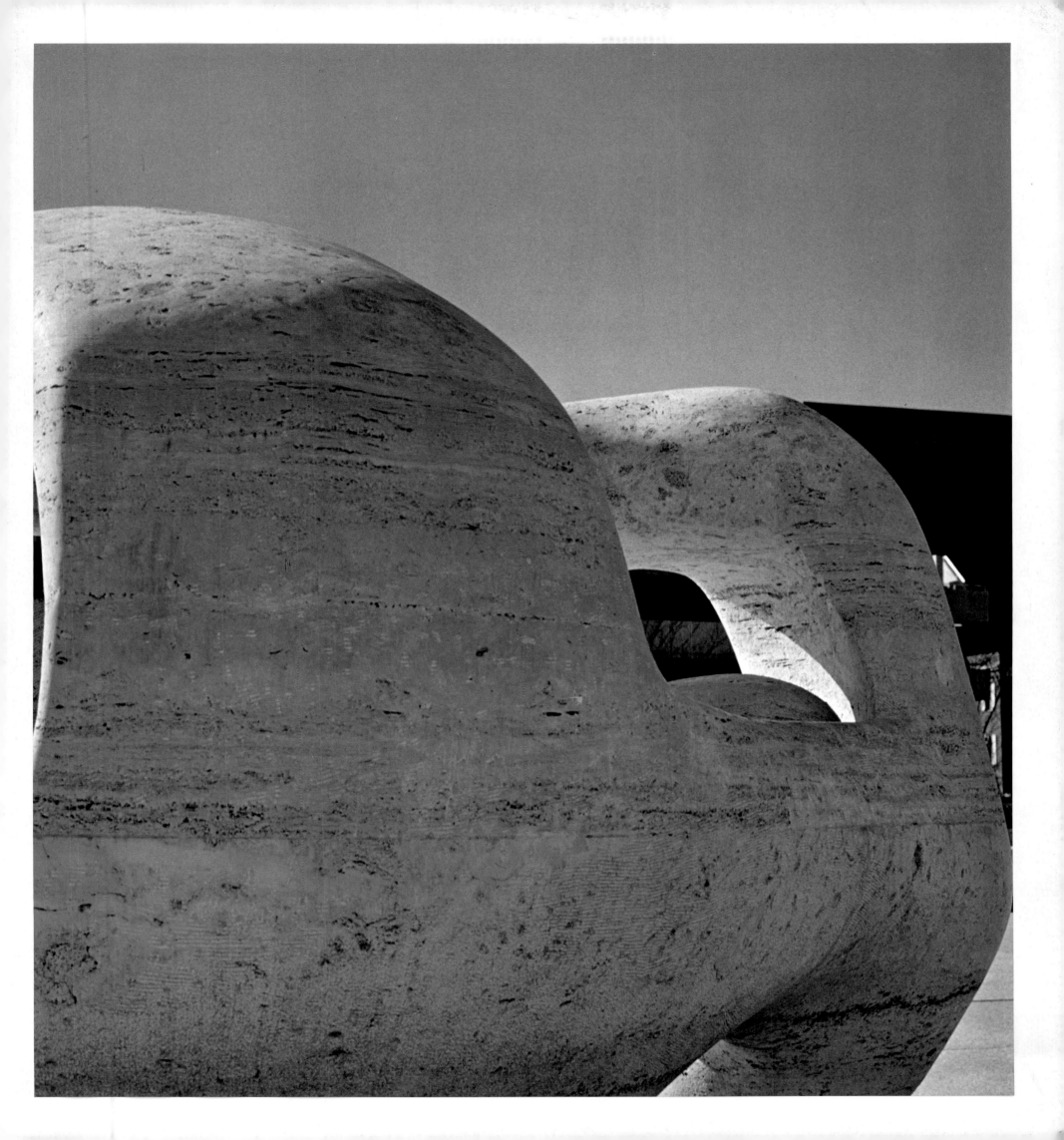

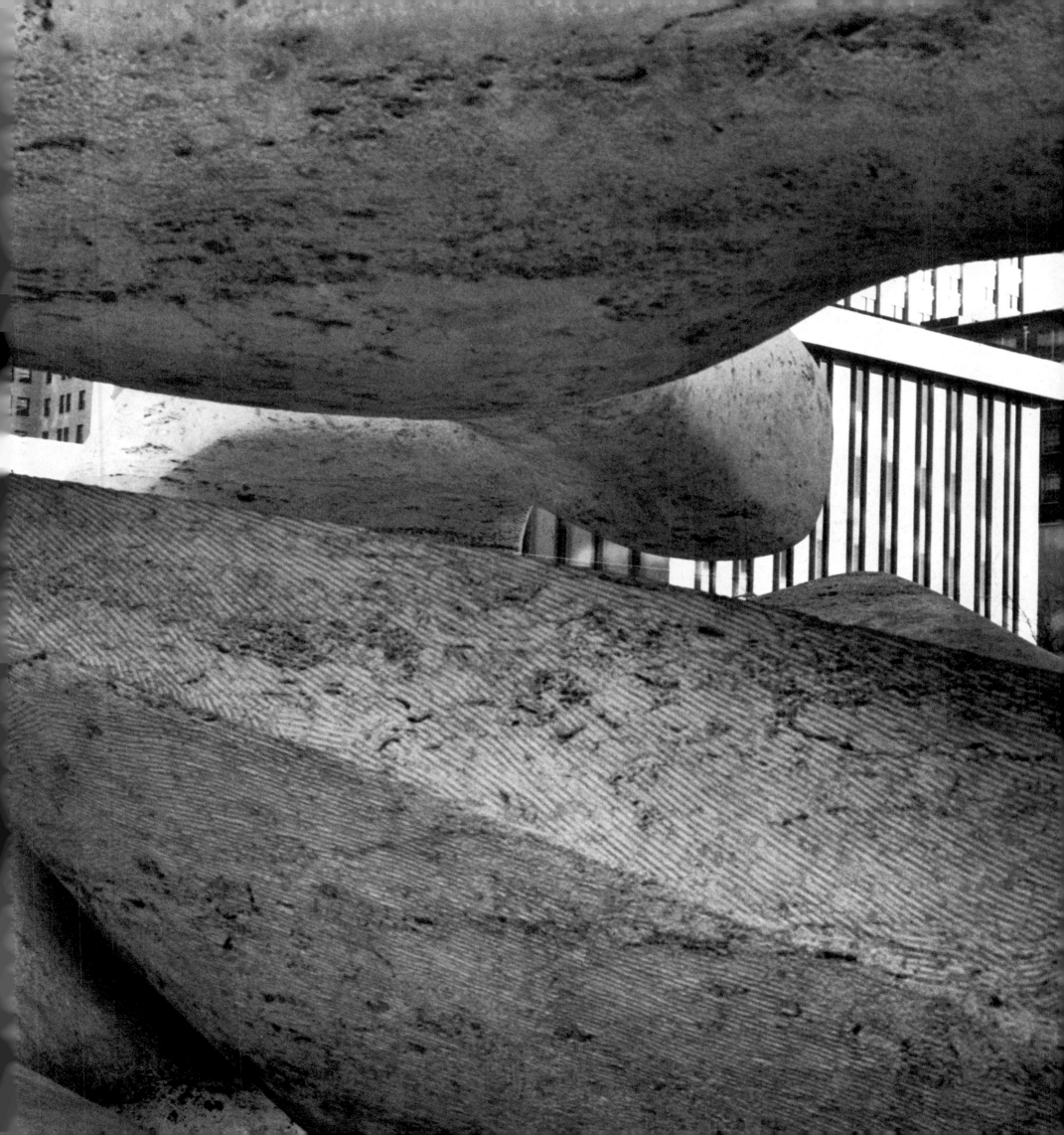

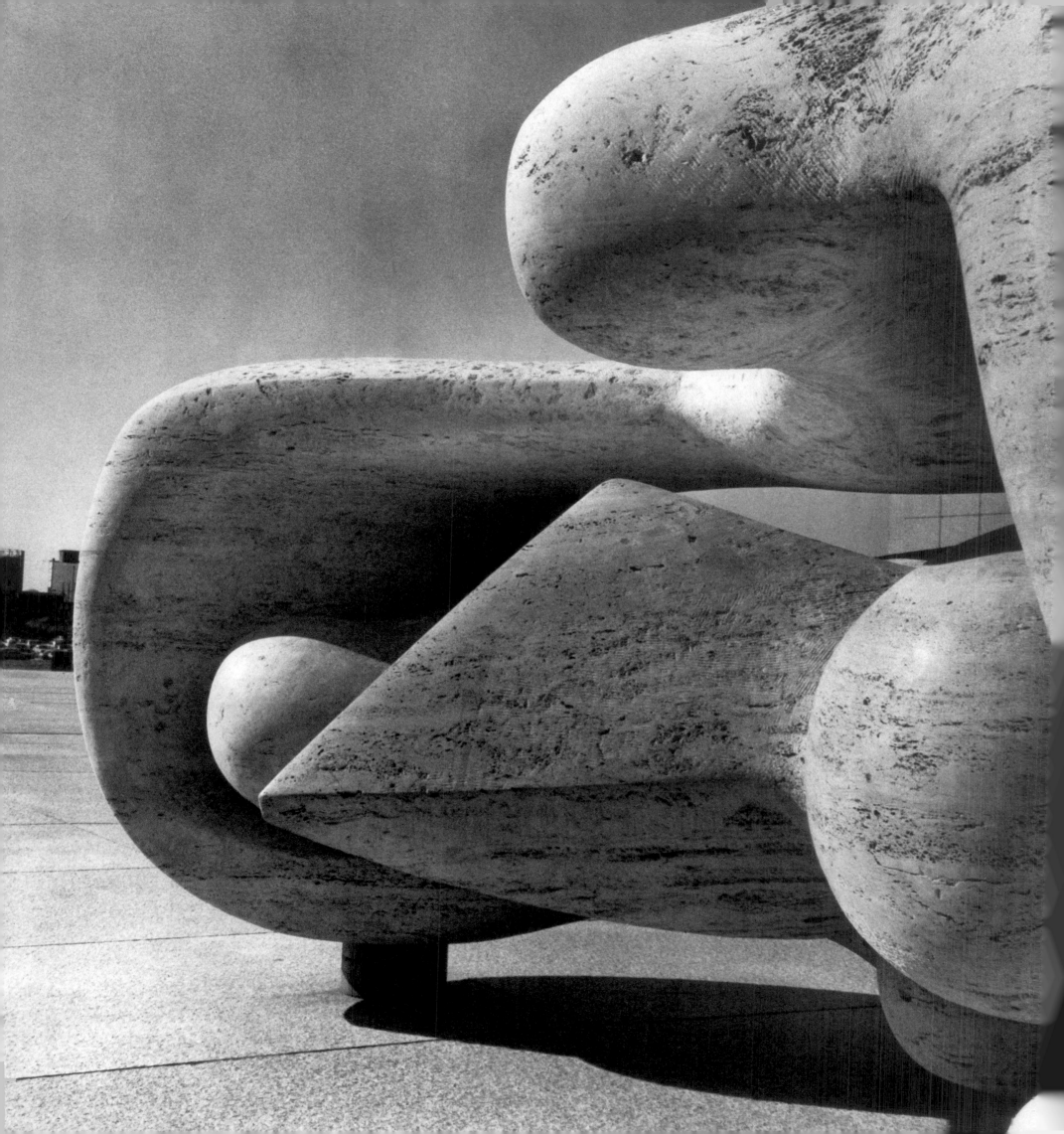

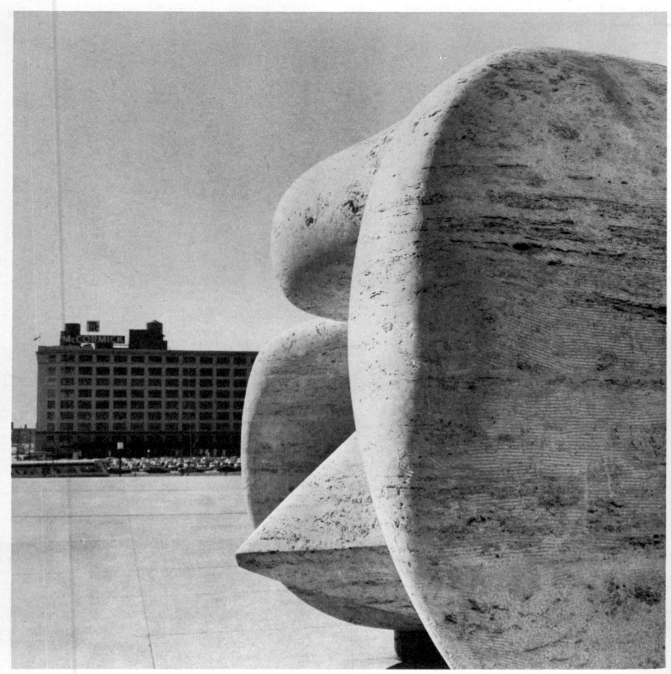

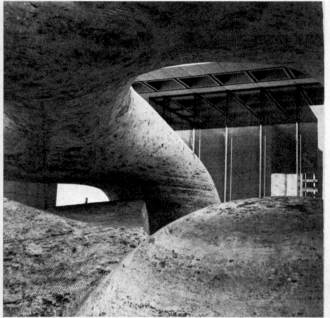

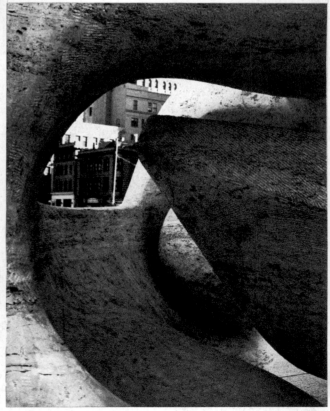

THE
ARCH

1963–69. BRONZE, H. 20′. BARTHOLOMEW COUNTY PUBLIC LIBRARY, COLUMBUS, INDIANA

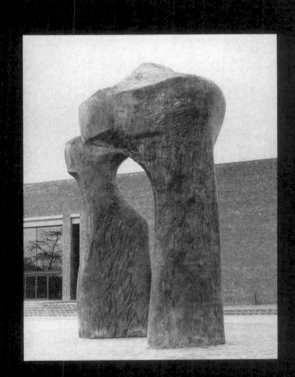

The Arch is a major sculpture located in a small midwestern city of the United States. Columbus, Indiana, has been the beneficiary of an unprecedented gift from the largest employer in town, the Cummins Engine Company, and its chairman, J. Irwin Miller. The architectural fees for scores of the buildings in the town (primarily in the public school system) were paid by the company on the condition that outstanding architects, approved by a committee of internationally recognized authorities, were chosen for the assignments. The architect I. M. Pei was selected for the library, which can be seen behind this sculpture, and the architects Eliel and Eero Saarinen for the church across the street from it.

Pei wanted some type of major construction at this particular location in the library plaza. He erected a plywood structure on the spot, painted it green, and adjusted its bulk to approximate the dimensions he had in mind. When Mr. and Mrs. Miller learned that a large version of

Moore's *The Arch* would be available, they decided to present the work as their gift to the plaza. When the sculpture was erected, the nearby schools dismissed most of their classes, and they sat watching the erection of *The Arch* and sketching it. It was a very pleasant community experience.

I traveled to Columbus to see the remarkable results of this architectural program, which is well worth a trip, and to photograph *The Arch*. I did not realize at the time how much planning had been done before the sculpture was chosen, and I had some reservations about the geometric surroundings for such an organic sculptural form. Although I wished I could see the work in the midst of a primeval forest, the transformations and metamorphoses I found in walking through and around the work would be astonishing in any setting. And the clusters of children and adults that gathered around the sculpture during the course of the day were impressive testimony to the human value of this particular placement.

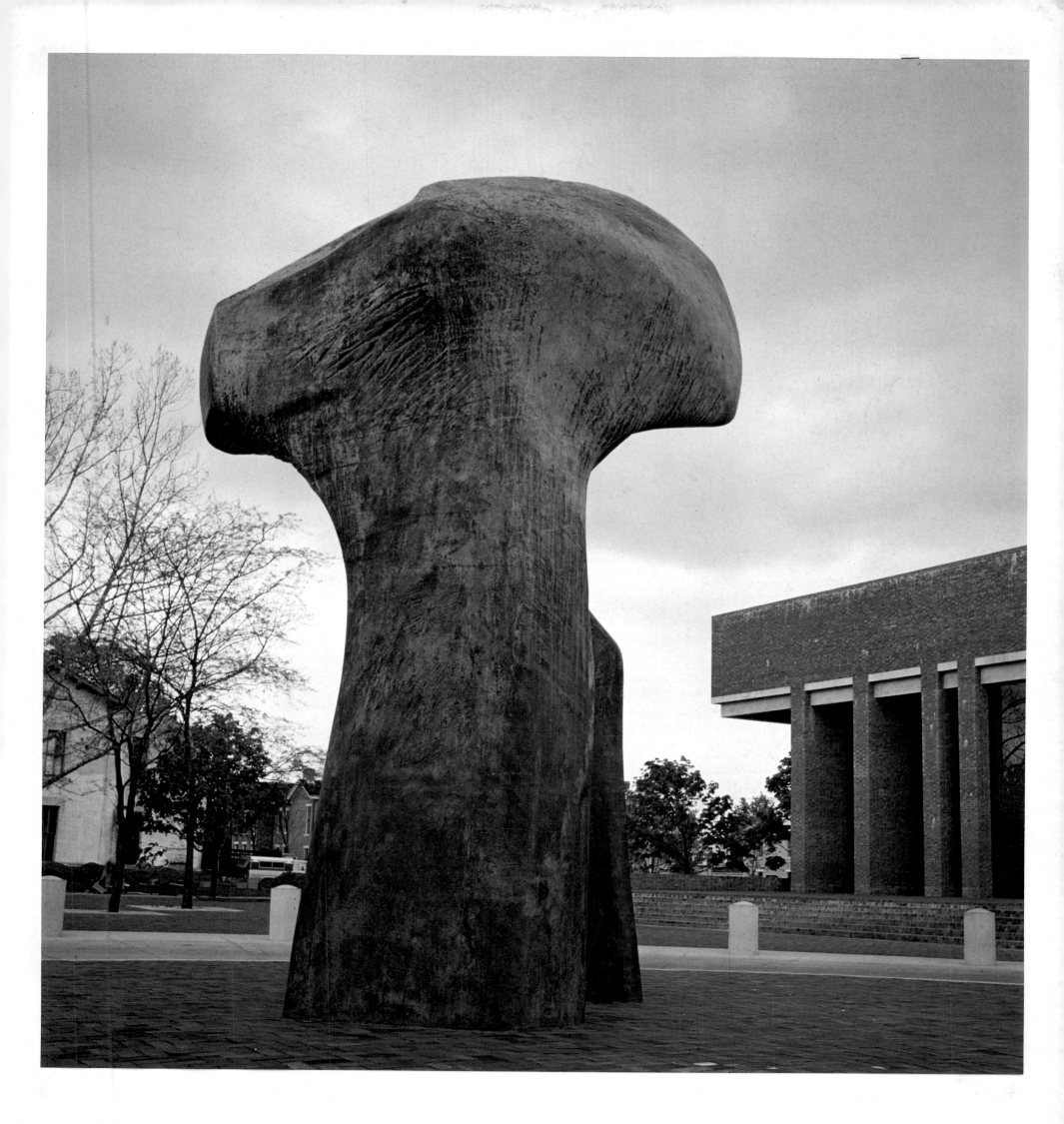

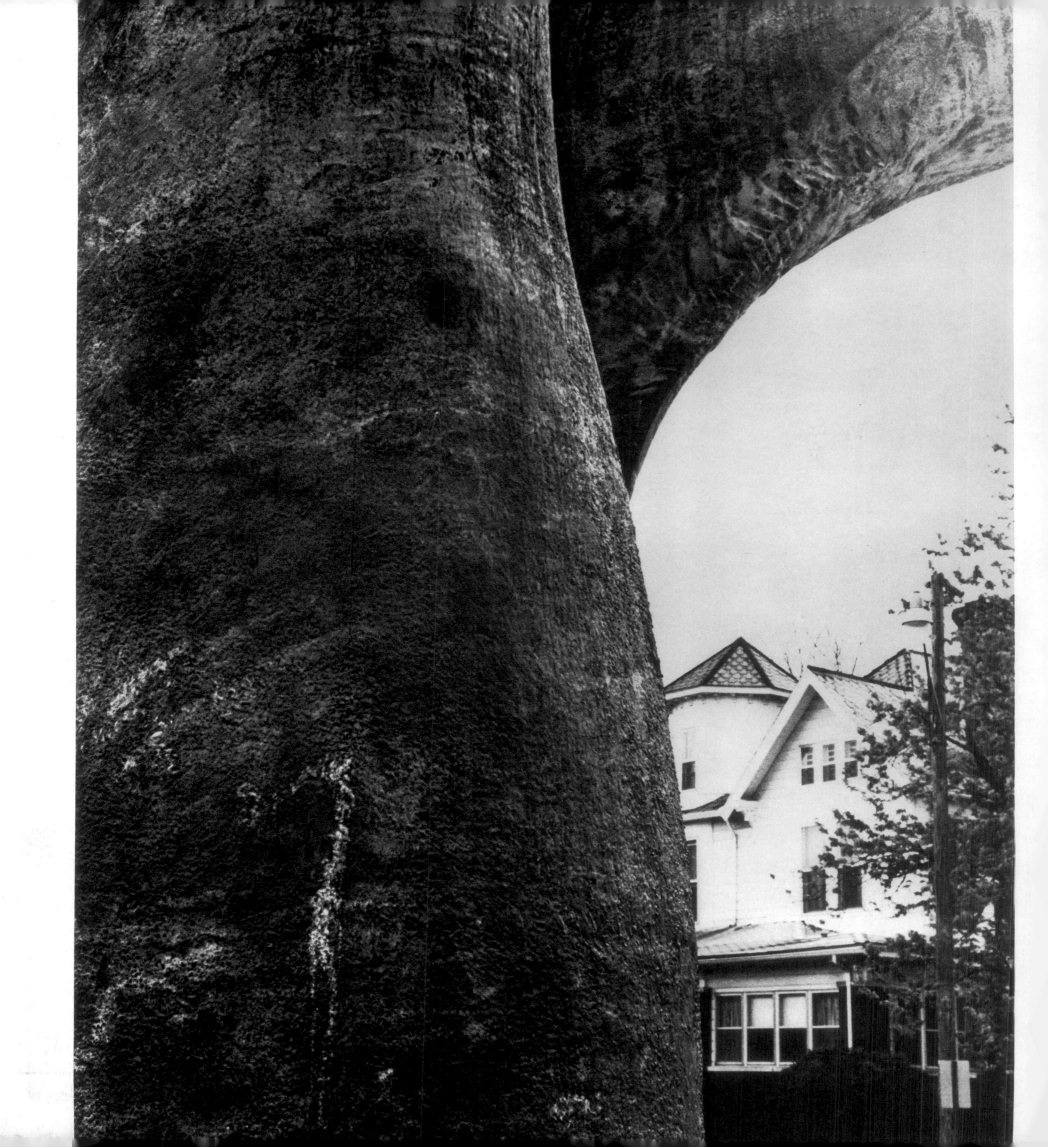

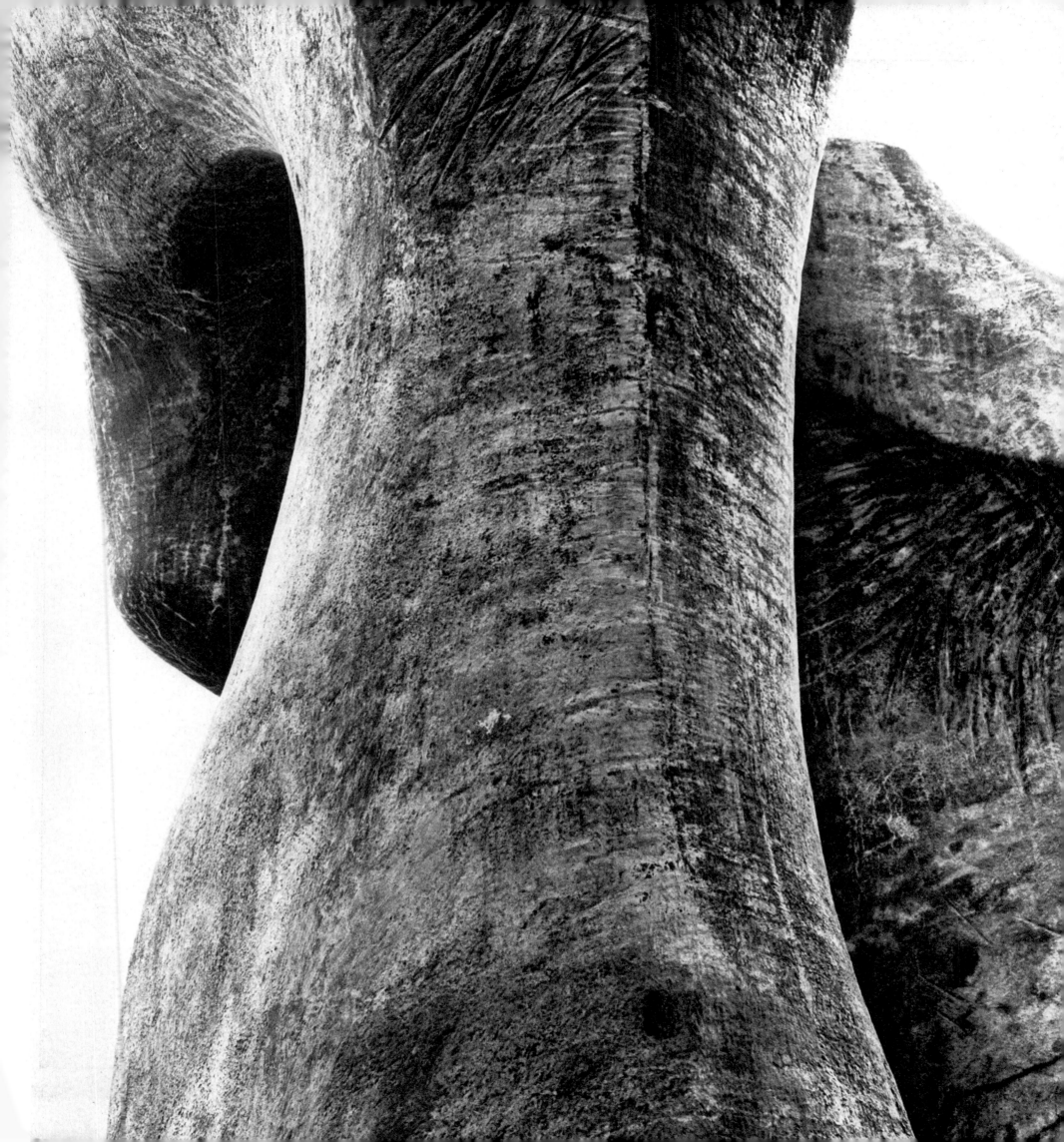

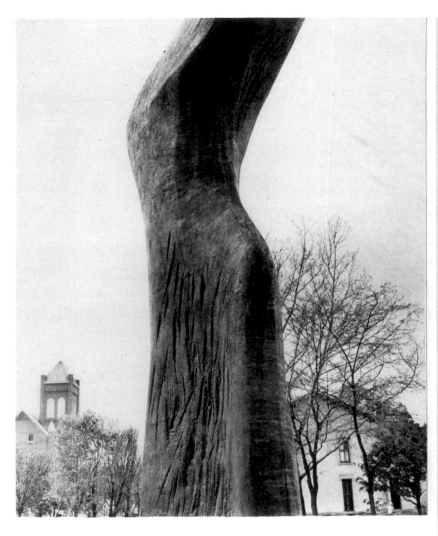

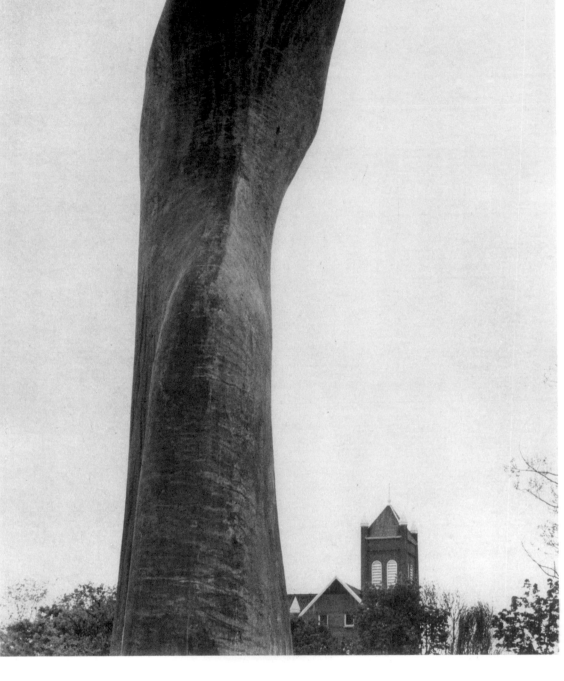

The architect I. M. Pei saw the seven-foot-high working model of this sculpture in the Museum of Modern Art, New York (see pp. 342–45). He said that if it were three times as big it would be just what he needed in front of a building he had just designed for Columbus, Indiana. I had always intended to make it bigger. Most everything I do I intend to make on a large scale if I am given the chance. So when required to make a work bigger, I am always pleased. Size itself has its own impact, and physically we can relate ourselves more strongly to a big sculpture than to a small one. At least I do.

I like the detail which looks like a leg. Also, the one which looks like a pair of legs. In some views it looks like a horse's legs. In the overall view it's a pity you see the doors of the building in the background.

—Henry Moore

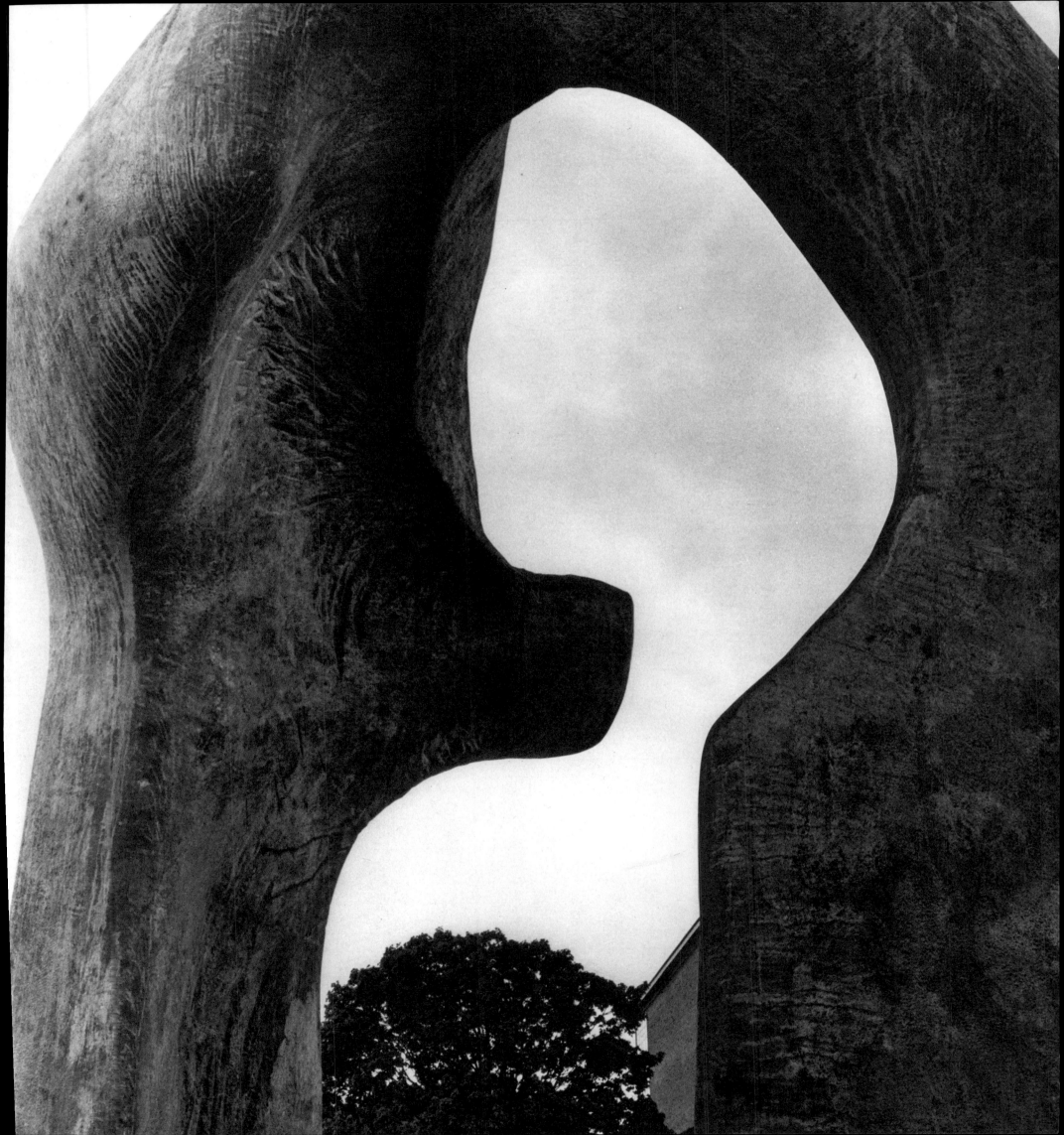

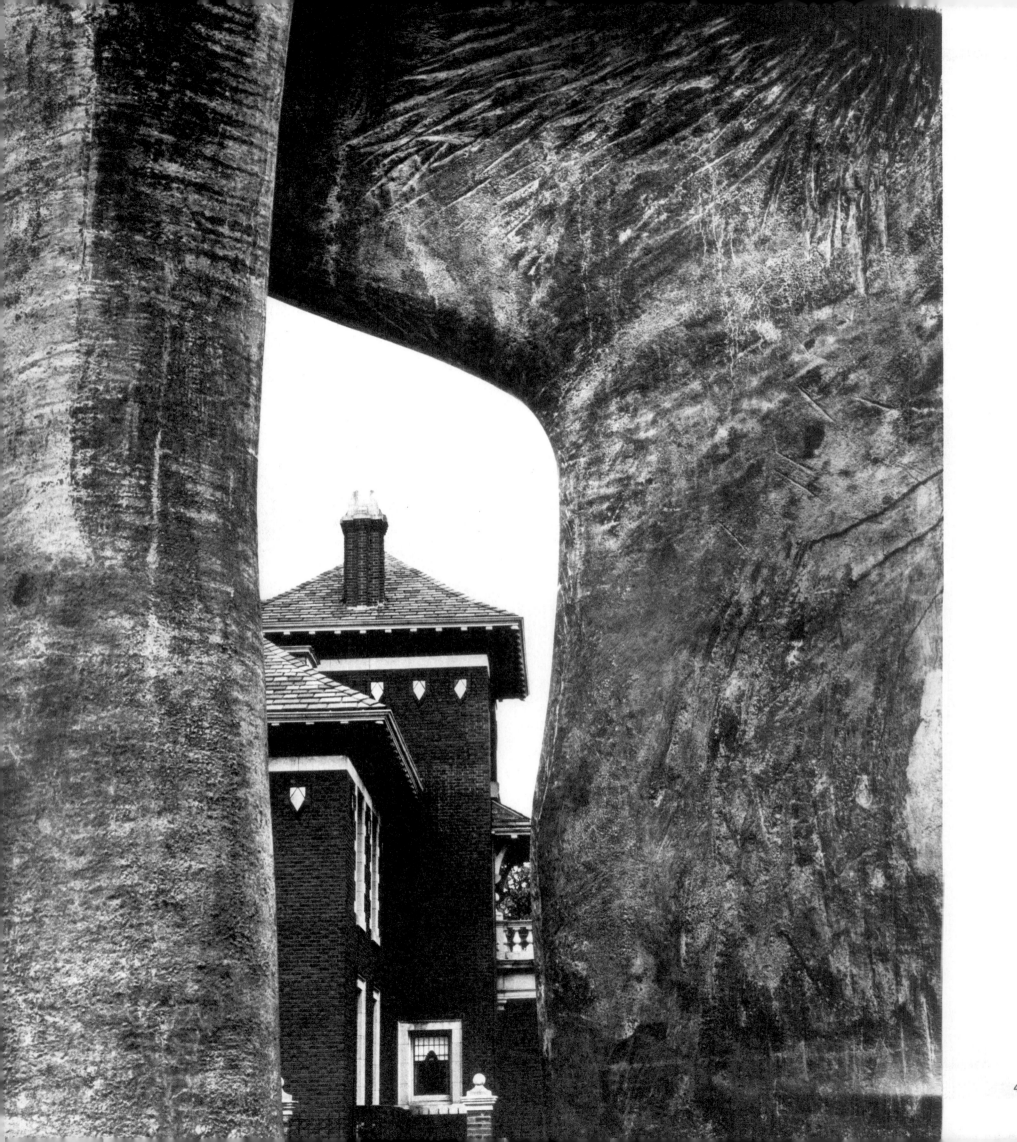

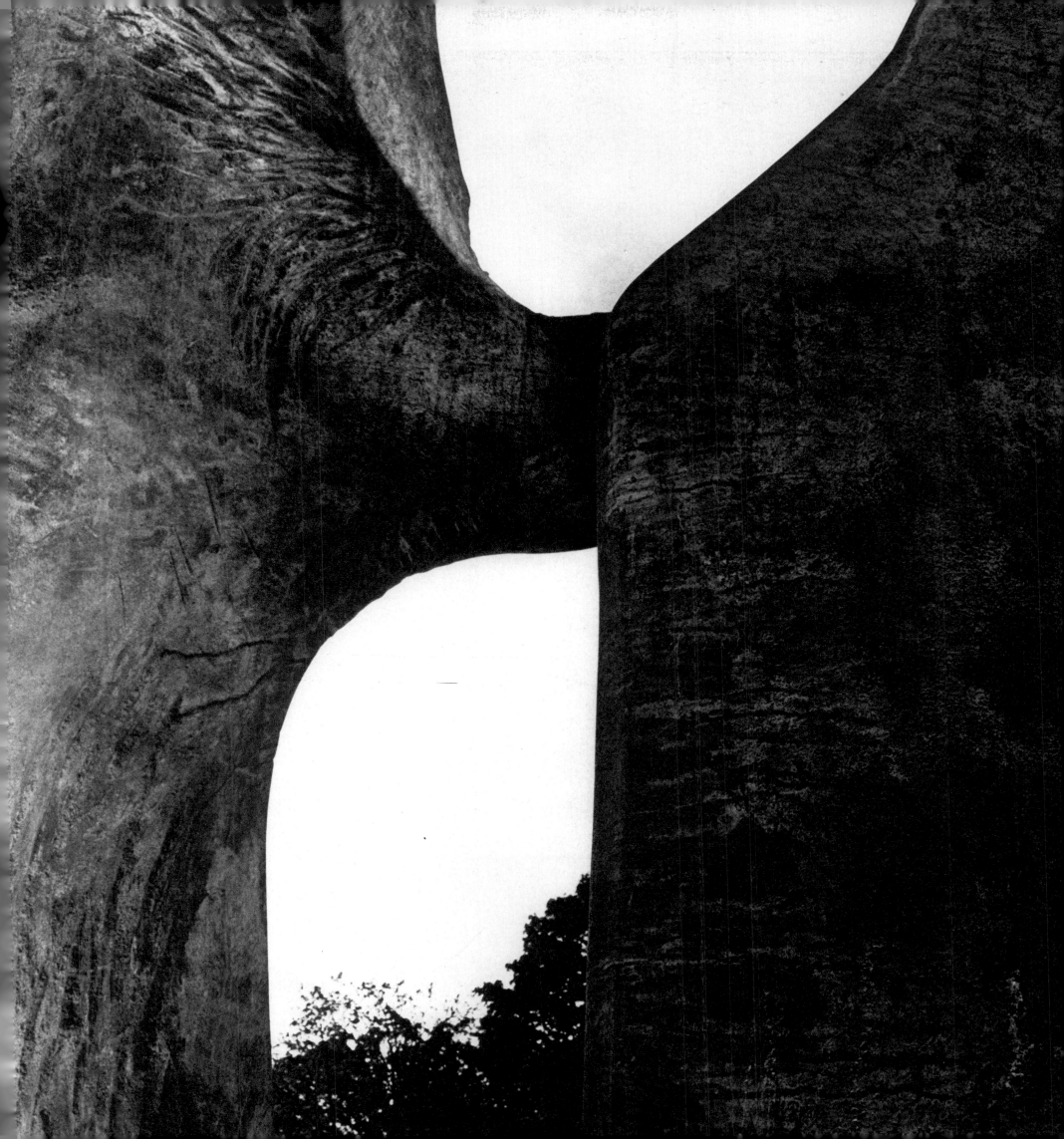

HILL ARCHES

1973. BRONZE, 18'. DEERE & COMPANY, MOLINE, ILLINOIS

A few years ago Moore acquired a piece of land used for sheep pasture that was adjacent to his property in Much Hadham, England. He was especially intrigued by a hill at the edge of the meadow, which could be seen against the horizon. The field was used by a neighboring farmer, and Moore loved to watch the sheep from the window of one of his studios. This was the inspiration for his marvelous drawings of sheep, as well as for his remarkable sculpture called the *Sheep Piece*, which I photographed in Much Hadham (see p. 489). But Moore also kept looking at the hill in the distance, wondering what sculptural shape would most effectively take advantage of that graceful swelling of the land.

Several years after he acquired the land Moore showed my wife and me a working model of a new sculpture that he had de-

signed for the hill. This seemed to us unlike anything of his that we had seen before. There were three pieces which fitted together, and a fourth egglike shape, which was placed on the base and carefully related to the other forms. Moore explained how he thought the piece would look from below, with its swooping arches rising into the sky and interacting with each other. He had decided he would create this on a large scale for his hilltop and call it *Hill Arches*.

Moore did not agree that this was a departure from his earlier work; he felt it was related to other things he had done in the past. I thought of the *Reclining Figure* of 1951, which I had photographed in Edinburgh (see pp. 282–87) and of Moore's comments about its form and space and realized that this new piece was indeed part of a long Moore tradition. Yet there was

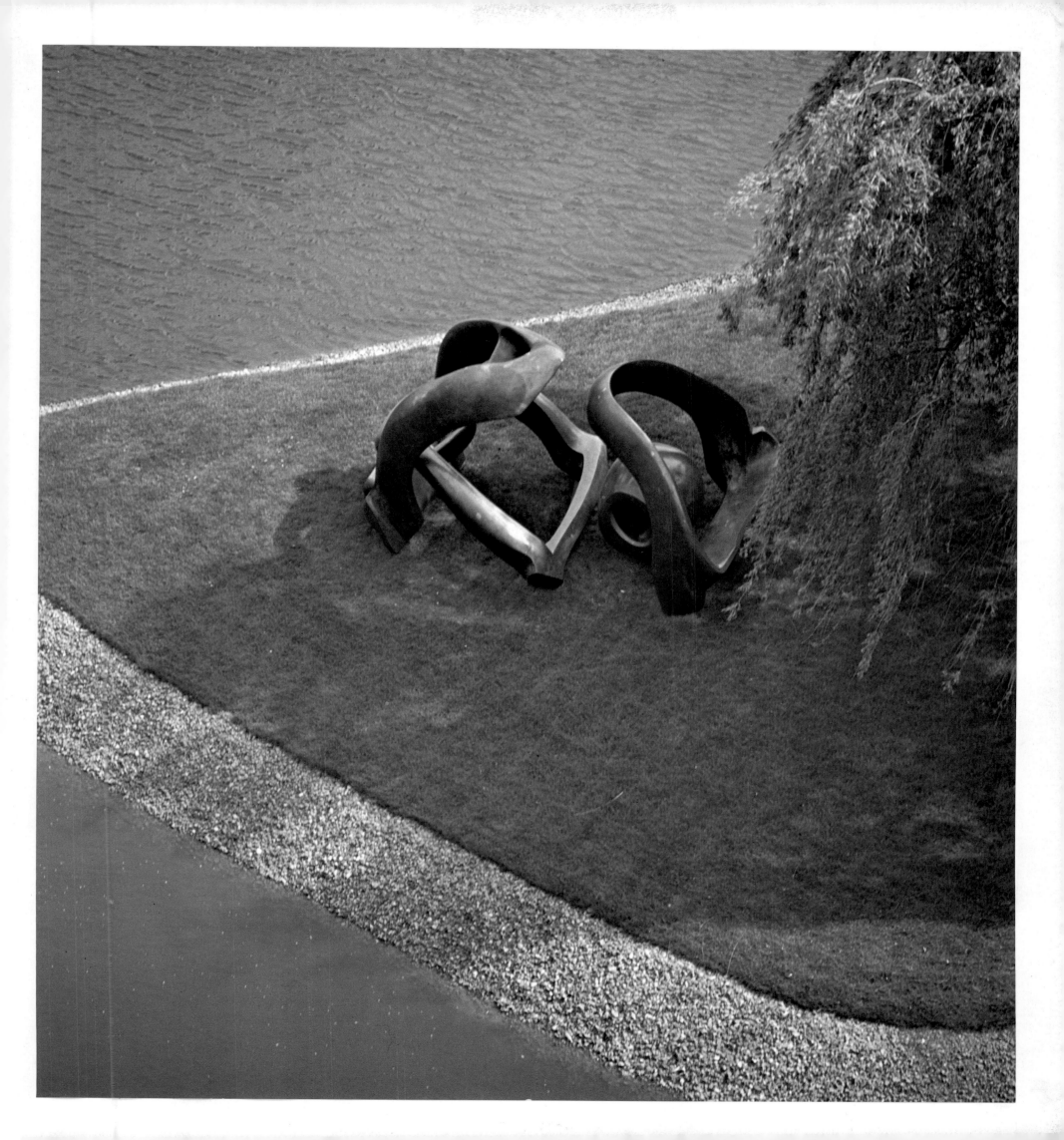

something about it that, to my eyes, was startlingly different. Gordon Bunshaft and I talked about it later, and neither of us was quite sure how we felt about the new piece. I decided to wait until I saw the large-scale sculpture before making a judgment.

The first cast was planned by Moore for its Much Hadham site. As it happened, however, William Hewitt, chairman of the board of Deere & Company, was interested in obtaining a large Moore sculpture for his company's headquarters in Moline, Illinois, and he felt that *Hill Arches* was just what he was looking for. Moore was intrigued by the location Hewitt had in mind, and he finally decided to let the first cast go to Moline instead of to his own home.

I made a special trip to Moline to photograph *Hill Arches* (see pp. 30–32), and as soon as I saw the work, I knew that Moore had once again triumphed in the creation of monumental forms and spaces. As I moved around—and even inside—the work, I could see clearly Moore's idea of

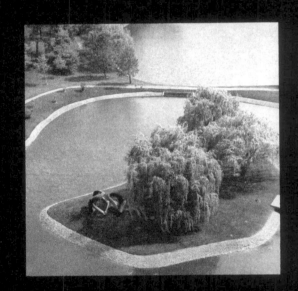

arches changing against the sky. The forms swept in and out, and the spaces were full of carved air, all of which looked especially fine against the blue sky, the Cor-Ten steel of the Saarinen building, and the lush foliage in the area. The egg part of the sculpture took on extra meaning for me when I learned that there was a pair of wild ducks on the island, and that the mother was sitting on a nest full of eggs. The sculpture seemed to have been made for them. And—as can be seen from one of the shots I took—the swans floating by, with their long, graceful necks, and the reflections they made in the almost still water were particularly helpful in echoing the shapes of the sculpture.

Through a curious turn of events, Moore changed his mind about putting *Hill Arches* on his own hill at Much Hadham and created another work for that location. But I'm sure he feels the name *Hill Arches* is as appropriate as ever and that its location on the island hill at Moline is an ideal resting place for this grand sculptural conception.

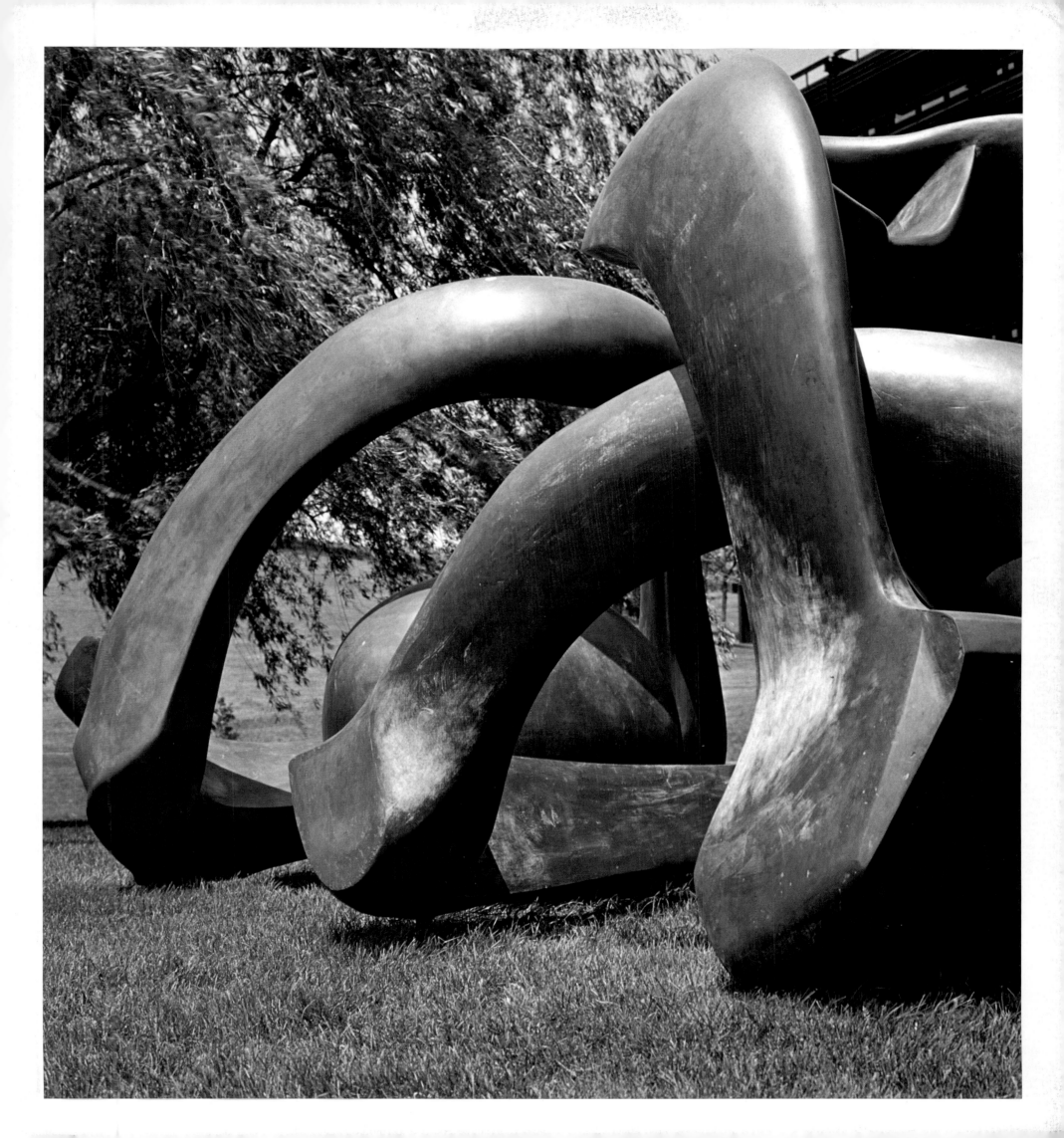

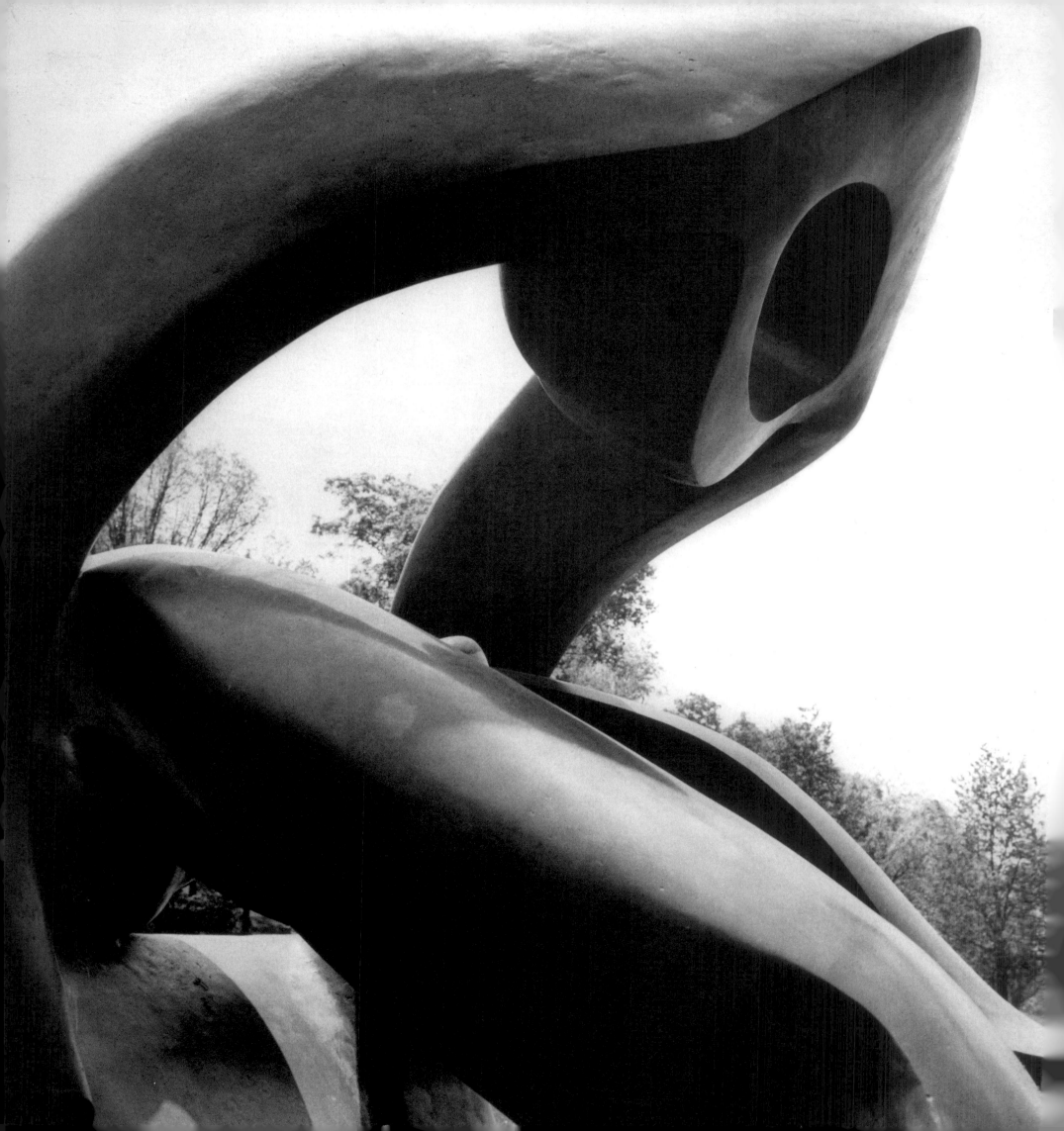

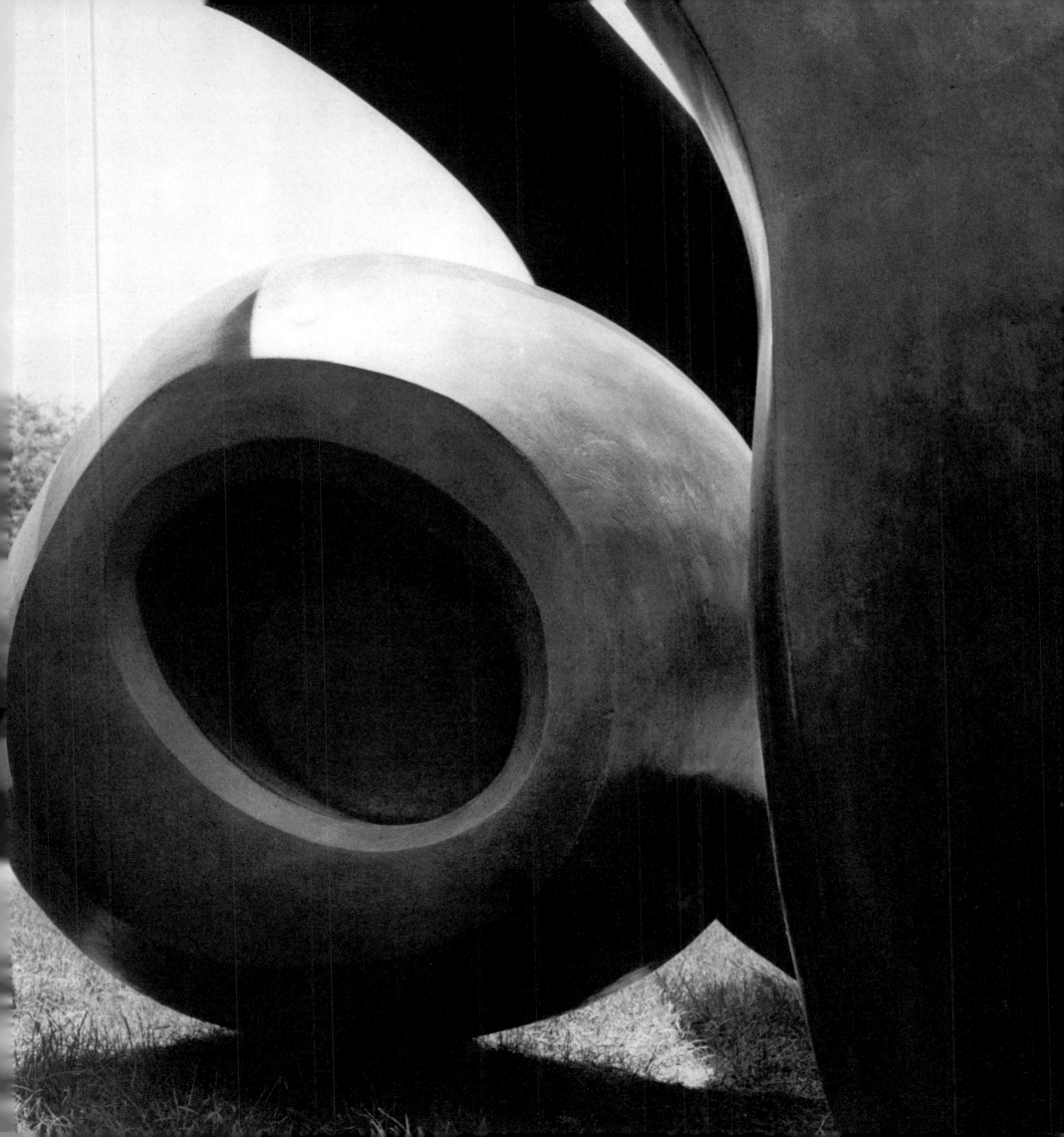

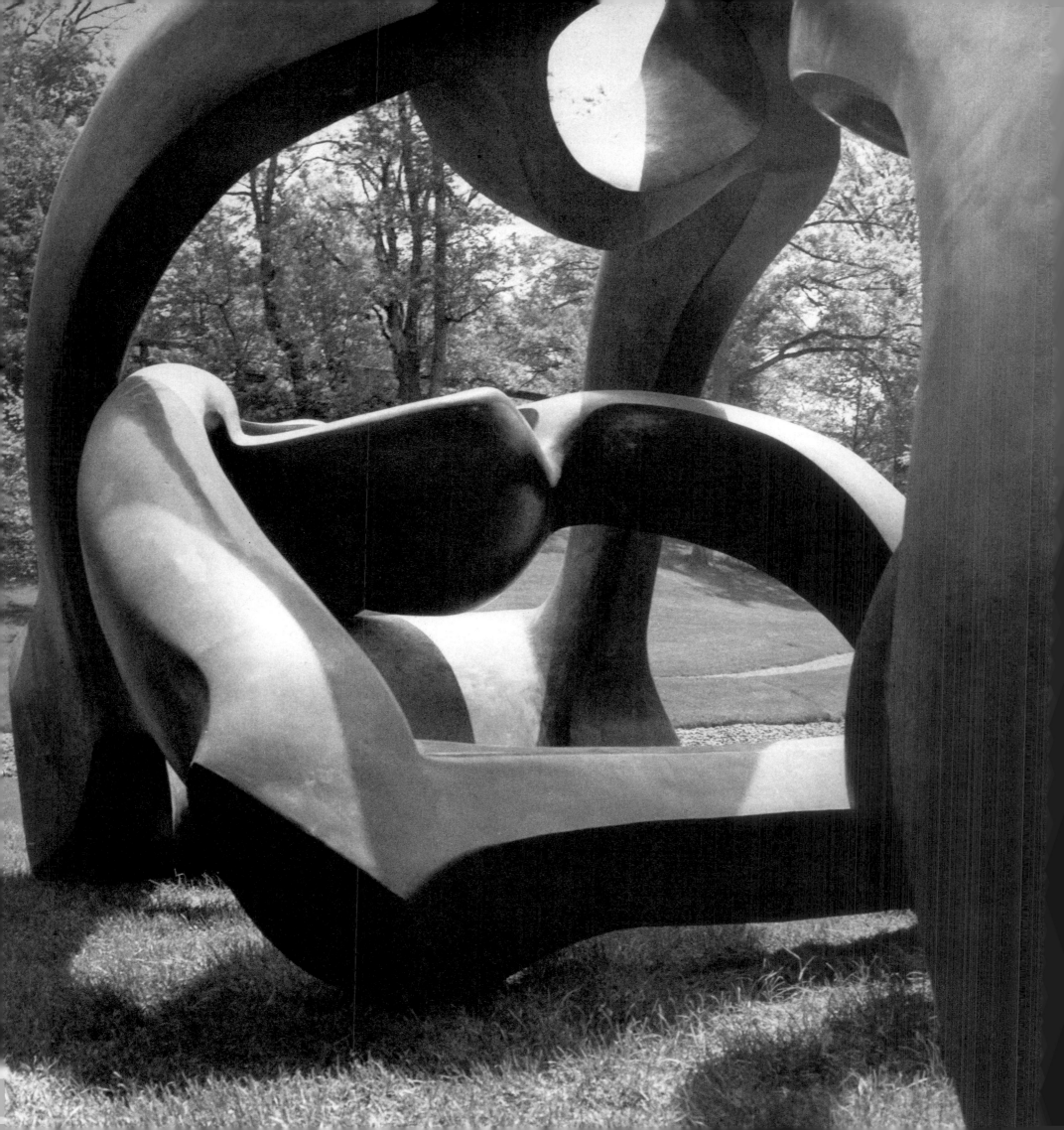

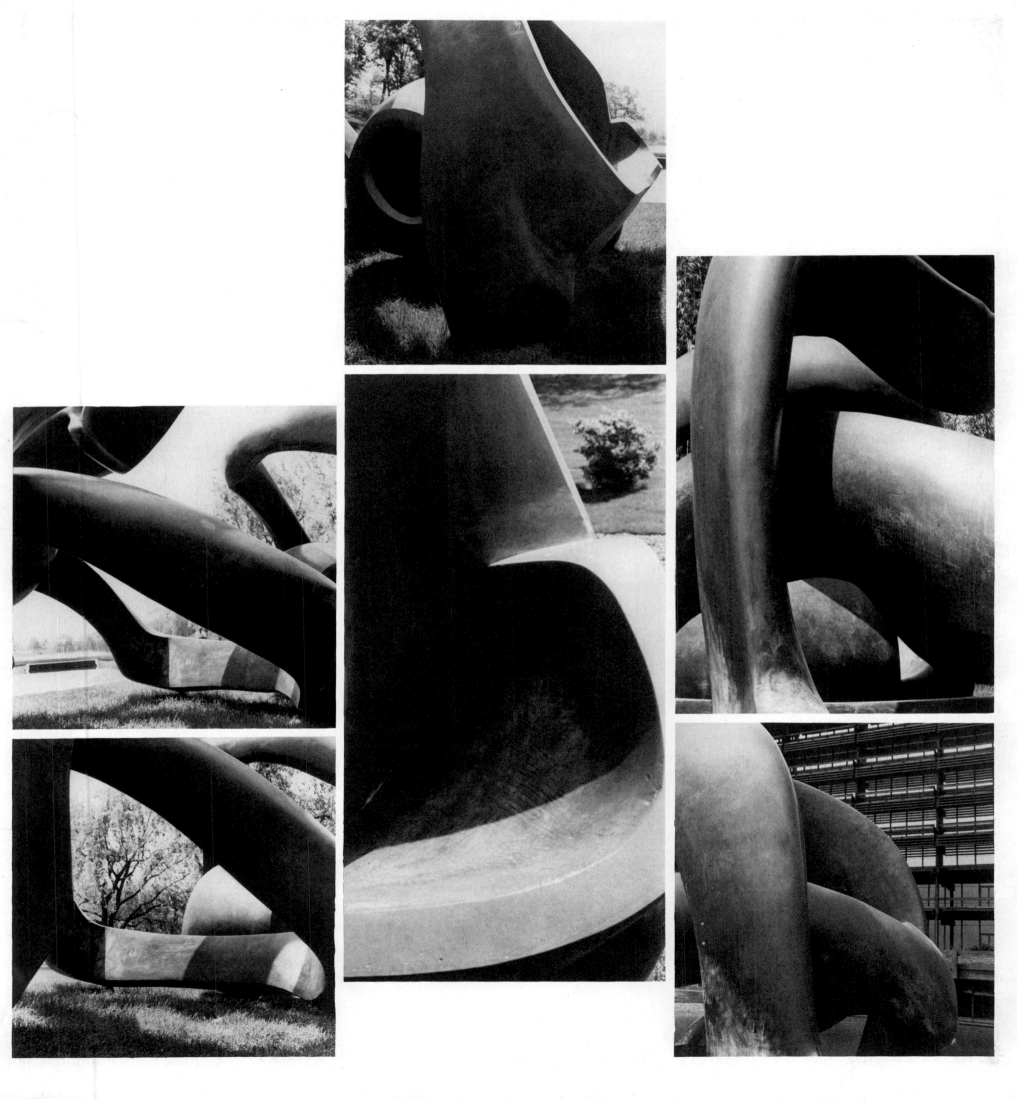

NUCLEAR ENERGY

1964. BRONZE, H. 12'. UNIVERSITY OF CHICAGO, ILLINOIS

Perhaps more than any other monumental sculpture by Henry Moore, this work has a distinctly architectural character. The forms inside the dome seem to have a spiritual quality—they could be the walls and windows of a chapel.

Located in front of the striking library building of Chicago University and surrounded by a large, open stretch of pavement, the piece can be viewed easily from all sides. From some directions one can see it against quite handsome backgrounds.

I traveled to Chicago twice to photograph *Nuclear Energy*. The first time it was raining heavily, and I had to hold an umbrella in one hand to keep my camera lens dry. But I was fascinated to see the

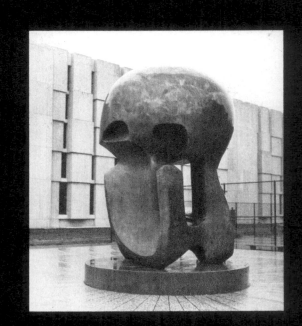

streaks of water on the sides of the sculpture, which made lovely striated lines that emphasized the subtly changing shapes in much the same way as the string Moore had used in some of his earlier work. It almost seemed as if Moore's uncanny genius for composing every detail of his sculpture so that a harmonious grouping of forms is seen from all possible perspectives had in this case gone so far as to anticipate the heightening effect of rain.

It was a bright, sunny day the second time I photographed *Nuclear Energy*, and the lights and shadows on the highly structured forms added even more dramatic strength to the piece. Most of the photographs shown here were taken on my second trip.

Four professors from the University of Chicago came to see me saying that they wanted to build a monument on the spot where the first controlled splitting of the atom took place. This had been in a small temporary hut, and no one could have known that such an important experiment was going on.

Eventually this temporary building had to come down, and in its place they wanted me to do a sculpture as a memorial. I had already made the maquette for this sculpture when they came to see me. It was a helmet-head idea. I showed it to them, and they agreed it would be appropriate and expressive of the subject. In its development and realization it became the Nuclear Energy sculpture.

I like the details which show its skull-like top. I meant the sculpture to suggest that it was man's cerebral activity that brought about the nuclear-fission discovery. It can also suggest the mushroom cloud, the destructive element of the atom bomb.

The lower half of the sculpture has something architectural about it, like the arches of a cathedral or entrances leading into a protective interior, suggesting the valuable and helpful side the splitting of the atom could have for mankind. And there are many other symbolic interpretations to be found in it.

<div align="right">

—Henry Moore

</div>

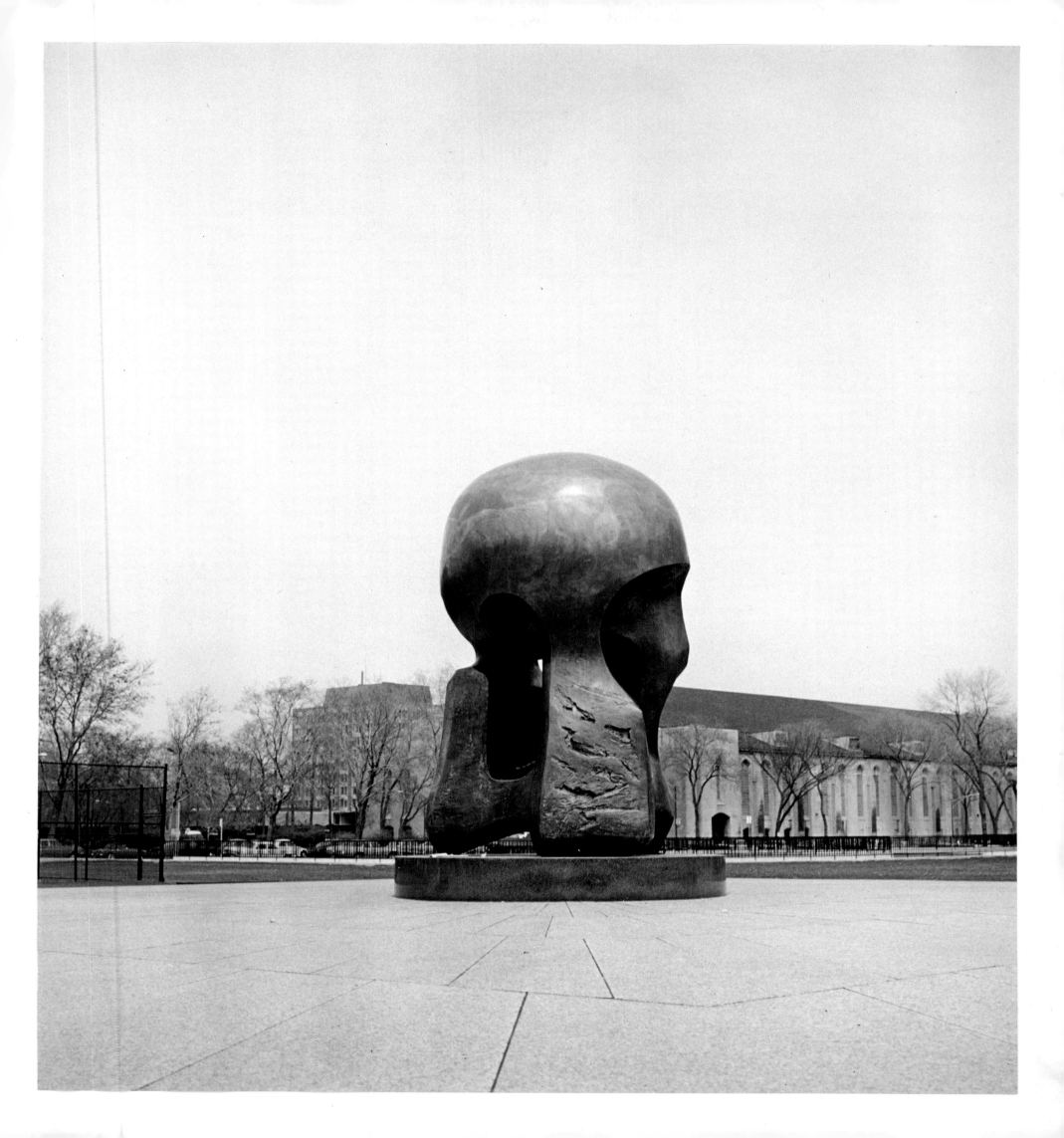

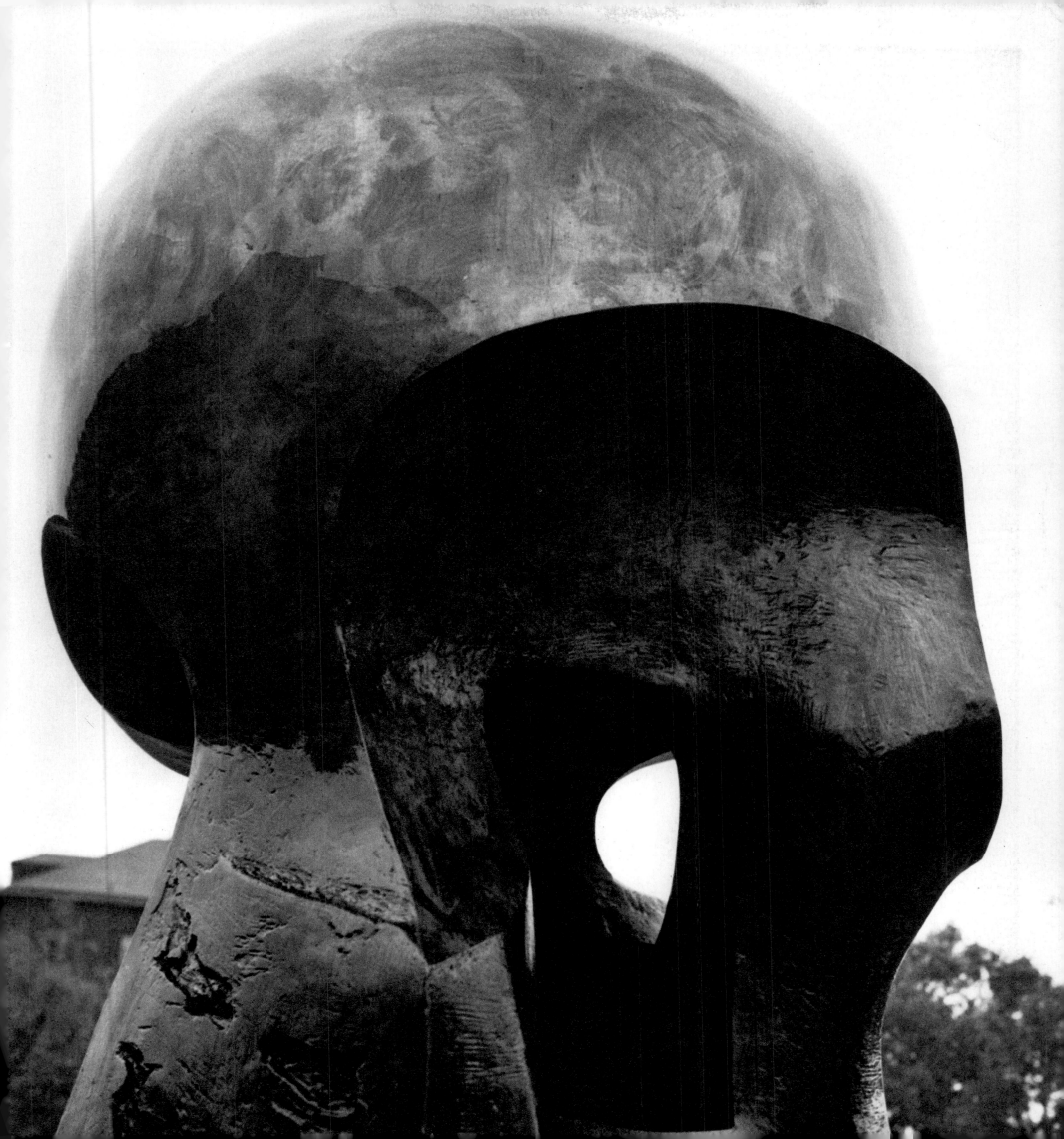

TWO-PIECE RECLINING FIGURE 9

1968. BRONZE, L. 98". NORTHPARK NATIONAL BANK, DALLAS, TEXAS

These were among the last photographs I took for this book. I happened to be in Dallas shortly before the book was ready to go to the printer when a friend mentioned that a Moore sculpture had recently been placed in the area. I had heard that the NorthPark Shopping Center was one of the most advanced architectural conceptions in the country, and I knew that Raymond Nasher, who had been the guiding light in its development, was a business executive with strong social awareness and a keen aesthetic sense. I was delighted, therefore, at the opportunity to visit the center—which was, if anything, more impressive than I had heard—and to see the fine Moore sculpture that Mr. Nasher had placed in front of the NorthPark National Bank.

Since I had not come to Dallas for the purpose of photographing sculpture, I did not have my camera with me, but I managed to borrow one from a friendly stranger. The weather was beautiful, and I was able to steal a half hour from my business affairs to

enjoy the marvelous forms of *Two-Piece Reclining Figure #9*.

I recognized similarities to *Bridge Prop* (see pp. 404–9), especially in the *Reclining Figure*'s long body element, which leans on the pelvic bone, and in the angular feet at the end of the sculpture. But the head and shoulder areas were completely different. As I moved around the sculpture, I found the inventions in the head area particularly fascinating.

The sculpture was well placed on a cleverly designed pedestal jutting out of the stairway approaching the building. The simplicity and strength of the building's architecture was well suited to the sculpture, and there were also some trees in the distance, which provided an attractive background from some angles. My general impression was that it was a most pleasant location in which both visitors to the bank and passers-by could enjoy the striking elements of a Moore sculpture.

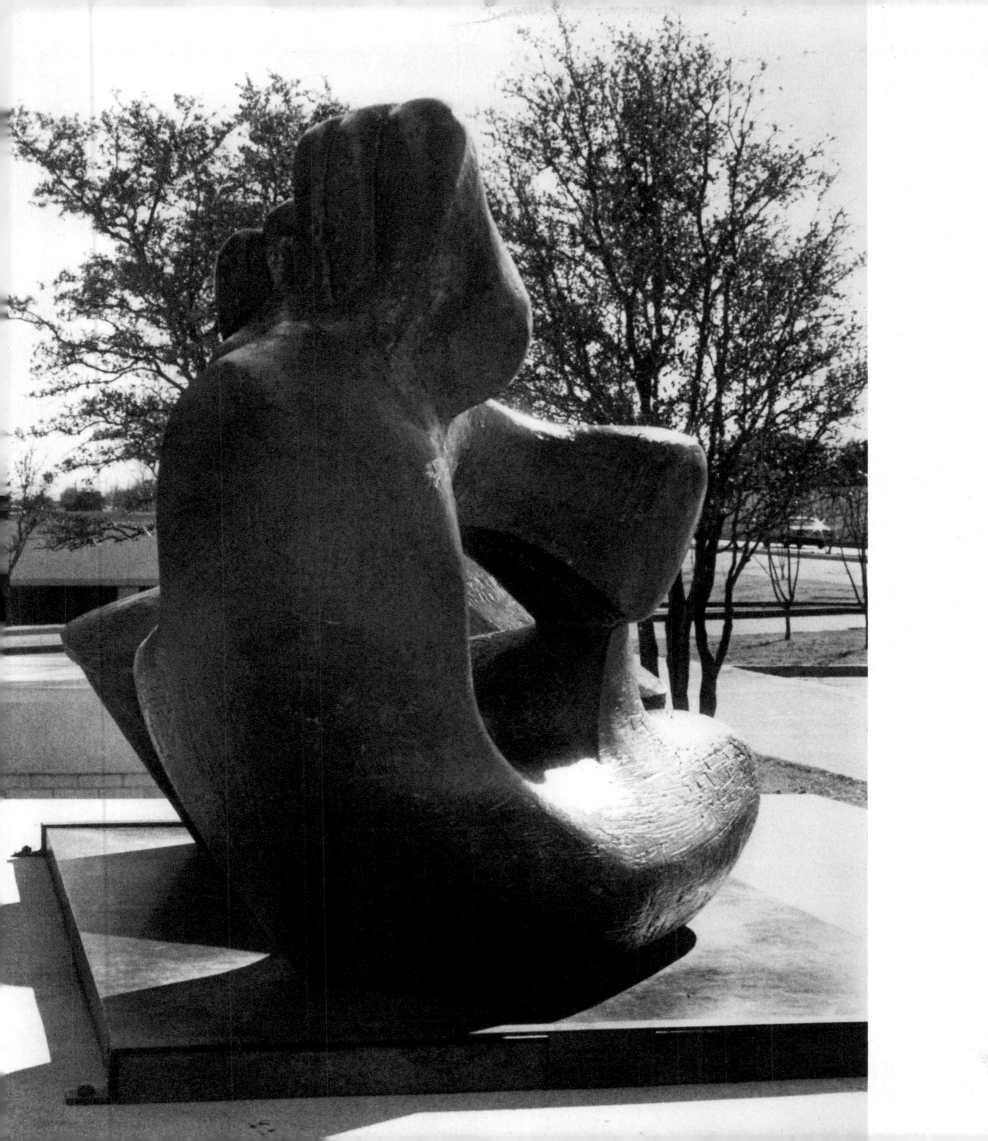

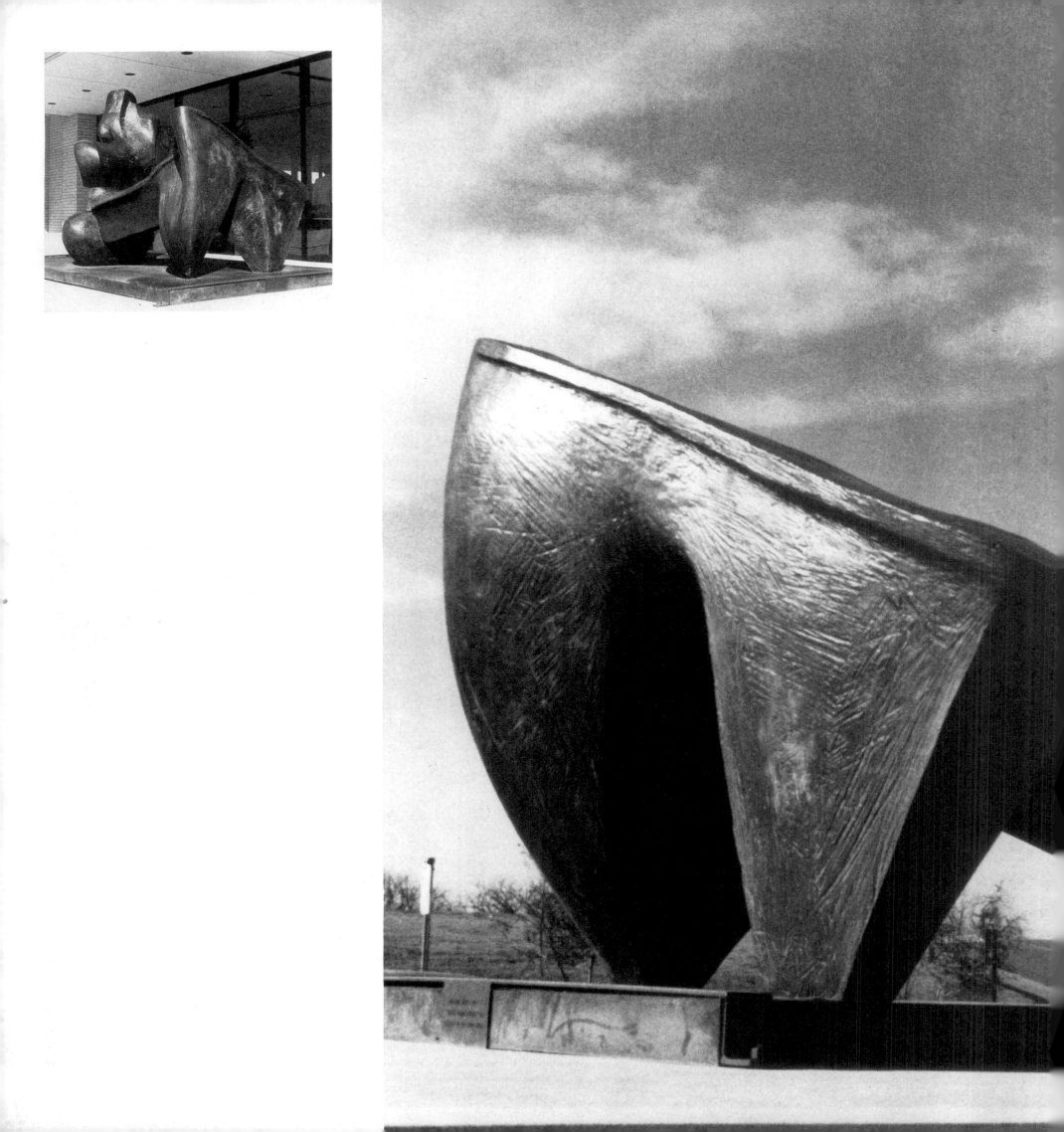

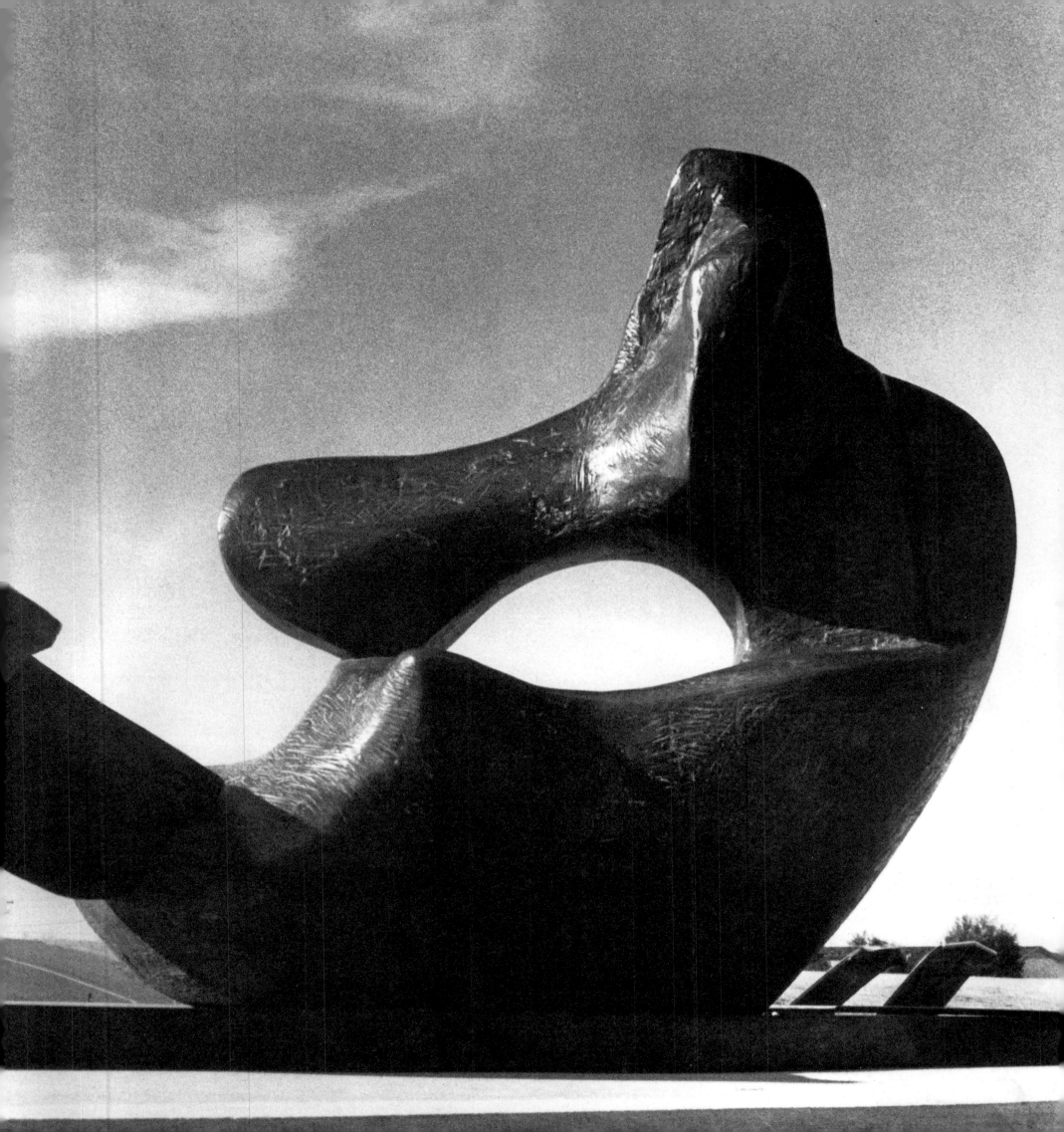

UPRIGHT MOTIVES 1, 2, 7

1955–56. BRONZE, H. 11′; 10′6″; 12′6″. AMON CARTER MUSEUM OF WESTERN ART, FORT WORTH, TEXAS

These are casts of the same Upright figures as those in Otterlo, the Netherlands (see pp. 168–73), but here they stand on a rather chunky base that seems out of proportion with the sculptures. Also, the location at the edge of a wide, open lawn with a fence on its outer perimeter is rather sterile. As large as these sculptures are, they seem decorative in this setting.

The Amon Carter Museum is a handsome building designed by Philip Johnson to house art of the American West. It is located some distance from the center of Fort Worth, and it is rather nice to see the sculpture against the city skyline. If the base for the works were not so

disturbing, it would be interesting to compare the organic forms of the sculptured Uprights with the geometric forms of the buildings in the distance, but since the vertical lines of the base are themselves geometric, the contrast is diminished.

Although I prefer the placement of the three works in a triangular position, as in Otterlo, the Netherlands, the fact that they are lined up in a row here enabled me to photograph some interesting relationships among the forms of the three Uprights. In some shots they look as if they are talking to one another, and it is quite remarkable to see that the shapes work so well in facing positions.

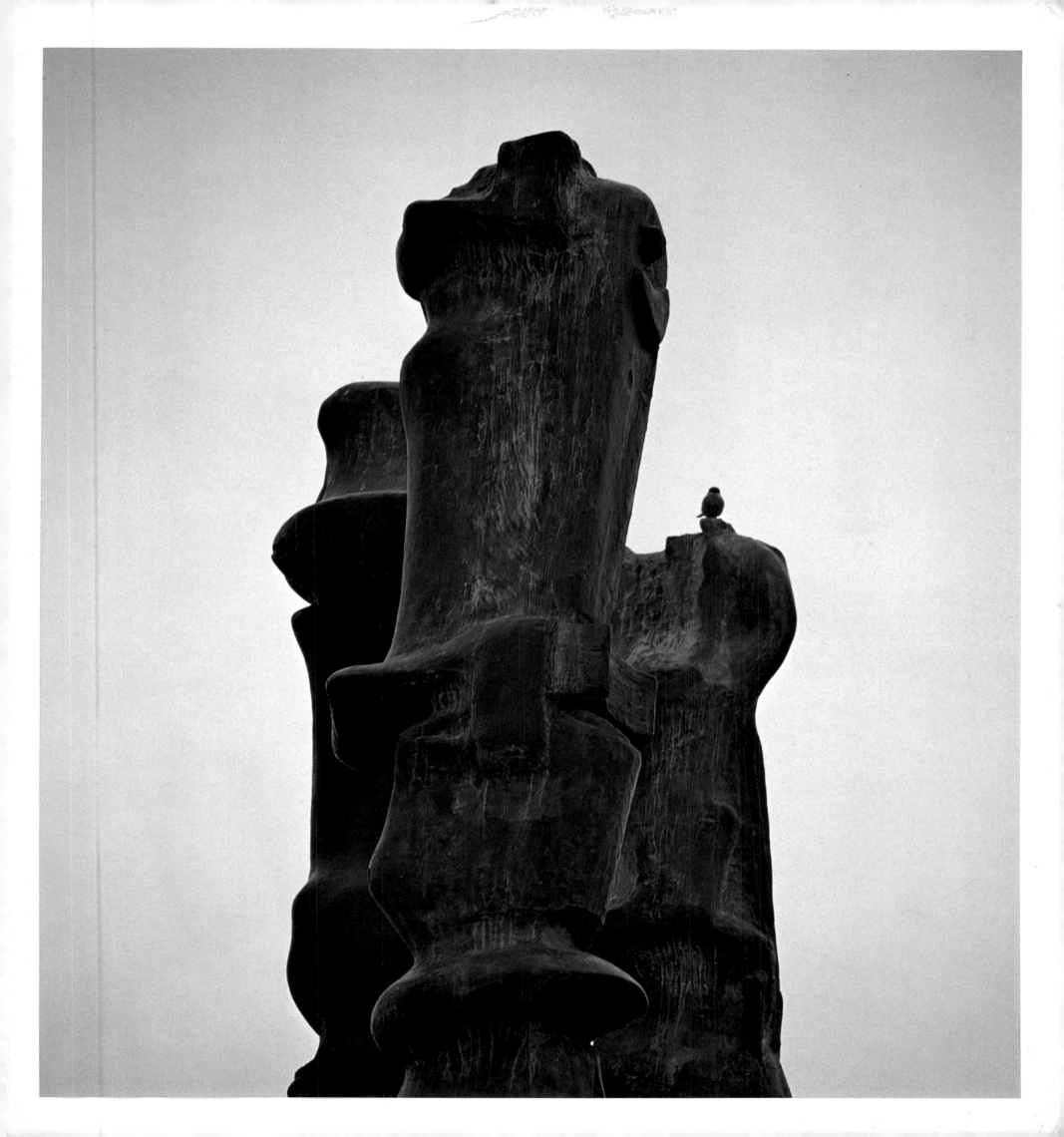

I think the base is too big for the sculpture.
It makes it very Germanic.
 Look at the bird in one of the photo-
graphs! I like that.
 —Henry Moore

WORKING MODEL FOR THE ARCH

1962–63. BRONZE, H. 78". STANFORD UNIVERSITY, CALIFORNIA

This sculpture, which was a gift from Nathan Cummings, is placed in front of the Nathan Cummings Art Building at Stanford University. Smaller in scale than the version in Columbus, Indiana (see pp. 430–37), it is still a strong work and commands a large area of the campus on which it stands.

I like the toughness of the oak tree in the background. It fits the character of the shoulders in the sculpture. The figure was originally meant to be a male torso with tensed shoulder-girdle bones forming a sort of arch.

I first called the sculpture Large Torso; *then I changed it to* The Arch. *The twisted, knotted strength of oak trees is something of what one wanted this figure to have.*

I like this setting, not only the tree but also the buildings in the background. This is an example where the shapes of the building seem to fit the shape of the sculpture, and it works.

—Henry Moore

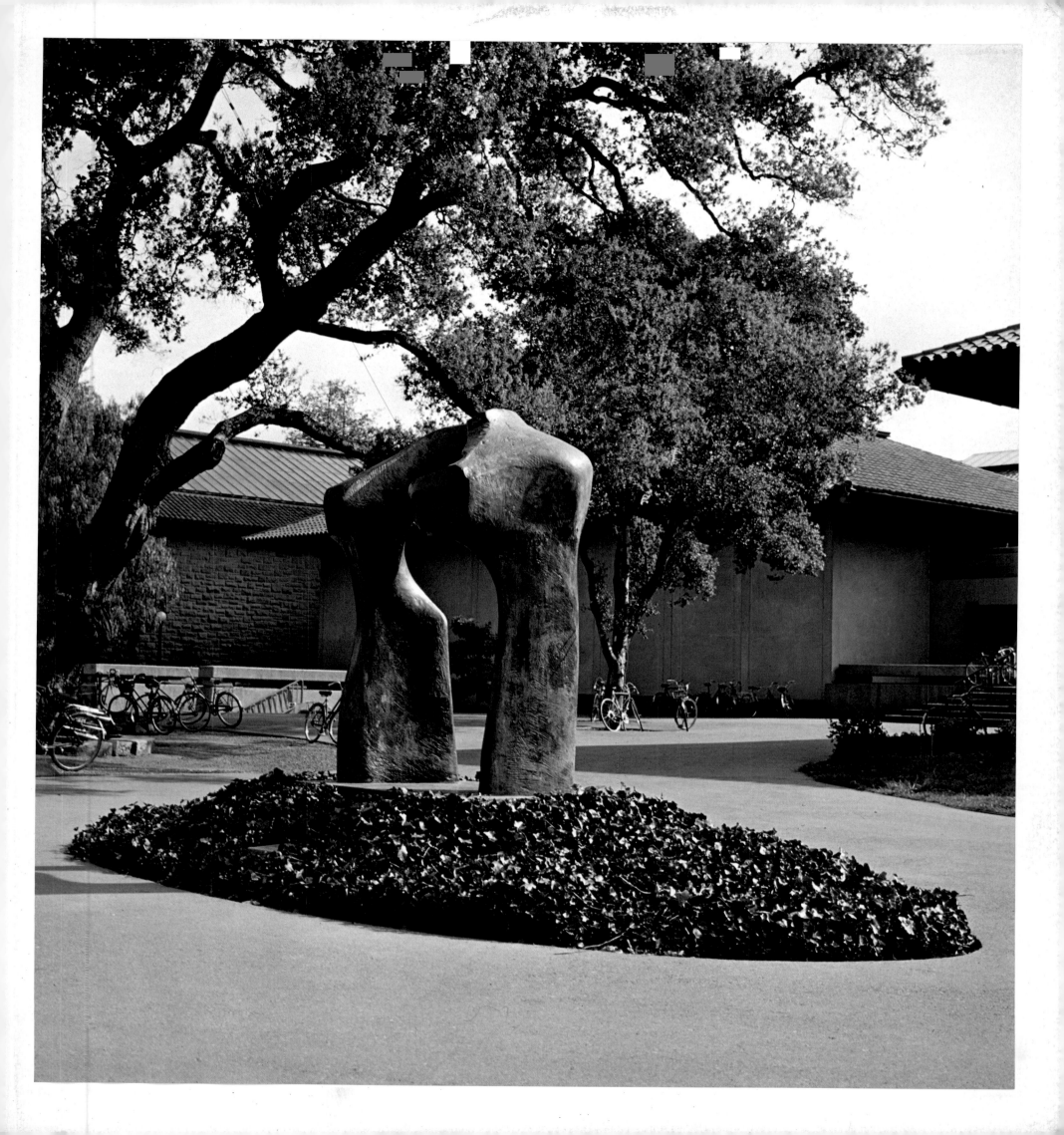

THREE-PIECE RECLINING FIGURE 1

1961–62. BRONZE, L. 9'5". LOS ANGELES COUNTY MUSEUM OF ART

When I happened to visit the Los Angeles County Museum on a brief trip to California, I didn't know that this cast was in the museum's garden and did not have my camera with me. I was able to borrow a camera from a friend, but, since it was somewhat unfamiliar to me, and I didn't have a light meter, I lacked the freedom I usually enjoy when looking for exciting views of a piece. Moreover, the sculpture is located in a spot with a hill sloping

downward on one side and trees above, casting flickering shadows over the forms, that makes photographing rather difficult. Nevertheless, the site is completely different from the two other locations in Cambridge, England, and Rochester, New York in which I saw the sculpture (see pp. 268–71; 380–85), and I think that some of the details photographed here of the remarkable, craggy work are especially revealing.

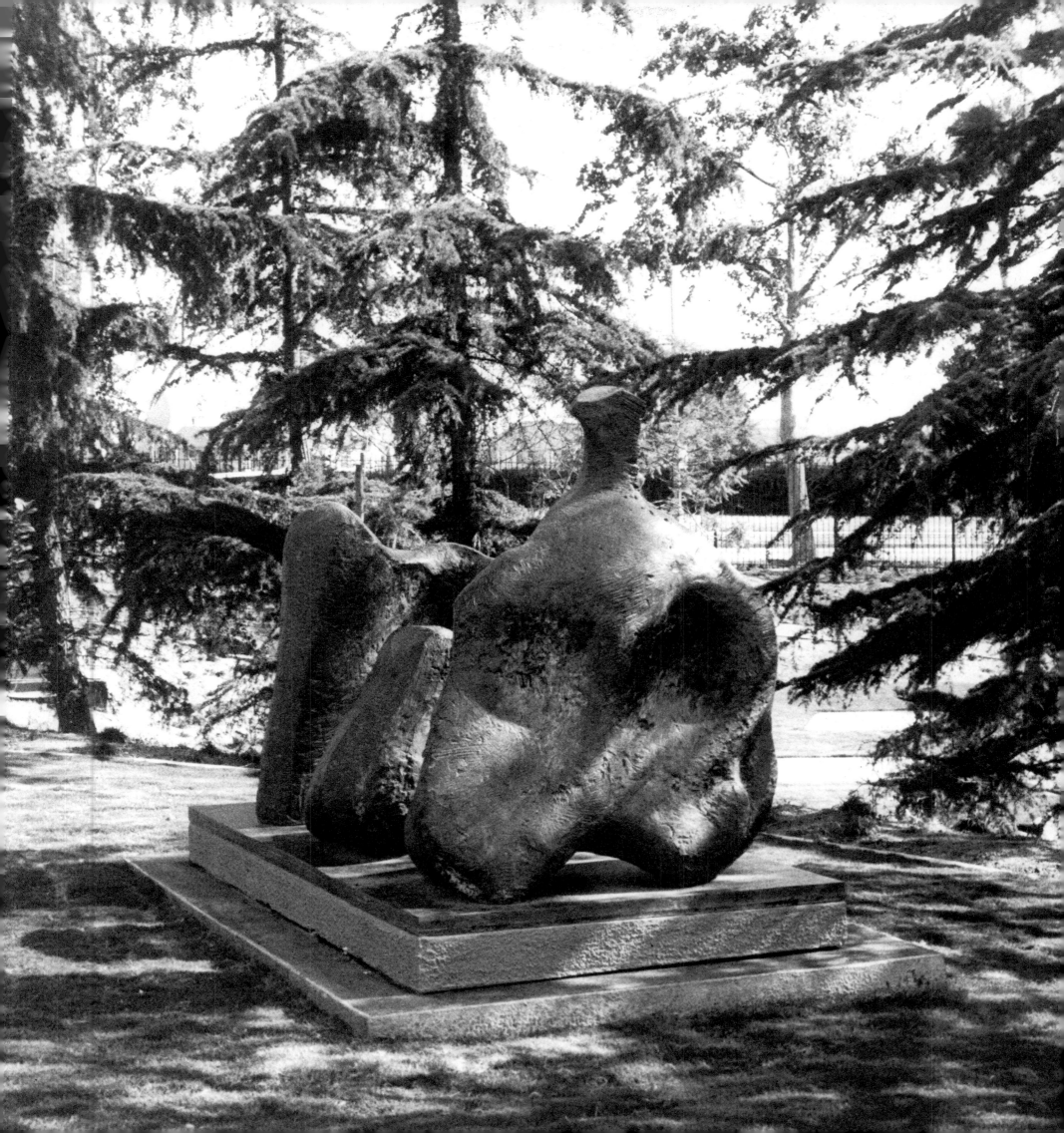

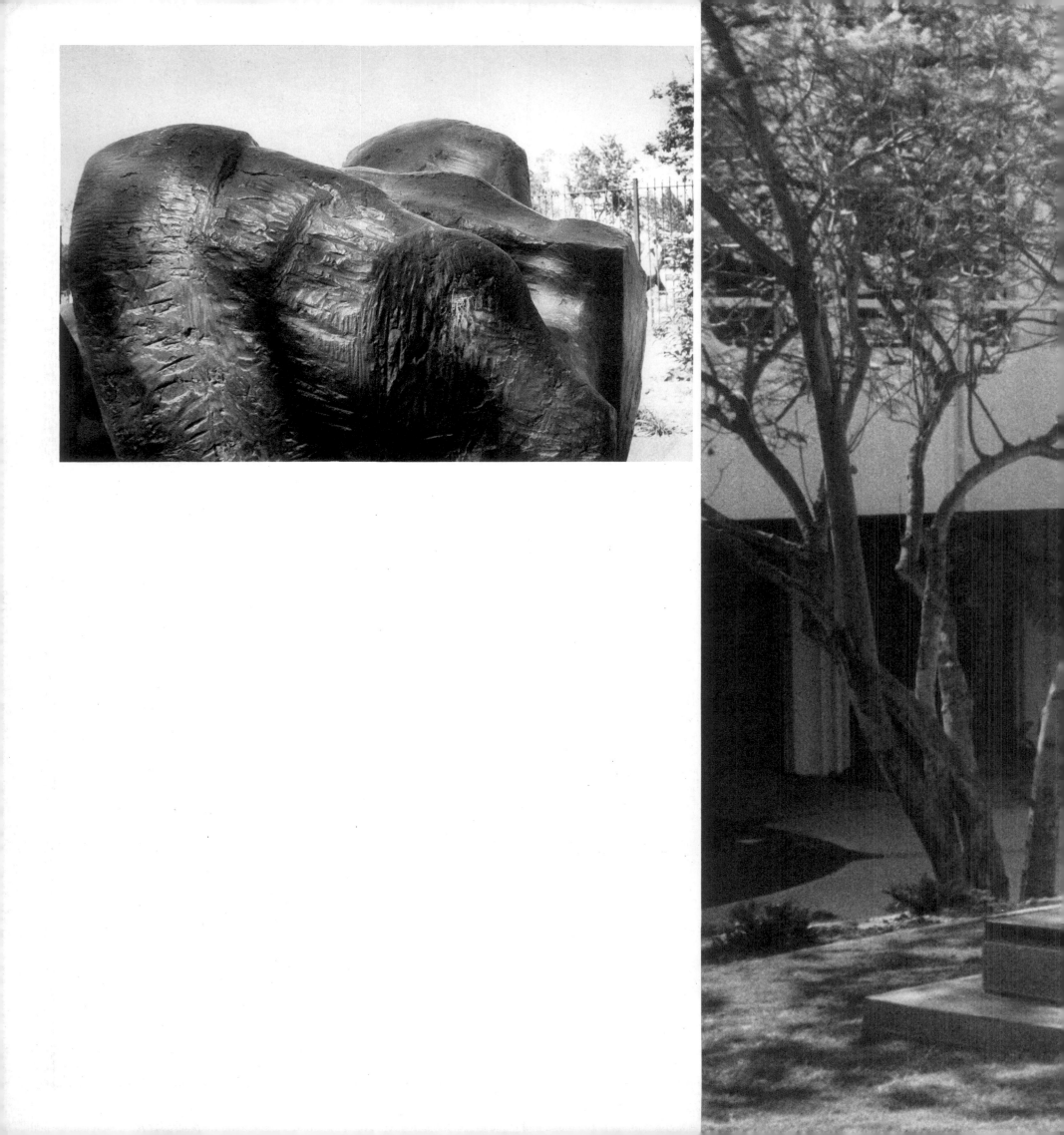

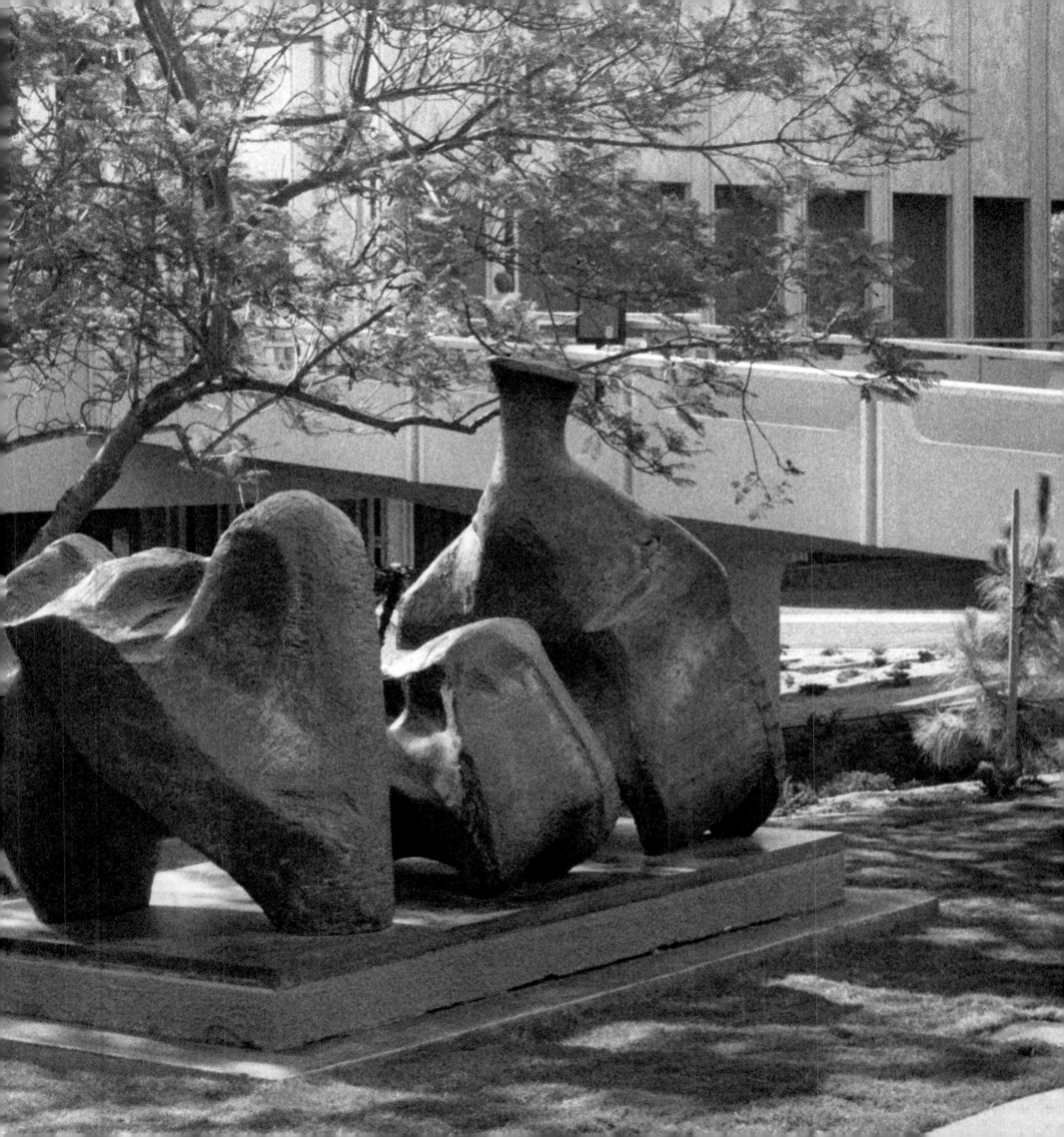

STANDING FIGURE: KNIFE-EDGE

1961. BRONZE, H. 9'4". MCA TOWER BUILDING, UNIVERSAL CITY, CALIFORNIA

This sculpture in the MCA Tower Building in Universal City, California, is the only piece in the book that is located indoors. The building's lobby is an especially attractive environment for a major Moore sculpture, however, for its large windows open onto well-placed foliage outside that provides many rich backgrounds against which to view the work. In addition, the black reflecting walls seem to add extra dimension to the space around the sculpture.

I photographed *Knife-edge* in Dublin (see pp. 314–17), where it was erected as a memorial to the poet William Butler Yeats. There the rough, textured surface of the piece seemed to reflect the woods in which it was located. Here in the MCA lobby, my attention was drawn to the astonishing changes of shape that took place as I moved around the sculpture. The effect of great formal variety was heightened by the rotating pedestal on which the sculpture is mounted, and the ease with which the piece can be turned.

I made a special trip to Universal City on a Saturday afternoon to see the sculpture, but because of heavy traffic on the Los Angeles Freeway, I did not arrive until quite late in the day. The building was locked, but arrangements were made to open the lobby for me. By the time I began photographing, the sun was low in the sky, and I had to work quickly against the growing darkness. Despite these difficulties, I think I was able to catch some of the lovely qualities of the sculpture in that setting.

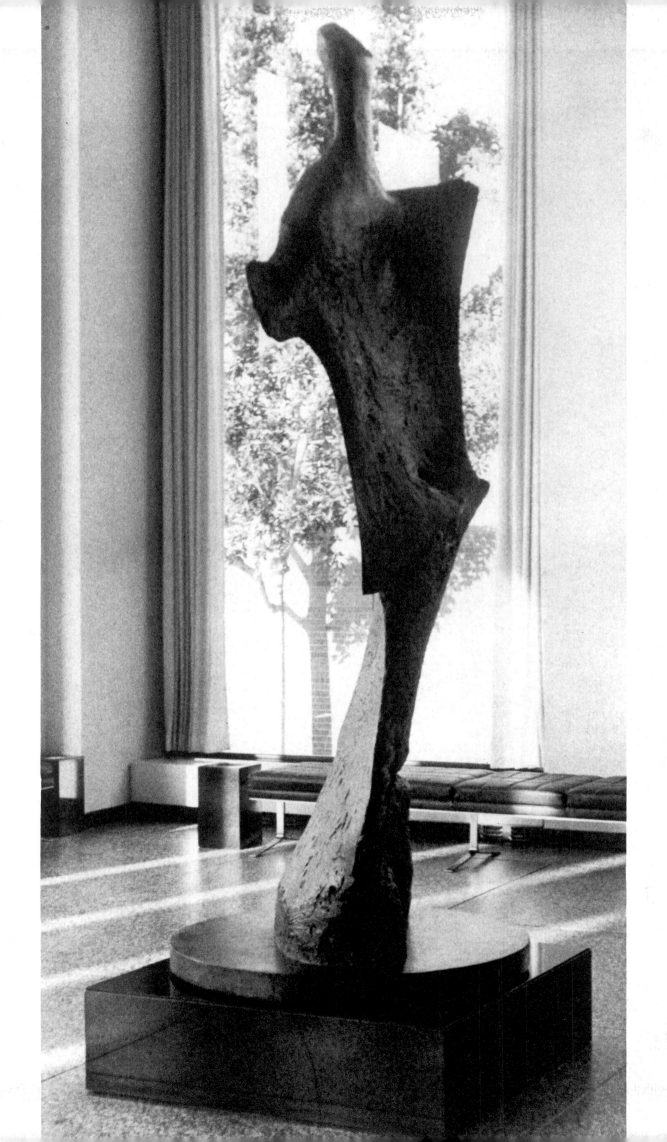

TWO-PIECE RECLINING FIGURE 3

1961. BRONZE, L. 94″. UNIVERSITY OF CALIFORNIA AT LOS ANGELES

Located in a lovely sculpture garden near the university museum, and in front of a striking building on the UCLA campus, this sculpture is extremely well placed. Indeed, the siting of all the sculptures in the area has been handled tastefully. An Arp sculpture, for instance, stands beside a tree with a similar shape. The Moore figure, the only sculpture within an extended lane of trees, has probably become part of the consciousness of most students whose

classes are held in its vicinity.

Because the sculpture is so close to the ground—virtually at grass level—it has quite a different effect from the casts in Goteborg, Sweden, and London (see pp. 204–8; 246–47). One does not see the piece against treetops, as in Goteborg, and it is less monumental, but one is drawn to the cavelike forms and giant boulders in the lower part of the sculpture, since one can go right up to the piece and look into it.

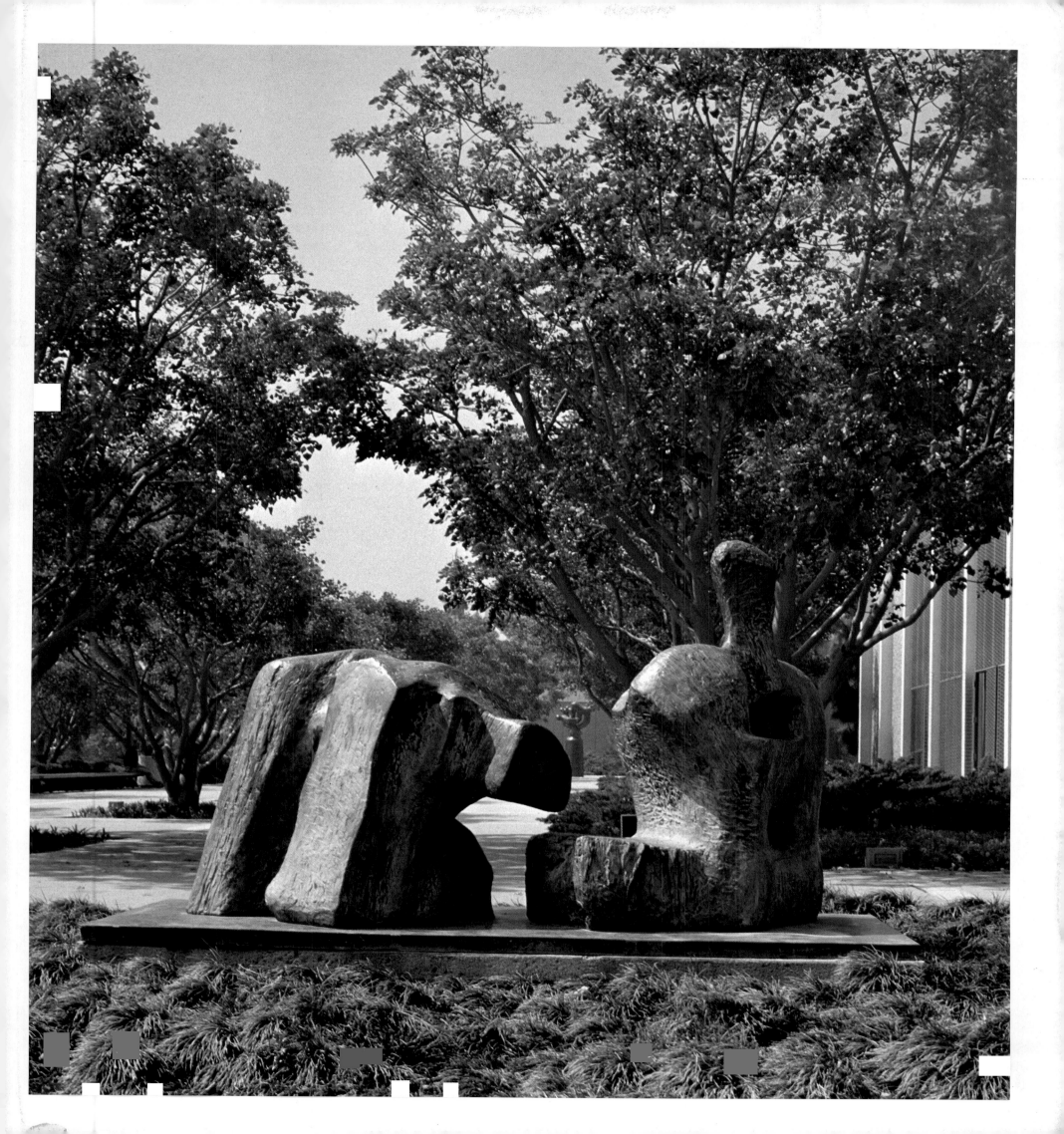

The idea of planting things around the
sculpture is all right. This is a good
location. A very nice light. The
details look like huge rocks.

—Henry Moore

THE
FLORENCE
EXHIBITION,
1972

Undoubtedly, the greatest outdoor exhibition of Moore's sculpture took place in Florence in Forte di Belvedere in 1972. Although this site differed from all others photographed for this book in that it was not that of a permanent installation, the placement of Moore's work in this setting was such an ideal expression of his concept of sculpture displayed in the open air that it seemed appropriate to include a small selection of photographs taken at the Florence exhibition.

When Moore was invited to hold the exhibition, he wrote the following letter to the mayor of Florence:

"Hoglands"—Much Hadham
My dear Mayor,
I want to tell you how happy it makes me to have been invited to hold this exhibition of my work in your great city.
I have loved Florence since my first visit in 1925, as a young student spending a

five-month's travelling scholarship to Italy. It was the most impressionable stage of my development—out of the full five months, I stayed three months in Florence. At first it was the early Florentines I studied most, especially Giotto, because of his evident sculptural qualities. Later Masaccio became an obsession, and each day I paid an early morning visit to the Carmine chapel before going anywhere else. . . . Towards the end of my three months, it was Michelangelo who engaged me most, and he has remained an ideal ever since.

I have made many subsequent visits to Italy, of course, and always to Florence. For the last seven years my family and I have made our home in Tuscany for two months every summer, where I work on my marble sculptures, and when I need refreshing in spirit, in little over an hour from our house I can be in Florence surrounded by the great paintings and sculptures I love.

And so my close relationship with Florence grows, and I feel it is my artistic home. Therefore, this opportunity to hold an exhibition at the Forte di Belvedere, I accept with gratitude, but also with some apprehension!

No better site for showing sculpture in the open air, in relationship to architecture, and to a town could be found anywhere in the world than the Forte di Belvedere, with its impressive environs and its wonderful panoramic views of the city. Yet its own powerful grandeur and architectural monumentality make it a frightening competitor for any sculpture—and so I know that showing my work here would be a formidable challenge, but one I should accept: I know also that to realise the exhibition I must count on a lot of generous help from others.

May I, Mr. Mayor, thank you and your

committee, and all those who have given so much time and effort to make this exhibition possible.

Yours sincerely,
Henry Moore

Michelangelo did not, of course, design the space of the Forte di Belvedere for the purpose of exhibiting works of art, but if he had done so, he could not have been more successful. Throughout the area there are irregularly shaped spaces in which a particular work or a group of works can be given a magnificent setting. In the 1972 exhibition the Moore figures were seen against the glory of the Florentine landscape. On one side was the beautiful town itself; on others the lovely hillsides that roll out beyond the fort. In the interior settings gracefully shaped walls and other

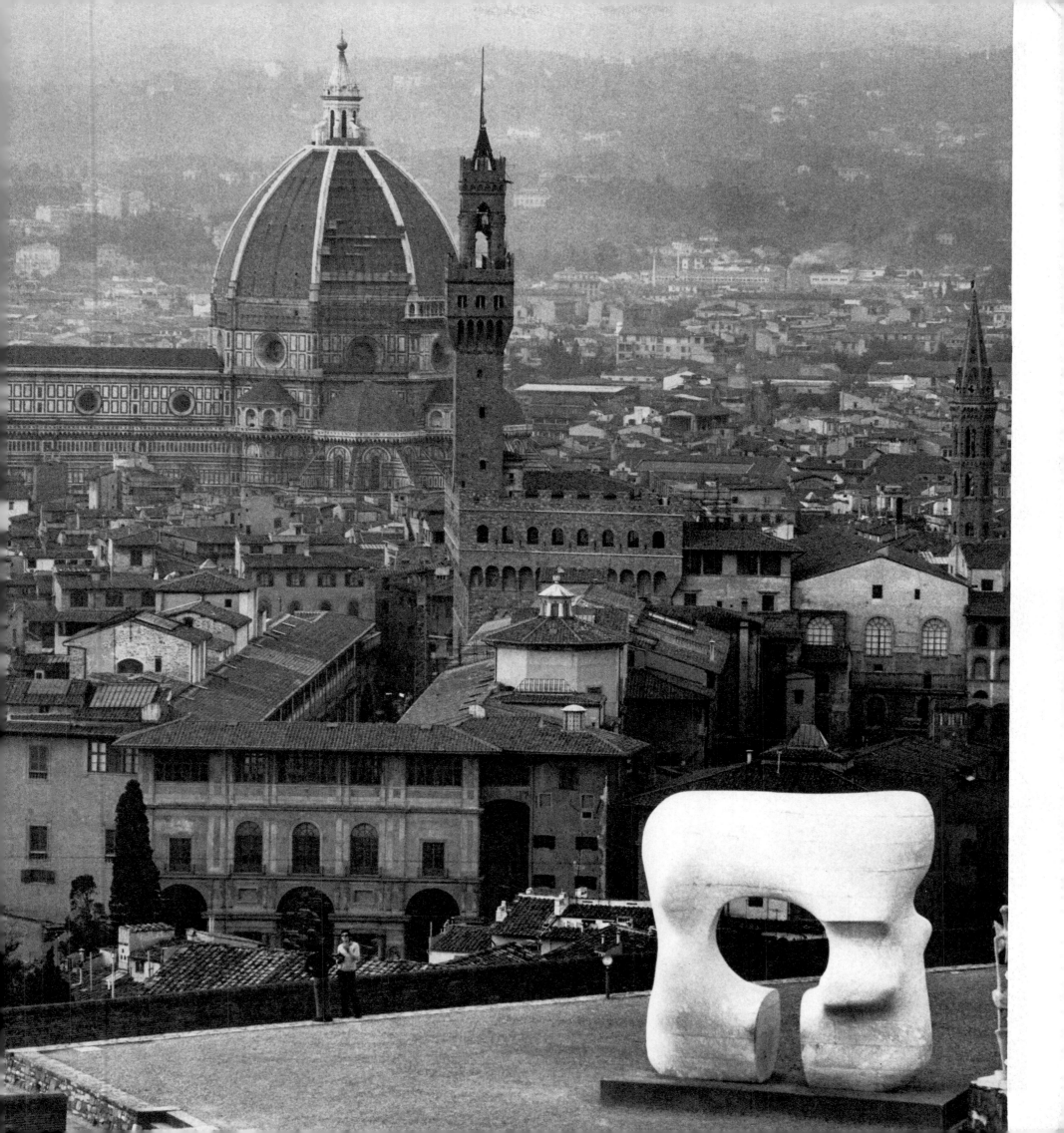

architectural elements provided equally fine backgrounds for some of the smaller figures.

What was so extraordinary about the Florence exhibition was that the background was itself an historic masterpiece, and the sculptures were challenged to live up to the measure of its greatness. The installation of the works was done with extraordinary sensitivity, taking full advantage of every opportunity provided by the site, and it is said that throughout the summer of the exhibition an unprecedented number of photographs were taken in this location by visitors who wanted to record their experiences.

My wife and I were not able to visit the exhibition until a week before it closed. I had arranged to meet Moore there, and we spent a few hours walking around the area. While I photographed the sculpture, Moore signed catalogues, answered questions for editors of several magazines from different

countries, was filmed for a television program about the exhibition, and talked to old friends who were there with their families. I never had such a difficult time photographing; there were so many people there, it was almost impossible to see the sculpture. I spent two whole days at the exhibition with my camera.

When I made the trip to Florence, I brought with me some photographs of the *Double Oval* in Purchase, New York (see pp. 368–73). By coincidence, *Double Oval* was one of the few major Moore sculptures not in the exhibition, and he seemed pleased to be reminded that his oeuvre was even larger than the remarkable collection of works that had been gathered together in the Forte di Belvedere.

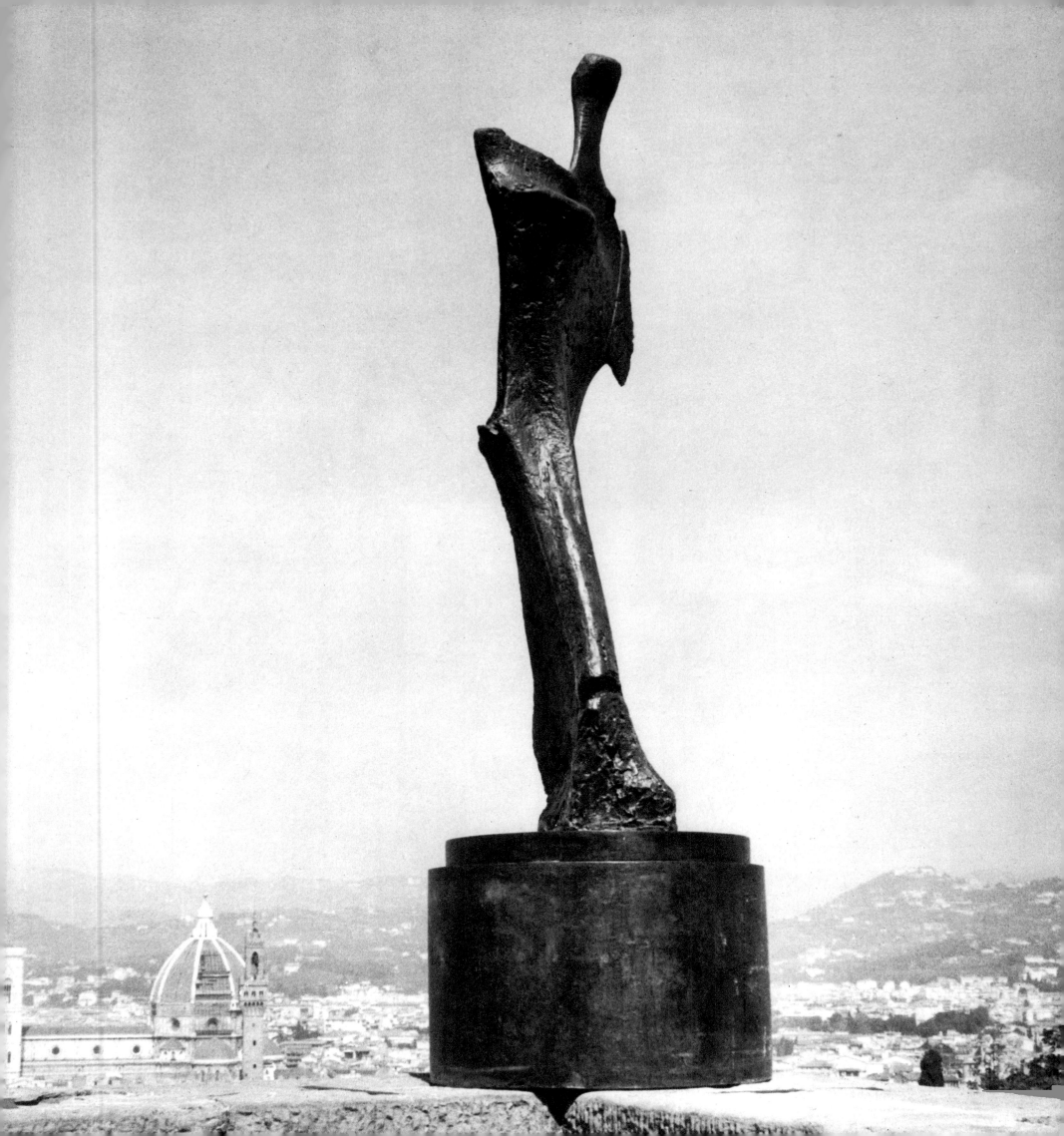

Only a few of the works at the Florence exhibition are shown here, many with backgrounds that show how marvelous the Moore sculptures looked in that unique setting:

The *Square Form with Cut* (1969–70, H. 55 1/4″, p. 477) had the place of honor in the exhibition and was located in a corner of the fort overlooking the heart of the city. This photograph, more than any other, captures the grandeur of this site as a setting for Moore's sculptures.

Standing Figure: Knife-edge (1961, H. 9′ 4″, p. 479) and *Standing Figure* (1950, H. 87″, p. 483) were both in impressive positions, standing on parapets and facing out into the vast expanse of the Florentine sky.

Two-Piece Reclining Figure: Points (1969–70, H. 12′ 6″, p. 476) is one of Moore's most powerful works. My wife and I own a cast of the working model of this piece, and

we both have found it a joy to live with.

The Arch (1963–69, 20′, p. 482), one of the fiberglass casts made especially for the exhibition, is now on the grounds of Moore's house at Much Hadham, England. It was interesting to compare the white version of this remarkable piece with the green-and-brown bronze casts I had photographed elsewhere (see pp. 342–45; 430–37; 462–63).

The color photograph of *Large Two Forms* (1969–70, H. 55 1/4″, p. 475), taken from a terrace above the sculpture, shows the beautiful effect of the fiberglass cast of this piece against the rich background of Florentine roofs.

Oval with Points (1969, H. 11′, p. 474) was located on a lovely stretch of lawn with forested hills in the background, but I chose a detail of the two points almost touching, which is one of my favorite photographs of the piece. (Somehow I was

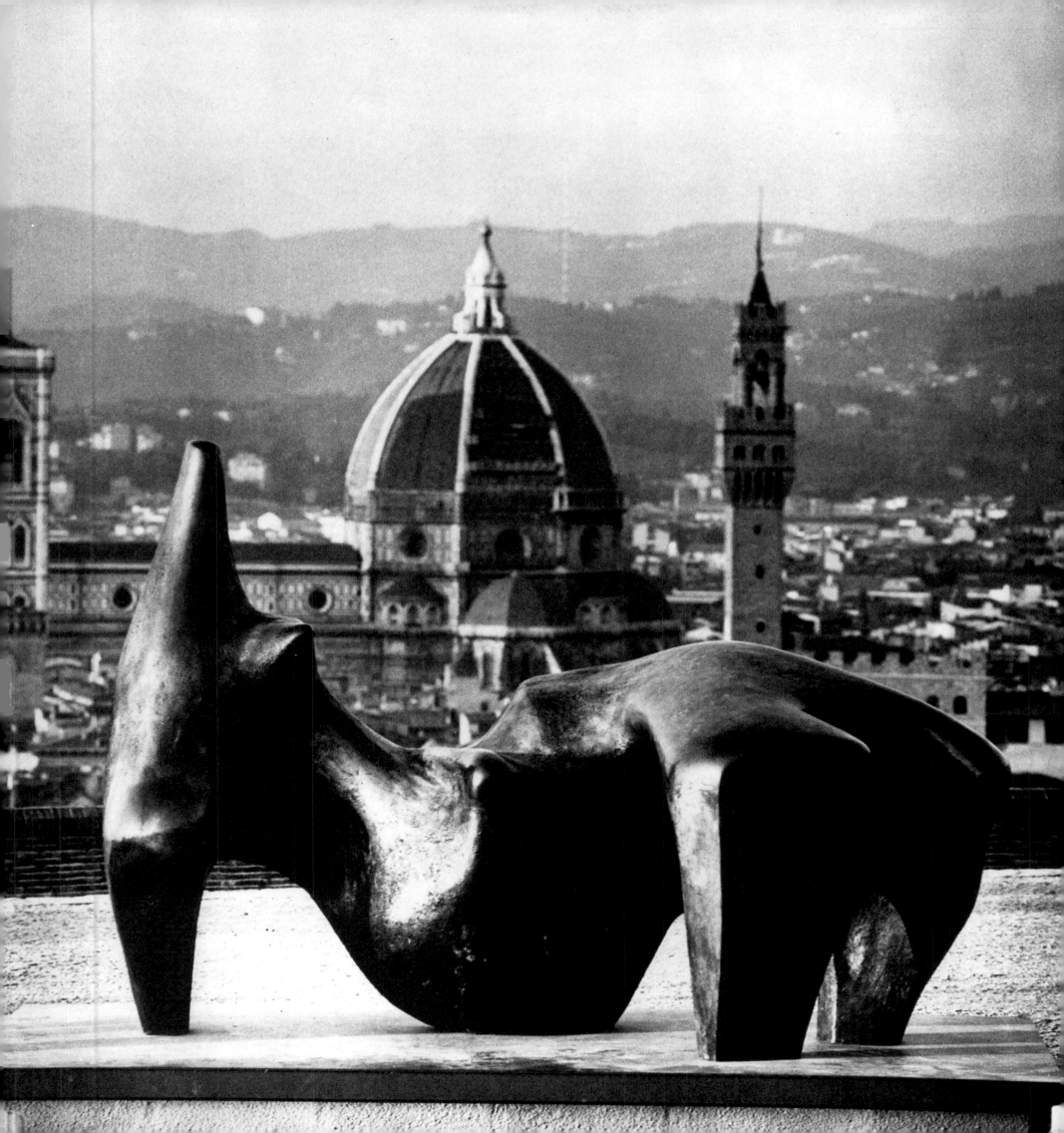

not able to get the same shot when I photographed another cast in Princeton; see pp. 410–15.)

Woman (1957–58, H. 60″, p. 478) was located toward the center of the grounds, where there was no view of the Florentine landscape, but, since I had not photographed the piece elsewhere, I have included a detail here.

Torso (1967, H. 42″, p. 480) was also in this area. There is an interesting story about the piece. When I first saw a cast of *Torso* in Moore's studio a few years ago, I mentioned that something about it did not seem right. He agreed and said that he was wondering about a long leg that stretched out from what is now a flat, round stump. He wasn't going to let the cast out of his hands until he made up his mind about it. The next time I saw the piece the long leg had been cut off, and the sculpture was in perfect balance. I thought this a wonderful example of Moore's rigorous self-criticism in the creation of his works, and I was delighted to see the piece in its final form at

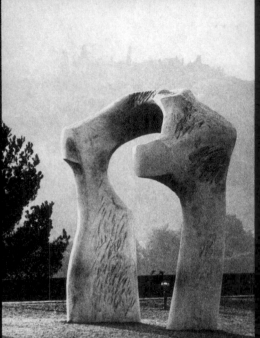

the Florence exhibition.

Reclining Figure (1969–70, L. 13′, p. 481) was set on top of Michelangelo's grand sixteenth-century terrace; with Brunelleschi's exquisite fifteenth-century dome (the Duomo of Florence Cathedral) and Arnolfo di Cambio's soaring fourteenth-century tower on the Palazzo Vecchio in the distance, it was the perfect location to show off Moore's mountainous, twentieth-century forms.

This cast of *Upright Motive #1: Glenkiln Cross* (1955–56, H. 11′, p. 484) was placed on one of the striking angular sections at the rear of the fort and looked most impressive against the outlying hills of Florence.

Moore was, of course, extremely pleased with the exhibition—it had been an enormous effort to plan, prepare, and set it up. It would be hard to find another sculptor of our time—or of any time—who had made so many monumental sculptures, of such variety, as to justify an exhibition of this sort.

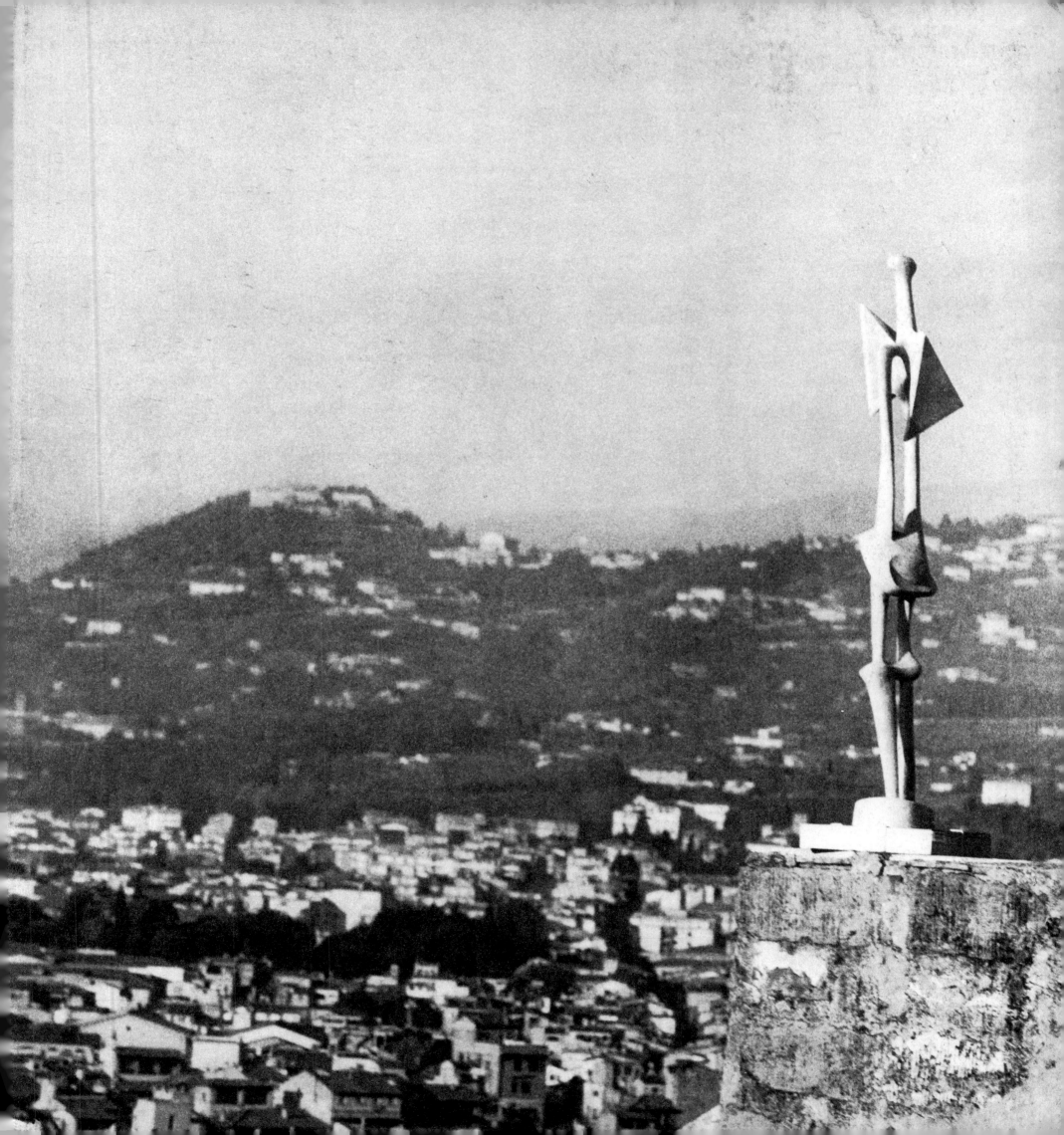

HENRY MOORE'S HOME
IN
MUCH HADHAM

These photographs were taken at "Hoglands," which is Moore's home in Much Hadham. Although there are no mountains in the distance to provide a background for the sculptures, and there are no seas or lakes or Renaissance towns against which the figures can be seen, there is something special about this site that can be found nowhere else in the world. For this is the one setting in which the sculptor himself has carefully and sensitively placed his own work, using the same intuitive vision that enables him to create the sculptures to find the right placement for them.

For Moore, selecting the site for each figure was not an impulsive or haphazard process. He carefully considered the background for each work, giving thought to the form and color of the sculpture in relation to surrounding trees, bushes, open stretches of lawn, and views of the sky. All of these factors also played a part in his judgment of

how high each sculpture should be from the ground and in what direction it should face.

The remarkable sensitivity with which the garden itself has been designed by the sculptor's wife adds much to the beauty of the setting. For while Henry Moore has been busy developing his archetypal forms, Irina Moore has devoted her creative energies to the garden. And as all visitors to Much Hadham can see for themselves, her achievements contribute a unique richness to the environment (see p. 493).

My wife and I have visited the Moores in Much Hadham several times a year for almost fifteen years, and seeing them has always been the high point of our trips abroad. Their simple sixteenth-century house adapted and expanded to provide room for their own collection of sculptures, paintings, drawings, and books, and with the lovely garden visible through the large windows— all this makes "Hoglands" an oasis in the busy industrialized world of the twentieth

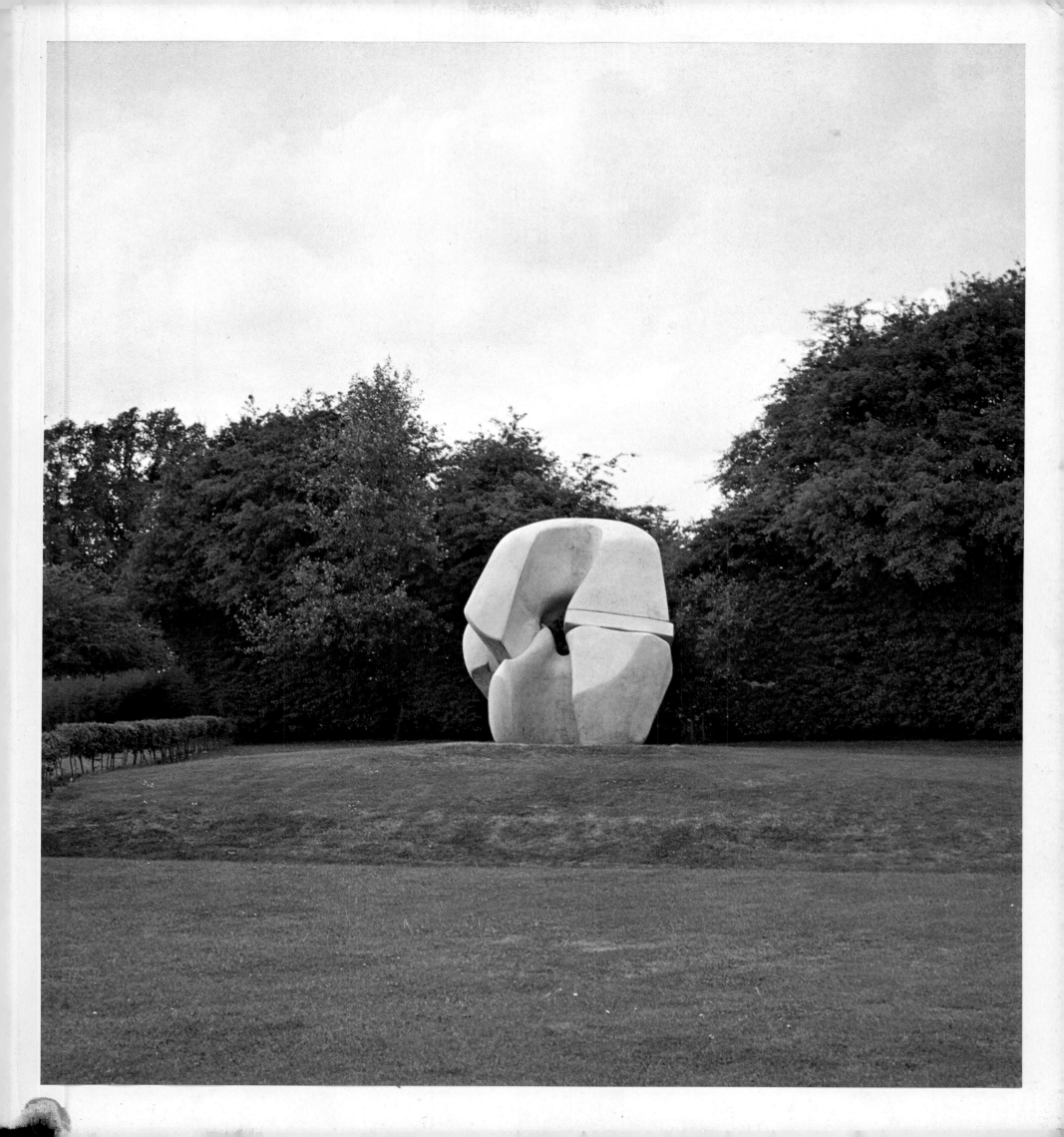

century. Whenever we have visited the Moores
we have enjoyed most the opportunity to sit
for a while in their warm and friendly
living room, with its fine works of art and
its table full of miscellaneous objects—one
of which is a small stone that Moore picked
up in Carrara, where he is convinced
Michelangelo dropped it over four hundred
years ago. We always take a walk to the
various studios on the grounds and enjoy
seeing the sculptures in the garden.

The large version of *Locking Piece*
(1963–64, H. 9′ 7 1/2″, p. 487) is
particularly striking in its setting against
the dark-green foliage.

A cast of *Sundial* (1955–56)
in front of the Time/Life Building is, I
believe, the only major sculpture in London
that I did not photograph; the smaller
version shown here is located near

the Moore house.

Draped Seated Woman (1957–58, H.
73″, p. 492); *Knife-edge: Two Piece* (1962–
65, L. 12′, p. 491); *Relief #1* (1959, H. 88″,
p. 490); and *Upright Motive #2* (1955, H.
10′ 6″, p. 486) are all located on a wide
stretch of lawn that Moore passes every day
as he walks from his house to his various
studios.

Sheep Piece (1972, H. 14′ 6″, p. 489) is
placed in the grazing pasture beyond the
studio where Moore works on his
maquettes. A window of that studio looks
out on the pasture, and the sculptor made
all of his beautiful drawings of sheep while
looking through that window. He has
watched the sheep through all the seasons
of the year, and talks about their habits as
if they were his good friends. Moore made
the *Sheep Piece* (which from some views

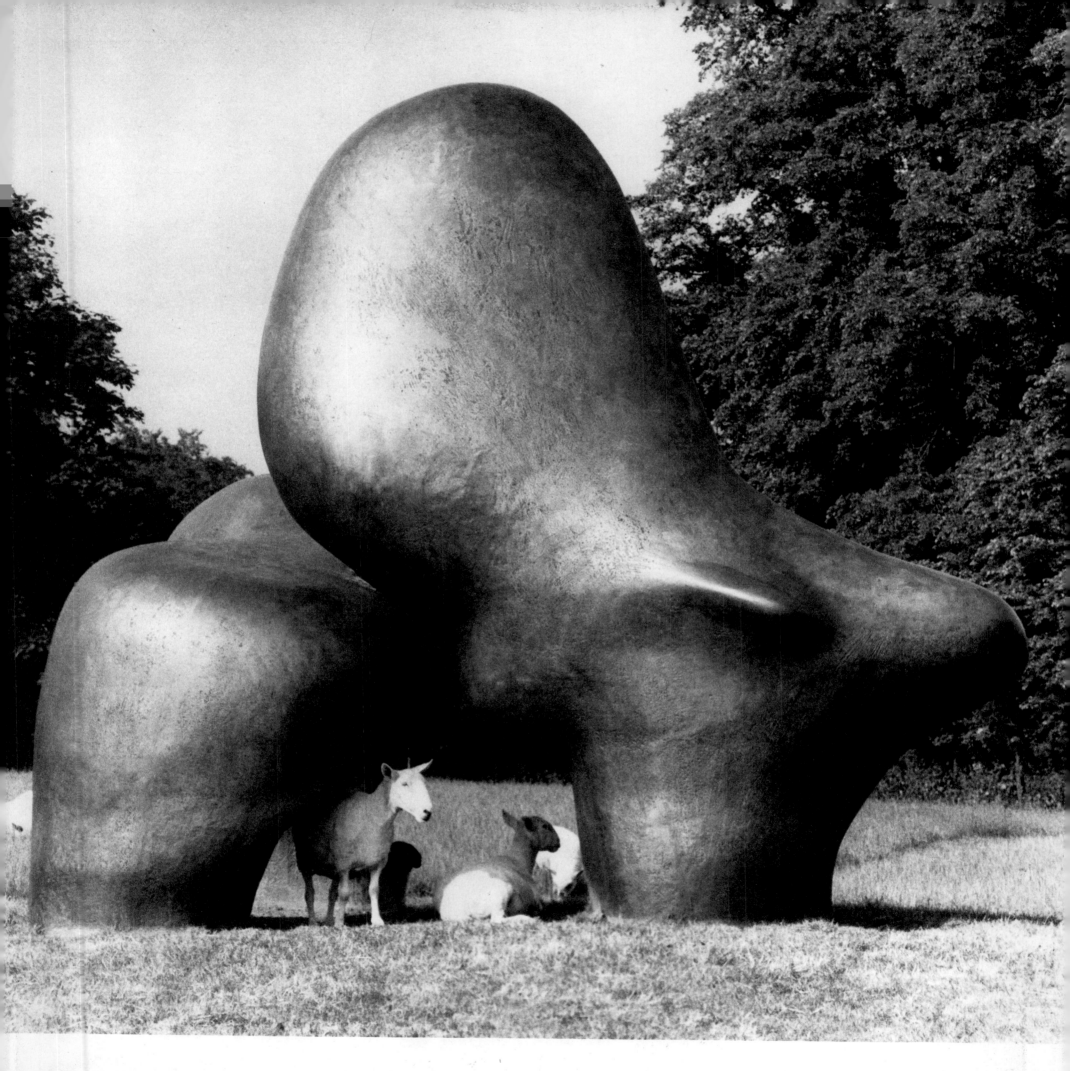

suggests two mating animals) as a gift to the sheep, for it is perfect in size for them to walk under and to rub against its inner surfaces, which the sheep like to do as a way of cleaning their wool. They usually gather around the sculpture in the late afternoon, and on one visit I was lucky enough to take a whole series of photographs showing these lovely objects of Moore's affection as they enjoyed to the full their gift from the great sculptor who is their friend.

The Moores have bequeathed their home in Much Hadham to the nation, so that one day it will be a museum that people can visit to see how the sculptor lived and worked during his lifetime. Because it will eventually be a public place in which to view Moore's sculptures, and because it is one of the finest settings one could find for many of his works, it seemed appropriate to close this book with a few pages of photographs taken on one of our recent trips to Much Hadham.

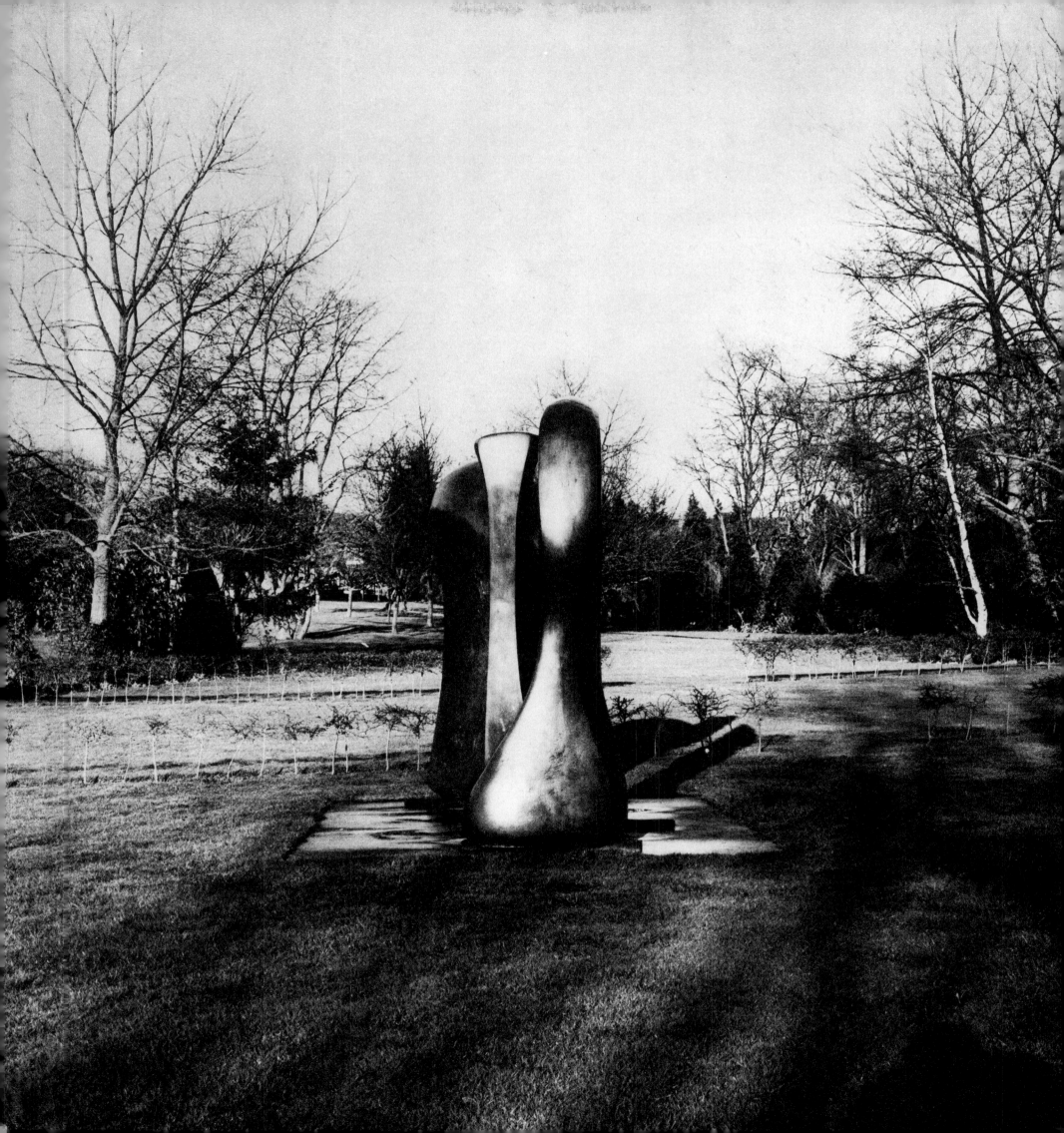